Handbook of Research on Heritage Management and Preservation

Patrick Ngulube
University of South Africa, South Africa

A volume in the Advances in Religious and
Cultural Studies (ARCS) Book Series

Published in the United States of America by
IGI Global
Information Science Reference (an imprint of IGI Global)
701 E. Chocolate Avenue
Hershey PA, USA 17033
Tel: 717-533-8845
Fax: 717-533-8661
E-mail: cust@igi-global.com
Web site: http://www.igi-global.com

Library of Congress Cataloging-in-Publication Data

Names: Ngulube, Patrick, editor.
Title: Handbook of research on heritage management and preservation / Patrick
 Ngulube, editor.
Description: Hershey, PA : Information Science Reference, 2017. | Includes
 bibliographical references.
Identifiers: LCCN 2017016106| ISBN 9781522531371 (hardcover) | ISBN
 9781522531388 (ebook)
Subjects: LCSH: Cultural property--Protection. | Museums--Collection
 management.
Classification: LCC CC135 .H357 2017 | DDC 069/.4--dc23 LC record available at https://lccn.loc.gov/2017016106

This book is published in the IGI Global book series Advances in Religious and Cultural Studies (ARCS) (ISSN: 2475-675X; eISSN: 2475-6768)

British Cataloguing in Publication Data
A Cataloguing in Publication record for this book is available from the British Library.

All work contributed to this book is new, previously-unpublished material. The views expressed in this book are those of the authors, but not necessarily of the publisher.

For electronic access to this publication, please contact: eresources@igi-global.com.

Advances in Religious and Cultural Studies (ARCS) Book Series

Nancy Erbe
California State University-Dominguez Hills, USA

ISSN:2475-675X
EISSN:2475-6768

MISSION

In the era of globalization, the diversity of the world and various cultures becomes apparent as cross-cultural interactions turn into a daily occurrence for individuals in all professions. Understanding these differences is necessary in order to promote effective partnerships and interactions between those from different religious and cultural backgrounds.

The **Advances in Religious and Cultural Studies (ARCS)** book series brings together a collection of scholarly publications on topics pertaining to religious beliefs, culture, population studies, and sociology. Books published within this series are ideal for professionals, theorists, researchers, and students seeking the latest research on collective human behavior in terms of religion, social structure, and cultural identity and practice.

COVERAGE

- Impact of Religion on Society
- Gender
- Cults and Religious Movements
- Human Rights and Ethics
- Politics and Religion
- Globalization and Culture
- Stereotypes and Racism
- Cross-Cultural Interaction
- Group Behavior
- Social Stratification and Classes

IGI Global is currently accepting manuscripts for publication within this series. To submit a proposal for a volume in this series, please contact our Acquisition Editors at Acquisitions@igi-global.com or visit: http://www.igi-global.com/publish/.

Titles in this Series

For a list of additional titles in this series, please visit: www.igi-global.com/book-series

701 East Chocolate Avenue, Hershey, PA 17033, USA
Tel: 717-533-8845 x100 • Fax: 717-533-8661
E-Mail: cust@igi-global.com • www.igi-global.com

List of Contributors

Table of Contents

Detailed Table of Contents

Section 1

Chapter 1

Patrick Ngulube, University of South Africa, South Africa

This chapter discusses the use of conceptual and theoretical frameworks in social science research with a focus on heritage studies. Incorporating theory or developing a conceptual framework is a critical part of the research design process. It assists in explaining the issue under study and refining the research questions. Linking theory and empirical constructs is fundamental to both quantitative and qualitative research, although some studies suggest that this is something that a number of researchers in the latter research tradition tend to ignore. Theories provide a theoretical framework for conceptualising research. Without a theoretical or a conceptual framework, the analysis of the findings results in a mere narration. Many researchers encounter difficulties in distinguishing between and using a conceptual framework and a theoretical framework as research tools. There are recurring doubts about their utility in the research endeavour and how one might select a good theory. Consequently, there is limited engagement with theory.

Chapter 2

Olefhile Mosweu, University of South Africa, South Africa
Lekoko Sylvester Kenosi, Qatar National Library, Qatar

Appraisal is defined as a set of recordkeeping processes involved with determining how long to keep records and what ultimately will become the archival representation for the future. It has been described as the most intellectually demanding, controversial, and debated issue in archival science. This is because there are different opinions regarding how records appraisal should be undertaken and thus no two archivists will approach records appraisal in exactly the same way due to the absence of a perfect formula. The objective of this chapter is to discuss appraisal theories and their applicability in appraisal practice. The thesis of this chapter is that any of the four appraisal methodologies would be able to select the future archive, including a combination of the various appraisal methodologies as it allows one to tap from the strength of each.

This chapter discusses archival access, archival programming, and archival advocacy and the manner in which these programmes are conducted within archival institutions, particularly in Africa. The chapter begins by defining the terms access, archival programming, archival advocacy, and outreach programmes and provides the parameters within which such programs and activities are executed. The chapter reveals that in many archival institutions, public programming is either lacking or does not receive adequate attention from senior management resulting in low utilization of archival materials. The chapter suggests various ways through which African archival institutions may publicize their holdings in order to reach out to potential users and manuscript donors.

The literature on action research and how it should be applied is extensive. However, this chapter is not intended to be a substitute for or to provide a synopsis of the substantial body of literature on action research. Its aim is instead to show the potential benefits of this underutilised research approach in heritage management research. Although there are many varieties of action research, the major elements of action research processes are action, research, and participation. Action research has a collaborative social change agenda, with democratic transformation being achieved through the participation of professional researchers and practitioners. It bridges the divide between the outsiders (researchers) and insiders (stakeholders), and differs from many conventional research strategies in that it identifies a problem and attempts to provide a solution that leads to a change in the community or organisation. The case study on developing a public programming strategy for archival institutions in South Africa presented in this chapter illustrates this point.

Makerere University archives are kept in Makerere University Library (Maklib) but their utilisation is limited. This chapter reports the findings of a study that analysed the types of archives in Maklib and the extent of their utilisation. A mixed method approach of a questionnaire, observation, and documents analysis was used. The data obtained was analysed as descriptive statistics. The population of the study included 302 Maklib users who visited the Africana Special Collection Section between May and June 2017. The findings revealed that the scope of the archives collection is limited in time and content, few users, limited publicity of existing records, deplorable state of the paper records, and long waiting time for the information to be provided. Recommendations include widening the collection, digitisation of the archives, further development of human resources capacity, and initiation of outreach programmes to boost the archives visibility and attract users.

Alistair G. Tough, University of Glasgow, UK

This chapter offers a reflection on the experience of writing a biographical study of one White British family resident in East and Central Africa over the greater part of the twentieth century. It offers also some tentative generalisations on the subject of White British diasporas in East and Central Africa and heritage provision for them. Questions of class and classification in the colonial services and in the commercial sphere are discussed. The difficulties that arise in studying people who served in the lower echelons of the colonial services—which the author characterises as the 'warrant officer' class—are considered and potentially useful source materials are identified. This discussion is illustrated with particular reference to the Carr family. The role of memory institutions in Africa is discussed in relation to White British diasporas and it is argued that provision for this group is currently neglected. The potential for ancestral tourism is briefly explored.

Ruth Mpatawuwa Abankwah, University of Namibia, Namibia

This chapter emphasises that audio-visual (AV) resources are very fragile and need to be stored in ideal conditions to preserve them for posterity. It describes different types of AV materials and the conditions under which they should be kept. It is based on a study that was conducted in the Eastern and Southern Africa Regional Branch of the International Council on Archives (ESARBICA) region. Data were gathered using quantitative and qualitative methods. The results revealed lack of equipment to monitor environmental conditions, absence of policies to govern the acquisition, appraisal, access, preservation, retention, digitisation and disposal of AV materials, and failure to apply the records life cycle (or any model) to AV records. The results point to a need for national archives to develop guidelines that apply to AV materials particularly in Africa. Particular attention should be given to training AV archivists in the region using an integrated curriculum.

Trywell Kalusopa, University of Zululand, South Africa

As the digital world unfolds, Africa continues to grapple with the issues of preservation and access of digital materials. This chapter demonstrates through a systematic literature review how Africa could learn from other efforts in the world to develop and guide their own strategic and policy options to deal with issues of preservation and access of digital materials. The chapter reviews literature on global or universal collaborative strategies and efforts on digital preservation initiated in the developed world as a learning curve for Africa. The current challenges of national and institutional capacities regarding the preservation of digital materials in selected African countries that have made some visible efforts and impact are also discussed. The chapter then makes several recommendations on the strategic and policy options for improving the state of material preservation, human and material requirements in order to improve the long-term preservation, and standards for the longer-term usability and interoperability of digital materials in Africa.

Concerns about sensitive content in born-digital records seem to be a major factor in inhibiting the deposit of public records in dedicated digital repositories in Western countries. These concerns are much exacerbated by the changed nature of the process of reviewing records. The University of Glasgow, working in collaboration with the Foreign and Commonwealth Office, received funding to investigate the technology-assisted sensitivity reviewing of born-digital records. As part of this research, some preliminary research in a commonwealth country in Sub-Saharan Africa was carried out. The research, reported in this chapter, was carried out in Malawi by the late Dr. Mathews J. Phiri. He found that already there is a real, albeit limited, demand for technology-assisted sensitivity reviewing of born-digital records in Malawi. The available evidence suggests that within the next decade there is likely to be an increase in the need for effective means of assessing sensitivity in born-digital records.

Heritage institutions, especially in developing countries throughout the world, have difficulties in achieving ideal environmental conditions in the preservation of paper materials. Concerns exist about improving environmental conditions in heritage institutions considering the limited storage facilities and resources in most developing countries in Africa. This chapter redefines suitable strategies for various environmental factors impacting preservation in heritage institutions in the East and Southern African Region. The chapter discusses effective activities, environmental factors, and explores knowledge and skills required for achieving ideal storage conditions. Furthermore, it discusses the key challenges of maintaining ideal and constant environmental conditions for paper-based materials particularly in developing countries where resources are limited. The chapter concludes by providing a recommendation of an environmental conditions management framework that can be used to effectively manage environmental conditions in heritage institutions.

A good record keeping system has a number of components that should be in place for the record keeping system to work optimally for the proper management of records in an organisation. This chapter presents and discusses the components of a recordkeeping system that include a records policy, people or staff, classification system, tracking, capturing business processes and controls, physical handling and storage, preservation, retention and disposition, Compliance monitoring and auditing, vital records protection and disaster preparedness, access, and training.

This chapter looks at the management of public sector records and archives in Botswana. The chapter starts with an overview of developments in the East and Southern African Regional Branch of the International Council on Archives (ESARBICA), which provides a foundation for discussion of developments in Botswana. It looks at the extent to which the Botswana National Archives and Records Services (BNARS) has fulfilled its role as the overseer of the creation, maintenance, use, disposition of public sector records, and preservation of the country's cultural heritage. It also looks at the impact of information and communication technologies and management of electronic records together with issues of staffing, training, and the challenges and prospects the country is faced with in managing records and archives as a symbol of cultural heritage. The chapter is based on an extensive review of the literature and the author's personal experience. It ends with recommendations on future directions.

The benefits of records management have been well documented; from preserving evidence and supporting accountability and transparency, to preserving nations' documentary heritage. Governments as with many other organisations have realised the importance of records management for good governance and have put in place policies, programmes and procedures aimed at managing their records effectively and efficiently. In spite of the many benefits that can be derived from records management and efforts made, challenges continue to be reported. This chapter discusses these challenges within the context of the records management programme of the Namibia public sector. The author cites studies conducted by various researchers on records management in a variety of public sector institutions ranging from central government, regional and local authorities and academic institutions. Some recommendations to address a number of the challenges identified are presented.

This chapter discusses the role of the archives legislation, the national archives, and the records and archives management (RAM) training institutions in nurturing public records and archives management in Uganda's public sector (UPS). Specific areas addressed include the legal framework and regulations related to recordkeeping, the role of the Uganda National Archives (UNA) and RAM education and training institutions that train records and archives managers in the delivery of their services. It also reports findings of a study that investigated issues, controversies, and constraints bearing on the management of public sector records and archives in government of Uganda ministries.

Section 2

This chapter contributes to theoretical debates in the study of the economics of cultural heritage conservation. In particular, it deals with the economic analysis, the effects, and the normative aspects of decision making on the preservation of artistic and historical heritage. The different concepts of conservation (re-use, restoration, preservation) are discussed from an economic and historical perspective. A formalised model is presented to ground the analysis. The most relevant dilemmas characterising the issue are studied on this basis. The impossibility of deriving optimum solutions from the market is argued together with the arbitrariness of all non-market decisions on this subject. The rejection of the current definition of conservation as "preservation" on economic grounds is therefore suggested, given its pure ideological nature.

According to a number of myths, the cultural effects of globalization and modernization have not really impeded East Asian countries' efforts towards cultural heritage preservation. In tandem with this, many "fascinated" members of the African intelligentsia view Eastern Asian nations such as China, South Korea, Japan, Singapore, Malaysia, and Thailand among others as true models to be emulated by their nations in the realm of cultural heritage preservation. This chapter examines the extent to which this thesis is plausible, through a critical study of the impact of globalization and modernization on cultural heritage preservation in China and Nigeria. The chapter begins by exploring the question of cultural preservation in an era of modernization and cultural globalization and ends up assessing the degree to which China and Nigeria's efforts towards cultural heritage preservation have been affected by cultural globalization and a West-dominated model of modernization.

The main aim of this chapter is to provide assistance to institutions and individuals involved in cultural heritage management (for example, contract work), especially entry level. An overview of important aspects to take note of are given and some are discussed in detail. The concept of protection as indicated in the National Heritage Resources Act, the methodology of heritage resources management (also known as CRM), the concept of cultural significance, and the way of dealing with graves are all defined. This is placed in a global perspective by including applicable international conventions related to the protection of heritage. Information on the cultural context within South Africa is given to provide an understanding of possible issues to be dealt with. The result is a reference guide for the management of the cultural heritage of South Africa.

The chapter discusses the South African museum sector in terms of changing museum functions as well as museum management. The research findings confirm the perception of a sector in crisis. Museum professional associations do not have the capacity to promote a professional museum service. Though there are museum professionals that keep up to date with museological trends and technology, a picture is painted of museums not supported by government departments, debilitating bureaucratic structures that hamper creativity and responsiveness to public demands, institutional performance structures that direct museums away from museum functions, problematic recruitment practices, and problematic models assessing the value of museums. Research is based on literature study, a review of the South African Museums Association Bulletin (SAMAB), a peer-reviewed journal dealing with museum matters, an analysis of policy recommendations of museum professional associations and interviews with the museum association leadership.

Museums in Zimbabwe often face several conservation challenges caused by different agents of deterioration. The Batonga Community Museum find it challenging to maintain and properly take care of the collections on display. This chapter examines the effectiveness of the conservation strategies being employed at the BCM. The study made use of qualitative and ethnographic research approaches. The majority of collections at the BCM are deteriorating at an unprecedented level. The study gathered that bats have posed serious and extreme conservation challenges as well as affected the presentation of exhibitions. The chapter concludes that bats are the main problem bedeviling the museum and needs immediate control.

The chapter challenges the concept of undefined, infinity, and indefinite retention periods of collections in Zimbabwe's state museums and underscores the need for each state museum to develop a collections management policy. The concept of indefinitely retaining collections characterizes Zimbabwe's National Museums. In that regard, this chapter interrogates issues surrounding collections management in Zimbabwe's state museums. Museums in Zimbabwe are overburdened with inherited collections from the past with limited supporting information. This coupled with the need to store contemporary collections congests the storage space in museums. A multiple case study approach was employed to examine the state of collections in three selected state museums in Zimbabwe. Findings revealed that collections in these museums have been inherited from the past collectors who amassed collections with limited information about them. There was no formal collections management policy. The chapter proposes a regime to guide museums in dealing with their collections.

Marlvern Mabgwe, Midlands State University, Zimbabwe
Petronella Katekwe, Midlands State University, Zimbabwe

This chapter evaluates the pattern and trend of mass media coverage of Zimbabwe's cultural heritage, with a focus on the newspaper publications produced between the years 2010 and 2015. The working hypothesis is that the level and nature of mass media coverage of cultural heritage is directly proportional to the nature of public opinion and attitude towards their own cultural heritage. As such, in order for cultural heritage to make a meaningful contribution to socio-economic and political developmental in Zimbabwe, there is a need for cultural heritage to be visible in all mass media productions. Using document analysis, questionnaires, and interviews, the research identified that the coverage of cultural heritage in mass media in Zimbabwe is alarmingly low. That jeopardizes the regard of cultural heritage as a driver for socio-economic and political development amongst the public. However, through reprioritization of media agenda-setting, media policy, and fostering of a closer collaboration between heritage managers and media professionals, the situation can be salvaged in Zimbabwe.

Foreword

Records and archives management as a discipline has continued to evolve through time and space, defying numerous obstacles that for centuries stood in its way to becoming a distinct profession.

A breakthrough came in the aftermath of the French Revolution which led to the establishment of the French Archives Nationale in 1789 and thereafter numerous other archival institutions across the world.

These two important developments in Europe inspired the development of many of the theories, principles, and practices that largely define the academic foundations of the study of records and archives management.

As the records and archives profession continues to experience rapid changes driven by technological underpinnings, it ought to be remembered that there can be no practice of records and archives management without reference to the underlying theories, principles and practices which have evolved over time and which today form the centerpiece of academic engagement and research in heritage studies.

This book by Prof. Patrick Ngulube examines a wide range of topical issues pertaining to the study of records and archives management within the broader context of heritage studies. The topics discussed range from the use of conceptual and theoretical frameworks in records and archives management to theories of appraisal; archival access and public programming; managing audio-visual archives and preservation and access to digital records. Other topics include managing public sector records and conservation of cultural heritage.

The broad range of personal reflections and insights by individual authors which are exhibited in this book together blend into a rich mix of ideas on archival theory and practice. The emphasis of this book though is on interpretation of archival theories and principles and their application to archival practice.

Justus M. Wamukoya
Moi University, Kenya

Preface

Ask any person on the street what heritage management is about and you will hear a variety of answers. Heritage management is partly about preserving the legacy of the past that is in the custody of memory institutions such as archives, libraries and museums. Archives, libraries and museums as sites of memory and heritage play a key role in the development of a knowledge-based society and a heritage conscious people. These heritage management institutions acquire, accession, arrange, describe, preserve and make accessible their collections and holdings for the sustainable development of humankind. Archives, libraries and museums as preservers of heritage assets are in the danger of declining, disappearing and destruction partially due to neglect, conflict, environmental factors, industralisation and globalisation. Collections and holdings cannot be available for the current and future generations if they are not managed properly. People who manage these heritage assets must be trained. Heritage theory and training are still at a nascent stage in many countries, particularly in the developing world.

There is a need to initiate intervention strategies that may ensure that archives, libraries and museums are managed for posterity. Heritage assets should be systematically managed by putting in place proper policies, maintenance procedures, security and risks measures, and retrieval, access and preservation plans. For these intervention strategies to be effective, they must be informed by research that is based on sound methodologies, theories and best practices. In addressing some of these issues, this handbook adopted an interdisciplinary approach in recognition of the fact that there is a convergence in the management of heritage institutions such as archives, libraries and museums. The common mission of archives, museum and libraries is to preserve and provide access to heritage holdings for the present and future generations.

Heritage management practitioners can ill-afford to operate in silos in the face of this convergence which is partly driven by information and communication technologies. Although there is a need for collaboration, rivalry among these institutions cannot be ruled out as they at times compete for the same funds and clientele. There is a need to expose the professionals in these fields and institutions to various facets of managing and preserving heritage assets in the wake of a changing information environment by providing a one-stop-shop of heritage management exemplars. That was the aim of this handbook when it was conceptualized. However, there were no substantial scholarly contributions from the field of libraries. Consequently, this handbook focuses more on archives and museums than libraries. Matters of the application of theories and research methodologies in heritage management, and the preservation strategies discussed by various authors in this book remain relevant to archives, libraries and museums. The various chapters in this handbook underscore aspects of heritage management that have a potential of fostering the sustainable management of heritage assets found in archives, libraries and museums.

This compilation of research on heritage management and preservation adds to the scholarly literature in the field. The book is a scholarly peer-reviewed, edited book. Two scholars reviewed each chapter through a double-blind methodology, plus the editor and some members of the Advisory Editorial Board also reviewed each chapter. Staff at IGI Global also reviewed the content for grammar, writing-style and format.

The book is structured into 21 chapters. The book is divided into two parts. The first 14 chapters deal with records management and archival admiration matters. The last seven chapters are devoted to issues related to monuments and museums. Except for the two major divisions of the text, the order of chapters is somewhat arbitrary. They can be read in any order. Some chapters may become more relevant in different heritage contexts than others. Many contributions underscore the need to properly manage heritage assets for posterity.

The first chapter discusses the use of conceptual and theoretical frameworks in research with a focus on heritage studies. The importance of these conceptual tools is presented and explained. It is apparent that without a theoretical or a conceptual framework research is partial. There should be a sustained engagement with theory in order to produce research which is theoretically sound. The second chapter presents various theories of appraising records and their applicability in appraisal practice. This chapter is a prelude to the next twelve chapters that are concerned with the management of records and archives. Appraisal is a highly contested archival practice. The chapter presents four major appraisal methodologies and demonstrates their strengths and weaknesses.

Chapter 3 discusses archival access, archival programming and archival advocacy with a focus on Africa. The chapter argues that in Africa, archival public programmes are either lacking or receive limited attention. Consequently, archival holdings are underutilised. The chapter suggests various ways through which archival institution in Africa may publicize their holdings in order to reach out to potential users and manuscript donors. Chapter 4 builds on theoretical block provided by Chapter 3 to show the potential benefits of using the action research approach in heritage management studies. The chapter presents a case study on developing a public programming strategy for archival institutions in South Africa to illustrate the potential of action research in answering certain heritage management research questions.

Chapter 5 extends the debate on access and the underutilisation of archival holdings. This case study discusses the underutilisation of archives kept in the Makerere University Library. This chapter reports the findings of a study that analysed the types of archives in the special collections in the Library and the extent of their utilisation. The findings revealed that the scope of the archives collection is limited in time and content, paper records are in a deplorable state and there is a lack of public programming programmes. The study recommends the widening of the scope of the collection, digitisation of the archives, further development of human resources capacity and initiation of outreach programmes to boost the visibility of the archives and attract users.

Chapter 6 discusses the role of memory institutions in Africa in relation to White British diasporas and demonstrate that people who served in the lower echelons of the colonial services are currently neglected. Heritage institutions should give attention to all collections relating to society irrespective of class as they are fundamental to heritage provision. This study reminds the readers of the various "absences" in our holdings and collections due to a variety of reasons. The chapter offers a reflection on the experience of writing a biographical study of one White British family resident in east and central Africa over the greater part of the twentieth century. Chapter 7 deals with audio-visual (AV) resources which

are also neglected in many archival institutions in the developing world. This chapter emphasises that audio-visual (AV) resources are very fragile and need to be stored in ideal conditions to preserve them for posterity. It is based on a study which was conducted in the Eastern and Southern Africa Regional Branch of the International Council on Archives (ESARBICA) region. The results revealed a lack of equipment to monitor environmental conditions, an absence of policies to govern the acquisition, appraisal, access, preservation, retention, digitisation and disposal of AV materials, and a failure to apply appropriate models in the management of AV records.

Chapter 8 addresses the problem of preserving and providing access to digital materials. Digital materials pose a challenge to archives, libraries and museums in Africa. This chapter reviews the literature on global collaborative strategies and efforts on digital preservation initiated in the developed world as a learning curve for Africa. The chapter makes several recommendations on the strategic and policy options for improving the state of digital material preservation and human and material requirements in order to improve the long term preservation, usability and interoperability of digital materials in Africa. Chapter 9 continues with the debate on digital materials. The author argues that concerns about sensitive content in born-digital records seem to be a major factor in inhibiting the deposit of public records in dedicated digital repositories in Western countries, The University of Glasgow, working in collaboration with the Foreign and Commonwealth Office, received funding to investigate the technology-assisted sensitivity reviewing of born-digital records. As part of this project, research which was conducted in Malawi found that already there was a real, albeit limited, demand for technology-assisted sensitivity reviewing of born-digital records in Malawi.

Preservation challenges are not limited to digital materials. Chapter 10 demonstrates that heritage institutions, especially in developing countries throughout the world, have difficulties in achieving ideal environmental conditions in the preservation of paper materials. This chapter redefines suitable strategies for various environmental factors prevalent in heritage institutions in the east and southern African region. The chapter concludes by providing a recommendation of an environmental conditions management framework that may be used to effectively manage environmental conditions in heritage institutions in a given context.

The benefits of records management include preserving evidence, supporting accountability and transparency, fostering justice and human rights, and preserving nations' documentary heritage. Using the existing literature, Chapter 11 presents the components of a good record keeping system that may facilitate the proper management of records in an organisation. The next three chapters discuss the management of public sector records in the context of Botswana, Namibia and Uganda. These case studies are fundamental to building theories about the management of records in the African environment. Chapter 12 looks at the management of public sector records and archives in Botswana. The chapter is based on an extensive review of the literature and the author's personal experience. It ends with recommendations on future directions for research. Using the same approach as Chapter 12, Chapter 13 discusses the records management programme of the public sector in Namibia. Chapter 14 discusses the role of the archives legislation, the national archives; and the records and archives management training institutions in nurturing public records and archives management in the public sector of Uganda. It also reports findings of a study that investigated constraints relating to the management of public sector records and archives in government ministries of Uganda. Chapter 14 concludes the section on the management of records and archives. The next section deals with the management and preservation of heritage assets in museums and monuments.

Chapter 15 serves as a reminder that the economics of cultural heritage conservation are fundamental to the preservation of heritage assets in archives, libraries and museums. This chapter contributes to theoretical debates in the study of the economics of cultural heritage conservation. In particular, it deals with the economic analysis, the effects and the normative aspects of decision-making on the preservation of artistic and historical heritage. A formalised model is presented to ground the analysis. The rejection of the current definition of conservation as "preservation" on economic grounds is suggested, given its pure ideological nature.

Museums perform an important role in the preservation of cultural heritage on behalf of society. The next five chapters present various case studies on the management of museums. Chapter 16 explores the question of cultural preservation in an era of modernization and cultural globalization and assesses the degree to which China and Nigeria's efforts towards cultural heritage preservation have been affected by cultural globalization and a West-dominated model of modernization. Chapter 17 provides a South African context of heritage management. After giving the discussion a global perspective, a reference guide for the management of the cultural heritage of South Africa is provided.

Chapter 18 also addresses the South African context by discussing the South African museum sector in relation to the changing museum functions as well as museum management. The research findings confirm the perception of a sector in crisis. Museum professional associations do not have the capacity to promote a professional museum service. Though there are museum professionals that keep up to date with museological trends and technology, a picture is painted of museums not supported by government departments, debilitating bureaucratic structures that hamper creativity and responsiveness to public demands, institutional performance structures that direct museums away from museum functions, problematic recruitment practices and little or no understanding of models that are used to assess the value of museums.

The next three studies provide case studies from Zimbabwe. Chapter 19 examines the effectiveness of conservation strategies employed at Batonga Community Museums. The research observed that the majority of ethnographic collections at the museums are deteriorating at an unprecedented level. Chapter 20 investigates the concept of undefined, infinity and indefinite retention periods of collections in selected state museums in Zimbabwe. The findings of the study revealed that collections in these museums have been inherited from the past collectors who accumulated collections without fully describing them. The chapter underscores the need for each state museum to develop a collections management policy. Chapter 21 concludes this section. The chapter sought to find out the extent to which Zimbabwe's rich cultural heritage had featured as news in Zimbabwe's print media between 2010 and 2015. Using content analysis, questionnaires and interviews, researchers identified that print media (in the form of newspapers) in Zimbabwe had an alarmingly low level of coverage of cultural heritage issues. The authors argued that the situation can be addressed by reprioritising the media agenda and fostering cooperation between heritage scholars and the media fraternity. Only then can aspirations around cultural heritage resources enshrined at national, regional and global levels towards revitalization of human development may become tangible.

The chapters presented in this book provide a sounding starting point in managing and preserving the rich cultural heritage in the custody of archives, museums and archives.

Enjoy the read!

Patrick Ngulube
University of South Africa, South Africa

Acknowledgment

This book would not have been possible without the help, guidance and great support that I have received from so many people over the years. I am grateful to all of those with whom I have had the pleasure to work during this project. Specifically, I wish to acknowledge the valuable contributions of the reviewers who acted as gatekeepers and quality assured and checked the coherence, and content presentation of chapters. Some of the authors also served as referees; I highly appreciate their double task. I am also indebted to the authors whose work appears herein. Their commitment to their work and to this project was sterling. Marianne Caesar at IGI Global maintained a steadying hand through the process of developing this book. I will use the same opportunity to thank all the copyright holders who granted some authors the right to use their work in this book. All this would not have been possible without the support of my family, and close friends from the indigenous community.

Section 1

Chapter 1

Overcoming the Difficulties Associated With Using Conceptual and Theoretical Frameworks in Heritage Studies

Patrick Ngulube
University of South Africa, South Africa

ABSTRACT

This chapter discusses the use of conceptual and theoretical frameworks in social science research with a focus on heritage studies. Incorporating theory or developing a conceptual framework is a critical part of the research design process. It assists in explaining the issue under study and refining the research questions. Linking theory and empirical constructs is fundamental to both quantitative and qualitative research, although some studies suggest that this is something that a number of researchers in the latter research tradition tend to ignore. Theories provide a theoretical framework for conceptualising research. Without a theoretical or a conceptual framework, the analysis of the findings results in a mere narration. Many researchers encounter difficulties in distinguishing between and using a conceptual framework and a theoretical framework as research tools. There are recurring doubts about their utility in the research endeavour and how one might select a good theory. Consequently, there is limited engagement with theory.

INTRODUCTION

Conceptual or theoretical frameworks serve as the glue that holds the components of social research together, and in the absence of this glue, the research design falls apart. These conceptual tools give focus and direction to empirical research; the implication, therefore, is that theory is inseparable from research, and that conducting research without either a conceptual or theoretical framework is inconceivable. A conceptual or theoretical framework enhances the goals of research, and research conducted without either one is poor. As Suddaby (2015) observes: "Knowledge accumulation simply cannot occur without a conceptual framework" (p. 2). Furthermore:

DOI: 10.4018/978-1-5225-3137-1.ch001

Scuttling theoretical and conceptual frameworks is taking the risk that we accept answers that may leave out major parts of the whole, misinterpret the meaning of the findings, or miss incongruencies and contradictions. (Ivey, 2015, p. 153)

If used appropriately, conceptual and theoretical frameworks can enrich and enhance research (Cooper & Meadows, 2016), and they help researchers to reflect on their work and develop a "more critical sensitivity towards the activity of social research" (Cooper & Meadows, 2016, p. 20). Researchers are prompted by theory to consider the justification for their research, and their responsibilities and obligations in research. In other words, theory compels researchers to reflect on their role in knowledge production and its value to their field. Concepts and theories are the conceptual tools that provide direction and meaning to a research enterprise and help to identify its implications. Furthermore, the way in which data is collected and interpreted depends on the researcher's conceptual or theoretical perspective.

Many researchers, including heritage management professionals, find developing and using theoretical and conceptual frameworks difficult because the extant literature offers limited guidance (Grant & Onsanloo, 2014; Green, 2014; Ngulube, Mathipa, & Gumbo, 2015). Consequently, some researchers misuse theory. Identifying and applying theoretical or conceptual frameworks is not straightforward, since they are not found "readymade in the literature" waiting for researchers to apply them (Maxwell, 2012, p. xi). There are a number of misconceptions about theory that have contributed to its abuse and limited application. The limited application of theory or conceptual tools by researchers in heritage management may be partially attributed to the relative immaturity of heritage studies as a field as compared with disciplines such as education, medicine and physics. In this regard, May (2001) makes the following observation:

The idea of theory, or the ability to explain and understand the findings of research within a conceptual framework that makes 'sense' of the data, is the mark of a mature discipline whose aim is the systematic study of particular phenomenon. (p. 29)

As this quotation suggests, a discipline is considered to be mature if it can articulate and apply theory in the valuation and production of knowledge. Although Chapter 2 is devoted to the discussion of theory in archival science, Heritage Studies appears to have a weak theoretical base, and that tends to undermine its development as a discipline. Heritage management researchers should engage rigorously with theory, bearing in mind that theoretical development and practical improvement can be reciprocal. Research conducted in the absence of theory may be problematic for the advancement of heritage management as a discipline.

One does not cease to be practical when one engages with theory. Practice is fundamental to theorising, because it provides a platform for testing theories and generating questions for further research. Theoretically sound research has the potential to inform practice appropriately and establish sound practice guidelines. Theorising and conceptual framing may provide a deeper understanding and explanation of certain processes, actions, events and structures related to the management of heritage assets, including libraries, museums and archives.

The notions of a theoretical framework and conceptual framework have been explained differently by different scholars. The terminology applied to them tends to be loose, inconsistent and at times contradictory, and one is left wondering what the correct terminology in fact is. In some of the literature, theoretical frameworks are referred to as conceptual frameworks (Ocholla & Le Roux, 2011; Maxwell,

2013). Ravitch and Riggan (2012, p. xiv) posit that a theoretical framework is an aspect of a conceptual framework. As will be discussed later, we consider a conceptual framework to be an aspect of a theoretical framework, because a conceptual framework may be made up of concepts or aspects or parts of a given theory or theories. The major similarity between a theoretical framework and a conceptual framework is that they are both conceptual tools that are fundamental to empirical research.

The six objectives of the present chapter are to enable readers to:

- Understand the terminology relating to the concept of theory in social sciences;
- Grasp the potential contribution of theoretical and conceptual frameworks to heritage research and practice;
- Distinguish research paradigms from a theoretical research framework;
- Appreciate the differences between a conceptual framework and a theoretical framework; and
- Apply a conceptual or theoretical framework to their research.

The rest of this chapter is organised into eight sections. First, the relationship between models, concepts and theory is discussed. Theory construction and use (induction, deduction and abduction) is then considered, after which the distinction between research paradigms and a theoretical research framework is examined. The differences between conceptual and theoretical frameworks are reviewed, followed by a discussion of the stages in the research process when theory is used. The strategies for identifying and applying conceptual and theoretical frameworks are considered. The application of theory in heritage studies is examined before, last of all, some areas for further research are suggested.

MODELS, CONCEPTS AND THEORIES

Although these three key terms associated with conceptual and theoretical frameworks are not synonymous, they overlap and share elements of meaning, as will be demonstrated shortly. The terms "models" and "theory" are on occasion incorrectly used interchangeably and uncritically (Gunnell, 1969; Ngulube et al., 2015). This is not entirely surprising, as conceptual conflations and confusion are part and parcel of our modern legacy. A theory predicts or explains a phenomenon, whereas a model merely describes it. A model can be used to depict or illustrate a theory; theorists use models to order and simplify their view of reality by outlining characteristics that are relevant to the problem to be investigated so as to operationalise the nature of relationships among concepts. There are a variety of models that may be used to represent certain aspects of the real world. Modelling can be used as an approach to theory construction – an example of this is mathematical modelling, in which relationships between variables are described mathematically based on functions. First of all, variables to be included are identified, after which the metrics on which the variables are measured are determined (Jaccard & Jacoby, 2010).

Social scientists do not often use mathematical modelling because of the complexity of the mathematical operations involved. However, on occasion they do use mathematical models such as structural equation models, chaos theory models, catastrophe theory models, Bayesian probability models, expected-utility models, linear regression models and information theory models (Jaccard & Jacoby, 2010). Models are embedded in theories. A model is a "formal representation of exactly how a theory might be realised, showing how the explanatory factors are (1) to be measured, (2) predicted to be linked with each other

and (3) how they relate to what is being described or explained" (Six & Bellamy, 2012, p. 35). Models may be used to test or represent a theory.

Concepts are terms or words that represent a particular aspect of reality or object. Concepts are the building blocks of a theory, as illustrated in Figure 2. In other words, a theory is based on the relationship between a set of concepts. Concepts applied in a research project should be defined in order to "clarify the theoretical focus of your research" (Hennink, Hutter, & Bailey, 2011, p. 39), and to operationalise the research questions in research instruments such as questionnaires and interview guides. Scientists begin the process of research by forming concepts (Frankfort-Nachmias & Nachmias, 2008, p. 24); concepts constitute a professional language in a given context, and they are used to classify and structure experiences and observations.

Concepts are the ingredients of theories. Theories involve relationships between concepts and variables, and they explain, describe, predict or control aspects of social reality. Researchers use theories to explain or interpret research findings. Theories, frameworks and models help researchers to see what lies behind the data, and theories connect all "propositional knowledge we have about a topic of interest and offer explanations for why something is the way it is" (Cronin, Coughlan, & Smith, 2015, p. 5). Theories apply across many situations with few limiting conditions, and in some cases theories compete with one another. Researchers should be able to evaluate the existing theories and choose one that is relevant to their inquiry, based on some of the criteria discussed later.

Although Suddaby (2015) is of the view that there is widespread agreement on what theory is, the definition of theory is in fact hotly contested. Some researchers, such as Adams, Cochrane and Dunne (2012) and Llewelyn (2003), identify theory with any form of conceptualisation. This makes it very difficult to establish common ground regarding the nature of theory. For instance, Adams et al. (2012) state:

Theory has a multitude of meanings, not all of which can be easily reconciled, making it a concept open to wide appropriation. For example, theory can simply mean an idea about a social configuration, or it can mean an intellectual formula that enables one to structure experience (or data), in terms of research; sometimes it is used broadly and is synonymous with philosophy, or it is used specifically as an interpretive description of experience. Theorizing can be an expansive business, in that it can be thought of as an act that generates new ways of thinking about the way the world is configured, and may be generalized and transferred to a multitude of new concepts in the expectation that it will throw light on them. (p. 1)

A theory may be defined as "a set of interrelated variables, definitions and propositions that specifies relationships among the variables" (Collis & Hussey, 2014, p. 51). In other words, a theory is a relationship between concepts. Thus, "[t]heory consists of plausible relationships produced from concepts and sets of concepts" (Strauss & Corbin, 1994, p. 278). Even the most commonly quoted definition (Nieswiadomy, 2012, p. 83) formulated by Kerlinger (1973) underscores these aspects of a theory.[1] These definitions demonstrate that the understanding "of what theory 'is' in the social sciences has grown up in the shadow of what theory 'is' in the natural sciences" (Llewelyn, 2003, p. 664). The common understanding of theory in the social sciences, as it is in the natural sciences, is that theories are made up of interrelated concepts and the relationships between them (Nieswiadomy, 2012). Propositional statements are theoretical statements that specify relationships between related concepts. Components of a theory (i.e., concepts) may be used as a conceptual framework of a study, as will be explained later. A theory provides an explanation of reality. When someone has a theory about something, this means that they are able to explain how and why things work the way they do.

Theories may be loosely divided into grand theories and middle-range theories. According to Jaccard and Jacoby (2010), "grand theories are seen as comprehensive, inclusive theories of human behaviour and society, whereas middle-range theories are more focused accounts of specific phenomena" (p. 296). Grand theories include developmentalism, dependency analysis, institutionalism, rational choice, Freudianism, environmentalism, materialism, structuralism and evolutionary perspectives. Theories in this category form the basis of middle-range theories, which are the focus of this chapter. More detailed overviews of grand theories appear elsewhere (e.g., Matson, 2012; Wiarda, 2010). Grand theories are more common in the natural sciences than in the social sciences (Camp, 2001) and they cover a wider scope than middle-range theories, which fall between "minor hypotheses" and "grand theories" (Merton, 1968, p. 39).

Merton (1968) introduced the notion of middle-range theory to "bridge the chasm between grand theory and abstracted empiricism" (Pawson, 2000, p. 286). Merton was opposed to the development of a total theoretical system that purported to explain all aspects of social phenomenon, preferring

theories that lie between the minor but necessary working hypotheses that evolve in abundance during day-to-day research and the all-inclusive systematic efforts to develop a unified theory that will explain all the observed uniformities of social behaviour, social organisation and social change. (Merton, 1968, p. 39)

Merton's theorising integrates theory and empirical research. Middle-range theories are powerful for their descriptive, relational and explanatory power, and they may be employed in descriptive, correlational, and experimental research designs respectively. Descriptive research, including case studies, surveys, grounded theory, ethnographies and phenomenological studies, generates and tests descriptive theories. Descriptive theories answer the question: What is this? (Diers, 1979, p. 103). Their focus is on factor-searching. Relational theories that specify, for instance, relations between events, situations, individuals and groups are developed after descriptive theories have been validated. They answer the question: What's happening here? (Diers, 1979, p. 125). They are concerned with searching for relationships. Lastly, experimental research generates and tests explanatory theories. It deals with cause and effect, that is, the "why" of changes in a phenomenon; the question that is answered is: What will happen if…? (Diers, 1979, p. 145). The experimental design is predictive, and its focus is on association-seeking.

The use of these types of theory depends on the research question. A theory must be used for its descriptive, relational, or explanatory value rather than for any other reason. Thus, theories explain and predict phenomena and help researchers to answer the "what", "how" or "why" of a particular phenomenon.

Following Parsons and Shils (1962, pp. 50–51), theorising may be further classified as ad-hoc classificatory systems, categorical systems or taxonomies, conceptual frameworks and theoretical systems, as illustrated in Figure 2. At the lowest level of the theorising hierarchy illustrated we find ad-hoc classificatory systems. Ad-hoc classificatory systems are characterised by arbitrary categories constructed in order to organise and summarise research data. These systems simply arrange observations, and are not derived from a theory of social order (Frankfort-Nachmias & Nachmias, 2008). For instance, a heritage studies researcher might use the Likert scale of measurement to categorise responses to the questionnaire statement, "All heritage institutions are aggressively promoting their collections after realising that low patronage results from the low level of awareness of their collections and holdings by the public" into five categories: "Agree", "Strongly Agree", "No Opinion", "Disagree", and "Strongly Disagree".

Figure 1. Levels of theorising in social research

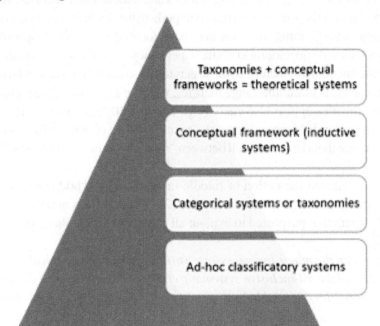

Categorical systems or taxonomies are the second level of theory. They consist of categories constructed to fit empirical observations (Parsons & Shils, 1962). Taxonomies define and summarise categories, and enable researchers to describe relationships among categories (Frankfort-Nachmias & Nachmias, 2008). Conceptual frameworks systematically place descriptive categories in a structure of explicit propositions. Although conceptual frameworks belong to a higher level than taxonomies because their "propositions summarize behaviors as well as provide explanations and predictions for vast numbers of empirical observations" (Frankfort-Nachmias & Nachmias, 2008, p. 35), unlike theories they have limited explanatory and predictive power. This is because they depend on empirical observation in the earlier stages of theorising.

As shown in Figure 1, taxonomies and conceptual frameworks constitute theoretical systems in that they systematically relate descriptions, explanations and predictions (Frankfort-Nachmias & Nachmias, 2008). The propositions of a theoretical system are interrelated in a manner that allows some to be derived from others. Although a theoretical system consists of a set of propositions as a conceptual framework, the propositions in the latter form a deductive system. Propositions from a conceptual framework are not established from an *a-priori* set of universal generalisations.

THEORY CONSTRUCTION AND USE

Theory construction is done inductively, and is used deductively and abductively. Deduction has been characterised by Babbie (2007) as the "derivation of expectations and hypotheses from theories" (p. 57) and induction as the "development of generalisations from specific observations" (p. 57). For instance, theory may be developed using the grounded theory and case study approaches through induction. Simi-

lar findings from multiple cases can be used to develop a general theory to cover all the cases. In other words, a set of observations is used to develop a theory about a phenomenon. On the other hand, the grounded theory approach builds relationships between concepts in the data generated from an investigation in order to construct or discover a theory. Qualitative research, which is inductive in approach, is a generator of many theories that are used by quantitative research, which is deductive in nature.

It is important to bear in mind that even if qualitative research is inductive, designing a qualitative study is based on deductive reasoning in the sense that the extant literature or existing theory is used to "deduce or develop a deductive conceptual framework, which is used to guide the data collection" (Hennink et al., 2011, p. 32). Whether one is doing grounded theory as propounded by Glaser and Strauss (1967) or ethnomethodology (Garfinkle, 1967), it is impossible to completely ignore pre-existing ideas, values, theories and beliefs. Data collection in the research process is guided by pre-existing knowledge (Hennink et al., 2011). The literature and theory provide preliminary theoretical knowledge that helps in the conceptualisation of research. The research process does not start as a *tabula rasa*. It is noteworthy that this is in line with coherence theory, which posits that scientific claims are true when they are logical and compatible with pre-existing knowledge. Clearly, there is a relationship between existing knowledge and knowledge that is yet to be explored and described.

Pre-existing knowledge is embedded in the extant literature and theories. Other qualitative researchers such as Wengraf (2001) and Maxwell (2013) emphasise the importance of theory in research in general and qualitative research in particular. Maxwell (2013) states that theory is an essential ingredient of any research design because it guides other design decisions made during the research process. Linking theories to a research design is "a crucial insight associated with qualitative research, but one underestimated, ignored or even denied by researchers declaring themselves to be 'qualitative'" (Wengraf, 2001, pp. 55–6). Clearly, incorporating theory in research is crucial to both qualitative and quantitative researchers, and by implication to mixed methods research (MMR).

It is vital to underscore the point that the rejection of theory in the 1960s by qualitative researchers such as Glaser and Strauss (1967) should be seen in light of the "widespread dissatisfaction with the development of theory in the social sciences" during that time (Flick, 2014, p. 67). There was a shift from the use of grand theories that attempted to explain everything towards context-specific ones. Grand theories have limited empirical ground in comparison with middle-range ones. As already explained, middle-range theories integrate theory and empirical evidence in a specific context.

While theories are essential to the research design, they should be understood as versions of the world that may change and are developed and refined through research. Therefore, theories are not "(right or wrong) representations of facts, but versions through which the world is seen" (Flick, 2014, p. 140). They are continuously revised, evaluated, constructed and reconstructed. As a result of their explanatory power in answering "Why?" questions, theories may be used by qualitative, quantitative and mixed methods researchers for different reasons. The power of theories lies in their capacity to capture and summarise phenomena (Adams, 1975).

Quantitative researchers start with an existing theory to formulate a research question or hypothesis, and use the theory to deduce an explanation of the data. Qualitative researchers use existing theories to generate broader theories about social reality without theoretical preconceptions. Care is taken to ensure that theories do not channel the researchers' thinking too narrowly. Theories emerge from the data, and there is minimal reliance on existing theories to explain a social phenomenon. The development of theory is inductive. MMR uses theory abductively. Abductive logic entails moving back and forth between theory and data; for instance, the back-and-forth movement is evident in exploratory MMR approaches

in terms of which results from a qualitative study which is inductive and data-driven are used for instrument development for the subsequent deductive theory-driven strand. An abductive approach provides for the use of both inductive and deductive logic in a single study (Riazi, 2016, p. 3).

RESEARCH PARADIGMS VERSUS THEORETICAL RESEARCH FRAMEWORKS

Some scholars refer to research frameworks such as the interpretive approach, critical theory, and symbolic interactionism (Anfara, 2008; Denzin & Lincoln, 2003; Henning, Van Rensburg, & Smit, 2004) as theoretical frameworks, without making a clear distinction between research frameworks such as paradigms and theories. A failure to differentiate between theoretical frameworks and paradigms complicates the understanding of research paradigms and theoretical frameworks (Hays & Singh, 2012). The two authors caution against confusing these terms. Creswell (2009) demonstrates that the levels of theorising include, "formal theories, epistemological theories, methodological theories and meta-theories" (p. 71). Paradigms provide a research framework, while formal theories provide a theoretical or conceptual framework. The difference between a conceptual framework and a theoretical framework is stated later. Theories are different from research paradigms because they emerge from research.

Epistemology is a theory of knowledge, but it does not emanate from research and it does not explain anything about a phenomenon under investigation. In other words, "paradigms or frameworks do not, of themselves, describe, explain, or interpret anything. But they tell us how descriptions, explanations and interpretations should be developed within the tradition in which they are working" (Six & Bellamy, 2012, p. 33). Paradigms provide a philosophical framework for describing and understanding social reality. Thus, they provide a philosophical framework for obtaining empirical data about social reality, while theories explain or interpret the data.

Paradigms are the basis of the philosophical assumptions made by researchers, while theories or metatheories provide theoretical foundations for research. Thus, the ontology and epistemology that constitute a paradigm are theoretical perspectives or some philosophical stance, and not theories, as they do not show relationships between concepts. This distinction is important for novice researchers and people who want to use theories in their research. Epistemological paradigms provide theoretical perspectives for the research, but are not themselves theories. Epistemological assumptions determine the kind of knowledge that is employed to deal with what ontological assumptions define as real.

Theories provide the answer to a "Why?" question. For example, why are some organisations managing their heritage assets better than others? Suppose that someone proposed a theory of management – that the ability to manage heritage assets depends on adapting to the environment, for example. Then the theory could be offered as a partial answer as to why other organisations are failing to manage their heritage assets: they cannot adapt to the environment. In answering the question "Why?" we may be interested to know the connection between "managing" and "adaptation to the environment", and what counts as adaptation to the environment and whether there is something that can be done to improve the organisation's adaptation to the environment and thus the management of heritage assets.

In addition to giving explanations, theories may also offer predictions. For instance, if the organisation is adapting to the environment and the theory is correct, it would be possible to predict that management of the heritage asset will improve. The testing or development of the theory might be conducted within a positivist or interpretivist perspective. Even though epistemology is by definition the theory

of knowledge, it does not explain the "what", "how" or "why" of the adaptation of the heritage assets to the environment.

Now that the difference between research paradigms and theoretical framework has been established, let us turn our attention to distinguishing between conceptual and theoretical frameworks.

DIFFERENCES BETWEEN CONCEPTUAL AND THEORETICAL FRAMEWORKS

A distinction between theoretical frameworks and research frameworks was has already been made. in the previous sections. This section examines the differences between conceptual and theoretical frameworks.

Some researchers use the notions of conceptual frameworks and theoretical frameworks interchangeably (Anfara, 2008; Kitchel & Ball, 2014; Maxwell, 2013; Ocholla & Le Roux, 2011). To some scholars the two notions are conceptually different, as a theoretical framework is considered an aspect of a conceptual framework (Imenda, 2014, p. 187; Ngulube et al., Mathipa, & Gumbo, 2015, p. 61; Ravitch & Riggan, 2012, p. xiv). The equating of concepts used to provide an explanation of the connection between social reality to and theory partly explains in part why some social scientists erroneously use theoretical and conceptual frameworks interchangeably.

Miles and Huberman (1994) and Ravitch and Riggan (2012) are of the view that theories are part of the conceptual framework of a study. We argue that a conceptual framework and theoretical framework are conceptually different, although they are both tools of conceptualising research. Table 1 outlines some of the definitions of conceptual and theoretical frameworks found in the extant literature in order to demonstrate that they are different to some degree.

All the statements in Table 1 partially demonstrate that a conceptual framework and a theoretical framework are different. A conceptual framework consists of concepts that inform a research project. The concepts are generally represented diagrammatically to show ing the relationship between conceptsthem. Antonenko (2015) views this as a superficial way of defining a conceptual framework. Having said that, in conceptual frameworks concepts are mapped diagrammatically, or by means of what Maxwell (2013) terms concept mapping. In other words, a conceptual framework maps the concepts that are explored in a research project. It is a framework that includes concepts that guide the research, and data collection and analysis.

Figure 2 illustrates that when some parts of concepts that constitute a theory are used as a conceptual tool to guide the research, we should regard this as a conceptual framework. Even concepts from various theories can constitute a conceptual framework of a study.

Thus far, we can state that a conceptual framework is made up of concepts that form part of a theory, or concepts from various theories. However, a conceptual framework may also be developed for a study "relying solely on personal experiences and knowledge of the context of practice, and, in fact, this reflective exercise can prove very beneficial because it helps organize one's thinking on the research problem before delving into existing literature" (Antonenko, 2015, p. 60). From these arguments, we can deduce that a conceptual framework is inductively developed by the researcher through pulling together various components of theories, various concepts embedded in the extant literature, diverse theories, and sources and experiences. Unlike theoretical frameworks that are derived from established theories that have already been tested, conceptual frameworks are not ready made. Theoretical frameworks are like turnkey systems, if we are to use computing language, while conceptual frameworks are inductively developed.

Table 1. Defining conceptual and theoretical frameworks

Conceptual Framework	Theoretical Framework
A 'conceptual framework' is a less-developed explanation of events (Vithal, Jansen, & Jansen, 2013, p. 19)	A THEORY or THEORETICAL FRAMEWORK could be described as well-developed, coherent explanation for an event... (Vithal, Jansen, & Jansen, 2013, p. 17)
A conceptual framework explains either graphically or in a narrative form, the main things to be studied - the key factors, constructs or variable – and the presumed relationships among them. Frameworks can be rudimentary or elaborate, theory-driven or commonsensical, descriptive or causal (Miles & Huberman, 1994, p. 18)	A theoretical framework is the roadmap we use in our expedition of finding solutions to research problems (Bezuidenhout, 2014, p. 37)
The conceptual framework, as both a process and a framework that helps to direct and ground researchers, is "an argument about why the topic of a study matters, and why the methods proposed to study it are appropriate and rigorous" (Ravitch & Riggan, 2012, p. 9)	The theoretical framework is a structure that identifies and describes the major elements, variables, or constructs that organize your scholarship (Ennis, 1999, p. 129)
A conceptual framework is "a set of concepts and aspects of theories that assist in establishing coherence in research" and are "less developed than theories" (Ngulube et al., 2015, p.48)	A theoretical framework of an empirical study refers to the system of concepts, assumptions, expectations, beliefs and theories that informs the research (Schurink, 2009, p. 806)
A conceptual framework is "a theory-based and evidence-driven argument that is developed to justify the significance of the problem, define relevant concepts, establish theoretical and empirical rationale, guide selection of appropriate methods, and scaffold data analysis and interpretation" (Antonenko 2015, 2015, p. 57)	It is a logically structured representation of the concepts, variables and relationships involved in a scientific study with the purpose of clearly identifying what will be explored, examined, measured or described (Desjardins, 2010)
A conceptual framework links concepts from several theories, from previous research results, or from the researcher's own experience (Nieswiadomy, 2012, p. 94-95)	A theoretical framework presents a broad, general explanation of the relationships between the concepts of interest in a research study; it is based on *one* existing theory (Nieswiadomy, 2012, p. 87)
A conceptual framework may be defined as an end result of bringing together a number of related concepts to explain or predict a given event, or give a broader understanding of the phenomenon of interest – or simply, of a research problem (Imenda, 2014, p. 189)	A theoretical framework is the application of a theory, or a set of concepts drawn from one and the same theory, to offer an explanation of an event, or shed some light on a particular phenomenon or research problem (Imenda, 2014, p. 189)

Figure 2. Concepts as the building blocks of conceptual and theoretical frameworks

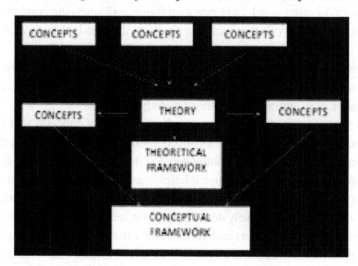

Researchers should also note that theories may shed particular light on a set of data, while at the same time creating shadows. Theories cannot describe the entire phenomenon, as they explain a phenomenon from a certain angle. They are abstractions which provide a partial and incomplete explanation of a phenomenon (Bezuidenhout, 2014; Jaccard & Jacoby, 2010). That implies that different people may use a theory to explain different aspects of a phenomenon, and that no one theoretical position can explain all of social reality. This partly explains why some researchers find themselves using more than one theory to understand the problem under investigation and to shape the research questions and interpret the findings.

Researchers who adapt and combine various theories in a single study have been characterised as bricoleur-theorists (Denzin & Lincoln, 2005).[2] This implies the triangulation of theoretical positions. When a theory is used as a lens through which social reality may be investigated, understood or interpreted, the net result is a theoretical framework, but when various theories are used we end up with a conceptual framework. Thus, a theoretical framework is used when an inquiry is underpinned by a single theory (Green, 2014; Nieswiadomy, 2012), and if aspects of a theory or components of various theories are used to give coherence to the research design, they constitute a conceptual framework rather than a theoretical framework. It would be incorrect to regard the framework as theoretical if the entire theory is not used to explain the phenomenon under investigation. This suggests that a conceptual framework is narrower and structured more loosely than theories or a theoretical framework, and gives credence to the notion that a conceptual framework is a "less-developed explanation of events" (Vithal et al., 2013, p. 19), and can be "rudimentary or elaborate, theory-driven or commonsensical" (Miles & Huberman, 1994, p. 18).

It should be borne in mind that a theoretical or conceptual framework should not be used simply because the researcher has been told by reviewers or project supervisors that it is needed for an inquiry. These conceptual tools are not just a "nice" thing to have in a research project: they assist in ordering and operationalising the research design. This implies that these tools should be used only if they are appropriate for the research problems and questions. For instance, researchers should show clearly why a conceptual framework was more appropriate for the inquiry than a theoretical framework.

For example, a conceptual framework may be used if there is no theory that fits the concepts to be studied, or when various theories are used to guide a study in the absence of a single theory that offers a comprehensive answer to the research question. Researchers should be explicit about how the theoretical framework assisted in guiding or developing their research. They should situate their theory within the research paradigm that informs the research, and they should clearly describe the concepts and linkages they wanted to understand by using a certain theoretical or conceptual framework. In other words, they should explain how these conceptual tools helped them to frame the research questions, make assumptions about the research problem, identify what variables to include in the research design, ring-fence the literature review and combine the findings into a coherent structure. Furthermore, researchers should be explicit about how and why a particular theory is more applicable to their studies than an alternative one.

Failure to understand and explain the utility of a theory or theories to an empirical inquiry may lead to a number of conceptual and practical mistakes such as theory dropping, theory positioning and theory diversification (Kumasi, Charbonneau, & Walster, 2013, p. 178). Theory dropping in a research inquiry entails the introduction of a theory or theories that is or are never mentioned again in the discussion of the findings and conclusion. If one views a theoretical framework as analogous to a washing line onto which one pegs washed clothes to dry, as suggested by Ngulube et al., (2015, p. 61) theory dropping is akin to someone washing their clothes and drying them on tree-tops or on the ground even though a washing line has been provided. Some researchers mention the theory in the abstract and conclusion,

without discussing it in the literature review section as is customary. This constitutes a failure to position the theory. Theory diversification occurs when multiple theories are introduced without the researchers making it abundantly clear how these theories informed the research design (Kumasi et al., 2013).

Researchers should avoid using multiple terms such as "frameworks", "models" and "theory" in their discussion of theory: consistency is required in naming conventions in order to communicate a clear message to the reader. Mismatching theory with a particular study and selecting discounted theories are bound to undermine the advancement of scholarship in a discipline. Researchers should avoid these pitfalls if they are going to make any meaningful contribution to the theoretical advancement of their field.

The use of established criteria to evaluate the selected theory for an inquiry may also alleviate the problems discussed above. The following criteria should be a good starting point in evaluating the suitability of theories for a study and their elegance (Shoemaker, Tankard, Jr., & Lasorsa, 2004):

- Testability (Can you measure the variables/concepts?)
- Falsifiability (Is the theory specific enough to be disproved?)
- Parsimony (Is the theory as simple as it can be?)
- Explanatory power (How much can the theory explain?)
- Predictive power (How much can the theory predict?)
- Scope (How much can this apply?)
- Cumulative nature of science (How many studies contribute to the development and refinement of the theory?)
- Degree of formal development (To what degree is the theory formalised by the researcher and the field?)
- Heuristic value (Does this theory help generate ideas for more theory?)
- Aesthetics (Is the theory "beautiful" in its own right?)

Shoemaker et al. (2004) suggest that researchers should be selective and cautious when using this list, the value of which will vary from context to context.

STAGES OF THE RESEARCH PROCESS DURING WHICH THEORY SHOULD BE USED

A distinction between theoretical frameworks and conceptual frameworks has already been made above. This section discusses the stages of the research process during which theory is applied. There are two schools of thought about this: one recommends theory before research, and the other research before theory. The theory-then-research-strategy school follows the stages set out below (Reynolds, 1971):

- Construct a theory or model.
- Select a proposition derived from the theory or model for empirical investigation.
- Design a research project to test the proposition (p. 140).

Depending on the results, the theory may be either rejected or accepted. On the other hand, the research-then-theory strategy school states that empirical research suggests problems for theory. According to Reynolds, (1971) the stages in this strategy are:

- Investigate a phenomenon and delineate its attributes.
- Measure the attributes in a variety of situations.
- Analyse the data to determine whether there are systematic patterns of variation.
- Construct a theory after systematic patterns are discovered (p. 144).

Theory formulation and refinement are common to both schools, and researchers may exercise a choice. However, the view advanced in this chapter is that pre-existing knowledge should inform empirical research. Relevant theories underpinning the knowledge base of the research problem to be investigated should be considered at the start of a research study (Ravitch & Riggan, 2012; Sinclair, 2007). Theories form the "conceptual and theoretical framework within which data is collected, interpreted and understood" (Bezuidenhout, 2014, p. 38), and they constitute the glue that keeps the various parts of the research process together. Just like the research question, theories are central to the research plan, and existing theories may assist in adapting and refining the research questions.

Researchers should note that the process of developing a theoretical or conceptual framework is developmental and experiential (Sinclair, 2007). It is important to establish coherence between the theoretical or conceptual framework and all the components of the research process. We need to remember that in the end it is more practical to have either a theoretical framework or a conceptual framework to explain a phenomenon, not both.

STRATEGIES FOR IDENTIFYING AND APPLYING CONCEPTUAL AND THEORETICAL FRAMEWORKS

The literature provides both conceptual and operational definitions of concepts. Conceptual definitions specify what needs to be assessed by a study, while operational definitions specify how the theory will be tested (Jaccard & Jacoby, 2010). The concepts may be developed from personal experiences or by consulting the relevant literature. Consider the concept of public programming, which is the subject of chapter 6. Conceptually, this can be defined as a group of activities carried out by heritage institutions to attract the public to utilise their collections and holdings. We suggest that the properties of this definition are "activities" and "public". Activities may include outreach and marketing. The intention is for the public to respond positively to these activities by utilising the heritage resources. The glue that binds the two properties together is policies supporting the activities of heritage institutions and their capacity to execute the activities. In operationalising the properties of public programming, heritage professionals may ask:

- What are the existing public programming activities?
- Who are the users of collections and holdings at heritage institutions?
- Are there policies to support public programming activities?
- Do heritage managers have the knowledge and skills to conduct public programming activities?
- What product mix strategy can support public programming?

The concepts are operationalised by the methodology used to measure them. Concepts are measured through indicators. The conceptualisation might be achieved thorough using personal experience or consulting the relevant scholarly literature.

Consulting the relevant scholarly literature helps to:

- Develop a conceptual definition of a construct on the basis of shared meaning;
- Identify the key properties of a concept and assign priorities to them;
- Identify what theory or theories was or were used to explain relationships among concepts; and
- Establish how the concepts have been measured in an empirical investigation.

Asking simple, relevant questions when reading the literature and defining relationships among constructs can help a researcher to formulate a theoretical or conceptual framework. Some of the questions that may serve as a guide to come up with a relevant theoretical framework have been suggested in the literature (Flick, 2014; Ngulube et al., 2015; Sinclair, 2007):

- What types of knowledge about the phenomenon are available?
- What is the underlying paradigm of the design?
- What theory will best guide the study?
- Why has this theory been selected for the study?
- Has the theory been applied or tested through theory-linked research?
- What other theories are relevant to my study?
- Can I apply these theories to my study?
- Does the theory have a clear application outcome?
- Does the theory cover all the specific objectives or subquestions of the research?

Answering these questions may enable researchers to develop a conceptual system and check the coherence between the conceptual or theoretical framework and various elements of the research design.

Selected Heritage Conceptual Frameworks

As pointed out earlier, theory development in the heritage management field is still at the nascent stage. Consequently, many researchers in the field rely on conceptual frameworks, models and benchmarks, although some of them mistakenly refer to these as theoretical frameworks. Guidelines provided by the African Union (AU), New Partnership for Africa's Development (NEPAD) and United Nations (UN) are instructive guidelines that apply to libraries, museums and archives. Some examples of conceptual tools that come to mind in the field of records and archives are the guidelines provided by the International Council on Archives (ICA), the United Nations Educational, Scientific and Cultural Organisation (UNESCO) and the International Standards Organisation (ISO). Some of the guidelines formulated by ICA are *ICA Guidelines and Functional Requirements for Electronic Records Management Systems* (ICA, 2008), ISAD(G): *General International Standard Archival Description* (ICA, 2011), and *Principles of Access to Archives* (ICA, 2012). The International Records Management Trust (IRMT) has complemented the efforts of ICA by providing frameworks such as *The E-Records Readiness Assessment Tool* (IRMT, 2004) and *Integrating Records Management in ICT Systems: Good Practice Indicators* (IRMT, 2009).

In the case of museums and cultural heritage, one thinks of model for evaluating museum environmental management needs (Dardes, 1998), the Burra Charter of Australia (Australia ICOMOS Incorporated, 2013), *Charter for the Protection and Management of the Archaeological Heritage* (International Council on Monuments and Sites (ICOMOS), 1990), *ICOMOS International Cultural Tourism Charter*

(ICOMOS, 2002), *Guidance on Heritage Impact Assessments for Cultural World Heritage Properties* (ICOMOS, 2011), *Approaches for the Conservation of Twentieth-Century Architectural Heritage Madrid Document 2014* (ICOMOS, 2014), *Convention Concerning the Protection of the World Cultural and Natural Heritage* (UNESCO, 1972), *Johannesburg Declaration on World Heritage in Africa and Sustainable Development* (UNESCO, 2002) and *Identification and Documentation of Modern Heritage* (UNESCO, 2003).

There are numerous guidelines in the library field, including those provided by the American Library Association (ALA), International Federation of Library Associations and Institutions (IFLA) and various national library associations.

Theories and Heritage Studies

Heritage management scholars use a variety of theories to understand the heritage phenomenon, including those that are specific to heritage management, and those borrowed from other disciplines. Theory operates "at many levels in research, such as formal theories, epistemological theories, methodological theories and meta-theories" (Creswell, 2009, p. 71). Consequently, there are many ways of theorising about heritage phenomena.

This chapter provides a non-exhaustive and non-prescriptive list of theories that may be used to explain a phenomenon in heritage management and other social contexts. This partial list offers a sense of what theories are like, and the theories that are presented here are concerned with change and stability, which are at the centre of many heritage management sites such as archives, museums and libraries. The life-cycle model, teleological model, dialectical model and evolutionary model are the four frameworks that have been most commonly used in process-based analysis of change (Jaccard & Jacoby, 2010). Process theories such as Vroom's expectancy theory (1964), Adam's equity theory, goal setting theory and reinforcement theory may be applicable to heritage management research, but they are not covered here because of limitations of space. The resources, processes and values theory propounded by Christensen (1997) complements the process theories. Readers are referred to the extant literature and websites for a wide selection of theories they may use in their research (e.g., Ball, n.d.; Larsen, Allen, Vance & Eargle, 2015).

The examples of theories given below were chosen because they apply to many organisations, including archives, libraries and museums. Systems theory, chaos theory and rubbish theory have been used in this context, and are briefly explained here. These examples are intended to familiarise the readers with theories that may form the theoretical frameworks of their research so that as they think about their research they may apply them and build upon them to identify other theories that may be relevant to their studies. It must be noted that the net result is a conceptual framework instead of a theoretical one if certain components of these theories are used in a particular heritage management study, as already explained.

Systems Theory

Systems theory adopts a holistic approach in analysing the interrelationships and connections between the elements of the system (Jaccard & Jacoby, 2010). This implies that one cannot define a system solely by explaining its subsystems. The concepts of feedback and equifinality are essential in systems thinking: the feedback loop regulates the behaviour of the system, the input of the system is transformed into an output, and the output is brought back to the system as input in a circular manner (Jaccard & Jacoby, 2010).

Although it appears to be a grand theory, heritage professionals may use systems theory to analyse the inputs and outputs of a heritage institution. The heritage system is a subsystem within larger economic, social, political, educational and technical systems. These systems are interrelated, and they keep the greater system alive. The systems approach considers how the systems are interrelated and interact with one another, how they depend on one another, how each system functions, and how the systems allow the functions to be achieved. For instance, analysis of the heritage system may be conducted to determine what constrains the development of the system, the conditions and barriers that prevent the system from achieving its goals and the energy and resources required to achieve those goals.

Chaos Theory

Chaos theory, which has its origins in mathematical modelling, can be applied to determine the changes in systems over time. Chaos theory may be applied to "nonlinear dynamic systems" (Levy, 1994, p. 167). The thinking is that what appears to be chaotic is in fact generated by a systematic function. The chaos theorist identifies patterns that appear to be chaotic and endeavours to isolate the function that generates that "chaos" (Jaccard & Jacoby, 2010). A wide range of heritage assets are chaotic in nature. Heritage organisations operate in an environment that is not simple, stable and certain, and they are exposed to both stability and instability. Chaos theory may be used to understand, describe and track organisational behaviour and its unpredictability in a variety of contexts, and it may help heritage practitioners to appreciate and understand the role of leadership in organisational change and managing in chaos and complexity.

Rubbish Theory

According to Thompson (1979), the value of an object is not static, but changeable: this value may rise and fall depending upon context as the object ages. Rubbish can be transformed into gold. Is rubbish theory relevant to collection management approaches in heritage institutions such as libraries, museums and archives? The question that rubbish theory answers is: What gives things their worth? The theory categorises things as durables, transients and rubbish. A thing can change from being rubbish to being durable, and vice versa. This theory may inform collection development studies in heritage management.

FUTURE RESEARCH DIRECTIONS

Studies to ascertain the prevalence and the understanding of conceptual and theoretical frameworks in heritage management research are useful. Finding out the extent to which theory and concepts are explored by heritage management researchers may shed light on the understanding of their use in the field. Research on theory application in heritage studies may also shed light on the most influential theories in the field and the reasons behind the preference for them. Further studies on how to build heritage management theories will advance scholarship in the field.

CONCLUSION

The approach taken in this chapter was philosophical, and unlike other chapters in this book, the present chapter does not employ conventional research methods, but rather serves to argue a particular aspect of a disciplinary knowledge base (Burbules & Warnick, 2006). The benefits of sound philosophical methods extend from

various resources ranging from conceptual tools to explore and clarify the underlying assumptions of competing value frameworks; to skills for critically reflecting on conventional views and assessing their worth … and finally to visions of radically different possibilities that can stretch the imagination and expand the spirit. (Burbules & Warnick, 2006, p. 501)

The philosophical lens was used in this chapter to demonstrate that theory is fundamental to research, and lends academic rigour to scholarly work. The use of theory contributes to the growth and maturity of a discipline, and connects the body of knowledge within the discipline to broader science. Atheoretical research has a place in heritage studies, but the generalisability of the knowledge thus produced, and its relationship with science, is severely limited. This chapter encourages heritage researchers to use theory and conceptual frameworks. They will be able to use theory appropriately if they are aware of the relationships among concepts, models and theories, the differences between research paradigms and theoretical frameworks, the distinction between conceptual and theoretical frameworks and the strategies for applying and identifying a theoretical or conceptual framework.

REFERENCES

Adams, J., Cochrane, M., & Dunne, L. (2012). Introduction. In J. Adams, M. Cochrane, & L. Dunne (Eds.), *Applying theory to educational research: An introductory approach with case studies* (pp. 1–10). Chichester, UK: Wiley-Blackwell.

Adams, R. (1975). Where do our ideas come from? Descartes vs Locke. In S. Stitch (Ed.), Innate ideas (71–87). Berkeley, CA: University of California Press.

Anfara, V. A. Jr. (2008). Theoretical frameworks. In L. Given (Ed.), *The SAGE encyclopedia of qualitative research methods* (pp. 870–874). Thousand Oaks, CA: Sage.

Antonenko, P. D. (2015). The instrumental value of conceptual frameworks in educational technology research. *Educational Technology Research and Development, 63*(1), 53–71. doi:10.1007/s11423-014-9363-4

Australia ICOMOS Incorporated. (2013). *The Burra Charter: The Australia ICOMOS Charter for Places of Cultural Significance*. Retrieved July 27, 2017, from: http://australia.icomos.org/wp-content/uploads/The-Burra-Charter-2013-Adopted-31.10.2013.pdf

Babbie, E. (2007). Paradigms, theory and social research. In *The practice of social research* (11th ed.; pp. 30–59). Belmont, CA: Thomson Wadsworth.

Ball, B. (n.d.). *A summary of motivation theories*. Retrieved July 2, 2017, from: http://www.yourcoach.be/blog/wp-content/uploads/2012/03/A-summary-of-motivation-theories1.pdf

Bezuidenhout, R. M. (2014). Theory in research. In F. du Plooy-Cilliers, C. Davis, & R. M. Bezuidenhout (Eds.), *Research matters* (pp. 36–59). Claremont: Juta & Company.

Burbules, N. C., & Warnick, B. R. (2006). Philosophical inquiry. In J. I. Green, G. Camilli, P. B. Elmore, A. Skukauskaite, & E. Grace (Eds.), *Handbook of complementary methods in education research* (pp. 489–502). London: Lawrence Erlbaum.

Camp, W. G. (2001). Formulating and evaluating theoretical frameworks for career and technical education. *Career and Technical Education Research, 26*(1), 4–25. doi:10.5328/JVER26.1.4

Christensen, C. M. (1997). *The innovator's dilemma: When new technologies cause great firms to fail*. Boston, MA: Harvard Business School Press.

Collis, J., & Hussey, R. (2014). *Business research: A practical guide for undergraduate and postgraduate students*. London: Palgrave. doi:10.1007/978-1-137-03748-0

Cooper, G., & Meadows, R. (2016). Conceptualising social life. In N. Gilbert & P. Stoneman (Eds.), *Researching social life* (4th ed.; pp. 10–24). Los Angeles, CA: Sage.

Creswell, J. W. (2009). *Research design: Qualitative, quantitative, and mixed methods approaches* (3rd ed.). Los Angeles, CA: Sage.

Cronin, P., Coughlan, M., & Smith, V. (2015). *Understanding nursing and healthcare research*. Los Angeles, CA: Sage.

Dardes, K. (1998). *The conservation assessment. A proposed model for evaluating museum environmental management needs*. Retrieved June 27, 2017, from: http://www.getty.edu/conservation/publications

Denzin, N. K., & Lincoln, Y. S. (2003). *The landscape of qualitative research* (2nd ed.). Thousand Oaks, CA: Sage.

Denzin, N. K., & Lincoln, Y. S. (2005). Introduction: The discipline and practice of qualitative research. In N. K. Denzin & Y. S. Lincoln (Eds.), *The Sage handbook of qualitative research* (3rd ed., pp. 1–32). Thousand Oaks, CA: Sage.

Desjardins, F. J. (2010). *Theoretical Framework*. Retrieved July 27, 2017, from: https://youtu.be/EcnufgQzMjc

Diers, D. (1979). *Research in nursing practice*. Philadelphia: Lippincott.

Ennis, C. D. (1999). The theoretical framework: The central piece in the research plan. *Journal of Teaching in Physical Education, 18*(2), 129–140. doi:10.1123/jtpe.18.2.129

Flick, U. (2014). *An introduction to qualitative research* (5th ed.). Los Angeles, CA: Sage.

Frankfort-Nachmias, C., & Nachmias, D. (2008). *Research methods in the social sciences* (7th ed.). New York: Worth.

Garfinkle, H. (1967). *Studies in ethnomethodology*. Englewood Cliffs, NJ: Prentice Hall.

Glaser, B., & Strauss, A. (1967). *The discovery of grounded theory: Strategies for qualitative research.* New York: Aldine de Gruyter.

Grant, C., & Osanloo, A. (2014). Understanding, selecting, and integrating a theoretical framework in dissertation research: Creating the blueprint for your "house". Administrative Issues Journal: Connecting Education, Practice, and Research, 4(2), 12-26.

Gravemeijer, K. (1994). *Developing realistic mathematics education.* Utrecht, The Netherlands: CD-B Press.

Green, H. (2014). Use of theoretical and conceptual frameworks in qualitative research. *Nurse Researcher, 21*(6), 34–38. doi:10.7748/nr.21.6.34.e1252 PMID:25059086

Gunnell, J. G. (1969). The idea of a theoretical framework: A philosophical critique. *Administration & Society, 1,* 140–176.

Hays, D. G., & Singh, A. A. (2012). *Qualitative inquiry in clinical and educational settings.* New York, NY: The Guilford Press.

Henning, E., Van Rensburg, W., & Smit, B. (2004). *Finding your way in qualitative research.* Pretoria, South Africa: Van Schaik.

Hennink, M., Hutter, I., & Bailey, A. (2011). *Qualitative research methods.* Los Angeles, CA: Sage.

ICA. (2011). *ISAD(G): General International Standard Archival Description* (2nd ed.). Retrieved June 27, 2017, from: http://www.ica.org/en/isadg-general-international-standard-archival-description-second-edition

ICA. (2012). *Principles of Access to Archives.* Retrieved June 27, 2017, from http://www.ica.org/sites/default/files/ICA_Access-principles_EN.pdf

ICA (International Council on Archives). (2008). *ICA Guidelines and Functional Requirements for Electronic Records Management Systems.* Retrieved June 27, 2017, from: http://www.ica.org/sites/default/files/1%20Overview.pdf

ICOMOS. (2002). *ICOMOS International Cultural Tourism Charter: Principles and Guidelines for Managing Tourism at Places of Cultural and Heritage Significance.* Retrieved June 27, 2017, from: http://australia.icomos.org/wp-content/uploads/ICOMOS-International-Cultural-Tourism-Charter-English.pdf#7s8d6f87

ICOMOS. (2011). *Guidance on Heritage Impact Assessments for Cultural World Heritage Properties.* Retrieved June 27, 2017, from: http://www.icomos.org/world_heritage/HIA_20110201.pdf

ICOMOS. (2014). *Approaches for the Conservation of Twentieth-Century Architectural Heritage Madrid Document 2014* (2nd ed.). Retrieved June 27, 2017, from: http://www.icomos-isc20c.org/pdf/madrid_doc_10.26.pdf

ICOMOS (International Council on Monuments and Sites). (1990). *Charter for the Protection and Management of the Archaeological Heritage.* Retrieved January 27, 2017, from: http://www.icomos.org/charters/arch_e.pdf

Imenda, S. (2014). Is there a conceptual difference between theoretical and conceptual frameworks? *Sosyal Bilimler Dergisi. Journal of Social Sciences*, *38*(2), 185–195.

IRMT. (2009). *Integrating Records Management in ICT Systems: Good Practice Indicators*. Retrieved June 27, 2017, from: http://www.irmt.org/documents/educ_training/term%20resources/IRMT_Good_Practice_Indicators.pdf

IRMT (International Records Management Trust). (2004). *The E-Records Readiness Assessment Tool*. Retrieved June 27, 2017, from: http://www.irmt.org/portfolio/e-records-readiness-assessment-2005

Ivey, J. (2015). Demystifying research: How important is a conceptual framework? *Pediatric Nursing*, *14*(3), 145-153.

Jaccard, J., & Jacoby, J. (2010). *Theory construction and model-building skills*. New York: The Guilford Press.

Kerlinger, F. (1973). *Foundations of behavioural research* (2nd ed.). New York: Holt, Rinehart & Winston.

Kitchel, T., & Ball, A. L. (2014). Quantitative theoretical and conceptual framework use in agricultural education research. *Journal of Agricultural Education*, *55*(1), 186–199.

Kumasi, K. D., Charbonneau, D. H., & Walster, D. (2013). Theory talk in the library science scholarly literature: An exploratory analysis. *Library & Information Science Research*, *35*(3), 175–180. doi:10.1016/j.lisr.2013.02.004

Larsen, K. R., Allen, G., Vance, A., & Eargle, D. (Eds.). (2015). *Theories used in IS research Wiki*. Retrieved September 15, 2017, from: http://IS.TheorizeIt.org

Levy, D. (1994). Chaos theory and strategy: Theory, applications, and managerial implications. *Strategic Management Journal*, *15*(S2), 167–178. doi:10.1002/smj.4250151011

Llewelyn, S. (2003). What counts as "theory" in qualitative management and accounting research? Introducing five levels of theorizing. *Accounting, Auditing & Accountability Journal*, *16*(4), 662–708. doi:10.1108/09513570310492344

Lysaght, Z. (2011). Epistemological and paradigmatic ecumenism in "Pasteur's Quadrant": Tales from doctoral research. The Third Asian Conference on Education Osaka, Japan, Official Conference Proceedings 2011. (The International Academic Forum (IAFOR): Nagakute-cho), pp. 567-579. Retrieved January 31, 2017, from: http://papers.iafor.org/conference-proceedings/ACE/ACE2011_proceedings.pdf

Matson, W. (2012). *Grand theories and everyday beliefs: Science, philosophy, and their histories*. Oxford, UK: Oxford University Press.

Maxwell, J. A. (2012). Foreword. In S. M. Ravitch & M. Riggan (Eds.), *Reason and rigor: How conceptual frameworks guide research* (pp. xi–xii). Thousand Oaks, CA: Sage.

Maxwell, J. A. (2013). *Qualitative research design: An interactive approach* (3rd ed.). Thousand Oaks, CA: Sage.

May, T. (2001). *Social research: Issues, methods and process* (3rd ed.). Buckingham, UK: Open University Press.

Merton, R. K. (1968). *Social theory and social structure*. New York: Free Press.

Miles, M. B., & Huberman, A. M. (1994). *Qualitative data analysis: An expanded sourcebook of new methods* (2nd ed.). London: Sage.

Ngulube, P., Mathipa, E. R., & Gumbo, M. T. (2015). Theoretical and conceptual framework in the social sciences. In E. R. Mathipa & M. T. Gumbo (Eds.), Addressing research challenges: Making headway for developing researchers (pp. 43–66). Noordwyk: Mosala-Masedi.

Nieswiadomy, R. M. (2012). *Foundations of nursing research* (6th ed.). Boston: Pearson Education.

Ocholla, D. N., & Le Roux, J. (2011). Conceptions and misconceptions of theoretical frameworks in library and information science research: A case study of selected theses and dissertations from eastern and southern African universities. *Mousaion, 29*(2), 61–74.

Parsons, T., & Shils, E. A. (1962). *Toward a general theory of action*. New York: Harper and Row.

Pawson, R. (2000). Middle-range realism. *Archives Européennes de Sociologie, 41*(2), 283–325. doi:10.1017/S0003975600007050

Ravitch, S. M., & Riggan, M. (2012). *Reason and rigor: How conceptual frameworks guide research*. Thousand Oaks, CA: Sage.

Reynolds, P. D. (1971). *A primer in theory construction*. New York: Macmillan.

Riazi, A. M. (2016). *The Routledge encyclopedia of research methods in applied linguistics: Quantitative, qualitative, and mixed methods research*. London: Routledge.

Schurink, E. (2009). Qualitative research design as tool for trustworthy research. *Journal of Public Administration, 44*(4), 803–823.

Shoemaker, P. J., Tankard, J. W. Jr, & Lasorsa, D. L. (2004). *How to build social sciences theories*. Thousand Oaks, CA: Sage. doi:10.4135/9781412990110

Sinclair, M. (2007). Editorial: A guide to understanding theoretical and conceptual frameworks. *Evidence-Based Midwifery, 5*(2), 39.

Six, P., & Bellamy, C. (2012). *Principles of methodology: Research design in social science*. Los Angeles, CA: Sage.

Strauss, A., & Corbin, J. (1994). Grounded theory methodology. In N. K. Denzin & Y. S. Lincoln (Eds.), *Handbook of qualitative research* (pp. 273–285). Thousand Oaks, CA: Sage.

Suddaby, R. (2015). Editor's comments: Why theory? *Academy of Management Review, 4015*(1), 1–5.

Thompson, M. (1979). *Rubbish theory: The creation and destruction of value* (2nd ed.). Chicago: University of Chicago Press.

UNESCO. (1972). *Convention Concerning the Protection of the World Cultural and Natural Heritage*. Retrieved January 2, 2017, from: http://whc.unesco.org/en/convention/

UNESCO. (2002). *Johannesburg Declaration on World Heritage in Africa and Sustainable Development*. Retrieved January 27, 2017, from: http://whc.unesco.org/uploads/events/documents/event-500-1.pdf

UNESCO. (2003). *World Heritage Papers 5: Identification and Documentation of Modern Heritage*. Retrieved June 27, 2017, from: http://whc.unesco.org/uploads/activities/documents/activity-38-1.pdf

Vithal, R., Jansen, J. D., & Jansen, J. (2013). *Designing your first research proposal: A manual for researchers in education and the social sciences*. Claremont: Juta.

Vroom, V. H. (1964). *Work and motivation*. New York: John Wiley & Sons.

Wengraf, T. (2001). *Qualitative research interviewing: Biographic narrative and semi-structured methods*. London: Sage. doi:10.4135/9781849209717

Wiarda, H. (Ed.). (2010). *Grand theories and ideologies in the social sciences*. New York: Palgrave Macmillan. doi:10.1057/9780230112612

ADDITIONAL READING

Creswell, J. W. (2013). The use of theory. In J. W. Creswell (Ed.), *Research design: Qualitative, quantitative, and mixed methods approaches* (4th ed.; pp. 51–76). Los Angeles, CA: Sage.

Fisher, K. E., Erdelez, S., & McKechnie, L. E. F. (Eds.), *Theories of information behaviour*. Medford, NJ: Information Today.

Haig, B. D. (2005). An abductive theory of scientific method. *Psychological Methods*, *10*(4), 371–388. doi:10.1037/1082-989X.10.4.371 PMID:16392993

Jopela, A. (2011). Traditional custodianship: A useful framework for heritage management in southern Africa? *Conservation and Management of Archaeological Sites*, *13*(2–3), 103–122. doi:10.1179/1753 55211X13179154165908

Leshem, S. (2007). Thinking about conceptual frameworks in a research community of practice: A case of a doctoral programme. *Innovations in Education and Teaching International*, *44*(3), 287–299. doi:10.1080/14703290701486696

Leshem, S., & Trafford, V. N. (2007). Overlooking the conceptual framework. *Innovations in Education and Teaching International*, *44*(1), 93–105. doi:10.1080/14703290601081407

Lester, F. K. (2005). On the theoretical frameworks, conceptual and philosophical foundations for research in mathematics education. *ZDM: International Reviews on Mathematical Education*, *37*(6), 457–467.

Murphy, P. (1996). Chaos theory as a model for managing issues and crises. *Public Relations Review*, *22*(2), 95–113. doi:10.1016/S0363-8111(96)90001-6

Ndoro, W., & Pwiti, G. (2009). *Legal frameworks for the protection of immovable cultural heritage in Africa*. Rome: ICCROM. Retrieved June 27, 2017, from: www.iccrom.org/ifrcdn/pdf/ICCROM_ICS05_LegalFrameworkAfrica_en.pdf

Pettigrew, K. E., & McKechnie, L. E. F. (2001). The use of theory in information science research. *Journal of the American Society for Information Science and Technology, 52*(1), 62–73. doi:10.1002/1532-2890(2000)52:1<62::AID-ASI1061>3.0.CO;2-J

Reeves, S., Albert, M., Kuper, A., & Hodges, B. D. (2008). Why use theories in qualitative research? *BMJ (Clinical Research Ed.), 337*(aug07 3), 631–634. doi:10.1136/bmj.a949 PMID:18687730

Sandelowski, M. (1993). Theory unmasked: The uses and guises of theory in qualitative research. *Research in Nursing & Health, 16*(3), 213–218. doi:10.1002/nur.4770160308 PMID:8497673

Santos, F. M., & Eisenhardt, K. M. (2005). Organizational boundaries and theories of organization. *Organization Science, 16*(5), 491–508. doi:10.1287/orsc.1050.0152

Sutton, R. I., & Staw, B. M. (1995). What theory is not. *Administrative Science Quarterly, 40*(3), 371–384. doi:10.2307/2393788

Thomas, G. (1997). What's the use of theory? *Harvard Educational Review, 67*(1), 75–105. doi:10.17763/haer.67.1.1x807532771w5u48

Wacker, J. G. (2004). A theory of formal conceptual definitions: Developing theory-building measurement instruments. *Journal of Operations Management, 22*(5), 629–650. doi:10.1016/j.jom.2004.08.002

KEY TERMS AND DEFINITIONS

Heritage Studies: An interdisciplinary field concerned with the preservation and communication of cultural heritage artefacts in institutions such as museums, archives, and libraries.

Operationalise: To define concepts used in an empirical inquiry, and identify variables to be measured using research protocols such as questionnaires.

Theory: Description and explanation of how the identified concepts or constructs in a cognitive field are related.

ENDNOTES

[1.] According to Kerlinger (1973), "A theory is a set of interrelated constructs (concepts), definitions, and propositions that present a systematic view of phenomena by specifying relations among variables, with the purpose of explaining and predicting the phenomena" (p. 9).

[2.] Adapting perspectives from different theories "resembles the thinking process that Lawler (1985) characterizes by the French word *bricolage*... A bricoleur is a handy man who invents pragmatic solutions in practical situations.... [T]he bricoleur has become adept at using whatever is available. The bricoleur's tools and materials are very heterogeneous: Some remain from earlier jobs, others have been collected with a certain project in mind" (Gravemeijer, 1994, p. 447).

Chapter 2
Theories of Appraisal in Archives:
From Hillary Jenkinson to Terry Cook's Times

Olefhile Mosweu
University of South Africa, South Africa

Lekoko Sylvester Kenosi
Qatar National Library, Qatar

ABSTRACT

Appraisal is defined as a set of recordkeeping processes involved with determining how long to keep records and what ultimately will become the archival representation for the future. It has been described as the most intellectually demanding, controversial, and debated issue in archival science. This is because there are different opinions regarding how records appraisal should be undertaken and thus no two archivists will approach records appraisal in exactly the same way due to the absence of a perfect formula. The objective of this chapter is to discuss appraisal theories and their applicability in appraisal practice. The thesis of this chapter is that any of the four appraisal methodologies would be able to select the future archive, including a combination of the various appraisal methodologies as it allows one to tap from the strength of each.

INTRODUCTION

This chapter brings to the fore issues, controversies and ideas on how records appraisal should be conducted as alluded to by archives and records management professionals, and commentators. Appraisal is the set of recordkeeping processes involved with determining how long to keep records, and what ultimately will become the archival representation for the future. Appraisal is possibly the most contested of archival functions and the most discussed in the professional literature.

DOI: 10.4018/978-1-5225-3137-1.ch002

The thesis of this book chapter is that appraisal of records, being arguably the centre of archival practice, is a difficult undertaking which cannot be successfully achieved by adopting a single appraisal methodology. This chapter acknowledges that each appraisal school of thought can be used to inform appraisal decisions in the selection of the archive. It argues that appraisal practice is influenced by the environment under which it takes place. It therefore, follows that the selection of archival documents cannot be based on a single appraisal methodology. The objectives of this chapter are to; identify the different schools of archival appraisal and discuss the strengths and weaknesses of each in the selection of archival documents. Available literature is used to highlight the criticism and appreciation of each of the appraisal methodologies, when selecting archival records; present the nature and goal of each appraisal school. The chapter concludes, in cognizance of the aforementioned, that over and above being informed by the different appraisal schools of thought, it is imperative that the appraiser or the archivist have enough time for research, thinking, consultation and studying.

BACKGROUND

No function is as troubling and as important to archivists as records appraisal (Ngulube 2001; Garaba, 2007; Greene, 2009; Cook, 2011). Greene (2009) avers that since the 1940s, most archivists agree that archival appraisal is their primary function but they do not agree on how it should be done. There is simply no one way of doing it. This is also attested to by scholars such as Stuckey (2004), Kenosi and Moatlhodi (2012), Thanye, Kalusopa and Bwalya (2015) and Couture (2005), just to mention a few. The Queensland State Archives defines it as "the process of evaluating business activities and records to determine which records need to be captured and how long those records needs to be kept to meet business, accountability requirements and community expectations" (Queensland State Archives, 2010, p. 5). The first activity involves the evaluation of records either for preservation or destruction, the second has to do with the totality of measures taken to ensure long term access. In agreement, IRMT (1999) and the National Archives of UK (TNA) (2004) note that records appraisal involves making decisions on what records need to be kept and for how long in order to enable an organisation to keep utilizing them for operations. Secondly, appraisal is done for purposes of deciding which records have archival value and can be transferred to an archival repository for permanent preservation as archives. This kind of appraisal is often referred to as appraising for enduring value while the former is appraisal for continuing utility (IRMT 1999). Although the second reason for undertaking appraisal as espoused by Queensland State Archives (2010) refers to ensuring access to archival records, in essence it is more or less a similar reason to the one put forward by both IRMT (1999) and TNA (2004), which is the selection of records for permanent preservation. This is because the whole idea of preserving the future archive is to make it accessible (Ngulube, 2001; Forde, 2007; Oweru & Mnjama 2014).

Greene (2003) opines that amongst other archival functions, it is the most intellectually demanding. It is also the most controversial and the most debated issue in the archives and records management profession. There are differences of opinion regarding how records appraisal should be undertaken and thus no two archivists will approach records appraisal in exactly the same way (Bailey, 1997; Stuckey, 2004; Cook, 2011). Appraisal practice is influenced by prevailing circumstances on the ground. For example, the development of appraisal in the United States developed from a situation where there was a lack of standardised approach to organisational record-keeping (Stuckey, 2004) and also due to the independent nature of state archives with the US federal system as well as the unique states' own factors that influence

appraisal practices (Rhee, 2016). In the former Soviet Union, appraisal of records obtained a strictly and centrally controlled regime, an all-union system of all Soviet Archives which was established through a decree by Vladimir Lenin on 1 June 1918 (Grimsted, 1982; Bridges, 1988; Allen & Baumann, 1991). The decree linked all Soviet archives into former USSR's centralized archival administration known as the State Archival Fond (Gosudarstvennyi arkhivnyifond), which brought together under state jurisdiction of all the records of previous governmental jurisdictions (Allen & Baumann, 1991). The two examples of records appraisal in the US and former USSR show that it was highly controlled in the USSR and sort of undertaken in an environment free of government in the US. Perhaps this explains why Bailey (1997) concluded that archivists are the products of the society in which they live. This school of thought considers appraisal as the cornerstone of archives as it is through appraisal that archivists decide future historical records. Furthermore, all other archival work such as arrangement, description, preservation, reference and outreach take place only after appraisal has been done.

This chapter discusses four approaches to records appraisal, namely, Macro Appraisal, European School of Appraisal, American School of Appraisal, the German school of appraisal, and the Documentation Strategy.

THE EUROPEAN THEORY OF RECORDS APPRAISAL

The European School of Appraisal is synonymous with Hillary Jenkinson, the English archivist. His views on appraisal were influenced by the times in which he lived. According to Stapleton (1984) during the time Jenkinson originated his appraisal method, there were huge volumes of records. The First World War had led to the creation of large quantities of records in England (Jenkinson, 1922). Jenkinson felt the need to study the nature and characteristics of archival documents as that would enable him to have an understanding of archival principles that could be used to guide the creation of the archives of the present and the future.

Jenkinson (1922) defines archives as:

A document which may be said to belong to the class of archives is one which was drawn up or used in the course of an administrative or executive transaction (whether public or private) of which itself formed a part; and subsequently preserved in their own custody for their own information by the person or persons responsible for that transaction and their legitimate successors. (p. 11)

For Jenkinson, there is no distinction between records and archives and so both are synonymous (Tschan, 2001). Jenkinson preferred the word archives as it is common in many languages (Jenkinson, 1922). The mere fact that the records were filed means they were selected and deemed to qualify as archives. The coming into being of records through natural accumulation during the course of regular organizational activity, their creation and preservation by their creators for their own use, gave archives their impartiality and authenticity (Tschan, 2001; Hohmann, 2016). For Schellenberg (1956a), archives are records that have been selected for permanent preservation. Jenkinson (1922) argues that archives are selected for permanent preservation as they possess some value that qualifies them to be archives. Such value is different from the one referred to by Schellenberg.

According to Stapleton (1984), Jenkinson believed that the only records that can be preserved and thus considered to be archival should satisfy the information needs of creators. These should be in the

custody of creators and the duty of the archivist is to provide unbroken custody of records. This can also serve the needs of the researchers. Jenkinson was of the view that records are preserved for use by the creator so it is the creator who has the power to decide which records should be kept (Jenkinson, 1922). To Jenkinson, the fact that archives are composed of interrelated records in a contextual whole which gives them meaning is actually what qualifies them for preservation.

Jenkinson prohibits archivists from carrying out records appraisal (Gwynn, 2008). His approach is "hands off" and believes that this will keep the hands of archivists pure. Therefore, archivists are forbidden from making value judgments on the future of the archive. Rather, the main duty of the archivist is to keep the integrity of records and ensure that they become available for future consultation. He also did not support destruction of records except duplicates. The records creator is the one who is responsible for weeding of records before they are transferred to the archives. Thus the creator is responsible for selection of records for use and not the archivist. For Jenkinson, the archivist is just a custodian of records passed to him, and not a selector and arbiter. The archivist is viewed as a passive recipient of records who is supposed to keep them safely. He felt there were no grounds for destroying records. According to Tschan (2001), Jenkinson's view was that any alteration or destruction of records diminishes their integrity and their value as evidence of past events. Honer and Graham (2001) also opine that the intervention of archivists in appraisal as third parties corrupts the records.

According to Honer and Graham (2001), the records creator is responsible for selecting records for preservation because they know the administrative structures of their organization. This suggests that they would not have to undertake research to understand the organizational functions which will enable them to appraise records which is contrary to the ideals of macro appraisal. Honer and Graham (2001), in agreement with Jenkinson add that the involvement of archivists in appraisal destroys the evidential value of records through an application of sets of variables to records. The interests of researchers should not be taken into consideration when appraising records. This will save their evidential value from destruction. Jenkinson was of the idea that the need for appraisal can be avoided if records are prevented from accumulation (Stapleton, 1984). Records creators should deal with the matter before the records reached the archival repository and the custody of the archivist. Jenkinson's views on the role of the archivist in appraisal demonstrates his desire for records to be left alone and intact so as to maintain their impartiality. He thought the integrity of records should be protected at all costs. It was the intention of Jenkinson (1922) that the integral characteristics of archives: impartiality, authenticity, interrelatedness, and naturalness be not disturbed. Out of these, interrelatedness and impartiality, are core for records appraisal (Hohmann, 2016), hence his views that once created, records be left alone. According to Goodman (2010), Jenkinson's approach to records appraisal rests on three key points; archivists should have the technical knowledge of how the record was made so that it can be preserved properly (e.g. its composition); archivists should be concerned with the safety of archives in their custody; all records should be retained or preserved and their original state should be retained.

Strengths of the European Theory of Records of Appraisal

The strength of the European School lies in its definition of the archives which advocates for the acceptance of the characteristics of records such as impartial, authentic, natural and interrelated (Duranti, 1994). Duranti thinks that archivists should be impartial as placing value judgement on records (which is the practice of appraisal) is in conflict with the stated characteristics of records. The European School seeks to maintain the impartiality of records by being against appraisal and so does Duranti (1994).

Maintaining records in their intact state is the hallmark of traditional archival theory (Stuckey, 2004; Hohmann, 2016) and perhaps the subscription of this school to this thinking is its main strength.

Weaknesses of the European Method of Records Appraisal

The Jenkinsonian view of appraisal advocates for records creators to appraise records because they are knowledgeable about their organization including its structures and functions. Other scholars feel records creators are not better placed to appraise records. Boom (1991) point out that in appraisal, records creators have amongst themselves timid persons who would prefer to destroy everything they are involved in while others would want to keep everything. Still others would want to preserve records that appear useful for their research interests. According to Schellenberg (1956a), records creators are not qualified to appraise records because they have not been trained as historians. Schellenberg opined that archivists have received training in history and this makes them better placed to appraise records and select those with historical value. He also thinks that other professionals in the social science can assist the archivist to appraise records.

Secondly, the appraisal of records by creators is also problematic as there is bound to be some conflict of interest. Appraisal is evaluation and self-evaluation is subjective. Chances are that creators may destroy those records which do not stand them in good stead, i.e. records that may implicate them in corruption. Thirdly, Jenkinson is against the destruction of records. This is not practical today as space is not adequate and it is also expensive. Compared to the times of Schellenberg, the Second World War era, Jenkinson's era did not produce voluminous records hence his idea that no records should be destroyed. Fourthly, Jenkinson's definition does not make a distinction between records and archives. The life cycle approach to the management of records demonstrates that records and archives are different.

The approach to archival appraisal in the United Kingdom will not be complete without mentioning the influence of the Grigg report of 1954. The report came out of the Royal Commission on Departmental Records chaired by Sir James Grigg (TNA, 2004). The report formed the basis of the Public Records Act enacted in 1958. The law ended the haphazard legal position as regards duties of custody and disposal of 'public records'. According to TNA (2004), the Act defined 'public records' and assigned custodial duties for records to the Public Records Office (PRO) and departments. The Grigg report on records appraisal basically departed from appraisal views held by Jenkinson (1922). Through its influence, TNA adopted, like most archival agencies, the records value system as advocated through American archivist, T.R. Schellenberg's taxonomy of value whereby appraisal was selection of records was informed by the value to the organisation that created them and a secondary value to historians.

AMERICAN SCHOOL OF APPRAISAL

The lead thinker in the American School of Appraisal is Theodore Schellenberg, the American archivist of the mid-20th century. His views on records appraisal, just like those of Jenkinson, were influenced by the environment in which he lived. His views on records appraisal are documented in his 1956 text entitled *Modern Archives: Principles & Techniques*. During his time records were produced in large quantities due to population growth and modern technologies and an increase in population which led to increased government activity (Schellenberg, 1956b). Increased government activity in turn led to production of mass records. Furthermore, the world wars also produced large quantities of records. Reducing records

was thus essential as space for storage was inadequate (Schellenberg, 1956b). It would also be expensive to maintain staff members who managed such voluminous records. Researchers and scholars would not be served well if records exist in large quantities as retrieval to locate desired ones for research would be difficult. A better understanding of Schellenberg's views on records appraisal can be arrived at by a close study of his views on the nature of records and archives, the reason for the preservation of archival material and the role of the archivist in records appraisal (Tschan, 2002).

Schellenberg's view was that there is a distinct difference between records and archives (Tschan, 2002). According to Schellenberg (1956a) records are defined as:

All books, papers, maps, photographs, or other documentary materials, regardless of physical form or characteristics, made or received by any public or private institution in pursuance of its legal obligations or in connection with the transaction of its proper business and preserved or appropriate for preservation by that institution or its legitimate successor as evidence of its functions, policies, decisions, procedures, operations, or other activities or because of the informational value of the data contained in them (p.16).

Archives on the other hand are defined as records that have been adjudged to be worthy of permanent preservation for reasons other than those for which they were created such as for reference and research purpose (Schellenberg, 1956a). According to Tschan (2002), there is a striking similarity in the principle of Schellenberg's definition to that of Jenkinson's definition of archives. Tschan (2002) opines that for Jenkinson, archival documents are created when they cease to be used for current organizational business and are set aside for preservation after a tacit judgment is imposed on them to establish their worthiness for archival custody. According to Schellenberg (1956a), the first element to be discussed when discussing the nature of archives relates to the reason for their accumulation. To qualify as archives, records should have accumulated in the course of conducting organizational business to accomplish some purpose (Hohmann, 2016).

The appraisal of records is undertaken in order to determine what records should be preserved. To qualify as archives worthy of preservation, the records must be preserved for reasons other than for which they were created such as cultural and official values. Schellenberg (1956b) points that records have values and such values inform what records need to be preserved and what records can be destroyed. The values are primary and secondary values. Honer and Grahan (2001) indicate that primary values are values that a record has to the organization while secondary values refer to the value that a record has to other entities such as researchers, other that the creating agency itself. For Schellenberg archivists have a role to play in the appraisal of records (Schellenberg, 1956a). Modern records are just too voluminous to be all preserved as Jenkinson suggests. The archivist appraises records to select those that qualify as archives on the basis of their value. According to Tschan (2002, p.182) "Schellenberg advocates selection based on the value of records for perceived research needs of those other than the creator." The American School of Appraisal places the responsibility of appraising records for their primary values on records creators while for secondary values, archivists should take the lead (Graham & Honer, 2001). Records should first be appraised 5 – 7 years after years of administrative use to determine their primary value which encompasses continued accountability. The archivists should anticipate the secondary value of records and preserve them for the benefit of researchers. 80% of records are preserved at the first review. Schellenberg is against Jenkinson's call for archivists to be passive custodians of records without taking part in appraisal.

Cook (1997) indicates that due to large quantities of modern records, "it is obviously no longer possible for any agency to preserve all records which result from its activities. The emphasis of archives work," he noted in conscious contrast to Jenkinson, "has shifted from preservation of records to selection of records for preservation." Thus the archivist is better suited to appraising records with secondary values while administrators should assess primary value of records (Honer & Graham, 2001). Schellenberg (1956a) is convinced that archivists can select archives with historical and future research value because to him, an archivist has historical training. In passing value judgments on secondary values, Schellenberg prohibits researchers from taking part in appraisal as they are deemed too close to their subject so much that they may be biased to serve their interests (Honer & Graham, 2001). However, Schellenberg allows other scholars and public officials to assist the archivists in undertaking appraisal (Schellenberg, 1956a).

According to Schellenberg (1956b), deciding what records to keep and what records to destroy should be guided by the following questions:

- Which organizational units in the central office of an agency have primary responsibility for making decisions regarding its organization, programs, policies, and procedures? Which organizational units carry on activities that are auxiliary to making such decisions? Which field officers have discretion in making such decisions? Which record series are essential to reflect such decisions?
- Which functions of an agency do the records relate? Are they substantive functions? Which record series are essential to show how each substantive function was performed at each organizational level in both the central and field offices?
- What supervisory and management activities are involved in administering a given function? What are the successive transactions in its execution? Which records pertain to the executive direction, as distinct from the execution of the function? To what extent are such records physically duplicated at various organizational levels? Which records summarize the successive transactions performed under the function? Which records should be preserved in exemplary form to show the work processes at the lower organizational levels?

Strength of the American School of Appraisal

The American School of Appraisal does include an assessment of organizational functions (Schellenberg, 1956b) and so does macro appraisal methodology. Another strong point of the school is that records creators can also be included in the appraisal process to help the archivist (Schellenberg, 1956a). Schellenberg's methodology was developed in order to deal with a real situation which was to deal with voluminous records. The methodology was developed from practice. He had to devise means to deal with huge records created by the Second World War as well as technological advancements. His taxonomy of values is widely accepted and influences records appraisal across the globe.

Weaknesses of the American School of Appraisal

According to and Honer and Graham (2001) the American school of appraisal has the various weaknesses. There was a tendency to select records that document policy formulation but not policy implementation. Secondly, records have to be assessed on a file by file basis which is resource intensive and not suitable for the appraisal of records in large quantities. Thirdly, this method lacked strategies for prioritizing records creating bodies. Fourthly, there was too much focus on administrative history as a lot of emphasis

was put on the need to document organizational structures and functions of creating agencies. Fifthly, the approach is not suitable when dealing with electronic records. This is because, after 25 years, though the medium carrying may still be available, the records themselves will not accessible due to technological obsolescence. Additionally, no mechanisms were put in place to provide for recording the basis on which appraisal decisions were taken (Honer & Graham, 2001).

Another weakness of the American School of appraisal is its definition of the archives. Its notion that archives are records selected for preservation (Schellenberg, 1956a) while the rest is records management has literally divided the profession of archives and records management though there are no theoretical connotations that support this division. The other weakness is that the archivist is given too much power to decide what an archive becomes. Even macro appraisal is content with power given to the archivist in appraisal as the thinking is that the archivist is appointed legally to be the custodians of societal memory (Greene, 2003). However, giving too much power for the archivist to decide the record of the future is that such power may be abused as there is no guarantee that the archivist will be objective. Another weakness inherent in the Schellenberg's methodology is that the archivist is allowed to appraise records even though he understand very little in terms of organizational functions which creates the context in which records are created.

THE DOCUMENTARY STRATEGY AS A CONTEMPORARY AMERICAN METHOD OF RECORDS APPRAISAL

Another method of records selection developed by American archival scholars is the Documentation Strategy. The chief architects of this method are Helen Samuels and Richard Cox. Helen Samuels defines the documentary strategy by contrasting it with a collections policy which is viewed as less comprehensive because its placement of papers is deemed ad hoc (Malkmus, 2008). Hackman and Warnow – Blewett (1987, p. 48) defines a documentary strategy as "a plan formulated to assure the documentation of an issue, activity or geographic area." International Council on Archives (2005) indicates that documentation strategies entail an identification and evaluation of the roles of organizations and individuals in a specific subject or a geographical area.

According to Cox (1996), the Documentary Strategy has four basic components. Firstly, it should be viewed as an analytical tool whose methodology considers the nature, complexities, challenges, and issues presented by records appraised i.e. whether they are topical, geographical or specified in some other manner. Using architectural records as an example, questions such as whether they should be viewed primarily as evidence of architects, as products of a profession, or in conjunction with the built environment and a much broader aspect of testimony to the basic human impulse to have shelter arise. These have to be considered during the appraisal process.

Secondly, archival Documentary Strategy is "an interdisciplinary process and even more, an exercise in administration, public relations, and politics" (Cox 1996, p. 146). This is the reason why the long held North American notion in archival theory which gave archivists the sole responsibility to select the future archive was ditched in favour of a more collaborative and coordinated process that involves records creators, archivists, and the varied users of records to combine their knowledge in the archival appraisal process. Thus, this elevates the appraisal process beyond an intellectual pursuit but also an exercise in administration, public relations, and politics (Cox, 1996). Collaboration meant that archives were no longer selected with the scholarly historical user in mind but expanded to include both the cre-

ators of records and a much wider spectrum of users, enabling requisite knowledge for the solid appraisal of records. Samuels (1991) argues that records of modern institutions cross institutional lines, thus the acquisition of modern archives becomes difficult for archivists when working alone in their selection (Malkmus, 2008). Alexander and Samuels (1987) add that the complexity of records means that it is no longer possible to assume that the papers of an individual scientist represent a complete record of his or her work, nor would it be wise to rest assured that an aggregation of papers of many individual scientists comprehensively documents a particular scientific field, or science in general. Working alone to appraise records without the involvement of records creators, users and custodians would be a mammoth task for the archivist hence the involvement of a team of appraisers.

Cox (1996) puts the third element of the Documentary Strategy appraisal approach as the recognition of inherent documentary problems. These are borne from the massive records under consideration, complexities brought by the nature of documentation (found in different record formats including those created and stored in sophisticated information technologies) and varied institutional records policies, interests, and related matters. By recognizing that it is impossible for archival methods to cope with massive records created by modern organisations, the inability to examine all records, assess all fonds and evaluate record-creating entities, the Documentary Strategy puts emphasis on analysis and planning (Cox, 1996). Part of this analysis and planning, in recognition of the stated challenges, manifests itself in encouraging the creation of institutional archives over and above collecting archives from creating agencies.

The last component of the Documentary Strategy as conceptualized by Cox (1996) is that prior to undertaking records appraisal, a documented plan to guide the activity should be in place. He notes that in selecting the future archive, it was probably still the case for most archival appraisal and acquisition to exclude documenting a plan prior to the exercise and just rely on the result of efforts to inspect actual records closely and determine their potential values based on the said inspection. Formulating the plan is an attempt to create the context under which the appraisal process obtains and it includes the documentary objectives for the topic, geographic area or the aspect being considered. The plan considers documentary problems created by modern organisations before records are examined. The plan assists archivists and the whole collaborating team to strategically be aware of documentary sources needed to justify archival records to be retained. According to Cox (1996), the plan helps to select what may be missing from archival repositories by answering questions such as "What does all the currently preserved archival documentation represent? Is it comprehensive, representative, or fragmentary, or do we even know?" (Cox 1996, p. 148).

Historical Development of the Documentation Strategy

The documentation strategy came about in the mid-1980s as a proactive and collaborative alternative to passive acquisition of records in the quest to the creation of a more usable historical record (Malkmus, 2008). It is an approach to records appraisal that employs societal thinking (Cook, 1997).

As an approach for selecting the future archive, Documentation Strategy was hatched to resolve documentation problems through its planned and coordinated collection activities. Modern organizations produced voluminous and complex records which demanded new approaches in the selection of the future archive by archivists and other stakeholders concerned with records management (Alexander & Samuels, 1987). Modern technologies also altered the nature of records. All these changes posed problems to archivists in records appraisal as they were found wanting in terms of supporting their decision making.

Huge volumes of complex records produced by modern organisations thus influenced the development of the Documentation Strategy whereby it became decisive for appraisal to be undertaken by a team of personnel from different (Williams, 2012: Malkmus, 2008: Samuels, 1991: Hackman and Warnow –Blewett, 1987: Samuels et al. 1986: Cook, 1992). According to Samuels (1991), Documentation strategy is designed, promoted and implemented by a team of records creators, administrators, archivists and users from multiple institutions. This team endeavors to document a topic or area of activity as a way to document poorly documented sectors in society. Samuels et al (1986) justify the cooperation of multiple institutions in the selection of the future on the basis that institutions do not exist in isolation whether public or private. Central to the success of the Documentary strategy is functional analysis of institutions being documented (Williams, 2012: Malkmus, 2008; Samuels, 1991). Analysis is informed by research and it enables archivists to understand the records creating context.

The Documentary strategy is similar the National Archives of Canada's Macro Appraisal and the Dutch PIVOT in that functional analysis is a central feature in the process (Cook, 1997). According to Samuels et al. (1986), this analysis is in two forms. The first one is the analysis of the history and scope of a topic to determine documentation purpose of the strategy and to define the topic to be documented. The second one is an analysis of available sources of information to facilitate the adequate gathering of records for the topic or issue. Apart from guiding the appraisal of an archivist's institution or sponsoring organization Cook (1997) observes that inter institutional analysis that enables the archivist to appraise or document related personal records which may supplement institutional archives. Functional analysis studies the records creating context before appraising individual fonds and a series of records (Cook, 1997). An understanding of the functions of an organization is a prerequisite for successful appraisal of records. The documentation strategy came about in the mid-1980s as a proactive and collaborative alternative to passive acquisition of records in the quest to the creation of a more usable historical record (Malkmus, 2008). It is an approach to records appraisal that employs societal thinking (Cook, 1997). As an approach for selecting the future archive, Documentation Strategy was hatched to resolve documentation problems through its planned and coordinated collection activities. Modern organizations produced voluminous and complex records which demanded new approaches in the selection of the future archive by archivists and other stakeholders concerned with records management (Alexander & Samuels, 1987). Modern technologies also altered the nature of records. All these changes posed problems to archivists in records appraisal as they were found wanting in terms of supporting their decision making.

Huge volumes of complex records produced by modern organisations thus influenced the development of the Documentation Strategy whereby it became decisive for appraisal to be undertaken by a team of personnel from different (Williams, 2012: Malkmus, 2008: Samuels, 1991; Hackman & Warnow – Blewett, 1987; Samuels et al. 1986; Cook, 1992). According to Samuels (1991), Documentation strategy is designed, promoted and implemented by a team of records creators, administrators, archivists and users from multiple institutions. This team endeavors to document a topic or area of activity as a way to document poorly documented sectors in society. Samuels et al (1986) justify the cooperation of multiple institutions in the selection of the future on the basis that institutions do not exist in isolation whether public or private. Central to the success of the Documentary strategy is functional analysis of institutions being documented (Williams, 2012; Malkmus, 2008; Samuels, 1991). Analysis is informed by research and it enables archivists to understand the records creating context.

The Documentary strategy is similar the National Archives of Canada's Macro Appraisal and the Dutch PIVOT in that functional analysis is a central feature in the process (Cook, 1997). According to Samuels et al. (1986), this analysis is in two forms. The first one is the analysis of the history and scope

of a topic to determine documentation purpose of the strategy and to define the topic to be documented. The second one is an analysis of available sources of information to facilitate the adequate gathering of records for the topic or issue. Apart from guiding the appraisal of an archivist's institution or sponsoring organization Cook (1997) observes that inter institutional analysis that enables the archivist to appraise or document related personal records which may supplement institutional archives. Functional analysis studies the records creating context before appraising individual fonds and a series of records (Cook, 1997). An understanding of the functions of an organization is a prerequisite for successful appraisal of records.

Documentation Strategy Process

The concept of Documentary strategy recognizes that in order for an archivist to select the future archive, they have to undertake an analysis that transcends the record itself and the creating agency. Thus, Documentation strategy involves a multi institutional cooperative functional analysis of records documenting issues, themes, activities and societal functions (Cook, 1997). Hackman and Warnow-Blewett (1987) add that not only institutions cooperate in the documentation, even individuals who influence the creation, retention and archival accessioning of some of the records documented for appraisal also take part. It is also the assertion of Samuels et al. (1986) that functional analysis of many institutions is relevant as it is not enough to enable an archivist to make a decision when selecting the future record.

Scholars like Hans Boom cited in Cook (1992, p. 185) assert that "archival appraisal is fragmented, uncoordinated, random and haphazard." Uneasiness with the effectiveness of the process to select and preserve records of enduring value gave birth to the documentation strategy (Cox, 1989). Contrary to Boom's assertion that archival appraisal is fragmented and uncoordinated process, Documentary strategy as an appraisal approach is actually underpinned by analysis and planning which precede any documentation efforts. As a process the Documentation strategy starts with the recognition by a champion or mover, not necessarily an archivist, that there is a need to address the issue of a poorly documented specific sector in society (Samuels, 1991). A topic, theme or geographic area is then selected and a body of advisers and participants are brought together to guide the documentation effort. The Route 128 phenomenon in Massachusetts (Alexander & Samuels, 1987), Western New York (Cox, 1989) and London Organizing Committee of the Olympic Games and Paralympic Games (LOCOG project) (2012) are some Documentation strategy projects.

The documentation of 2012 London Organising Committee of the Olympic Games and Paralympic Games (LOCOG project) depict the idea of selecting records that document societal actions. The LOCOG records emanated from the efforts of athletes, private sponsors and British government. For example, records documenting the games go beyond just the games. Through an organisation called *The Record*, plans were made prior to the start of the games (Williams 2012). Stakeholders congregated to devise a plan on how to build a legacy for the games years before they actually started and that legacy was partly to be built on evidence or games' documentation. In 2008, potential stakeholders such as Hackman and Warnow-Blewett's many institutions and individuals influencing the creation and management of records. The British Olympic Association and the Olympic Delivery Authority (ODA) congregated to devise a plan to on how to build a legacy for the games years before they actually started and that legacy was partly to be built on evidence or games' documentation. The objectives of *The Record* were to ensure that records created before, during and after the 2012 Olympic and Paralympic Games and the Cultural

Olympiad were properly managed, permanently preserved and appropriately shared. Effective management of these records would:

- Support the effective delivery of the sports and cultural events across the UK;
- Mitigate reputational, financial and operational risks;
- Guarantee legal and regulatory compliance;
- Support openness and transparency for all;
- Enable public accountability and scrutiny post-2012;
- Secure a long-term legacy for the benefit of future generations of planners, policy makers, researchers, learning and education professionals, and the general public' (Williams 2012, p. 28).

The selected archives from LOCOG quashed the idea that The Record was to a retrospective post game reality but rather would provide records that served as evidence for the government and the public of whether promised ambitions were fulfilled, amongst others (Williams, 2012).

Stakeholder engagement for The Record as it relates to LOCOG demonstrated that in archival Documentation Strategy, the body of advisors lead and, monitor the project and provide intellectual and political support (Alexander & Samuels, 1987). The site chosen to be the host for documentation, not necessarily an archival repository, must sustain the project with resources and commitment. According to Samuels (1991), the actual documentation is then done with records creators, users and custodians as they have the knowledge of the topic and its documentation. The documented body of archives must then be placed or housed in some archival institution.

In terms of scope, corporate archivists and personal manuscript archivists assemble together to appraise records across all media (Cook, 1997). These records formats include official records, personal manuscripts, oral history, published information and other institutional records. The multiple institutions produce records of all kinds such as visual, published documents, aural, artifactual and machine readable records and each unique type of evidence (Samuels et al. 1986). Documentation of a topic, theme or historical event is time specific though it can be altered to meet the demands occasioned by changes over time.

Strength of Documentary Strategy

As a method for the selection of the future archive, the documentary strategy has notable strengths identified in the literature. Malkmus (2008) posit that it is an effective outreach and public relations tool. For example, the Milwaukee Documentation strategy project in the US made the local archives more visible to the community and raised interest in it leading to community appreciating the need to preserve historical records. Perhaps archival institutions can have increased access and usage as a result of taking part in a Documentation strategy project.

Samuels (1991) points out that Documentation strategy emphasizes cooperation between multiple institutions in the selection of archives. Cooperation by institutions allow for the provision of comprehensive description and reference. Williams (2012) adds that this cooperation makes it possible to refine and change documentation goals due to the availability of multiple opinions and expertise. Alexander and Samuels (1987) credits also the Documentation strategy for its capability to reduce costs associated with funding of Documentary strategy projects which are expensive to undertake. Cooperating institu-

tions can pool their resources together to meet costs associated with facilities for archives and records management services including storage and reference.

Cox (1989) also indicates that the multi institutional cooperation in the selection of the archive by organizations which may include both private and public organizations is the way to go as records are shaped and influenced by external forces in the form of government, legal regulations and cultural trends. Alexander and Samuels (1987) further point out that discussions between archivists, records users and creators over the selection of the archive help to establish the relative merits of selecting and preserving archival records. The assembly of a team of experts, records creators, users and archivists has an advantage in the selection of the future archive compared to an archivist working alone (Samuels et al. 1986). Furthermore, the selection of archives by cooperative effort compensates for archivists' lack of expertise in the appraisal of an integrated body of information from multiple organizations. In terms of productivity, a lone archivist would take long to select archives from large masses of records. Hence Cook (1997) is of the view that the Documentary strategy enables archivists to cope with large masses of records produced by modern and complex organizations and contemporary societies (Cook, 1997).

Documentation strategy also accommodates the collection of oral histories thus facilitating the filling of gaps in the available being documented. Malkmus (2008) notes that as a concept, documentation strategy is highly useful in the documentation of topical issues such as women's liberation, AIDS epidemic and immigration, amongst others. Cook (1997) opines that it enables appraisal of records across all media. This is made possible by the large pool of personnel involved in Documentary strategy projects. Team members are experts in their own areas. Furthermore, one key feature of the Documentation strategy is that it encourages the establishment of archival programmes among institutions. Awareness of the value of archives is raised through education programmes and seminars by archivists and records managers.

Weaknesses of the Documentary Strategy

The Documentary strategy has weaknesses which are highlighted by a number of scholars. Malkmus (2008) puts across some weakness of the Documentary strategy. It is deficient when it comes to the collection of electronic records. The rapid obsolescence of electronic records require proactive appraisal to accession digital records. The documentation of selected topics for archival preservation may take a decade to acquire while electronic formats and communications change every ten to fifteen years. Documentation strategy also has theoretical and practical problems. It promotes simultaneous, centralized appraisal and acquisition of records which is cumbersome and elusive.

Documentary strategy is financially not feasible to undertake as archival institutions operate in environments characterized by inadequate financial resources thus funding is problematic (Malkmus, 2008.) The documentation of Western New York experienced inadequate funding and had to narrow their ambitions (Cox, 1989). The Milwaukee project became too encompassing, experienced inadequate funding and had to narrow their ambitions. Terry Abrahams feels that archivists have inadequate time to devote to documentary strategy projects and they also have to justify commitment to it (Malkmus, 2008). Cox (1989) agrees and adds that documentation analysis and planning, which are part of the Documentary strategy, are not an easy methodology to grasp as they require lengthy period of time to master by individuals and institutions (Cox, 1989). However, time is not a luxury for both archivists and the team involved in the documentation. In theory, documentary strategy is ideal as it can incorporate parts of inventory, scheduling and functional approaches but in practice it is difficult to undertake and organize as so many people are involved in a thorough process (International Council of Archives, 2005).

Cook (1992) also finds faults with how themes and subjects seem to be chosen arbitrarily and artificially with no distinction between a function and a theme even though this distinction is fundamental in the selection of archives. Cook opines that it is unarchival to base the documentation of modern organizational records through the thematic approach. Hence, Cook (1992, p. 187) indicates that though "documentation strategy is based on organic and provenance based structure which is a sound archival practice, its subject or thematic and geographical underpinnings cannot be accepted as the prime focus for appraisal."

According to Cox (1989), the logistics involved for the preparation of documentation analysis and planning are tedious and involving as the host institution is responsible for calling meetings, developing agendas, preparing reports and contacting required experts. Thus, the full complement of resources needed to support activities for documentation planning and analysis are uncertain (Cox, 1989). Documenting strategy may involve documenting a geographical region. It is the contention of Cox (1989) that documenting a region is a difficult undertaking as a geographical area has diverse institutions that create many different kinds of records that could be unfamiliar to the assembled team that is involved in the documentation. Cox (1989)) thus concludes that as a result of this difficulty, "seeking to document a region was akin to trying to document the world" Cook (1992).

GERMAN SCHOOL OF APPRAISAL

Developments in appraisal of records in Europe can be traced to the violent French revolution and slowly evolved to the present times. The proliferation of records occasioned by the information age drove the appraisal agenda, including problems associated with it, when faced with the need to appraise government records within a carefully regulated environment (Turner, 1992). Germany was one of the first countries to explore archival appraisal and this obtained in an environment where administrative activities have been traditionally rationalized (Couture, 2005). In this context, as far back as 1833, the Prussian government developed means to judge the value of documents it created. By 1858, it was normal practice for government documents to be destroyed only with the permission of archival authorities. The role of the national archivist was codified by 1857 in Bavaria (Couture, 2005). This indicates that the Germans have a long history of grappling with the idea and practice of archival appraisal. They appraised records to preserve them as Couture (2005) puts it, based on knowledge of history and an empirical analysis of society's documentary sources together with practical experience and intuitive insights which resulted in an understanding of society and past events (Turner, 1992). To this end, Cook (2011, p177) opined that Hans Booms' appraisal offered the best analysis of appraisal values, in reference to an earlier assertion he made to the effect that "all appraisal theory (and appraisal work) would necessarily be socially conditioned and subjective, 'rooted in the very essence of human existence: it is a condition that cannot be changed or removed, only confined."

The German School of Appraisal is one of the schools of records appraisal which have been formulated by archivists over the years in their quest to address the issue of how appraisal should be done. The lead thinker in this school is Hans Booms. He was born in Germany in 1924, where he received archival education and started work as an archivist of the Federal German Archives in 1955 (Booms, 1987). Boom's appraisal methodology is regarded as the societal model of records appraisal. According to Stuckey (2004, p. 133);

This theory of appraisal is founded on working out directly the values, ideas and trends in the society creating the records, and turning these into ways of appraising the records themselves. This theory places society, instead of the records, at the centre of any theory of appraisal. It changes the values of the agencies that actually creates the records to a value put on social processes.

Kenosi and Moatlhodi (2012) indicate that Booms' appraisal approach centres on society, hence his ideology was named the 'societal model. Thus to him, society's views are important in the determination of the future archive. Booms practiced his trade as an archivist a decade after the Second World War and clearly the issue of voluminous records which had to be reduced was one of his priorities as an archivist. That is why he probably posits that "the most challenging function of archival science is to reduce the growing quantity of documentation to the form of a documentary heritage that is of a useable and storable quality" (Booms, 1987, p. 101). Archives are the documentation of past activities which may be stored in written, printed, photographic, mechanical or automated forms, generated by the totality of the social and political processes in society and these should be selected by the archivist as having archival value (Boom, 1987). Records that are selected for permanent preservation are those that best document significant past societal events while those that document insignificant events are deemed to be worthless and will not be selected for permanent preservation (Booms, 1991).

The Influence of Society on Appraisal Decision

Booms (1987) define society as an all-encompassing concept for human existence in general where human beings are seen as social animals. Human beings are members of a community both as an individual and as a group. The society has a structure within which individuals exist and society's dominant views are found within the structure. Individual members of society are influenced by societal values and norms in terms of thinking and the way they do things. Archivists operate within societal structures hence they are bound to be influenced by their environment when they undertake records appraisal to select archival documents which Booms refers to as the documentary heritage. Booms (1987, p. 76) defines the documentary heritage as "the totality of the existing evidence of historical activity, or as all the surviving documentation on past events."

Booms (1991)'s view on records appraisal is that when the archivist decides what to keep and what to destroy, which is in essence the construction of society's documentary heritage, the archivist must first establish the value of records to society. In conducting appraisal, the archivist has to take into consideration the subject opinions and ideas of society as they are part of the very society in which they live. Archivists have to anticipate what society holds as valuable in deciding the archival record. This anticipation is done by analyzing the opinions published at the time the records being appraised were created. Such opinions are a reflection of what society values most. Booms (1991:31) succinctly indicates that "archivists have no other choice than to conduct their appraisal according to the emphasis and weight placed on events of the time by contemporaries."

In order to understand what society valued in the past, the archivist has to carry out research to acquaint themselves with the values of the time in which the records were created (Booms, 1991). This is what Booms referred to as the Documentation Plan. His theory sought to build societal documentary heritage which is accountable to the public and which is also verified critically by the historical method that is scholarly. According to Booms (1991), understanding past societal values entails an analysis of political events of the time when records being appraised were created. This analysis gives a picture

of events, actions, failures and developments which led to nowhere as well those that were deemed significant and important.

Booms (1991) opine that in order to prepare for records appraisal, an archivist has to go through three steps before actually undertaking records appraisal itself. The first step is to undertake an analysis of the administrative structures of the records creator at the time in which the records being appraised were created. This analysis of record creating functions enables the archivist to make connections between societal documentary needs and the records appraisal. The second step, according to Booms (1991), is to provide an administrative history of the individual records creating functions. The administrative history should be reviewed and updated regularly. This regular review of administrative histories could have been influenced by facts in Germany. Every time a new government was formed, administrative structures changed. An understanding of the administrative structures enables an understanding of the provenance of records which Booms (1991) describes as the foundation of the appraisal process. The last step in the preparation of for appraisal is to investigate the contents of the registry. This investigation helps in the development of the standard records retention schedule. The development of the standard records retention schedule suggests that appraisal only applies to records common to administrative functions. After the third preparatory step (Booms, 1991), then actual records appraisal takes place whereby the archivist select only records which document organizational activities carried by an agency as it performs its primary function. Records that principally enable the organization to perform its core functions are preserved while those whose contribution is insignificant are destroyed. At the first instance 60% of the records will be destroyed while another 25% will be destroyed using the historical criteria.

Strengths of the German School of Appraisal

Appraisal of records involves an assessment of functions just like in the macro appraisal methodology. This method allows appraisal of records in large quantities and in a fairly short period of time as only the functions and not individual files are appraised. This method demands that the archivist undertake research in order to understand the functions. This empowers the archivist to have knowledge about organizations and so the archivist is better placed to appraise records of any agency. The German School recognizes the needs of society in appraisal so it serves citizens who want to "know how they have ruled themselves, and to allow them to build understanding of their place in the communities to which they consider themselves to belong, including of course the national community" (Eastwood, 2002, p. 66).

Weaknesses of the German School of Appraisal

The German School of appraisal gives too much power to the archivist to decide the future archive, just like the American school. This can be too dangerous as the archivist may abuse his power and be subjective e.g. the archivist can destroy records that paint him or his friends badly. Also, where records are poorly classified, appraisal at the broader level of functions will not be appropriate but rather file by file appraisal will be suitable. This school also relies on public opinion to select the future archive but public opinion is unreliable as what is important for some sections of the society may not be deemed important by others. Thus, relying on public opinion to select the archive may put the archivist at crossroads and may find it difficult to appraise records on that basis.

MACRO APPRAISAL (FUNCTIONAL APPRAISAL)

The chief proponent of this school of appraisal is Terry Cook, the Canadian archivist (Bailey, 1997). This method approaches appraisal in a systematic and logical way in its endeavor to create what Bailey calls a better archival record. The approach was conceived as a form of Total archives that sought to document the people and government of Canada (Boles, 2005). Appraisal shifts from determining the value of the record (Schellenbergian method) for purposes of research to an assessment of the functional and structural circumstances which have led to the creation of records (Bailey, 1997; Boles, 2005). This is an assessment of the importance of the context in which records were created or their provenance. The detailed research and analysis is undertaken to understand circumstances of records creation such as the history of the record creator (administrative history), the mandate, the functions, structure decision making processes the way records are created and changes to records creation overtime.

Greene (2003) asserts that this understanding allows an archivist to determine organizational core functions e.g. what an organization was set up to do. As a result, the archivist is able to understand what should be documented as proof of the performance of the core mandate. Greene (2003)'s view is that in macro appraisal functions that create records are assessed first, not the records themselves. The purpose of doing so is to identify the record creator's purpose and intent. An understanding of the functions and organizational structure helps to identify records of enduring value. Greene (2003) adds that the best archives are those records that document records creator – client relationships.

The detailed analysis of organizational functions allows archivists to focus on the complex functions and sub functions (Bailey, 1997). This analysis identifies areas where records are likely to be created or found and then the actual records are assessed and the records are assessed through what is called micro appraisal. This is actually where macro appraisal meets the more traditional methods (Bailey, 1997). For example, issues such as what time span do the records cover, how complete or authentic are they, how much is there, and what legislative requirements affect them. Bailey (1997) points out that this helps to avoid duplication of appraisal effort which is a characteristic of the Documentation Strategy and the value based Schellenbergian method. The benefits are both theoretical and practical. The theoretical benefit is that it enables those important functions in society which should be documented. Practically, this method has the ability to focus appraisal activities on records of the highest potential value. The analysis allows records of great importance created at sub functions level to be documented.

Goals of Macro Appraisal

According to Cook (2001) the documentation goals of macro appraisal are preserving selected records which; provide government and the public with information about the policies, decisions and programs of government institutions over time for the purposes of review, scrutiny and understanding.

According to Cook (2001), macro appraisal answers the following questions; what are the mandated functions and activities of government institutions?; how important are these functions and activities across government and within institutions?; how important are these functions and activities across government and within the broader context of society?; what aspects or features need to be documented if a function or activity has importance? What constituents sufficient documentation from an archival perspective?; where in government is the Office of Primary interest for a particular function or activity?: is the Office of Primary interest the location of the best archival record which documents the function or activity? According to Bailey (1997) Cook states that macro appraisal approach requires that archivists

be committed to undertaking research into records creation processes and more importantly into the operational functions that lead to the records creation processes.

Macro appraisal requires that the archives should only acquire records that document the functions of government (Cook, 2001). Thus, the focus is shifted from records themselves to the context which led to the creation of the records. Greene (2003) adds that in order to preserve society's documentary heritage, archivists have to carry out research and analyze functional profiles and administrative structures of government including policies and business programmes. Research is necessary because records follow, relate to and support business functions. Furthermore, the best way for an archivist to understand government business activities and thus make informed appraisal decisions for records preservation is to evaluate and analyze government core functions.

Strengths of Macro Appraisal

Macro appraisal has its own strengths. It caters for the appraisal of records in other media such as electronic records, audio visual material, maps, art, drawings, photography (Bailey, 1997). Appraising at functional level implies that records are classified according to functions. Macro appraisal also avoids the acquisition of worthless records in large quantities which leads to backlogs whilst waiting for processing (Bailey, 1997). Macro appraisal also has theoretical advantages it identifies important functions in society which should be documented and it is practical as it focuses appraisal activities on records of the highest archival potential value (Bailey, 1997).

Weaknesses of Macro Appraisal

Booms (1987) is of the view that an assessment of organization's functions is not sufficient to form society's documentary heritage thus appraisal should not be solely based on such a methodology. This is because an assessment of organizational functions does avail the future archive but only from public records. Since public records do not represent the total sum of the activities of the historical and political life then the documentary heritage should include the acquisition of private archives. Cook (1992) says that records that show tension filled opinions of the public as it relates to state official position have potential for permanent preservation. Yiotis and Lindberg (2005) opine that this kind of thinking could "create an archival record biased towards the vocal 10% while the records from the silent 90% do not get preserved as they do not display any tension." (p. 5) Duranti (1994) also disagrees and says that selecting records that display tension only contrasts with the procedural and formal neutrality of the whole archive and thus will undermine the impartiality and authenticity of the record.

APPRAISAL OF ELECTRONIC RECORDS

The emergence of electronic records, in conjunction with the volume of modern documentation and the changing nature of modern institutions, has initiated considerable debate on the theory and practice of archival appraisal (Bantin, 1998). Anderson, Eaton and Schwartz (2015) point out that for the archival profession, the determination of what is and is not preserved over time is continually informed by theories and practices of appraisal. This includes the appraisal of electronic records. One notable difference that emerges between the four schools of records appraisal lies in the inclusion of electronic records in the

appraisal process. With exception of the macro appraisal school of thought, (Cook, 1997: 39; Anderson *et al.*, 2015), the rest do not really cater for the appraisal of records (Honer & Graham, 2001; Malkmus, 2008; Kenosi & Moatlhodi, 2012: 29). Anderson et al (2015) observe that macro-appraisal methodologies have been applied to the assessment of digital records in both the United States and Canada since the 1990s. The digital revolution has altered the way society creates, uses, communicates, and manages information as well as how archivists acquire, preserve, and manage access to records. Cook (1997) is of the opinion that the macro appraisal methodology of records appraisal is particularly relevant in an age when the record is becoming increasingly electronic.

CONCLUSION

Records appraisal is without doubt the cornerstone of archival science as different scholars have asserted. Though no two appraisers agree on how records appraisal should be undertaken, Craig (1992) points out that the process of assessment has implications for everyday work activities regardless of the appraisal model chosen. The implementation of any of the appraisal models is a practical, managerial and administrative issue. Thus, all the appraisal models imply that the appraiser or the archivist have enough time for research, thinking, consultation and studying. This is also echoed by Cook (2005: 103) who avers that "appraisal requires extensive research by archivists into institutional functionality, organizational structures and work-place cultures, recordkeeping systems, information workflows, recording media and recording technologies, and into changes in all these across space and time". He adds that appraisal is not simply a process or procedure or template or the standardized application of models but a work of complex scholarship.

Appraisal methodology chosen to inform selection is dictated by the environment in which it takes place thus, any of the four appraisal methodologies would be able to select the future archival record. Perhaps they can be combined so as to tap from the strength of each. The appraisal of records presents uneasy ethical questions to archivists. Kenosi (1999) best captures this dilemma when he equates the controversial nature of appraisal to the discomfort that a medical doctor goes through when they have to euthanize a patient. Just like in medicine where the principal mission of a physician is to preserve life, appraisal by archivists is a bitter pill to swallow and only happens as a worst case scenario. Just like in medicine where the preservation of life is paramount to everyone, archivists are also taught that their primary vocation is the preservation of documents and not necessarily their destruction.

REFERENCES

Alexander, P. N., & Samuels, H. W. (1987). The Roots of 128: A Hypothetical Documentation Strategy. *The American Archivist, 71*(4), 518–531. doi:10.17723/aarc.50.4.v889q1182r11p36u

Allen, M. B., & Baumann, R. M. (1991). Evolving appraisal and accessioning policies of Soviet Archives. *The American Archivist, 54*(Winter), 96–111. doi:10.17723/aarc.54.1.n488un809u87v150

Bailey, C. (1997). From the Top down: The Practice of Macro Appraisal. *Archivaria, 43*, 89–128.

Bridges, E. C. (1988). The Soviet Union's Archival Research Center: Observations of an American visitor. *The American Archivist, 51*(Fall), 486–500. doi:10.17723/aarc.51.4.5p05tu52176x8t60

Booms, H. (1991). Urberlieferungsbildung: Keeping Archives as a Social and Political Activity. *Archivaria, 33*, 25–33.

Booms, H. (1987). Society and the Formation of a Documentary Heritage: Issues in the Appraisal of Archival Sources. *Archivaria, 24*, 69–107.

Cook, T. (2011). We are what we keep; we keep what we are': Archival appraisal past, present and future. *Journal of the Society of Archivists, 32*(2), 173–189. doi:10.1080/00379816.2011.619688

Cook, T. (2005). Macro appraisal in Theory and Practice: Origins, Characteristics, and implementation in Canada, 1950-2000. *Archival Science, 5*(2-4), 101–161. doi:10.1007/s10502-005-9010-2

Cook, T. (2001). *Appraisal Methodology: Macro Appraisal and Functional Analysis – Part B: Guidelines for performing an archival appraisal on Government records*. Retrieved 27 August, 2016, from: http://www.bac-lac.gc.ca/eng/services/government-information-resources/disposition/records-appraisal-disposition-program/Pages/appraisal-methodology-part-b-guidelines.aspx

Cook, T. (1997). What is Past is Prologue: A History of Archival Ideas since 1898, and the Future Paradigm Shift. *Archivaria, 43*, 17–63.

Cook, T. (1992). Documentation Strategy. *Archivaria, 34*, 181–191.

Cook, T. (1992). Mind over matter: Towards a new theory of archival appraisal. In B. L. Craig (Ed.), *The Archival Imagination: Essays in Honour of Hugh A. Taylor* (pp. 38–70). Ottawa, Canada: Association of Canadian Archivists.

Couture, C. (2005). Archival Appraisal: A Status Report. *Archivaria, 59*, 83–107.

Cox, R. J. (1989). A Documentary Strategy Case Study: Western New York. *The American Archivist, 52*(2), 192–200. doi:10.17723/aarc.52.2.6280321313744409

Cox, R. J. (1996, Spring). The Archival Documentation Strategy and its implications for the appraisal of architectural records. *The American Archivist*, 144–154.

Craig, B. L. (1992). The acts of the appraisers: The context, the plan and the records. *Archivaria, 34*, 175–180.

Duranti, L. (1994). The concept of appraisal and archival theory. *The American Archivist, 57*(2), 328–344. doi:10.17723/aarc.57.2.pu548273j5j1p816

Eastwood, T. (2002). Reflections on the Goal of Archival Appraisal in Democratic Societies. *Archivaria, 54*, 59–71.

Forde, H. (2007). *Preserving archives*. London: Facet.

Garaba, F. (2007). The State of Archival Appraisal Practices in the ESARBICA Region. *African Journal of Library Archives and Information Science, 17*(1), 59–63.

Goodman, A. (2010) *Appraisal Reading Response*. Retrieved 27 August, 2016 http://www.godaisies.com/notes/Amanda%20Goodman_Appraisal_Reading_Response.pdf

Greene, M. (2003). *Advanced Appraisal Workshop*. Retrieved 27 August, 2017, from: http://www.pac-sclsurvey.org/documents/greene/SyllabusReadingList.pdf

Greene, M. (2009). *A Brief and Opinionated History of Archival Appraisal Theory, to 2005*. (Unpublished)

Grimsted, P. K. (1982). Lenin's Archival Decree of 1918: The Bolshevik legacy for Soviet Archival Theory and Practice. *The American Archivist, 45*(4), 429–443. doi:10.17723/aarc.45.4.tjn5811686q4u0r1

Gywnn, D. (2008). *Comparison of Jenkinson's and Schellenberg's Views on Appraisal and Valuation*. Retrieved 20 October, 2016, from: http://www.davidgwynn.com/pdf/505_appraisal.pdf

Hackman, L. J., & Warnow-Blewett, J. (1987). Documentation Strategy Process: A Model and a Case Study. *The American Archivist, 50*(1), 11–47. doi:10.17723/aarc.50.1.uxr6766121033766

Hohmann, P. (2016). On impartiality and interrelatedness: Reactions to Jenkinsonian Appraisal in the Twentieth Century. *The American Archivist, 79*(1), 14–25. doi:10.17723/0360-9081.79.1.14

Honer, E., & Graham, S. (2001). Should Users Have a Role in Determining the Future Archive? The Approach Adopted by the Public Record Office, the UK National Archive, to the Selection of Records for Preservation. *LIBER Quarterly, 11*(4), 382–399. doi:10.18352/lq.7657

International Council on Archives. (2005) *Committee on Archives: Guidelines on Appraisal*. Retrieved 26 October, 2016 from: http://www.ica.org

International Records Management Trust. (1999). *Building records appraisal systems*, Retrieved 27 August, 2017, from: http://www.irmt.org/documents/educ_training/public_sector_rec/IRMT_build_rec_appraisal.pdf

Jenkinson, H. (1922). *A Manual for Archives Administration*. London: Academic Press.

Johnson, E. S. (2008). Our Archives, Our Selves: Documentation Strategy and Re-Appraisal of Professional Identity. *The American Archivist, 71*, 190–202.

Kenosi, L., & Moatlhodi, T. (2012). The Determination of value Archival Science and the ever evolving theories Of Records Selection. *The Eastern Librarian, 23*(1), 24–36. doi:10.3329/el.v23i1.12116

Kenosi, L. S. (1999). The Paradox of Appraisal and Archival Theory: An Uneasy marriage Relationship. Is there a Case for divorce? *South African Archives Journal, 41*, 20–28.

Malkmus, D. J. (2008). Documentation Strategy: Mastodon or Retro-Success? *The American Archivist, 71*(2), 384–409. doi:10.17723/aarc.71.2.v63t471576057107

National Archives of UK. (2004). *Appraisal Policy background paper – the 'Grigg System' and beyond*. Retrieved 27 September, 2017, from: http://www.nationalarchives.gov.uk/documents/information-management/background_appraisal.pdf

National Archives of UK. (2013). *Best practice guide to appraising and selecting records for The National Archives*. Retrieved 27 September, 2017, from: http://www.nationalarchives.gov.uk/documents/information-management/best-practice-guide-appraising-and-selecting.pdf

Ngulube, P. (2001). Archival appraisal and the future of historical research. *South African Historical Journal*, *45*(1), 249–265. doi:10.1080/02582470108671410

Oweru, P. J., & Mnjama, N. (2014). Archival preservation practices at the Records and Archives Management Department in Tanzania. *Mousaion*, *32*(3), 136–165.

Queensland State Archives. (2010). *Glossary of archival and recordkeeping terms*. Retrieved 27 August, 2016, from: http://www.archives.qld.gov.au/Recordkeeping/GRKDownloads/Documents/GlossaryOfArchivalRKTerms.pdf

Reed, B. (2009). *Archival Appraisal and Acquisition. In Encyclopedia of Library and Information Sciences* (3rd ed.). New York: Taylor and Francis.

Samuels, H. W. (1991). Improving our Disposition: Documentation Strategy. *Archivaria*, *33*, 125–140.

Samuels, H. W., Orwell, G., & Clarke, A. C. (1986). Who Controls the Past? *The American Archivist*, *49*(2), 109–124. doi:10.17723/aarc.49.2.t76m2130txw40746

Schellenberg, T. R. (1956a). *Modern Archives: Principles & Techniques*. Chicago: Academic Press.

Schellenberg, T. R. (1956b). *The Appraisal of Modern Records*. Retrieved 25 April, 2016, from: http://www.archives.gov/research/alic/reference/archives-resources/appraisal-of-records.html

Stuckey, S. (2004). *Western theories of appraisal - from Europe to America to the perspective of an international society*. Retrieved 3 October, 2017, from: http://www.archives.go.jp/publication/archives/wp-content/uploads/2015/03/acv_18_p127.pdf

Thanye, K., Kalusopa, T., & Bwalya, K. J. (2015). Assessment of the appraisal practices of architectural records at the Gaborone City Council in Botswana. *ESARBICA Journal*, *34*, 45–64.

Tschan, R. (2002, Fall). A Comparison of Jenkinson and Schellenberg on Appraisal. *The American Archivist*, *65*, 1761–195.

Turner, J. (1992). *A study of the theory of appraisal for selection*. Retrieved 25 September, 2017, from: https://open.library.ubc.ca/cIRcle/collections/ubctheses/831/items/1.0086420

Williams, C. (2012). On the Record: Towards a Documentation Strategy. *Journal of the Society of Archivists*, *33*(1), 3–40. doi:10.1080/00379816.2012.665316

Yiotis, K., & Lindberg, L. (2005). *Two theories of appraisal: Cook and Duranti*. Retrieved 30 November, 2016, from: http://citeseerx.ist.psu.edu/viewdoc/download;jsessionid=7971BF35AF577D82CF4DF4C3C504797F?doi=10.1.1.306.4272&rep=rep1&type=pdf

ADDITIONAL READING

Blouin, F. X., Jr., & Rosenberg, W. G. (2013). Processing the past: Contesting authority in history and the archives. New York: Oxford University Press. Retrieved July 27, 2015, from Pratt Manhattan library http://cat.pratt.edu/record=b1188250~S0

Cocciolo, A. (2016). Email as cultural heritage resource: Appraisal solutions from an art museum context. *Records Management Journal*, 26(1), 68–82. doi:10.1108/RMJ-04-2015-0014

Cross, 2011). Appraising archivists: documentation and the need for accountability in the appraisal process, Unpublished Masters Thesis, Western Washington University, Retrieved 3 October, 2017, from: http://cedar.wwu.edu/cgi/viewcontent.cgi?article=1110&context=wwuet

Hedstrom, M. (1989). New Appraisal Techniques: The Effect of Theory on Practice. Provenance. *Journal of the Society of Georgia Archivists*, 7(2), 1–21. http://digitalcommons.kennesaw.edu/cgi/viewcontent.cgi?article=1217&context=provenance Retrieved 3 October, 2017

Minnesota Historical Society. (2009). How do you appraise government records? Retrieved 3 October, 2017, from: http://www.mnhs.org/preserve/records/recordsguidelines/docs_pdfs/02Sept2009V3Ch2.pdf

Sink, R. (1990). Appraisal: The Process of Choice. *The American Archivist*, 53(3), 452–458. doi:10.17723/aarc.53.3.g6606115k3854665

Turnbaugh, R. C. (1997). Information Technology, Records, and State Archives. *The American Archivist*, 60(2), 184–200. doi:10.17723/aarc.60.2.e6247tm502671537

Walters, T. O. (1996). Contemporary Archival Appraisal Methods and Preservation Decision-Making, American Archivist 59, 322-338.Rapport, L (1981) No grandfather clause: Reappraising accessioned records. *The American Archivist*, 44(2), 143–150.

Shallcross, M. J., & Prom, C. J. (Eds.). (2016). *Appraisal and acquisition strategies*. Chicago, IL: Society of American Archivists.

KEY TERMS AND DEFINITIONS

Appraisal: The practice and process of assessing values in records to determine what can be preserved as archives and destroyed because they are no longer useful.

Appraisal School: The approach that informs a particular method of records appraisal. It can also be regarded as an appraisal approach. Further still, in this context, the term means records appraisal methodology.

Archives: Records with enduring value beyond the use of the creating agency and selected for permanent preservation through the archival appraisal process.

Theory: Some statement meant to explain how something is done or ought to be done, including the relationships between constituent parts that make up the whole entity.

Chapter 3
Archival Access and Public Programming

Nathan Mnjama
University of Botswana, Botswana

ABSTRACT

This chapter discusses archival access, archival programming, and archival advocacy and the manner in which these programmes are conducted within archival institutions, particularly in Africa. The chapter begins by defining the terms access, archival programming, archival advocacy, and outreach programmes and provides the parameters within which such programs and activities are executed. The chapter reveals that in many archival institutions, public programming is either lacking or does not receive adequate attention from senior management resulting in low utilization of archival materials. The chapter suggests various ways through which African archival institutions may publicize their holdings in order to reach out to potential users and manuscript donors.

INTRODUCTION

Archives and manuscript collections when well preserved play a pivotal role in the preservation of corporate memory as well as in the transmission of culture, building of national identity and in providing valuable sources of information on a variety of issues. The primary goal of preservation is to prolong the life of documentary heritage and to ensure the long term accessibility of such collections by government agencies, institutions, business organizations and the public at large. However, preserving the collections without making them accessible is of no value. According to Ketelaar (1992, p. 5) "archives - well preserved and accessible to the people - are as essential in a free democracy as government of the people, by the people, for the people. Because archives are not only tools of the government, not only sources for historical research, access to public archives gives the people the possibility to exercise their rights and to control their governments, its successes, its failures." Walne (1988) defines access as "the availability of records or archives for consultation as a result of legal authorization and the existence of finding aids". McCausland (1993, p. 273) defined access to include "the terms and conditions of availability of records or information maintained by archives for examination and consultation by

DOI: 10.4018/978-1-5225-3137-1.ch003

researchers." Reference service, which is another term commonly used in relation to access to records is the general name given to the facilities and services that "enable researchers to use the archives and its records once access to them is approved" (McCausland, 1993, p.273). As can be seen from the above definitions, access to records and archives is usually determined by laws, policies and procedures that are established by governments. Such laws usually regulate closure periods, rights of access to public records, ensure the protection of privacy rights of its citizens from intrusion by researchers and other information seekers and in some cases it provide protection to copyright holders. Blaise and David (1993, p.107) argued that "the essential utility and value of information housed in archives is expressed through research use". Maidabino (2010) argued that:

the accessibility and use of records of human knowledge, their preservation and passages or communication among successive generations no doubt constitute the greatest single treasure of the human heritage.

Further, it cannot be overstated that access to information especially government held information constitutes a basic human right. The right of access to information was stated in the African Commission on Human and Peoples' Rights "Declaration on Freedom of Expression adopted by African States in 2002 when they wrote saying:

1. Public bodies hold information not for themselves but as custodians of the public good and everyone has a right to access this information, subject only to clearly defined rules established by law.
2. The right to information shall be guaranteed by law in accordance with the following principles:
 a. Everyone has the right to access information held by public bodies;
 b. Everyone has the right to access information held by private bodies which is necessary for the exercise or protection of any right;
 c. Any refusal to disclose information shall be subject to appeal to an independent body and/or the courts;
 d. Public bodies shall be required, even in the absence of a request, actively to publish important information of significant public interest;
 e. No one shall be subject to any sanction for releasing in good faith information on wrongdoing, or that which would disclose a serious threat to health, safety or the environment save where the imposition of sanctions serves a legitimate interest and is necessary in a democratic society; and
 f. Secrecy laws shall be amended as necessary to comply with freedom of information principles.
3. Everyone has the right to access and update or otherwise correct their personal information, whether it is held by public or by private bodies." (African Commission on Human and Peoples Rights, 2002)

While the need to access information is necessary, this need must be balanced against the need to protect the privacy of others mentioned in the archives. Walne (1988) defined privacy as "the right to be secure from unauthorized disclosure of information contained in records/archives relating to personal or private matters."

To a very large extent access and utilization of archives by the public is dependent on the facilities provided by the archival institutions, the manner in which archives have been organised, the access policies formulated by the governing institution and the amount of publicity given to the archives holdings

through various methods. Access to privately donated papers and collections is usually covered under donor agreements, though in many instances donors would follow the regulations provided for under the archival law. Other factors that may impact on the accessibility to the records may be cases where records are fragile or in poor state. However, for archives to be accessible, the public must be made aware of their existence through various channels of communication. This chapter explores some of the methods that archival institutions in Africa may explore as they seek to increase accessibility of their holdings to the community around them.

METHODOLOGY

This chapter is based on a review of literature on the broad subject of access and archival programming in the East and Southern African region. Published sources as well as online searches were conducted particularly those relating to the African region.

THE OBJECTIVES OF THE CHAPTER

The broad objective of this chapter is to demonstrate the centrality of archival programming to issues of access and also to understand the methods that are used in archival programming and advocacy in the East and Southern African region. The specific objectives of the study are:

1. To understand basic concepts and principles in archival programming.
2. To determine why archival institutions in the African should be engaged in archival programming activities.
3. To discuss the various methods used in archival programming and advocacy.
4. To propose the way forward in the African region relating to archival programming.

ARCHIVES PUBLIC PROGRAMMING

According to Gregor, (2006), archival public programming is a function performed by archives in order to create awareness of archives within society as well as to promote their use and educate their sponsors and users on how to use them. Harris (1993, p.5) a South African archivist defines archival public programming as "that group of activities whereby archival institutions secure both responsiveness to user needs and public participation in all their functions." He further argues that "public programming is arguably the clearest manifestation of archivists having embraced the notion that use is indeed the goal of all their endeavors" (Harris, 1993, p.5). Pederson, and Casterline (1982, p.8) defined public programmes as "tools that support and enhance other archival functions, including research, reference, preservation, and collecting. They can be highly educational, both for planners and participants; they can foster a greater appreciation for history and historical records; and they help ensure firm and continuing support for archival endeavours"

A closely related activity in archival programming are outreach programmes which the Society of American Archivists (2005) defined as "organized activities of archives or manuscript repositories

intended to acquaint potential users with their holdings and their research and reference value". Peace-Moses (2005) in *A Glossary of Archival and Records Terminology* defined outreach as "the process of identifying and providing services to constituencies with needs relevant to the repository's mission, especially underserved groups, and tailoring services to meet those needs." According to Palmer and Stevenson (2011, p.1) "outreach has arguably been part of the archivist's core mission since the inception of the public archive, with the role of the archivist as not only one of protecting and preserving the archives but also of enabling access. Palmer and Stevenson (2011, p. 1) went further to explain that "the term outreach highlights the archivist as not just a gatekeeper, but also as a facilitator- promoting the riches of the hidden or little-known collections for communities that that might be encouraged to "use" the archives."

Advocacy is yet another term that is usually associated with archival programming. According to Hackman (2011), advocacy is "activities consciously aimed to persuade individuals or organizations to act on behalf of a program or institution." Oestreicher asserted that "Archives advocate when they undertake specific actions to justify their existence, to fulfill their mission, and to expand their influence". The importance of archival advocacy was stated by Moyo (2012, p. 83) who pointed out that "a key element in ensuring that archives are known and are accessed is advocacy".

As can be seen from the foregoing definitions, archival programming, advocacy and archival outreach aim at reaching a variety of constituencies ranging from researchers, resource allocators, colleagues and the general public. In the real sense, archival programming is the promotional and public relations activity of the archives. In a personal communication between Peace-Moses and Chapman Smith (2004) it was observed that:

Effective outreach is more than an event or a series of activities. It is the process of assessing and developing institutional capacity to meet the needs of under served audiences. This process may lead an institution to reframe its mission, vision and goals to the contemporary situation. Successful outreach requires an environmental assessment of community (potential constituent) needs, potential partners and resources, and potential impact. This type of assessment will also help an institution develop an effective marketing plan and strategies for whatever programming is developed. Why are you doing any programming or collecting? What's the benefit/value? Who are you trying to reach? How do you know they will come? Who will use the collection? What's your institution's brand or how are you perceived? How are you differentiated from others? On the collections side, some institutions are reassessing the cataloguing of their collections based on their outreach. They are finding new stories documented in collections that align better with current community needs. Others have changed their acquisition priorities based on outreach. (Personal communication, Richard Peace-Moses V Chapman Smith (7 June, 2004)

Throughout this chapter, the terms archival outreach programmes, archival programming and archival advocacy will be used interchangeably to describe those activities undertaken by an archival service in order to promote the use of its archival holdings.

WHY UNDERTAKE ARCHIVES PUBLIC PROGRAMMING?

According to Snoj and Petermanec (2001, p. 315) marketing knowledge products is vital to libraries and other information centres as this helps the library to create competitive advantage through:

1. Development of new services or changes of the existing ones to satisfy their users better;
2. Improvement of their organizational status and image to different stakeholders; and thereby;
3. Improve their performance in general.

While the above sentiments are true, there are also specific reasons why archival institutions engage themselves in archival programming. These are discussed below.

Firstly, archival institutions are treasure houses of information held on behalf of the society in the form of original documents such as letters, reports, photographs, maps, plans, etc. which have been selected for permanent preservation because of their continuing value to the society. Yet despite, the fact that archival institutions hold valuable heritage collections, archival institutions especially in Africa remain underutilised possibly due to inadequate marketing strategies or lack of marketing strategies completely (Mnjama, 2008). Jimerson (2003) posited that archivists and records managers should identify their user clientele, develop outreach methods for informing users, provides intellectual and physical access, establish and administer access policies and provide on-site or remote outreach-services.

A review of literature, especially literature emanating from Africa indicates that this is not being done successfully. For instance, Mbaruk and Otike (n.d) observed that the Zanzibar National Archives had not applied any meaniful marketing strategy in order to improve its services. Likewise, a study by (Moalafi, 2010) conducted in Botswana showed that archival institutions have been inactive in marketing their services to the public. Moalafi (2010, p. 80) came to the conclusion that (it is necessary for Botswana National Archives and Records Services to market the archival information resources because knowledge about its resources is relatively low. A more recent study by Mophorisa and Jain (2013, p. 54) also revealed that

external communication strategies reported by Botswana National Archives and Records Services archivists to be in use for public awareness were ineffective and that has been the status quo for years.

Botswana is not the only archival institution in the Africa region which is struggling with marketing its services and products. A similar study conducted by Kamatula (2011) in Tanzania revealed that the Records and Archives Management Department had not been aggressive enough in conducting promotional and public relations activities, and where these activities have been undertaken, the focus had been on reaching the urban folks and not rural communities who are in desperate need of learning and utilising archival services. An earlier study conducted by Mbwilo (2011, p.99) on the management and preservation of the East African Community records revealed that "there were no measures that had been taken to publicize the records of the former EAC locally and regionally". These observations point to the fact that archival institutions need to market archives to the public and hence incease their access and utilization as well as diversifying the users. It can, therefore, be concluded that the major reason as to why archival institutions in the african region ought to underatke archival programming is to increase the number of users utilizing archival services.

Secondly, archival institutions traditionally, have been perceived as places where only creators of archives were the major users of the archives. The other group of users were academicians and genealogists can obtain valuable information. Other key users of archival services are the creators of the records themselves which in most instances happen to be public institutions such as ministries, departments and government agencies. There is therefore a need to change this public perception concerning the archives. As Cook (1997, p.15) has rightly observed

archives are not a private playground where professional staff can indulge their interest in history or their desire to shape the past by rubbing shoulders only with prominent historians: it is a sacred public trust of society's memories that must be widely shared.

Access to records and archives is a very important aspect in the society and there is a need for the general public to be made aware of the treasures the archival institutions are holding on behalf of the society. No wonder Abioye (2009) stressed the need for historical transformation of access arguing that

in the past access to archives was restricted to the creators and their legitimate successors. Archives at this time were considered as arsenals of law. The focus has since shifted with the gradual liberalization of access.

Describing the value of archives to the society, Maidabino (2010, p.1) argued that

Archives served as vital means for the preservation and presentation of the cultural heritage and National identity as well as tool for administrative efficiency. More so, archives compliment the human memory thereby allowing the flow of recorded knowledge of the past for future use.

Based on the above understanding, it is imperative that the use of archives should be promoted as widely as possible using various marketing strategies. The need to diversify the kind of users utilizing archival services as well as attracting new users can therefore be argued to be the second reason for undertaking archival programming activities.

Thirdly, the reason why outreach programmes may have to be undertaken stems from the fact that access to government held records enables citizens to hold their governments accountable for its decisions. Democracy only thrives where governments are accountable to the electorate. There is no way governments can be held accountable for its decisions and actions if records that document those activities are not available for public scrutiny. No wonder Gray (1984) asserted that accountability is the rendering of an account, which is the disclosure of information and the submission of the account to external verification. This suggests some form of auditing by or on behalf of those to whom the organization and its management is accountable. Being accountable is also closely linked to being transparent. Transparency requires the disclosure of information in one way or other. For governments to be seen to be accountable to the electorate, they must be transparent in their dealings, and this really demands that access to government held information is maintained. It is for this reason that Mwakyembe (2002, p.1) argued that "without transparency, there can be no accountability."

Even though many governments have embraced good governance to include aspects of public accountability and transparency, nonetheless many governments are still unable to grant access to government held records and information. McCullum (1998, p.3) a Canadian journalist remarked:

Information is power from whatever perspective you hold. Those who disseminate information, especially in the age of information revolution and the technology, which makes it possible, have enormous power- power for good or evil. Power to support democratic growth or subvert it. Power to influence lives. Power to bring down governments and raise up new political and economic ideologies. It is that power that must be used for the greater good of all citizens, all countries, all cultures and all societies.

Fourthly, archival institutions ought to engage in archival programming so as to increase the usage of their holding. Ghering (1998, p.1) rightly posited that, "it is almost unanimous belief among archival professionals that archives are undervalued, under-appreciated and under-funded in today's society". No wonder Mason (2004, p.1) argued that "if they hope to increase the use of their facilities, archives must develop programs and services which inform the public about their holdings and reference procedures." Similar sentiments on the need to increase the use of archival resources were also expressed by the Canadian archivist Ericson (1990, p. 117) when he wrote saying "if after we brilliantly and meticulously appraise, arrange, describe and conserve our records nobody comes to use them, then we have wasted our time." In Africa, just like in many developed countries, archives are underutilised. A study carried out by Ngulube and Tafor (2006, p. 77) revealed that African archives are no exception to this observation. To them "outreach and public programmes remain the key to promoting and encouraging the use of services by users." Mason (2007, p. 1) argues that

if they (archivist) can hope to increase the use of their facilities, archives must develop programs and services which inform the public about their holdings and reference procedures.

Archival institutions must therefore aim at re-engineering or transforming themselves from their custodial role and begin to play a major role in the collection and dissemination products that meets the public's expectations. This transformation demands an aggressive marketing programmes if the society is to develop a new image of the archives.

Fifthly, the changing role of archival institutions is yet another factor why archival institutions ought to market themselves. Traditionally, archival institutions have played a custodial role of collecting and preserving historical materials whose users were academicians especially historians and genealogists. Today's society is changing extremely fast and as Craig (1990-91, p.137) has rightly observed:

these tomorrows needs (will be quite different from the elitist interests and expectations which fostered the emergence of modern archival institutions in the nineteenth century. To catch the jet into the future vision it seems that we must jettison the baggage of the past practices and climb aboard quickly, or risk being left behind in outdated institutions which will inevitably become peripheral to society's needs. Does not the fate of the dinosaur await traditional archives in the future world of information?

There is, therefore, a need to extend the use of archives to the general public and this can only happen through outreach programmes. It can therefore be argued that the real reason why archivists conduct outreach programmes lies in the desire to attract users to the archives.

Sixthly, another reason why archivists must pay attention to outreach programmes lies in the fact that, archivists are operating in an age of great competition where every government function must be justified. Archivists can no longer expect continued funding if they can not justify their existence. Harris (1993, p.12) stressed that:

if most of us were forced to justify our existence through the numbers of scholars we served, we would be out of business. There are other groups that would benefit from using archival materials, but we must first educate them as to how and why.

Similar sentiments were expressed by Mason (2007, p. 1) when he argued that "everything must be justified these days and it is no longer good enough to point out the value in preserving the past, when large portions of society consider last week a long time ago." Mazikana (2007, p. 2) too shared similar sentiments when he wrote saying "demand for allocation of national resources will always be large and the competition stiff. Moreover an outreach programme to the society may also result in the archivist's role being appreciated. The more the society is aware of the value of its archival holdings, the greater the support the archival institutions will expect to receive. This is a view that Lekaukau (1993, p.32) supported when she wrote saying "publicity programmes can help create awareness. Popularising the services can lead to a situation where fiscal authorities can be convinced to allocate more resources to the archival institutions to undertake programmes that can directly benefit the common man." Only those who are able to demonstrate their relevance to national development are able to win in the battle for allocation of the resources." Archival institutions are no exception to this and must endeavour to make their activities and programmes known in order to survive this competition. While looking at archival institutions in the East and Southern African region in relation to linking themselves to public sector reforms, Mazikana (2007, p. 2) came to the conclusion that:

Records and archives management have not been able to attract the substantive funding required to take make the difference partly because the link has not been established between records keeping and national development issues such as poverty reduction, infrastructure development and environmental protection. The link has also not been made between records management and the successful implementation of public sector reforms.

The failure to make this linkage represents an opportunity that has beenmissed, the opportunity to mainstream records management into the public sector reforms and thus raise the profile as well as the resource base for records and archives management.

Mazikana (2007, p. 12) came to the conclusion that "there is also need to change the culture of archival institutions so that they can embrace new concepts and new ways of doing things." This I believe includes the way archival services promote themselves to the communities around them.

Moreover, archivists' manuscripts curators and other records professionals are not only competing for budgetary resources, but increasingly they have to operate under stiff competition from other information providers, who are able to apply technological solutions to the manner in which archives and historical records are made accessible. Maher (1997) in his acceptance address of the chairmanship of the Society of American Archivists observed that:

With the increasingly complex and competitive information environment within which archives exist, we are in fact in the rather strange position of being at risk of losing the archivist in archives. In the years since Gracy spoke, we have witnessed society as a whole become increasingly focused on information, and increasingly interested in using information in non-conventional forms. In such an information age, one would think that archives should prosper, but most programs are still grossly under-supported, often under-used, and archivists remain under-compensated and still marginalized on key issues of information policy.

Finally, the need to conduct archival programmes stems from the fact that many users of archives are unfamiliar with the manner in which archives are organized and described. If archives are to exploited fully then there is a need to find alternative ways of making known the existence of the collections to the public and find procedures which will work, while keeping in mind that "use cannot take precedence over conservation of the materials, [and] therein lies the public service dilemma of archives" (Wilson, 1990-91, p. 94).

METHODS FOR ARCHIVAL PROGRAMMING

An examination of archival legislation in the East and Southern Africa indicates that South Africa is the only country in the region that specifically makes mention of conducting promotional activities aimed at reaching the community especially the less privileged. Section 5 (1) (c) of the NARS Act states that

the National Archivist shall with special emphasis on activities designed to reach out to less privileged sectors of society, make known information concerning records by means such as publications, exhibitions and lending of records.

Reaching out to the less privileged members of the society by archival institutions has been a neglected area in the past.

Archival programming can be conducted in various ways ranging from public presentations, workshops, publication and distribution of brochures, flyers, press releases, newsletters, mass media advertisements and features, public displays and exhibitions, archives open days and archives week, curricular exercises, news releases, using the telephone to market the (telemarketing) and using the Internet. Archival institutions should assess their strengths before embarking on any of the listed archival public programmes discussed below. Clear identification of user requirements and user needs is a vital step in designing outreach programmes, as one form of outreach programme may be appealing to one set of users, but be totally useless in other situations. In other cases, it may also be necessary to use a combination of some of the methods discussed below in order to reach to the targeted audience. Based on a review of literature, the discussion that follows describes the advantages and disadvantages of the major outreach programmes that an archival institution may undertake. For the sake of clarity, these activities have been grouped into promotion and public relations, advertising, personal sealing. Each of these areas is discussed below.

Promotion and Public Relations

Nicholas (1998, p. 302) refers to promotion as "the means of informing your users what you do and what you can do." Public relation activities were defined by Kotler and Fox (1995, p. 351) as

efforts to obtain favourable interest in the institution and/or its programmes typically through planting significant news about them in publications, through obtaining favourable unpaid presentations on radio, television, or in other media, or through the institutions own activities and programmes.

Another definition of public relations was offered by McNamara (2008), who sees public relations as efforts aimed at helping the public to understand the company and its products. Some of the common aspects of promotions and public relation activities include:

Publications: Guides, Inventories Handbills, Pamphlets, Newsletters

One of the ways through which archival institutions can publicize their holdings is through an extensive publication programme. The publication of brochures, handbills, flyers and posters containing information on the types of materials held by the archives, its access policy and opening hours, telephone numbers, locations and how to get there, availability of certain services such as photocopying, reproduction of photographs, microfilming, scanning etc and the fees charged for any services provided. The brochures may also contain an appeal for donations of manuscripts relating to the local community. The major advantage of brochures is that they provide one of the cheapest and simplest way of marketing the archives. They can and are easily produced and distributed to the community leaving around the archives repository. Moreover, such publications can also be mailed to schools or can be placed in other library and information centres, and may also be distributed during public exhibitions and shows.

In addition to the publications discussed above, and depending on the availability of resources, the archival institution can make known its holdings through the publication of guides, inventories and specialist guides. The special guides may be produced as a way of bringing together collections which are heavily consulted or those for an area which is of interest to the community. Kenya National Archives provides an example of an archival institution that has been marketing its services through a publication programme (Kenya National Archives, 2007). South Africa too has a wide range of publications showing their different activities and services provided by the national archives. Details concerning South Africa National Archives and its programmes can be obtained at National Archives and Records Services (NAIRS) website available at: http://www.national.archives.gov.za/.

The main advantage to be derived out of publishing guides and inventories is that these serve as major retrieval tools in the identification and retrieval of records. They can also be distributed to distant locations such as colleges and schools, and particularly those located in remote and rural areas where other promotional activities are not easy to reach, thus enabling potential researchers to determine whether a visit to the archives repository would be worthwhile or not. It must, however be remembered that in as much as the publication of guides, inventories and subject guides have been applauded for use on archival outreach programmes, they suffer from one major disadvantage in that very often they become obsolete as soon as they are published and require regular updating as soon as new acquisitions are made. This is an area where many African archival institutions have been found to be lagging behind. For instance, in Botswana, the last published Guide to the Contents of Botswana National Archives was last published in 1984. A new guide incorporating all acquisitions after 1984 is yet to be compiled. Moyo (2012, p. 82) also observed that in Zimbabwe the production of finding aids had not kept pace with the demands of the researchers as many archival collections were yet to be processed and findings aids published. Many of the guides published by African archival institutions are in dire need of updating so as to include newly processed collections.

Newsletters are yet another type of publication which some archival institution produce from time to time in order to share archives and records management news with the wider community. Newsletters have the advantage of reaching a wide readership quickly and efficiently. Moreover, newsletters can easily be produced in-house and distributed through the archives mailing list. However, just like library newslet-

ters, care must be taken to ensure that such newsletters are well thought out and properly planned. For as Ford (1988, p. 682) rightly observed "if well thought out and properly planned, the library newsletter can be a valued source of useful information and a good public relations tool." She however caution that, if it is not done for the right reason, not directed to the right audience or not properly presented, the newsletter will simply become another addition of to a growing accumulation of worthless paper and an exercise in futility for the staff members who labour over it." In the case of Botswana, the publication of *Tshedimoso* a regular newsletter published by the Botswana National Archives and Records Services provides a good example of such publications. Archival institutions are also encouraged to increase and make contributions to any publications that are being produced by their parent ministries.

Another type of publication that may be used to publicize the activities of national archives are annual reports that are produced at the end of each year. In some archival institutions, the publication of the annual report is a mandatory requirement of the national government.

It cannot be over emphasized that whatever publications may emanate from the archival institution they ought to be of good quality, written in simple and clear language, informative and well- edited. Wherever possible such materials should contain illustrations of materials drawn from the repository itself.

Guided Tours to the Archives

Another approach to reaching the community around the archives repository is through guided tours to the archives, its facilities and its resources. These organized information visits to the archives should include a talk on the basic functions of the archives centre. The talk may be accompanied with a slide power point presentation, video or film show. Guided tours especially to school children and other community groups are a very useful tool in reaching out to the community. Proper arrangement, however, need to be put in place to ensure that school children are not left to roam alone in the archives repositories without the tour guide. Although some archivists may consider guided tours especially of school children to the archives a waste of time, nonetheless, this is a very important way of introducing school children into the world of archives. The immediate benefits of guided tours especially to school children may not be realized immediately, but it is an effort worth in investing in as these children are the future researchers in the society. It is however, very important that guided tours should be focused to a particular theme or subject, unless the tour was meant to introduce the visitors to the general aspects of archives work.

Archives Open Days and Archives Weeks

Another event which an archival institution may organize in order to market itself is Archives Open Day or Archives Week. Organizing archival open days or archives week when the community can walk in freely into the archives and be shown the operations of archival institution may be organized to coincide with national events such as Independence Day celebrations. Open days/ Archives Week may also be organized around themes such as the firsts in the society, prominent personalities in the history of the nation or major historical events. Open days and Archives Week may be used for the distribution of leaflets, flyers and other simple publications. Organizing Open Days and Archives week may be a time consuming exercise and need careful planning. Just like guided tours to the archives, the benefits of open days and Archive Week may not be realized immediately, but they may to the donation of manuscripts from the community in the later days.

Archival Exhibitions

Another method of drawing the public's attention to the rich heritage of archival materials is through archival exhibitions. Pederson (1988, p.319) describes archival exhibits as "the use of archival materials to present ideas which inform or educate the viewer." According to her, archival exhibitions may be used to:

1. Showcase rare, valuable or unique material from the collection.
2. Inform viewers about the nature of archival materials, archival work and the hosting of archives.
3. Educate on a point of history that is supported by material.
4. Interest, intrigue and inspire the public.

Archival exhibitions can be carried writhing the galleries of archival institutions themselves or they can be organized to coincide with major events in the country. The Official opening of the exhibition may also be arranged to coincide with a special talk by a prominent scholar or researcher on a topic that draws heavily on archival sources. Archival exhibitions may also be mounted as part of cultural activities and festivities especially where archival materials are being used to portray a significant event in the history of the nation or community. In Kenya for instance, exhibitions on the Mau Mau crisis have been used successfully by the Kenya National Archives to illustrate the struggle for independence.

Several African archival institutions participate in national exhibitions and trade fairs where valuable historical materials are on display throughout the year. It is also common practice for archival institutions to exhibit their holdings in annual trade fairs usually held in their major cities. For instance, Kenya for example, participates in the Annual Agricultural Trade Fair held in Nairobi each year. Botswana too exhibits its collections during the in the Annual Trade fair held in Gaborone. Swaziland too is known to participate in annul exhibitions such as the Swaziland International Trade Fair (Hlope &Wamukoya, 2007, p. 99). Kamatula (2011, p. 80) indicated that the Tanzania Archives and Records Management Department participates in the Annual Dar es Salaam International Trade Fair held in Dar es Salaam each year as well as participating in the Mwalimu Nyerere Exhibition on 14th October each year in order to remember the first President of the Republic of Tanzania Mwalimu Julius Nyerere. Participation in the trade fairs also provides an opportune moment for archival institutions to showcase their holdings, attract new users and it is an avenue for the distribution and sale of some of the archives publications. As far as possible, careful consideration should be made when selecting materials for archival exhibitions. It is always advisable that exhibited materials should be in good, condition. Damaged fragile, rare, unique, materials should never be displayed. The area selected for the exhibition should provide moderate and stable temperatures and relative humidity. Moreover, the area selected should be secure enough, clean and darkened enough to avoid excessive exposure of the exhibited materials to direct sunlight and UV radiation.

The greatest advantage to be derived from archival exhibitions is that it is the easiest way of reaching large audiences within a relatively short time, but they do indeed provide initial contacts with potential researchers and donors of manuscripts.

Seminars, Workshops and Conferences

Promoting the use of archival resources may be achieved through active participation of archives staff in seminars, workshops and conferences locally and regionally which may or may not directly deal with

archives but nonetheless provides an ideal forum for the archivist to advocate the use of archives under his custody.

Public lectures also provide the opportunity for the archives to reach out to other professionals especially if the relevance of the archives to the themes of the conference can be established. Participation in local seminars and workshops will also result in networking with other information professionals through which a great deal of information may be shared. Participation in some of these activities provide one of the cheapest ways of spreading word around concerning the archives repository and its programmes.

The National Archives itself may organize its own series of workshops and seminars to be held annually where invitations will be sent out to specific target groups. The archives may design a series of talks on topics of special interest based on the information resources available in the archives repository.

Other Public Relations Activities

There are other public outreach activities that an archival institution may consider utilizing. The archives office may participate or organize singly or jointly with other local organizations and companies' photography, drawing or writing competition. At the University of Pretoria in South Africa, a photography competition in which students are asked to take different aspects of their student life is held annually. Through this activity, an excellent collection capturing different aspects of the University has been built.

Showing of historical films may also be one method of marketing the archives services. For a considerable number of years, the Kenya National Archives used to organize films shows based on the struggle for independence every Saturday morning. These films shows were very popular with the youth and were a very good marketing strategy.

Visits to schools, colleges and other institutions should also form part of the public programming. Specially designed educational kits should wherever possible to be used to encourage students to use archives materials or encourage them to visit the archives to see original source materials.

Within Africa one way of publicizing archives is through attendance of public gathering usually organized by chiefs or other prominent citizens in the rural communities. Participation in such forums may generate interest in archives, and inspire local communities not only to deposit their records with the archival institution, but may also result in an a programme for collecting oral sources in order to supplement official records which in most cases appear to document the activities of colonial administrators.

Personal Selling

Personal selling has been defined by the Marketing Dictionary (2008) as

the delivery of a specially designed message to a prospect by a seller, usually in the form of face-to-face communication, personal correspondence, or a personal telephone conversation.

The Marketing Dictionary (2008) further asserts that "unlike advertising, a personal sales message can be more specifically targeted to individual prospects and easily altered if the desired behavior does not occur." Personal selling offers several advantages. Firstly, personal selling enables the organization to design programmes and activities that aim at reaching specific target groups and individuals. In this way, it is easier to win or woo specific user groups into the archives. Secondly, through personal selling, it becomes easier to know and appreciate the specific needs of each user group or individual, and through

these contacts, immediate feedback can be provided which can be used to improve the services being offered. However, despite these advantages, it must be remembered that personal selling is costlier than other methods of promotion. Moreover, personal selling may not reach as many potential users as other methods such as advertising and broadcasts. Some of the methods used in personal selling include mail and telephone enquiries. These are further discussed below.

The handling and responding to telephone enquiries forms part of archives public programming. It cannot be overstated that every archival institution has a responsibility to respond to mail enquiries within a reasonable time. Failure to do so may portray the institution as unfriendly or a lack of interest in its users. As far as possible where information is readily available, this should be provided to the inquirer immediately e.g. through the mailing of information leaflets, simple guides etc. However, the amount of time spent on each mail enquiry should be limited to providing basic reference details and at no point should the archivist become the substitute for the researcher. Moreover, the archivist should not attempt to interpret the records for the researcher as this may result in the researcher ignoring certain sources.

Information Communication Technologies and Archival Programming

The Internet has become one of the most popular and the fastest growing outreach programme in the world. The use of the Internet to publicize archival holding cannot be overstated. The advantage of using the Internet to publicize the archives was perhaps best summed by Abraham (1997) Head, Special Collections and Archives at the University of Idaho Library when he wrote saying:

Establishing an archival presence on the World Wide Web is an effective and economical form of outreach. Unlike printed materials there are no production costs and no left over inventory. Unlike lectures there is no scheduling, no prima donna speaker, no invitations, and no caterers. And unlike exhibits, there is no physical presence to monitor and protect. In addition, a web site is available, to those with the equipment, 24 hours a day, seven days a week, at no additional cost. Plus, it is infinitely and immediately updatable, upgradable, and enhanceable.

As can be seen from the above statement, there are many advantages to be gained through the use of the Internet. The ease and speed at which databases can be searched provides a major incentive for archives to advertise their holding via this medium. Moreover, the ease with which links can be established to other archival sources locally and regionally also justifies the need to advertise collections on the Internet. Finally, it can not be overstated, that those archival institutions which have established their collections are able to reach users from remote locations who are able to search their websites and determine if a visit to the archives would be worthwhile.

Several archival institutions in the region have already established their presence in the World Wide Web. A visit to some of these websites indicates that most of them only provide limited information for their users. In the case of Zimbabwe National Archives, Ngulube, Sibanda and Makoni (2013) observed that while Zimbabwe National Archives had created its own website, the information given in the website was not very useful to the researchers. The information posted include: contact information, finding aids, regulations for use, and hours of opening, links to other archival and historical sites. Much of the information provided in these web sites are any different from the results that were reported in the United States of America where it was reported that "the web at this point in time is predominantly used to convey information about repositories, not information held by the repositories"(Abraham, 2001, p. 5).

Despite the many advantages offered to archival institutions by the Internet, a survey on archival web sites conducted in the United States by Bruemmer (1997) the Archivist at Charles Babbage Institute revealed that archival institutions only provide information relating to collection descriptions and inventories rather than placing the actual documents. Other known limitations or disadvantages associated with the Internet are that web sites very often change their URLS or frequently disappear altogether. In some other instances web sites are infrequently updated or are poorly designed or overcrowded. Moreover, many users find it extremely difficult to spend long hours reading information from computer screens, but this limitation can be overcome through the provision of printing facilities whereby users can download and print portions of entries that they are interested in (Wells, 1999).

A survey conducted by Ngulube and Tafor (2006) revealed that some of the websites provided by African national archival institutions in East and Southern African countries were not accessible or very useful to those seeking information from there. Their study therefore recommended that

records managers in ESARBICA region should formulate policies and guidelines to facilitate capturing of web-based records into formal record keeping system, adding metadata documenting the content, context and structure the records, checking the comprehensiveness and completeness of the records, establishing best practices, disposing of the records in the most appropriate manner and preserving and making web resources accessible in the future. (Ngulube & Tafor, 2006, p. 71)

Moreover, within the African continent, there is however, danger that by placing archival materials on the Internet, only the urban communities with Internet access facilities will be reached, leaving the vast majority of the rural folks unreached thus perpetuating the digital divide between the information urban rich and the rural information poor. Digital divide itself has been defined by Bridges (2001) as "the division between those who have access to ICT and are using it effectively, and those who do not." Bridges further observed that "more often than not, the information "have-nots" are in developing countries, and in disadvantaged groups within countries. To Bridges the digital divide is thus a lost opportunity -- the opportunity for the information "have-nots" to use ICT to improve their lives.

The use of media in marketing is revolutionizing the manner in which organizations are marketing their services and products. Social media has been defined as "forms of electronic communication (such as websites for social networking and microblogging) through which users create online communities to share information, ideas, personal messages, and other content (such as videos)" (Merriam Webster, 2017). The use of social media in marketing has resulted in the development of the concept of social media marketing. Social media marketing has been defined as

The use of social media websites and social networks to market a company's products and services. Social media marketing provides companies with a way to reach new customers and engage with existing customers. (Investopedia, 2017)

Social media enables people to create and share information freely. Social media and social networking are often used interchangeably, yet strictly speaking the terms though interrelated are not the same. A recent study by Saurombe (2016, p. 314) covering 14 countries in the East and Southern African Region indicated that "Most of the national archives in the ESARBICA region were reluctant to make use of technology such as social media." The study, however, noted that "The Directors of the National Archives and the archivists did acknowledge that social media could help reach out to more people, particularly

young people" which is a clear indication that that social media can be utilized to reach potential users of archival services. While it is acknowledged that web 2.0 technologies have great potential in promoting the use of archives, Jimmerson (2011, p. 304) was quick to point out that "we must remember that these resources will not solve all needs and are not available to everyone. The Internet and its many social networking features still do not provide access to all available sources of information. Many people lack the motivation or the connectivity to become active participants in online culture."

Advertising

Advertising is defined in Webster's Dictionary "as the action of calling something to the attention of the public especially by paid announcements, to call public attention by emphasizing desirable qualities so as to arouse a desire to buy or patronize". McNamara (2008) opines that "advertising is bringing a product (or service) to the attention of potential and current customers." He goes further to state that "advertising is typically done with signs, brochures, commercials, direct mailings or e-mail messages, personal contact, etc. For communication to be classified as advertising it must have the following characteristics. It must be paid for, delivered to an audience via mass media, and be attempting to persuade." Advertising has four major characteristics namely: it is persuasive in nature in that it seeks to persuade potential clients to utilize the service or consume the product; it is non-personal in that there is no face to face interaction; it is paid for by a sponsor; and the message is normally transmitted through mass media such as radio, television or newspapers. Some of the methods that may be used to advertise archival services include the radio and television and newspapers.

Radio programmes are very effective especially with rural communities who rely on them for news and other information. A study conducted by Hlope and Wamukoya (2007, p.99) in Swaziland showed that since 2004, Swaziland National Archives has been broadcasting a 15 minute special programme on archives every Thursday between 1615 and 1630. However, to be effective, radio programmes must be aired at convenient hours when the vast majority of the rural population can be reached in their homes. The ideal time may be in the evenings just before or after the evening news.

Radio programmes may be augmented by playing archives old archives songs, press releases announcing the acquisition of new archival materials or the opening of hitherto restricted collections. Subject to the availability of funds, the archival institution may also consider placing paid up adverts in the local dailies drawing the publics attention to the arrival of new archival materials or the opening of particular papers which might of interest to the wider community.

CONCLUSION

It cannot be overstated that all archives public programmes should be evaluated regularly to determine their impact in the community. After the completion of each event, the archival institution should carry out an evaluation to determine if the purpose of the event had been achieved. The evaluation process should also determine the actual costs for conducting the event, the amount of time spent in bringing the event together, the revenues (if any) generated by the event, the manner in which the event was promoted, the problems encountered in carrying out the event and the lessons learnt. The evaluation of the event can be carried out through the completion of a simple questionnaire specifically designed to solicit the views of the participants. A report should be compiled and retained for future planning of

other or similar events. Studies conducted in various African countries indicate that very few archival institutions in Africa undertake archival programming (Ngulube, 2003, Katuu, 1999). These findings were confirmed in a recent study by Saurombe (2017) who reported that public programming initiatives were not a priority in the East and Southern African regions. The major reasons for the failure to undertake extensive archival programming activities were identified lack of public programming policies, budgetary constraints, shortage of staff and lack of transport. Saurombe also reported the low utilization of ICTs in in archival programming activities in the region. An earlier study by Kavulya (2004, p.125) on Marketing of Library Services: A Case Study of Selected University Libraries in Kenya came to the conclusion that: "university libraries in Kenya have tended to concentrate more on public relations and advertising, thus defining marketing in terms of informing users about the services already available instead of finding out what are their expectations from the information service." Similar observations were also made by Kiplang'at (1999, p.115) who noted that "the rural populace tends to get by passed by information coming from external and conventional sources and what does get through in any systematic fashion is often not suitable for the daily practical needs." The observations made by the above librarians are not any different from what is happening among in archival institutions in Africa. Many of the archival institutions have not been aggressive enough in conducting promotional and public relations activities, and where these activities have been undertaken, the focus has been on reaching the urban folks and not rural communities who are in desperate need of learning and utilising archival services.

This Chapter has shown that various methods may be deployed in order to promote and encourage the use of archival resources and services in Africa. It is of vital importance that each archival institutions assesses its strengths and weaknesses, the resources available, the target audience and develop a clear vision of what it they wishes to achieve out of these outreach programmes. The chapter has also shown that archival institutions ignoring carrying out of archives public programmes do so to their own peril. The use of modern information communication technologies which has not been fully utilized by many archival institutions in Africa need to be fully exploited if African archival institutions are to remain visible in their local communities and in the world at large. It is for this reason that Ngulube and Tafor (2006, p.77) strongly argue that "outreach and public programme remain the key to promoting and encouraging the use of services by the users." No wonder Kavulya (2004, p.125) advised that "to be useful, promotion activities need to be done within the broader perspective of marketing process, which includes defining the institutional objectives, contacting research market, carrying out marketing strategies and evaluating these strategies periodically to ensure the achievement of the stated objectives." This is the challenge to all African archival institutions.

It cannot be overstated that archival institutions in the East and Southern African region have a major task ahead of them. During the XXIV East and Southern African Regional Branch of the International Council on Archives General Conference held in Lilongwe, Malawi a resolution was passed calling on archival programming. The resolution read: "Realizing that current public programing and advocacy strategies have not been very effective in reaching potential users and in meeting their needs, this conference urges member states to utilize ICT's to enhance their public archives programming" (ESARBICA Resolutions (2017). Clearly as is this chapter has shown, various archival programming activities that have been undertaken in the East and southern African region had not achieved the desired results. A new strategy is therefore required by these institutions. A similar proposal was also made by Nesmith (2010, p.171) who recommended that a new paradigm in marketing archival services needs to be developed. In his view, "new public programming' would have two interrelated dimensions: greater commitment to the history of records and archives and more active pursuit of a wider role for archives in public affairs.

The two come together as archivists employ their knowledge of records and archiving to help identify and contextualize records for public affairs purposes". In addition to what Nesmith recommends, it is suggested that archival institutions must undertake a needs assessment with users to determine their specific needs. Archival programming should aim at addressing the needs of the users and not simply what the archival institutions thinks the users need to know. Collaboration between the archival institution and the users should be the key in all future archival programming and advocacy activities. Failure to embark on new strategies of marketing the use of archives may result in gross under-utilization of archival services thus rendering them as mere cultural institutions playing minimal role in the socio-cultural and political development of our nations.

REFERENCES

Abioye, A. (2009). Searchers' perceptions of access regulations in Nigerian national archives. *Library Philosophy and Practice*. Retrieved August 17, 2017 from: http://unllib.unl.edu/LPP/abioye.htm

Abraham, T. (1997). *The Next Step: Outreach on the World Wide Web*. Paper prepared for the Annual Meeting of the Society of Rocky Mountain Archivists, Cheyenne, WY. Retrieved January 24, 2008 from: http://www.uidaho.edu/special-collections/papers/outreach.htm

African Commission on Human and Peoples Rights. (2002). *Resolution on the Adoption of the Declaration of Principles on Freedom of Expression in Africa*. Retrieved August 1, 2017 from: http://www.achpr.org/sessions/32nd/resolutions/62/

Blaise, G. & David, E. (1990). From Paper Archives to People Archives: Public Programming in the Management of Archives. *Archivaria, 31*, 101-113.

Bridges.org. (2001). *Overview of the Digital Divide?* Retrieved February 2008 from: Retrieved August 17, 2017 from: http://www.bridges.org/digital_divide

Bruemmer, B. H. (1997). *An Analysis of World-Wide Web Sites For Archival Repositories*. Retrieved January 24, 2008, from http://www.cbi.umn.edu/bruce/arcweb.htm

Cook, T. (1997). The Place of Archives and Archives as Place: Preserving societal memory at the end of the Millennium. In *Proceedings of the 14th Biennial Conference of the East and southern African regional Branch of the International council on archives on archives and the protection of the people's rights*. Pretoria National Archives of South Africa.

Craig, B. L. (1990-91). What are the Client? Who are the Products? The Future of Archival Public Services in Perspective. *Archivaria, 31*, 135–141.

Ericson, T. L. (1990-91). Preoccupied With Our Own Gardens: Outreach and Archivists. *Archivaria, 31*, 114-122.

Ford, S. (1988). The Library Newsletter: Is it for you? *College & Research Libraries, 49*.

Ghering, C. A. (1998). *Archives, Outreach and Digital exhibits*. Retrieved January 17, 2005 from: htt-personal.si.umich.edu/~cghering/600Paper.html

Gray, S. J. (1984). *Information disclosure and Multinationals*. London: Wisey/IRM.

Gregor, A. A. P. (2001). Going Public: A History of Public Programming at the Hudson's Bay Company Archives M. A. Thesis Department of history (Archival Studies) University of Manitoba

Hackam, L. (2011). *Many Happy Returns: Advocacy and the Development of Archives*. Chicago: Society of American Archivists. Retrieved September 19, 2017 from: https://issuesandadvocacy.wordpress.com/2016/07/21/great-advocates-larry-hackman/

Harris, V. (1993). Community Resource or Scholars' Domain? Archival Public programming and the User as a Factor in Shaping Archival theory and Practice. *S A Archives Journal, 35*, 4-13

Hlope, P., & Wamukoya, J. (2007). Utilization of Archival Information at Swaziland National Archives. *ESARBICA Journal, 26*, 85–112.

Investopedia. (2017). *Social Media Marketing*. Retrieved August 3, 20017 from: http://www.investopedia.com/terms/s/social-media-marketing-smm.asp

Jimerson, R. C. (2003). Archives and manuscripts: Reference, access, and use. *OCLC Systems & Services, 19*(1), 13–17.

Jimmerson, R. C. (2011). Archives 101 in a 2.0 World: The continued need for Parrall systems. In *A Different Kind of WEB: New Connections Between Archives and Users* (pp. 1–19). Chicago: Society of American Archivists.

Kamatula, G. (2011). Marketing and Public Programming in Records and Archives at the Tanzania Records and Archives Management Department (RAMD). *Journal of the Society of South African Archivists, 44*, 304–333.

Katuu, S. (1999). User Studies and User Educational Programmes and their Implications for Archival Institutions in Africa. In *Archives and the Protection of People's Rights, Proceedings of XV*th *Biennial Conference of the East and southern African regional Branch of the International council on archives on archives and the protection of the people's rights*. Pretoria National Archives of South Africa.

Kavulya, J. M. (2004). Marketing of Library Services: A Case Study of Selected University Libraries in Kenya. *Library Management, 25*(3), 118–126. doi:10.1108/01435120410522334

Kenya National Archives. (2007). *Publications*. Retrieved September 12, 2007 from: http://www.kenyarchives.go.ke/publications.htm

Ketelaar, E. (1992). Archives of the People, for the People, by the People. *S. A. Archives Journal, 34*, 5–15.

Kiplanga't, J. (1999). An Analysis of the Opportunities for Information Technology in Iproving Access, Transfer and use of Agricultural Information in the Rural Areas of Kenya. *Library Management, 20*(2), 115–127. doi:10.1108/01435129910251575

Kotler, P., & Fox, K. F. A. (1995). *Strategic Marketing for Educational institutions* (2nd ed.). Englewood Cliffs, NJ: Prentice Hall.

Lekaukau. T. M. (1993). Catering for the User Needs, with Special Reference to Botswana National archives and Records Services. *S A Archives Journal, 35*, 24-32.

Maher, J. (1997). *Society and Archives*. Retrieved September 15, 2017 from: http://chnm.gmu.edu/ digitalhistory/links/cached/chapter1/link1.12a_maher.html

Maidabino, A. A. (2010). The Availability, Organization, and Use of Archival Records: A Study of Public Archives Agencies in the Northwestern States of Nigeria. *Library Philosophy and Practice*. Retrieved August 16, 2017 from: http://www.webpages.uidaho.edu/~mbolin/maidabino2.htm

Maphorisa, O. M., & Jain, P. (2013). Applicability of the Gaps Model of Service Quality inMarketing of Information Services at Botswana National Archives and Records Services. *Zambia Library Association Journal, 28*(1&2), 45–55.

Marketing Dictionary. (2008). *Personal selling*. Retrieved February 19, 2008 from: http://www.answers. com/topic/personal-selling?cat=biz-fin

Mason, M. K. (2007). *Outreach Programs: Can They Really Help to Garner Support for and Increase Use of Archives?* Retrieved September 4, 2007 from: http://www.moyak.com/researcher/resume/papers/ arch4mkm.html

Mazikana, P. (2007). *A missed opportunity: archival institutions and public sector reforms*. Paper presented at the XIX Bi-Annual East and Southern Africa Regional Branch of the International Council on Archives (ESARBICA) General Conference on "Empowering Society With Information: The Role of Archives and Records as Tools of Accountability", Tanzania.

Mazikana, P. C. (1999). Access to records: Conditions and constrains. In *Proceedings of the 15th Biennial Conference of the East and southern African regional Branch of the International council on archives on archives and the protection of the people's rights*. Pretoria: National Archives of South Africa.

Mbaruk, H., & Otike, J. (n.d.). *Marketing information services in Africa: a case study of Zanzibar National Archives*. Retrieved August 4, 2017 from: https://www.academia.edu/10825917/Marketing_information_services_in_Africa_a_case_study_of_Zanzibar_National_Archives

Mbwilo, F. (2011). *The Management and Access to the Former East African Community Archives* (MARM Dissertation). University of Botswana.

McCausland, S. (1993). Access and Reference Services. In *Keeping Archives*. Port of Melbourne: The Australian Society of Archivists.

McCullum, H. (1998, January 22). Media's Role in Democracy development. *Times of Zambia.*

McNamara, C. (2008). *Basic Definitions: Advertising, Marketing, Promotion, Public Relations and Publicity, and Sales*. Retrieved February 19, 2008 from: http://www.managementhelp.org/ad_prmot/ defntion.htm

Mnjama, N. (2008). The Orentlicher Principles on the Preservation and Access to Archives Bearing Witness to Human Rights Violations. *Information Development*, *24*(3), 213–225.

Mnjama, N. M. (2003). Records Management and Freedom of Information: A Marriage Partnership. *Information Development*, *19*(3), 183–188. doi:10.1177/0266666903193006

Moalafi, J. M. (2010). *Utilization of Archival Information Resources at Botswana National Archives and Records Services* (Degree of Master of Archives and Records Management Thesis). University of Botswana.

Moyo, C. (2012). Access to Archives at the National Archives of Zimbabwe Over the years. In P. Ngulube (Ed.), *National Archives 75@30: 75 Years of Archiving Excellence at the National Archives of Zimbabwe* (pp. 78–86). Harare: National Archives of Zimbabwe.

Nesmith, T. (2010). Archivists and public affairs Towards a New Archival Public Programming. In *Better off forgetting? Essays on archives, public policy, and collective memory*. Toronto: University of Toronto Press. Retrieved August 5, 2017 from: https://books.google.co.bw/books?id=ORihHjTvyrcC&pg=PA1 69&lpg=PA169&dq=Nesmith:+Archivists+and+Public+Affairs&source=bl&ots=BiaeP2wQRf&sig =0r2Ix7NBBv861wpo6W8nut5INeE&hl=en&sa=X&ved=0ahUKEwiu3t7Hp8DVAhUlCsAKHTxID BAQ6AEIOTAE#v=onepage&q=Nesmith%3A%20Archivists%20and%20Public%20Affairs&f=false

Ngulube, P. (2003). *Preservation and Access to Public Records and archives in South Africa* (PhD Thesis). University of Kwa-Zulu Natal, Pietermaritzburg.

Ngulube, P. (2006). Nature and Accessibility of Public Archives in the Custody of Selected National Archival Institutions in Africa. *ESARBICA Journal*, *25*, 142.

Ngulube, P., Sibanda, P., & Makoni, N. L. S. (2013). Mapping Access and use of Archival Materials held at the Bulawayo Archives in Zimbabwe. *ESARBICA Journal*, *32*, 123–137.

Ngulube, P., & Tafor, V. F. (2006). The Management of Public Records and Archives in the Member Countries of ESARBICA. *Journal of the Society of Archivists*, *27*(1), 1, 57–83. doi:10.1080/00039810600691288

Nicholas, J. (1998). *Marketing and Promotion of Library Services*. Retrieved September 19, 2017 from: https://www.scribd.com/document/165083194/Marketing-and-Promotion-of-Library-Services

Oestreicher, C. (2013). *Archival Advocacy> SAA Sampler*. Retrieved August 16, 2017 from: http://files. archivists.org/pubs/SamplerSeries/ArchivalAdvocacySampler.pdf

Palmer, J., & Stevenson, J. (2011). Something worth Still Sitting For? Some Implication of Web.2.0 for Outreach. In *A Different Kind of WEB: New Connections Between Archives and Users* (pp. 1–19). Chicago: Society of American Archivits.

Peace-Moses, R. (2005). *A Glossary of Archival and Records Terminology*. Retrieved September 4, 2007 from: http://www.archivists.org/glossary/list.asp

Pederson, A, (1988). User Education and Public Relations. In *Keeping Archives*. Port of Melbourne: The Australian Society of Archivists.

Pederson, A., & Casterline, G. (1982). *Archives and Manuscripts: Public Programs*. Chicago: Society of American Archivists.

Saurombe, N. P. (2016). *Public Programming of Public Archives in the East and Southern Africa Regional Branch of the International Council on Archives (ESARBICA): Towards an Inclusive and Integrated Framework* (PhD Thesis). University of South Africa.

Snoj, B., & Petermanec, Z. (2001). Let users judge the quality of Faculty Library services. *New Library World*, *102*(1168), 314–324. doi:10.1108/03074800110406196

Society of American Archivists. (2005). *A Glossary of Archival and Records Terminology*. Retrieved September 4, 2007 from: http://www.archivists.org/glossary/list.asp

Walne, P. (1988). *Dictionary of Archival Terminology* (2nd ed.). Munich: K.G. Saur. doi:10.1515/9783110977691

Wilson, I. E. (1990-91). Towards a Vision of Archival Services. *Archivaria*, *31*, 91–100.

Chapter 4

Using Action Research to Develop a Public Programming Strategy for Heritage Assets, With an Example From South Africa

Patrick Ngulube
University of South Africa, South Africa

ABSTRACT

The literature on action research and how it should be applied is extensive. However, this chapter is not intended to be a substitute for or to provide a synopsis of the substantial body of literature on action research. Its aim is instead to show the potential benefits of this underutilised research approach in heritage management research. Although there are many varieties of action research, the major elements of action research processes are action, research, and participation. Action research has a collaborative social change agenda, with democratic transformation being achieved through the participation of professional researchers and practitioners. It bridges the divide between the outsiders (researchers) and insiders (stakeholders), and differs from many conventional research strategies in that it identifies a problem and attempts to provide a solution that leads to a change in the community or organisation. The case study on developing a public programming strategy for archival institutions in South Africa presented in this chapter illustrates this point.

INTRODUCTION

Action research is a participatory, collaborative and democratic approach in the development and application of practical knowledge that encompasses all stakeholders in the context of a scientific inquiry. According to Cooke and Cox (2005) action research has been used to positively change behaviour, and transform and improve the social context in which it occurs, "for example in sustaining social move-

DOI: 10.4018/978-1-5225-3137-1.ch004

ments, in international development, in education, in social work, and in (confronting) psychology" (p. xxxi). Compared with other research approaches, action research provides real "added value" (Eikeland, 2012, p. 9), and it bridges the gap between "outsiders" or "knower-researchers" and "insiders" or "known-researched" (Eikeland, 2012; Herr & Anderson, 2005; McNiff, 2014). The research results that are arrived at collaboratively by the researchers and participants are used to transform and guide a practical development intervention.

The literature on action research and how it should be applied is extensive, as evidenced by the numerous articles, books, handbooks and journals on the subject, some of which are included in the list of references at the end of this chapter. However, a search of the top ten journals indexed in the Web of Science and Scopus databases in each of the fields in heritage studies (i.e., archives, libraries and museums)[1] revealed only limited use of participatory approaches in describing, explaining, exploring and understanding the dynamic research matters in the field. There may be a variety of reasons for this, the first being the emphasis on 'publish or perish,' causing researchers in heritage studies to choose an easier research approach, and thus to shy away from an approach such as action research, which is relatively complex and sometimes questionable. Second, a lack of understanding of this transformative and emancipatory research strategy owing to the existence of a variety of hybrids of action research may contribute to its low uptake. Third, the fact that until the 1990s action research struggled for legitimacy made it a late entrant into the arena of field methods (Noffke & Somekh, 2009). Fourth, emerging researchers struggle with the conflicting and contradictory messages in action research texts about conducting action research and its characteristics (McNiff, 2014). These four obstacles constitute real difficulties for heritage professionals even if they were to think about implementing action research to inform their practice.

Texts that aim to make the action research approach accessible, especially to those who are new to the field, are therefore extremely valuable. The application of action research may lead to the production of actionable and practical knowledge, proving the criticism that most of the knowledge that heritage management practitioners produce has little relevance to heritage management to be unfounded.

Action research offers heritage management professionals an excellent opportunity to improve their practice and open communicative spaces in which to explore pertinent issues on the main agenda of heritage institutions, such as the presences and absences in heritage collections, equity in the utilisation of heritage assets, the sustainability of heritage assets and appropriate funding models. Communicative spaces provide an opportunity to engage in a constructive dialogue among stakeholders, and facilitate the development of sustainable solutions for the betterment of society. In other words, communicative spaces open the dialogue of communicative action among stakeholders.

The objective of this chapter is to encourage heritage professionals to think systematically about how to conduct action research, including how to overcome the epistemological, ethical and quality assurance difficulties associated with it as a research approach. Having read this chapter, readers should therefore be able to:

- Explain the relationship between action research and research philosophical perspectives;
- Understand the principles of action research and appreciate what counts as action research;
- Understand the various types of action research;
- Appreciate how mixed methods approaches have been used in action research;
- Discuss ethical considerations in action research;
- Establish quality in action research studies;

- Use the development of a public programming strategy for heritage assets as a lens to understand the application of action research approaches in their contexts; and
- Open their learning, as well as their mistakes, to the scrutiny of other action researchers.

The rest of this chapter examines the relationship between action research and research philosophical perspectives, mixed methods approaches in action research, genesis and moments in action research, a taxonomy of varieties of action research, action research theory, the degree to which researchers position themselves in action research, ethical considerations in action research, a public programming strategy for archives in South Africa, how action research studies are evaluated, and areas for further research.

RELATIONSHIP BETWEEN ACTION RESEARCH AND RESEARCH PHILOSOPHICAL PERSPECTIVES

Owing to its historical roots in experimental psychology and social research, the philosophical foundations of action research are widely contested. Research is based on philosophical assumptions which are sometimes referred to as paradigms (Collis & Hussey, 2014; Creswell, 2013; Ngulube, 2015b). Paradigms encompass ontologies and epistemologies, as shown in Figure 1. The use of research methodology terminology in this chapter should be understood in accordance with the conceptual framework provided in Figure 1.

The ontologies (which seek to identify the nature of reality) and the epistemologies (which seek to identify what constitutes valid knowledge) are embedded in two major paradigms, namely positivism and interpretivism (Collis & Hussey, 2014; Ngulube, 2015b).[2] The realist ontology that informs the positivist epistemology assumes that reality is objective, singular and external to the knower. The positivist epistemology is premised on the fact that only observable and measurable phenomena can yield valid knowledge. On the other hand, the constructivist ontology that informs the interpretivist epistemology assumes that reality is subjective, multifaceted and socially constructed. Valid knowledge derives from subjective information from participants. The methodology of the positivist is quantitative, while that of the interpretivist is qualitative.

The theoretical perspective of a qualitative researcher is shaped by social science theories (e.g. ethnography) and social justice theories (advocacy and participatory theories) (Creswell, 2013, p. 23). Social constructivism, which focuses on how individuals construct meanings of their experiences, is another emergent philosophical assumption used by some qualitative researchers. However, unlike Creswell (2013), Denzin and Lincoln (2011) do not identify it as another perspective different from interpretivism. We believe that interpretivism is informed by a constructivist ontology, which implies that the two cannot be considered as theoretical perspectives distinct from each other. The third philosophical assumption is pragmatism, which combines qualitative and quantitative methodologies. Pragmatists do not focus on methods; instead, their emphasis is the outcome of the research problem at hand.

All the philosophical assumptions mentioned above apply to action research, which may employ quantitative, qualitative and mixed methods research methodologies. Kemmis and McTaggart (2005, p. 560) are of the view that action research should not be methodologically driven at the expense of practice. Undeniably, action research is interpretive and investigates human actions and social practice (Williamson, 2013). The paradigmatic assumption of action research is the existence of multiple subjec-

tive realities (Ebersöhn, Eloff, & Ferreira, 2010), with action researchers constructing, re-constructing and co-constructing reality collaboratively with research participants.

This implies that action research has more of an interpretivist epistemology than a positivist one, which partly explains why Figure 1 depicts action research as a purely qualitative approach. Indeed, many research inquiries based on participatory approaches utilise qualitative methods (Silver, 2016). The aim of action research is not to generalise findings (Riazi, 2016, p. 5); this in part explains why Cooke and Cox (2005) describe quantitative approaches as "atypical of the genre" (p. xxiv) and why action research "cannot be evaluated using positivist methods" (Cooke & Cox, 2005, p. xxxvii), as will be explained later.

Although action research is "extremely well suited for qualitative and case-study approaches", this does not exclude its use in quantitative or mixed methods approaches. However, qualitative approaches are preferred by researchers for their "nuanced attention to participants' perspectives and power relations, and the usefulness of qualitative findings for redressing power imbalances" (Giacomini, 2010, p. 141).

However, there is a school of thought that subscribes to the view that action can be understood from both a quantitative and a qualitative worldview. It is possible to adopt both an objective and a subjective perspective when conducting action research, as this assists in explaining different aspects of practice. Like the case study research approach, action research has become transparadigmatic and transdisciplinary, despite initially being grounded in the interpretivist epistemology. The blending of normative and qualitative research methods is acceptable in action research, as explained in the section on mixed methods research in action research. This implies that qualitative, quantitative and mixed methods research may be used in action research, depending on the research questions.

Action research may also be used with other qualitative approaches such as discourse analysis and historical methods in line with methodological triangulation. In discourse analysis, the focus is on who is saying what about what and to whom, while historical methods recognise that practice is constructed and reconstructed historically (Kemmis & McTaggart, 2005). Historical approaches apply mainly when practice is studied in its social context rather than its individual aspect. The blending of qualitative and qualitative methodologies during the course of action research is the subject of the next section.

MIXED METHODS APPROACHES IN ACTION RESEARCH

Mixed methods research lends itself to action research (Ivankova, 2015; Marti, 2016). The use of multiple methodologies was identified by Coghlan and Shani (2014) as one of the ways of achieving rigour in action research. Mixed methods research is based on the philosophical assumption of pragmatism that is illustrated in Figure 1. The ontology of mixed methods research is based on pluralism; methodological pluralism advocates the bridging of the quantitative–qualitative "divide". Some of the reasons why mixed methods research is gaining popularity in the research methodology landscape are set out below.

- MMR provides a better understanding of "wicked problems" because "it stimulates new kinds of questions and involves the use of innovations in methodology needed to address complexity" (Mertens et al., 2016, p. 5);
- MMR enables researchers to be more flexible, integrative, and holistic in their investigative techniques (Powell et al., 2008);
- MMR may prove superior in increasing the integrity and applicability of findings in the study of new or complex initiatives and interactions (Schifferdecker & Reed, 2009);

Figure 1. Action research in the research design landscape (adapted from Ngulube & Ngulube, 2017)

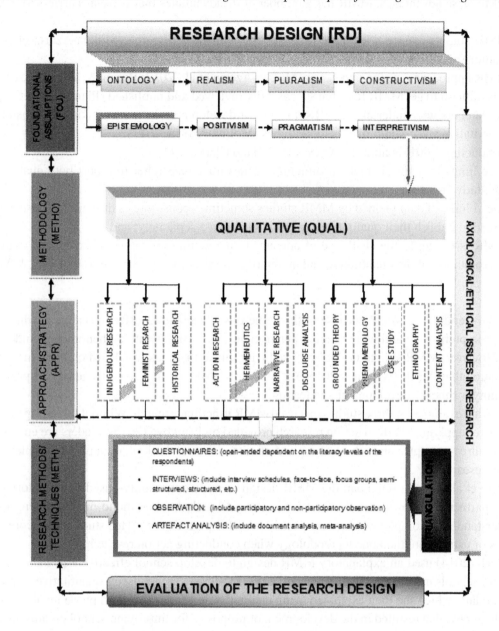

- MMR offers opportunities for innovation and multiple perspectives on and insights into a phenomenon (Cameron, 2013);
- MMR can answer research questions that the other methodologies cannot (Molina-Azorín, 2011);
- MMR deals with confirmatory and exploratory questions simultaneously (Tashakkori & Teddlie, 2010);
- MMR provides better inferences (Molina-Azorín, 2011); and
- MMR provides the opportunity for presenting a greater diversity of divergent views (Molina-Azorín, 2011).

Despite these advantages, MMR has a number of disadvantages that serve as barriers to its uptake:

- MMR studies require a lot more time than monomethod research (Molina-Azorín et al., 2012; Romm & Ngulube, 2015);
- MMR approaches are too expensive (Molina-Azorín et al., 2012; Romm & Ngulube, 2015);
- It is difficult to get MMR research successfully reviewed and published (Plano Clark et al., 2008);
- Researchers who undertake MMR studies must develop a broader set of skills that span both the quantitative and quantitative methodologies (Molina-Azorín, 2011);
- Conducting MMR is not easy (Creswell & Plano Clark, 2011);
- Page limits by journals make it difficult at times for a researcher to report both qualitative and qualitative results;
- The volume of data yielded by MMR studies sometimes constitutes a difficulty, as researchers are forced to publish their qualitative and quantitative data separately; and
- MMR is not up to the challenge of adequately integrating the "design, execution, analysis and interpretation of the quantitative and qualitative strands of research" (Grafton, Lillis, & Mahama, 2011, p. 12).

Scholars tend to use MMR because of the numerous advantages it offers researchers who are interested in comprehensive and wide-ranging perspectives and insights into a phenomenon under investigation. However, MMR should not be confused with mixed methods (MM) which leans more towards triangulation than MMR (Ngulube, 2015b). The use of MMR has the added advantage of providing an opportunity for theory development and testing.

Below are examples of three studies that used MMR in action research. Without forgetting the instructive tools for applying MMR in action research provided by Ivankova (2015), readers are encouraged to use these three examples and others as a point of entry when embarking on an MMR implementation in action research.

Lucero et al. (2016) used a parallel MMR design to study community-based participatory research (CBPR) partnership practices in the United States, and concluded that mono-methods were not suited for understanding a complex phenomenon such as CBPR partnerships. This study underscored the advantages of using more than one methodology when conducting action research.

Shuayb (2014) used an explanatory MMR design to develop school effectiveness and care in three secondary schools in Lebanon. In this sequential design, the researcher used a quantitative methodology to collect data, which she then explained using qualitative methods. The third phase involved an action research process that resulted in the development of proposals for improving school organisation, based on information gathered during the qualitative and quantitative stages.

Westhues et al. (2008) conducted a five-year participatory action research (PAR) study in Canada to "explore, develop, pilot, and evaluate how best to provide community-based mental health services and supports that are effective for people from culturally diverse backgrounds" (p. 702). They used MMR to manage a complex research project and to develop a conceptual framework from four subprojects. The conceptual framework helped the researchers to build theory from their research.

GENESIS AND MOMENTS IN ACTION RESEARCH

The founder of action research is Kurt Lewin, who advocates research that leads to some action. Although action research may have been in existence in the context of applied research prior to this, it was only labelled as such in the 1930s (McNiff, 2014). The development of action research can be traced to experimentalism, philosophical pragmatism, critical theory, political activism, feminism, phenomenology and hermeneutics, and post-modernism (Eikeland, 2012). It was first applied in the field of social psychology by Lewin in 1946, and in other fields such as education by Corey in 1953. Its popularity has since grown, as partly demonstrated by the length of the list of references at the end of this chapter. However, little is known about its utilisation in heritage studies.

Action research is different from traditional research focused on creating knowledge. It aims at creating knowledge and taking action. The most famous aphorism about action research is: "no action without research; no research without action" (Cooke & Cox, 2005, p. xxii) – in other words, it is "research in action rather than research about action" (Coghlan & Brannick, 2014, p. 6). In contrast to other approaches, action research deals with specific concrete and practical issues, and enhances self-development (Ebersöhn et al., 2010). This implies that the goal of research should go beyond describing, understanding and explaining the social world, and focus in addition on changing it (Coghlan & Brannick, 2014). In other words, action research is distinguishable from traditional research by its additional therapeutic stage after the production of actionable knowledge. Practical change is the core research outcome of action research, and is achieved through a cyclical process:

- Assess a situation that requires change on the basis on which action will be planned (reconnaissance);
- Plan to take action;
- Take action;
- Evaluate the action, both intended and unintended; and
- Start another cycle and amend the plan.

The five steps in action research outlined above and in Figure 2 are not static; they are dynamic processes that should be regarded as "moments" in action research (Kemmis & McTaggart, 1988). There is the planning moment, followed by the action moment. These steps may overlap, and these moments are constructive and reconstructive (Townsend, 2013). The plan to make change is identified and deliberated upon. The resulting plan is implemented through action. The plans are re-examined and redesigned after observing and reflecting on the plan in action. Each moment in action research depicted in Figure 2 increases the researcher's knowledge of the identified heritage problem that needs attention.

Townsend (2013, p. 19) expanded the conceptualisation of moments in conducting action research as depicted Figure 2 into six steps:

- **Refining Focus:** Consultation, dialogue and reflection to identify the context that requires change;
- **Conducting Reconnaissance:** The problem is refined and developed and potential action is identified;
- **Reflecting on Progress:** What was learnt from reconnaissance?
- **Planning for Action:** What actions should now be taken? How should the action steps proceed? How can the outcome of the actions be observed?

Figure 2. Iterative steps in action research

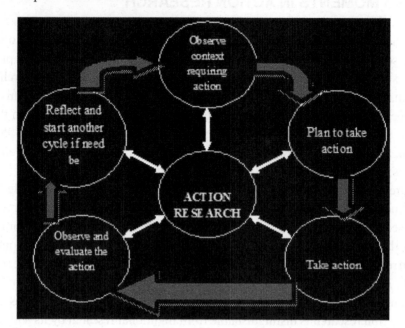

- **Implementing and Observing Action:** Implementation of the action plan, monitoring and observing the immediate effect of the action; and
- **Reflecting and Evaluating Change:** What has changed? Should we revise our focus?

Irrespective of the model that one adopts, the researcher must ask and answer the following questions in order to effectively achieve the steps in action research (Noffke & Somekh, 2009; Townsend, 2013):

- Is there something that needs to be changed in the management of the institution or development of the community?
- Have the issue(s) that need to be changed been identified?
- What irregularities or opportunities need to be changed?
- Why does the issue need attention?
- What will your role be?
- What action may help to improve the situation?
- What obstacles do you anticipate when taking action?
- How will the practices be modified in light of reflection?
- How will the project help the institution?

Attending to all these questions makes it possible to produce knowledge that is relevant and empowering to all those involved in the action research process, irrespective of what type of action research is used. The diversity of action research is discussed in the next section.

TAXONOMY OF VARIETIES OF ACTION RESEARCH

There are different approaches within action research. Consequently, it is difficult to assign a specific definition, as there are many different "action research traditions, all with varying perspectives" (Mc-Niff, 2014, p. 13). The use of action research terms without qualification leads to confusion on the part of many researchers, and this may account for its limited adoption in many fields (Williamson, 2013). Table 1 sets out a number of definitions of action research and identifies their commonalities.

Herr and Anderson (2005) recommend an eclectic approach to defining action research. What is of paramount importance to the two authors is for the researchers to make their definition of action research clear from the outset in order to help the readers to appreciate "the kinds of epistemological, ethical, and political decisions" they make (Herr & Anderson, 2005, p. 5).

The definitions presented in Table 1 illustrate the different approaches to action research found in the literature. These may be attributed in part to the theoretical orientations of the authors. The next section discusses action research variants and traditions.

Table 1. Defining action research

Source	Definition	Common points
Bless, Higson-Smith, & Sithole (2013, p 389)	AR is a "form of participatory research which combines social action and research to resolve a specific problem facing a community and to increase human understanding of similar problems and their solutions"	Combines social action and research to bring about change
Greenwood, & Levin. (2007a, p. 3)	AR is "social research carried out by a team that encompasses a professional action researcher and the members of an organisation, community, or network ("stakeholders") who are seeking to improve the participants' situation"	Change based on a participatory process
McNiff (2014, p. 14)	AR is universally acknowledged as being about change, collaborative and democratic practices, and a commitment towards the well-being of humans and other entities, including animals and the living planet	Collaborative change committed to the inclusion of all the voices in the living planet
Newton (2006, p. 2)	AR is a type of applied social research that aims to improve the social situations through change interventions involving a process of collaboration between researchers and participants	Change based on the active collaboration with participants
Reason & Bradbury (2008, p.1)	AR is a participatory, democratic process concerned with developing practical knowing in the pursuit of worthwhile human purposes, grounded in a participatory worldview	Change based on a participatory democratic worldview
Riazi (2016, p. 5)	AR is the intervention in the functioning of an aspect of the real world (e.g,, a classroom) to bring about a positive change, hence the term "action research"	Intervention to bring about positive change
Shani & Pasmore in Shani, Coghlan, & Cirella (2012, p. 51)	AR is an inquiry process in which researchers and practitioners work together to achieve two objectives: to deal with an organizational issue and to generate scientific knowledge	Collaborative inquiry process that leads to positive change
Silver (2016, p. 141)	AR refers broadly to an applied form of social research that overtly aims to improve the social situation under study while simultaneously generating knowledge about it	Improvement of social situation
Kemmis & McTaggart, (1988, p. 5)	AR is a form of collective self-reflective enquiry undertaken by participants in social situations in order to improve the rationality and justice of their own social or educational practices, as well as their understanding of those practices and the situations in which the practices are carried out	Self-reflective enquiry in order to improve practice
Zhang, Levenson, & Crossley (2015, p. 152)	AR is a research process that collaboratively involves the subjects under study with the objective of using the research results to influence organizational outcomes	Collaborative inquiry process that influences organisational change

Action Research Variants and Traditions

Smith (2007) divides action research into two major schools of thought. On the one hand, there is the British tradition, which views action research as research aimed at enhancing practice, and on the other, there is American action research, which is oriented towards bringing about positive social change. Following up on the two schools of thought on action research, the Australians have advocated "critical and emancipatory" action research (Kemmis & McTaggart, 2005, p. 560). A distinction between classical action research, which aims at improvement and change, and participatory action research, which is based on critical theory and aims at empowerment is another variant. Varieties and traditions of action research have emerged from these schools of thought, including collaborative action research, critical action research, action learning, participatory action research, participatory research, action science and action inquiry (Kemmis & McTaggart, 2005, p. 559; Riazi, 2016, p. 5; Williamson, 2013, p. 189).

The focus of these action research variants is influenced by their ancestry: their historical roots influence their theoretical assumptions and determine the objectives of their research agenda. For instance, participatory action research (PAR) emanated from the quest for freedom from the inequality, exploitation, oppression and human misery associated with the colonial subjugation of the developing world, genocide of the Indians and Aborigines and enslavement of Blacks in the West (Greenwood & Levin, 2007b). Another profound influence on PAR has been the work of Paulo Freire (1972), critical theory, literacy and development workers, feminists, labour activists, civil rights movements and academics (Brydon-Miller et al., 2013). PAR is "distinct in its focus on collaboration, political engagement, and an explicit commitment to social justice" (Brydon-Miller et al., 2013, p. 349). Therefore, PAR challenges the existing political agendas and social contexts and affirms the ability of ordinary people to understand and transform their own situation through education, research and action. This is a direct assault on existing power relations and an empowerment of the ordinary people through knowledge. As a result of its ancestry and theoretical foundations, PAR is "distinct in its focus on collaboration, political engagement, and an explicit commitment to social justice" (Brydon-Miller et al., 2013, p. 349). Some scholars, such as Park (1997), have also described PAR as "research of the people, by the people, and for the people" (p. 8).

Some variants of action research, such as action science, emerged from dissatisfaction with a lack of rigour in some shades of action research, as they bypassed the rigorous processes developed by Lewin. Action science emphasises theories of action and aims at producing actionable knowledge and contributing to theory building and testing (Greenwood & Levin, 2007a). Argyris, Putman and Smith (1985) deal with the issue of objectivity in action research in the form of science in human action.

Despite the growing number of action research variants and traditions, the main purpose of all of them is to take action to solve a local problem and improve practice. Moreover, there are practical similarities between action research variants (Eikeland, 2012), with the differences between them perhaps being more an issue of terminology rather than being truly conceptually based. Townsend (2013, p. 8) cautions that no action research approach is better than another, and it is not unusual to find components of all these forms of action research in one project. Indeed, all action research traditions are concerned with:

(a) generation of new knowledge, (b) the achievement of action-oriented outcomes, (c) the education of both researcher and participants, (d) results that are relevant to the local setting, and (e) a sound and appropriate research methodology (Herr & Anderson, 2005, p. 54).

In summary, one can state that the various ways of conceptualising action research demonstrate the different philosophical and theoretical perspectives that each action researcher is influenced by. All the various types of action research already in existence and those currently evolving are "hybrids of action research" (Ebersöhn et al., 2010, p. 126). All these action research varieties have an 'action' perspective and 'action turn' in common, although their epistemological assumptions and procedures may differ. All action research includes a diagnostic stage and a therapeutic stage (Stephens, Barton, & Haslett, 2009, p. 477), and all share an emphasis on a cycle of action and reflection.

They are all interventionist and involve some degree of co-inquiry and collaboration. The defining characteristic of all these shades of action research is participation, as described by Reason and Bradbury (2001). In short, action research advocates relevant, interventionist and practical research, and is discontented with "disengaged, contemplative, and/or spectator based concepts of social science and with research feigning value neutrality and zero practical 'reactivity'" (Eikeland, 2012, p. 14).

ACTION RESEARCH THEORY

Action research theory is the foundation on which all action research studies are based (Kemmis, 2001; Kemmis & McTaggart, 2005). Chapter 1 underscores various ways of using theory in research. Action research theory is fundamental in building relationships in action research studies. Theory determines the feasibility and successful execution of an action research inquiry. Shani and Pasmore (2010) describe an action research model consisting of four components, namely context, quality of relationships, quality of the action research process itself, and outcomes. The context refers to the factors that may influence the action research project, and includes organisational factors such as resources and history that may affect "the readiness and capability for participating in action research" (p. 253). The quality of relationships entails issues such as trust, ownership, ethics and power relations between participants and researchers. The quality of the action research process itself directs the spotlight onto the "dual focus of both the inquiry process and the implementation process" (p. 253). Outcomes have to do with the ability of action research to produce sustainable actionable knowledge. Good action research may be judged in terms of this theory.

The quality of relationships in action research hinges upon creating and sustaining communicative spaces. The concept of communicative spaces is based in part on the theory of communicative action postulated by Habermas (1987). Communicative action helps participants to explore their knowledge of practice through "mutual recognition, reciprocal perspective taking, a shared willingness to consider one's own conditions through the eyes of the stranger, and to learn from one another" (Habermas, 1998, p. 159). Mutual interpretation and agreement based on knowledge, skills and ethical consideration fosters solidarity and opens up communicative spaces between participants (Kemmis & McTaggart, 2005, p. 578). According to Kemmis (2001), the first step that is central to action research is the creation of a communicative space. The communicative space facilitates the coming together of people to "explore problems and issues, always holding open the question of whether they will commit themselves to the authentic and binding work of mutual understanding and consensus" (Kemmis, 2001, pp. 103–104).

DEGREE TO WHICH RESEARCHERS POSITION THEMSELVES IN ACTION RESEARCH

Researchers should critically evaluate their positionality when conducting and writing about action research (McNiff, 2014). Positionality has been described in terms of first-, second- and third-person voices (Chandler & Torbert, 2003; McNiff, 2013; McNiff, 2014; Reason & Bradbury, 2008). Chandler and Torbert (2003) describe researcher positionality in the following words:

Sometimes research is conducted and reported in one's own, frankly subjective voice (first-person); sometimes in multiple intersubjective voices (second-person); and some-times in an anonymous, generalized voice (third-person) (pp. 139–140).

The question of how the researchers position themselves in the research context is important. However, the issues of positionality of Black African researchers researching African issues may differ from the long-established traditions (Keikelame, 2017). There is agreement that researchers may be either inside or outside the action that they will be investigating. Insiders are usually the practitioners in the context that is being investigated, and outsiders are generally researchers and consultants (Eikeland, 2012). Outsiders may see the practitioners in the field as either subjects, participants or colleagues (McNiff, 2013). Herr and Anderson (2005) explain that the insider–outsider relationship contributes to the knowledge base and professional transformation of the context being investigated in the following dimensions:

- Insiders studying their own practices;
- Insiders working collaboratively with other insiders;
- Insiders working collaboratively with outsiders;
- Reciprocal collaboration between outsider–insider teams;
- Outsiders working collaboratively with insiders;
- Outsiders studying insiders; and
- Multiple personalities.

These positionality dimensions are influenced by the interests being served by the research. Reciprocal collaboration between outsider–insider teams, and outsiders working collaboratively with insiders were the typical dimensions of positionality of the researchers in the example of the public programming strategy research project described later. Our interests were practically and emancipatorily oriented, as explained by Habermas (1987), who identifies three major forms of human interests, namely technical, practical and emancipatory:

- Technical interests focus on the production of technical knowledge that aims at influencing, controlling and explaining a given context;
- Practical interests focus on understanding and making judgements about the world through meaning-making and interpretation based on hermeneutics; and
- Emancipatory interests critically question the existing situation in order for people to take control of their lives.

The focus of technical interest in action research is on establishing the effectiveness of an intervention. The action researcher identifies a problem and finds a solution, and the stakeholders become actively involved in implementing that solution. Practical interests place emphasis on understanding specific practices in a given context. Emancipatory interests are concerned with collaboration between the action researchers and the stakeholders in order to determine a solution to a given problem and promote social change and justice.

ETHICAL CONSIDERATIONS IN ACTION RESEARCH

Some of the ethical considerations in action research are similar to those encountered in other research approaches, while others are particular to action research (Silver, 2016). Ethical issues within research are commonly dealt with through the following questions (Ginsberg & Mertens, 2009):

- What is the ethically proper way to collect, process, and report research data?
- How should social scientists behave in relation to their research subjects?
- What ethical considerations are imposed by the preexisting social context in which any specific piece of research is contemplated? (p. 582).

While these questions provide an instructive framework for thinking about ethics in research, we should bear in mind that one size does not fit all. There is a need to reconceptualise research ethics in the context of action research. In contrast to conventional mainstream research in social science, there is an explicit link between "action" and the findings generated from the research process. Action researchers intervene in the social lives of others with the intention of transforming things. This is a significant responsibility that raises different ethical questions altogether. Action researchers should be "realistic about how participants can be involved in research projects and the impact they can have" (Silver, 2016, p. 151). Ideally, the participants should be involved in the planning, implementation, data analysis and reporting of the findings. A number of ethical dilemmas, relating among other things to participant selection, insider–outsider issues, anonymity and sharing and using findings may arise in action research.

Some of the questions to consider when dealing with ethical dilemmas are:

- How is the participation of stakeholders taken into account?
- How do you deal with insider–outsider issues?
- How do you select an issue to plan action for when the community is divided?
- Are the role and responsibilities of the participants clearly defined?
- Are the political contexts that influence the process of the intended change well understood?
- What mechanisms are used to review roles and responsibilities as the project progresses?
- Should proper names be changed to preserve the identities of the individuals who participate in the project, as dictated by ethical principles?
- How much ownership do participants have over the research, data, interpretations and outcomes?
- How effective and sustainable are the proposed improvements and interventions?
- Are researchers transparent and accountable for research methods and processes?

Answers to these questions may vary from context to context. The fundamental thing is to be transparent regarding whatever action is taken. An audit trail of all the decisions should be available and made explicit to institutional ethics committees and the readers. The research story should underscore the facts. For instance, if the participants' identities are not kept secret or anonymised because they wish to be recognised for their contributions, then written permission that they are happy for their identities to be made public should be obtained.

DEVELOPING A PUBLIC PROGRAMMING STRATEGY FOR ARCHIVES IN SOUTH AFRICA

This case study demonstrates the use of action research in heritage management studies. The lessons learnt from it may be used in other heritage management studies in order to build theory on public programming in the context of heritage studies. Archives, libraries and museums exist to be utilised so as to bring about social change (Millett, 2015; Saurombe & Ngulube, 2016), but these institutions must justify their existence in the face of competing national priorities. The case study is based on a three-year action research project carried out from 2015 to 2017 with the objective of promoting the visibility and use of public archives in South Africa through public programming.

Attempts have been made in silos by different archives repositories in South Africa to promote the visibility and use of archives by citizens through various public programming initiatives, but these have had limited success: scholars such as Ngoepe and Ngulube (2011), Van der Walt (2011), and Venson, Ngoepe and Ngulube (2014) point out that public archives repositories in South Africa are struggling to reach out to potential users. Although the National Archives and Records Service of South Africa Act No 43 of 1996 and the legislation of the nine provincial archival institutions emphasise the need for public archives repositories to reach out to the less privileged sectors of society and make known information concerning records through, among other things, publications, exhibitions and the lending of records, it would seem that, for various reasons, public archives repositories in South Africa are unsuccessful in this.

Facilitating access and use is fundamental to all archival functions such as acquisition, accession, appraisal, arrangement, description and preservation, which are undertaken to facilitate access to the information contained in archives for the present and future generations. Public programming promotes the utilisation of archives, and constitutes the last part of the access equation after preservation. Accessible archives are key to developing national awareness and identity, preserving national memory and national heritage, building information and knowledge-based societies, encouraging responsible citizenship, facilitating research and education, supporting decision-making, fostering accountability and good governance, promoting transparency and justice, and protecting human rights and entitlements. It was in this light that a multidisciplinary project team was constituted at the University of South Africa (Unisa) as part of community engagement in order to promote the use of archives in South Africa. The project, which was funded by Unisa, was entitled "Promoting the visibility and use of public archives in South Africa through public programming". Ethical clearance for the project was obtained from Unisa before it was executed.

The project was executed according to the steps in the action research process described by Townsend (2013), as outlined in the preceding sections. A relationship with all heads of archival institutions in South Africa was established by means of three two-hour face-to-face meetings with the leadership of the archival institutions before the research was undertaken. It was necessary to identify the intersection

between our research interests as professional researchers and the business difficulties experienced by archival institutions with regard to making archives visible. We established that there was sufficient overlap between our interests and the need of national archival institutions to promote the use of archives in South Africa. As suggested by Fricke (2006), the initial conversations were aimed at defining the scope of the work, how it was going to be carried out and how the knowledge that was going to be generated was to be used in practice. Furthermore, the aim was to underscore the role of archivists as researchers in the project rather than those being researched. Thus, communicative spaces were created as envisaged in the communicative theory already discussed.

Our research approach was not in fact conceptualised from the outset as action research. As Greenwood, Whyte and Harkavy (1993) note:

No one may mandate in advance that a particular research process will become a fully developed participatory action research project. Participation is a process that must be generated. It begins with participatory intent and continues by building participatory processes into the activity within the limits set by the participants and the conditions (p. 176).

We later realised that action research was going to be the appropriate research strategy because it provided an opportunity to bridge the gap between research and actionable knowledge that was going to matter to the archival institutions, as it had the potential to increase their effectiveness. Action research, with its focus on positively transforming the social context in which the practice is located, was more appealing than any other research approach. Thus, action research had the potential to bridge the academia–industry divide by developing "successful actionable knowledge" (Sexton & Lu, 2009, p. 684). A team of professional researchers from Unisa sought to establish the extent to which citizens utilised archives in South Africa. The research sought to bring about change in the utilisation of archival information and services in South Africa.

The research project involved academics, master's and doctoral students from Unisa and representatives of the National Archives and Records Services of South Africa, National Film Archives and nine provincial archives, namely, Eastern Cape, Free State, Gauteng, KwaZulu-Natal, Limpopo, Mpumalanga, Northern Cape, North West and Western Cape. Two participants working in outreach and advocacy sections were invited from each institution, making up a total population of twenty-two "insiders".

The archivists involved in outreach programmes at various archival institutions in South Africa were invited to research their own practice in order to give them control over what counted as knowledge about practice as they generated knowledge to be applied in their contexts. This would also give them ownership of the knowledge as opposed to knowledge they applied from outside. It was the responsibility of the research team from Unisa to ensure that the whole process of engagement with practitioners yielded scientifically useful evidence.

The intention was for participants from the research context to collaborate with the team of researchers from the university ("outsiders") to identify and agree on the situation that required change, and plan for action. The insider–outsider relationship was reciprocal and collaborative. The results are reported in the second person as a means to convey the multiple intersubjective voices that informed the project.

The participants in the project possessed varying skills sets, levels of research expertise and degrees of understanding of the problems, and had various reasons for being involved. They came from organisations with a variety of organisational cultures. The playing field had to be levelled to deal with the power relations between "insiders" (archives staff) and "outsiders" (researchers). Positionalities had to

be reflected upon: What did it mean to be an outsider with invested interests in the project? Reflecting on positionalities helped us to understand how the collaboration evolved over time and how the degree of participation shifted and changed across different actors in the project. Control over decision-making and interpretation was shared by both sides. We were committed to participate and facilitate learning. We did not act as distanced and neutral observers. Such an approach is critical to action research processes and outcomes (Reason & Bradbury, 2001).

First, we conducted a workshop with the twenty-two targeted archivists. The workshop was facilitated by an expert who was not part of the project research team. The workshop identified the business difficulties that the national archival institutions faced with regard to taking the archives to the people, including unspoken agendas that may entail the "proverbial 'elephants in the room' that everyone in the organization knows are challenges yet that culturally may be taboo to discuss openly" (Zhang et al., 2015, p. 163). The workshop gave the participants an opportunity to articulate what they considered important in their programming activities and how the programming activities influenced the promotion of the use of archival holdings in South Africa. The workshop resulted in an action plan, which was called a public programming strategy (see Appendix).

Data collected from the workshop was supplemented with data from focus group interviews and documents from the participating archival institutions. Three focus groups in two teams of eight and one team of six participants were conducted. Data was analysed and summarised by means of thematic techniques. This phase resulted in a report co-authored by the facilitator, action research team and the participants. This reconnaissance phase involved the analysis of the archival landscape in South Africa. Landscape analysis included market analysis, customer analysis and competitor analysis. The major findings revealed by a SWOT[3] analysis were that while archives contained unique, freely available information, they faced competition from libraries and museums, had a vaguely defined market, lacked funding and training, had inadequate technology and limited political will, and were governed by inadequate legislation. After establishing the market within which archives in South Africa were operating, the critical success factors were identified as:

- Improving and communicating archives content;
- Improving technology and using existing infrastructure to make the archives visible;
- Improving the physical accessibility of archives;
- Improving funding and budgeting;
- Building capacity of staff;
- Reviewing legislation; and
- Promoting positive perceptions of archives.

After understanding the market and reflecting on the critical success factors, we developed a marketing or public programming strategy with clear marketing objectives in order to alleviate the problem of the lack of visibility of the archives in South Africa (see Table 2 in the Appendix for details of the strategy). We attached values of integrity, trust, accountability, honesty and transparency to the marketing-cum-public programming strategy. The marketing mix was formulated as a basis for implementing the action plan.[4] The achievement of key performance indicators was to be a basis for monitoring and observing the immediate effect of the plan. A second workshop with the same participants was conducted one year later to review progress. We discovered that the marketing/programming plan was being implemented to varying degrees and yielding results that differed from province to province. We agreed to modify our

plan in light of the evaluation, and continued with a revised cycle of action. Another workshop is to be conducted to review what has been achieved after our previous evaluation. If need be, a new action–reflection cycle will be initiated until the objective of promoting archives in South Africa has been achieved.

Action research was used as a tool for institutional and personal development. The research exercise helped practitioners to better understand their practice through their reflection on it (McNiff, 2013). This led to the improvement of their practice and the significant visibility of archives. The project also gave archivists from various provinces the opportunity to work together and to hear what other people had to say. As a result of the communicative space provided by the project the archivists developed trust, and created collaborative knowledge and skills in mutual problem solution. The communicative space made it possible for us to overcome our individual differences and respectfully challenge each other in our thinking, and produced a comprehensive and analytical report reflecting different perspectives. This strengthened our personal development and the institutional growth of the various archival institutions, as information gathered was used to initiate change in public programming.

EVALUATING ACTION RESEARCH STUDIES

Action research has been criticised for its lack of rigour (Coghlan & Shani, 2014). Criteria for evaluating action research need to be developed. The question is: Should we develop a criterion for each action research variant, or should we develop one embracing all the shades of action research? There is no consensus as to what constitutes good quality action research (Coghlan & Shani, 2014); this is due in part to the fact that there are many shades of action research, as demonstrated in the previous section, which implies that the criteria for evaluating action research will vary from context to context (Reason and Bradbury, 2008). Although criteria developed for conventional qualitative and quantitative studies exist, there is a need to explore their appropriateness for action research (Stone, 2016, p. 153). Evaluation of qualitative studies is a contested terrain. Although quantitative methods can be used in action research, we have demonstrated that many action research studies employ qualitative methods. The contested nature of the evaluation of qualitative research relates to the criteria that should be used. Should we use the classical principles embedded in the positivist paradigm such as internal validity, external validity, reliability and objectivity? (Ngulube, 2015b).

Greenwood and Levin (2007c, p. 6) consider credibility and validity to be the researcher's "amulet" in conventional science research, but that these do not apply in evaluating action research studies; therefore, action research should not be judged using classical principles embedded in the positivist paradigm (Coghlan & Shani, 2014). Should we then have a unique evaluative standard based on an interpretivist epistemology, including plausibility (i.e. is the claim plausible?), credibility (i.e. is the claim supported by credible evidence?) and relevance (i.e. what is the claim's relevance to knowledge about the world?). Is the research trustworthy?

Although the expertise of the researcher may determine the quality of qualitative research, strategies to achieve rigour in qualitative research have been suggested (Creswell, 2013; Ngulube, 2015a). Maintaining the audit trail of the research project may enhance the credibility, plausibility, authenticity and dependability of a qualitative study. Qualitative researchers should record and document their research activities, any changes to the research plans and the reasons for any deviations and exceptions. Documenting data collection and analysis processes ensures that qualitative research is not "limited to a mechanistic analysis and reporting of content" (Cambra-Fierro & Wilson, 2010, p. 18).

Those who do not subscribe to the positivist and interpretivist epistemology ask relatively different questions because they think research should have value-relevant criteria such as empowerment, community betterment and moral solidarity. Their question, then, is: To what extent does the research deal with matters of social inequality and improve the lives of the marginalised? According to Coghlan and Brannick (2014), three elements constitute a good action research project: "a good story, rigorous reflection on the story and an extrapolation of usable knowledge or theory from the reflection on the story" (p. 16).

This implies that the major dimensions of assessing quality and rigour in action research should aim at establishing the extent to which the research:

- Reflects the level of collaborative partnership between the researcher(s) and participants;
- Demonstrates a reflexive concern for practical outcomes;
- Approach is suitable for extending the frontiers of knowledge at various levels;
- Is significant; and
- Results in sustainable change (Reason, 2006).

Action research can be considered credible if the researchers and the community are willing to accept the results and act on them to produce the desired outcomes. For Greenwood and Levin (2007c, p. 68) credibility has both internal and external dimensions. Internal credibility is concerned with the extent to which the group generating knowledge trusts the results produced by the research. External credibility, on the other hand, focuses on the extent to which people who did not participate in the action research process consider the results to be believable. The conceptual frameworks provided by Coghlan and Brannick (2014), Greenwood and Levin (2007a,b,c,d), and Reason and Bradbury (2008) may be combined to form a starting point to determine the quality of various shades of action research and the extent to which they are rigorous, reflective and relevant to the context under study.

FUTURE RESEARCH DIRECTIONS

A study to understand the extent to which heritage management practitioners are clear about action research will be instructive. There are many shades of action research, and it will be useful to determine which variety of action research is best suited for heritage studies. Management support is vital for the implementation of changes anticipated by action research, and so ascertaining the level of support that management is prepared to offer for action research interventions would be helpful.

CONCLUSION

As an approach to inquiry, action research is multidimensional, multi-purposeful and flexible. There is no single or right way to conduct action research. This chapter examined the relationship between action research and research philosophical perspectives and demonstrated that it has evolved to include the realist and constructivist ontology, to the extent that mixed methods approaches are now feasible in action research. The origins and various shades of action research were presented. Consideration was given to action research theory, the degree to which researchers position themselves in action research and ethical considerations in action research. An example of an action research project that developed

a public programming strategy for archives in South Africa was given. There was also a discussion of how action research studies may be evaluated. It is evident that evaluating action research studies is not easy. The next step is for heritage professionals to utilise the various shades of action research in the field for their potential value.

ACKNOWLEDGMENT

We would like to thank two anonymous reviewers and the National Archives and Records Services of South Africa for helpful comments on an earlier, and very different, version of this chapter. We would like to thank the Community Engagement Department at the University of South Africa for financial support. Any errors are our own.

REFERENCES

Argyris, C., Putman, R., & Smith, D. (1985). *Action science*. San Francisco: Jossey-Bass.

Bless, C., Higson-Smith, C., & Sithole, S. L. (2013). *Fundamentals of social research methods: An African perspective* (3rd ed.). Cape Town: Juta.

Brydon-Miller, M., Kral, M., Maguire, P., Noffke, S., & Sabhlok, A. (2013). Jazz and the banyan tree: Roots and riffs on participatory action research. In N. K. Denzin & Y. Lincoln (Eds.), *Strategies of qualitative inquiry* (4th ed.; pp. 347–375). Los Angeles: Sage.

Cambra-Fierro, J., & Wilson, A. (2010). Qualitative data analysis software: Will it ever become mainstream? Evidence from Spain. *International Journal of Market Research*, *53*(1), 17–24. doi:10.2501/IJMR-53-1-017-024

Cameron, R. (2013). Mixed methods research: a world of metaphors. In W. Midgley., K. Trimmer, & A. Davies (Eds.), Metaphors for, in and of education research (pp. 51–65). Newcastle upon Tyne, UK: Cambridge Scholars Publishing.

Chandler, D., & Torbert, B. (2003). Transforming inquiry and action: Interweaving 27 flavors of action research. *Action Research*, *1*(2), 133–152. doi:10.1177/14767503030012002

Coghlan, D., & Brannick, T. (2014). *Doing action research in your own organisation* (4th ed.). Thousand Oaks, CA: Sage.

Coghlan, D., & Shani, A. B. R. (2005). Roles, politics and ethics in action research design. *Systemic Practice and Action Research*, *18*(6), 533–546. doi:10.1007/s11213-005-9465-3

Coghlan, D., & Shani, A. B. (2014). Creating action research quality in organization development: Rigorous, reflective and relevant. *Systemic Practice and Action Research*, *27*(6), 523–536. doi:10.1007/s11213-013-9311-y

Collis, J., & Hussey, R. (2014). *Business research: A practical guide for undergraduate and postgraduate students*. London: Palgrave. doi:10.1007/978-1-137-03748-0

Cooke, B., & Cox, J. W. (2005). Introduction. In B. Cooke & J. W. Cox (Eds.), *Fundamentals of action research: The early years* (Vol. 1, pp. xvii–xliii). Thousand Oaks, CA: Sage.

Corey, S. M. (1953). *Action research to improve school practice*. New York: Teachers College Press.

Creswell, J. W. (2013). *Qualitative inquiry and research design: Choosing among five approaches* (3rd ed.). Los Angeles: Sage.

Creswell, J. W., & Plano Clark, V. L. (2011). *Designing and conducting mixed methods research* (2nd ed.). Thousand Oaks, CA: Sage.

Denzin, N. K., & Lincoln, Y. S. (2011). *Introduction: The discipline and practice of qualitative research. In The SAGE handbook of qualitative research* (4th ed.; pp. 1–19). Thousand Oaks, CA: Sage.

Ebersöhn, L., Eloff, I., & Ferreira, R. (2010). First steps in action research. K. Maree (Ed.), First steps in research (pp. 124–143). Pretoria: Van Schaik.

Eikeland, O. (2012). Action research – Applied research, intervention research, collaborative research, practitioner research, or praxis research? *International Journal of Action Research, 8*(1), 9–44.

Freire, P. (1972). *Pedagogy of the oppressed*. Harmondsworth, UK: Penguin Books.

Fricke, W. (2006). General reflections on how to practice and train for action research. *International Journal of Action Research, 2*, 269–282.

Giacomini, M. (2010). Theory matters in qualitative health research. In I. Bourgeault, R. Dingwall, & R. De Vries (Eds.), *The SAGE handbook of qualitative methods in health research* (pp. 125–157). London: Sage. doi:10.4135/9781446268247.n8

Ginsberg, P. E., & Mertens, D. M. (2009). Frontiers in social research ethics: Fertile ground for evolution. In D. M. Mertens & P. E. Ginsberg (Eds.), *The handbook of social research ethics* (pp. 580–614). Thousand Oaks, CA: Sage. doi:10.4135/9781483348971.n37

Grafton, J., Lillis, A. M., & Mahama, H. (2011). Mixed methods research in accounting. *Qualitative Research in Accounting & Management, 8*(1), 5–21.

Greenwood, D. J., & Levin, M. (2007b). A history of action research. In D. J. Greenwood & M. Levin (Eds.), *Introduction to action research* (pp. 13–35). Thousand Oaks, CA: Sage; doi:10.1108/11766091111124676

Greenwood, D. J., & Levin, M. (2007a). Introduction: Action research, diversity, and democracy. In D. J. Greenwood & M. Levin (Eds.), *Introduction to action research* (pp. 3–12). Thousand Oaks, CA: Sage. doi:10.4135/9781412984614.n1

Greenwood, D. J., & Levin, M. (2007b). A history of action research. In D. J. Greenwood & M. Levin (Eds.), *Introduction to action research* (pp. 13–35). Thousand Oaks, CA: Sage. doi:10.4135/9781412984614.n2

Greenwood, D. J., & Levin, M. (2007c). An epistemological foundation of action research. In D. J. Greenwood & M. Levin (Eds.), *Introduction to action research* (pp. 55–76). Thousand Oaks, CA: Sage. doi:10.4135/9781412984614.n4

Greenwood, D. J., & Levin, M. (2007d). Action science and organizational learning. In D. J. Greenwood & M. Levin (Eds.), *Introduction to action research* (pp. 224–236). Thousand Oaks, CA: Sage. doi:10.4135/9781412984614.n15

Greenwood, D. J., Whyte, W. F., & Harkavy, I. (1993). Participatory action research as a process and as a goal. *Human Relations*, *46*(2), 175–192. doi:10.1177/001872679304600203

Habermas, J. (1987). *The theory of communicative action: The critique of functionalist reason*. Oxford, UK: Polity.

Habermas, J., & Rehg, W. (1998). Remarks on legitimation through human rights. *Philosophy and Social Criticism*, *24*(2/3), 157–171. doi:10.1177/019145379802400211

Herr, K., & Anderson, G. L. (2005). *The action research dissertation: A guide for students and faculty*. Thousand Oaks, CA: Sage.

Ivankova, N. (2015). *Mixed methods applications in action research: From methods to community action*. London: Sage.

Keikelame, M. J. (2017). 'The tortoise under the couch': An African woman's reflections on negotiating insider–outsider positionalities and issues of serendipity on conducting a qualitative research project in Cape Town, South Africa. *International Journal of Social Research Methodology*, 1–12. doi:10.1080/13645579.2017.1357910

Kemmis, S. (2001). Exploring the relevance of critical theory for action research: Emancipatory action research in the footsteps of Jürgen Habermas. In P. Reason & H. Bradbury (Eds.), *Handbook of action research* (pp. 94–105). London: Sage.

Kemmis, S., & McTaggart, R. (1988). *The action research planner* (3rd ed.). Geelong: Deakin University Press.

Kemmis, S., & McTaggart, R. (2005). Participatory action research: Communicative action and the public sphere. In N. K. Denzin & Y. S. Lincoln (Eds.), *The Sage handbook of qualitative research* (3rd ed.; pp. 559–603). Thousand Oaks, CA: Sage.

Lewin, K. (1946). Action research and minority problems. *The Journal of Social Issues*, *2*(4), 34–46. doi:10.1111/j.1540-4560.1946.tb02295.x

Lucero, J., Wallerstein, N., Duran, B., Alegria, M., Greene-Moton, E., Israel, B., & Hat, E. R. W. et al. (2016). Development of a mixed methods investigation of process and outcomes of community-based participatory research. *Journal of Mixed Methods Research*, 1–20. Retrieved from sagepub.com/journalsPermissions.nav

Marti, J. (2016). Measuring in action research: Four ways of integrating quantitative methods in participatory dynamics. *Action Research*, *14*(2), 168–183. doi:10.1177/1476750315590883

McNiff, J. (2013). *Action research: Principles and practice* (3rd ed.). London: Routledge.

McNiff, J. (2014). *Writing and doing action research*. Thousand Oaks, CA: Sage.

Mertens, D. M., Bazeley, P., Bowleg, L., Fielding, N., Maxwell, J., Molina-Azorín, J. F., & Niglas, K. (2016). Expanding thinking through a kaleidoscopic look into the future: Implications of the Mixed Methods International Research Association's Task Force Report on the Future of Mixed Methods. *Journal of Mixed Methods Research*, 1–7. doi:10.1177/1558689816649719

Millett, R. A. (2015). Evaluation and social equity functioning in museums. *Visitor Studies*, *18*(1), 3–16. doi:10.1080/10645578.2015.1016331

Molina-Azorín, J. F. (2011). The use and added value of mixed methods in management research. *Journal of Mixed Methods Research*, *5*(1), 7–24. doi:10.1177/1558689810384490

Molina-Azorín, J. F., López-Gamero, M. D., Pereira-Moliner, J., & Pertusa-Ortega, E. M. (2012). Mixed methods studies in entrepreneurship research: Applications and contributions. *Entrepreneurship and Regional Development*, *24*(5-6), 425–456. doi:10.1080/08985626.2011.603363

Newton, J. (2006). Action research. In V. Jupp (Ed.), *The Sage dictionary of social research methods* (pp. 2–3). London: Sage.

Ngoepe, M., & Ngulube, P. (2011). Assessing the extent to which the National Archives and Records Service of South Africa has fulfilled its mandate of taking the archives to the people. *Innovation: Journal of Appropriate Librarianship and Information Work in Southern Africa*, *42*, 3–22.

Ngulube, P. (2015a). Qualitative data analysis and interpretation: Systematic search for meaning. In E. R. Mathipa & M. T. Gumbo (Eds.), Addressing research challenges: Making headway for developing researchers (pp. 131–156). Noordywk: Mosala-Masedi.

Ngulube, P. (2015b). Trends in research methodological procedures used in knowledge management studies. *African Journal of Library Archives and Information Science*, *25*(2), 125–143.

Ngulube, P., & Ngulube, B. (2017). Application and contribution of hermeneutic and eidetic phenomenology to indigenous knowledge systems research. In P. Ngulube (Ed.), *Handbook of research on theoretical perspectives on indigenous knowledge systems in developing countries* (pp. 128–150). Hershey, PA: IGI Global. doi:10.4018/978-1-5225-0833-5.ch006

Noffke, S., & Somekh, B. (2009). *The Sage handbook of educational action research*. London: Sage. doi:10.4135/9780857021021

Park, P. (1997). Participatory research, democracy, and community. *Practical Anthropology*, *19*(3), 8–13. doi:10.17730/praa.19.3.272k84p84u6801g4

Plano Clark, V. L., Huddleston-Casas, C. A., Churchill, S. L., O'Neil Green, D., & Garrett, A. L. (2008). Mixed methods approaches in family science research. *Journal of Family Issues*, *29*(11), 1543–1566. doi:10.1177/0192513X08318251

Powell, H., Mihalas, S., Onwuegbuzie, A., Suldo, S., & Daley, C. (2008). Mixed methods research in school psychology: A mixed methods investigation of trends in the literature. *Psychology in the Schools*, *45*(4), 291–309. doi:10.1002/pits.20296

Reason, P. (2006). Choice and quality in action research practice. *Journal of Management Inquiry*, *15*(2), 187–203. doi:10.1177/1056492606288074

Reason, P., & Bradbury, H. (2001). Introduction: Inquiry and participation in search of a world worthy of human aspiration. In P. Reason & H. Bradbury (Eds.), *Handbook of action research* (pp. 1–14). London: Sage. doi:10.1016/B978-075065398-5/50002-9

Reason, P., & Bradbury, H. (2008). Introduction. In P. Reason & H. Bradbury (Eds.), *The SAGE handbook of action research: Participatory inquiry and practice* (2nd ed.; pp. 1–14). London: Sage. doi:10.4135/9781848607934

Riazi, A. M. (2016). *The Routledge encyclopedia of research methods in applied linguistics: Quantitative, qualitative, and mixed methods research*. London: Routledge.

Romm, N., & Ngulube, P. (2015). Mixed methods research. In E. R. Mathipa & M. T. Gumbo (Eds.), *Addressing research challenges: Making headway for developing researchers* (pp. 157–175). Noordywk: Mosala-Masedi.

Saurombe, N., & Ngulube, P. (2016). Public programming skills of archivists in selected national memory institutions of east and southern Africa. *Mousaion, 34*(1), 23–42.

Schifferdecker, K. E., & Reed, V. A. (2009). Using mixed methods research in medical education: Basic guidelines for researchers. *Medical Education, 43*(7), 637–644. doi:10.1111/j.1365-2923.2009.03386.x PMID:19573186

Sexton, M., & Lu, S. (2009). The challenges of creating actionable knowledge: An action research perspective. *Construction Management and Economics, 27*(7), 683–694. doi:10.1080/01446190903037702

Shani (Rami), A. B., & Pasmore, W. A. (2010). Organisation inquiry: Towards a new model of the action research process. In D. Coghlan & A. B. Shani (Eds.), Fundamentals of organisational development (pp. 249–260). London: Sage.

Shani (Rami), A. B., Coghlan, D., & Cirella, S. (2012). Action research and collaborative management research: More than meets the eye? *International Journal of Action Research, 8*(1), 45–67.

Shuayb, M. (2014). Appreciative inquiry as a method for participatory change in secondary schools in Lebanon. *Journal of Mixed Methods Research, 8*(3), 299–307. doi:10.1177/1558689814527876

Silver, C. (2016). Participatory approaches to social research. In N. Gilbert & P. Stoneman (Eds.), *Researching social life* (4th ed.; pp. 139–159). Los Angeles: Sage.

Smith, M. K. (2007) Action research. In *The encyclopedia of informal education*. Retrieved May, 13, 2017, from http://infed.org/mobi/action-research/

Stephens, J., Barton, J., & Haslett, T. (2009). Action research: Its foundations in open systems thinking and relationship to the scientific method. *Systemic Practice and Action Research, 22*, 475–488. doi:10.1007/s11213-009-9147-7

Tashakkori, A., & Teddlie, C. (2010). Overview of contemporary issues in mixed methods research. In A. Tashakkori & C. Teddlie (Eds.), *SAGE handbook of mixed methods in social and behavioral research* (2nd ed.; pp. 1–41). Thousand Oaks, CA: Sage. doi:10.4135/9781506335193

Townsend, A. (2013). *Action research: The challenges of understanding changing practice*. Berkshire: Open University Press.

Van der Walt, T. (2011). Re-thinking and re-positioning archives: Taking archives to the children. *ES-ARBICA Journal, 30*, 115–134.

Venson, S. L., Ngoepe, M., & Ngulube, P. (2014). The role of public archives in national development in the East and Southern Africa Regional Branch of the International Council on Archives. *Innovation: Journal of Appropriate Librarianship and Information Work, 48*, 46–68.

Westhues, A., Ochocka, J., Jacobson, N., Simich, L., Maiter, S., Janzen, R., & Fleras, A. (2008). Developing theory from complexity: Reflections on a collaborative mixed method participatory action research study. *Qualitative Health Research, 18*(5), 701–717. doi:10.1177/1049732308316531 PMID:18420539

Williamson, K. (2013). Action research: Theory and practice. In K. Williamson & G. Johanson (Eds.), *Research methods: Information, systems and contexts* (pp. 188–202). Prahran, Australia: Tilde.

Zhang, W., Levenson, A., & Crossley, C. (2015). Move your research from the ivy tower to the board room: A primer on action research for academics, consultants, and business executives. *Human Resource Management, 54*(1), 151–174. doi:10.1002/hrm.21616

ADDITIONAL READING

Burns, A. (2009). Action research. In J. Heigham & R. A. Croker (Eds.), *Qualitative research in applied linguistics* (pp. 112–134). London: Palgrave Macmillan. doi:10.1057/9780230239517_6

Eikeland, O. (2007). From epistemology to gnoseology – Understanding the knowledge claims of action research. *Management Research News, 30*(5), 344–358. doi:10.1108/01409170710746346

Eikeland, O. (2007). Why should mainstream social researchers be interested in action research? *International Journal of Action Research, 3*(1/2), 38–64.

McIntyre, A. (2008). *Participatory action research*. Thousand Oaks, CA: Sage.

KEY TERMS AND DEFINITIONS

Action Research: An interactive and collaborative process of generating and applying relevant and valid knowledge by "insiders" (usually individuals, organisations, or communities) and "outsiders" (mostly researchers, educationalists, social workers, or consultants) in order to move closer to improving and transforming practice.

Heritage Assets: A generic term which is sometimes used by social and cultural organisations such as archives, libraries and museums to describe their collections and holdings with tangible and intangible value which have artistic, cultural, economic, historical, social, scientific, spiritual and technological significance for the public, and contribute to the development of a sustainable knowledge-based society.

Marketing Strategy: Usually drawn from marketing research, the marketing strategy combines all the marketing goals of an organisation into one comprehensive plan focusing on increasing marketing opportunities using limited resources, with the ultimate goal of achieving a sustainable competitive advantage.

Participatory Approaches: A broad set of collaborative research approaches with outcomes promoting the technical, practical, and emancipatory interests of the community involved in the research.

Public Programming: A planned sequence of community outreach programmes and promotional activities, which include lectures, seminars, workshops, exhibits, displays, tours, newsletters, websites, and film shows, aimed at informing the wider community about heritage assets and the need to utilise them.

Triangulation: A strategy that validates data through the use of multiple approaches, multiple theories, or multiple sources of evidence.

ENDNOTES

1. There are many databases, such as Google Scholar, that can be used for examples, but these two were selected because they are highly regarded scientific indices.
2. Greenwood and Levin (2007c) refer to the two epistemologies as logical positivism and hermeneutics. This thinking is influenced by the hermeneutic phenomenology school, which refers to hermeneutic phenomenology as interpretive phenomenology. Collis and Hussey (2014) referred to the epistemologies as positivism and phenomenology as result of the same influence.
3. SWOT stands for strengths, weaknesses, opportunities and threats.
4. An interesting discussion on creating a competitive advantage is found in Kim, W. C. & Mauborgne, R. (2005). *Blue ocean strategy: How to create uncontested space and make the competition irrelevant*. Boston, MA: Harvard Business Review Press.

APPENDIX

Archives Marketing/ Public Programming Strategy (2015–2017)

Table 2. Strategy

Archives Mission	The Archives mission, which supports the vision of the Department of Arts and Culture, can be summarised as follows: ● Preserving national archives heritage for use by the government and people of South Africa ● Promoting efficient, accountable and transparent government
Marketing Objectives	The objectives of this marketing campaign are as follows: 1. To enhance the visibility of the archives to 20% of SA by April 2017 2. To communicate the content of the archival holdings to 20% of SA by April 2017 3. To develop officials responsible for public programming 4. To promote positive perceptions of archives to 20% of SA by 2017
Target Market	This marketing campaign will target South Africans of all races from the age of 14 upwards.
Focus	This marketing campaign will focus on market development, where the aim will be to capture that segment of the above identified target market that did not know about the Archives.
Value Proposition	Our value proposition to our target market will be the fact that we can provide them with unique, authentic, cost-effective and reliable and evidence-based information to satisfy any of their information needs.
Core Differentiation Strategy	Our value proposition indicates the quality of our information. In that regard, we will differentiate ourselves from our competitors by highlighting that quality to our target market and by employing quality differentiation approaches.
Positioning	We would like to position the Archives as a professional institution that houses quality, unique, authentic, reliable information and that embraces the values of integrity, trust, accountability, honesty, identity, morals and transparency. These are the same values that our customers also embrace, and so to connect with our target market and position the Archives as desired we will also embrace these values and attach them to this marketing campaign and everything we do.
Marketing Mix	To achieve the above-mentioned objectives and align with our core strategy and positioning, our marketing campaign will be implemented as follows (more detail available in the Key Performance Indicator (KPI) section):

Marketing Mix (continued):

Product:	Place:	Promotion:
● We will package our content for the benefits of our target market and in line with our strategy. ● We will develop a corporate identity. ● Our Archivist will be presentable in order to reflect the identified value proposition of the Archives.	● We will improve the visual appearance of the Archives (offices, outreach and online facilities). ● We will improve the visibility of the archives on maps, cities and surrounding areas.	● We will develop communication material that includes the message: "Archives: your memory, identity, heritage and culture." ● We will covey our message to our target market via various channels which include (but are not limited to) the media, website, social networks, school outreach programmes and proximity messaging services. ● Access to these channels will be through the partnership we will create with various relevant stakeholders.

Table 3. STRATEGY IMPLEMENTATION PLAN

Key Performance Indicator (KPI)	Initiatives	Measures	Targets
Enhance Visibility	• Permanent exhibitions • Mobile exhibitions • Landmark signs of the Archives • Standard and branded outreach material and facilities (outreach toolkit) • Visually appealing website • Community outreach programmes	• Number of permanent exhibitions • Number of mobile exhibitions • Discussions on the erection of landmarks • Percentage complete on the website • Number of outreach programmes	• 4 permanent exhibitions • 1 mobile exhibitions • Discussions complete by when? • Erected landmarks • 80% complete website by next workshop • 3 programmes per year
Content of the Archives	• Design/Develop a toolkit that addresses different customer needs • Design/Develop packages in line with commemoration events • Develop a general toolkit on accessing the Archives	• Number of toolkits developed	• 1 general toolkit • 2 toolkits addressing different needs • 1 toolkit on commemorative events: national and local event • Archives career brochure o All completed in March 2017
Development of officials responsible for public programming	• Workshop • Training • Mentorship programmes • Social networks • Qualifications in public programming	• Number of workshops, training, mentorship programmes • Active social network group	• 2 workshops or training opportunities per year (ESARBICA 2017, OHASA 2016?) • 2-day public programming workshop • Mentorship programmes (internal and external) – student work shadowing • Facebook pages • Ongoing activity on social network page (National Archives Facebook page)
Promotion of positive perception about Archives	• Develop advertising and communication material (brochures, articles, radio talks, etc.) • Establish partnerships with stakeholders (radio, Unisa radio, community radio, newspaper, etc.) • Publish material to print media • Revive the Archives news publications • Organise press release for workshops	• Number of advertising and communication materials • Number of partnerships with stakeholders • Active NARSSA Archives newsletters • Number of press releases per workshop (e-connect, NARS website and Unisa radio)	• 2 articles • 2 press releases • Active NARSSA newsletter (resuscitate)

Chapter 5
The Nature and Utilisation of Archival Records Deposited in Makerere University Library, Uganda

David Luyombya
Makerere University, Uganda

George William Kiyingi
Makerere University, Uganda

Monica Naluwooza
Makerere University, Uganda

ABSTRACT

Makerere University archives are kept in Makerere University Library (Maklib) but their utilisation is limited. This chapter reports the findings of a study that analysed the types of archives in Maklib and the extent of their utilisation. A mixed method approach of a questionnaire, observation, and documents analysis was used. The data obtained was analysed as descriptive statistics. The population of the study included 302 Maklib users who visited the Africana Special Collection Section between May and June 2017. The findings revealed that the scope of the archives collection is limited in time and content, few users, limited publicity of existing records, deplorable state of the paper records, and long waiting time for the information to be provided. Recommendations include widening the collection, digitisation of the archives, further development of human resources capacity, and initiation of outreach programmes to boost the archives visibility and attract users.

DOI: 10.4018/978-1-5225-3137-1.ch005

INTRODUCTION

Many university libraries around the world keep archival records to facilitate access to primary information sources (Purcell, 2015; Oakleaf, 2010; Kalfatovic et al., 2008). While academic libraries collect primarily published materials, some also take on records that contribute significantly to the understanding of the history and workings of their parent institution. Given and MacTavish (2010) observe in their research that it is common to find academic libraries maintaining archival records in addition to other information materials and the mission is to retain all records that have been identified to be of permanent value to the academic institution. Archival records have been defined and explained in different ways by different authors. Authors Zolotarevsky (2010) and McKemmish, Reed and Piggott (2005) define archival records as records of value to an organisation deemed worthy of permanent preservation. Archival records provide evidence and information about organisation's policies and actions. According to the International Council of Archives (2014), archival records are records whose content has been appraised as having continuing value to the organisation keeping them. In the context of this chapter, the term 'archival records' is used to refer to those records selected by Makerere university administration and deposited in Maklib for permanent care for their value and suitability as part of the University's history and mandate. These records provide evidence of the University deliberations, decisions and actions relating to its management and administrative functions. The archival records should be made available to researchers who need to consult them.

Makerere University, established in 1922, is the oldest university in Uganda. The University traces its roots to a technical school which was later renamed Uganda Technical College. It began offering various courses in medical care, agriculture, veterinary sciences and teacher training. It expanded over the years to become a centre of higher education in East Africa in 1935. In 1937, the college started developing into an institution of higher education, offering post-school certificate courses. In 1949, it became a University college affiliated to the university college of London, offering courses leading to the general degrees of its then mother institution. On July 1970, Makerere became an independent national university of the republic of Uganda, offering undergraduate and postgraduate course. The University Library (Maklib) was built in 1939 and opened in 1940. Since inception, Maklib embarked on a collection-development programme of published and unpublished information sources to support teaching, learning, research and innovations in the University (Musoke and Namugera, 2013). As part of collecting the unpublished information sources, Maklib collects records related specifically to the historical development of the University.

The archival collections are managed in the Africana Special Collection Section located on the fourth floor of the Main Library building. The Library collections are accessible through Maklib online catalogue known as MAKULA. This study investigated the nature and use of the University archives that exist in Maklib and the value of the collection to the University community and the public.

STATEMENT OF THE PROBLEM

Makerere University Library's mission is to meet the study, teaching and research information needs of its users (Makerere University Library, n.d.). In order to accomplish this mission, Maklib should collect, keep and make available the University archival records. However, previous studies on the utilisation of

library resources in Maklib appear to have limited focus specifically on the University archival records collections (Kawalya, 2011, Musoke, 2010; Nakiganda (2009), Musoke and Kinengyere, 2008). There is hardly any literature about how the University archives in Maklib are utilised, yet resources are invested in their management. This study was, therefore, designed to provide empirical evidence on the nature of the University archival records in Maklib, their utilisation, the challenges faced by the users when accessing them and the innovative approaches that can be applied to promote their utilisation.

OBJECTIVES OF THE CHAPTER

The five objectives of the chapter are to:

- Establish the nature of the University archival records available in Maklib;
- Identify the users of the University archival records in Maklib;
- Establish how the users of the archival records obtained information about the archival collection and services;
- Identify the challenges faced in accessing the archival records and using them; and
- Identify the best resources required to promote awareness and the use of the university archives in Maklib.

RESEARCH QUESTIONS

- What is the nature of the University archival records in Maklib?
- Who are the users of the University archival records in Maklib?
- How do the archives users get to know about the University archival collection and services, and what subjects or themes do they consult from the archives?
- What are the challenges faced by the archives users when accessing the University archives and using the archival records?
- What strategy should be adopted to improve the utilisation of the University archival records in Maklib?

This chapter proposes a theoretical framework to assess the utilisation of archival records in Maklib. The framework is adaptable and can easily be used in other types of libraries.

THEORETICAL FRAMEWORK: CONNECTIVITY THEORY

Theories provide a framework on which research is built and a basis of support for the topical issues studied (Ngulube, Mathipa and Gumbo, 2015; Sote and Aramide, 2010). This point is also underscored in Chapter One of this text. This study, therefore, made use of the connectivity theory, known popularly as a learning theory of the digital age (Downes, 2012). According to Dunaway (2011) and Bell (2011), the theory is based on the principles that:

1. Learning is a process of connecting specialised nodes of information sources;
2. Learning may reside in non-human appliances;
3. Nurturing and maintaining connections is needed to facilitate continuous learning;
4. Learning and knowledge rest in a diversity of options;
5. The capacity to know more is more critical than what is currently known;
6. The ability to see connections between fields, ideas and concepts is a core
 a. skill; and
7. Currency (accurate, up-to-date knowledge) is the intent of all connectivist
 b. learning activities.

The application of this theory to this study is two-fold. First, maintaining connections to the archival records will promote learning about their existence and attract more users. Secondly, a variety of access options to the archival records will help connect the diversity of users to the library; they will thus explore knowledge from the existing archival records and obtain accurate facts from them as indicated in the principles of connectivism. Collecting and utilising information is the basic thrust of any library. The theory assists the researcher to ensure that the knowledge that resides in the archival records is connected to the right people in the right context in order to promote their utilisation. The theory further helps one to understand that the process of utilising archival records requires connecting users to the collections and making sure that the present and future users access the archival records. Therefore, the library should collect relevant archival records so that the users know about their existence.

SIGNIFICANCE OF THE CHAPTER

This chapter serves to:

1. Explain the context and content of the University archives in Maklib in order to promote their accessibility;
2. Promote understanding of archival materials in Maklib by reporting the state of the records to the readers of this chapter, and
3. Document chain of utilisation of the University archival materials.

REVIEW OF LITERATURE

Academic institutions view the building of a library collection in relation to their mission and goal (Verzosa, 2006). The purpose is not simply to cater for immediate needs but to build a coherent and reliable collection to meet the objectives of the intended users. Chaputula and Kanyundo (2014) report that planning the resources to acquire in a library helps in building a vibrant collection.

Taylor (2009) attests that library administrators should focus on the trends of users and be eager to know if the users are satisfied with the existing resources. Prom (2010) remarks that college and university libraries must be aware of the kinds of information being sought and how it can be collected and then determine its optimum utilisation. According to Purcell (2015), meeting users' needs is the major reason for the development of library services.

Many libraries provide a series of services (user education, refresher courses, outreach programmes and so forth) with the aim of promoting access to their collections, awareness and the usage of the existing information resources; library resources cannot be utilised if the users are not aware of their availability (Oakleaf, 2010; Given and MacTavish, 2010). The purpose of depositing archival collections in university libraries would, therefore, lose meaning if the users were not aware of their existence (Otu and Asante, 2015; Abioye, 2009; Harris, 2000). Ngulube (2009) and Bailey (2007) argue that the ultimate reason for collecting archival records is to facilitate their use. According to Murambiwa and Ngulube (2011), Mnjama (2010) and Jimerson (2003), unless archival records are first identified and collected, adequately housed, and professionally administered, their utilisation cannot be assured.

To maintain their status as major information providers, academic libraries are using new technologies to deliver their services (Branin, 2003; Kemoni, 2002). Improvements in technology have changed the way in which information is presented and circulated in academic libraries (Ndinoshiho, 2010). With technology applications, the collections of academic libraries are not limited to print formats that require users to visit the library physically. Technological advances have compelled libraries to digitise their information materials collections as an accepted methodology to enhance access to their resources via the Internet (Babu & Krishnamurthy, 2013). Aviles and Eastman (2012) held the view that "digital resources are free from the one place at a time" limitation making delivery of services quick and cheap. Peters and Pickover (2001) advocate for digitisation of archives in libraries in order to:

- Reduce the handling and use of fragile original material as the original item would be handled less.
- Allow increased access to the materials; a single copy can be mounted on a web server and this can be viewed by a large number of users.

In Uganda there is a gap in the nature, access and levels of usage of archival records resources in academic libraries (Kawalya, 2011; Musoke and Kinengyere, 2008). To address the knowledge gap, this chapter sought to establish the current state of the archival records in Maklib and their utilisation.

RESEARCH METHODOLOGY

The study utilised predominantly a quantitative approach. The data was collected using a combination of data collection tools with the questionnaire as the principal instrument for data collection (Creswell, 2014). A structured questionnaire, which comprised both open-ended and closed-ended questions, was designed and administered to the users of the Africana Special Collection Section. Unlike the other sections of Maklib which can be accessed by users, the Africana Special Collection Section is not accessed by users. Records are ordered through the Issue Desk which is located in the reading area. An Order Form is filled by the users and handed to the Issue Desk which in turn registers the request before passing it over to the repository staff for retrieval of the required archival material.

The study was carried out in May to June 2017, at a time of the University calendar year when the Library was expected to be serving many readers, especially students as they worked on their coursework and prepared for end-of-academic-year examinations.

The target population in this study was the users of the Africana Special Collection Section who, at the time of collecting the data, had entered the Library to seek information from the University archives.

Archives are significant records which were created by the University and deposited in Maklib to provide evidence of its deliberations, decisions and actions relating to its management and administrative functions. The sample was purposively selected through voluntary participation (Leedy and Ormond, 2013). Using this sampling method, questionnaires were given to every person who entered the Africana Special Collection Section of Maklib. Users were free to accept or to reject participating in the study. To encourage participation, the Issue Desk Officer at the Africana Special Collection Section encouraged those who came to seek library services from this Section to participate in the study for their views for improved library services. Those who were seeking University archival materials were targeted to provide a picture of the utilisation of the University archives through their perspective. To avoid double participation users were asked to confirm if they had participated in this study or not. At the end of the two months, 5673 users of the Africana Special Collection Section had complied with the request to participate in this study and had completed and submitted their answered questionnaires. There were about 93 users of the Africana Special Collection Section per day over the 2 months (61days) as the Library was open every day including Sunday since it was examination season. Observation and document analysis were also employed to collect qualitative data that was to be used for clarifying gaps in quantitative data (Babbie, 2007).

Data obtained from the study was analysed using mixed data analysis methods (Miles and Huberman, 2014). The quantitative methods entailed entering the quantitative data into the Statistical Package for Social Sciences (SPSS) software for descriptive data analysis to show prevalence of the certain variables e.g. categories of users, and sources of information, for which frequency tables were obtained. Thematic analysis was used to analyse the qualitative data (Clarke and Braun, 2013) by identifying themes and patterns of meaning across the data collected through interviews.

RESULTS AND DISCUSSION OF FINDINGS

The results presented here are based on the objectives of the chapter.

As indicated in Table 1, 5673 questionnaires were issued during the course of the study and 5342 indicating 94% were returned. The invalid responses were 0.7% of the total issued questionnaires. Since the Africana Special Collection Section does not house only University archival records, the study aimed to establish whether the respondents were there for University archival records or other information resources. The questionnaire was intended to locate the archives users in relation to other Maklib users. After eliminating invalid responses, the usable responses of the total questionnaire issued were 302 indicating 5.3%. The findings confirmed that the archival records in Maklib were not being accessed and used by many of the Library users. This begs the question: Why are the Library users not utilising the

Table 1. Response rate from research participants

Questionnaires	Number/Units	%
Issued	5673	**100%**
Returned	5342	94%
Invalid responses	29	0.7%
Usable responses	302	5.3%

availability of the university archives? Those who had come for other information materials rather than to consult the University archives were asked to indicate what they looked for in this Section of Maklib. They indicated Africana materials, manuscripts, newspapers and photographic collections as what they were seeking from the Library.

University Archival Records in Maklib

Analysis of the University archival records housed in Maklib established that the collection was limited in time and content. The composition and extent of the archives collection is shown in Table 2.

By examining the catalogue, the collection showed that the university archives were limited in scope and time as illustrated in Table 3. For example minutes of faculty boards were last transferred in 1967. The most recent transfer was in 2015 of which were Dissertations and Theses. This implies that the identification and processing of the University Archives is not ongoing or the Library archives section is detached from the University records management system. As a practice, archives are identified from the records management system. There was no evidence to suggest any relationship between Maklib and the University records system. From this observation, the archives don't seem to be growing and the low utilisation may be partly explained by the limited scope of this collection.

Other archival collections in African Section related to the Buganda/Mengo government (45 files), the Church Missionary Society (66 files) and Government of Uganda official papers (39 files). The Government of Uganda official papers in this Section is a result of the Library being a legal depository of all works published in Uganda, including government publications. Following the passing of the Makerere University College (Deposit Library) Act, 1958 and the revision of the same Act in 1964, Maklib became the first legal deposit library in Uganda. With the legal deposit arrangement Maklib collects various materials under this legislation. The deposited government of Uganda papers shed light on the events leading up to Uganda's independence in 1962 and the personalities connected with Uganda's politics, such as Ignatius Musaazi, the founding president-general, and Abubakar Mayanja, the founding secretary-general of the first political party in Uganda, the Uganda National Congress (UNC).

Table 2. University archival materials in the Africana Section

Category of the Archives	Date Range	Size of the Collection
Makerere College School Governing body minutes	1899- 1943	39 files
Memorabilia related to the University activities	1831- 1947	85 files
Research Applications	1926 - 1948	66 files
University plans for buildings	1880 - 1992	13 files
Minutes of Faculty Boards	1948 - 1967	67 boxes
Extra Mural Studies - Annual Reports	1954 - 1973	62 items
Commissions on Higher Education	1937- 1977	17 files
Policy documents	1877 - 1979	02 files
Confidential Reports and Letters	1945 - 1953	01file
Confidential Reports and Letters	1945 - 1953	01file
Dissertations and Theses	1970- 2015	25 square meters

The materials were in hard copy and the paper on which the records are captured was brittle which posed a threat to the continued existence of these records. The records were also not kept in suitable environment as some records looked too old and dirty proving a truly unfriendly environment to the archives users. For researchers consulting large-sized records such as maps and architectural drawings, the surfaces were not suitable for consulting these records. The archives collections were in areas that had no air conditioning and humidity control facilities. All in all, adequate provision did not seem to exist for the storage of the University archival records and as a result, the archives utilisation continues to experience very slow development. However, observation of the reference services offered by the Africana Section Issue Desk showed that although the records are not digitized, the access to the catalogue is managed electronically at least in part since details about the archives are entered into the archival management module of the Virtual Integrated Library System. Assessing of individual users needs and matching them to the holdings of the archives starts from the Virtual integrated library system.

Categories of Users of the University Archives

Further analysis of the findings revealed that the respondents belonged to two main categories, i.e. internal and external users as elaborated below.

The majority of the users were Masters Students (23%). This implies that master's students are making a lot of independent research requiring them to consult the University archives. The PhD students were both from within and outside Makerere University with the majority being doctoral students registered at Makerere University. The other external users who visited Maklib seeking information from the University archives constituted 17% by the users from outside Uganda (foreign users) and 14% is by newspaper reporters.

Table 3. Categories of University archives users (n= 302)

Category of Respondent	No. of Users	% of Responses
Internal Users		
PhD Students	60	20
Masters students	71	23
External Users		
Independent Researchers	63	21
PhD Students	15	05
Newspaper reporters	43	14
Foreigners	50	17
Total	302	100

How Users Got to Know About the Existence of the University Archives in Maklib

This chapter was interested in establishing how the archives users got to know about the existing university archival records in Maklib. To establish how the respondents got to know about the archives, a selected number of sources were given to the respondents to choose from. The results are indicated in Tables 4.

The majority of the respondents 164 (54%) indicated that their source of information about the university archival records was from their lecturers/professors. Those who got to know about the archives from colleagues accounted for 17%. Sixteen (5%) relied on electronic sources. When asked to specify which electronic sources, they indicated the University Library online catalogue, the MAKULA section of the University Website. The number of respondents accessing the university archives through electronic sources was small implying that much of the archival records collection was more accessible to end users within the library premises. Access through the internet and intranet by those who could not personally visit the library was very limited and the link to Africana section on the Maklib website was not functioning. As such, it was not possible to access any individual documents in these collections.

The respondents were asked to list other sources of information not indicated in the questionnaire which they used to find out about the University archives in Maklib. Twenty-three per cent of the respondents reported details as indicated in Table 5.

Table 4. Source of information about the University archives (n= 302)

Sources	No. of Respondents	%
Through lecturers/ professors	164	54
Heard from colleagues	50	17
Library website	16	5
Other sources	72	24
Total	302	100

Table 5. Other sources

Source
Brainstorming and then just asking who I think could know about archives
All of the above to varying degrees
Luck
All of the above
Past experience
Knowledge of history and experience
Government offices

None of the respondents prioritised the sources; that is, where they included several sources they did not indicate which was the most reliable. Also, several issues could be seen to be represented in the one answer (for example, 'all the above' could be seen to be related 'to all the above to varying degrees'). The responses above suggest a relationship between user awareness and utilisation.

Search Topics

The participants were asked to describe what they were looking for from the archives collection. Table 6 provides responses on what the archives users were searching for when they visited Africana.

As indicated in Table 6, the majority of the respondents were looking for dissertations and theses (34%). Information requested also focused on deliberations, decisions and actions of various university offices (29%). Materials which contained substantial statistical information such as the number of students in each course at various stages of the University's existence were also sought (23%). Findings further revealed that archives users sought for information with emphasis on the history of Makerere university or individual faculties (09%). Those who indicated that they wanted other information (05%) did not specify what they exactly wanted from the University archives.

User Satisfaction With Information Obtained From the Archival Records

The respondents were asked about the level of satisfaction they derived from accessing the university archives. The literature indicates that it is important to obtain library users' feedback to form a basis for improving the services offered to them (Babu and Krishnamurthy, 2013). The participants were asked whether they were satisfied with the information obtained from the archival collections, i.e. the archival materials consulted. Table 7 gives a summary of the responses.

Table 6. Information users sought from the archives (n=302)

Information Users Seek	Responses	%
Dissertations & theses	104	34
University Deliberations, Decisions and Actions	89	29
Statistics	68	23
History about the University	27	09
Others	14	05

Table 7. Level of satisfaction with information obtained from the archives collection (n= 302)

Are You Satisfied with the Archival Information You Look For?	No. of Respondents	%
No	194	64
Yes	77	25
Not sure	34	11
Total	302	100

As indicated in Table 7, the results revealed that only 77 (25%) of the respondents were satisfied with the information obtained from the University archives collection. Sixty-four per cent indicated 'no', implying that they were not satisfied with regard to the information required. Thirty four (11%) were not able to comment on the information they got from the archives and hence they were not sure. The respondents indicated issues such as inadequacy of the archival records, relevance and accuracy, among others, as causes of low satisfaction. A failure to provide relevant and accurate information may lead to the potential archives users not to come to the archives (Murambiwa & Ngulube, 2011). Persons who have taken the time and trouble to come to the archives to use the records should be able to access the records.

Respondents' Expectations With Regard to Format of Information Required

The respondents were asked whether the archives were in a format that met their expectation. The aim was to find out the format of the archival materials that the users expected to use when they access the archives. Table 8 shows the results.

A total of 144 (48%) respondents expected to find complete articles or documents when they accessed the archives. However, 133 (44%) were not sure of what they expected and were ready to accept whatever was available. All the participants indicated that archival materials should be made available online with full text, which implies the need to digitise the University archives collection. We also observed that the users faced a wide range of challenges.

Problems Encountered in Utilising the Archives

The respondents were asked about the problems they faced in relation to archives access and utilisation. Table 9 indicates their responses.

Findings revealed that the users of the archival records encountered many problems. The deteriorating state of the paper records was a major barrier to using of the archival records (49%). Some records had decayed and depreciated to the extent that they were illegible. The waiting time for delivery of a required records was another challenge; 54 (18%) respondents indicated that the requested items were delivered after they had waited for over 30 minutes. Observation established that the archives were under closed access and the library staff had to assist the individual users by getting them what they needed. Locating the required record seemed a problem to the library staff, which was discouraging potential archives users from utilising them. The assistance provided to the users was also questioned (12%) as the librarians took long in their search for the items. The other problem related to the lack of required archival records (12%) and to the limited number of copies (10%). The respondents indicated that they

Table 8. Respondents' expectations while accessing archival records (n= 302)

What do You Expect to Access When You Request Archival Records?	No. of Respondents	%
Full text	144	48
Abstract/summary	15	05
Index	10	03
Whatever was available	133	44
Total	302	100

Table 9. Problems encountered while accessing archival records (n= 302)

Problems	No. of respondents	%
Deteriorating paper	148	49
Time in which the information is provided	54	18
Amount of aid received from Library staff	36	12
Lack of required information	34	11
Limited number of copies	30	10
Total	302	100

did not have ready access to some documents because the library had only one copy to share. General observation further revealed that many users, who visited the Africana Issue Desk with a task in hand, ended up walking out of the archives section empty-handed. The literature indicates that there is a need for archival information literacy to help users understand what to expect from an archival repository or else users will be discouraged from visiting the facility (Prom, 2010).

Suggestions for Promoting the Archives Utilisation

The respondents were required to indicate what they considered a solution for them to get maximum benefit from the archives collection and their responses are indicated in Table 10:

As indicated in Table 10, the archives users required ready access to the materials they looked for. The suggestions further demonstrates that the University archives collections are not yet digitized. Digitisation would make electronic copies available for sharing electronically and remotely even where the hard copies are limited in number. Customer care by the library staff was also lacking as the archives users demanded a cheerful attitude.

Table 10. Suggestions for promoting archival records utilisation

I expect the material to be accessible. I come to the archives section but find material missing
Internet archives/sources
I hate being forced to read the archival records only from the library
One central searchable database (Web-based) that will locate all archival documents
Information on materials yet to be processed or are in the process of becoming available, hopefully before I finish my study
A cheerful attitude
Electronic copies of the materials since you have few copies of what we want
Permission to borrow archives
Knowledgeable staff is key, but variable in my experience
Suggestions about other archival sources
Advice or opinion on how to use the records effectively

FUTURE RESEARCH DIRECTIONS

There seem to be a lack of systematic coordination of the management of the university archives in Maklib. As such, there is need to investigate the University management support, state of preservation and feasibility of digitization to find innovative ways to guide the collecting and management of the university archives.

RECOMMENDATIONS

The chapter proposes that Maklib should consider and implement key initiatives in the following strategic areas to ensure effective and efficient services at the African Section:

Widen the University Archives Collection

The findings determined that the University archives collection was limited. A university archives policy should be established to guide the management of the University archives. This is necessary to steer regular identification and transferring of the university archives to Maklib. Processing and transferring more University archives to Maklib will enable the Library to operate and meet the university archives users' needs in an effective and efficient way. Failure to process more university archives means that the library will be unable to meet its archives users' expectations both in the present and the future. Since the archival collection in Maklib is also not limited to materials from the University, the Maklib archives repository should have a link to the national archives to improve access to information on heritage and culture.

Raising Awareness

The Africana Special Collection Section should endeavour to launch user education programmes and outreach activities to raise awareness of the existence of the university archives because the total number of the archives users in the two months of the study was small compared to the total number of users accessing the Africana daily. Once users become aware of the existence of the archives they will tend to use them. The implication of this is that archives which users are not aware of would be underutilised. Thus what is fundamental to archival information provision is the creation of user awareness. This should involve launching:

Education Programmes

The programmes would involve training library users in archives searching skills so as to be able to locate what they need faster and effectively. Archival information literacy sessions should be conducted to demonstrate the available university archives. This approach will enable the library staff to build a relationship with the users so as to know them better and be able to meet their needs appropriately. Such instructions should promote the best use of the Maklib archives collections. In this regard, special responsibility rests on the University Librarian and the Africana Special Collection Section staff to launch a training programme targeting current and potential archives users.

Outreach Activities

Staff from the Africana Special Collection Section should go out to meet the library users. They should talk with university students in constituent colleges to spread information about the contents of the university archives. They should encourage all library users to visit the section for their research. Library staff can also organise seminars and workshops. They can increase publicity through newspapers, radio and television. Through this publicity effort the general public and all university students regardless of courses pursued will learn more about what is available in the archives collection in Maklib.

Development of Human Resources

Maklib management should focus on investing in capacity-building to train staff in customer care, archives arrangement and dissemination. This will be necessary to facilitate faster access to the archives. Staff training provides effective customer services to those seeking information from archival records. The Africana Section should be manned by staff with archives retrieval, dissemination and public relations skills. This will require employing staff skilled in archives management in the Africana Special Collection Section. Services from Makerere University East African School of Library and Information Science (EASLIS) can be utilised by Maklib for apprenticeship training in skills such as archival arrangement and description. The staff in the Africana Section should be re-trained in providing modern archives services. Staff can also visit other university libraries to learn from their experiences. Participation in seminars and conferences to learn about best practices is also another option. This will create an experienced team of staff with the knowledge and skills critical to the needs of university archives users in Maklib.

Processing and Organising the Collection

It will be very helpful for the African Section staff to have the archival collection better organised so that they are ready for the users. Since the archival repository service cannot be compared to a library service, primary resources should be effectively organised following archival principles to ease access. This will reduce on waiting time when archival materials are required.

Automation and Digitisation of Archives

To increase access and usage of the archives collection in Maklib, the content should be converted to digital form. The problem of limited copies will be solved by digitising the collections. This has the potential to vastly expand accessibility as a number of users could gain access to the same information at the same time. The digital content should be uploaded in OPAC. Digitisation will offer preservation benefits to reduce the handling of fragile and heavily used original materials. It will also create back-up copies. Digitisation will reduce physical wear and tear of the original copies of the archival records.

CONCLUSION

Basing on the findings of this study, the conclusion can be drawn that despite the existence of archival records in Maklib, the collection was not diverse enough. A limited number of copies existed and many of the respondents noted that this was a barrier to the use of the university archival records resources. Accessing the records also took too long. This resulted in difficulty in meeting the library users' archival information needs on time.

The archives collection will require some degree of active intervention by the Maklib and the entire university management to identify the archives regularly, collect and preserve them and promote continued access to them through making the users aware of their existence. The connectivity theory would provide the framework to connect library users to the archival collection and to promote the use of the available materials.

REFERENCES

Abioye, A. (2009). Searchers' perceptions of access regulations in Nigerian national archives. *Library Philosophy and Practice*. Retrieved December 14, 2016, from http://unllib.unl.edu/LPP/abioye.htm

Aviles, M., & Eastman, J. K. (2012). Utilizing technology effectively to improve Millennials' educational performance: An exploratory look at business students' perceptions. *Journal of International Education in Business*, *5*(2), 96–113. doi:10.1108/18363261211281726

Babu, P. B., & Krishnamurthy, M. (2013). Library automation to resource discovery: A review of emerging challenges. *The Electronic Library*, *31*(4), 433–451. doi:10.1108/EL-11-2011-0159

Bailey, S. (2007). Taking the road less travelled by: The future of the archive and records management profession in the digital age. *Journal of the Society of Archivists*, *28*(2), 117–124. doi:10.1080/00379810701607777

Bell, F. (2011). Connectivism: Its place in theory-informed research and innovation in technology enabled learning. *International Review of Research in Open and Distance Learning*, *12*(3), 98–118. doi:10.19173/irrodl.v12i3.902

Branin, J. J. (2003). Knowledge management in academic libraries: Building the knowledge bank at the Ohio State University. *Journal of Library Administration*, *39*(4), 41–56. doi:10.1300/J111v39n04_05

Chaputula, A. H., & Kanyundo, A. J. (2014). Collection development policy: How its absence has affected collection development practices at Mzuzu University Library. *Journal of Librarianship and Information Science*, *46*(4), 317–325. doi:10.1177/0961000614531005

Clarke, V., & Braun, V. (n.d.). Teaching thematic analysis: Overcoming challenges and developing strategies for effective learning. *The Psychologist*, *26*(2), 120–123.

Downes, S. (2012). *Connectivism and connective knowledge: Essays on meaning and learning networks*. National Research Council Canada. Retrieved January 13, 2017, from http://www.downes.ca/files/books/Connective_Knowledge-19May2012.Pdf

Dunaway, M. K. (2011). Connectivism: Learning theory, and pedagogical practice for networked information landscapes. *RSR. Reference Services Review, 39*(4), 675–685. doi:10.1108/00907321111186686

Given, L. M., & MacTavish, L. (2010). What is old is new again: The reconvergence of libraries, archives and museums in the digital age. *The Library Quarterly, 80*(1), 7–32. doi:10.1086/648461

Gould, E., & Gomez, R. (2010). New challenges for libraries in the information age: A comparative study of ICT in public libraries in 25 countries. *Information Development, 26*(2), 166–176. doi:10.1177/0266666910367739

Harris, V. (2000). *Exploring archives: An introduction to archival ideas and practice in South Africa* (2nd ed.). Pretoria: National Archives of South Africa. Retrieved March 13, 2017, from http://www.dlib.org/dlib/november01/peters/11peters.html

International Council of Archives. (2000). *International standard for archival description (general)* (2nd ed.). International Council of Archives.

Jimerson, R. C. (2003). Archives and manuscripts: Reference, access, and use. *OCLC Systems & Services, 19*(1), 13–16. doi:10.1108/10650750310462811

Kalfatovic, M. R., Kapsalis, E., Spiess, K. P., Van Camp, A., & Michael, E. (2008). Smithsonian Team Flickr: A library, archives, and museums collaboration in web 2.0 space. *Archival Science, 8*(4), 267–277. doi:10.1007/s10502-009-9089-y

Kawalya, J. (2011). Building the national memory in Uganda: The role of legal deposit legislation. *Information Development, 27*(2), 117–124. doi:10.1177/0266666911401180

Kemoni, H. (2002). The utilisation of archival information by researchers in Kenya: A case study of the University of Nairobi. *African Journal of Library Archives and Information Science, 12*(1), 69–80.

Laver, T. Z. (2003). In a class by themselves: Faculty papers at research university archives and manuscript repositories. *The American Archivist, 66*(1), 159–169. doi:10.17723/aarc.66.1.b713206u71162k50

Lor, P. J. (2008). Digital libraries and archiving knowledge: Some critical questions. *South African Journal of Library and Information Science, 74*(2), 116–128.

Lugya, F., & Mbawaki, I. (2011). Usability of Makula among Makerere University Library users: A case study. In *Proceeding of the 3rd International Conference on Qualitative and Quantitative Methods in Libraries*. Athens, Greece: National Hellenic Research Foundation. Retrieved January 19, 2017, from http://dspace.mak.ac.ug/handle/123456789/1967

Lugya, F. K. (2011). *Usability of Makula among Makerere University library users*. Retrieved January 12, 2017, from http:/hdI.handle.net/123456789/1967

Makerere University Library. (n.d.). *Makerere University Mission*. Retrieved July 9, 2017, from http://www.mak.ac.ug/university-services/university-library

Massis, B. E. (2011). Information literacy instruction in the library: Now more than ever. *New Library World, 112*(5/6), 274–277. doi:10.1108/03074801111136301

McKemmish, S., Reed, B., & Piggott, M. (2005). The archives. In S. McKemmish, M. Piggott, B. Reed, & F. Upward (Eds.), *Archives: Recordkeeping in society.* Centre for Information Studies. doi:10.1016/B978-1-876938-84-0.50007-X

Miles, M. B. A., & Huberman, M. (2014). *Qualitative Data Analysis: a methods sourcebook* (3rd ed.). Sage Publications.

Mnjama, N. (2010). Preservation and management of audiovisual archives in Botswana. *African Journal of Library Archives and Information Science, 10*(2), 139–148.

Murambiwa, I. M., & Ngulube, P. (2011). Measuring access to public archives and developing an access index: Experiences of the national archives of Zimbabwe. *ESARBICA Journal, 30*, 83–101.

Musoke, M. G. N. (2008). Strategies for addressing the university library users' changing needs and practices in Sub-Saharan Africa. *Journal of Academic Librarianship, 34*(6), 532–538. doi:10.1016/j.acalib.2008.10.002

Musoke, M. G. N., Kakai, M., & Akiteng, F. (Eds.). (2005). Library automation in East and Southern African Universities: In Proceedings of a Sub-regional Conference. Makerere University.

Musoke, M. G. N., & Kinengyere, A. A. (2008). Changing strategies to enhance the usage of electronic resources among the academic community in Uganda with particular reference to Makerere University. In D. Rosenberg (Ed.), *Evaluating electronic resource programmes and provision: Case studies from Africa and Asia. INASP Research and Education Case Studies No 3.* Oxford, UK: INASP.

Musoke, M. G. N., & Namugera, L. (2013). *The End Justified the Means: Building Makerere University Library Extension with a Low Budget.* Kampala: Makerere University.

Nakiganda, M. (2009). Preserving the past and creating the future: A case for Makerere University, Uganda. In *Proceedings of the 75th IFLA General Conference and Council.* Milan, Italy: IFLA.

Ngulube, P. (2009). *Preservation and access to public records and archives in South Africa.* Saarbrücken: Lambert Academic Publishing.

Ngulube, P., Mathipa, E. R., & Gumbo, M. T. (2015). Theoretical and conceptual framework in the social sciences. In E. R. Mathipa & M. T. Gumbo (Eds.), Addressing research challenges: Making headway for developing researchers (pp. 43-66). Noordywk: Mosala-MASEDI Publishers & Booksellers cc.

Oakleaf, M. (2010). *Value of academic libraries: A comprehensive research review and report.* Chicago: Association of College and Research Libraries. Retrieved March 23, 2017, from www.acrl.ala.org/value

Otu, O. B., & Asante, E. (2015). Awareness and use of the national archives: Evidence from the Volta and Eastern regional archives. *Brazilian Journal of Information Studies: Research Trends, 9*(2), 21–25.

Peters, D., & Pickover, M. (2001). DISA: Insights of an African model for digital library development. *D-Lib Magazine, 7*(11). doi:10.1045/november2001-peters

Prom, C. J. (2010). Optimum access? Processing in college and university archives. *The American Archivist, 73*(1), 146–174. doi:10.17723/aarc.73.1.519m6003k7110760

Purcell, A. D. (2015). *Academic archives: Managing the next generation of college and university archives, records, and special collections*. Chicago, IL: American Library Association.

Sote, A., & Aramide, K. A. (2010). Influence of self-efficacy, perceived ease of use and perceived usefulness on e-library usage by academic staff in Nigerian universities. In Proceedings of the Second Professional Summit on Information Science and Technology. University of Nigeria.

Trant, J. (2009). Emerging convergence? Thoughts on museums, archives, libraries, and professional training. *Museum Management and Curatorship, 24*(4), 369–487. doi:10.1080/09647770903314738

Uganda. (1964). *University College (Deposit Library) Act*. Government Printers.

Verzosa, F. A. (2006). *The changing nature of collection development in academic libraries*. Center for Human Research and Development Foundation Inc.

Zolotarevsky, M. (2010). The information retrieval needs of archival users: A case study from the Jabotinsky Institute, Israel. *Comma: International Journal on Archives, 20*(2), 47–53.

KEY TERMS AND DEFINITIONS

Africana Special Collection: A section of the university library with a collection by Africans on Africa.

Archives: These are records material preserved for their historical value.

Archives Utilisation: Access to records.

Uganda: Is a country in Africa which is zero degrees on the equator.

University Archives: Records of historical value to a university because the information they contain provides evidence of important transactions and obligations.

University Archives Users: A section of the Library users who come to consult records on the past business of Makerere University.

University Library: A specialized academic library institution for the university community and general public.

Chapter 6
White British Diasporas in East and Central Africa:
Resources for Study and Future Heritage Provision

Alistair G. Tough
University of Glasgow, UK

ABSTRACT

This chapter offers a reflection on the experience of writing a biographical study of one White British family resident in East and Central Africa over the greater part of the twentieth century. It offers also some tentative generalisations on the subject of White British diasporas in East and Central Africa and heritage provision for them. Questions of class and classification in the colonial services and in the commercial sphere are discussed. The difficulties that arise in studying people who served in the lower echelons of the colonial services—which the author characterises as the 'warrant officer' class—are considered and potentially useful source materials are identified. This discussion is illustrated with particular reference to the Carr family. The role of memory institutions in Africa is discussed in relation to White British diasporas and it is argued that provision for this group is currently neglected. The potential for ancestral tourism is briefly explored.

INTRODUCTION

Diasporas – the mass migration of identifiable groups of people from their established areas of settlement to new areas – are a growing area of interest. As Zeleza's work demonstrates, so far as African diasporas are concerned, the focus of attention is being re-balanced with East and Southern African perspectives supplementing an earlier focus on West Africa, the Atlantic and the Americas (Zeleza, 2014). At a conference held in Malta in 2015, 'The Commonwealth and its People: Diasporas, Identities, Memories' papers were given on a range of diasporas (Conference, 2015). These included: African diasporas in the West Indies; Indian diasporas in Africa, the West Indies and throughout the Commonwealth; Maltese diasporas in the former Ottoman Empire and Australia; and a range of diasporic communities in the UK.

DOI: 10.4018/978-1-5225-3137-1.ch006

In this essay the author makes no special claims for the White British diaspora in East / Central Africa. It is worthy of study and consideration in just the same way as any other dispersal of people from their original homeland.

Literature regarding the White British diaspora in East / Central Africa understandably tends to focus on expatriate civil servants. This is hardly surprising given that expatriate civil servants had a leading role in establishing and running governments in the colonial era. Furthermore, works such as those of Ehrlich, Ferguson, Heussler and Kirk-Greene tend to give disproportionate attention to administrative officers – District Commissioners, Provincial Commissioners and Chief Secretaries – and the class to which they belonged at the expense of other parts of the civil service and of the wider diaspora (Ehrlich, 1973; Ferguson, 2002; Heussler, 1963; Kirk-Greene, 1999). This imbalance has been perpetuated by some African historians. Thus, for instance, Chipungu and his co-authors succeed in offering a nuanced portrayal of the varied roles of chiefs in colonial administration whilst continuing to adhere to the view that the colonial service was a single monolithic institution (Chipungu, 1992).

CLASS AND CLASSIFICATION

Within the ranks of the Colonial Civil Service a key distinction existed between those who might be characterised, in the terms used by the armed forces, as commissioned officers and those who were effectively warrant officers. Characteristically, the commissioned officers entered the Colonial Administrative Service or the higher ranks of the technical branches of the colonial service. This part of the service was recruited in the United Kingdom via the Colonial Office, its members were entitled to regular home leave and retirement to the UK was standard practice for them (Furse, 1962). In contrast, the lower ranks of the colonial technical and support services were usually recruited via the Crown Agents for the Colonies or locally. Their leave and pension entitlements were often less generous. However, the boundary between the commissioned officers and the warrant officers was porous. Especially in times of expansion, as Baker has demonstrated, promotion to the more responsible and privileged positions was both possible and even commonplace (Baker, 2003).

The Colonial Administrative Service included in its ranks: District Commissioners (DCs) and Provincial Commissioners (PCs); Agricultural, Educational, Forestry and Medical Officers; graduate engineers; and, generally speaking, those with degrees or public school education. The colonial technical and support services included: sanitary officials; lower grade public works overseers; merchant marine services; senior prison staff; game rangers; compositors; nurses; and a range of others.

It may be argued that a similar distinction can be observed in the commercial sphere. Senior positions in mining companies and in plantation agriculture were often filled by those with degrees or public school education. Amongst their ranks were graduate engineers and geologists. The recruitment of premium apprentices served to bring public school men into the commercial sphere. Interestingly, the son of Lord Tweedsmuir (aka John Buchan) joined the colonial service because his father could not afford to purchase a premium apprenticeship for him (Tweedsmuir, 1971). Clerks, prospectors, mechanics and labour supervisors occupied a subordinate position in the commercial sphere. However, for them also the boundary was porous. This is exemplified by Ernest Carr who is mentioned below. He progressed from routine clerical work to become a surveyor and valuer.

THE CARR FAMILY

A primary focus of this essay will be on Norman Carr (1912-97) and Barbara Carr (b. 1920), husband and wife, and their wider family. What follows is a summary of an article by the author devoted to the Carrs (Tough, in press). This is a family with British roots who have moved between Malawi, Mozambique, South Africa, the UK and Zambia. Norman and Barbara's family backgrounds and the life stories of their children will also be given some attention. To provide a contrast, mention will also be made of George and Joy Adamson. The Carr family were chosen as the focus of this study by a process of good fortune. At a time when the author had read already Norman Carr's books, he came across Carr's staff file in the National Records and Archives of Malawi (National Records and Archives of Malawi, multiple dates). Reading this file demonstrated that Carr was a more significant figure in the development of record keeping systems than he had acknowledged in his autobiographical publications and that he would provide a suitable figure around which to construct this study.

Norman's father, Ernest Carr (1882-1931), worked for the African Lakes Corporation from 1900 before setting up his own business as an auctioneer and surveyor in Malawi (then Nyasaland). Ernest died young leaving his wife and four children facing poverty. Aged 18 Norman became a locally recruited civil servant, initially on a temporary basis. In the headquarters of the Nyasaland Government he was responsible for confidential record keeping. Then he became a game warden

Norman Carr pioneered community-based conservation in Africa in the 1940s when he persuaded Chief Nsefu to create a game reserve in Zambia (formerly Northern Rhodesia)'s Luangwa Valley. To begin with Nsefu was sceptical – he asked why would people who had nice houses in towns want to come into the bush? To keep costs down the tourist lodges were built of local materials – uneven tree branches with grass thatching. For severely practical reasons mosquito nets were fitted and paraffin lamps used. In this way a particular 'safari style' came into being in several countries independently.

Norman was born in Chinde, a British concession in Mozambique (then Portuguese East Africa), and had a good understanding of the realities of life for villagers. The cost of creating conventional National Parks fell particularly on local people who lost land and opportunities to hunt for meat. So Norman hit on the idea of a reserve run by local people where they would benefit from entrance fees paid by visitors. On the same basis, he was happy to accept that 'big game' hunters had a role to play in conservation because the large fees they paid make a significant contribution to the public revenues of developing countries. During the 1950s Norman became concerned about habitat degradation caused by a rapid growth in the animal population: large areas of woodland were devastated. Norman advocated culling on the grounds that success in conservation depended on the defence of the habitat rather than the protection of individual animals.

The Norman Carr Safari company was founded in 1962 during the transition to independence. Its creation represented a determination to stay on in an independent African country. Norman was happy to embrace the transition to a society in which race would no longer determine people's life chances and proud to have appointed Zambia's first 'Brown white hunter' (Anon., 2004). His decision to stay split the Carr family, with Barbara demonstrating a firm determination to leave. Over subsequent decades the Carrs' children have tended to follow their father's lead. Judy Carr is involved in community-based conservation also in the Luangwa Valley. Pamela Guhrs became a wildlife artist whilst her brother Adrian became a professional hunter before taking over their father's safari business for a time. Operating only in the Luangwa Valley, Norman Carr Safaris pioneered a significant innovation – walking safaris. These involve sleeping out in the bush and provide a more equal relationship between human beings and wild-

life than can be achieved from a 4 wheel drive vehicle. In 1979 Norman was a founder of the Save the Rhino Trust which campaigned against the commercial extermination of the rhinoceros. He remained in Zambia until a fatal illness necessitated treatment abroad.

One of the intriguing challenges in writing about Norman Carr is trying to understand how he negotiated the complexities of colonial administration in the 1940s and 1950s. It seems that his sympathies lay with the District Commissioners (who saw their primary role as promoting the interests of indigenous people) rather than with his colleagues in the Game Department. Most of the Game staff wanted to adopt a 'command and control' approach to conservation. Amongst the latter was Major Eustace Poles who as the game warden based in Mpika had responsibility for the central part of the Luangwa Valley whilst Norman Carr had responsibility for the southern and northern parts. It is not fanciful to suggest that the pattern that exists in Zambia today with national parks in the South and North Luangwa but not in the Munyamadzi Corridor reflects Poles failure to engage local people in conservation. One possible and partial explanation of this situation is that Norman's experience as a record keeper, working in close proximity to the Attorney General and Chief Secretary, provided him with insights into the functioning of government and that these helped him to achieve his own goals without jeopardising his career.

Barbara Carr was born in Iraq, the daughter of a regular soldier who later became Director of Prisons in Malawi. According to her two autobiographical books, she entered into marriage a convinced Imperialist and with the intention of being a good colonial wife. However, she found life on isolated bush stations dismally unfulfilling, even when she was able to take up paid employment (Carr, 1965 and 1969). She acquired a reputation as a 'purple cow' - a woman who was constantly grumbling, all too evidently un-interested in other women's children and domestic activities, and suspected of sneering at their voluntary work for the indigenous people (Bradley, 1950). She left her husband in the late 1950s on a tentative basis and settled in South Africa permanently in the early 1960s. There she became a best-selling author, a noted feminist and ardent supporter of Apartheid and the racist ideology that it espoused and a critic of British colonialism. In 'The beastly wilds' (Carr, 1969) she wrote:

... a game ranger employed by the British Government was more of a slave than a Southern negro on a cotton plantation and his family too were enmeshed in the chains. ... (p. 254)

This sentiment was readily received by white South African readers and her books became best sellers. Barbara moved to the UK after the end of Apartheid and now lives in Cornwall.

At first sight, Barbara may not seem a very appealing person because of the explicit racism of the books she wrote in the 1960s. However, it is worth making an effort not to read her life backwards. She became a supporter of Apartheid in mid-life at a time when her children's future seemed to be threatened by the emergence of independent African nations. It should be borne in mind that in her early teens she learnt to read and write Chichewa so that when she left for boarding school it would be possible for her to correspond with indigenous people in Zomba.

Joy Adamson (1910-80) is best remembered for the book 'Born free' and the highly successful film based on it (Adamson, 1960). She was of Austrian origin, a gifted artist and characterised by her biographer Adrian House as having 'histrionic personality disorder' (House, 1993). She had an apparently successful relationship with John Carberry – a notorious sadist – and a deeply troubled relationship with her husband. A large collection of her paintings of Kenyan people and of tropical fish is displayed in museums in Nairobi and Mombasa. She was murdered in Kenya in 1980.

George Adamson (1906-89) was born in India. His family re-located to Kenya in 1924. Like Norman Carr he spent most of his adult life as a game warden and otherwise engaged in animal conservation. He was murdered in Kenya in 1989. David Attenborough, the celebrated television naturalist, had commented on the atmosphere of violence and fear that surrounded the Adamsons' animal adoption activities: "Elsa's story, at first sight so touching and tender, had started with violence ... it ended as it had begun" (Attenborough, 2010). George and Joy Adamson provide helpful comparisons with the Carrs. They have some things in common – the husbands' occupation in wildlife conservation, their troubled marriages and the high intelligence of both the women. There are, however, significant differences. One of these is the nature of the white settler population in the country in which they worked. This was encapsulated by contemporaries in the expression "Kenya for the officers, Rhodesia for the NCOs". On a personal level, the most significant contrast is that Norman Carr aimed to work with indigenous peoples in pursuit of wildlife conservation whilst the Adamsons sought to impose their objectives on local people and were willing to resort to coercion.

PRIMARY SOURCE MATERIALS AND DIGITAL RESOURCES

It is conventional to distinguish publications from true primary sources. In this context, however, the distinction becomes blurred. Many personal testimonies are available in print (albeit often in very short print runs) and some official publications that were once widely available are now so scarce that accessing even one surviving copy may be a challenge. Primary sources that should be acknowledged here include: Colonial Office Lists; the Staff Lists issued by each colony; the Annual Reports about each colony that were published in London for the Colonial Office; memoirs, published and unpublished; other publications; and archives and personal papers. Each of these will be dealt with below.

The Colonial Office List was published in the UK annually, except in wartime. It was modelled on the Navy List and the Army List. It lists 'commissioned' officers but only some senior 'warrant' officers. Crucially, colonial civil servants were only included if they had completed ten years of service. So many people who were invalided out of the service or left for other reasons do not appear. One of these is the second Lord Tweedsmuir whose autobiography describes how he needed prolonged recuperation after he had been invalided out of Uganda (Tweedsmuir, 1971). Entries follow a predetermined structure: name; year of birth; education; military service; postings in the colonial service, usually in chronological order; awards and honours; and sometimes publications or scientific accomplishments. Anthony Kirk-Greene created a compilation volume, taking the last entry relating to each person who had been included in the Colonial Office List to create a biographical dictionary (Kirk-Greene, 1991).

The Staff Lists issued by each colony bear some resemblance to the Colonial Office Lists but there are important differences. They are published four times per year by the Government Printer in the colony to which they relate. They list both 'Commissioned' and 'Warrant' officers, including locally recruited White British staff. Staff with less than 10 years service are not excluded as is the case with the Colonial Office List. Whilst there are some variations between colonies, the Staff Lists commonly provide detailed information about each officer's leave (including date of departure and anticipated date of return), salary and examinations passed (in local languages and the law).

It is worth bearing in mind that the Staff Lists were used for commercial and social purposes as well as for official purposes. Shop keepers and trading companies bought copies and used the information on salaries to fix the credit that might be given to customers who worked in the civil service. Thus the credit available to Emily Carr during the 1930s would have been determined by her son's earnings as she was keeping house for him following her husband's death. The staff list was used also to determine where guests should sit at dinner parties that were hosted and attended by civil servants. Norman Carr's place would have been at the outermost margins of any dining table in Zomba.

The Annual Reports about each colony that were published in London for the Colonial Office form a uniform series. The text and illustrations were supplied by the Chief Secretary of the colony in question. He in turn relied on departmental chiefs to supply him with information. The Annual Reports are calm and authoritative in tone and might be regarded as particularly good sources for the 'official view' and recent legislation.

Memoirs, both published and unpublished, are a crucial source for the study of White British diasporas in East and Central Africa. Both Norman and Barbara Carr wrote autobiographical books. Barbara Carr's account of her married life subjects her husband to sharp criticism (Carr, B. 1969). Perhaps her most damaging revelation was that two adolescent lions that Norman was preparing to return to the wild had killed an African child. He did not reply to her comments in his books. A careful scrutiny of Norman Carr's books shows that whilst he rarely made untruthful statements, he did simplify and even misrepresent events in order to craft an entertaining story (Carr, N.J. 1962, 1969, 1996) . In addition, the choice of subject matter was probably shaped by the desire to maintain a particular image in the eyes of safari clients. This may explain why he did not write about his early education in commercial subjects or his time in charge of government record keeping. In studying the Carr family, another memoir has been of particular value: Sir Kenneth Bradley's 'Diary of a district officer' which vividly describes the Luangwa Valley as it was when Norman first worked there (Bradley, 1947). Bradley's book is unusual amongst colonial memoirs in that it is of real literary merit and was a best-seller. A substantial list of unpublished memoirs and diaries has been compiled by Anthony Kirk-Greene (Kirk-Greene, 1991). The greatest single concentration of unpublished memoirs and diaries is probably in Oxford University's library system. Nonetheless, memoirs and diaries can be found scattered across the Commonwealth. It is illustrative of this that one important source for the study of Norman Carr takes the form of the diaries and personal papers of Major Eustace Poles, game ranger at Mpika: these are housed in the Library of the Zoological Society of London

The term 'other publications' is, by its nature, a broad and ill-defined category. It may be used to cover a range of printed materials produced by or aimed at White British diasporic communities. Contemporary publications aimed at settlers and colonists include newspapers and 'quality' local interest magazines. Newspapers written by settlers and aimed at the diasporic community often consisted of only a few pages. For example, in the 1930s the Nyasaland Times was produced by folding one large sheet of paper to produce 4 pages. Colonial newspapers may be difficult to access. Sometimes the national library of the country will possess a set. Or it may be necessary to visit a university library or the national archives. It is worth bearing in mind that the British Library holds some colonial newspapers and may make these available in microfiche or microfilm format. 'Quality' is a subjective term. Nonetheless it is apposite in this setting as it accurately expresses the intentions of such magazines at the Northern Rhodesia Journal which characteristically published a mix of articles on wildlife, geography and historical subjects along with good quality illustrations. Similar publications existed in most of the territories of British East and

Central Africa. Sometimes they were printed on expensive clay-loaded paper so that high resolution photographs could be used. Most 'quality' local interest magazines came into existence in the decade after 1945 and ceased publication in the decade of independence. An exception is the Journal of the Society of Malawi which is still going strong today. Also worthy of mention are the Women's Corona Society publications which were aimed originally at the wives of serving colonial officers but seem to have reached a wider audience (Swaisland, 1992). Similar in intent is Emily Bradley's book "Dearest Priscilla" which was aimed at recently-married women preparing to embark for an African colony (Bradley, 1950).

The archives consulted in undertaking this study of the Carr family are listed below. They include three national archives, the archives of two business companies and one set of personal diaries and papers. Many archive repositories have some degree of formality in relation to gaining access. Readers' cards are often issued and the production of ID is often required. It should be added that getting access to national archives in East and Central Africa is likely to be more bureaucratic, expensive and time consuming than is customarily the case in Europe and North America. For instance, an annual research permit fee of US $ 500 is payable for access to the National Archives of Zimbabwe (plus a daily charge of $1) and the National Archives of Zambia charges between 68 and 450 Kwacha. In both instances, research permission has to be obtained. For this reason, those undertaking diasporic studies may wish to use the services of research agents, where these are available.

The archives consulted in undertaking a study of the Carr family do not include the diaries of Barbara Carr, although it is evident that these once existed as she reproduces an extract from them in one of her books (Carr, B 1969). Nor do the sources used include Norman Carr's personal papers. The reason is that these no longer exist. The destruction of diaries and other papers is a common phenomenon: it may be even more common amongst diasporic communities who are often on the move and those who live in climates where the survival of paper and other media is put at risk by humidity and insects.

Oral history resources in the custody of archival institutions in East and Central Africa were not used in this study. They have a strong tendency to focus on political activists who campaigned for independence. Whilst Norman Carr was not opposed to independence, he played no active part in such campaigns.

The digital resources used in undertaking this study of the Carr family are listed below also. They include Find My Past, an online commercial service for family historians which made it possible to work out how Norman Carr's parents met. They include too a family history website for the Bishop family. Alexander Bishop was Ernest Carr's best friend and much detail relating to their friendship is available from this website and from no other source. Academic historians are sometimes reluctant to make use of the websites produced by family historians. Whilst it is understandable that professionals may have reservations regarding the outputs of amateurs, these can be of great interest. Michael Moss, co-author of an award-winning book on medical services in the Royal Navy in the era of Admiral Nelson, has stated that the work of family historians on ships' officers and surgeons – much of it available online - was of material assistance in that study (Brockliss, Cardwell and Moss, 2005).

THE ROLE OF MEMORY INSTITUTIONS

In countries where the White British element of the population has become the majority and/or a dominant component - Australia, Canada and New Zealand – memory institutions make an effort to provide services

for and shape their holdings to meet the needs of indigenous peoples (Miller, 2017 and McKemmish, 2005). In the United Kingdom itself, many memory institutions (including The National Archives) seek to provide services for and shape their holdings to meet the needs of immigrant minorities, particularly from the West Indies and South Asia (The National Archives, 2017). In addition, some immigrant minorities in the UK have set up 'community archives' and related projects: these have sometimes received financial support from public or NGO funds, as was the case with the Casbah project (Casbah, 2001).

In contrast, in East and Central Africa there does not be much emphasis on the current provision of services aimed at White British (or other European) diasporas. Some explanations for this pattern come to mind immediately. Memory institutions in East and Central Africa have had to work in resource poor environments for a long time (Musembi, 1986). In addition, many national archive services are preoccupied with providing advice on current records management (Lowry & Wamukoya, 2014). And in some instances, there are political considerations which in turn may pivot on racial resentments from a by-gone era.

Nonetheless, it would be sensible to give this some fresh thought to the provision by archival and other memory institutions of services for White British diasporic communities, both in-country and elsewhere. In some instances, national archives and museum services already possess rich accumulations of artefacts, personal papers and of the records of clubs and associations from these communities: the manuscript collections held by the national archives in Malawi, Zambia and Zimbabwe are examples of this pattern. So there are existing holdings to promote and display. A further facet is the recent phenomenon of ancestral tourism. At present ancestral tourism consists overwhelmingly of visitors from Canada and the United States travelling to the United Kingdom and continental Europe to investigate their roots. There is no intrinsic reason why memory institutions in the countries East and Central Africa should not exploit this opportunity to promote their services and their countries' tourism strategies. Digital finding aids, complete with provision for user contributions via Wikis, provide attractive tools for this kind of sensitisation (Gollins and Bayne, 2015). Also, for memory institutions to make provision for ethnic minorities can have symbolic significance in that it demonstrates that citizenship is not limited by skin colour.

ACKNOWLEDGMENT

The author has received assistance from a great many people. He would like to acknowledge the following especially: Professor Patrick Ngulube (editor of this volume), two anonymous reviewers whose comments helped to improve this chapter, Judy Carr (Norman and Barbara Carr's daughter), Dawn Sinclair (Archivist, Harper Collins), Austin Chilanga (Archivist, National Records and Archives, Malawi), Paul Lihoma (Director, National Records and Archives, Malawi), Emmanuel Sianjani (Archivist, National Archives of Zambia), Michael Palmer (Archivist, Zoological Society of London), Micki Ling (who produced the maps), Rosalind Pulvermacher (Librarian, Foreign and Commonwealth Office) Terry Barringer (bibliographer and independent scholar), Dora Wimbush (Honorary Librarian, Society of Malawi), Martin Nankumba (Manager, CFAO, Blantyre), Pat Royale (relative by marriage of Norman Carr) and Milena Dobreva (University of Malta).

REFERENCES

Adamson, J. (1960). *Born free. A lioness of two worlds*. London: William Collins.

Anon. (2004). *Luangwa. Memories of Eden. David Kelly paints South Luangwa National Park*. Lombarda: David Kelly.

Attenborough, D. (2010). *A life on air* (rev. ed.). London: BBC Books.

Baker, C. (2003). *A fine chest of medals*. Cardiff, UK: Mpemba Books.

Bradley, E. (1950). *Dearest Priscilla. Letters to the wife of a colonial civil servant*. London: Max Parrish.

Bradley, K. (1947). *Diary of a District Officer*. London: Thomas Nelson.

Brockliss, L., Cardwell, J., & Moss, M. (2005). *Nelson's surgeon*. London: Oxford University Press.

Casbah. (2001). *Caribbean Studies and history of Black and Asian peoples in the United Kingdom*. Preserved in the United Kingdom Web Archive. Retrieved 18 September 2017 from, https://www.webarchive.org.uk/ukwa/target/59703347/source/alpha

Carr, B. (1965). *Cherries on my plate*. Cape Town: Timmins.

Carr, B. (1969). *The beastly wilds*. London: Wingate-Baker.

Carr, N. J. (1996). *Kakuli. Harae*. CBC Publishing.

Carr, N. J. (1962). *Return to the wild*. London: Collins.

Carr, N. J. (1969). *The white impala*. London: Collins.

Chipungu, S. (Ed.). (1992). *Guardians in their time. Experiences of Zambians under colonial rule, 1890-1964*. London: Macmillan.

Ehrlich, C. (1973). Building and caretaking. Economic policy in British Tropical Africa. *The Economic History Review*, 26(4).

Furse, R. (1962). *Aucuparius. Recollections of a recruiting officer*. London: Oxford University Press.

Ferguson, N. (2002). *Empire: the rise and demise of the British World Order and the Lessons for Global Power*. London: Allen Lane.

Gollins, T., & Bayne, E. (2015). Finding archived records in a digital age. In Is digital different? How information creation, capture, preservation and discovery are being transformed. London: Facet Publishing.

Heussler, R. (1963). *Yesterday's rulers: the making of the British colonial service*. Syracuse, NY: Syracuse University Press.

House, A. (1993). *Great safari. Lives of George and Joy Adamson*. London: Harper Collins.

Kirk-Greene, A. H. M. (1991). *A biographical dictionary of the British Colonial Service, 1939-1966*. London: Hans Zell.

Kirk-Greene, A. H. M. (1999). *On crown service*. London: I.B. Tauris.

Lowry, J., & Wamukoya, J. (Eds.). (2014). Integrity in government through records management. Farnham: Ashgate.

McKemmish, S. (Eds.). (2005). *Archives: recordkeeping in society*. Wagga Wagga, Australia: Centre for Information Studies. doi:10.1533/9781780634166

Miller, L. (2017). *Archives principles and practices* (2nd ed.). London: Facet Publishing.

Musembi, M. (1986). Development of archival services in East Africa. In Kukubo, R. (ed.) *Proceedings of 9th biennial general conference East and Southern African Regional Branch of the International Council on Archives*. Roma: University Press of Lesotho.

National Records and Archives of Malawi (n.d.). *Personal file of Norman J. Carr. Reference Appt, 4031 (original Secretariat reference 1064)*. Zomba: Records Centre.

Swaisland, C. (1992). *Women's Corona Society, 1950-90*. London: Women's Corona Society.

National Archives. (2017). *Research guide to migration*. Retrieved 18 September 2017 from, http://www.nationalarchives.gov.uk/help-with-your-research/research-guides/?research-category=social-and-cultural-history&sub-category%5B%5D=migration

Tough, A. G. (in press). Norman Carr's Malawi days: From poacher to record keeper. *The Society of Malawi Journal*.

Tweedsmuir, L. (1971). *Always a countryman*. London: Robert Hale.

Zeleza, P. (2014). *Africa's resurgence: Domestic, Global and Diaspora Transformations*. Los Angeles, CA: Tsehai Publishers.

Bishops in Africa. (n.d.). Retrieved 19 September 2017 from http://myweb.tiscali.co.uk/espenett/index04.htm

Barbara Lamport-Stokes photographic collection. (n.d.). Available in digitised form at the Library of the Society of Malawi, Blantyre, Malawi.

Old Clarkonian Association website. (n.d.). Retrieved 19 September 2017 from http://www.clarkscollege.co.uk/

Passenger Lists. (n.d.). Retrieved March 2013 from http://www.findmypast.co.uk/

Wikipedia. (n.d.). *East African campaign (World War II)*. Retrieved 19 September 2017 from http://en.wikipedia.org/wiki/East_African_Campaign_(World_War_II)

ADDITIONAL READING

Carr, N. J. (1987). *A guide to the wildlife of the Luangwa Valley*. Lusaka: Save the Rhino Trust.

Carr, N. J. (1979). *The valley of the elephants*. London: Collins.

Coe, M. (2001). History of wildlife conservation and management in Mid-Luangwa Valley. *Biological Conservation, 97*(3), 405. doi:10.1016/S0006-3207(00)00118-X

Darling, S. F. (1960). *Wild life in an African territory*. London: Oxford University Press.

Darling, S. F. (1970). *Wilderness and plenty: the Reith Lectures 1969*. London: British Broadcasting Corporation.

Debenham, F. (1955). *Nyasaland. The land of the lake*. London: Her Majesty's Stationery Office.

Dodds, D., & Patton, D. (1968). *Report to the Government of the Republic of Zambia on Wildlife and Land-use survey of the Luangwa Valley*. Rome: Food and Agriculture Organisation.

Dunlap, R. C. (1973). *Luangwa Valley conservation and development project, Zambia. A tourism plan for the Luangwa Valley*. Rome: Food and Agriculture Organisation.

MacKenzie, J. (1987). Chivalry, Social Darwinism and ritualised killing: the hunting ethos in central Africa up to 1914. In D. Anderson & R. Grove (Eds.), *Conservation in Africa: people, politics and practice*. Cambridge University Press.

Mfune, O. (2011). *From fortresses to sustainable development: the changing face of environmental conservation in Africa, the case of Zambia*. (Unpublished doctoral dissertation). University of Glasgow.

Tough, A. G. (2011). Oral culture, written records and understanding the twentieth century colonial archive. The significance of understanding from within. *Archival Science, 12*(3).

Tough, A. G., & Lihoma, P. (2012). Development of recordkeeping systems in the British Empire and Commonwealth, 1870s - 1960s. *Archives & Manuscripts., 40*(3), 191–216. doi:10.1080/01576895.2012.738786

Van Sittert, L. (2005). Bringing in the wild: The commodification of wild animals in the Cape Colony / Province, c. 1850 -1950. *Journal of African History, 46*.

Weiner, M. (2004). *English culture and the decline of the industrial spirit, 1850-1980* (2nd ed.). Cambridge University Press. doi:10.1017/CBO9780511735073

APPENDIX

Archives Used

- The National Archives of the United Kingdom
- The National Archives of Zambia
- The National Records and Archives of Malawi
- The personal papers of Major Eustace Poles in the Library of the Zoological Society of London
- The records of Harper Collins, publishers, in the Company Archives and Glasgow University Archives and Special Collections
- The records of the African Lakes Corporation in Glasgow University Archives and Special Collections

Chapter 7
Managing Audio-Visual Resources in Selected Developed and Developing Countries

Ruth Mpatawuwa Abankwah
University of Namibia, Namibia

ABSTRACT

This chapter emphasises that audio-visual (AV) resources are very fragile and need to be stored in ideal conditions to preserve them for posterity. It describes different types of AV materials and the conditions under which they should be kept. It is based on a study that was conducted in the Eastern and Southern Africa Regional Branch of the International Council on Archives (ESARBICA) region. Data were gathered using quantitative and qualitative methods. The results revealed lack of equipment to monitor environmental conditions, absence of policies to govern the acquisition, appraisal, access, preservation, retention, digitisation and disposal of AV materials, and failure to apply the records life cycle (or any model) to AV records. The results point to a need for national archives to develop guidelines that apply to AV materials particularly in Africa. Particular attention should be given to training AV archivists in the region using an integrated curriculum.

INTRODUCTION

UNESCO declared 27 October as the World Day for heritage (UNESCO, 2007a) to curtail loss, neglect and natural decay of AV resources. Many national archives worldwide have taken advantage of Information Technology (IT) to improve access to their cultural heritage (Hall, 2015; Jacobsen, 2008; Lawetz, 2008). Lawetz (2008) opined that "it is an acceptable fact that audio-visual and video recordings have to be digitised to follow preservation aims" (p. 36). The use of AV media has indeed revolutionised archives from dusty basements; making them accessible by all information users. For instance, the Truth and Reconciliation court hearings in South Africa, and Seychelles Digital Archives, among others, can

DOI: 10.4018/978-1-5225-3137-1.ch007

easily be accessed online (Kenosi, 2008; Seychelles National Archives, 2011). This shows the ease with which computer users are able to access materials that are created or converted in digital format.

AV resources are an indispensable part of cultural and intellectual heritage world-wide, albeit their dissipation on daily basis (UNESCO, 2007b). They are prone to decay and distortion because of their chemical composition. They are made of polymers which are greatly affected by environmental conditions such as heat, cold, dust and humidity. Other dangers that threaten AV materials include floods, fires, storms, earthquakes, human negligence, physical decay and technological obsolescence (Peoples & Maguire, 2015; UNESCO, 2007b). In some instances, the deterioration occurs over time and it may be undetected. This chapter gives a clear definition of AV materials, it covers types and characteristics of AV materials, composition of AV carriers, the historic background to management and preservation of AV heritage, the need to manage, and preserve AV materials, archival legislation and policies, application of archival functions to AV materials, application of the records life-cycle concept to AV materials, intellectual control over AV materials, preservation of AV materials, building and design of archival institutions, environmental control and storage conditions, general security and staff training.

Definition of Audio-Visual Materials

The term audio-visual (AV) denotes a combination of the words sound and visual. AV resources or materials are records or archives in pictorial and aural form regardless of their physical make-up or recording process used (Edmondson, 2016). The term is also used to describe information content held in storage and transmission media, images, and sound rather than, or sometimes in addition to, as well textual content (Hedstrom & Montgomery, 1998). AV materials may be motion pictures with sound, such as video cassettes, CDs, CD-ROMs, 3-D imaging, DVDs, cinematographic films; sound recordings such as gramophone/phonographs record disks, reel-to-reel tapes, magnetic audio tapes, tape-slide displays, traditional music and speeches; maps, drawings, photographs, photographic negatives, scripts, posters, manuscripts, slides, transparencies and art works. The term AV archives also refers to the organizations or units responsible for collecting, preserving, documenting and providing access to and making use of AV materials (Harrison, 1997/98). In this chapter, the terms AV resources, AV records and AV materials will be used interchangeably to refer to the above definitions.

Types and Characteristics of AV Materials

AV materials differ from traditional textual records, in format and characteristics. They are more versatile than textual records as they can capture specific details about events. Details that cannot be captured by textual sources include; intonation, facial expressions, appearance and gestures (Digital Preservation and Access for Global Audio Heritage, 2007; Edmondson, 2016). For instance, AV materials portray people, places and things that cannot easily be experienced first-hand. The Library and Archives Canada (2007) grouped AV media into three categories, namely motion picture film, magnetic tape and discs. Some of the major formats are discussed below.

Motion Picture Film

Films are usually stored in flat circular canisters or wound on reels. They appear in 8mm, 16mm, 35mm and 70mm form. They may be in colour or black and white, with acetate or nitrocellulose bases.

Motion pictures are made of a complicated chemical composition that has layers of organic materials. For instance, there are four to five layers in black and white films, while colour has nine layers (Byers, 2003). Gelatine, which is used in both black and white, and colour films is unstable in hot and humid environments. It is sensitive to water; hence it is susceptible to fungus and germs. The author therefore concluded that the destructive processes of film are determined by natural laws that cannot be altered, hence the need to preserve them under proper storage conditions.

Magnetic Tape Media

Magnetic tape media include video and audiotapes. Video media is normally on open-reel videotapes in VHS, Umatic, Betamax and other configurations. Video media include open-reel videotape, half-inch video cassettes in (VHS), three-quarter inch Umatic cassettes, one- inch C-format videotape, two-inch videotape, 1-inch C-format videotape, Video 8 High 8 and half-inch Beta cassettes in both analogue and digital formats. Audio media are recorded on open-reel ¼ inch audiotape, ¼-inch open reel audiotapes, ¼- inch audiocassettes, 1/8 mini cassettes and digital audiotapes (DAT) (National Film and Sound Archive, 2016).

It should be noted that while tapes and grooved discs are analogue, Compact Discs (CD) are digital. Examples of such recordings are Digital Audio Tapes (DAT), Digital Compact Cassettes (DCC) and Mini Discs. The CD sound recording use pits and flat areas to store information (Byers, 2003). Some audiotapes are made of acetate or polyester material, which is coated with iron oxide, while others are made out of ferric oxide that is coated with chromium dioxide (Byers, 2003). The magnetism in these particles makes it possible for images and sound to be recorded onto the tape as electronic signals can be recorded, erased and played back instantly (Library and Archives Canada, 2007). It should also be noted that all reel-to-reel audio and analogue audiocassettes have iron oxide, which does not seem to exhibit stability problems. Chromium dioxide and its substitute (cobalt doped iron oxide) are also used for basing analogue audiocassettes and most video formats (Schuller, 2004a). Forgas (1997) noted that videotapes are composed of four thin layers which comprise polyester, binder and magnetic (Byers, 2003).

Paton (1999) categorized magnetic recordings into monaural formats and stereo formats. Archival monaural formats include full-track, half-track, two-lane highway and four-track, while stereo formats include two-track, half-track and four-track. Magnetic materials are in two parts: the support or base film and the magnetic layer. The support material is historically cellulose acetate, which can easily become brittle and deteriorate. Polyvinyl chloride (PVC), which succeeded cellulose acetate, has proved to be more durable, and more recent polyethylene-terephthalate (PET), which is commonly known as polyester, is more chemically stable (Schuller, 2004b). Although other formats exist, different terminology is used by different audio technicians, hence the lack of standardization.

While tapes and grooved discs are analogue, Compact Discs such as Digital Audio Tapes (DAT), Digital Compact Cassettes (DCC) and Mini Discs are digital (Byer, 2003). The author noted that the biggest advantage of analogue recordings is that they are suitable for preserving archival materials. Another type of AV materials is in the form of discs. These are discussed below.

Discs

The term "discs" applies to all mechanical carriers or phonograph records. Sound and visual information can be captured on discs. The information is recorded in a continuous groove tracked by a stylus or

laser (Edmundson, 2016). Phonograph records contain historical recordings for posterity. This medium derives its uniqueness from its permanence and its ability to use mechanical vibration to record and reproduce sound. The fact that its equipment is not portable offers an additional advantage in terms of preservation. Nevertheless, Edmundson (2016) observed that the medium is very fragile and therefore sensitive to poor handling. Further technological innovations led to optical media.

Optical Media

Optical discs contain digital information embedded in an organic dye that is highly susceptible to light, and thus unstable. They are susceptible to mechanical damage through scratches, which obstruct the laser beam from reading the recorded information (Saffady, 1998; Schuller, 2004a). The Library and Archives Canada (2007) and Schuller (2004a) reported that the latest optical discs are recorded on digital versatile discs (DVDs). Technological developments have led to the development of optical disks or laser disks. These discs are 4 ¾ -inch CDs and 12-inch videodiscs. While the former are used for music recordings, the latter are used for moving image productions and interactive video programs. They include videodiscs used to record moving images, Read Only Memory (CD-ROMs, Write Once/Read Many times (WORM) digital optical disks and Erasable optical disks (CD-Rs) (Library and Archives Canada, 2005). Optical discs are made out of a polycarbonate-base that is laminated with aluminium and lacquer.

HISTORIC BACKGROUND TO THE DEVELOPMENT OF AUDIOVISUAL ARCHIVES

The Global Perspective

The AV revolution evolved from the discovery of photography, which gradually led to multimedia technology. Bubenik (2005) noted four basic technological processes in the evolution of AV materials. These included: photochemical registration (photography and film), mechanical registration (sound, cylinder, gram and plate), electromagnetic registration (sound, including sound film and television) and optical and magnetic registration (multimedia). Harrison (1997/98) reported that the Phonogrammarchive in Vienna, was the first sound archive to be established as a research archive in in 1899, .

Bubenik (2005) traced the development of AV documentation to old Sumerians and Egyptians 5000 years ago. The Sumerians and Egyptians constructed special vaults to preserve important information. The period after 1935 led to the formation of the International Federation of Film Archives (FIAF) (Forgas, 1997). In 1978, the International Federation of television Archives (FIAT) was established through a collaborative effort of Instut National de L'Audiovisuel (Paris), the British Broadcasting Corporation (London), Radiotelevisione Italiana (Rome, and Norddeutshr Rundfunk-Fernsenhen (Hamburg). These were by then the major television networks worldwide (Kula 1983). Hall (2015) and Saintville (1986) observed that it was after such efforts that government authorities in France began to take interest and responsibility for preserving AV materials. In the United States of America, organizations included the National Center for Film and Video Preservation, the Association of Moving Image Archivists (AMIA), the Museum of Modern Art in New Yolk (which aimed at preserving video art), the National Archive and Records Administration, the Library of Congress and the UCLA Film and Television Archives (Edmondson, 2016).

The concept of preservation of AV archives arose from the need to re-use audio-visual documents for educational, commercial and historical purposes. This seems to have been the trend in developed and developing countries (Hall, 2015). Thus, there are traces of visual records in Europe, Africa, Australia, and the Western Hemisphere (Vlcek & Wiman, 1989). Sound archives, and private collections dated way back to 1900 while cylinders were introduced during the period between1900–1902. Diamond Discs were introduced in 1912, microphones and electrical amplifiers were introduced in 1925. In the late 1920s instantaneous recording on blank aluminum discs provided a means to make custom single recordings (Peoples &Margue, 2015). In the late forties, recordists began using magnetic media to record sound. Polyester tape was introduced in the sixties (Hall, 2015).

Schuursma (2007) observed the origins of sound archives in many countries world-wide. While the broadcasting archives developed out of necessity to records radio programmes,the above author argued that some of the sound and broadcasting archives were established as a result of momentary needs without considering the overall structure at a national level thereby neglecting the needs of the country as a whole. Commenting on the need for specialised sound archives in Europe, Schuursma (2007) further noted that some countries such as United States of America, United Kingdom, and India, followed this approach. Examples ranged from the:

Department of Sound Records of the Imperial War Museum in London to the Ethnomusicology Archive of the University of California in Los Angeles, and from the sound archive of the Netherlands Theater Institute in Amsterdam to the audio collection of the Indian Classical Music Foundation in Bombay.

Nonetheless, the above author also pointed to the need for some archives who had a general mandate to collect 'archives' but later realised the need to cater for specialised sound archives. Examples of such archives included the Library of Congress in Washington DC and the British Columbia in Victoria (Schuursma, 2007). This is the approach which various developing countries including Botswana, Zimbabwe, and Namibia followed (Hillebretch, 2010; Matangira, 2003; Mnjama, 2010)

The African Continent

The historical development of AV archives in Africa differed from that of the developed world (Klaue, 2004). AV archival services developed at a slow pace. Mazikana (1997/98) pointed out that a large part of the continent could not afford to operate an AV unit. Matangira (2003) depicted a gloomy picture of the AV landscape in the East and Southern Africa Regional Branch of the International Council on Archives (ESARBICA). The author alluded to the neglect of archiving AV materials in some of ESARBICA states whose history of archiving dates back as far as 1935 for Zimbabwe, 1947, for Malawi, 1963, for Mozambique and 1965, for Kenya, just to mention a few. The National Film, Video and Sound Archives (NFVSA) of South Africa were formed in 1964 (National Archives and Resource Service of South Africa 2016). Although the National Archives of Zimbabwe (NAZ) were established in 1935, the audio-visual unit (AVU) was only established in 1988 (Matangira, 2003). The biggest challenge highlighted by various authors were lack of skills and resources to secure AV equipment, absence of policies, and preservation programs (Phuthelogo & Abankwah, 2015; Matangira, 2003; Mnjama 2010; Zinyengere, 2008). However, the situation changed as many countries realised the need and importance of managing information contained in AV formats (Phuthelogo & Abankwah, 2015; Ross, 2009). For instance, the ARSC Technical Committee reported that the time was right for archives and other heritage

institutions to migrate their analogue holdings to digital format (Ross, 2009). Hillebrecht (2010) was concerned about the rich audio visual collections in Namibia and he cautioned that such materials were in danger of being irretrievably lost if strategies were not put in place to preserve them.

The National Film, Video and Sound Archives (NFVSA) of South Africa are an exception. NFVSA is a specialized repository for audio-visual materials, with a mandate to collect and preserve AV materials that are produced in South Africa (National Archives and Resource Services of South Africa, 2016). In line with the Truth and Reconciliation's Commission spirit, the National Archives of South Africa was mandated to preserve AV resources for access (Kenosi, 2008). The author cited SAHA (2004) that highlighted that "the national archives has Human Rights Violations hearings tapes constituting 435.5 hours of testimony recorded on 308 videotapes, starting with the first open public hearing in East London on 15 April 1996 and ending in the city of Cape Town on I I June 1997" (Kenosi, 2008, p. 87).

APPLICATION OF THE RECORDS LIFE-CYCLE CONCEPT TO AV MATERIALS

Various authors including Abankwah (2007), Mnjama (2005) and Ngulube and Tafor (2006) observed that the legislation in the ESARBICA national archives did not adequately cover the records life cycle. This explains why Abankwah (2007) concluded that some archival institutions in ESARBICA were not in control of the full life cycle of records. Mnjama (1996a) further pointed out that African national archives concentrated on managing the last phase of the life-cycle, to the detriment of the other phases. However, Mnjama (2005) and Chebani (2003) reported that Botswana was among the first countries in the region to embrace the idea of managing archives through the entire records life-cycle. Mnjama (1996a) urged African national archives to play a more active role in managing records across all the phases of the life-cycle. This would require, among other things, devising procedures for handling records in AV media.

Although audio-visual technology has improved the creation and collection of information, most of the AV materials are fragile hence they are susceptible to loss and destruction (Byers, 2003). For instance, cellulose nitrate films are highly flammable and they have a tendency to curl. This explains why cellulose nitrate films were replaced with diacetate films. Unfortunately, the latter are characterised with so many problems including high humidity absorption, medium contraction, colour fading and a tendency to tone down progressively (Bereijo 2004a; Bereijo 2004b).

Magnetic tapes also have problems. Paton (1998, p. 189) cited Bogart (n.d.) who stated "…although magnetic tape has historically been considered fairly sturdy, it does deteriorate over time, sometimes catastrophically". This is due to its chemical composition which leads to degradation of the magnetic tape binder resulting in hydrolysis. This process results in the softening, embrittlement, loss of cohesiveness or loss of lubrication of the binder. Degradation of the tape backing can also be caused by the presence of vinegar syndrome, which results in a damaged film as shown in Figure 1 below:

Bereijo (2004a, p.326) explained that the vinegar syndrome or vinegar smell is a result of a decomposition of cellulose acetate films "which results in the production of acetic acid, a substance that can be characterised by its characteristic smell of vinegar". Likewise, decomposition of nitrate films results in a contraction of the diacetates and triacetates which are manifested as small waves known as the 'channelling effect'. The above author warned that the degradation of cellulose acetate films has a catalytic effect on other films, hence the need to isolate affected films to prevent further deterioration. He further reported that polyster is a more stable medium, hence it replaced cellulose acetate.

Figure 1: A Film affected by vinegar syndrome
Source: National Film and Sound Archives of Australia (2016).

Various materials and chemicals are added to the 'final products' of the plastics at the manufacturing stage. It is at this stage that the lifespan of the product is determined. St-Laurent (1996) observed that environmental factors such as storage conditions, temperature, humidity, and handling affect stability of the plastics, which in turn affects the manufacturing process. The vulnerability of AV materials therefore means that unless good information management practices are applied to the management and preservation of these fragile resources, the information they contain will not be kept for future generations. UNESCO (2007b) cited Van Bogart (1995) who suggested that audio-visual materials require specific care and handling to ensure long term preservation of the recorded information. He recommended that acetate tapes should be stored in low-temperature and low-humidity environment to minimise the rate of deterioration on the acetate backing (UNESCO, 2007b). Given the instability of AV materials and the fact that the recording media becomes obsolete with time, Dollar (2000) recommended periodic transcription of information from old media to new media to preserve some information indefinitely. Dollar (2000) referred to this process as 'migration'. Nevertheless, it is important to understand the regulatory framework that governs the management of AV materials.

REGULATORY FRAMEWORK THAT GOVERNS AV ARCHIVES

Mapiye (2012, p. 20) stated that:

Good records management depends on a well-established regulatory framework which provides the rules and regulations archival institutions should follow. The collection and preservation of AV materials should be supported by the law and clearly defined standards, policies and procedures should be outlined.

Standards That Govern the Management of Audio-Visual Records

Mapiye (2015) stressed the need for heritage organisations and other commercial organisations to standardise records management policies and procedures to ensure safety and protection of all records regardless of format, hence the need for International records management standards such as ISO 15489 (ISO 15489:1, 2001). Such standards include legislation and policies, legal deposit, copyright of AV materials. Technical standards are also stipulated by various bodies/committees such as the Association for Recorded Sound Collections (ARSC), the Association for Research Libraries (ARL), the Library and Archives Canada (LAC) and The International Association of Sound and Audio-visual Archives (IASA) Technical Committee publication TC-04 (Resenblum, Burr & Guastavino, 2013). The latter guidelines are updated regularly, the latest being TC-05. Most of the guidelines can be accessed online.

Different standards apply to different formats. For instance Compact Disc Standards apply to CDs (original products of Philips and Sony) (IASA, 2017). Miliano (2004) further observed that colour was used to identify CD formats; Philips-Sony used for Red Book CD Digital Audio, the yellow Book standard specified the CD as a data file carrier and the Green Book described CD-I or interactive data, while the Blue Book referred to Enhanced (multimedia) CD, and the White Book specified CD-V (video) characteristics. The Orange Book is the standard that refers to Recordable and Rewritable CDs. Graphics were used to distinguish CDs; CD (Extended) Graphics, CD-TEXT, CD-MIDI, CD Single (8cm), CD Maxi-single (12cm) and CDV Single (12cm). The section below discusses legislation and policy which govern AV materials.

Archival Legislation and Policies

Mnjama (2005, p. 464) stated that archival legislation "provides the legal framework under which national archives operate". It provides the essential framework that enables a national records and archives service to operate with authority in its dealings with other agencies of the state (Roper & Millar, 1999b). Klaue (1997, p. 24) stressed that a legal framework gives AV archives a mandate to function, regardless of whether or not an archive is "integrated into a state archive or exists as an independent institution…". Kofler (2004) argued that the organisational structures of archival institutions should include the management of film, video and recorded sound collections. Such an arrangement would facilitate the application of uniform principles to the preservation, restoration, cataloguing and documentation of AV materials. Nevertheless, Klaue (1997) observed that many archives did not uphold regulatory procedures, resulting in various problems, such as:

- Failure to define and incorporate AV materials into appropriate archival goals and laws;
- Failure to define the rights and powers of archives in relation to audio-visual materials and hence inability to reflect them in international legal conventions

Smith (1993) stressed the need for archivists to acquaint themselves with the law in as far as it applies to the following regulatory mechanisms, which are intended to protect the materials.

1. Time periods, as they affect records retention or disposal;
2. Storage media and methods of transferring archival materials from one medium to another;
3. Records-handling practices;
4. Reliability of information;
5. Accessibility to information;
6. Security of information;
7. Use of materials; and
8. The information and content of materials.

Legal Deposit

Kofler (1997) recognised the need for written legal deposit laws for AV materials similar to text materials. However, he observed that such a law is limited by the cost of AV materials and their fragile nature. This problem is compounded by the obligation of private AV archives to deposit material with a public archival establishment (Kofler, 1997). He reported that this requirement is only realised "…in a few cases and is often reduced to cinematographic films…" (Kofler 1997, p. 47). He conceded that this problem could be resolved by stipulating those AV materials which should be covered by the deposit regulations.

Closely related to the freedom of information legislation is privacy legislation which "prohibits the disclosure to third parties of personal information contained in records and provides for the subjects of information to have access to it to check its accuracy and, if necessary, to correct it" (Roper and Millar, 1999a, p. 74). Smith (1993) advised archivists to familiarise themselves with legislation and statutory responsibilities which require them to provide access and disclose certain information under certain circumstances (Smith, 1993). Roper and Millar (1999a) noted that official secrets legislation or regulations normally specify procedures for declassifying records which are no longer sensitive. In the absence of such procedures, "the records and archives legislation should make appropriate provision" to uphold the legal despisit requirement (Roper and Millar, 1999a, p. 75). Roper and Millar (1999a) conceded that archives legislation should cover private records and archives. That is, it should prohibit or regulate "the export of materials constituting the national cultural heritage" (Roper and Millar 1999a:40).

Access and Disclosure

UNESCO examined the legal and ethical issues, which affect access to AV materials. It was highlighted that there is a conflict "between access and preservation and the protection of rights in the materials" (Harrison 1994). A UNESCO meeting proposed the following:

1. A study of legal problems facing AV archives;
2. A long-term strategy for handling international agreements on AV archiving;
3. A need to co-ordinate the international strategy in various ways, including agreements with rights holders, agreement among AV associations, conventions and international agreements, as well as regional or national conventions;
4. A need for unity between the AV associations in the development of a "joint concept and approach towards legal issues and legislation" (Harrison 1994 UNESCO); and
5. A need for a clear legislation stating what AV archives are and what they are mandated to do (Harrison, 1994).

Copyright

Mokoena (2002, p. 87) defined copyright as "that right which the copyright holder has over his or her original work and protects the copyright holder against unsolicited copying of his work". It is the exclusive right to the printing and reproduction of a work. It exists to legally protect the creators and publishers of works in order to prevent unauthorised and unfair use of original works (Mapiye, 2015). Copyright covers print and audio-visual materials such as literary works (novels, poems, scripts, books of history), musical works, dramatic works, folklore (folktales, folk songs, folk dances and folk plays), sound recordings, graphic work, photographs, sculpture and other artistic works, films, published editions and computer programs (Botswana Government, 2000; Rosin 2005).

Mapiye (2015, p. 21) also argued that "it is vital that archivists and creating agencies establish all the copyright owners of AV materials as this will help the organisation to avoid problems when people request the materials". In the event that the rights for the works cannot be established, reasonable agreements should be made specifically addressing the rights the organisation can have over the AV materials (Buys & Assmann, 2012). Pinion (1997) argued that legal issues in the management of AV materials cover various aspects including deposit, preservation, access and arrangement. Copyright legislation protects creators and publishers of works from unfair copying of original work (Pinion, 2004). Pinion (2004) believed that AV materials such as sound recordings and moving images are 'performance works' and therefore their rights go beyond the content of the physical format. These are referred to as 'neighbouring rights' that are owned by those who take part in creating the final product (IFLA 2003; SADC nations agree to standardise cyber laws 2005). Performers' rights exist in different countries including, Austria, the United Kingdom and the United States of America (Pinion, 2004).

According to Pinion (1997) performance arts (sound and moving images) cannot be covered by copyright legislation, hence the need for neighbouring rights legislation. The above author argues that copyright and neighbouring rights complicate the management of AV archives as agreements between creators and producers may restrict access to the items. She asserted that Audio-visual archivists should ensure that copyright and associated agreements are upheld (Pinion, 1997). Pinion (1997) further argued that access to the collections is dependent on negotiation of appropriate terms.

Copyright and neighbouring legislation varies from country to country. For instance, in Botswana, the copyright act covers all works under the direction or control of the state or any department of the government of Botswana (Botswana Government, 2000). In Namibia, the Namibian Copyright and Neighbouring Rights Protection Act 6 of 1994 only puts emphasis on broad issues pertaining to access but it does not mention any specific issues with regard to AV materials (National Library & Information Act 4 of 2000).

The South Africa's copyright Act (Number 98 of 1978) as amended up to copyright Act (2002), advocates separate copyright protection for cinematographic film. In the South African Act, originality did not refer to originality of thought. Rather it referred to "original skill of labour in executing the work" (Mokoena, 2002, p. 87). Edmondson (2004) suggested that a code of ethics for AV archiving should be compiled. Such a code should draw on comparative sources from many countries, bearing in mind particular reference to codes within library science, archival science and museum fields.

Nonetheless, Mnjama (2010) reported that Copyright was problematic for most audio-visual materials as they can be copied or the information migrated to new formats and mediums. Mnjama's (2005) study of the archival landscape in Eastern and Southern Africa revealed that most of the archival legislation was outdated. Abankwah (2007) discovered that media organisations in ESARBICA were not guided

by any policy in the management of their AV collections. Abankwah (2007) recommended that national archives in ESARBICA should update their Acts to reflect the management of AV materials. The policy statements should reflect aspects of archival practices that are applicable to AV formats and, where necessary, new policies should be designed to meet the specific needs of AV materials. This implies that the organisational structures of archival institutions should include the management of film, video and recorded sound collections. Such an arrangement would facilitate the application of uniform principles to the preservation, restoration, cataloguing and documentation of AV materials (Kofler, 2004).

In an attempt to address some of the challenges related to access and copyright issues, Buys and Assmann (2013) recommended that archives and other institutions in South Africa should ensure that permission is obtained from companies or individuals who own the copyright of the work, adapted materials, and locally commissioned AV materials.

APPLICATION OF ARCHIVAL FUNCTIONS TO AV MATERIALS

The functions of managing archival information are central to the management of AV materials. These functions are acquisition, appraisal and selection, accessioning, arrangement and description, preservation and access (Cox, 1992).

Acquisition

Acquisition forms a framework on which the appraisal and selection processes are carried out. This means that national archives' mandates should be very clear on the types of programmes supported by their collection (Abankwah, 2007). The "RODLIBRARY" (2017) concedes to the need for acquisition policies which cover different formats of audio-visual materials. Ward (1990, p. 15) pointed out that, unlike textual archival repositories, which receive inherited and deposit materials, sound archives rarely keep the above materials. The sound repository is "either run by …a radio organisation or record company, or it is supported by public or private funds to receive deposits of material in a specified geographical or subject area" (Ward, 1990, p. 15). This is the case with some national archives such as the National Video and Sound Archives of South Africa (NFVSA). Sections 14 (3) and 14(4) of the National Archives of South Africa Act No 43, of 1996, clearly spell out the mandate of the national archive, regarding the acquisition of AV materials. Nonetheless, other Acts such as the Public Archives and Documentation Service Act of Kenya, Chapter 10, (2015) (Revised edition), National Archives and Records Services of Botswana (2007) and the Archives Act 12 of Namibia (1992) of Namibia, are silent on acquisition of AV archives.

Appraisal and Selection

Forde (1990) stressed that appraisal is one of the most important duties of an archivist. It entails a determination of what is to be thrown away, hence identifying permanent records. The appraisal of AV materials should follow set guidelines. These include specific appraisal standards and principles, age, subject content (subject content of AV materials to future researchers should be ascertained), uniqueness (their ability to document the mundane, trivial and everyday texture of life), quality (good technical quality covering clear focus, audible sound and proper exposure) and quantity (the extent to which technology

and other factors accelerate production levels may necessitate weeding and sampling techniques) (Harrison, 1997). The appraisal guidelines should incorporate acquisition policies with other institutions to ease the burden of preserving the audio-visual records. Despite the recommended guidelines, Harrison (1997) argued that attempts to collect AV materials is guided by selection of what is available, rather than appraisal. "Selection is a necessity because of the volume of the material involved and the very nature of the material" (Harrison, 1997, p. 140). Increased recording makes selection imperative. Tape recording has become easier with improved recording equipment. This therefore makes the preservation of AV archives crucial as it is more complex than that of print materials.

Accessioning

Accession is a vital stage of archiving, as it provides information about ownership and copyright (Harrison, 1997). The main purpose of accessioning is to control the physical and intellectual materials of a repository (Brunton & Robinson 1993a; Cox, 1992). Just as for paper records, initial accessioning of AV materials should include the physical transfer of the materials from the creators to the archives while observing the principle of original order (Schuller, 2004b). He argued that recordings should retain their original length and sequence. In the case of machine-readable materials, related documentation and technical specifications, which are required to access and use the materials, should be transferred at the same time (Schuller, 2004b)). The organisation of AV materials requires that they are arranged and clearly described for ease of retrieval. Roper and Millar (1999a, p. 61) asserted that "arrangement and description achieve control over the holdings of the archival institution".

Arrangement and Description

Brunton and Robinson (1993b) opined that the process of arranging archival documents requires archivists to have knowledge of why and how the records were created and used, hence the application of the principle of provenance. Abankwah (2007) suggested that there should be some variation in the way the archival principle of provenance is applied to AV materials. For instance, with videocassettes or CDs, one is more interested in the content, the producer and date of production than the originating office. In this regard, the archival principle of provenance may not apply to some AV materials. There is therefore a need to consider the different policies between various collecting agencies such as museums, libraries and archives. Harrison (1997) saw a need to re-examine the concepts which govern the management of AV materials, in particular, and archival materials, in general.

The physical content of the archives (including digital resources) needs to be clearly described to ease access. Edmondson (2016) opined the need for good documentation and collection control when he noted that it requires discipline and it is time consuming, but it saves unnecessary losses and double handling. It is therefore a reflection of good housekeeping and a prerequisite to preservation. Koch (1997, p. 7) argued that the technical complexities of intellectual control for audiovisual materials are due to the characteristics of non-print materials, the diverse nature of non-print materials and cataloguing practices and procedures. Koch (1997) realised a need to devise finding aids and to set bibliographic or intellectual standards to facilitate access to AV resources.

Malden (2005) observed that subject catalogues for AV materials should be detailed enough to ensure speedy access to AV collections. The subject catalogue should contain the following details:

1. Summary entry;
2. Analytical entry-shot list;
3. Timings or time code, which are essential to find a specific shot or sequence in a long programme and are also an essential part of a digitised catalogue;
4. Order of shotlisting-chronologica1/sequential or thematic or actuality/interviews/ pieces to camera; and
5. Shot types.

Edmondson (2016), Miliano (2004) and McMullen (2004) further stated that international standards for cataloguing AV materials should be followed. These standards were developed by the following international organisations for AV materials: International Federation of Films and Archives (FIAF), International Association of Sound and Audio Visual Archives (IASA), Association of Moving Image Archives (AMIA) and International Federation of Films and Archives (FIAT).

Preservation and Access

Edmondson (2016), argues that the goal of preservation is access and without access, preservation has no purpose and it is an end in itself. Ngulube (2002) held similar views when he stressed that the preservation of archives derives from their format, the storage environment and the frequency with which they are handled and used. Schuller (2004b) realised that each detail of an audiovisual document is potential information and any damage leads to loss of information. Wiener earlier (1987) warned that, despite the popularity of videos, "the preservation of motion pictures recorded on their original film medium, especially older and rare films, is increasingly becoming urgent and problematic". Matangira (2003) noted that access to AV collections in the region was affected by various factors, which included lack of playback equipment, uncatalogued materials and lack of access copies. The author observed that "in most cases institutions cannot afford to have multiple copies of the same material" (Matangira, 2003, p. 47). In such situations, access was given to the original/master copies.

Given the constraints listed above, it is important that archivists promote full access to archival materials, while at the same time upholding established policies which restrict the use of records (Pinion, 1997). This is the only way long-term preservation of AV materials can be realised. Edmondson (2016) identified basic principles which should be used to guide preservation and access to AV materials. These are discussed below:

Storage Environments

Proper environmental conditions are required to ensure longevity of AV records. The storage area should be free of biological pests, light, extreme temperatures and humidity, atmospheric pollution and dust (Kodak Imaging in Action, Eastman Kodak Company, Rochester 1995). Other environmental conditions include water, physical security, fire and mishandling (Edmondson, 2016; Schwirtlich, 1993 & Weber 1997/98). Although controlling storage temperatures and Relative Humidity (RH) is more critical for non-textual media (Feather, 1996 & Bereijo, 2004b) noticed a lack of consistency in recommended temperatures and humidity for AV materials. Buchmann (1999) stated that archivists did not seem to

reach an agreement on precise standard temperature and humidity figures for AV materials. The situation is aggravated by the fact that most archives do not operate under ideal conditions (Edmondson, 2004).

AV ARCHIVING IN AFRICA

In some African countries (particularly the East and Southern Africa Regional Branch of the International Council on Archives (ESARBICA), the deterioration of AV materials is exacerbated by lack of guidelines, lack of or outdated policies, shortage or lack of expertise, harsh climatic conditions, financial constraints, vinegar syndrome, poor infrastructure to preserve records and failure to apply the records cycle concept to the management and preservation of AV materials (Abankwah, 2007; Matangira 2003; Mazikana, 1997/98; Mnjama 1996a; Ngulube, 2003).

Tropical regions are faced with harsh environmental conditions and yet they cannot afford to acquire or maintain air conditioning equipment (Chida, 1994). This was particularly evident in cases where air conditioners were dysfunctional (Ngulube 2005). This makes it difficult for them to meet the recommended climatic controls for AV materials. Other studies in ESARBICA, such as that of Mnjama (2005, p.457), discovered that "over half the archives are under-equipped".

Abankwah (2007) reported that AV materials in most of the ESARBICA national archives and some media organisations were in danger of dissipation as they were not kept under ideal conditions which included inadequate buildings, inadequate security and disaster management and lack of or inadequate equipment. The situation was exacerbated by lack of knowledge and skills to preserve AV materials and financial constraints.

Harrison (1997/98) discovered adverse conditions in storage rooms at many national archives in Africa. He observed storerooms and sheds with leaking roofs, broken doors and windows. He particularly singled out Tanzania as one of the countries where an international mission was launched to rescue the situation.

The problem of shortage of storage space for archival materials was observed in various archival institutions such as in the case of the National Archives of Malawi, in the case of South African archival repositories, in the case of the National Archives of Zimbabwe (NAZ) and in the case of the Radio Botswana Music Library (Matangira 2016; Mwangwera, 2003; Ngulube, 2003; Setshwane, 2005). Other problems associated with poor management of AV resources in some national archives in Africa were attributed to lack of written disaster management plans (Ngulube 2003, p. 334) and failure to apply the records cycle to AV materials (Abankwah, 2007). Moreover, Ngulube (2003) reported that only one archival institution in South Africa had a written disaster preparedness plan. He concluded that disaster preparedness and security of records were not accorded priority in archival institutions in South Africa and the rest of the ESARBICA. Abankwah (2007) confirmed the above findings.

Notwithstanding leaking roofs, broken windows, unstable foundations, fire detection/suppression systems, disaster preparedness and environmental monitoring, Edmondson (2004) put more emphasis on good management and surveillance practice

Given the current dissipation of AV materials on the continent due to inadequate storage facilities, the present author disagrees with Edmondson's (2004) assertion above. Archivists (particularly AV archivists) should heed Schuller's (1997) advice that archival materials should be housed in an appropriate environment which requires them to meet ideal conditions. However, other strategies may be required to safeguard AV materials. Such strategies include migrating AV materials to accessible formats.

CONTENT MIGRATION OR REFORMATTING

Edmondson (2016) and Ngulube (2003) argued that migration is a preservation strategy to promote access. According to Ngulube (2003, p.77), reformatting "is generally associated with safeguarding materials on a medium that is threatened by instability or technological obsolescence, it can also be used to shift from original documents."

Nonetheless, Edmondson (2016) argued that migration often results in loss of information and it may open up unpredictable risks in future when copying technology becomes obsolete. This explains why Hunter (2000) had reservations about the longevity and reliability of migrated objects or archival materials. Other authors including (Dollar 2000; Ngulube, 2003) pointed out the shortcomings of migration as a preservation technique. For instance, Ngulube (2002, p. 119) stated that "while reformatting may preserve the content of a document, it does not always save the actual object". Wato (2002, p. 127) pointed out that copying from one medium to another "only works when the information is encoded in a format that is hardware and software dependent". The above author argued that software obsolescence renders previous versions obsolete. Ngulube (2003) was concerned about intellectual property issues of reformatting. He therefore concluded that digitisation was not a panacea to all preservation problems. He felt that digitisation increased preservation problems. This implies that AV archivists should explore other alternatives to protect their resources. One such alternative is going back to the traditional records management model.

GENERAL SECURITY

The general security of the archival premises and the collections is crucial to any preservation programme. Ward (1990) realised a need for security in the archival repository. He believed that the archivist's priority should be the security of the collections. This is particularly important with archival recordings, which may be vulnerable to vandalism and theft if there is no proper supervision in the search rooms.

Lewis (2005) emphasised the need to protect AV materials from shock and vibration. He warned that failure to do so would result in serious damage, including breakage of the recording media itself, problems with reels and cassette shells, broken containers and major shocks that might cause disarrangement to magnetic particles. Bereijo (2004b) and Lewis (2005) held similar views. The latter recommended risk elimination through training of staff and users. Other strategies include disabling the record function on the equipment, disabling media with an anti-recording interlock and protection from strong electromagnetic fields. Ward (1990, p. 85) recommended that originals "should not be used for playback, even by staff". This is due to the fragile nature of sound recordings. He advised that copies be made to protect originals from rapid deterioration. They should be on reel-to-reel tape which is reliable and durable.

Nevertheless, Ward (1990) suggested that, ideally a third copy should be made for the processes of cataloguing, transcribing and listening, while a second copy is kept "for security and for use as a master from which all subsequent copies are run off" (Ward 1990, p. 85). He stressed that duplicate copies for researchers could be kept under lock and key, in a room adjacent to the search area, while original copies are locked up in a store which is restricted to staff. Roberts (1993) suggested that there should be a copy that is used as a reference/viewing copy by clients. In an attempt to strengthen security, staff should accompany authorised visitors to the reference areas. This would require that the same door be used for entrance and exit and bags should be left in lockers on entry to the study area (Ward, 1990).

According to Buchmann (1999), preservation has a direct bearing on the planning and construction of all areas of an archive building. It should clean, made of concrete, temperate and able to withstand storms with less damage. Fortson (1992) discouraged the use of carpeting in stack areas, because carpets retain water. He stressed that proper drains should be provided for all stack areas, backed up with routine inspections to ensure that they are clear of debris. Additionally, water alarms should be placed in areas which have water problems. Mazikana (1997/98) reported that many archival buildings in Africa were inadequate. This means that AV materials are neither secure nor stored under ideal conditions. Training of AV archivist should be regarded as a preservation strategy.

EDUCATION AND TRAINING

Harrison (2004) stated that education of AV archivists is the key to the development of sound, film and television archives. The author reported that UNESCO considered training of AV archivists a priority area when the organisation launched a Memory of the World project. Several authors (Matangira, 2003; Tamulha, 2001; Zinyengere, 2008) felt that lack of technical skills and knowledge was one of the problems in the region. Matangira (2003, P. 35) pointed out that "…most of the archivists responsible for the audiovisual collections in these institutions, lack the necessary technical know how for handling and storage of archives in those media". Tafor (2001) supported the latter when she noted that less than 40% of the national archives in ESARBICA were not rendering effective service because most of their staff were unqualified. Matangira (2003) believed that archivists should be exposed to AV archiving through informal and formal training. This explains why Zingyengere (2008) suggested that archivists should be attached specialised AV units or specialised AV archives such as the National Film, Video and Sound Archives (NFVSA) of South Africa. Few universities in the region offer specialised modules in AV archiving. The few universities include the Department of Library and Information Studies at the University of Botswana, the Department of Information and Communication Studies at the University of Namibia, the Department of Library and Information Science at the University of Makerere, and the National University of Science and Technology (NUST), in Zimbabwe (Mnjama, 2010; College of Computing and Information Science, 2017). The content and depth of coverage differs from university to university. This explains why Harrison (1997/98) revealed a growing gap between the provision of AV education and the provision of professional education, in both developed and developing countries. The author believed that all archivists should be equipped with professional knowledge of archival principles and special knowledge of the distinctive characteristics of AV materials and special knowledge of the distinctive characteristics of AV materials and their equipment. However, Matangira (2003) noted that funding was a major barrier to formal training.

According to Harrison (2004), the special skills required of an AV archivist do not come unaided or untaught. Skills such as bibliographic description, handling, storage and conservation require a different approach from contemporary techniques of handling text materials. Wato (2002) and Mnjama (2002) saw a need for multidisciplinary training, which equips archivists with information technology (IT) skills. Nonetheless, there are deficiencies in the training of staff for audiovisual archives that's is why Cook (1990) referred to the international model which requires professional staff to be graduates who have undergone a specialised training in an archive school and that Para-professionals should obtain a basic secondary education level, accompanied by specific training such as in-house training courses. Abankwah (2007) suggested that such specialist training would be appropriate for AV archivists in Southern Africa.

SOLUTIONS AND RECOMMENDATIONS

The problems and controversies raised in the chapter require concerted efforts by stakeholders; international organisations, professional bodies, heritage institutions, and various government bodies to raise awareness of the importance of preserving audio-visual materials just like any other record. These records should be preserved for posterity. This means that funds should be raised and channelled into training of audio-visual archivists. This goal will only be realised through an integrated curricula which should motivate various schools and faculties at universities to 'inject' audio-visual training in their curricula. The future audio-visual archivists could come from schools and colleges of computing, library and information science, business schools, media schools and records and archives management schools. Regional centers should be developed to train specialists in audio visual archives while at the same time encouraging informal training through professional attachments to AV units in various national archives. NFVSA should be considered as the first regional training center for AV archivists in Africa.

FUTURE RESEARCH DIRECTIONS

The chapter suggests the following future studies:

1. A comparative study of selected national archives in ESARBICA and national archives in the developed world;
2. A study on standards and legislation that pertain to AV materials in different countries of ESARBICA;
3. A longitudinal case study on the impact of digitising archival AV materials. The case study should be carried out on selected national archives in ESARBICA region which have digitised their AV collections;
4. A study on ideal climatic conditions for AV materials in tropical countries;
5. A study should be conducted on controlling and monitoring the environmental conditions in repositories where AV materials are kept;
6. A study should be conducted on the relationship between the structural placement of national archives vis-à-vis their ability to preserve AV materials.

CONCLUSION

The chapter has given an overview of the factors that affect the management and preservation of AV materials. Specific examples have been highlighted with emphasis on the developing countries. It therefore behooves national archives on the continent to heed UNESCO's (2007) declaration of 27 October 2007 as the World Day for Audio-visual Heritage, to educate the public on the importance of preserving AV materials.

REFERENCES

Abankwah, R., & Ngulube, P. (2012). Environmental conditions and the storage of audio visual materials in archival institutions in the ESARBICA region. *ESARBICA Journal, 31*, 75–82.

Abankwah, R. M. (2007). *The management of audio-visual materials in the member states of the East and Southern Africa Regional Branch of the International Council on Archives (ESARBIACA)* (PhD. Dissertation). University of KwaZulu-Natal.

Archives Act 12 of Namibia. (1992). Retrieved September, 18, from https://laws.parliament.na/annotated-laws-regulations/law-regulation.php?id=319

Bereijo, A. (2004a). The conservation and preservation of film and magnetic materials (1): Film materials. *Library Review, 53*(6), 323–331. doi:10.1108/00242530410544411

Bereijo, A. (2004b). The conservation and preservation of film and magnetic materials (2): Magnetic materials. *Library Review, 53*(7), 372–378. doi:10.1108/00242530410552313

Botswana Government. (2000). *Copyright and Neighbouring Rights Act: supplement A*. Gaborone: Government Printer.

Brunton, P., & Robinson, T. (1993a). Accessioning. In Keeping archives (2nd ed.; pp. 207-221). Port Melbourne: The Australian Society of Archives.

Brunton, P., & Robinson, T. (1993b). Arrangement and description. In Keeping archives (2nd ed.; pp. 222-247). Port Melbourne: The Australian Society of Archives.

Bubenik, B. (2005, October). *Storage equipment and technology: from shelves to near on-line Mass Storage development of storage technologies*. Paper presented at the FIAT/IASA Southern African Workshop on Film, Video and Sound Archives, SABC, Johannesburg, South Africa.

Buchmann, W. (1999). Preservation: Buildings and equipment. *Journal of the Society of Archivists, 20*(1), 5–23. doi:10.1080/003798199103695

Buys, R., & Assmann, I. (2013). Copyright vs Accessibility: The challenge of exploitation. *International Association of Sound and Audio-visual Archives Journal, 41*, 7–14.

Byers, F. R. (2003). *Information Technology: Care and Handling of CD's and DVD's- A Guide for Librarians and Archivists*. National Institute of Standards and Technology and Council on Library and Information Resources. Retrieved September 15, 2003, from http://www.itl.nist.gov/iad/894.05/docs/CDandDVDCareandHandlingGuide.pdf

Chebani, B. B. (2003). *The role of restructuring national archives institutions: Botswana case study* (Unpublished MSc. Thesis). University of Wales.

Chida, M. (1994). Preservation management in tropical countries: a challenging responsibility and limited resources: the case of Zimbabwe National Archives. *ESARBICA Journal, 4*, 22–33.

College of Computing and Information Science. (2017). Retrieved January, 10, 2017, from https://www.mak.ac.ug/academic-units/colleges-and-departments

Cook, M. (1990). The management of information from archives (2nd ed.). Bookfield: Gower.

Cox, R. J. (1992). *Managing institutional archives: foundational principles and practices.* Westport, CT: Greenwood Press.

Dollar, C. M. (2000). *Authentic electronic records: strategies for long-term access.* Chicago: Cohasset Associates, Inc.

Edmondson, R. (2004). *Ethics and new technology.* Retrieved from http://www.unesco.org/webworld/ ramp/html

Edmondson, R. (2016). *Audiovisual archiving: philosophies and principles* (3rd ed.). United Nations Educational, Scientific and Cultural Organization. Retrieved May, 20, 2016 http://unesdoc.unesco.org/ images/0024/002439/243973e.pdf

Feather, J. (1996). *Preservation and the management of library collection* (2nd ed.). London: Library Association Publishing.

Forde, J. W. (1990). *Archival principles and practice: a guide for archives management.* Jefferson, NC: McFarland.

Forde, J. W. (1990). *Archival principles and practice: a guide for archives management.* Jefferson, NC: McFarland.

Forgas, L. (1997). The preservation of videotape: Review and implications for libraries and archives. *Libri, 47*(1), 43–56. doi:10.1515/libr.1997.47.1.43

Fortson, J. (1992). *Disaster planning and recovery: a how-to-do-it manual for librarians and archivists.* New York: Neal-Schuman, Inc.

Hall, A. S. (2015). *Save our lives: America's Recorded Sound Heritage Project, Preserving Sound Recordings.* Retrieved from http://www.loc.gov/folklife/sos/preserve1.html

Harrison, H. P. (1997). Selection and Audio Visual Collections. In *Audio-visual archives: A practical appraisal* (pp. 126-143). Paris: UNESCO. Retrieved from http://unesdoc.unesco.org/ images/0010/001096/109612eo.pdf

Harrison, H. P. (1997/98). Audio-Visual Archives Worldwide. In *World Information Report* (pp. 182-188). Paris: UNESCO. Retrieved from http://unesdoc.unesco.org/images/0010/001096/109612eo.pdf

Hedstrom, M., & Montgomery, S. (1998). *Digital preservation needs and requirements in RLG member institutions, a study commissioned by the Research Libraries Group, Mountain View.* Research Libraries Group. Retrieved from http://www.rlg.org/preserv/digpres.htm

Hillebrecht, W. (2010). *The Preservation of the Audio Heritage of Namibia. Challenges and Opportunities.* Basler Afrika Bibliographien Klosterberg.

Hunter, G. S. (2000). *Preserving digital information.* New York: Neal-Schuman, Inc.

IASA. (2017). *Guidelines on the Production and Preservation of Digital Audio Objects.* Retrieved from https://www.iasa-web.org/tc04/audio-preservation

IFLA. (2003). *Audio-visual and Multimedia Section Annual Report January 2001-2003*. Retrieved from http://www.ifla.org/VII/s35/annual/sp35.htm

ISO 15415489:1. (2001). *Information and Documentation-Records Management, Part 1: General*. Geneva: ISO. Retrieved from www.iso.org/catalogue_detail.html

Jacobson, M. (2008). Migration of 1.5 million hours of audio-visual material, Swedish National Archive of Recorded Sound and Moving Image (SLBA). *IASA Journal, 31*, 25-35. Retrieved from https://www.iasa-web.org/sites/default/files/iasa-journal-31-all.pdf

Kenosi, L. (2008). The South African Truth Commission's Audio-visual Record and Great Access Illusion. *IASA Journal, 31*, 85-89. Retrieved from https://www.iasa-web.org/sites/default/files/iasa-journal-31-all.pdf

Klaue, W. (1997). Audio-visual records as archival material. In H. P. Harrison (Ed.), *Audio-visual archives: A practical reader* (pp. 23–27). Paris: UNESCO.

Klaue, W. (2004). *Education and training, audiovisual archives*. Retrieved from http://www.unesco.org/webworld/ramp/html/

Koch, G. (1997). A typology of media archives. In Audio-visual archives: A practical reader (p. 32-34). Paris: UNESCO, PG1-97/WS/4.

Kodak Imaging in Action, Eastman Kodak Company, Rochester. (1995). In *Audio visual archives, a practical reader*. Paris: UNESCO. Retrieved from http://unesdoc.unesco.org/images/0010/001096/109612eo.pdf

Kofler, B. (2004). *Legal issues in audiovisual archives*. Retrieved from http: www.unesco.org/webworld/ramp/htm

Lawetz, H. (2008). When archives go digital. *IASA Journal, 31*, 36-41. Retrieved from https://www.iasa-web.org/sites/default/files/iasa-journal-31-all.pdf

Lewis, A. F. (2005). *Risk reduction through preventive care, handling and storage*. Retrieved from http://www.arl.org/preserv/sound_savings_proceedings/lewis.html

Library and Archives Canada. (2007). *Managing Audiovisual Records in the Government of Canada*. Retrieved from http://www.collectionscanada.ca/html

Malden, S. (2005, October). *Issues in cataloguing of visual material*. Paper presented at the FIAT/IASA Southern African Workshop on Film, Video and Sound Archives, SABC, Johannesburg, South Africa.

Mapiye, T. (2015). *The management of audio visual materials in Namibia: A comparative study of the national archives of Namibia and media organisations* (Unpublished undergraduate research report). University of Namibia, Windhoek, Namibia.

Matangira, V. (2003). Audiovisual archiving in the third world; problems and perspectives: An analysis of audiovisual archiving in the East and Southern African Region Branch of the International Council on Archives (ESARBICA). *ESARBICA Journal, 22*, 43–49.

Matangira, V. (2016). *Records and archives management in postcolonial Zimbabwe's Public Service* (PhD dissertation). University of Namibia.

Mazikana, P. C. (1997/98). Africa: archives. In World Information Report, 144-154.

McMullen, M. (2004, June). *IASA Cataloguing rules for audio-visual media cataloguing and documentation committee publication project: Final report on the minimum level of description of a sound recording for an entry in a catalogue or discography*. Retrieved from http://www.gov.unesco.org/webworld/ramp/html

Miliano, M. (2004). *IASA cataloguing rules for audio-visual media cataloguing and documentation committee publication project*. Retrieved from http://www.unesco.org/webworld/ramp/html

Mnjama, N. (1996a). National archives and the challenges of managing the entire life-cycle of records. *S. A. Archives Journal, 38*, 24–32.

Mnjama, N. (1996b). Establishing a records management programme: Some practical considerations. *ESARBICA Journal, 15*, 29–37.

Mnjama, N. (2005). Archival landscape in Eastern and Southern Africa. *Library Management, 26*(8/9), 457–470. doi:10.1108/01435120510631747

Mnjama, N. (2010). Preservation and management of audio-visual archives in Botswana. *African Journal of Library Archives and Information Science, 20*, 139–148.

Mokoena, L. (2002). South Africa oral history projects: Copyright and other legal implications. *ESARBICA Journal, 21*, 87–90.

Mwangwera, M. (2003, April). *Report on Audio-visual archives in Malawi*. Paper presented at the FIAT/IFTA workshop, Lusaka. Retrieved from http://www.Fiatifta.org/aboutfiat/ members/archive/Malawi_nat_arch.html

National Archives and Records Services of Botswana. 1978, as amended 2007. (n.d.). Retrieved from http://en.wikipedia.org/wiki/National_Archives_and_Records_Administration

National Archives and Records Services of South Africa. (2016). Retrieved from http://www.national-government.co.za/units/view/123/Social-Services/National-Archives-and-Records-Service-of-South-Africa-NARSSA

National Archives and Resource Services (NARS). (2007). Retrieved from http://www.national.archives.gov.za

National Film & Sound Archive of Australia. (n.d.). Retrieved from https://www.nfsa.gov.au/

National Film and Sound Archive. (2016). *Preservation*. Retrieved from http://www.nfsa.afc.gov.au/Screensound/Screenso.nsf/

National Library and Information Act 4 of 2000. (n.d.). Retrieved from http://www.lac.org.na/laws/annoNAM/LIBRARIES%20(2000)%20-%20Namibia%20Library%20and%20Information%20Service%20Act%204%20of%202000%20(annotated).pdf

Ngulube, P. (2002). Preservation reformatting strategies in selected Sub-Saharan African archival institutions. *African Journal of Library and Information Science, 12*(2), 117–132.

Ngulube, P. (2003). *Preservation and access to public records and archives in South Africa* (Ph. D. dissertation). University of Natal.

Ngulube, P. (2005). Environmental monitoring and control at national archives and libraries in Eastern and Southern Africa. *Libri*, *55*(2-3), 154–168. doi:10.1515/LIBR.2005.154

Ngulube, P., & Tafor, V. F. (2006). The management of public records and archives in the member countries of ESARBICA. *Journal of the Society of Archivists*, *27*(1), 57–83. doi:10.1080/00039810600691288

Paton, C. A. (1999). Preservation re-recording of audio-visual recordings in archives: problems, priorities, technologies and recommendations. *American Archivists*, (61), 188-219.

Peoples, C., & Maguire, M. (2015). *ARSC Guide to Audio Preservation: Recorded Sound at Risk*. Retrieved from http://www.clir.org/pubs/reports/pub164/pub164.pdf

Pinion, C. F. (1997). Legal issues in AV archives: an introduction. In *Audio-visual archives: A practical appraisal* (pp. 55-60). Paris: UNESCO. Retrieved from http://unesdoc.unesco.org/images/0010/001096/109612eo.pdf

Puthelogo, T., & Abankwah, R. M. (2015). An analysis of the broadcasting migration process from analogue to digital format: A comparison of Botswana Television and Namibian Broadcasting Cooperation. *IASA Journal*, *44*, 65–73.

Resenblum, A. L., Burr, G., & Guastavino, C. (2013). Survey: Adoption of Published Standards in Cylinder and 78 RMP Disc Digitization. *IASA Journal*, *41*, 55.

Roberts, D. (1993). Managing records in special formats. In Keeping archives (2nd ed.; pp. 385-427). Port Melbourne: The Australian Society of Archives.

RODLIBRARY. (2017). *Audio-Visual Material Policy*. University of Iowa. Retrieved from https://www.library.uni.edu/about-us/policies/collection-management/audio-visual-materials-policy

Roper, M., & Millar, L. (Eds.). (1999a). *The Management of public sector records: principles and context*. London: International Records Management Trust.

Roper, M., & Millar, L. (Eds.). (1999b). *Managing archives*. London: International Records Management Trust.

Rosin, M. (2005, October). *Rights, including broadcasts and non-broadcast material*. Paper presented at the FIAT/IASA Southern African Workshop on Film, Video and Sound Archives, SABC, Johannesburg, South Africa.

Ross, J. (2009). *Preservation of Archival Sound Recoding*. Retrieved from http://www.arsc-audio.org/pdf/ARSCTC_preservation.pdf

SADC Nations Agree to Standardise Cyber Laws. (2005, May 25). *The Botswana Gazette*, p. 6.

Saffady, W. (1998). *Managing electronic records*. Prairie Village, KS: ARMA International.

Saintville, D. (1986). The preservation of moving images in France. In Panorama of audio-visual archives (pp. 3-7). London: BBC Data Publication.

Schuller, D. (1997). Storage Handling and Conservation: preserving of audio and visual m In *Audio-visual archives: A practical appraisal* (pp. 280-291). Paris: UNESCO. Retrieved from http://unesdoc.unesco.org/images/0010/001096/109612eo.pdf

Schuller, D. (2004a). Sound recordings: Problems of preservation. In J. Feather (Ed.), *Managing preservation for libraries and archives: current practice and future developments* (pp. 113–131). Aldershot, UK: Ashgate Publishing Ltd.

Schuller, D. (2004b). *Strategies for the safeguarding of audio and video materials in the long.* Retrieved from http: http://www. Unesco.org/webworld/ramp/html/r9704e15.htm

Schuursma, R. (2007). *Approaches to the national organisation of sound archives.* Retrieved March, 8, 2013 from http://www.unesco.org/webworld/ramp/html

Schwirtlich, A. M., & Reed, B. (1993). Managing the acquisition process. In Keeping archives (2nd ed.; pp. 137-156). Port Melbourne: The Australian Society of Archives.

Setshwane, T. (2005). *Preservation of sound recordings at the Department of Information and Broadcasting: The case study of Radio Botswana Music Library* (MIS dissertation). University of Botswana.

Seychelle National Archives. (2011). Retrieved from http://www.sna.gov.sc/exhibitions.aspx

Smith, H. (1993). Legal responsibilities and issues. In Keeping archives (2nd ed.). Port Melbourne: The Australian Society of Archives.

South, A. C. A. 1978 (Act No. 98 of 1978, as amended up to Copyright Amendment Act 2002. (n.d.). Retrieved from http://www.wipo.int/wipolex/en/details.jsp?id=4067

St-Laurette, G. (1996). *The care and handling of recorded sound materials.* Retrieved from http://www.palimpsest.stanford.edu/byauth/st-laurent/care.html

Tafor, V. F. (2001). *The management of public records in the member states of ESARBICA* (MIS dissertation). University of Natal.

Tamulha, K. S. (2001). *The Preservation and Use of Photographic Materials: A Case Study of the Department of Surveys and Mapping Air Photo Library* (MLIS Dissertation). University of Botswana, Gaborone, Botswana.

UNESCO. (2007a). *UNESCO World Day for audiovisual heritage-feasibility study launched.* Retrieved from http://www.unesco.org/webworld/mdm/en/index_mdm.html

UNESCO. (2007b). *Audiovisual Archives: A practical reader.* Retrieved from http://www.org/webworld/ramp/html

Ward, A. (1990). *A manual of sound archive administration.* Brookfield: Gower Publishing Company Ltd.

Wato, R. (2002). Challenges and opportunities of information technology for archival practices in the 21st Century. *ESARBICA Journal, 17,* 125–134.

Weber, H. (1997/98). Preservation of archival holdings and unique library materials. In World Information Report. Paris: UNESCO.

Zinyengere, I. (2008). African Audio-Visual Archives: Bleak or Bright Future: A Case Study. *News, 46,* 37–41.

KEY TERMS AND DEFINITIONS

Audio-Visual Heritage: These are archives in audio-visual format.

Audio-Visual Materials and Audio-Visual Resources: These terms are used synonymously to refer to a combination of sound, audio and visual.

Audio-Visual Records: Records that combine audio and visual format.

ESARBICA: Eastern and Sothern Africa Regional Branch of the International Council of Archives. This council is responsible for records and archives management issues in the region including training.

Integrated Curriculum: This is a cross-cutting curriculum that combines disciplines to address market needs/demands.

Records Life Cycle: The stages all formats of records go through from creation to disposal.

UNESCO: United Nations Educational Scientific and Cultural Organisation.

Chapter 8
Preservation and Access to Digital Materials:
Strategic Policy Options for Africa

Trywell Kalusopa
University of Zululand, South Africa

ABSTRACT

As the digital world unfolds, Africa continues to grapple with the issues of preservation and access of digital materials. This chapter demonstrates through a systematic literature review how Africa could learn from other efforts in the world to develop and guide their own strategic and policy options to deal with issues of preservation and access of digital materials. The chapter reviews literature on global or universal collaborative strategies and efforts on digital preservation initiated in the developed world as a learning curve for Africa. The current challenges of national and institutional capacities regarding the preservation of digital materials in selected African countries that have made some visible efforts and impact are also discussed. The chapter then makes several recommendations on the strategic and policy options for improving the state of material preservation, human and material requirements in order to improve the long-term preservation, and standards for the longer-term usability and interoperability of digital materials in Africa.

INTRODUCTION

In memory institutions of the world, preservation, in general terms, involves understanding the spiritual, ritual, or cultural perceptions of the value for specific objects, and ensuring these values are maintained and respected. The assigned connotation is "something assigned to objects of cultural or spiritual significance based on interpretations and perceived values by user populations, a process known as social construction of an object" (Barker, 2003, p.77). In these institutions, the focus is often placed on the "informational content and physical attributes, or artifactual value, of collected materials" (Foot, 2006, p.19). In that regard, preservation policies "are primarily concerned with the maintenance of these two things, either through reformatting to preserve textual information, or repairs and environmental controls

DOI: 10.4018/978-1-5225-3137-1.ch008

to ensure continued existence of their physical structure" (Foot, 2006, p.19). In library and archival science, the term 'preservation' can thus be said to be an umbrella word under which most librarians and archivists group all the policies and options for preservation action, including conservation treatments of different formats of information materials (Kalusopa & Zulu, 2009).

Historical accounts show that the challenges of preserving paper-based information materials were propelled by the discovery of the Fourdrinier machine in 1806, which was driven to meet the high demand for paper (Harvey, 1993). However, owing to developments in science and technology over the past two centuries, we are now in the midst of a transition from essentially output of information in paper format to output in a variety of multi-media such as picture, sound, text or combination of these; and increasingly being stored in electronic media (Zulu, 2005; Kalusopa & Zulu, 2009). These information resources in the digital era now range from simple text based files e.g. word processing files to highly sophisticated web based resources such as; databases, websites, e-mails and storage mediums such as; diskettes, flush drives, CD ROMS, etc. For that reason, the world is continuously witnessing challenges of digital material preservation of the digital surrogates (Kalusopa & Zulu, 2009). These are created as a result of converting analogue materials to digital form (digitization) and those that are born digital for which there has never been and is never intended to be an analogue equivalent, and digital records.

This chapter focuses on issues of preservation and access of digital materials with specific reference to Africa. The chapter is a systematic review of extant literature that sought to present how Africa could learn from other efforts in world in developing and guiding their own strategic and policy options to deal with issues of preservation and access of digital materials. The chapter initially presents the definitional and conceptual view of digital preservation and access. It reviews literature on some selected digital preservation requirements and strategies. Then, some of the selected significant universal as well as national efforts in digital preservation in developed countries are presented. The current challenges of national and institutional capacities regarding the preservation in digital materials preservation from selected countries that have made some visible efforts and impact in Africa are discussed. The chapter then makes several recommendations on the strategic and policy options for improving the state of material preservation; human and material requirements in order to improve the long term preservation and standards for the longer term usability and interoperability of digital materials in Africa.

DIGITAL PRESERVATION AND ACCESS: CONCEPTS AND DEFINITIONS

In existing literature reviewed, there appears to be some lack of precise definitions regarding the concepts and terms that embrace digital preservation as an emerging area of research and discipline. However, what is true is that there is some relative consensus on some working definitions that continue to evolve over time.

In that light, digital material has been defined as a broad term encompassing digital surrogates created as a result of converting analogue materials to digital form (digitization), and 'born digital' for which there has never been and is never intended to be an analogue equivalent, and digital records (DPC, 2015, p.1). Digital preservation thus refers to all of the actions required to maintain access to digital materials beyond the limits of media failure or technological change. Those "materials may be records created during the day-to-day business of an organization; 'born-digital' materials created for

a specific purpose (e.g. teaching resources); or the products of digitization projects" (DPC, 2015, p.1). Accordingly, the terms digital preservation and digital archiving are usually regarded as synonymous terms, and used interchangeably in literature. Though the two concepts have a common ground, that is, to make available and accessible digital materials in the future; they are not necessarily synonymous. Digital preservation can be seen as the series of adopted management activities necessary to ensure a continued access to digital materials for as long as necessary (DPC, 2015). Digital archiving, however, refers to the process of creating digital backup as an ongoing maintenance as opposed to strategies for long-term digital preservation access. In this context, 'access' is assumed to "mean continued, ongoing usability of a digital resource, retaining all qualities of authenticity, accuracy and functionality deemed to be essential for the purposes the digital material was created and/or acquired for" (DPC, 2015, p.1).

The general consensus seems to be that digital preservation involves the management of digital information over a period of time, is ongoing, continuous and is far embracing than the mere attention to storage media. It thus involves a set of activities and processes that guarantee access to information and all kinds of records; scientific as well as cultural heritage that exists in digital formats (United Nations Educational, Scientific and Cultural Organization [UNESCO], 2003b; DPC, 2009; Kirchhoff, 2008; Maemura, Moles, & Becker, 2017). As aptly put by the DPC & Pennock, (2013), digital preservation should therefore be approached from the perspective of defining broadly the purpose, actions and setting appropriate strategies required to maintain access to digital materials beyond the limits of media failure and technological change. The goal of digital preservation is the accurate rendering of authenticated content over time thus underlining digital continuity; where, digital continuity is broadly defined as the ability to make digital information continuously usable for as long as required (UNESCO, 2003a; Maemura, Moles, & Becker, 2017). This chapter adopts this conceptual view and broad definition.

DIGITAL PRESERVATION REQUIREMENTS

Hedstrom (1995) posits that in order to preserve digital materials on a scale commensurate with mass storage capabilities and in formats that are accessible and usable, it is necessary to articulate some basic requirements. There are two ways to examine digital preservation requirements: (a) from the perspective of users of digital materials; and (b) from the view of libraries, archives, and other custodians who assume responsibility for their maintenance, preservation, and distribution. Libraries and archives will not accomplish their preservation missions if they do not satisfy the requirements of their users by preserving materials in formats that enable the types of analyses that users wish to perform. The potential uses of digital materials are therefore varied, unpredictable, and almost endless. Preserving digital materials in formats that are reliable and usable, however, will require long-term maintenance of structural characteristics, descriptive metadata, and display, computational, and analytical capabilities that are very demanding of both mass storage and software for retrieval and interpretation. According to Michelson and Rothenberg (1992, p.236), digital preservation requirements may be defined differently by archives, libraries, and other types of repositories. However, all these institutions need storage systems capable of handling digital information in a wide variety of formats, including text, data, graphics, video, and sound. Ideally, storage media should have a long life expectancy, a high degree of disaster resistance, sufficient durability to withstand regular use, and very large storage capacities.

DIGITAL PRESERVATION STRATEGIES

The issue of digital material preservation has brought apprehension all over the world. Technologies are becoming obsolete at a faster rate and yet strategies are either not in place or the ones in place are overtaken by new technologies and thus not being unresourceful. However, in order to combat challenges of digital preservation, several strategies continue to be adopted to help preserve digital materials. In literature, several strategies have been put forward. Hilde van Wijngaarden, Digital Preservation Officer, at the Koninklijke Bibliotheek/ National Library of the Netherlands once summed these strategies into two as:

1. Processing the original which include: migration, normalization and data-extraction.
2. Keeping the original: which include: emulation, encapsulation, technology preservation (hardware museum), re-engineering/data recovery/digital archaeology.

Some of these selected strategies for digital preservation are explained below.

Migration

Migration is the preservation approach which has been most widely practiced to date (Joint Information Systems Committee [JISC], 2008). Migration is simply a means of overcoming technological obsolescence by transferring digital resources from one hardware/software generation to the next. At its simplest, migration is defined as the copying or conversion of digital objects from one technology to another, whilst preserving their significant properties (JISC, 2008). Migration is based on the assumption that content is more important than functionality or 'look' and 'feel'. The potential loss of data and attributes may compromise the integrity and authenticity of a digital object, which is a major issue for digital archivists. There are advantages and disadvantages of migration. In literature the following have been identified as advantages (JISC, 2008):

- It is a commonly used strategy and procedures for the simple migration are well established.
- It is reliable way to preserve the intellectual content of digital objects and is particularly suited to page-based documents.
- Conversion software for some formats is readily available.

The disadvantages include (JISC, 2008):

- It requires a large commitment of resources, both initially and over time.
- At the point of obsolescence, it is labour intensive unless it can be automated, since formats evolve so rapidly in that as collections grow, the work involved in migration also increases. The migration on request approach may mitigate this to some extent, in that migration is not carried out on digital objects which may not be used; standardization of formats also makes batch migration easier.
- Some of the data or attributes (e.g. formatting) of the digital object may be lost during migration.
- The authenticity of the record may be compromised in that there is likely to be a significant loss of functionality in the case of complex digital objects.

Technology Emulation

It is important to underscore the fact that for a long time migration was seen as the only viable approach, whereas emulation was looked upon with incredulity due to its technical complexity and initial costs. However, the focus of emulation is on preserving the environment for a digital object. Emulation does not seek to look "backwards in time to the old technology used to create the resource", instead, it looks to "existing (or even future) technology to mimic the environment" (Russell, 2002, p.18). This permits the digital resource to run and appear as though it were in its "original technical environment" (Russell, 2002, p.18). Although emulation as an approach for preservation has been viewed with some skepticism, it is continues to gain support because it offers potentially a solution for the very long term. In an attempt to be technology independent and to allow for use of new (and presumably) better future technology, emulation advocates suggest that the digital object is stored simply as a bit stream (or byte stream) and with it detailed specifications for the technical environment which can be re-created on demand in the future. It has been documented that in 2004, the "National Library of the Netherlands (Koninklijke Bibliotheek, [KB]) and the Nationaal Archief of the Netherlands acknowledged the need for emulation, especially for rendering complex digital objects without affecting their authenticity and integrity" In that regard, a project was initiated to explore the "feasibility of emulation by developing and testing an emulator designed for digital preservation purposes" (van der Hoeven, Lohman, & Verdegem, 2007, p.123). Thus, in July 2007 that "project ended and delivered a durable x86 component-based computer emulator: Dioscuri, the first modular emulator for digital preservation" (van der Hoeven, Lohman, & Verdegem, 2007, p.123).

Encapsulation

DPC (2015) delineates encapsulation as the grouping together of resources and whatever is necessary to maintain access to it. This can include metadata, software viewers, and discrete files forming the digital resource. It provides a useful means of focusing attention on what elements are needed for access and ensuring that all supporting information required for access a maintained as one entity. Encapsulation is further described by Haag (2002) that in contrast to the migration approach, it retains the record in its original form, but encapsulates it with a set of instructions on how the original should be interpreted. This would need to be a detailed formal description of the file format and what the information means. This encapsulating layer could be expressed using XML, for example. If the original software used to interpret the data file is complex, then the description must also be complex and care would need to be taken to ensure that it was sufficiently complete. Encapsulation is considered a key element of emulation.

Back Up Strategy and Byte Replication

The other strategy cited in literature relates to "content-specific" digital preservation, namely back up strategy and byte replication. In a typical storage backup system, a "copy of the data is replicated at multiple locations. When a change is made to one copy, that change gets mirrored to the other locations according to the backup schedule (e.g., nightly)" (Johnston, 2014, p.1). Therefore, if one copy is compromised, perhaps through bit rot deterioration, then all copies will be replaced with this corrupt version. Additionally, the preservation of digital content demands disaster planning and risk mitigation. The key point to underscore is that to always assess and determine the risks if some or all of the backups fail.

The other shortcoming or challenges to consider is whether the data would be recovered if say digital forensic approaches were applied and at what cost this would be. In addition, usually, content may only be retrieved via the software with which it was originally backed up. This implies that if "special software or hardware is required to access the content and if it has been compressed via a proprietary technology, the long-term future accessibility and authenticity of the content – key goals of digital preservation – cannot be assured" (Kirchhoff, 2008, p.287).

In the case of byte replication, "identical, multiple copies of files, file systems, or websites are created" (Kirchhoff, 2008, p.287). These files are "stored in different locations across many components without the use of specialized software" (Kirchhoff, 2008, p.287). However, replicated data may introduce difficulties in refreshing, migration, versioning, and access control since the data is located in multiple places. Also as observed by Kirchhoff (2008, p.287) "simple byte replication includes no provision for ensuring the content is usable when the file formats are no longer current, nor is there any inherent provision for ensuring that the content remains discoverable…"

Web Archiving

In contemporary times, there has been an increase in a number of organizations that have been involved in web archiving. Universities, historical societies, and state and local governments in world have now recognized the need for and importance of preserving a variety of web content for posterity. Many organizations create websites as part of their communication with the public and other organizations as they are powerful tools for sharing information. Websites document the public character of organizations and their interaction with their audiences and customers (National Archives, UK, 2011, p.15). Web archiving is the process of collecting websites and the information that they contain from the World Wide Web, and preserving these in an archive. Web archiving is a similar process to traditional archiving of paper or parchment documents; the information is selected, stored, preserved and made available to people (National Archives, UK, 2011, p.14). Web archiving technology "enables the capture, preservation and reproduction of valuable content from the live web in an archival setting, so that it can be independently managed and preserved for future generations" DPC & Pennock, 2013, p.1). Access is usually provided to the archived websites, for use by government, businesses, organizations, researchers, historians and the public (National Archives, UK, 2011). As in traditional archives, web archives are collected and cared for by archivists, in this case 'web archivists (National Archives, UK, 2011, p.14).

However, challenges remains which include: selection, technological (technical expertise), legal (copyright) challenges and access (Grotke, 2011). Usually, organizations that plan to embark on a web archiving initiative are advised to be clear about their business needs before doing so. In other words, the key driver to any web archiving initiative should be the clarity of the business needs as they have significant influence on the web archiving strategy and selection policy.

Cloud Computing

Cloud computing is another strategy which now offers solution to the problem of digital preservation (Dečman & Vintar 2013). For many organizations, the cloud represents an attractive model to deliver efficient IT services in which data is stored online without having to run their own computing services. Usually, any cloud computing environment is a layered architecture consisting of an Infrastructure as a Service (IaaS) and Software as a Service (SaaS). This is the e-delivery of hosted services over the

internet, the content of which comes from somewhere other than the users own computing device, be it a desktop computer, a laptop, a smart phone, or a tablet (Dale Prince, 2011). Cloud computing has made significant progress in libraries and archival communities as many services offered by libraries and archives have migrated to the cloud without much of a difficulty. For instance, journal subscription and subsequent access to the content of journals are hosted by third parties (National Institute of Standards and Technology [NIST], 2011).

However, the cloud storage providers, like any other company, can go bankrupt and cease to operate or be acquired by another company which will eventually lead to the loss of records or inaccessibility of records. With reported cases of hackers having unauthorized access to an organization's network, questions have been raised as to whether archivists should continue to trust the cloud for the preservation of documentary heritage. It has been reported that Google in addressing these challenges has installed a "server-side" encryption as a default service to its cloud customers as a way of protecting clients' data (Kirk, 2013).

Notwithstanding these shortcomings, the cloud offers incalculable digital preservation opportunities which libraries and archives may use to offer services to their users such as: reduced cost; scalability; paying only for what they need; remote access. Undoubtedly, cloud computing has a great potential for memory institutions as many organizations are getting their business files into cloud- based document-management solutions. Thus, the International Data Corporation (IDC) has envisaged that by the year 2020, as much as 15 per cent of the information in the 'digital universe' could be part of a cloud-based service. However, the issue of trusting ones' data to recluse remains a risk concern.

UNIVERSAL EFFORTS IN DIGITAL MATERIAL PRESERVATION

The issue of digital preservation has led to a variety of organizations, initiatives, projects to put in place universal alliances and global efforts. Collaboration has been seen as essential ingredient to the development process of preserving digital resources over the years. Some of these efforts are already in place while others are still underway. In terms of universal efforts, UNESCO has been at the forefront in initiating collaborative strategies to be adopted to preserve digital material. Others include: the International Federation of Library Associations and Institutions (IFLA), Joint Information Systems Committee (JISC) and Digital Preservation Coalition (DPC) (UNESCO, 2003a). Thus, UNESCO's drive has led to proclamation of a charter on the Preservation of the Digital Heritage. The Charter is a declaration of principles to assist UN Member States in preparation of national policies to preserve and provide access to digital heritage. The Charter describes the digital heritage as those unique resources of human knowledge and expression in digital form, and recognizes both the risk to this material through technological obsolescence and the urgency required to ensure its preservation (UNESCO, 2003b). IFLA has its guidelines produced by a working group representing IFLA and the International Council of Archives (ICA) that was commissioned by UNESCO to establish guidelines for digitization programmes for collections and holdings in the public domain (UNESCO, 2003c).. The IFLA guidelines identify and discuss the key issues involved in the conceptualization, planning and implementation of a digitization project, with recommendations for "best practice" to be followed at each stage of the process. Of particular interest is the special effort has been made to consider the particular circumstances of the countries of the developing world. Other universal efforts have been by the DPC which was established in 2001 to foster joint action to address the urgent challenges of securing the preservation of digital resources in the UK

and to work with others internationally to secure global digital memory and knowledge base. Its aim since its launch has been to raise the profile of digital preservation on behalf of all its members, which it has pursued through work with international bodies such as UNESCO and the European Commission (DPC, 2002). DPC has also managed to have a joint service of the Digital Preservation Coalition and Preserving Access to Digital Information (PADI) which in form of a quarterly summary publication of selected recent activity in the field of digital preservation compiled from the PADI gateway, the digital preservation and mailing lists and other sources.

Essentially, because digital preservation demands long term commitment and very often a shared responsibility, it thrives on collaboration and strategic alliances. As observed by Day (2008), collaborative efforts of the DPC from the U.K, the Nestor (Network of Expertise in the Long-Term SToRage) from Germany and the Data Preservation for the Social Sciences (DATA-PASS) from the U.S have brought out some positive achievements to heritage institutions. These collaborative efforts have tended to focus on metadata standards; file formats advocacy and network; interoperability, authenticity, reliability and accuracy of records. As will be discussed in the proceeding sections, the Library of Congress has also been at the forefront of such collaborative efforts and formed network of partners who undertook the collection and preservation of digital records in the U.S. (NDIIPP, 2008). Similarly, institutional repositories that use open source repository software and interoperability tools such as DSPACE, FEDORA, and Open Archives Initiative Protocol for Metadata Harvesting (OAI-PMH) continue to collaborate on digital preservation. It also documented that the WorldCat through collaborative initiatives receives cataloguing information from well over 72,000 libraries around the world and users of Google books can search over two billion records (Waibel & Erway, 2009). More importantly, conferences on digital preservation and research have alluded to the various roles archivists and private organisations should play in the whole scheme of digital preservation. One of such conferences is the Vancouver declaration on digital preservation held by the UNESCO in 2012 (UnescoVancouver Declaration, 2012). In essence, no one institution can vouch to have the capacity to address the erratic challenges of digital preservation.

Another universal effort is the International Research on Permanent Authentic Records in Electronic Systems (InterPARES) (www.interpares.org). This project aims to develop the knowledge essential to the long-term preservation of authentic records created and/or maintained in digital form and provide the basis for standards, policies, strategies and plans of action capable of ensuring the longevity of such material and the ability of its users to trust its authenticity. InterPARES has developed in three initial phases (Duranti, 2007, p.113):

- InterPARES 1 (1999-2001) focused on the development of theory and methods ensuring the preservation of the authenticity of records created and/or maintained in databases and document management systems in the course of administrative activities. Its findings present the perspective of the records preserver.
- InterPARES 2 (2002-2007) continued to research issues of authenticity, and examined the issues of reliability and accuracy during the entire lifecycle of records, from creation to permanent preservation. It focused on records produced in dynamic and interactive digital environments in the course of artistic, scientific and governmental activities.
- InterPARES 3 (2007-2012) built upon the findings of InterPARES 1 and 2, as well as other digital preservation projects worldwide. It put theory into practice, working with archives and archival / records units within organizations of limited financial and / or human resources to implement sound records management and preservation programs.

The fourth phase is InterPARES Trust (ITrust 2013-2018) which is a multi-national, interdisciplinary research project exploring issues concerning digital records and data entrusted to the Internet (InterPARES Trust, 2017a). The ITrust builds on the foundations of InterPARES (International Research into the Preservation of Authentic Records in Electronic Systems) carried out in three phases from 1998 through 2012. The research findings and products of the first three phases of the InterPARES Project can be found at interpares.org. The overall aim of IP Trust is to develop frameworks that will support the development of integrated and consistent local, national and international networks of policies, procedures, regulations, standards and legislation concerning digital records entrusted to the Internet so as to ensure public trust grounded on evidence of good governance and a persistent digital memory (InterPARES Trust, 2017a). For this reason, the research project is divided into a number of teams as follows: Team Africa, Team Asia, Team Australasia, Team Europe, Team Latin America, Team North America, and the Transnational team (InterPARES Trust 2017b).Currently, research is progressing on all the continents.

In Africa, 'Team Africa' is coordinated by the University of South Africa's Department of Information Science and comprises collaborating partners in Botswana, Kenya, South Africa and Zimbabwe (InterPARES Trust, 2016a). Team Africa's overall aim is to ensure that the experience gained from their participation in the global project will yield results that are relevant to the African setting and empower records and archives professional based on action-oriented outcomes. However, in preliminary findings, records professionals in each of those countries face similar challenges in the new digital age, including preservation. Therefore, it is anticipated that these four case studies will provide a common investigative process that would draw on professional similarities; and it is expected that this will present prospects for professionals to engage on wider variety of challenges in digital era in Africa (InterPARES Trust, 2016b).

In all, it will be reasonably fair to therefore say that universal organizations, projects and initiatives efforts as discussed above and among many others, are geared towards achieving a common goal that has been ably summarized by UNESCO (2003a, p.1) in its charter as "to maintain access to digital resources over a long term by safeguarding not necessarily the storage media but the content and documentation and thus taking care of the aspect of information integrity at large". The future of digital preservation depends on the collaborative efforts from all the various stakeholders the study has identified. Therefore, collaboration, participation, strategic alliances, and synergy should form part of the solutions to the unending problems of digital preservation.

NATIONAL INITIATIVES IN DIGITAL PRESERVATION IN THE DEVELOPED WORLD

Different states and countries have also made efforts to come up with strategies on how to deal with the digital preservation. Apparently, countries especially in the Western world have shown or demonstrated significant efforts to achieve this. The countries were selected both for their geographical spread as well the immense efforts that they continue to spur global efforts in digital preservation. The African countries, however, continue to lag behind in such efforts due to several factors as has been alluded to in the proceeding sections of this chapter. It would be useful therefore to review some of these efforts in the developed world so that African countries can gauge and map their own strategic policy options on preservation efforts. Below are some of the states and countries whose efforts in digital preservation have been discussed and which the Africa countries could learn from.

United Kingdom

Though awareness on the problem of digital preservation started way back in 1993, by the late 1990s, the UK had not come up with a national strategy on digital preservation. It is for this reason, that the JISC of the Higher Education Funding Council (HEFCE) and the British Library (BL) recognised the need for a British national policy and action on the long-term preservation of digital information. As aptly put by Ross (2003), it is clear that up to 1993 a "certain narrow-mindedness had pervaded studies of electronic information as the focus had been predominately by national archives on the preservation of records about the national governments themselves"

Currently, a lot of digital preservation work is being undertaken at the National Archives by the digital preservation department. The records of government are increasingly created in electronic form and the National Archives are playing an active role in storing and preserving digital material. However, the diversity of electronic records and frequent changes in computer technology present a range of challenges that need to be tackled in order to ensure that these records remain accessible over the long-term. Undoubtedly, a number of coalitions and projects have been funded to help face the preservation of digital material challenge. As earlier mentioned, one of the initiatives is the DPC, which was established in 2001 to foster joint action to deal with the urgent challenges of securing the preservation of digital resources in the UK and globally. There is also the Humanities Advanced Technology and Information Institute (HATII) of the University of Glasgow that has since 1997 been conducting research and has been participating in projects aimed at preservation of digital resources. HATII is a seat of the European Union's (EU) Electronic Resource Preservation and Access Network (ERPANET) since 2001.

Further efforts in the UK are demonstrated by a decade of creating a digital preservation bibliography, which now includes thousands of articles, items of grey literature, and project websites often rich with resources. (National Archives, 2005). Efforts continue to date.

In web archiving, the National Archives has developed guidance explains what web archiving is and how it can be used to capture information which is published online. It is aimed at people who are new to the concept of web archiving, and those who may have heard about it, but are unsure of potential options and methods available (National Archives, UK, 2011).

United States of America

The preservation of digital content was recognised as a major challenge in the 1990's in the US. The Library of Congress (LC) has been a pioneer in the field of digital information preservation. Even before the onset of the World Wide Web (WWW), the LC was digitizing and making selected items from its collections available in electronic form. This programme which was called the American Memory, began as a pilot in 1990 under the National Digital Information Infrastructure and Preservation Program (NDIIPP). In 1998, the LC assembled a National Digital Strategy Advisory Board to guide the Library and its partners as they worked towards developing a strategy and plan (Library of Congress, 2016). As a consequence, the LC commissioned the National Research Council Computer Science and Telecommunications Board of the National Academy of Sciences (NAS) to evaluate the Library's readiness to meet the challenges of the digital world. The NAS report, *LC 21: A Digital Strategy for the Library of Congress*, recommended that the Library, working with other federal and non-federal institutions, take the lead in a national, cooperative effort to archive and preserve digital information. This effort resulted

in the US Congress passing special legislation (Public Law 106-554) in December 2000 in recognition of the importance of preserving digital content for future generations.

Other US initiatives include the activities of the Digital Library Federation (DFL) whose mission is to bring together, from across the nation and beyond, digitised materials that will be made accessible to students, scholars, and citizens.

The DFL has also established the The Global Digital Format Registry initiatives which is aimed at encouraging academic institutions to create digital institutional repositories into which the intellectual capital of a college or university can be preserved for reuse -gathering up not just the articles and books of the completed scholarly endeavor but also the data sets, presentations, and course-related materials that faculty generate (Digital Library Federation [DFL], 2005).

On the other hand, as part of the United States National Archives and Records Administration (NARA)'s e-government initiative, an Electronic Records Archives (ERA) project was started in 1998 as a comprehensive means for preserving electronic records free from dependence on any specific hardware and software. NARA developed policy and technological guidance for electronic archiving whose programme became operational in 2007. Currently, NARA provides a host of links on electronic records management, including requirements for the transfer of archival electronic records and managing web records. These provide tools for agencies to access transfer and access electronic records for as long as required. Other prominent projects in the US are the National Digital Information Infrastructure Preservation program [NDIIPP], 2008), Research Libraries Group [RLG]), Online Computer Library Center [OCLC], 2002), National Information Standards Organization [NISO], 2010) and the National Archives and Records Administration on Electronics Records Archives. Being the brainchild of the Library of Congress, the NDIIPP (2008) developed a national strategy to collect, archive, and preserve digital records for the current and future generations.

In terms of web archiving, the Library of Congress has been leading this initiative. In July 2003, the LC joined with 10 other national libraries and the Internet Archive and formed the International Internet Preservation Consortium (IIPC), acknowledging the importance of international collaboration for the preservation of internet content. The goals of the consortium include collecting a rich body of internet content from around the world and fostering the development and use of common tools, techniques, and standards that enable the creation of international archives (Grotke, 2011). Today, the consortium has almost 40 member organizations that meet regularly, virtually and in person, to discuss and solve issues related to access, harvesting, and preservation. The Library of Congress with partners organizations through the National Digital Stewardship Alliance (NDSA). The NDSA is open to any organization that has demonstrated a commitment to digital preservation and that shares the stated goals of the consortium.

Australia

The issue of digital preservation can be said to have taken root simultaneously or rather began almost at the same time in Australia and the UK. The first major meetings that seem to have spurred major efforts by a few professionals in libraries and Archives seem to have started in 1993.In 2001 the National Archives of Australian drafted a Green Paper, which outlined strategies for the preservation of digital records. Agency to Researcher Digital Preservation Project is part of the outcome of the Green Paper (National Library of Australia, 2003)

Another project in Australia that was also formed to confront the digital preservation issue is the Digital Preservation Project (DPP). This is a research and development project being carried out by the Preservation Section of the Collection Management Branch of the National Archives. The project began in July 2001. Its objective is to create a way of storing Commonwealth agency electronic records that are assessed as being 'national archives' and preserving them so that they can be made available to researchers in the future.

Other notable efforts in Australia came out of the Secretariat of the Department of the Prime Minister and Cabinet that launched the Digital Recordkeeping Initiative, on behalf of the National Archives in 2004. The Initiative works towards developing and promoting a single Australasian approach to digital public recordkeeping across all jurisdictions and provides a space for communication and information sharing between the members (National Archives, 2005).

There is also the National Library of Australia's Preserving Access to Digital Information (PADI) initiative which aims to provide mechanisms that will help to ensure that information in digital form is managed with appropriate consideration for preservation and future access. PADI advocates for the use of standards as one strategy, which may be used to assist in preserving the integrity of and access to digital information (National Archives, 2005).

The National Library of Australia (NLA) remains the institution that has effectively undertaken digital preservation initiatives in a number of local and international collaborations. PANDORA project (Preserving and Accessing Networked Documentary of Australians) and the Council of Australian State Libraries are some of the examples (Cathro, Webb & Whiting, 2009). As a statutory authority within the portfolio of the Department of Communications, Information Technology, and the Arts, the NLA holdings cover Australia's published and documentary heritage, including oral and folk history. The NLA believes in international collaboration as a key element in the digital preservation. Consequently, it has been reported that it has worked with the U.S. Library of Congress and contributed to the OCLC/ RLG Working Group on Preservation Metadata and the Working Group on Digital Archive Attributes. NLA has contributed significantly to the OAIS reference model and other international projects in digital preservation as well as the development of Preservation Management of Digital Material (Beagrie, 2008).

Netherlands

In the Netherlands, both the National Library of the Netherlands and Nationaal Archief of the Netherlands are responsible for the long-term preservation of an important part of the Dutch cultural, scientific and governmental heritage. The Nationaal Archief of the Netherlands has a legal obligation to preserve and give access to archival records of Dutch governmental organizations (OCW, 2002). The KB's mission is to ensure permanent access to information which also includes digitally stored information. With an increasing amount of digitized and born-digital documents and applications, new protocols and strategies for preservation and access are required. To secure storage of digital objects, the KB operates an electronic repository, called the e-Depot (KB, 2006), which by December 2007 contains more than ten million digital objects, varying from PDF documents to interactive multimedia applications. At this moment the Nationaal Archief of the Netherlands is developing a digital depot system which is expected to be fully operational by the end of 2008 (van der Hoeven, 2007, p.123).

CHALLENGES OF DIGITAL MATERIAL PRESERVATION IN AFRICA

In Africa, digital preservation efforts seem to have been isolated and have not taken ground. From literature reviewed, such significant efforts can be traced to the time the National Library of South Africa was tasked with reporting on digitization activities on the African continent. The purpose of this project was to investigate digitization activities at national libraries and to encourage cooperation amongst heritage institutions (libraries, archives and museums) at either the national or the international level. According to Tshepe (2005), the finding to this study concluded that preservation of digital collections in the long-term, though mentioned at workshops and articles by African authors, collaborative programmes on the African continent remained elusive and was a long way to go. Earlier studies by Mutiti in a survey conducted in 1999, involving National Archival institutions in Botswana, Kenya, Malawi, Namibia, Seychelles, South Africa, Swaziland, Tanzania, Zambia and Zimbabwe, found that hardly any digitization programmes were in place. Only one country was undertaking a photograph-imaging project whilst another country had identified the need for document conversion and had planned a feasibility study. However, in the spirit of cooperation to face the preservation of digital material issues in Africa, the Historical Archives of Mozambique in cooperation with DISA hosted an 'International Workshop on Automation and Digitization of Libraries and Archives' in Maputo in 2001. Case studies of the automation and digitization of national archives were presented by participants from different countries (Tsebe, 2005). There was another workshop on 'Safeguarding African Documentary Heritage' held in Cape Town in 2001 as well funded by UNESCO/IFLA. Participants from different countries were trained in preservation management and traditional and digital reformatting techniques. (Tsebe, 2005). The University of Botswana in cooperation with DISA also hosted a workshop on managing digital libraries in Gaborone in 2004 in the same effort to combat the digital preservation issue. Despite all these efforts, to date there are still no concrete steps taken to address some of the recommendations that were cited then. Recent studies by Adu Kasusse et al (2016); Adu (2015); Ngoepe & Keakopa (2011); Tembo, Kalusopa & Zulu (2006); Bekele (2006); Ngulube (2003) also confirm this uncoordinated efforts and lack of depth of on the subject in Africa. Below we discuss some of these isolated efforts and challenges hitherto in selected countries Africa.

South Africa

The digital material preservation in South Africa is said to have been spurred by DISA (Digital Imaging Project of South Africa) which was established in 1997 (Tshepe, 2005). DISA aimed at investigating and implementing digital technologies to enable scholars and researchers from around the world to access South African material of high socio-political interest that would otherwise be difficult to locate and use. Both the National Library and National Archives of South Africa took part in the project (Tsebe, 2005).

It has been reported that several digitization actions gave rise to the audit in January 2008 sponsored by the Carnegie Corporation of New York. For that reason, through the office of the Programme Officer: Libraries and Information, the corporation then convened a meeting in South Africa with South African digitization stakeholders. The meeting was partly prompted by the fact that the Corporation had received a number of proposals from different organizations and institutions in South Africa for funding to digitize South African resources as well as South African material at the United States Library of Congress (http://hdl.handle.net/10907/87). It was then pointed out that in examining the South African digitization proposals; the Corporation had identified the key challenges namely: gaps in technological

know-how; and lack of a standard approach to digitization tools, which could inhibit the ready exporting, importing or general sharing of digital content. In February 2009, South African practitioners and leaders in the field of digitization met to find ways of accelerating the development of digital collections as well as increasing the scope and extent of digitized South African resources available on the Web. At this meeting, it was agreed that there was need for the collaborative production of a reference document for managers' level that would provide a valuable framework for organizations considering the digitization of their resources. A document *'Managing Digital Collections: A Collaborative Initiative on the South African Framework'* (http://hdl.handle.net/10907/87) was subsequently produced. The objective of this Framework is to provide high-level principles for planning and managing the full digital collection life cycle. It provides principles and guidelines to assist planners, policy developers and managers of digital collections gain a sense of the digitization landscape.

In sum, a variety of digitization initiatives in South Africa, have been undertaken, including the following:

- DISA, a collaborative effort by a consortium of South African Higher Education Institutions (HEIs) that has been partially funded by the Andrew W. Mellon Foundation and has focused on historical material, especially related to the Freedom Struggle. DISA has become a center of digitization expertise in South Africa, and provides training and support across South Africa and elsewhere in Africa. Collections are accessible from the DISA (www.disa.ukzn.ac.za) and Aluka (www.aluka.org) websites.
- Sabinet has embarked on the digitization of African journals (www.sabinet.co.za/open_access. html).
- SARADA (www.sarada.org) is compiling a digitized record of the major South African rock art collections.
- Many Higher Education Institution (HEIs), including those at the universities of the Witwatersrand, Cape Town, Pretoria, Johannesburg, Rhodes and Stellenbosch, are digitizing their library and other collections. Some activities use in-house resources; others are wholly or partially dependent on donor funding.
- The NLSA, the Nelson Mandela Foundation and the Desmond Tutu Foundation are contemplating the digitization of some of their holdings.
- There are activists such as SAHA promote access to material, inter alia via digitization and web publication.

In addition to this, it also important to underscore the fact that South Africa, like any other African country, has a National Archives and Records Service whose purpose is the proper management and care of the records of governmental bodies; and the preservation and use of a national archival heritage; and to provide for matters connected therewith (Ngoepe & Keakopa, 2011). The first core function of the national archives is encapsulated in the mandate to preserve a national archival heritage for use by the government and people of South Africa (Ngoepe & Keakopa, 2011) This entails acquiring and managing records of national importance, which includes both public and non-public records (Ngulube, 2003). It also entails making records available to members of the public who may wish to use them for purposes of research of past events or to document or vindicate their rights. However, the National Archives and Records Service of South Africa are faced with a major preservation challenges. These challenges include budgetary constraints in the face of the need for improved access; limited human

resource skills; new developments in ICT; and invasion by ambitious IT vendors and product developers who prescribe systems which have no long term preservation and accessibility value (Ngoepe & Keakopa, 2011). Physical preservation of the holdings has not been given that much attention in the past. In South Africa, government agencies have not yet addressed the long-term preservation of electronic records, but NARS is taking the initiative and has started looking at options for the long-term preservation of electronic records. Leading scholars in South Africa, however, are of the view that until the right strategy has been found, agencies should be left with the custody of electronic records (Ngoepe, 2017). In his recent systematic review, Ngoepe (2017, p.11) bemoans and admits that this challenge in the public sector in South Africa remains. He affirms that, currently there exists "no infrastructure to ingest digital records into archival custody in South Africa," and as such, the most permissible and "interim solution for the preservation of digital record" is that "the National Archives and Records Service of South Africa (NARSSA) should be encouraged to develop a policy on distributed custody to allow government entities to create interim solutions for preserving digital records" Ngoepe (2017, p.11). Other recommendations proposed include: enhance in "capacity development and provision of sustainable infrastructure required to preserve digital records". The review also recommended further empirical research "to assess digital records lost during migration and the recovery of such records, as well as technological requirements for the preservation of digital records in public entities" (Ngoepe, 2017, p.11).

At the time of writing this chapter, there were other national-level activities related to many aspects of eResearch related to digital preservation, including ((http://hdl.handle.net/10907/87):

- The creation of open access repositories for research outputs at several universities;
- The High Performance Computing Centre (HPCC), which is part of the Meraka Institute and housed at UCT;
- The current roll-out and commissioning of SANReN, which will provide affordable high bandwidth connectivity between local and global research organizations (including HEIs);
- The establishment of a national Electronic Theses and Dissertations (ETD) central repository, hosted at the NRF, for the harvesting of ETD repositories at South African universities; and
- The management of a national scholarly publication program by the Academy of Science of South Africa (ASSAf).

However, there is no coordinated initiative to support the digitization and preservation of research material. This implies that organizations, institutions have continues pursue digitization and digital preservation initiatives individually or collectively depending on the availability of resources.

Ghana

Literature reviewed indicates that currently there is no significant research literature on national digital preservation initiatives in Ghana. Adu (2015) observed that there are some fragmented attempts on institutional repository initiatives in some of the public universities in Ghana. These were identified as: University of Ghana, University of Cape Coast and Kwame Nkrumah University of Science and Technology. On institutional repositories, Kwame Nkrumah University of Science and Technology Institutional Repository services, collects, organizes, and provides open access to scholarly works produced by the University's faculty, staff and students. The University further subscribes to over fifty Databases (E-Resources) through the Consortium of Academic and Research Libraries in Ghana (CARLIGH). The

University of Cape Coast on the other hand is equally building institutional repositories to preserve the intellectual outputs of both the staff and students. In doing this, the University believes, it will increase its global visibility, showcase the academic and research outputs of the University and facilities to preserve UCC's intellectual heritage for posterity. UGSpace is an open access electronic archive for the collection, preservation and distribution of digital materials.

Botswana

The Government of Botswana is at the forefront in investing and spearheading the ICT revolution through investment and guided by the ICT policy. The country has realized that computerization can stimulate efficient and effective manipulation of data, hence improvement in productivity leading to economic growth and development. This therefore means that electronic records are increasingly being produced in most government departments and offices and the Botswana National Archives and Records Services Department has the responsibility to manage these records. The Botswana National Archives mission thus envisages to provide efficient and effective economic management of all Public Records throughout their life cycle (from creation to disposition), and the preservation of those Public Records of Archival value for posterity and access purposes. The department provides the same service to the parastatal on an advisory basis. The increasing production of electronic records has undoubtedly raised issues of challenges of preservation of digital materials However, like other African countries, Botswana is still grappling with how to deal with digital material preservation. A study by Tembo, Kalusopa & Zulu (2006) revealed among other issues the revealed the following on the state of digital material preservation in Botswana:

- Lack of a national policy framework on digital material preservation;
- Relevant legislation on ICTs, especially on digital material preservation, is yet to be drawn and enacted;
- Lack of clearly defined institutional responsibility for digital material preservation;
- Absence of coordinated national initiatives and programmes on digitization;
- Gaps in human resources in terms of knowledge, skills and competencies to drive Digital material preservation in heritage institutions;
- Lack of standards in digital material preservation in terms of hardware, software, storage media and metadata;
- Haphazard approach to digital material preservation in most institutions;
- Absence of local institutions that could serve as models for 'best practices' (or centres of excellence) in digital material preservation;
- The management of indigenous knowledge systems, in terms of their digitization, remains to be addressed;
- Disaster planning and recovery in most heritage organizations remains to be addressed

Ethiopia

Ethiopia has been using computers at least since the early 1960s. Like Botswana, the rate of adoption of computers for various tasks has accelerated during the last two decades. Consequently, many documents are now produced and remain in electronic format making them susceptible to their preservation challenges. However, a UNESCO survey by Bekele (2006) revealed, among other findings, the following:

- Most organizations use the electronic form to store most of their documents. Traditional formats such as type and handwritten format are being replaced by computer based electronic formats.
- Most organizations do not have adequate Digital Management Programmes (DMP).
- Organizations do not have the appropriate policy nor do they allocate the necessary personnel and other resources for this purpose but have adequate programs for paper-based document preservation.
- Most organizations are aware of the need and consequences that come from lack of DMP but were not taking serious actions to develop such programmmes program.
- Most organizations have digital production and storage practices that do not facilitate digital preservation
- Very few organizations use standard formats for their digital preservation given

Uganda

In Uganda, Luyombya (2010) examined the framework for effective management of digital records in Uganda by surveying 23 ministries that form the Uganda Public Service (UPS). The study sought to establish the current state of digital records in the UPS and determine the factors hindering the management of digital records. The findings of the study revealed that problems with Digital Records Management (DRM) were due to the absence of ICT facilities with recordkeeping functionality, lack of clear policies, guidelines and procedures, and the fact that the Uganda Records and Archives legislation is not implemented and not properly enforced. The study noted that lack of appropriate institutional and managerial structures can be attributed to the failure to implement the National Records and Archives Act. The study, however, recommended the need for a legal infrastructure, appropriate policies, procedures and guidelines and skilled human resource capacity. Kasusse et al (2016:3) also established that that the Makerere University Library (Africana Section) is a legal deposit center with the mandate of acquiring all publication on and about Uganda. In recent years, the library evolved a new niche of harvesting "born-digital" news articles on and about Uganda and Africa from local and international news portals for purposes of including them to the Makerere Institutional Repository formerly known as the Uganda Science Digital Library (USDL). The USDL is a digitization projects that was initiated in Makerere University Library in 2004 through collaborative linkages with Tufts University, University of Tennessee, Knoxville and the University of Bergen, Norway. USDL was created using Dspace as a preservation strategy to guarantee permanent access to scholarly materials. It also sought to digitize cultural heritage materials and provide wider and easier access to these materials, conserve the originals, possibly add value to images and collections, and opportunities for income generation (Namaganda, 2011).

STRATEGIC POLICY OPTIONS FOR AFRICA ON DIGITAL PRESERVATION

Garret and Waters (1996) contend that the question of preserving or archiving digital information is not a new one and has been explored at a variety of levels over the last five decades. Though many countries in Africa have undertaken extensive digitization programs to convert old analog such as paper records into digital formats that can be more easily processed and exchanged (Bayissa et al 2009; Hamooya & Njobvu, 2010), it is important to note that this technology, in itself, is not a technology for management and preservation of records and information (Katuu & Ngoepe, 2015). The erroneous belief that digiti-

zation alone solves information problems has led to a number of poor outcomes for countries, such as loss of access to trustworthy original records of transactions, uncertainty about the integrity of digital surrogates, and even loss or irretrievability of digital copies of records (Bayissa, Ketema, & Birhanu, 2009; Hamooya & Njobvu, 2010). Digitization has proven to be no panacea. Nor has it addressed the need to manage new records and information generated in native digital formats.

Archivists responsible for records have been acutely aware of the difficulties entailed in trying to ensure that digital information survives for future generations. This is because there are major challenges faced in preserving digital materials and information at large. This scenario is not different in Africa and perhaps more acute and present challenges in the adoption of policy options. What then are the options for Africa?

The following have been identified by several scholars as are some of the strategic options for Africa (Adu & Ngulube, 2017; Adu, 2015; Kasusse et al., 2016; Ngoepe & Keakopa, 2011; Tembo, Kalusopa & Zulu 2006; Bekele 2006; Ngulube 2003; Tembo, Zulu & Kalusopa, 2006):

- **Policy Formulation:** National governments should to appoint a National Technical Committees that would formulate digital preservation policy frameworks. Membership to the National Technical Committee should be drawn from all relevant stakeholders. Such a National Technical Committees should work within the framework of the relevant the National ICT Policy framework
- **Legislation:** National governments should to appoint should appoint National Technical Committees to design and formulate legislation that seeks to harmonise the various pieces of legislation that relate to national digital preservation in countries.
- **National Co-Ordination:** The National Archives and Records Services should be live up to the responsibility for co-ordinating all national digital material preservation initiatives, activities and programmes.
- **Sensitisation and Awareness:** In order to bring on board institutional leadership, digital sensitisation campaign and advocacy should be linked to e-governance and national productivity programmes.
- **Digital Preservation Standards:** The relevant institutions should establish National Technical Committees that would formulate national standards on digitization based on international practice. At the regional level, Regional Technical Committee should be established to articulate standards used by participating countries in such regions. The National Technical Committees would be tasked, among other things, to look at ways of adopting and adapting international standards including metadata.
- **Human Resource Development:** Organizations at national level should recruit and develop (through various short-term and long term training strategies) digitisation personnel, as well put measures in place for their retention. In addition, posts for digitisation should be created in their staff establishments or structures.
- **Centre of Excellence:** National governments should designate national institutions to serve as the Centres of Excellence.
- **Disaster Planning, Mitigation and Recovery:** The National Archives and Records Services should work together with the National Disaster Management Offices in devising guidelines to mitigate disasters.

FUTURE RESEARCH DIRECTIONS

It is instructive to observe that evidently the preservation of digital materials stills presents enormous challenges and although many have attempted to offer solutions, the debate about which methods can be used is still raging globally and more so in Africa. In Africa, therefore future research efforts should be geared towards, among other issues, the following:

- This chapter has established that evidently, digital information is not durable and the goal of digital preservation is to maintain the ability to display, retrieve, and use digital collections in the face of rapidly changing technological and organizational infrastructures and elements. Incorporation of ways to access digital archival records into already existing e-Government strategies could further improves well-known benefits of e-Government such as: increased accountability and transparency. Thus, the value of e-government services highly depends on whether government is able to authentically preserve the digital records and provide means of access to its designated community. The question of digital continuity in the context of e-government drive remains a valuable future research area.
- This chapter affirms that the development of standards to address policy, procedural and technical issues associated with conversion and migration from one recordkeeping system to another, regardless of record format, remains a concern in Africa. Practical research on arriving at some lasting standards and solutions could be valuable, going forward research niche area.
- This systematic review has confirmed that innovative digitization or digital imaging technologies have been used, mainly in developed countries but slow or absent in Africa, to capture rare manuscripts, photographs, slides, journals, paintings and monographs, and to promote their long-term preservation and wider accessibility. Digitization and preservation are inevitably linked, especially where vulnerable collections are concerned. This has given rise to new processes, behavioral disciplines, know-how, skills and facilities that are required to support the digitization initiatives. Research in this direction would be useful.

CONCLUSION

This chapter has presented a systematic review regarding the status of digital material preservation in world, and dovetailed this to Africa. It outlines the strategic policy options or recommendations available for the continent to improve the current situation. The chapter has shown that Africa faces the same challenges that other countries are facing with regards to digital material preservation. These mainly centre on the fact that awareness, techniques, standards and the laws governing the management and preservation of digital materials have not kept abreast of the technological changes. As a result, several institutions risk losing a lot of their heritage materials forever, unless concerned bodies take appropriate measures to implement adequate digital material preservation programmes. The chapter has also identified funding, level of security and privacy, skills training and technological obsolescence as factors that pose key threats to digital preservation in Africa. The chapter notes that backup strategy, migration,

metadata and trusted repositories are still widely used preservation strategy but that cloud computing, refreshing and emulation remain present as preservation strategies used to address the digital preservation challenges. The chapter recommends: clarity in policy formulation; well-crafted legislative framework; national collaborative and participatory opportunities; sensitization and awareness programs; human resource technical skilling; development of centers of excellence; clear disaster and recovery plans are key strategic policy options for Africa.

REFERENCES

Adu, K. K. (2015). *Framework for digital preservation of electronic government in Ghana* (Unpublished doctoral dissertation). University of South Africa, Pretoria, South Africa.

Adu, K. K., & Ngulube, P. (2017). Key threats and challenges to the preservation of digital records of public institutions in Ghana. *Information Communication and Society, 20*(8), 1127–1145. doi:10.1080 /1369118X.2016.1218527

Barker, A. W. (2003). Archaeological ethics: Museums and collections. In L.J. Zimmerman, K.D. Vitelli, & J. Hollowell-Zimmer (Eds.), Ethical Issues in Archaeology (pp. 71-84). Walnut Creek, CA: AltaMira Press.

Bayissa, G., Ketema, G., & Birhanu, Y. (2010). Status of digitization process in selected institutions of Ethiopia: A baseline stakeholders' analysis survey report. *Ethiopia Journal of Education & Science, 2*(5), 1–18.

Beagrie, N. (2008). *Digital preservation policies*. Retrieved July 4, 2016, from http://www.beagri.com

Bekele, D. (2006). *Digital Material Preservation in Ethiopia. Report to UNESCO under its Digital Heritage Project*. Paris: UNESCO.

Botswana Government. (2005). *Mission Statement: Botswana National Archives and Records Service*. Retrieved July 8, 2014, from http://www.digital preservation\Botswana\.html

Cathro, W., Webb, C., & Whiting, J. (2009). *Archiving the web: the Pandora archive at the national Library of Australia - National Library of Australia Staff Papers*. Retrieved July 6, 2016, from https://www.nla.gov.au/digital-preservation/related-staff-papers

Day, M. (2008). Toward distributed infrastructure for digital preservation: The roles of collaboration and trust. *International Journal of Digital Curation, 1*(3), 15–28. doi:10.2218/ijdc.v3i1.39

Dečman M. & Vintar M. (2013). A possible solution for digital preservation of e-government. *Aslib Proceedings, 65*(4), 406 – 424. 4910.1108/AP-05-2012-00

Digital Library Federation. (1995). *America's Heritage: Mission and Goals for a Digital Library Federation*. Retrieved September 29, 2016, from http://www.diglib.org/about/dlfcharter.htm

Digital Preservation Coalition. (2002). *DPC/PADI What's new in digital preservation*. Retrieved October 10, 2007, from http://www.dpconline.org/graphics/whatsnew/

Digital Preservation Coalition. (2015). *Digital Preservation Handbook*. Retrieved September 10, 2017, from http://www.dpconline.org/handbook/contentshttp://dpconline.org/docs/digital-preservation-handbook2/1552-dp-handbook-digital-preservation-briefing/file

Digital Preservation Coalition & Pennock. (2013). *Web Archiving, DPC Technology Watch Reports*. Retrieved September 10, 2017, from http://www.dpconline.org/about/working-groups-and-task-forces/524-web-archiving-andpreservation-task-force

Duranti, L. (2007). Reflections on the InterPARES 2 Project (2002– 2007): An Overview. *Archivaria: The Journal of the Association of Canadian Archivists, 64*, 113–121.

Duranti, L. (2015). *Overview of InterPARES Trust - Work to Date. Third International Symposium of InterPARES Trust*. Retrieved 5th June, 5, 2017, from https://interparestrust.org/assets/public/dissemination/IPT_20150515_InternationalSymposium3_Duranti_InterPARESTrustOverview_Presentation.pdf

Estonian Ministry of Economic Affairs and Communications. (2016). *Transforming Digital Continuity: Enhancing It Resilience Cloud Computing: A Joint Research*. Retrieved September 29, 2016 from https://www.Mkm.Ee/.../Transforming_Digital_Continuity-_Joint_Research_Report_Final

Foot, M. (2006). Preservation policies and planning. In G.E. Gorman & S.J. Shep (Eds.), Preservation management for libraries and museums (pp. 19–41). London: Facet.

Garrett, J., & Waters, D. (1996). *Preserving Digital Information: Report of the Task Force on Archiving of Digital Information*. Retrieved September 29, 2016, from https://www.clir.org/pubs/reports/pub6

Grotke, A. (2011). *Web Archiving at the Library of Congress*. Retrieved June 10, 2017, from http://www.infotoday.com/cilmag/dec11/Grotke.shtml

Haag, D. (2002). *Digital Preservation Testbed White Paper XML and Digital Preservation*. Retrieved September 29, 2016, from http://www.digitaleduurzaamheid.nl/bibliotheek/docs/white-paper_xml-en.pdf#search='whAT%20IS%20ENCAPSULATION%20IN%20DIGITAL%20PRESERVATION.'

Hammoya, C., & Njobvu, B. (2010). Digitization of archival materials: The case of National Archives of Zambia. *ESARBICA Journal, 29*, 234–247.

Harvey, R. (1993). *Preservation in Libraries: Principles, Strategies and Practices for librarians*. London: Bower.

Hedstrom, M. (1995). Electronic Archives: Integrity and Access in the Network Environment. In *Proceedings of the Second Conference on Scholarship and Technology in the Humanities*. London: Bowker-Saur. doi:10.17723/aarc.58.3.n7353726666u41v5

Horrigan, J. B. (2016). *Digital Readiness Gaps*. Retrieved September 21, 2016, from http://www.pewinternet.org/files/2016/09/PI_2016.09.20_Digital-Readiness-Gaps_FINAL.pdf

IFLA. (2002). *Guidelines for Digitization Projects: for collections and holdings in the public domain, particularly those held by libraries and archives*. Retrieved September 20, 2016, from http://www.ifla.org/VII/s19/pubs/digit-guide.pdf

InterPARES Trust. (2017a). *About the Research*. Retrieved August, 17, 2017, from https://interparestrust. org/trust/about_research/summary

InterPARES Trust. (2017b). *About Us: Team Index*. Retrieved August, 17, 2017, from https://interparestrust.org/trust/aboutus

InterPARES Trust - Team Africa. (2016a). *Proposal - AF03 Enterprise digital records management in Zimbabwe*. Pretoria: InterPARES Trust - Team Africa.

InterPARES Trust - Team Africa. (2016b). *Proposal - AF04 Enterprise digital records management in Botswana*. Pretoria: InterPARES Trust - Team Africa.

JISC. (2008). *Selecting the right preservation*. Retrieved September 23, 2016, from http://www.paradigm. ac.uk/workbook/preservatio-strategies/selecting-migration.html

Johnston, L. R. (2014). *Why Engage in Preseravtion of Data for Long Term*. Retrieved September 10, 2017, from https://www.lib.umn.edu/about/staff/lisa-johnston

Kalusopa, T. (2017). *Implementation of enterprise-wide systems to manage trustworthy digital records in Botswana's public sector*. Paper Presented at XXIV Biennial ESARBICA General Conference: Public Sector Records - Accountability and Transparency, Lilongwe, Malawi.

Kalusopa, T., & Zulu, S. (2009). *Digital heritage material preservation in Botswana: Problems and prospects*. Retrieved September 23, 2016, from http//: www.emeraldinsight.com

Katuu, S., & Ngoepe, M. (2015) *Managing digital heritage – an analysis of the education and training curriculum for Africa's archives and records professionals*. Retrieved September 20, 2016, from https:// interparestrust.org/assets/.../Katuu-Ngoepe_20151022_ICCSM2015_Paper.pdf

Keakopa, S. (2006). *Management of Electronic Records in Botswana, Namibia and South Africa: Opportunities and Challenges* (Unpublished doctoral dissertation). University College London, London, UK.

Kirchhoff, A. J. (2008). Digital preservation: Challenges and implementation. *Learned Publishing, 21*(4), 285–294. doi:10.1087/095315108X356716

Kirk, J. (2013). *Google to encrypt cloud storage data by default*. Retrieved September 23, 2016, from http://www.computerworld.com/s/article/9241670/Google_t

Library of Congress. (2016). *Library of Congress Digital Preservation Tools and Services Inventory*. Retrieved September 23, 2016, from http://www.digitalpreservation.gov/about/resources.html

Luyombya, D. (2011). ICT and digital records management in the Ugandan public service. *Records Management Journal, 21*(2), 135–144. doi:10.1108/09565691111152062

Maemura, E., Moles, N., & Becker, C. (2017). Organizational assessment frameworks for digital preservation: A literature review and mapping. *Journal of the Association for Information Science and Technology, 68*(7), 1619–1637. doi:10.1002/asi.23807

Michelson, A., & Rothenberg, J. (1992, Spring). Scholarly Communication and Information Technology: Exploring the Impact of Changes in the Research Process on Archives. *The American Archivist, 55*, 236–315. doi:10.17723/aarc.55.2.52274215u65j75pg

Mutiti, N. (2001). The challenges of managing electronic records in the ESARBICA region. *ESARBICA Journal, 20*(3), 57–61.

Namaganda, A. (2011). *Digitization of Uganda's music cultural heritage: lessons from Makerere University Library Digital Archive.* Paper presented at the 2nd International Conference on African Digital Libraries and Archives (ICADLA-2), University of Witwatersrand, Johannesburg, South Africa.

National Archives UK. (2011). *Web Archiving Guidance.* Retrieved from: https://nationalarchives.gov.uk/documents/information-management/web-archivingguidance.pdf

National Archives and Records Service of South Africa (NARSSA). (2006). *Records Management Policy Manual.* Pretoria, South Africa: NARSSA.

National Archives of U.K. (2014). *The Technical Registry PRONOM.* Retrieved April 23, 2017, from http://www.nationalarchives.gov.uk/PRONOM/

National Archives (UK). (2005). *Digital Preservation.* Retrieved October 7, 2016, from http://www.digitalpreservation/UK/theNationalArchivesServicesforprofessionalsPreservationDigitalpreservation.htm

National Digital Information Infrastructure and Preservation programme (NDIIPP). (2005). NDIIPP holds three workshops for states, territories at library. *Library of Congress Information Bull, 64*(9), 1-2.

National Institute of Standards and Technology (NIST). (2011). *NIST definition of cloud computing.* Retrieved September 20, 2016, from http//csrc.nist.gov/publications/nistpubs/800-145/SP800-145.pdf

Ngoepe, M. (2017). *Archival orthodoxy of post-custodial realities for digital records in South Africa.* Archives and Manuscripts; doi:10.1080/01576895.2016.1277361

Ngoepe, M., & Keakopa, S. M. (2011). An Assessment of the State of National Archival and Records Systems in the ESARBICA region: A South Africa-Botswana Comparison. *Records Management Journal, 21*(2), 145–160. doi:10.1108/09565691111152071

Ngulube, P. (2003). *Preservation and access to public records and archives in South Africa* (Unpublished doctoral dissertation). University of Natal, Durban.

Ngulube, P. (2009). *Preservation and access to public records and archives in South Africa.* Saarbrucken: Lambert Academic Publishing AG & Co. KG.

OCLC/RLG. (2002). *Preservation Metadata Working Group.* Retrieved April 23, 2017, from http://www.oclc.org/research/pmwg/

Ross, S. (2003). *Challenges to Digital Preservation and Building Digital Libraries, 69th IFLA World Library and Information Congress and Council, 1-9 August, 2003, Berlin.* Retrieved April 23, 2017, from http://www.ifla.org

Rothenberg, J. (1995, January). Ensuring the Longevity of Digital Documents. *Scientific American, 272,* 42–47. doi:10.1038/scientificamerican0195-42

Russell, K. (2002). Libraries and digital preservation: Who is providing electronic access for tomorrow? In C. F. Dekker (Ed.), *Libraries, the Internet, and Scholarship* (pp. 1–30). New York: Marcel Dekker, Inc.

Tembo, E., Kalusopa, T., & Zulu, S. (2006). *Digital Material Preservation Project in Botswana. Report to UNESCO under its Digital Heritage Project*. Gaborone: University of Botswana.

Tsebe, J. (2005). *Networking Cultural Heritage: Africa*. Retrieved April 23, 2017, from http://www.ifla. org/IV/ifla71/papers/157e-Tsebe.pdf

UNESCO. (2003a). *DPC/PADI; What's new in digital preservation*. Retrieved April 23, 2017, from http:// www.digital preservation\UNIVERSAL\DPC-PADI

UNESCO. (2003b). *Charter on the preservation of the digital heritage*. Retrieved April 23, 2017, from http://portal.unesco.org/ci/en/file

UNESCO. (2003c). *Guidelines for the Preservation of Digital Heritage*. Retrieved April 23, 2017, from http://unesdoc.unesco.org/images/0013/001300/130071e.pdf

UNESCO/UBC. (2012). The memory of the world in the digital age: digitization and preservation. In *Proceeding of an international conference on permanent access to digital documentary*. Author.

van der Hoeven, J., Lohman, B., & Verdegem, R. (2007). Emulation for Digital Preservation in Practice: The Results. *International Journal of Digital Curation*, 2(2), 123–132. doi:10.2218/ijdc.v2i2.35

van Wijngaarden, H. (2004). Digital preservation in practice: The e-Depot at the Koninklijke Bibliotheek. *Vine*, 34(1), 21–26. doi:10.1108/03055720410530951

Waibel, G., & Erway, R. (2009). Think globally, act locally: Library, archive, and museum collaboration. *Museum Management and Curatorship*, 24(4), 323–335. doi:10.1080/09647770903314704

Zulu, S. F. C. (2005). *Issues in managing electronic records*. Gaborone: University of Botswana. (Unpublished)

KEY TERMS AND DEFINITIONS

Authenticity: This implies the digital material is what it purports to be. In the case of electronic records, it refers to the trustworthiness of the electronic record as a record. In the case of "born digital" and digitized materials, it refers to the fact that whatever is being cited is the same as it was when it was first created unless the accompanying metadata indicates any changes. Confidence in the authenticity of digital materials over time is particularly crucial owing to the ease with which alterations can be made.

Digital Archiving: Digital archiving is the process of creating digital backup as an ongoing maintenance as opposed to strategies for long-term digital preservation.

Digital Continuity: Digital continuity is the capacity of an organization or state to maintain its services and digital data relevant for the its functioning, regardless of any adverse changes or interruptions so as to enable stability, recovery and restoration of e-services rapidly in the event natural disaster.

Digital Preservation: Digital preservation is a series of adopted management activities necessary to ensure a continued access to digital materials for as long as required.

Digitization: Digitization is the process of converting information into a digital format making it easier to preserve, access, and share the content without any physical barrier worldwide.

Preservation: Preservation implies policies and options for maintenance of different formats of information materials so that the spiritual, ritual, or cultural perceptions of value are retained through reformatting the content and physical structure and environmental controls.

Web Archiving: Web archiving is a careful process of collection, selection, storage, appraisal and preservation of website records and information so to make it available to posterity.

Chapter 9

The Scope and Appetite for Technology–Assisted Sensitivity Reviewing of Born–Digital Records in a Resource Poor Environment:
A Case Study From Malawi

Alistair G. Tough
University of Glasgow, UK

ABSTRACT

Concerns about sensitive content in born-digital records seem to be a major factor in inhibiting the deposit of public records in dedicated digital repositories in Western countries. These concerns are much exacerbated by the changed nature of the process of reviewing records. The University of Glasgow, working in collaboration with the Foreign and Commonwealth Office, received funding to investigate the technology-assisted sensitivity reviewing of born-digital records. As part of this research, some preliminary research in a commonwealth country in Sub-Saharan Africa was carried out. The research, reported in this chapter, was carried out in Malawi by the late Dr. Mathews J. Phiri. He found that already there is a real, albeit limited, demand for technology-assisted sensitivity reviewing of born-digital records in Malawi. The available evidence suggests that within the next decade there is likely to be an increase in the need for effective means of assessing sensitivity in born-digital records.

DOI: 10.4018/978-1-5225-3137-1.ch009

INTRODUCTION

For many years a spirited debate has taken place over the custody of digital records (Tough, 2004). There are those who argue that records created digitally should be retained by the creating agency and the future role of archivists should be as facilitators of access (Upward, 2000). In the opposing camp are those who argue that archives must continue to take records into custody, irrespective of the format in which they are created (Cunningham, 2011). In recent years, the second group has prevailed. Large and expensive digital repositories have been created in Australia, the United Kingdom, the United States and elsewhere. However, most of the digital repositories remain massively under-utilised. Short-lived public bodies like Royal Commissions and other enquiries do deposit their records as they are bringing their existence to an end. However, few ministries, departments or agencies do so.

Concerns about sensitive content in born-digital records seem to be a major factor in inhibiting deposit of public records in dedicated digital repositories. In Western countries, this concern is primarily of two types. Firstly, there is concern in relation to sensitive personal data of the kind that is covered by data protection laws (e.g. regarding a person's denominational affiliation, sexual orientation, earnings, bank account details, et cetera). Secondly, there are concerns about national security, defence, anti-terrorist initiatives, et cetera). As Sir Alex Allan has expressed it, in relation to the British context (Allan, 2014):

The risk if this issue is not addressed satisfactorily is either that material will be released to TNA without proper review, leading to embarrassment when sensitive material is found to be in the public domain; or, perhaps as a reaction to the discovery of such releases, departments become risk averse and apply for blanket closures of records

Difficulties of the kind described by Sir Alex Allan are exemplified in events in the USA surrounding the release of e-mails created by Hillary Clinton as Secretary of State and controversially stored on a private server (Westwood, 2016). There were widespread complaints regarding the long delays in making these available: the delays were due to an acute anxiety that sensitive material might be accidentally made public. Approximately 30,000 e-mails had to be reviewed and, as the review was conducted by human beings without advanced technological aids, this proved a lengthy undertaking.

The concerns outlined above are much exacerbated by the changed nature of the process of reviewing records. Until quite recently, public records characteristically took the form of well-maintained filing systems, run by specialist records staff, which presented large numbers of individual documents in logical relationship to each other (Reed, 2005). This is no longer the case. Despite the availability of Electronic Document and Records Management Systems [EDRMS], the great majority of contemporary public sector records take the form of digital objects created and kept in poorly-organised systems that fail to create persistent links between related items (Moss, 2005). So reviewing often involves adopting a document by document rather than a file by file approach. This shift has tended to undermine long-established practices that involved retired civil servants, often people of high intellectual calibre, gathering to spend mornings reviewing files before going to an agreeable lunch. This productive human dynamic is not readily applied to the reviewing of born-digital records.

In the face of these challenges, it is hardly surprising that The National Archives of the United Kingdom has begun to investigate the possibility that technological solutions may help to address problems created by technology. TNA has undertaken these investigations in conjunction with several Higher Education Institutions. It has become clear that the way forward will not be straightforward. An aspect of this is the

significance of context. Some statements are sensitive if made in a civil service briefing and not sensitive if made in a newspaper article. Similarly, words uttered in a cabinet meeting may be confidential whilst the same words said in Parliament and recorded in Hansard cannot possibly be regarded as sensitive. So it has been accepted that it is not realistic to think that human intervention can be eliminated: what may be achievable is technology-assisted sensitivity reviewing of born-digital records. In essence, this involves extending Information Retrieval techniques and technologies in such a way as to support reviewers (McDonald, Macdonald & Ounis, 2014; Sebastiani, Esuli, Berardi, Macdonald & Ounis, 2015).

In 2016 the University of Glasgow, working in collaboration with the Foreign and Commonwealth Office, received funding to investigate the technology-assisted sensitivity reviewing of born-digital records generated by British diplomats at home and abroad. As part of this research it was agreed to carry out some preliminary research in a Commonwealth country in Sub-Saharan Africa. The shared legacy of legal and administrative systems makes this a sensible way to proceed. Malawi was selected as the site of this research for two reasons. Firstly, because Malawi is one of only 8 African countries to have signed up to the Open Government Partnership, thereby committing "to promote transparency, empower citizens, fight corruption, and harness new technologies to strengthen governance" (Open Government Partnership, undated). The emphasis on new technologies by the Open Government Partnership may be regarded as characteristic of donor behaviour. As Michael Moss has put it "Donors have insisted that such countries adopt new technology to manage business processes with little thought as to how born digital information, essential for the accountability of government, will be released by due process into the public domain" (Moss, 2016). In addition, the existing networks connecting people in Glasgow University with Malawi were a factor in selecting that country as the location in which to carry out the work.

OBJECTIVE AND METHOD

One of the objectives of this research project was to establish whether there appears to be an African perspective on these questions and a perceived need for change. The research in Malawi was focussed on parts of the public sector that are located at a distance from the capital, Lilongwe, as it was felt this approach might bring some interesting issues to light. The work was carried out by the late Dr Mathews J Phiri of Mzuzu University: a tribute to him appears as an appendix to this chapter. Amongst bodies at which field research was carried out were the following: the Judiciary (in Blantyre); Public Private Partnership Commission (in Blantyre); National Records and Archives of Malawi (in Zomba); National Statistical Office (in Zomba). In November 2016 Dr Phiri carried out research visits to these bodies, interviewing senior members of staff, witnessing demonstrations of systems and collecting documentation

FINDINGS

The research proved to be timely, not least in respect of the National Records and Archives of Malawi which is going through a period of profoundly significant change (Interview Lihoma, 2016). Of particular importance to this research, the Access to Information Bill being considered by the Malawian Parliament at the time of the field research provided that records (including born-digital records) should be transferred to the National Records and Archives of Malawi for public access after seven years. This legislation was signed into law by the President in 2017 (Khamula, 2017). This creates a challenging

situation, given that hitherto the National Records and Archives of Malawi has regarded sensitivity reviewing as the responsibility of depositing ministries, departments and agencies. At the very least, the National Records and Archives of Malawi will need to expand its skills-base to provide advice and guidance in response to such a change. The challenges facing the National Records and Archives of Malawi in respect of sensitivity reviewing of born-digital records need to be understood in the context of other major changes. Structurally the National Records and Archives of Malawi is reorganising itself from being a sub-department to become a fully-fledged department in its own right. Physically it is preparing to relocate its headquarters from Zomba to Lilongwe. Its operating legislation is also evolving to include digital records in the definition of a record.

It is anticipated that a prime source of born-digital records will be the Government Area Wide Network (GWAN) (Interview Lihoma, 2016). The GWAN project is at an early stage. The goal is to have an integrated network connecting all government offices, starting with the headquarters of ministries, departments and agencies in Lilongwe. It is intended that the services provided by GWAN will include

- Integrated Financial Management System (IFMIS)
- Human Resources Management Information System (HRMIS)
- Internet
- Email
- LAN services for ministries and departments
- Network security
- Website hosting for, amongst others, www.malawi.gov.mw

At present GWAN is slow and often down. However, the Regional Communications Infrastructure Project (RCIP) which is being financed by the World Bank has the potential to transform the effectiveness of GWAN (Interview Mwangwela and Mnthambala, 2016). RCIP aims to take advantage of the fibre-optic cables that pass from South Africa to Tanzania through Malawi to improve the quantity, availability and affordability of broadband within Malawi for both public and private users. RCIP could provide the capacity and reliability that GWAN currently lacks. So born-digital records and the challenges associated with sensitivity are matters that the public sector in Malawi will need to address in the near future.

What of the current reality? The capture of essentially oral communication is an integral part of well-designed and implemented record keeping systems. It is evident from the results of our research that many oral communications – both those occurring as one-to-one conversations by phone and those taking place in face-to-face meetings are not recorded at all. From the perspective of this research project, the big issue here is the absence of digital records that can be assessed for sensitivity. However, it should be acknowledged that the record keeping system run by the judiciary represents an exception to this pattern. Their EU funded Electronic Case Management System is seen as a virtual revolution in the judicial system's handling of cases (Interview Kumukani, 2016). At present it covers the higher judiciary and the Directorate of Public Prosecutions. It enables users to track the progress of cases through an integrated national e-justice system. Of particular note is the convention that telephone conversations relating to cases should be captured in writing in a digital format and the summary of the call should be circulated to colleagues. It is a moot point whether a full and effective implementation of GWAN would significantly reduce the widespread reliance on un-recorded oral communication in other parts of the public sector.

Then there is the challenge of managing e-mail accounts provided by third party services and used for the transaction of public business. In this respect there is a well-defined distinction between the Judiciary (at least, the higher judiciary) and the Public Private Partnership Commission (PPPC) on one hand and the National Records and Archives of Malawi and National Statistical Office on the other. The former possess reliable internal, i.e. official, e-mail systems whilst the latter do not. As a result, officers in the National Records and Archives of Malawi and National Statistical Office who wish to get on with their work are obliged to make use of free private e-mail systems like Hotmail and Yahoo. From the perspective of this research project, the big concern here is that many digital records are being created and/or transmitted in such a way that they are not captured in official systems and that therefore they cannot be assessed for sensitivity. For the time being, the National Records and Archives of Malawi and National Statistical Office are closer to the reality of the bulk of the public service, in that they have comparatively weak digital record keeping capacity.

It is worth giving some further attention to the PPPC, as their experience may give some indicators regarding the future. The PPPC is the implementation agency for Public Private Partnerships in Malawi and is responsible for developing guidelines on best practices to ministries in the roll-out of their PPP projects. It is the successor body to the Privatisation Commission and has inherited from that body a good record keeping system that is a hybrid of digital and analogue components. In passing, it is worthy of comment that when 50 public bodies were assessed for their auditing capability in 2011 only 2 received praise for the quality and comprehensive nature of their systems, and one of these was the Privatisation Commission (SGS, 2011). Now the PPPC aspires to a fully digital system. If GWAN is operationalised successfully then the experience of the PPPC may serve as an exemplar for implementation.

FUTURE RESEARCH DIRECTIONS

Already there is a real, albeit limited, demand for technology-assisted sensitivity reviewing of born-digital records in Malawi. The available evidence suggests that within the next decade there is likely to be an upward step-change in the need for effective means of assessing sensitivity in born-digital records.

It is worth bearing in mind, however, that Malawian (and possibly other Sub-Saharan countries) perspectives on the matter may be different from those espoused by the public sector in the UK, USA and continental Europe. As the author has written in a previous publication (Tough, 2009) sub-Saharan African countries:

May hold to concepts of accountability that are different from contemporary Western notions. In particular, they may see the eradication of corruption as primarily a matter of making corrupt officials and politicians accountable to the President via the machinery of government. . . . Harvard University's Robert Rotberg has pinned his hopes for progress on strengthening African leadership ... A similar stance has been adopted by Mo Ibrahim in establishing his foundation to promote ethical conduct on the part of leaders.

REFERENCES

Allan, S. A. (2014). *Government digital records and archives review*. London: Cabinet Office. Retrieved 1 August 2017 from https://www.gov.uk/government/publications/government-digital-records-and-archives-review-by-sir-alex-allan

Cunningham, A. (2011). Good digital records don't just happen. *Archivaria*, 71. (Spring 2011), 21-34

Khamula, O. (2017). Mutharika signs Access to Information Bill into law: New dawn for transparency in Malawi. *Nyasa Times*. Retrieved 21 September 2017 from https://www.nyasatimes.com/mutharika-signs-access-information-bill-law-new-dawn-transparency-malawi/

McDonald, G., Macdonald, C., & Ounis, I. (2014). Towards a Classifier for Digital Sensitivity Review. *Proceedings of 36th European Conference on Information Retrieval*. doi:10.1007/978-3-319-06028-6_48

Moss, M. (2005). The Hutton Inquiry, the President of Nigeria and What the Butler Hoped to See. *The English Historical Review*, *120*, 487. 577-592

Open Government Partnership. (n.d.). *About OGP*. Retrieved 1 August 2017 from https://www.open-govpartnership.org/about/about-ogp

Reed, B. (2005). Records. In *Archives: recordkeeping in society*. Wagga Wagga: Centre for Information Studies, Charles Sturt University. doi:10.1016/B978-1-876938-84-0.50005-6

Sebastiani, F., Esuli, A., Berardi, G., Macdonald, C., & Ounis, I. (2015). Semi-Automated Text Classification for Sensitivity Identification. *Proceedings of International Conference on Information and Knowledge Management.*

SGS. (2011). Draft audit report. Procurement review / audit of selected procuring entities in the public service. Lilongwe: Office of the Director of Government Procurement. Ref. ODPP/03/130/2011/1.

Tough, A. G. (2004). Post-custodial / pro-custodial argument from a records management perspective. *Journal of the Society of Archivists*, *25*(1), 19–26. doi:10.1080/0037981042000199115

Tough, A. G. (2009). Archives in sub-Saharan Africa half a century after independence. *Archival Science*, *9*(3-4), 2009. doi:10.1007/s10502-009-9078-1

Upward, F. (2000). Modelling the continuum as paradigm shift in recordkeeping and archiving processes, and beyond - a personal reflection. *Records Management Journal*, *10*(3), 115–139. doi:10.1108/EUM0000000007259

Westwood, S. (2016, May 17). A brief guide to Clinton scandals. *Washington Examiner.*

ADDITIONAL READING

Allan, S. A. (2014). *Records review*. London: Cabinet Office. Retrieved 1 August 2017 from https://www.gov.uk/government/publications/records-review-by-sir-alex-allan

Cabinet Office Digital Records and Information Management Team. (2017). *Better information for better government*. London: Cabinet Office.

McDonald, G., Macdonald, C., & Ounis, I. (2015). Using Part-of-Speech N-grams for Sensitive-text Classification. *Proceedings of International Conference on the Theory of Information Retrieval*.

The National Archives of the United Kingdom. (2016). *The application of technology-assisted review to born-digital records transfer. Inquiries and beyond: Research report*. Retrieved 1 August 2017 from http://www.nationalarchives.gov.uk/documents/technology-assisted-review-to-born-digital-records-transfer.pdf

Tough, A.G. (2011). *Electronic records management in Malawi: An introductory workbook*. Zomba: National Archives of Malawi.

APPENDIX

Mathews Phiri, An Appreciation

Mathews was a gifted teacher, a dedicated research academic and excellent company. He was a good friend too, invariably cheerful and positive in his outlook. Tragically he died, suddenly and utterly unexpectedly, just as he was setting out from Mzuzu to Glasgow to attend his Ph. D. graduation ceremony.

Mathews was originally from Nsanje in the low-lying and intensely hot far south of Malawi. His mother later moved to the Chikwawa district, closer to the big city of Blantyre but still in the Lower Shire valley. He studied at the University of Malawi, then the only university in the country. After graduating he taught mathematics in secondary schools for a time. His gifts as a teacher were noticed and he was offered a lectureship in Information Studies at Malawi's second public university in Mzuzu. When it was recognised that his department needed someone to teach Records Management, Mathews agreed to go overseas to obtain a recognised qualification. He spent a happy year in Aberystwyth where he obtained his master's degree.

Mathews was particularly well suited to the role of leading on Records Management as he had a strong commitment to the subject. Mathews' teaching duties at Mzuzu University were far from straightforward. His classes characteristically consisted of a mix of students, some of whom had good academic qualifications but little experience in the workplace whilst others had a good deal of relevant experience but modest qualifications. He managed this challenge with aplomb, seeking to engage both experience and intellectual attainments in the classroom.

Early in the twenty first century it was recognised that Malawi needed a postgraduate degree course in Librarianship and Information Science that would incorporate major archive and records studies components. After a prolonged period of preparation, an MLIS course was inaugurated at Mzuzu. The preparatory work was supported by the Scotland Malawi Partnership.

It was recognised that teaching the MLIS course would require well qualified academic staff. So Mathews returned to the UK to undertake doctoral study in the University of Glasgow. His research topic was the management of records in higher education in an era of corporatisation. He proved to be a conscientious and able research student. In particular, he accepted constructive criticism with great good will and made good use of advice when it was offered.

Mathews died from heart failure. In the week prior to his death, there had rarely been power in Mzuzu. On the day before Mathews died the power was on, so he started to catch up on the backlog of e-mail, word processing et cetera. The power stayed on all night, so he worked all night. The next morning Mathews should have driven to Lilongwe to begin his journey to Glasgow but he felt very ill. His wife Elizabeth called an ambulance and they got him to the nearby Regional Hospital quickly. There a cardiac illness was diagnosed and oxygen and an intravenous drip were provided. This resulted in a marked improvement in Mathews' blood pressure, pulse and respiration. Then a decision was made to move him to a ward. Unfortunately, the hospital could not provide oxygen whilst moving Mathews. Whilst the trolley was being moved from the Accident and Emergency Department to the ward, Mathews died of heart failure

Mathews was a practising Catholic. During his time in Glasgow he joined a congregation made up almost entirely of Africans – mainly Nigerians – where worship was conducted without the inhibitions found in many Scottish churches.

Mathews Phiri was born 14 Feb 1972 in Nsanje and died on 22 Nov 2016 in Mzuzu.

Chapter 10

Environmental Consideration in the Preservation of Paper Materials in Heritage Institutions in the East and Southern African Region

Thatayaone Segaetsho
University of Botswana, Botswana

ABSTRACT

Heritage institutions, especially in developing countries throughout the world, have difficulties in achieving ideal environmental conditions in the preservation of paper materials. Concerns exist about improving environmental conditions in heritage institutions considering the limited storage facilities and resources in most developing countries in Africa. This chapter redefines suitable strategies for various environmental factors impacting preservation in heritage institutions in the East and Southern African Region. The chapter discusses effective activities, environmental factors, and explores knowledge and skills required for achieving ideal storage conditions. Furthermore, it discusses the key challenges of maintaining ideal and constant environmental conditions for paper-based materials particularly in developing countries where resources are limited. The chapter concludes by providing a recommendation of an environmental conditions management framework that can be used to effectively manage environmental conditions in heritage institutions.

INTRODUCTION

Document heritage institutions such as libraries, archives and museums have the jurisdiction to make provision for the safety, well-being and dissemination of information resources to the public throughout the world. For these information resources to remain accessible in present and future years, heritage institutions have the responsibility of preserving them in perpetuity. However, due to the compounding

DOI: 10.4018/978-1-5225-3137-1.ch010

complexity of the custodial functions of heritage institutions, from analogue to digital, preservation work becomes harder and harder more especially in developing countries. The situation is compounded by the fact that only a few heritage institutions in most of the developing countries have appropriate policies, standards, procedures and guideline strategies for averting deterioration factors. The situation is further exacerbated by the fact that most small developing heritage institutions have limited air conditioning systems in place. Ideally, every heritage institution should aim at achieving and maintaining best preservation practices more especially in providing ideal storage conditions. But this may not be practical in every location. Therefore, the first step in preservation is to examine the environment in storage areas, examine conditions of collections themselves, and then make recommendations for improvement. In fact, preservation programmes are founded on providing an ideal and constant environment in storage, exhibition and reading areas. As such, heritage institutions throughout the world, only use preservation standards to help set their priorities for improvement and to identify areas where improvement can most readily be made.

A significant number of researchers in African region have conducted various studies related to preservation. For example, Mazikana (1992;1995), Ojo-Igbinoba (1993), Chida (1994), Khayundi (1995), Matwale (1995), Kemoni (1996), Kufa (1998), Alegbeleye (1999), Akussah (2002), Murray (2002), Matangira (2003), Ngulube (2002; 2005), Segaetsho and Mnjama (2012), Segaetsho (2014) and Thabakgolo and Jorosi (2014) conducted different studies in various African countries addressing preservation issues and giving various recommendations for improvement. Although these rigorous researches have been conducted on preservation, little has been emphasized on how to manage the activities deemed necessary for achieving an ideal and constant environment for paper based materials in small and developing heritage institutions. Writers tend to only present information on environmental factors and how they affect collections, but often neglect presenting information on how to manage activities centered on providing ideal environmental conditions. The necessity for individual institutions or countries to assess their situations and make improvements based on their capabilities and environment has been already emphasized by Peters (1996) who posited that; "recommendations of fixed values of temperature and humidity for the preservation of collections are not universally applicable" (p. 06). In fact, heritage institutions should adopt or devise environmental conditions management strategies that are aligned to their level of individual needs.

Deterioration due to environmental conditions is irreversible, although it can be minimized. It is, therefore, vital that basic procedures of monitoring and controlling environmental conditions be conducted. Heritage institutions thus must develop innovative strategies to suit the varied institutional setups, challenges and individual needs. In fact, information on preservation is diverse, often complex due to various jargons that might be only known by preservation experts, and often confusing to new professionals. The vast information on preservation often fails to provide abecedarian guidelines and knowledge for non-expert personnel who are concerned with preservation, particularly on storage conditions. It is, therefore, hard to find simple information explicitly explaining how to manage environmental conditions specific to paper based materials. Given these situations, the key question which this chapter addresses is; how can we effectively manage and achieve ideal and constant environmental conditions in heritage institutions, more especially in small and developing institutions with limited resources? To address this question, this chapter discusses the following: the chapter starts by providing a brief history of paper; an overview of effective activities and methods of achieving ideal environmental conditions in document heritage institutions; environmental factors affecting paper based materials, knowledge and skills required for monitoring and control of environmental conditions; Key challenges of maintaining ideal

and constant environmental conditions for paper based materials particularly in developing countries where resources are limited, theoretical models, and recommendation of managing environmental conditions through effective application of an Environmental Conditions Management Framework (ECMF).

BRIEF HISTORY OF PAPER

As put by Hunter (2011), the evolution of speaking, drawing and printing goes as far as 250BC where by cloths and papyrus were used as drawing and writing media for communication purposes. Due to increased demands for cheaper and easy-to-handle methods of drawing and writing, paper emerged as a preferred media. The history of paper goes as far as AD 105, after its invention by the Chinese Eunuch Ts'ai Lun (Hunter, 2011). Paper is a sheet of fibers macerated together into a thin filament or sheet. As put by Daniels (1996), it is "essentially a mat of cellulose fibres formed into a sheet by draining a suspension of fibres in water through a mesh" (p. 179). The fibres are therefore one of the important factors governing the structure and properties of paper. They are polymers made from glycosidic linkage chemically connected together to form what is known as cellulose. The chemical, mechanical and physical properties of paper are, therefore, highly influenced by the cellulose and other side compounds such as lignin and hemicellulose. During paper manufacturing process, other materials such as adhesives, additives such as fillers (sizing) and surface coatings or water repellents, wet strength additives, pigments and dyes are introduced making paper materials even more complex (Daniels, 1996). Paper is thus susceptible to different damages if exposed to different environmental conditions, inappropriate handing, and exposure to pests, mould and disasters. It is therefore well known within the heritage institutions that the understanding and control of environmental conditions becomes paramount in the preservation of paper materials. Monitoring and controlling the environment in which paper is stored, equipment, skills, and management strategies becomes core in preservation. The next section provides a look at some of the critical procedures for managing environmental conditions in heritage institutions.

MANAGING ENVIRONMENTAL CONDITIONS IN DOCUMENT HERITAGE INSTITUTIONS

Since the 1980s a common understanding is that environmental monitoring is a process of climate control, providing heating, humidification, cooling and dehumidification; i.e. providing ambient atmospheric conditions. Swartzburg (1980), and King and Pearson (1992), defined environmental monitoring as the process centered on monitoring and controlling light, temperature, relative humidity, air-pollutants and particulates matter. In some cases, other writers go on to even include housekeeping and other biological agents such as mould and pests as factors to consider as environmental considerations. However, from the various definitions explored in literature, the point is that there are exhaustless factors to consider when monitoring environmental conditions. Henderson (2013) indicated that environmental monitoring strategies should embrace the process of determining the deterioration factors to monitor depending on the type of collection, identifying their building location, establishing targets, purchasing, and installation of equipment. He further stated that the process then goes on to collecting and organizing data, analysis, presentation and acting on results followed by a review. The overarching mandate of environmental monitoring strategies should thus aim to maintain stable and ideal environmental conditions.

Given the above general definitions and principles of environmental considerations, this chapter argues that effective management of environmental conditions must be based on the following premises:

1. Policies, benchmarks, and standards that govern activities,
2. The building in which collections are stored has to be in a good or favorable conditions, maintained and well understood,
3. Detailed elementary procedures on how and what to physically, mechanically and chemically monitor and control, and
4. Documentation of all that has been done or is to be done.

The next section discusses effective management of environmental consideration based on the following subthemes; policies, benchmarks and standards; buildings/storage envelope; preservation documentation; preservation equipment; and effective monitoring and control procedures.

Policies, Benchmarks and Standards

Effective management activities and methods of environmental conditions, among others, mean being able to clearly state commitment statements on policies, standards and benchmarks adopted by an institution. Unfortunately, small and developing heritage institutions have challenges of establishing and implementing policies, benchmarks and standards. Cases where there are no policies in place have been highlighted in many countries such as Zambia (Kanyengo, 2009), South Africa (Ngulube, 2007), Botswana, (Segaetsho & Mnjama, 2012) and Uganda (Bearman & Kissel, 2000). The paucity of knowledge on regularities required for preservation was summarized by Olatokun (2008) highlighting that most African libraries have unfavorable government policies and human resources. In a nutshell, heritage institutions in most developing countries still lag behind in adopting foundational basis or frameworks for analysis, evaluation and exploration of preservation work. To illustrate this, Ngulube and Tafor (2006) observed that most archival institutions in East and Southern Africa Regional Branch of the International Council on Archives (ESARBICA) had limited preservation activities such as surveys, policies, disaster preparedness, environmental conditions monitoring and readers' rules.

It is, therefore, quite important that heritage institutions should address the issue of policies and standards that guide preservation in their countries. Small and developing heritage institutions should address the feasible preservation objectives such as storage conditions, disaster preparedness, general housekeeping and cleanliness rather than copying comprehensive preservation policies from developed countries. Although national legislation for heritage institutions are available in most countries, these institutions still have the task to thrash out national policies and standards that specifically guide preservation work for each country. For example, Lewis (2000), noted that it is necessary for individuals and institutions to develop preservation protocols or guidelines that are relevant to their setups.

Buildings/Storage Considerations

An important factor in environmental consideration is the ability to provide appropriate building or storage conditions for collections. As stressed by Lewis (2000), the starting point for developing a preservation programme should be ensuring that the building in which collections are housed meets

the basic requirements for the storage of heritage materials. Since in most cases the small developing institutions do not have any air-conditioning systems in place, it is difficult to maintain stable in-house environmental conditions. Similarly, even in the highly developed institutions, the sustained power supply and maintaining constant standard reading of temperature and relative humidity are seldom achievable. Therefore, the question of whether the building structures in most developing institutions are still stable or intact enough to limit the impact of external conditions becomes a central point of concern. Such situations also imply that even if Heat, Ventilation, and Air Condition (HVAC) systems are to be installed, maintaining constant and ideal conditions might still become a total fiasco. Given such situations, the obvious starting point for improvement must be, where possible, considering establishing new purpose-built structures. However, if new buildings cannot be obtained, the following basic cost effective practices can be used to fulfill the need for providing ideal storage conditions:

- If possible start by providing all possible maintenance work to improve the stability and innateness of the building.
- Staff offices, research/reference and work areas should be separated from the collections storage areas. Storage areas should be solely used for storage of collections and access to storage areas should be controlled.
- Flammable liquids and materials, audiovisual equipment and other interpretive materials, foams and supplies should be stored outside the storage rooms. If flammable materials are stored in the same areas as the protected heritage collections, this might run the risk of fires and even acidity. Such practices could result in un-prevented or poor strategies of minimizing the chances of disasters. Hlabaangan and Mnjama (2008) advised that preservation storage areas must be always separate from other offices and supplies store rooms.
- Storage buildings should be free from water, steam, drain, and fuel pipes. However, most of the building areas in developing institutions are not appropriately insulated to help maintain environmental conditions.
- If storage areas have windows, always provide blocking and insulation (e.g., cover windows with plywood sheets, curtains etc.). At least all windows, doors etc. should always be closed to minimize the impact of external conditions.
- Storage areas should have as few doors as possible to enhance environmental control but enough to meet requirements for employee safety.

Overall, the building infrastructure should be well understood, its materials composition should be known, all structural damages noted, and possible decay rate should be well documented and monitored.

Preservation Documentation

Documentation plays a vital part in allowing trace and feedback on what environmental measures have been carried out and what is still pending. Setlhabi (2010) citing Roberts (2004) noted that the strengths of documentation standards enable heritage institutions to exchange collections' information. Moreover, documentation allows easy understanding and implementation of guidelines, procedures and policies. It is, therefore, vital that managing environmental conditions should always have in place its own measures of documenting all the functions conducted by each institution.

Heritage institutions should have the ability to document everything that is in place as a preservation measure. Documentation should cover exhibit plans, historic furnishings reports, daily observations, noting occurrences such as unusual exterior climatic conditions, leaky roof, re-calibration of equipment, and unusual visitation pattern. Of course in most cases, heritage institutions fail to purchase preservation/conservation documentation systems. In such cases, documentation could be mainly in the form of Microsoft Word reports. Furthermore, Microsoft Excel software can also be used as a means of providing databases. Figure 1 illustrates an example of a preservation database created by the University of Botswana Library Special Collection as a means of providing preservation documentation.

As a matter of good practice, records on relative humidity, temperature readings and daily observations should be retained, reviewed and analyzed monthly to determine relative highs, lows, means, frequency and extent of fluctuation. However, interpretation of the statistical databases on environmental conditions such as temperature, RH and light could be a challenge if there is no a professional conservator. In such cases, heritage institutions could always have a once-off consultation with a conservator to assist. Records of annual seasonal variations and periodical spot checks of light to ensure that levels do not exceed the upper limits for sensitive objects should be always maintained. Annual external statistical conditions for comparison are always available for free in most countries through each country's Department of Meteorological Services. Readings or measurements on pollution gases and particulates matter in reading rooms, storage rooms or exhibition areas should be recorded on daily bases, weekly or monthly bases.

Monitoring and Control Procedures

As a good preservation process, and also an environmental strategy, it is important to be able to gauge the status of deterioration taking place. So, monitoring and controlling the agents of deterioration be-

Figure 1. An example of a Microsoft Excel preservation database used at University of Botswana Library Special Collections

comes vital in the sense that it allows early identification of possible hazards hence leading to immediate resolution before the damages can become severe. Thus, document heritage institutions should have clear structures of monitoring temperature, relative humidity, mould, light, air and particulates in storage areas. For example, when it comes to light, Ultraviolet (UV) radiation should be controlled by filtering materials that have UV absorbing properties. Moreover, as a good practice, researches have indicated that the UV filtering materials should also be periodically monitored to ensure their continued effectiveness in meeting the standards (Ritzenthaler, 1993). In cases where document heritage institutions don't have UV filters, basic practices such as avoiding direct sunlight without necessarily measuring the levels of UV light can work.

In most cases heritage institutions are located in cities and towns where there is industrialization. Such places also have the challenges of air pollution and air particulates such as soot. Harvey and Mahard (2014) clearly indicated the corollaries of adverse environmental conditions stating that; "they are usually insidious and gradual, and by the time they are obvious, it is often too late to save collections" (p. 89). As a good practice, heritage institutions should always make sure that all windows, doors etc. could be closed and are always closed to minimize the impact of external atmospheric conditions. Worrisomely, even though some heritage institutions have air-conditioning systems, given the challenges of power cuts, some end up switching air-conditions off at certain times. Such activities result in fluctuations in temperature and relative humidity and this is more damaging than not having the air-condition system at all.

Monitoring (inspections) for evidence of mould infestations should also be conducted on an ongoing basis with especially close inspection of collections on monthly basis. Although some countries such Botswana and Namibia have semi–arid climatic conditions largely because the countries experience short rainfalls, windy and dusty conditions during dry seasons, mould should still be always monitored. For those institutions protecting collections with archival packaging materials, frequent survey, cleaning and using appropriate cleaning equipment is vital.

Preservation Equipment

Taking care of paper materials requires being able to monitor and control the conditions in which materials are stored. As put by the British Library Preservation Advisory Center (2010), "Knowing the environmental conditions in a library or archive is essential for planning the best strategy for the preservation of collections and for targeting your resources effectively" (p. 1). Such a process requires availability of different equipment to be used. Basic environmental monitoring tools required include Heat Ventilation and Air Conditions (HVAC) systems, computer documentation systems and building structures desirable for preservation. Air quality control tools (e.g. ultraviolet photometric O_3 monitors, chemi-luminescent NO_x (where X=1, 2, 3 etc.) monitors and pulsed fluorescent SO_2 monitors), light monitoring tools (light meter), temperature and relative humidity tools (Data loggers) are also critical equipment in environmental monitoring. However, such equipment are not easy to purchase and use since they require huge finances and high technical skills. As expressed by Zaid, Abioye and Olatise (2012) in Nigeria, among the critical challenges in preservation is the shortage of human resources required to undertake the task of heritage preservation. Small developing heritage institutions are therefore tasked with the responsibilities of coming up with cost effective methods and tools for achieving ideal environmental conditions. Among others, heritage institutions could still use traditional tools such as thermometer, hygrometer for monitoring environmental conditions, physical inspections on daily bases and adopting traditional strategies such as opening windows to allow air circulation.

ENVIRONMENTAL FACTORS AFFECTING DOCUMENT HERITAGE

This section provides an overview of risks or basic deterioration factors that mainly affect paper based materials.

Security

Providing secure environment for collections is critical in preservation. Heritage institutions need to provide appropriate security measures encompassing both custodial and environmental measures. If security measures are not put in place, heritage materials are more likely to perish due to abuse especially by their users and custodians throughout the world. Security is an important role in preventing corrupt practice culminating into improper use, treatment, misuse, or deceitful act. A typical example of security challenges is observed during Timbuktu rebels in Mali. Abdel Kader Haïdara, a 50-year-old librarian in the south-west of Bamako, Haïdara when asked to comment in the theGuardian, lamented that "It was a great catastrophe. I knew that, if people continued like that, one day they would enter our library and smash up everything" (theGuardian, 2017, p. 01). As such, it is paramount that heritage institutions should strive to protect their holdings from deterioration due to abuse or negligence. If institutions cannot afford expensive security equipment such as CCTV, they can still improve their security measures by adding butler-bars in windows and doors. Abankwah (2011) cited an earlier work of Abankwah (2008) indicating that the librarians at the Radio Botswana library, South African Broadcasting Service (SABC) and the National Broadcasting Corporation (NBC) of Namibia did not inspect audio visual materials when the users returned them. This chapter recommends that to alleviate theft, institutions could politely physically inspect materials going in and out when customers access heritage areas. Subsequently, heritage institutions need to bait collections from environmental factors as will be discussed in the next sections.

Temperature and Relative Humidity

Relative humidity (RH) is a percentage expression of the amount of water vapour held in a specific amount of air compared to the maximum amount of water vapour that the same amount of air could hold at the same temperature and pressure (Feather, 1996; Millar & Roper, 1999). On the other hand, temperature is defined as the measure of the motion of electrically neutral groups of two or more atoms held together by chemical bonds in a material (Northeast Document Conservation Center, 2012). Millar and Roper (1999) defined temperature as the measure of the level of heat and cold in a substance, body or environment. Temperature works concomitant with RH in the sense that the higher the temperature, the more water vapour the air can hold. Therefore, as temperature changes, relative humidity also changes fluctuating drastically. Paper based materials are hygroscopic, they absorb moist when relative humidity increases and desorb moist when relative humidity decreases. Consequently, if materials loose too much moisture they become brittle. Similarly, if paper materials absorb too much moist the materials become weak, resulting into weakened chemical bonds and forces that hold the paper fibers together. Therefore, logically, avoiding damages is through providing constant and ideal temperature and relative humidity.

Heritage institutions should consider making sure that old and not intact enough buildings are maintained to avoid drastic fluctuations due to external climatic conditions. To some extent, the old and very cost effective strategy of putting water in bowels to improve relative humidity and temperature can still be used for improvement. At the same time, sources of nearby bodies of water (for example, wet grounds,

leaking pipes, moisture in walls, human respiration and perspiration, wet mopping, flooding, and cycles of condensation and evaporation) should always be monitored since they can contribute significantly to RH. Lack of fully understanding equipment installation and non-monitoring of storage environments should be avoided.

Air Pollution

Quality of air is also vital in environmental consideration. A variety of pollutant gases are observed both in the indoor and outdoor atmosphere. As such, national ambient air quality has been a concern both to human and heritage materials. Although literature continues to discover more and more pollutant gases, the common toxic compounds like Sulphur dioxide (SO_2), nitrogen dioxide (NO_2), ozone (O_3), carbon monoxide (CO), carbon dioxide (CO_2), chlorides and leads, nitric acid (HNO_3), acetic acid (CH_3COOH), nitrous acid, formic acid and hydrogen peroxide cause serious damage to collections. Determining the impact of gaseous emission is challenging and requires specialist equipment. The values of pH and gas leakages are, among others, the factors that can be monitored to gauge the level of risks due to toxic gases. Common deterioration effects associated to pollutant gases include oxidation and acid hydrolysis of cellulose fibres of paper materials. An important fact to highlight in this section is that, pollutant gases cause acidification of paper resulting in yellowish paper, brittleness and disfigurement of paper fibres.

Although literature continuously publishes various advanced methods of monitoring pollutant gases, such methods are quite expensive for most small and developing heritage institutions. The recommended common practice for such institutions is to use air pollution filters in addition to HVAC systems to filter out air pollutants by way of improving air quality within buildings. In cases where there are no HVAC systems, natural ventilation is also an effective method of controlling air pollution. Packaging process to create micro-climatic conditions can be used as a cost effective and passive environmental solution for heritage institutions. Routine ambient monitoring systems can also be used as strategic methods of monitoring air pollution. Both hand-manual and digital measurement using continuous monitoring instrumentation can be strategized as methods of monitoring air pollutants. Simple methods such as placing lead, silver and copper in storage areas to monitor their metallic luster can still be used.

Particulate Loss

Tiny mixtures of microscopic pieces of solid or liquid matter suspended in the atmospheric aerosols are one of the vital dangers to paper based collections. International common air particulates of concern include alkaline particles from cement dust, black soot from burning and other dusty particulates. The atmospheric aerosols such as insoluble minerals or crustal material, hygroscopic inorganic salts, and carbonaceous materials are among the common major sources of particulates. These atmospheric particles are formed through a complex sequence of chemical reactions and it is difficult for archivists, curators and librarians to analyse these formation processes. However, monitoring degrading effects caused by these particulates is vital. Reduced reflectance properties of collections have been discussed as a result of air particulate (Gordon, Tidbaldand Lombardo, 2012). Colour damages and loosing of texture quality are among the common issues of concern regarding air particulates. Soiling is among the deterioration effects detected in collections and is characterized by loss of surface texture, affected glossiness and damaged fibres.

Besides having monitoring equipment, particulate effect is difficult to measure. The easier and economic way of determining the impact of particulate damages in collections is through observing dust presence, evaluating activities carried out as housekeeping measures, and observing the influence of external effects such as burning. Dewah and Mnjama (2013) revealed that particulate damage such as dust is a serious challenge in most heritage institutions. Significant signs of corrosion, soiling and changed texture are mostly observed in most document heritage institutions. Such signs of particulates can be even severe in some institutions as shown in Figure 2 captured at Botswana National Archives and Records Services (BNARS) during an MPhil/PhD study by Segaetsho. The pictures clearly show the visibility and impact of particulates in collections.

Housekeeping which is supposed to be easy and cost effective is observed as a serious challenge in most heritage institutions. Kanyengo (2009) pointed out that cost-effective measures of cleaning store rooms using appropriate equipment such as vacuum cleaners are very minimal in most heritage institutions. Harvey and Mahard (2014) also observed that "monitoring environmental conditions need not be expensive" (p. 89). Basic cleaning and minimizing dust can save a lot of collections.

Mould

The presence of mould in collections has different effects that can lead to damaged materials. Moulds are microorganisms that generally have threadlike bodies called mycelium and reproduce by producing round or ovoid cells commonly known as mould spores (Stapleton, 2004). Mould is mainly associated with the presence of dump/wet areas with limited air circulation. Small and developing heritage institutions that mainly contain paper based materials need to be worried about the presence of mould. Document heritage materials are organic and hygroscopic; therefore, mould can become embedded within paper

Figure 2. Surface corrosions (left) and ingrained particulates (right) observed on some of BNARS collection using a handheld Digital Microscope (x500 magnifications)
Source: Field data, 2016

materials and other objects that can absorb moist. The impact of mould damage can be severe and the damages are incurable even through interventive measures. Figure 3 obtained from BNARS during an MPhil/PhD study by Segaetsho, illustrate some of the severe damages caused by mould on paper materials.

Mould is both dangerous to human beings and collections. Inhalation of toxic mould's powdery spores can be critically poisonous to human beings. As expressed by Cornell Library (2005) the growth of mould on surfaces of paper materials, books, art works, leather materials, parchments etc. can cause disfigurement, multicoloured stains, and greatly reduces material strength and appearance.

Light

Libraries, museums and archives need light for different purposes. Light is used for daily office work, reading and exhibitions. Sources of light are mainly lighting bulbs and natural light from the sun through windows and transparent roofing. The concern for light in environmental control is based on damages caused by light such as fading, colour changes or bleaching; brittleness, cracking and delamination to collections. Deterioration caused by light is cumulative, irreversible and, sadly, no conservation treatment can restore them. When determining the impact of deterioration due to light, heritage institutions should mainly observe the presence of discolouration, fading or foxing. However, foxing can occur in various mechanisms, as discussed by Daniels (1996). Similarly, discolouration is not exclusively caused by light alone, as other effects such as acidity and quality of the paper material itself such as presence of lignin also play a part. In fact, most of deterioration effects are not caused by one standalone deterioration or environmental factor, the damage occurs simultaneously from multiple deterioration effects. Light damage does not only affect structural layout through activation of photochemical reactions, but also affects the original aesthetic value of collections. For example, the common visible discolouration of newspapers due to lignin exposure to light can result in brittleness and even crumpling of document materials.

Figure 3. Surface areas without mould (left) and surface areas with fungi/mould (right), observed in some of collections at BNARS using handheld Digital Microscope (x500 magnification)
Source: Field data, 2016

A practical inexpensive way of controlling and monitoring light damages in heritage institutions, more particularly in small developing institutions, is using blue wool wards. International practice on minimizing risks of light includes little exposure of materials to light. For libraries, museums and archives buildings which have windows on store rooms, curtains and blinds should always be used. Always switching off lights and using filters to minimize ultraviolet radiations are also helpful. Another good practice is using lighting materials with less light intensity, and the intensity standard commonly proposed is that of an illumination of about 200 lux on the floor level (International Organisation Standards, ISO, 2003). The ISO standard further illustrates that with a view to preservation of documents, the accepted maximum limit for ultraviolet radiation is 75 µW/lm. It is thus paramount that document heritage institutions should always avoid direct light onto objects.

KNOWLEDGE AND SKILLS REQUIRED FOR ENVIRONMENTAL CONDITIONS MANAGEMENT

For a well-informed environmental monitoring and control system to be in place, staff need to have the right information and skills. Environmental monitoring strategies involve different processes of determining environmental factors to monitor, identifying their location, establishing targets, purchasing, and installation of equipment. These activities require skills and expertise that are relevant. With limited professionals in preservation, heritage institutions could run the risks of having collections which are damaged and in the long run resulting in collections which are not accessible. Loss of valuable materials in heritage institutions is exacerbated by the fact that most institutions fail to assign an officer responsible for preservation. A common thinking is that preservation is the responsibility for conservators or preservation specialists. Harvey and Mahard (2014) pointed out that "preservation is the responsibility of all, from creators of objects to the users of objects" (p. 18). Given these views, the basic skills for preservation should be instilled in everyone. Consequently, implementation of preservation should become easy in the sense that everyone will appreciate preservation activities.

In order to address the paucity of skills, staff in heritage institutions should have efficacious structures on how they can widen their scope of knowledge on preservation. Due to shortage of staff, heritage institutions go an extra-mile of using volunteers who also do not have skills. Although this helps, given the need for expertise in preservation, the volunteers also require at least to be supervised by someone with expertise. Related to the limited education there is always limited manpower. Illustrating the paucity of education in his study, Ngulube (2007) observed that:

it is difficult to escape the conclusion that most of the staff were ill-qualified for preservation activities because institutions offering library and information sciences/studies (LIS) education in South Africa do not pay much attention to preservation issues. (p. 45)

Similarly, prioritization, limited funds, lack of understanding and appreciation of preservation work remain as challenges linked to education in most document heritage institutions. Given the above overview of issues on skills and knowledge, the following skills are paramount for environmental conditions:

- Having an overall understanding of the definitions and principles of preservation.
- Understanding physical and chemical structures of materials. As already argued in the literature, understanding the structure of materials is key to understanding what preservation actions to take (Harvey & Mahard, 2014). If heritage institutions have minimal educational background, the institutions are more likely to have challenges in providing appropriate preservation structures.
- Technical knowhow of monitoring and controlling environmental conditions factors.
- Basic knowledge on preservation and conservation informatics.
- Basic knowledge on preservation policies, benchmarks and standards.
- Basic understanding of building construction engineering on materials, properties and structural stability of the building envelope.

Overall, environmental consideration is a complex phenomenon which requires various basic expertise cutting across various fields. It is, therefore, advisable for individuals, and even preservation experts, to determine their setups and try and get relevant information aligned to their needs to attain the principles required to achieve constant and ideal conditions.

KEY CHALLENGES OF MAINTAINING IDEAL ENVIRONMENTAL CONDITIONS IN DOCUMENT HERITAGE INSTITUTIONS

This section presents the key challenges in maintaining ideal environmental conditions for paper based materials, particularly in small and developing heritage institutions.

Economic and Financial Challenges

Although most heritage institutions are state owned in most countries, portions of budgets on preservation are very minimal. Studies have repeatedly highlighted financial challenges in most countries (Ngulube, 2007; Asiamah, 2008). Without economic and financial support, the preservation of document heritage will suffer a lot. Most financial support received in most institutions mainly focuses on acquisitions or collections development but forgetting to put in place measures that will make sure that the collections are safe and preserved. Similarly, low prioritization in preservation could be also resulting in the limited budgets allocated for preservation work. Ngulube (2007) concluded that the diminishing funding aid is the major infringement on preserving records and archival materials. To avert some of these challenges the following could be done:

- It is paramount that document heritage institutions should advocate for funding and permit buying and budgeting towards purchasing necessary equipment. However, it is important to note that in some cases it is not necessarily a question of money since some institutions have money allocated to preservation departments, but year after year money allocated for preservation ends up being returned. It is really difficult to explain why this is happening but one can argue that this could be due to the limited prioritization of preservation management. In order to resolve such challenges, heritage institutions should lobby heritage managers for prioritization, look for donations, and get help from well-established institutions.

- Heritage institutions should strive for having clear structures of accountability and high quality, i.e. value for money. Sponsors want evidence on the outcomes of their investment.

Administrative Challenges

Having clear structures for preservation is important in heritage institutions. Detailed procedures on policies, aims and objectives of preservation and administration of preservation are vital. Most of heritage institutions lack proper and clear positions for conservators or preservation positions. When advocating for the need for national preservation policies, Meliva (2013) indicated that countries without well determined uniform standards on preservation are more likely to have different challenges. Such a limitation implies that there is minimal administration, planning or prioritization of preservation functions. Most small and developing heritage institutions have limited input on policies from high positions, have insufficient funding to implement policies, and have limited resources in the form of human intellect (Asiamah, 2008). Therefore, in some institutions, although there are draft polices and guidelines, these are only used for reference purposes by lower position staff without any endorsement or official approval by higher management positions. Given such situations, the policies or guidelines do not necessarily assist/ guide management. More importantly, this means that the policies/guidelines do not bind management for administrative implementation, accountability, planning and decision making.

The limitation of documentation is also not an exception as a challenge in small and developing heritage institutions. A study by Setlhabi (2010) on documentation of material culture at Phuthadikobo Museum in Botswana revealed that the issue of documentation was a challenge even to the documentation of collections. She observed that Phuthadikobo Museum had no collection development policies. Such challenges corroborate the opinions in this chapter indicating the need to have clear administration functions that have clear policies in place. The challenges of administration suggest that, where possible, governments should take full responsibilities of custodianship of heritage institutions. The following could be done for improvement:

- Management should be actively involved and should fully understand the imperativeness of preservation.
- Challenges of structures that are not relevant and issues of shortage of staff should be improved.
- For heritage institutions to improve they need to compare the past activities with the present in order for them to propose the future. It is, therefore, vital that heritage institutions should document what they do on daily basis such that in the future they can revert back for improvement.
- As previously stated, preservation documentation need not to be only on advanced expensive systems, basic documentation process such as databases created using Microsoft Word, Microsoft Excel and many others can be effectively used to document all administrative activities.

Educational Challenges

Informed nations' development and economic growth need informed societies. Chan Wai-Yin and Ma Shu-Yun (2004) asserted that education level and health are the assets to enhance human productivity and economic growth. Education on preservation related issues is thus also vital for heritage institutions. A survey of most heritage institutions in Africa revealed that limited education on preservation is a challenge (Coates, 2000). Literature has explicitly indicated the paramountcy of preservation expertise

and skills. Ngulube (2005) emphasized that not only the challenges which are resources-based affect preservation, but also lack of preservation skills or knowledge is overwhelming in libraries and archives. Just to sample a few observations in Botswana, studies by Tamuhla (2001), Selatolo (2012), Segaetsho and Mnjama, (2012), Segaetsho (2014), Kootshabe and Mnjama (2014), and Thabakgolo and Jorosi (2014) have highlighted issues of limited skills in preservation related work. Olatokun (2008) revealed that 3 (26.7%) of respondents during a survey felt that there was lack of competent manpower in Nigerian University Libraries. However, education or training on preservation and conservation expertise is expensive. Therefore, the question is how can we instill the basics of preservation so that the preservation of heritage collections is achieved? Of course without specialty officers, preservation efforts are as ineffective as a school without teachers, a library without librarians and a museum without curators. In other words, heritage institutions without specialist staff are more likely to invest wrongly on preservation and ultimately culminate in poor environmental conditions.

One would expect each heritage institution to at least have one staff with requisite skills and knowledge in preservation. Unfortunately, only few heritage institutions have trained staff in preservation related work through workshops, seminars or presentations. Most of the staff responsible for preservation are trained in preservation and conservation of library and archives materials as part of library and archives modules (Ngulube, 2007). Such observations are an indication that staff responsible for preservation have no sufficient expertise in preservation and this could result in implementing wrongs things about preservation, let alone environmental conditions. To emphasize this point Murray (2006) indicated that having little knowledge is a dangerous when it comes to hands-on repairs since less skilled personnel can cause more damage than what originally needed repair.

Skills gaps are not only observed in staff entrusted with preservation but also in major stakeholders of heritage institutions. Such cases therefore imply that decision making in preservation work is less prioritized. Akussah (2003) observed that 54 members of the Records Class (40%) had no formal training in preservation. When commenting on the issue of skills and knowledge, the Acting Director at the University of Botswana Library Special Collections emphasized that due to limited basic knowledge on the paramountcy of preservation, most decision making did not consider preservation issues. Kootshabe and Mnjama (2014) have recently observed that about 51.3% of officers surveyed in ministries and departments in Botswana had challenges of limited basic skills in preservation. In previous years, Tamuhla (2001), Olatokun (2008), Kanyengo (2009), and Selatolo (2012) also indicated that preservation knowledge gaps were very significant in Tanzania, Nigeria, Zambia and Botswana respectively. The following can be established for improvement:

- Efforts should be made such that most staff have basic knowledge about preservation work. Continuous training in the form of workshops, conference attendance and short courses where possible should be done.
- Tertiary institutions, universities and consultants should establish short courses designed to assist with educating professionals on preservation issues. Relevant preservation institutions can also be identified where staff could be sent for short courses and training on preservation. Examples of such institutions are Canadian Conservation Institutes (CCI), International Centre for the Study of the Preservation and Restoration of Cultural Property (ICCROM), Northeast Document Conservation Center (NEDCC) and The South African Institute for Heritage Science and Conservation. Emphasizing on the same point at Ghana, Akussah (2005) advised that training opportunities in preservation were also available outside Ghana.

- Institutions could also request for educational support and funding through international associations such as UNESCO.
- Formal education continue to be revealed as an expensive process in most small developing heritage institutions. Therefore, the most important route specifically suitable for small developing institutions challenged with financial constraints is to highly consider having cost effective education structures such as non-formal education of personal reading in the profession, workshops, free webinars, staff exchange programmes etc.
- At national level, countries should establish National Preservation Offices. This offices should be a formally government sponsored center where all preservation strategic planning is established. These offices should come up with theoretical and strategic planning that guides all heritage institutions in the country. Small developing heritage institutions could then continuously visit the National Preservation Offices for training, consultation, treatment, and guidance and guidelines.

Technical and Operational Challenges

These are mainly on-the-field activities carried out as part of the work on environmental conditions. Heritage institutions still lack basic understanding of what is on the ground and coming up with appropriate solutions for the individuals' setup. In most cases, very little is done on monitoring measures for various risks such as temperature and relativity, light or ultraviolet and annual seasonal variables (Ngulube, 2005). Technical and operational challenges are also associated with challenges of not having policies and standards, and not sticking to preservation standards. The limited monitoring and control issues are mostly confirmed by various deterioration effects observed in the collection themselves. As already alluded to in previous sections, various deterioration effects associated with environmental conditions effects include discolouration, fungi, disruptive stress, brittleness, and foxing, warping/cockling and particulate loss. Despite awareness on the above deterioration effects by some of heritage institutions, a significant number of heritage institutions in most of the time confirm that they have operational challenges of monitoring environmental factors (Dewah & Mnjama, 2013). Document heritage institutions keep on bewailing that high brittleness is often observed in most institutions and materials are often challenged by warping, creases and cockling damages.

Light, more especially UV, continuously causes fading to collections; causes colour changes or bleaching, brittleness, cracking and delamination. Although discoloration occur in different forms, heritage institutions are also troubled by those discolouration effects associated with light, acidity, material quality and other issues such as foxing. Moreover, other issues of controlling particulates loss and ingrained particulates causing damage to collections also achingly affect technical and operational activities. Given the above challenges of deterioration, the ultimate critical consequences of the deterioration are the danger of losing not merely the original paper materials themselves but their intellectual content as well.

Infrastructure and Equipment Challenges

Most developing heritage institutions indicate that facilities for environmental conditions are not enough. The delimitation of equipment has been observed in the literature in most of the developing countries within East and Southern Africa Regional Branch of the International Council on Archives (ESARBICA). Mnjama (2010) observed that the challenge of limited equipment and facilities was also observed in the preservation of audio visual materials in Botswana. Most small and developing document heritage insti-

tutions have very little facilities and equipment available. The basics such as pH meter, carbon dioxide detector, sulfur dioxide detector and chlorine detector are always a challenge. Although Peters (1996) had indicated that the recommended fixed temperatures and relative values are not easy to achieve by all institutions, it is still important that institutions should at least aim for constant room temperature and relative humidity. Such process will limit too much fluctuation due to absorption and desorption of moist, hence minimizing the brittleness, desiccation etc. damages. Presence of HVAC systems for paper based collections storage areas need to be always considered. For example, in an attempt to establish the presence of air-condition systems in heritage institutions in Botswana, Segaetsho and Mnjama, (2012), and Thabakgolo and Jorosi (2014) pointed out that shortage of HVAC systems was a serious challenge. Mazikana (1992) and Ngulube (2007) also observed that infrastructure in many countries in Sub-Saharan Africa have collapsing air-conditioning systems. The consequences of limited HVAC systems also brings into light the impact of external climatic conditions that might be affecting heritage institutions. When arguing for the remedy of external climate changes, Dean (2002) suggested that "the key to achieving efficient climate control is to maintain interior conditions close to the exterior ones" (p. 01).

Another important factor to determine is the presence of restoration or conservation facilities. Most developing heritage institutions suffer from unavailability of restoration facilities or conservation studios on-site. In some instances, although some institutions have conservation studios they still outsource their conservation treatment functions such as binding of newspapers, making it difficult to take statistical readings on the deterioration of environmental conditions. For improvement the following could be done:

- Instruments for environmental control are expensive, and not available in most of developing countries which tend to have many small heritage institutions. As such, heritage institutions should try by all means to acquire appropriate equipment, revamp storage facilities, remove cracks, and install insulations, provide backup power and install HVAC systems.
- Governmental sectors should permit funding to buy equipment, budgeting towards purchasing necessary equipment and budget annually for the management of environmental conditions.
- Collaboration with local private manufacturing industries could also help in innovation of tailor-made equipment to address specific needs within heritage institutions.

Political and Social Challenges

Logically, countries with well renowned peace, democracy or good governance are more likely to achieve better preservation in their heritage institutions. In principle, preservation must take into consideration the needs of the users, i.e. we preserve what the society finds is important to preserve, hence what the society will access. It is, therefore, important that whatever preservation principles are put in place they should also conform to public opinions, cultural values and political stabilities. Public involvement in preservation should be considered as an important function. For example, Segaetsho (n.d) observed that 14 (66.8%) of the respondents in selected heritage institutions that participated in his PhD study in Botswana were of the view that social factors or societal behaviour towards preservation was a challenge. The study revealed issues of limited support from the public resulting in lack of appreciation by the public. Ramokate (2006) observed that records management and access to information was prioritized more than preservation. These equally affect the possibilities of achieving ideal storage conditions. From the author's experience, some customers and staff complain about low temperatures in store rooms and reading areas claiming that their health is in jeopardy. As such, lack of participation and appreciation by

both staff and the society in storage and reading areas is a challenge. Lack of awareness by communities in preservation activities is a challenge in most developing institutions. Similarly, lack of will to change and, appreciation and understanding of preservation activities is a challenge. To avert such challenges, it is important that frequent outreach activities be conducted in order to motivate the publics' interest in heritage activities.

Disaster Preparedness

One of the important activities in environmental consideration is to foretell the challenges associated with external climate changes. Heritage institutions should always be determining if at all external climate conditions are affecting their indoor conditions. These activities should link well with the various issues related to disaster preparedness. In the same vein, literature indicates that climate change plays a very significant role in how preservation is achieved. During the study of disaster management of library materials in federal universities in Cross River and Akwa Ibom States, Nigeria, Ottong and Ottong (2013) observed that while all of respondents had ever heard of disaster in libraries, 57.1% had once witnessed the occurrence of disasters in libraries. Emphasizing the issue of climate, Toledo (2007) stated that "climatic stability is more important than the internationally known and still recommended standard climatic values" (p. 3). However, it is unfortunate that most small and developing heritage institutions fail to link environmental conditions to the global world's climate change and disasters. For improvement, heritage institutions are recommended to establish the following:

- Initiate disaster preparedness guidelines for their institutions either in a form of a disaster plan or any format suitable for the institutions. The guidelines should clearly indicate the common stages of disaster handling such as, disaster preparedness, recovery stage, and disaster salvage stage.
- Institutions should establish small committees responsible for implementation of the disaster plan. The committee should liaison with other relevant institutions such as Fire marshal organisations, possible backup storage facilities and insurance organisations.

BRIEF OVERVIEW ON PRESERVATION THEORETICAL MODELS

In order to carefully plan, organize and administer preservation executions, institutions adopt different theoretical frameworks as guides to their operations. The common distinctive theoretical frameworks guiding heritage institutions are the Records Continuum Model (RCM), the Records Lifecycle Model (RLM), and the Hybrid Model or the Integrated Records Management Model. The growing interest in collection preservation has led to the development of different methods for prioritizing needs and evaluating conservation and preservation actions towards more effective collections management. A preservation policy maturity model: a practical tool for Greek libraries and archives (Gkinni, 2014) was lately suggested as one of the frameworks that can be used to guide formulation of preservation policies. The model evaluates preservation policies' maturity by answering simple questions that assess preservation performance against peer best practice, thus, self-assessing institutions' maturity level in terms of organizational evaluation, comprehension and recognition of problems, prioritization of needs and setting priorities. In the field of risk assessment, the Birmingham Museums and Art Gallery and the Museum of London presented the Risk Awareness Profiling Tool (RAPT). The RAPT was launched in 2010 as

an online tool that enables museums, archives, library or other heritage institution to assess their level of risk awareness with regard to preservation issues (Gkinni, 2014). RAPT allows heritage institutions to assess the level of asserts, systems, finances, collections and buildings status.

Another theoretical model observed in literature is a framework of knowledge management practice at Malaysian University Libraries (Rusuli, et al., 2012). A slightly convincing or relevant conceptual framework on preservation work has been lately opinioned by Krtalic and Hasenay (2011). They observed that preservation work is a complex activity comprising of diverse issues of cultural, social and technical context. As such, a preservation framework should be centered in five key components of 1) strategic and theoretical 2) economic and legal, 3) Educational, 4) technical and operational, and 5) cultural and social. Other frameworks that guide the executions of preservation of heritage collections include standards and benchmarks such as follows: International Organization for Standardization (ISO), Benchmarks in Collections Care for Museums, Archives and Libraries, (The Council for Museums, Archives and Libraries, 2002), Preservation and Protection of Museum Collections (National Park Service, 2005), British standards such as the Guide for the storage and exhibition of archival materials; BS PD 5454:2012 (British Standards Institution, 2012), and Preservation of Historical Records (National Research Council, 1986). The use and the importance of theoretical and conceptual models is the subject of Chapter One. Drawing from these existing models, the next section provides a recommendation on a management framework specific for environmental conditions.

KEY RECOMMENDATION: ENVIRONMENTAL CONDITIONS MANAGEMENT FRAMEWORK (ECMF)

An often-neglected but important social construct in preservation is the need to have a management framework on how to manage environmental conditions. This section provides an Environmental Conditions Management Framework (ECMF) that can be used to harmoniously manage environmental conditions in document heritage institutions.

The term 'Environmental Conditions Management Framework (ECMF)' used in this chapter consists of two key concepts/parts. The first one is 'Environmental conditions', which is defined as a process of climate control of equipment, providing heating, humidification, cooling and dehumidification. It is the process centred on monitoring and controlling of light, temperature, relative humidity, air-pollutants, mould and particulates matter (Swartzburg, 1980; King & Pearson, 1992 and Harvey, 1994). The second term is "Management framework" which is defined as the judicious use of means to accomplish environmental conditions. Overall, ECMF is the act or skill of administering, caring, planning, controlling and making decisions about how to achieve ideal light, temperature, relative humidity, air-pollutants, particulates matter, and prevention of mould. The framework is based on five premises:

Educational Consideration

Knowledge is power. Literature, especially on East and Southern African Region heritage institutions, continue to indicate a significant number of challenges on education, training and skills in environmental conditions. Building on the broad preservation framework by Krtalic and Hasenay (2012), this chapter advises that educational issues from the broad preservation frameworks need to be escalated to operational levels in order to provide clarity on all proper structures of operational education needed for environmental conditions.

Facilities and Resources Considerations

Providing constant and ideal conditions require strategic methods for providing appropriate building infrastructure and equipment to monitor and control risks. This chapter suggests that Environmental Conditions Management Framework should be based on the ability to provide cost effective facilities and resources appropriate for technical and operational needs in environmental conditions.

Risk Monitoring and Control

In agreement with the broad definition of environmental conditions by Swartzburg, 1980, King and Pearson, 1992, Harvey, 1994, and the Benchmarks in Collections Care for Museums, Archives and Libraries by the Museums, Archives and Libraries Council (2002), this chapter proposes that the ability to monitor and control risks associated to paper materials such as monitoring and controlling of light, temperature, relative humidity, air-pollutants, mould and particulates matter should be a fully-fleshed responsibility for environmental considerations. The ability to sustainably and cost effectively monitor and control physically, mechanically, chemically, and document environmental deterioration effects is vital.

Administrative Considerations

The process of providing technical and operational guidelines, planning, optimizing human actions, materials, and financial capabilities is essential for achieving ideal environmental conditions.

Records and Documentation

Small and developing heritage institutions often do not provide clerical structures of documentation on monitoring and controlling of risks in environmental conditions. Heritage institutions should provide clear documentation systems on all functions of environmental considerations to enhance proper evaluation and analysis on the impact of environmental conditions.

Figure 4 provides an overview of the Environmental Conditions Management Framework deemed appropriate for managing storage conditions for paper based collections. The framework is part of an MPhil/PhD recommendation by Segaetsho. As shown in Figure 4, the framework is not intended to be prescriptive but to assist preservation managers to be able to integrate the functions of environmental conditions into the overall preservation management programmes.

How ECMF Works

As already suggested above, Environmental Conditions Management Framework (ECMF) is the act or skill of administering, caring, controlling and making decisions about how to achieve ideal light, temperature, relative humidity, air-pollutants, particulates matter, and prevention of mould. In order to achieve these, ECMF suggests that management structures based on the premises of education, facilities and resources, administration, risk monitoring and control, and records and documentation should be well integrated in environmental consideration of paper based collections.

Figure 4. Environmental Conditions Management Framework (ECMF)
Source: Synthesis by Author, 2016

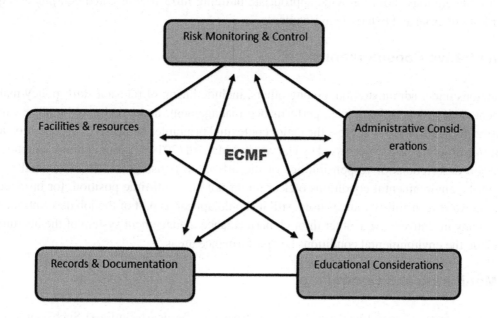

Educational Considerations

Educational issues are paramount in preservation work. Both literature and this chapter acknowledges that lack of training, skills and expertise is a challenge in preservation work more especially on technical and scientific understanding of the collections to be preserved. The ECMF suggests that a concrete structure on education related to environmental conditions should be inculcated to the broad preservation programmes and standards such as the Krtalic and Hasenay (2012). This should identify all skills gap required for managing the storage environments. Relevant curriculum, research and in-house training activities need to be clearly outlined. Preservation and conservation work requires skilled workers with basic understanding of paper manufacturing process, composition, and deterioration process, physical, mechanical and chemical reactions involved. Therefore, the most important route specifically suitable for small developing institutions challenged with financial constraints is to highly consider urging or pursuing the government to establish a National Preservation Office that will strategically provide preservation functions. Other cost effective education structures such as non-formal education of personal reading in the profession, workshops, free webinars and many others are also important.

Facilities and Resource Considerations

Economic/financial issues should be clearly outlined regarding environmental conditions. Heritage institutions should have clear structures on how they are sourcing funds and how they plan to purchase environmental conditions equipment. As already outlined in literature, preservation equipment are expensive, therefore, clear structures on monies used is vital. Heritage institutions particularly the small developing institutions should outline clear guidelines on principles and best practices that are economically sustainable and cost effective. Environmental consideration requires that both internal and external

environmental conditions are monitored. Too much fluctuations due to external environment need to be controlled. Institutions should provide appropriate building infrastructure, and equipment required to monitor both internal and external environments.

Administrative Considerations

The functions under administration, among others, include hiring of relevant staff, policy making and implementations, copy rights issues, performance management, and benchmarking. The function of administration should clearly address the major contextual principles and aims of preservation and these preservation aims are clearly discussed by Harvey and Mahard (2014). Administration structures should indicate job descriptions or responsibilities of the officer responsible for environmental conditions. Although the environmental conditions officer might not be a full-time position, for instances where by an assigned responsibility route is used, still it should appear as part of the job description. This will allow that any incentives given either through performance management system of the institutions will also include the environmental conditions key performance areas.

Risk Monitoring and Control

Hands-on technical and operational issues on risks also need to be clearly outlined. Such operations should dwell into how ideal conditions are to be achieved. Heritage institutions should outline clear guidelines on principles and best practices to be conducted such as considering adopting local and international guidelines such as the International Federation of Library Association (IFLA) and the Benchmarks in Collections Care for Museums, Archives and Libraries standards. Heritage institutions should clearly address activities and methods of environmental monitoring and control on light, temperature, relative humidity, mould, air-pollutants and particulates matter. This should adjudicate on detailed guidelines addressing the policies, benchmarks and standards; indicating the buildings/storage activities; providing daily documentation and preservation reports; and conducting monitoring and control activities and procedures for all environmental conditions' factors.

Documentation Considerations

In most cases, administration of preservation functions in terms of providing records across all the other functions is poor. It is, therefore, critical that institutions should have clear structures on how they document all the activities in their programmes. Such records should account for all educational, social, financial and operational activities.

Table 1 provides a summary of some of the baseline questions to be addressed under each function in the Environmental Conditions Management Framework (ECMF).

The ECMF model in this chapter is not rigid to other discoveries; it allows integration of prospects which should fit well in trying to resolve the issues of environmental conditions. It is through the evolvement of a cloud of activities and discoveries that would allow greater expansion in a continuum way. Sharing some of the views of a Records Continuum Model (RCM) (Upward, 2000), environmental conditions activities should not be viewed as discrete functions. This model provides a clear picture on coordination and governance of environmental conditions activities. The officer in charge of environmental conditions should be able to clearly account for educational, facilities and resources, risks, and

Table 1, Summery of ECMF functions (Source: Synthesis by Author, 2016)

ECMF Functions	Baseline Questions to Address
Facilities and resource considerations	How do you plan to fund basic environmental conditions activities? What are the basic sustainable and cost effective routes that you will adopt for environmental consideration? What are the basic equipment required for environmental conditions? Who are the people that can help you acquire all necessary facilities and resources to achieve the ideal storage conditions?
Educational considerations	Do you have a professionally qualified conservator in place, If not, how do you plan to educate yourself on environmental conditions? What basic skills do you need to achieve ideal environmental conditions? What relevant educational curriculum, research, and in-house educational measures do you have or require? How do you plan to provide documentation of all educational activities?
Administrational considerations	Does your institution have official preservation programme, adopted standards or benchmarks? Does your cultural setup, clientele etc. has influence on you achieving ideal conditions, i.e. do staff and clientele complain about low temperatures, not using sunlight, etc.? Do you have a professionally qualified conservator in place, If not, do you have an assigned responsibility given to a full time or part time officer? What formal documentation are you going to use as official reports, statistics or databases on environmental conditions? Are the environmental conditions functions inculcated as part of the key performance areas of the responsible officer? How do you plan to provide documentation of all administrative activities?
Risk monitoring and control	What are the major deterioration effects observed in your collection? What methods do you wish to put in place to be monitored and controlled on daily, weekly or monthly basis? Are all these daily activities somehow highlighted in preservation policy, standards or benchmarks? What equipment, resources and techniques do you require to monitor and control the environmental risks? How do you plan to provide documentation of all technical and operational functions?
Records and documentation	What preservation systems do you have in place and how can they inculcate environmental issues? What holistic official records do you have to document cutting across education, finance, social activities, operations and administration? What documentation, evaluation and analysis systems do you adopt to monitor and control environmental risks?

administration in environmental conditions. In such a manner, the framework has decentralized the broad preservation management framework (operational and technical issues) by Krtalic and Hasenay (2012) into the needful that has to be done in line with environmental considerations.

The five functions in ECMF should be perceived as a continuum that should always be addressed simultaneously. All the functions are interrelated and depends on one another. The framework is a build-on to the broad preservation model proposed by Krtalic and Hasenay (2012). The framework allows integration of other existing strategies such as preservation standards, conservation surveys, risk assessment etc. This model provides a clear picture on management/coordination of activities and governance of environmental conditions in relation to the broad preservation model as shown in Figure 5.

Implementation of ECMF

The following steps will assist document heritage institutions to establish proper ECMF programmes:

- The starting point calls for the establishment of a position for a professionally qualified personnel on preservation. To implement the management framework, conservators and preservation professionals should be in the four front of the model. They are the right people with skills and

Figure 5. Embedding ECMF into the preservation framework proposed by Krtalic and Hasenay (2012)
Source: Synthesis by Author, 2016

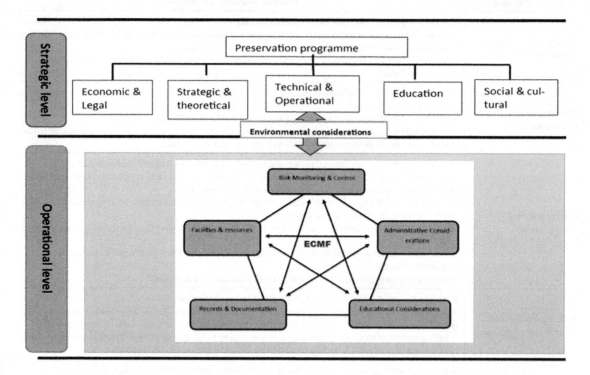

knowledge on administration, relevant education, operational and knowledge on which resources are required for environmental considerations. However, this could be more implementable at a higher national institution level. Small developing heritage institutions might not all be able to hire conservators.

- If the small developing heritage institutions do not have a conservator or preservation professional, at least an officer at administrative level should be assigned the responsibility to establish a baseline with advice from higher national institutions' conservators or preservation professionals. A technical officer could also be assigned under the supervision of an administrative officer. Avoid the danger of selecting low level officers in the position with no decision-making impact. In most cases, high management staff fails to understand the importance of preservation and as such there is a persisting challenge of lack of prioritization of preservation work. Therefore, heritage institutions should aim at ensuring that the administrative officer assigned to establish ECMF will be in a position to influence decisions on budgetary committees, policies of the heritage institution and so on.

- After agreement on action plans, all staff should provide an input on achieving the endevour of providing ideal environment for collections. Having established action plans through the guide of activities given in Table 1, the officer responsible for environmental conditions should engage other staff where possible to buy-in their support.

CONCLUSION

This chapter set out to redefine suitable strategies for various environmental factors impacting upon preservation in heritage institutions in the East and Southern African Region. The chapter concludes that the compounding complexity of the custodial functions of heritage institutions, from analogue to digital, make preservation harder and harder, particularly in developing countries. Concerns about improving environmental conditions in heritage institutions considering limited resources and facilities have been raised. However, under suitable storage conditions the rate of material deterioration decreases with time resulting in a prolonged life expectancy of materials. This chapter has revealed that environmental considerations should be based on having appropriate activities and procedures, having appropriate facilities and equipment, addressing the impact of deterioration on collections, and taking into consideration the education and training requirements. Furthermore, it is important to always evaluate and analyse the challenges that can be encountered in environmental conditions. The discussions in this chapter have revealed a group of challenges in environmental conditions such as educational challenges, social factors, administration, financial or economic challenges. Furthermore, the discussions highlighted issues of infrastructure and disasters. The chapter has provided an Environmental Conditions Management Framework on how to integrate all the activities and procedures, appropriate facilities and equipment, environmental conditions deterioration factors and challenges and, education and training required, to manage environmental conditions in document heritage institutions.

As a way forward, it is vital that heritage institutions should integrate different professional activities into preservation measures to allow easy work flow and cooperation. Heritage institutions should provide a clear picture on coordination and governance of environmental activities. Environmental activities should not be viewed as discrete functions, and therefore, officers in charge of environmental conditions should be able to clearly account for financial measures/implications, education, public involvement, operations, and administrative functions.

REFERENCES

Abankwah, R. (2008). *The management of audio-visual materials in the member states of the East and Southern Africa Regional Branch of the International Council on Archives (ESARBICA)* (Unpublished doctoral thesis). University of KwaZulu-Natal, Pietermaritzburg, South Africa.

Abankwah, R. (2011). Policies and strategies that govern the management of audio-visual materials in Eastern and Southern Africa Regional Branch of the International Council on Archives. *Journal of the South African Society of Archivists, 44*, 90–106.

Akussah, H. (2003). *Preserving documentary heritage in Ghana: the National Archives of Ghana in focus* (Unpublished doctoral thesis). University of Ghana, Legon, Ghana.

Akussah, H. (2005). Preservation of Public Records in Ghana: The training, education and awareness factors. *Information Development, 21*(4), 295–302. doi:10.1177/0266666905060090

Alegbeleye, G. O. (1999). *The role of the joint IFLA/ICA Committee on Preservation and Conservation of library and archival materials in Africa.* Paper presented at the 65TH IFLA Council and General Conference, Bangkok, Thailand.

Asiamah, K. O. (2008). Preservation of print and non-print library materials: A case study of the Kwame Nkrumah University of Science and Technology Main Library, Kumasi, Ghana. *Journal of Science and Technology, 28*(2), 142–149.

Bearman, F., & Kissel, E. (2000). A global approach: Setting up a preservation program at Makerere University Library in Kampala, Uganda, 2000. *The Book and Paper Annual Group, 18.* Retrieved October 13, 2016, from: http://aic.stanford.edu/sg/bpg/annual/v19/bp19-02.html

British Standards Institution. (2012). Guide for the storage and exhibition of archival materials; BSPD5454 2012. London: British Standards Institution (BSI Group).

Chan, W.-Y., & Ma, S.-Y. (2004). Heritage preservation and sustainability of Chinas' development. *Sustainable Development, 12*(1), 15–31. doi:10.1002/sd.224

Chida, M. (1994). Preservation management in tropical countries: A challenging responsibility and limited resources: The case of Zimbabwe National Archives. *ESARBICA Journal: Journal of the Eastern and Southern Africa Regional Branch of the International Council on Archives, 14*, 22–36.

Coates, P. R. (2000). *JICPA Survey of the conservation facilities and experts in Africa.* Retrieved October 13, 2016, from: http://www.epa-prema.net/jicpa/survey.htm

Cornell Library. (2005). *Passive climate control; mould.* Retrieved January 9, 2014, from: http://www.library.cornell.edu/preservation/librarypreservation/mee/glossary/glossary_popup.php?ID=69

Daniels, V. (1996). The chemistry of paper conservation. *Chemical Society Reviews, 25*(3), 179–186. doi:10.1039/cs9962500179

Dean, J. F. (2002). *Environment and passive climate control chiefly in tropical climates.* Paper Read at the 68th IFLA Council and General Conference, Glasgow, UK. Retrieved January 14, 2014, from: http://www.ifla.org/IV/ifla68/papers/120-158e.pdf

Dewah, P., & Mnjama, N. (2013). An assessment of the National Archives of Zimbabwe Gweru Records Center. *ESARBICA Journal, 23*, 87–101.

Dewey, J. (1916). *Democracy and education: An introduction to the philosophy of education.* New York: The Macmillan company.

Feather, J. (1996). *Preservation and management of library collections* (2nd ed.). London: Library Association Publishing.

Gkinni, Z. (2014). A preservation policy maturity model: A practical tool for Greek libraries and archives. *Journal of Insect Conservation, 37*(1), 55–64. doi:10.1080/19455224.2013.873729

Gordon, A., Tidblad, J., & Lombardo, T. (2012). *The effect of black carbon on soiling of materials.* Retrieved January 14, 2014, from: http://www.swereakimab.se/

Harvey, R. (1994). *Preservation in libraries: Principles, strategies and practices.* London: Bowker.

Harvey, R., & Mahard, M. R. (2014). *Preservation management handbook; 21st-century guide for libraries, archives and museums.* Lanham, MD: Rowman & Littlefield.

Henderson, J. (2013). *Environment: Managing the library and archive environment.* London: Preservation Advisory Center, British Library.

Hlabangaan, K., & Mnjama, N. (2008). Disaster preparedness in information centers in Gaborone, Botswana. *African Journal of Library Archives and Information Science, 18*(1), 63–74.

Hunter, D. (2011). *Papermaking. The History and Technique of and Ancient Craft.* New York: Dover publications.

International Organisation Standards (ISO). (2003). *Information and documentation: Document storage requirements for archives and library materials, ISO 11799.* Retrieved September 16, 2015, from: http://www.unal.edu.co/una/docs/DT/ISO-11799_requirements_for_archive_and_library_materials.pdf

Kanyengo, C. W. (2009). Preservation and conservation of information resources in the University of Zambia Library. *Journal of Archival Organization, 7*(3), 116–128. doi:10.1080/15332740903126736

Kemoni, H. N. (1996). Preservation and Conservation of Archive Materials: The Case of Kenya. *African Journal of Library Archives and Information Science, 6*(1), 46–51.

Khayundi, F. E. (1995). An Overview of Preservation and Conservation Programmes in Eastern and Southern Africa. In *Proceedings of the Pan-African Conference on the Preservation and Conservation of Library and Archival Materials.* The Hague: IFLA.

King, S., & Pearson, C. (1992). *Environmental control for cultural institutions: Appropriate design and the use of alternative technology.* Paris: Collogue Internationale de I ARAAFU.

Kootshabe, T. J., & Mnjama, N. (2014). Preservation of government records in Botswana. *Journal of the South African Society of Archivists, 47,* 26–49.

Kufa, J. C. (1998). A Pilot Project on Preservation Awareness Training in the University of Botswana Library. *Restaurator (Copenhagen), 19*(2), 108–113. doi:10.1515/rest.1998.19.2.108

Lewis, J. R. (2000). *Conservation and preservation activities in archives and library in developing countries: An advisory guideline on association of commonwealth archives and records managers.* London: Association of Commonwealth Archivists and Records Managers.

Matwale, G. M. (1995). A Review of Problems Related to the Establishment of Effective Conservation Programmes for Library and Archives Materials in Kenya. In *Proceedings of the Pan-African Conference on the Preservation and Conservation of Library and Archival Materials.* The Hague: IFLA.

Mazikana, P. C. (1992). *Survey of Archival Situation in Africa.* Paris: UNESCO.

Mazikana, P. C. (1995). An Evaluation of Preservation and Conservation Programmes and Facilities in Africa. In *Proceedings of the Pan-African Conference on the Preservation and Conservation of Library and Archival Materials.* The Hague: IFLA.

Meliva, T. (2013). *A Post-Soviet problem: The management of conservation.* Retrieved September 29, 2013, from: http://forum2013.iccrom.org/post-soviet-problem-management-conservation/

Millar, L., & Roper, M. (1999). *Managing public sector records: Preserving records.* London: International Records Management Trust.

Mnjama, N. (2010). Preservation and management of audiovisual. *African Journal of Library Archives and Information Science, 20*(2), 139–148.

Matangira, V. (2003). Audiovisual archiving in the third world – problems and perspectives: An analysis of audiovisual archiving in the East And Southern African Regional Branch of the International Council on Archives (ESARBICA) Region. *ESARBICA Journal: Journal of the Eastern and Southern Africa Regional Branch of the International Council on Archives, 22*, 43–49.

Murray, K. (2002). *Preservation Education and Training for South African Library and Archive Professionals and Students (MBibl).* Cape Town: University of Cape Town.

National Research Council. (1986). *Preservation of historical records.* Washington, DC: The National Academies Press.

National Park Service. (2005). *National Park Service Checklist for Preservation and Protection of Museum Collections, Museum hand book, part I.* Retrieved September 18, 2013, from: http://www.cr.nps.gov/museum/publications/MHI/AppendF.pdf

Northeast Document Conservation Center. (2012). *The Environment; monitoring temperature and relative humidity.* Retrieved December 9, 2013, from: www.nedcc.org/

Ngulube, P. (2002). Preservation reformatting strategies in selected Sub Saharan African archival institutions. *African Journal of Library Archives and Information Science, 12*(2), 117–132.

Ngulube, P. (2005). Environmental monitoring and control at National archives and libraries in eastern and southern Africa. *Libri, 55*(2-3), 154–168. doi:10.1515/LIBR.2005.154

Ngulube, P. (2007). Preserving South Africa's paper trail and making public records available for present and future generations. *ESARBICA Journal, 26*, 35–50.

Ngulube, P., & Tafor, V. F. (2006). The management of public sector records in the member countries of ESARBICA. *Journal of the Society of Archivists, 27*(1), 57–83. doi:10.1080/00039810600691288

Olatokun, W.M. (2008). A survey of preservation and conservation practices and techniques in Nigerian University Libraries. *LIBRES Library and Information Science Research Electronic Journal, 18*(2), 1-18.

Ojo-Igbinoba, M. E. (1993). *The practice of conservation of library materials in Sub-Saharan Africa.* African Studies Programme.

Ottong, E. J., & Ottong, U. J. (2013). Disaster management of library materials in federal universities in Cross River and Akwa Ibom States, Nigeria. *International Journal of Educational Research and Development, 2*(4), 98–104.

Peters, D. (1996). Our environment ruined? Environmental control reconsidered as a strategy for conservation. *Journal of Conservation and Museum Studies, 1.* Retrieved January 12, 2014, from: http://www.jcms-journal.com/article/view/jcms.1962/2

Ramokate, K. (2006). Preserving the African memory: Critical challenges for ESARBICA organisations. *ESARBICA Journal, 25*, 84–93.

Ritzenthaler, M. L. (1993). *Preserving archives and manuscripts*. Chicago: The Society of American Archivists.

Roberts, A. (2004). *Inventories and documentation in running a museum: A practical handbook*. Paris: ICOM.

Rose, W. (1994). Effects of climate control on the museum building envelope. *Journal of American Institute of Conservation, 33*(2), 199–210. doi:10.2307/3179428

Rusuli, M. S., Tasmin, R., & Takala, J. (2012). Knowledge record and knowledge preservation: A conceptual framework of knowledge management practice at Malaysian university libraries. *International Journal of Information Technology and Business Management, 3*(1), 30–37.

Segaetsho, T., & Mnjama, N. (2012). Preservation of library materials at the University of Botswana library. *Journal of the Society of South African Archivists, 45*, 68–84.

Segaetsho, T. (2014). Preservation risk assessment survey of the University of Botswana Library. *African Journal of Library Archives and Information Science, 24*(2), 175–186.

Segaetsho, T. (2016). "A nation without a past is a lost nation, and a people without a past is a people without a soul": A wakeup-call for preservation in libraries and archives in Botswana. In *8th Botswana Library Association Annual Conference*. University of Botswana Library Auditorium.

Segaetsho, T. (n.d.). *Environmental consideration in the preservation of library and archival paper materials in selected heritage institutions in Botswana* (Unpublished doctoral thesis). University of Botswana, Gaborone, Botswana.

Seitshiro, B. T. (2006). *A study of the syntactic structure and the lexical fields of Setswana proverbs* (Unpublished masters' dissertation). University of Botswana.

Selatolo, O. (2012). *Map preservation at department of survey and mapping in Gaborone, University of Botswana* (Unpublished masters' dissertation). University of Botswana, Gaborone, Botswana.

Setlhabi, K. G. (2010). *Documentation of material culture: A study of the ethnology division of Botswana National Museum* (Unpublished doctoral thesis). University of Botswana, Gaborone, Botswana.

Siele, M. P. (2012). *Preservation programme and preservation status of information materials: A survey of selected institutions in Botswana* (Unpublished masters' dissertation). University of Botswana, Gaborone, Botswana.

Swartzburg, S. G. (1980). *Preserving Library materials: A manual*. The Scarecrow Press.

Stapleton, R. M. (2004). *Pollution A To Z*. New York: Macmillan Reference USA.

Tamuhla, K. S. (2001). *The preservation and use of photographic materials: A case study of Department of Survey and Mapping Air Photo Library* (Unpublished masters' dissertation). University of Botswana, Gaborone, Botswana.

Thabakgolo, M., & Jorosi, B. N. (2014). Newspaper preservation at Botswana's legal repositories. *Journal of the South African Society of Archivists, 47*, 61–76.

The Guardian. (2017). *The book rustlers of Timbuktu: how Mali's ancient manuscripts were saved*. Retrieved August 9, 2017, from: https://www.theguardian.com/world/2014/may/23/book-rustlers-timbuktu-mali-ancient-manuscripts-saved

The Council for Museums, Archives and Libraries. (2002). Benchmarks in Collection Care for Museums, Archives, and Libraries: A Self-assessment Checklist. Pennsylvania State University.

Toledo, F. (2007). *Museum passive building in warm, humid climates, contribution to the experts roundtable on sustainable climate management strategies*. The Getty Conservation Institute. Retrieved August 4, 2016, from: http://www.getty.edu/conservation/our_projects/science/climate/paper_toledo.pdf

Upward, F. (2000). Modeling the continuum as paradigm shift in recordkeeping and archiving processes, and beyond-a personal reflection. *Records Management Journal, 10*(3), 115–139. doi:10.1108/EUM0000000007259

Zaid, Y., Abioye, A., & Olatise, O. (2012). *Training cultural heritage preservation: the experience of heritage institutions in Nigeria*. World and Information congress 78th general conference and assembly (IFLA). Retrieved August 14, 2015, from: http://conference.ifla.org/past-wlic/2012/session-200.htm

Chapter 11
A Framework for a Good Recordkeeping System

Lekoko Sylvester Kenosi
Qatar National Library, Qatar

Olefhile Mosweu
University of South Africa, South Africa

ABSTRACT

A good record keeping system has a number of components that should be in place for the record keeping system to work optimally for the proper management of records in an organisation. This chapter presents and discusses the components of a recordkeeping system that include a records policy, people or staff, classification system, tracking, capturing business processes and controls, physical handling and storage, preservation, retention and disposition, Compliance monitoring and auditing, vital records protection and disaster preparedness, access, and training.

INTRODUCTION

A system can simply be defined as a set of interconnected components assembled to accomplish given specific purpose. The University of Toronto Archives and Records Services (UTARMS) says a system is an array of components that interact to achieve some objective through a network of procedures that are integrated and designed to carry out a major activity (UTARMS, 1999). Ackoff (1981) suggests that a system is a set of two or more interrelated elements with the following properties:

- Each element has an effect on the functioning of the whole.
- Each element is affected by at least one other element in the system.
- All possible subgroups of elements also have the first two properties

Every profession has its own understanding of what a system should be with an inclination towards the key tenets of that profession. Within the record keeping profession Horsman (2001) defines a record keeping system as the whole of people, resources, methods, procedures, data and knowledge with which

DOI: 10.4018/978-1-5225-3137-1.ch011

an organization moulds into concrete the required quality of its records. The University of Tasmania (2015) defines it as a system which captures, manages and provides access to records through time. Recordkeeping systems can be either electronic or paper-based.

The International Council on Archives (ICA) defines a recordkeeping system as "an information system developed for the purpose of storing and retrieving records, organized to control the specific functions of creating, storing, and accessing records, to safeguard their authenticity and reliability" (ICA, 1997). ISO 15489 (2016) adopts a similar definition to that of international records body preferring to describe a records system as an information system which captures, manages and provides access to records through time.

The words recordkeeping and records management are used interchangeably in the context of this chapter. McKemmish (2000) indicates that in the context of Australia, recordkeeping systems comprise systems that manage both current records and records with archival value. This is largely due to the influence of the thinking behind the records continuum (Piggott, 1988; Upward, 2000; Flynn, 2001). In this context, recordkeeping thus include:

1. The creation of records in the course of business activity and the means to ensure the creation of adequate records.
2. The design, establishment and operation of recordkeeping systems.
3. The management of records used in business (traditionally regarded as the domain of records management) and as archives (traditionally regarded as the domain of archives administration).

The term records management is synonymous with paper records (Yusuf & Chell, 2000; Ngoepe, 2008) as influenced by the records life cycle concept whose development is credited to Theodore Schellenberg of the National Archives of the USA in 1934 (Shepherd & Yeo, 2003). In developing countries such as those in Africa's Eastern and Southern Africa region, the life cycle concept is popularly used as a framework for managing public sector records (Ngulube & Tafor, 2006). The dominant use of the term records management in developing countries such as those in Africa stems from the dominant management of paper based records systems.

Accordingly, the University of Tasmania (2015) avers that all recordkeeping systems should:

1. routinely capture all records within the scope of the business activity it covers
2. organize the records in a way that reflects the business processes of the records creator
3. protect the records from unauthorized alteration, destruction or transfer
4. routinely function as the primary source of information about actions that are documented in the records
5. provide an audit trail of who has viewed or altered a record and when
6. provide ready access to all relevant records and related metadata
7. have accurately documented policies, assigned responsibilities and formal methodologies for its management

Thus, one can deduce that a system can be broadly defined as an integrated set of elements that accomplish a defined objective. Given these definitions a framework for a good recordkeeping system would, therefore, attempt to outline all the essential components and sub-components of a good recordkeeping system. This means that it should provide an interconnected skeleton needed to deliver an accountable,

logical and quality driven records system. So, what is this skeleton and what are its components? Before going into the components, it is important to go through a brief evolution of recordkeeping systems so as to illuminate developments over the years.

EVOLUTION OF RECORDKEEPING SYSTEMS

Recordkeeping systems have a long history. The function of records management, including the types of records have evolved from the Stone Age to the Digital Age. In essence, the said changes were largely driven by the prevailing changes in information technology, storage media, recordkeeping regulations, and the globalization of business practices (Marsh, Deserno, & Kynaston, 2005). These authors opine that records have existed since humans first learnt how to record and activity or event and such records, over time, ranged from scratching symbols on a piece of stone to daubing ochre on cave walls. Ancient works such as Sumerian clay tablets, the Rosetta stone, the pyramids' hieroglyphs papyrus, the Dead Sea Scrolls, and the Domesday Book suggest that during those times records managers may have been the owners, authors, or custodians of such ancient works. According to Hurley (2004) changes in recordkeeping systems emanated from changes in the technological infrastructure, the way business is conducted and, partly as a result of the way recordkeeping is conducted. IRMT (2009) paper recordkeeping systems are better understood as almost everyone working in a typical office environment recognises the nature and purpose of paper, typewriters, carbon paper for creating duplicates, pre-printed forms, filing cabinets, ledgers for entering accounts, warehouses for storing volumes of paper records and mail rooms for sending and receiving paper-based records. Comparatively, for electronic keeping systems, computer equipment would be installed in organisations with little consideration for what tasks to be performed and how the products of those actions (records) will be managed (IRMT 2009). According to Marsh et al (2005) and IRMT (2009), the digital age has made it difficult to manage electronic records, due to fundamental differences between the two technologies. Reasons for managing records however, do not change even while record-keeping systems change.

THE NATURE OF RECORDKEEPING SYSTEMS

To understand recordkeeping systems, Bearman (1994) emphasizes that recordkeeping systems should firstly be recognized as systems and, secondly, as information systems. In the previous section, a system has already been defined. An information system refers to an organized collections of hardware, software, supplies, people, policies, and procedures, plus all the maintenance and training which are required to keep these components working together (Bearman, 1994). IFIP (1998) defines it in terms of its concern for the use of information by personnel in an organization principally through computer based systems. Such information is enclosed in physical and electronic records (Laudon & Laudon, 2012). The whole purpose of deploying information systems is to support workplace performance to meet individual, group and departmental needs (Regan and O'Connor, 2002). There is a need to clarify the difference between an information system and a recordkeeping system. According to Bearman (1994), recordkeeping systems are organized to accomplish the specific functions of creating, storing, and accessing records for evidential purposes. They are designed to be used by staff in the performance of organizational business and keep the evidence of tasks performed

The core components of a goof record keeping system are the records themselves, the people who use and create the records, a records policy, a well-designed and well executed file classification system, and a system that produces auditable records processes and controls and one with a clear retention and disposition scheme. Also, a good recordkeeping system should prepare for disaster and identify vital records. These components, their subcomponents and essential attributes, are discussed in greater detail below.

The Definition of a Record

If a recordkeeping system is geared towards the management of records how does one then define a record? ISO 15489 (2016) describes it as information created, received and maintained as evidence. It is also described as information produced by an organization or person, in pursuance of legal obligations or in the transaction of business. If records have legal value then a good recordkeeping system should be able to capture authentic, reliable and trustworthy records. Authentic records, as distinguished from forgeries, are records which truly represent what they purport to be (Duranti, 2009; ARMA International, 2014). A reliable recordkeeping system is one that not only habitually captures all records of a given organization, but one that also protects the records from unauthorized alteration, reflects the business processes of the records creator, and provides ready and controlled access to records. ARMA International (2014: 5) points out that a record is only as trustworthy as the system in which it is maintained, so hardware, network infrastructure, software, and storage should be monitored. Media and systems migration, including all appropriate metadata, should be a part of maintaining a reliable information environment to ensure that records remain reliable despite these activities or changes. Authoritative records possess the characteristics of being reliable, authentic, and useable, and having some integrity (ISO 15489, 2016).

Usability

A useable record is one that can be located, retrieved, presented and interpreted within a time period deemed reasonable by stakeholders (National Archives of Malaysia, 2011; University of Tasmania, 2014; ISO 15489, 2016). Useable records do not exist in isolation. They are related to others and this linkage comes from connected business processes or transactions that produce them (IRMT, 1999; ISO 15489, 2016). According to IRMT (1999), when records are linked to each through business processes, they become meaningful and make sense within the context of the overall functions and activities of the individual or organisation that created or used them. This make the records to be unique because they are maintained within the context of their creation.

Reliability

The reliability of a record refers to the trustworthiness of a record as a statement of fact relating to the content. The assessment for reliability is based on the completeness of the record, that is, the presence of all the formal elements required by the juridical-administrative system for that specific record to be capable of achieving the purposes for which it was generated (Duranti, 2009:52). The reliability of a record is its ability to serve as reliable evidence. Therefore, a record can be no more reliable than it was at the instant of its creation. The direct responsibility for maintaining the reliability of records is placed on the records creator (International Council on Archives, 1997). Records reliability is called for by international records management standards. They include ISO 15489 – 1 and ARMA's Generally

Accepted Recordkeeping Principles (ISO, 2016; ARMA International, 2013). These are standards that are widely accepted for the management of current records. ISO 15489 indicates that a reliable record is the one whose contents can be trusted as a full and accurate representation of the transactions, activities or facts to which they attest. It is a record which can be relied upon in the course of subsequent transactions or activities. Records should be created at the time of the event to which they relate, or soon afterwards, by individuals who have direct knowledge of the facts, or by systems routinely used to conduct the transaction (ISO, 2016).

Authenticity

Authoritative records possess the characteristic of authenticity (ISO, 2016). Just like reliability, record authenticity is mandated in standards for current records management such as ISO 15489-1 and ARMA's Generally Accepted Recordkeeping Principles (ISO, 2016; ARMA International, 2013). According to Rogers (2015), authenticity of a record is reliant upon establishing and preserving the identity and the integrity of a record from its point of creation and thereafter. Authenticity of records, especially those created and managed in the digital environment is also mandated in frameworks for long-term digital preservation such as OAIS – Open Archival Information Systems (Lavoie, 2014) and standards relating to the establishment and certification of Trusted Digital Repositories (ISO, 2014). An authentic record, according to Macneil (2000), is one that can be proven to be what it claims to be. Secondly, it is one that is free of falsification or inappropriate modification. The authenticity of a record is assessed in relation to its identity (i.e., was it written by the person who purports to have written it?) and its integrity (i.e., has it been altered in any way since it was first created and, if so, has such alteration changed its essential character?). Proving the authenticity of a record thus implies the need to preserve its identity and integrity over time. Park (2005) in agreement with Jenkinson (1937) observes that in archival science, authenticity has long been understood as a significant term for a long time because newly created records were assumed to be all authentic and only authentic records were managed and preserved in the archives. According to Park (2005) this long held assumption became fragile and weak due to the vulnerable nature of digital documents. This is because in the digital environment, preserving the identity and integrity of a record is complicated by the fact that, unlike in the paper world, there are no stable and enduring physical objects (Macneil, 2000).

Integrity

Integrity is one of the features of an authoritative record. According to ISO (2016), a record that possesses integrity is one that is complete and unaltered. A record should be protected against unauthorized alteration. Policies and procedures for managing records specify the additions or annotations made to a record after it is created, including the rules governing circumstances such additions or annotations can be authorized. This also includes the person who is authorized their addition. According to InterPARES (2002), the integrity of a record refers to its wholeness and soundness: a record has integrity when it is complete and uncorrupted in all its essential respects. Of notable importance is that a record that possess the characteristic of integrity does not need to be precisely the same as it was when first created for its integrity to exist and be demonstrated. Records in both digital and paper formats are subject to deterioration, alteration and/or loss. In the electronic world, the fragility of the media, the obsolescence of technology, and the idiosyncrasies of systems likewise affect the integrity of records (InterPARES,

2002). When we refer to an electronic record, we consider it essentially complete and uncorrupted if the message that it is meant to communicate in order to achieve its purpose is unaltered. Assuring integrity in such systems includes measures such as access control, user verification, audits trails, as well as documentation that demonstrates the normal functioning, regular maintenance and frequency of upgrades of records systems (DLM Forum, 2010). ICA/IRMT (2016) opine that the integrity of records relies on a records management framework made up of a combination of laws and policies, standards and practices, enabling technologies (e.g. IT systems) and qualified/trained people supported by an effective accountability and management structure comprising people who are aware of and understand the importance of records in achieving the goals and priorities of their business.

Records Management Standards

Records management is a well organised management activity underpinned by standards which provide best practice frameworks. Maina (2011) opines that their main role is to enhance universality of materials, products, processes and methods to enhance interoperability across different regions. Several records management standards are used to guide records management. These include ISO 15489-1 (2016) standard on records management and Model Requirements for the Management of Electronic Records (MoReq Standard) (European Communities, 2008).

At the apex of records management standards is the internationally acclaimed ISO 15489-1 (2016) which defines the concepts and principles from which approaches to the creation, capture and management of records are developed and these relate to;

1. Records, metadata for records and records systems;
2. Policies, assigned responsibilities, monitoring and training supporting the effective management of records;
3. Recurrent analysis of business context and the identification of records requirements;
4. Records controls;
5. Processes for creating, capturing and managing records.

ISO 15489-1:2016 applies to the creation, capture and management of records regardless of structure or form, in all types of business and technological environments, over time. It is applicable to both the public and private sectors. Its development was based on the Australian AS 4390-1996 records management standard (Crocket & Foster, 2004; Maina, 2011). Basically the standard;

- Provides guidance on determination of responsibilities of organizations for records and records policies, procedures, systems and processes.
- Provides guidance on records management in support of quality process framework to comply with ISO 9001 and 14001.
- Provides guidance on the design and implementation of a record system.
- Does not include the management of archival records within archival institutions (Maina, 2011:2)

ISO 15489-1 (2016) comes in two parts. The first provides general guidance and specifies the elements of records management, including defined necessary outcomes to be achieved. The second part

specifies the methodology for the implementation of a records management programme as well as the design commonly referred to as the DIRKS Model (United Nations, 2006; Maina, 2011; ISO, 2016).

MoReq2 Standard was developed through a deliberate effort by the European Commission which commissioned its development, working closely with the DLM Forum (European Communities, 2008). It is a regional standard for the EU and prospective users of electronic records management systems have its value when procuring electronic records management systems. In addition software suppliers have used it to guide software development processes. The standard;

- Serves as a practical tool in helping organizations meet their needs for the management of both computer based and paper-based records
- Assists records managers and Archivists to manage electronic records with the desired levels of confidence and integrity, by combining the advantages of electronic ways of working with classical records management theory.
- Specifies and addresses capabilities required for the management of electronic records by computer software. The specifications avoid discussions of records management philosophy, archival theory, decision taking. The specification mentions in several places that certain functions must be limited to an administrator

There are other national records management standards belonging to particular countries such as the United States of America, Australia, New Zealand, United Kingdom, Norway, Singapore and South Africa (Standards Malaysia, 2009; Lukičić, Tesla & Sruk, 2009; Wooster, 2017). These are briefly presented in Table 1.

It is notable that in terms of standard development and implementation, developed countries are at the forefront. For developing countries especially those in Africa, South Africa is the only country that has domesticated ISO 15489 records management standard (Maina, 2011). The standards have been used to evaluate the state of records management as best practice frameworks as well as to inform the development and implementation of records management programmes. Basically the standards stipulate basic components of a records management programme which are more or less the components of a recordkeeping system. Records management standards thus play a significant role in the development and implementation of good records keeping systems.

Theoretical Framework

As illustrated in Chapter One theories and concepts permeate science. Records management is mainly underpinned by the records life cycle (RLC) theory and the records continuum model (Buckland, 1994; Yusof & Chell, 2000; Upward, 2001; Chachage & Ngulube, 2006). The records life cycle, largely influenced by North America records management traditions and attributed to Theodore Schellenberg while working in the National Archives of the USA in the 1930s (Shepherd & Yeo, 2003). It is commonly used and widely accepted globally by authorities and professionals in the field as most integrated and comprehensive approach to records management (Akussah, 1996; Shepherd & Yeo, 2003). RLC says that records pass through various conceptual stages during their life, being records creation or receipt (born or adopted); semi-active, records use and maintenance and non-active stages, records destruction or transfer to an archival repository (Mnjama, 1996; Chachage & Ngulube, 2006). RLC is associated with the management of paper records.

Table 1. Selected records management standards

Country	Standard	Description and Use
United States of America	DoD 5015.2-STD Electronic Records Management Software Applications Design Criteria Standard	• It is used for evaluating records management systems. • Joint Interoperability Test Command (JITC) certifies records management software solutions according to this standard. • It defines the basic requirements based on operational, legislative and legal needs that must be met by records management application (RMA) products acquired by the Department of Defense (DoD) and its Components
Australia (State of Victoria	Victorian Electronic Records Strategy	• It is endorsed by the State Government of Victoria, Australia, and is accepted and used as the backbone of e-Governance by archival institutions around the world. • VERS specifies a standard format for electronic records that focuses on data integrity and authentic archiving
Netherlands	ReMANO	It is a catalogue of software specifications for ERM systems in Dutch government bodies
Norway	NOARK-4	It specifies functional requirements specification for ERM and case management systems used in all public authorities in Norway
Malaysia	ISO 15489-1, IDT	• Voluntary standard • Adapted from ISO 14589-1 International Records Management Standard • Applies to electronic records management systems • It is intended for use by the public and the private sector organizations that wish to introduce, develop and implement Electronic Records Management System or to assess prevailing electronic records management system capabilities currently in place
Germany	Document Management and Electronic Archiving in Electronic Business (DOMEA)	• Provides guidelines for the implementation of electronic records in Germany. • It consists of three main sections: Organization concept, Requirements catalogue and expansion modules. • Although IT vendors are not obligated to certify its ERM systems against DOMEA, there are 170,000 approved DOEMA licenses in Germany, Austria and Switzerland
South Africa	SANS 15489-1	• It is voluntary • Adapted from ISO 15489-1

Records Continuum Model

The Records Continuum Model (RCM), largely a concept synonymous with Australian records management traditions is attributed to Frank Upward, an Australian Archivist (Upward, 2001). RCM provides a continuum of care for records regardless of media, focusing on the nature of records, the recordkeeping processes, the behaviours and relationships of records in certain environments, and digital world and its emphasis on content, context and structure (Upward, 2005). Inactive records can become active at any time, according to the records continuum model (Atherton, 1985). According to Kemoni (2008), the advantages of the records continuum model over the life cycle model demonstrates that the mechanism behind the best practice is the integration of the management of documents, records and archives. Unlike life cycle model the continuum model does not create a distinction between roles of records managers and archivists as they are involved in all the stages of managing records (Kemoni, 2008; Ngoepe, 2008). Records management software such as electronic document and records management systems (EDRMS) provide typical testimony that the electronic environment is seamless and without boundaries and thus fit in well with the reasoning behind the RCM. RCM thus underpins the thinking behind this chapter. Figure 1 below is a graphic representation of the Records Continuum model by Spiteri.

Figure 1. Records Continuum Model (Spiteri, 2014)

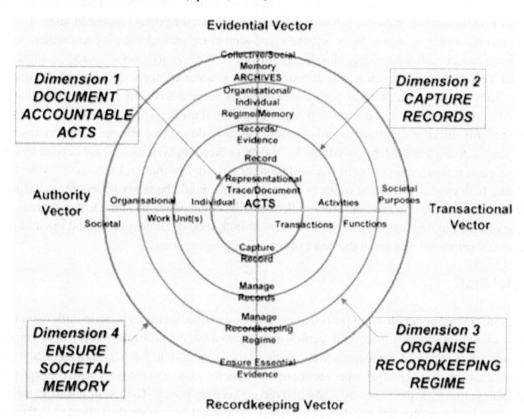

COMPONENTS OF A RECORDKEEPING SYSTEM

A recordkeeping system is made up of a number of components and these include a recordkeeping policy, people/staff, records classification system, tracking, Capturing Business Processes and Controls, physical storage and handling, preservation, access, retention and disposition, vital records protection and disaster preparedness, training, technology and compliance monitoring and auditing. These are individually presented in the next section.

Records Policy

A key element of a good recordkeeping system is a records policy. The University of Sheffield (2014) stated that "a records management policy when properly formulated is expected to describe the types as well as the nature of records to be generated, those to manage the records, as well as the competencies expected to be acquired by those people."

Any records management policy should be derived from a functional analysis of the organization the aim of which should be the creation and management of authentic, reliable and useable records capable of supporting rather than undermining business functions (ISO 15489, 2016). It is not enough to have a policy and not communicate it to staff, therefore, the organization must take upon itself the responsibility to communicate and implement the policy from top to bottom and vice versa. Regardless of how well

written the policy is, no policy can work in an organization without the support of those who really wield power. It is therefore important for top management to endorse the policy (ACARM, 2004).

The recordkeeping system is, in theory, the expression of top management's commitment to records management and its absolute concern for the proper care of the organization's recorded evidence. Shepherd and Yeo (2003) concur that a recordkeeping policy is a sub-component of a sound recordkeeping system. They observe that an ideal policy statement for a recordkeeping system is one that is least intrusive to staff undertaking business activity. The policy must incorporate a need for staff training, outline records directives, outline records operational procedures, and enforce rules, monitoring and implementation of a recordkeeping system. A good recordkeeping system does not happen by accident. Rather, a good recordkeeping system is a well thought out strategy that seeks to serve, even attempt to anticipate, both current and future needs of businesses and should be ready to accommodate new files borne out of a dynamic organization. Above all, a recordkeeping policy must not leave anything to guess work or chance but must attempt to communicate to both records professionals and novices the most fundamental principles that are at the heart of recordkeeping regimes.

People/ Staff

Records are created by people to support business processes. Since there can be no records without people it is important to state that a successful records management system is only possible if it is supported by the people who create and use records to serve their business mission. Even though records are the raw material of any business enterprise people are often either too lazy or to too busy with the organization's core business to follow the company's adopted record keeping policy, That is, in instances where such a policy exists. To resolve this problem there should be trained professionals dedicated to the management of records in an organization. This training should also be extended to non-records professionals in the organization to sensitize them about the benefits of proper records management. On this score Shepherd and Yeo (2003) again inform us that a good recordkeeping system requires people. In fact, human capital is the greatest resource of any organization. People not only design, implement, use the system but they are also responsible for marketing the system internally and externally.

A Records Classification System

Classification is a management tool that provides for a systematic arrangement of objects into groups or categories (Franks, 2013). Records classification is normally used for arranging business activities and resultant records into categories according to logically structured conventions, methods, and procedural rules as represented in a classification system (ISO 15489-1, 2016). In archival science, the classification of records is an undertaking of paramount importance. According to Foscarini (2009), the practice of classifying records results from the need to clarify the archival bond that exists among all the records participating in the same activity since the moment they are created, each has to be identified in their broader documentary, procedural, and provenancial contexts. Through records classification, the network of records formed as they accumulate is brought to light. Not only that because such a network is also established and perpetuated. In this way, the meaning of each record in relation to all the others as well as the structure of the whole of records (i.e., the archival fonds) can be understood and transmitted over time.

Classifying records and business information by functions and activities moves away from traditional classification based on organisational structure or subject. Functions and activities provide a more stable

framework for classification than organisational structures that are often subject to change through amalgamation, devolution and decentralization. The structure of an organisation may change many times, but the functions an organisation carries out usually remain much the same over time. Within the government sector, administrative change may periodically result in the loss or gain of functions between agencies. In these instances, functional classification makes it much easier for agencies to identify records that have to follow functions.

Microsoft (2008) avers that a well-designed recordkeeping system cannot operate without a file classification system. The classification of information according to a well thought out system has many advantages. Some of these advantages include the provision of an umbilical cord between similar records, a consistent manner of accumulating records, the easy design of appropriate retention and disposition periods for certain genres of records and security protection and access control measures. The file plan should describe each type of record in the enterprise, where they should be retained, how they need to be retained and who is responsible for managing them (Microsoft, 2008). Also, the file classification system adopted by any organization should be based on that particular organization's business activities (Commonwealth of Australia, 2003). The vocabulary used to represent each file should reflect the organization's business activities. A key feature of a file classification system is simplicity. All members of the organization should be familiar with the file index of the organization even if the work of filing is left to the trained hands of the organization's records professionals. It is important to emphasize that a records file classification system should aid retrieval and speedy access to the organizations' information resources.

Tracking

According to ISO 15489-1 (2016), organisations are expected to record the movement of records to ensure that users can locate the records whenever they need them (ISO 15489-1, 2016). Record tracking systems are used to manage the file movement. The tracking of records is one of the most innovative and effective means of ensuring efficiency and quality. A file tracking system has two distinct advantages. The first advantage is that it helps to locate the movement of files. The second advantage is that it helps to identify incompetent officers who fail to act on matters referred to them on time. A file tracking system improves productivity in the sense that in cases where time limits are imposed, nobody wants to be seen to be ineffective. A file tracking system may include such rudimentary information as the name and title of the officer having the file, the time when the file was dropped to their office, the time when he/she had finished acting on the file, and the dates. A file tracking system can either be analog or manual. The manual system is even more effective when the action officer is made to sign for receiving the file and a signature, time and date for releasing the file. In Botswana action officers used to hide files in their desks or take them home only to deny that they were ever in possession of the file once it was lost or missing and the file tracking system helped to nip this disease in the butt.

Studies have shown that where tracking of records is not well done, accountability for records becomes difficult. Poor accountability for records occasioned by inadequate tracking of records was reported in studies in the public sector of Botswana and Kenya. In Botswana, a study by Tshotlo and Mnjama (2010) at Gaborone City Council revealed that records officers relied on memory for file tracking but they still forgot, leading to difficulties in locating records. The trend of poor file tracking was also reported by in an earlier study in the public sector in Kenya (Kemoni, 2007). The study indicated that there were no procedures governing file tracking although the majority of officers reported using a file tracking

register as a tool for file tracking. In countries such as Sierra Leone and Swaziland, poor controls over the management of records led to proliferation of ghost employees in the public sector (IRMT, 2008; Mdluli, 2016) while in The Gambia weaknesses in the tracking of vouchers in the Treasury Unit, was amongst many reasons that led to difficulties in making financial decisions (IRMT, 1999).

Capturing Business Processes and Controls

The foremost objective of a recordkeeping system is to capture, in the best way possible, the processes of a given business entity. This is because businesses need to demonstrate, by way of records, that the decisions they take/took were informed by sound corporate ethics and operated within the correct parameters of the law. In a well-functioning state businesses operate within a controlled environment. This environment specifies the rights of the business owner, the rights of workers, fair competition and when and how to pay tax. Without records it is difficult to qualify if these due processes and controls have been observed. One of the biggest problems bedeviling most businesses is that critical records are often missing when needed mostly due to misfiling, loss or deliberate mutilation. A proper recordkeeping system ensures that no correspondence falls between the cracks by registering both incoming and outgoing official communication and placing them in the relevant files for action officers. It is desirable, in fact, necessary, that no recorded information should operate outside this controlled records framework.

ISO 15489 (2016) reminds us that the purpose of capturing records into records systems is to establish the relationship between records, the creator and the business context that gave birth to the records. In the electronic environment this process can be done through the use of metadata associated with a specific record. The same standard posits that this system can be applied to any record regardless of its format. The metadata system, if built into the procedures of a record system, has the potential to authoritatively retrace any record and its relationship with other records.

Technology

The definition of a record is technology neutral (ISO 15489-1, 2016). Marsh et al (2005) indicates that the medium used include clay tablets, the Rosetta stone, the pyramids' hieroglyphs papyrus, the Dead Sea Scrolls, and the Domesday Book as already highlighted under the section on recordkeeping systems. For long paper records keeping systems were the mainstay until the advent of computer mediated record keeping technologies. Today, there are hardwares and softwares available for records management. An electronic document and records management system (EDRMS) is one common software used for managing electronic records (InterPARES 2010). An EDRMS is designed to allow organizations to implement and enforce records management requirements stipulated in records management standards such as DoD 5015.2 of the US Department of Defence and Moreq2 of the European Union. It provides an environment in which a document can be declared a record, metadata can be added to establish its identity, and the record can be filed into a functional classification scheme in order to provide information about its provenance, nature and purpose (InterPARES 2010). The authenticity of records generated through a typical records management software such as an EDRMS is easy to verify unlike records created outside such systems.

Physical Storage and Handling

Information is stored in various physical storage mediums. A good recordkeeping system should contemplate physical storage. Shepherd and Yeo (2003), ascertain, for instance, that in the paper based system there is need for stationery and storage equipment such as files, boxes, cabinets and shelves. An electronic recordkeeping system also on the other hand, requires physical infrastructure such as computers, storage mediums and software. It is almost a truism that the physical records storage medium should address issues of security and disaster preparedness. In today's electronic recordkeeping environment the physical storage mediums of records should allow conversion, migration, retrieval and use without tampering with the integrity of records as evidence of a business transaction. Also, because the electronic medium is so versatile retention and disposition of records is actually easier today than it was ever before.

The handling of records should also take account of their physical and chemical properties (ISO 15489-1, 2016). Electronic and Audiovisual materials are much more fragile than paper and require more delicate handling approaches. While paper was easier to protect from unauthorized access developing fool proof handling systems that can guard against loss, destruction theft and disaster in the digital environment remains a big challenge.

Preservation

A preservation policy is important to support the development of a comprehensive preservation programme (Nsibirwa & Hoskins, 2008). A key component of a record-keeping framework is the ability not just to generate records but to preserve them in a usable state as well. This brings us to the definition of preservation. Debates have raged on in the interpretation of the terms "preservation" and "conservation". Ngulube (2003) states that the term preservation is also not clear in the perceptions of scholars. For example, "preservation is used in some cases as an umbrella term to refer to activities that prolong the life of documentary materials and conservation to refer to the physical and chemical treatment of individual materials" (Ngulube, 2003).

Traditionally, little attention was paid to current records and preservation was mostly associated with archives. Current thinking now widely accepts the fact that preservation is a continuum and should start with the creation of a record. In line with this thinking Edmondson (2004) believes that preservation is the totality of things necessary to ensure permanent accessibility and that potentially it embraces a great many processes, principles, attitudes, facilities and activities. In tandem with this thinking Ngulube (2003) again reminds his readers that conservation activities like restoration, and lamination constitutes aspects of preservation.

It is easier to make a positive impact on records through early intervention preservation programs than having to wait for the damage to occur first. Therefore, a framework that encompasses preservation at the records management level should be proactive as opposed to reactive and should never ever wait for the damage to occur first. The physical and chemical composition of analog records exposes them to decay form day one. Similarly, in the digital world the software that conveys electronic information is also susceptible to attacks from on day one. Therefore, it is helpful to minimize exposure through a careful preservation program at the records management level than at the archives management level. A lot of what has been discussed so far relates to the preservation of traditional records mediums. It should be stated for the record though, that, in the electronic environment preservation connotes more

than the mere act of fighting against decay but also embraces acts associated with warding off software and hardware obsolescence.

Retention and Disposition

It is impossible to keep records forever. According to ISO 15489-1 (2016), records accumulation needs to be controlled and this should be part of an organizational wide records management programme. Records differ in terms of value and importance. Storage considerations and implications, and the importance of a given record largely dictate which records to retain and which ones to dispose of. Human beings are continuously involved in deciding what to keep and what to destroy. However, most of the time these decisions are capricious and poorly thought out. A professional retention schedule is a systematic approach to the retention and disposition of records. Shepherd and Yeo (2003:147) remind us that:

a records management program aims to ensure that retention decisions are made rationally. One of its key justifications is protection of the organization against legal action. Besides retention of records needed for legal defense, this includes the ability to show why any particular records were destroyed. Irregularities in destruction procedures can bring suspicion... The existence of a structured retention system allows the organization to prove that any destruction took place as part of a normal business practice.

It is now widely acknowledged that retention schedules are a core component of any comprehensive records management programme. A records retention and disposal programme is a very important aspect of records management in an organization (Chinyemba & Ngulube, 2005). In Botswana and maybe in most parts of the developing world, retention schedules are published on paper. However, under today's electronic and analogue hybrid office systems, these kinds of retention schedules are no longer up to the task. Modern day retention schedules should endeavor to control both analogue and electronic records.

A comprehensive retention scheme should be linked to the institutions' file classification system and other metadata in what now becomes an integrated records management program. An organization's classification system defines the processes and activities of an organization and because of this provides the framework for drawing up retention schedules and decision. A well thought out file classification system will easily reveal and expose vital records and ephemera.

The electronic office environment, now dominated by databases has made it easier to manage retention schedules and classification schemes together. Shepherd and Yeo (2003) again inform us that in today's database dominated offices environment classification and retention metadata can be linked together. There are certain steps that need to be taken to ensure the success of a retention schedule. First, only top management can authorize the wide use of a retention schedule. This is because company executives are the only ones who can sanction the destruction of records. Again, the act of destroying even a single record is a big one requiring top management approval.

Vital Records Protection and Disaster Preparedness

Even though all parts of the human body are necessary for the sustenance of life not all of them are of equal value. For instance, a person can function with one eye, one hand, one ear and still be able to live a fulfilling life. However, there are some parts of the body that a person cannot function without. For example, no human being can function without a heart, brain, liver and lungs. To use this analogy in

the context of records management, all organizations have records which are as vital to their operations as the heart, lungs, and brain. They also have records which are important but not necessarily vital to their survival. Vital records are records synonymous to the human heart, lungs, liver and brain. In other words, vital records are records which are completely necessary for the functioning of an organization.

The University of Washington (2015) defines a vital record as recorded information regardless of format that must be protected in the event of emergency or a disaster. The State Records Authority of New South Wales (2002) view vital records as records that contain information essential to the survival of an organisation. The loss, damage, destruction and unavailability of vital records are a disaster on their own as it affects critical operations of an organisation. Vital records are required to support an organization's roles and responsibilities during a disruptive event such as a national security emergency or natural disaster (United States Department of Energy 2016).

Organizations need to identify records vital to their survival well ahead of a disaster. USAID (2012) and Diamond (1995) list the following as examples of records considered to be vital for the survival of an organisation;

- Automated Directives System (includes order of succession and delegations of
- Authority)
- Continuity of Operations Plan
- Emergency Personnel Contact List
- Patents, contracts, leases, copyrights, franchise, insurances and legal obligations
- Deeds and property tittles, fixed business assets and liabilities
- Site and Floor Plans
- Mission Directives and electronic communications
- Critical Program Implementation Records
- Time and Attendance Records
- Payroll Records and staffing patterns
- Financial System Records, tax and credit
- Records documenting contracts/Grants
- Official Personnel Files
- Damage and Loss Reports
- Freight records
- Grievance, disciplinary and adverse action records
- Property Inventory Records
- Leases on housing and other properties and motor vehicle files
- Board minutes and all legal obligations
- Participant Training Files
- Registration books and insurance documents for official vehicles

The above listed records genres can all be considered to be key to the functioning of an organization. It should be stated though, that, this list is not exhaustive. It is the responsibility of every organization to identify its vital records. The decision to select records that can be considered vital should arise from a team made up of top management, human resource, records management, legal division, information technology, finance and accounts, research and development, internal and external auditors and other key stakeholders. The best way to undertake a vital records programme is to keep a copy off-site, with

a trusted professional records management third party, who has the ability to restore the operation back to normal in the event of disaster. In addition, The United Nations Archives and Records Management Section (2016) emphasized that it is essential to always secure paper vital records in a fire-proof or bomb-proof safe, lockable storage cupboard, or lockable desk drawer.

A successful vital records programme is a necessary mechanism for the protection of vital records. Formal procedures for updating vital records regularly such as contact or personnel lists need to be in place in order to ensure that the vital records in storage are the most current versions. In addition, the United Nations Archives and Records Management Section (2016) mentions the value of backup systems as a way of preserving vital records in digital form in the event of a computer system failure. Moreover, maintaining all records systems as efficiently and as easily accessible as is possible makes a huge difference in the event of disaster.

Access

Every preservation programme carried out on any records medium is meant to enhance our ability to access them for administrative, legal, political and fiscal accountability. The ultimate goal of any record keeping programme is to ensure access to records for retrieval and use. The recordkeeping system should provide timely and efficient access to and retrieval of records needed in the continuing conduct of business and to satisfy related accountability requirements (ISO 15489-1, 2016). Gaining access to traditional paper records is very different from gaining access to electronic information. While it is easy but very effective to lock records in the drawer to prevent unauthorized access in the traditional environment, it is a bit complicated to control access in the electronic one. In the electronic environment passwords and access procedures defining levels of access are necessary to ensure the integrity of the recordkeeping system. Computer hackers have the means to alter, corrupt and manipulate electronic data with dire consequences for any organization.

Training

Staff training is a key element of any recordkeeping system. Staff undertaking records management functions should be qualified with adequate and regular financial support to implement and maintain a records management programme (IRMT, 2004). Furthermore, ISO 15489-1:2016 also recommends that organisations should establish an ongoing programme of records training for capacity building. This would enable the human part of the recordkeeping system to operate well within the system, enabling its sustained use. In addition, ISO 15489 (2016) says that organisations should strive to have adequate capacity in terms of numbers, skills and competences to perform records management duties at different levels. Training should be targeted towards any management group engaged in the business of the organization. Top management can only support a records management program if they are educated on the benefits of the system. Similarly, because top, middle and lower management work as a unit it helps to have all of them conversant on issues relating to records management. Lack of a proper and coordinated training program leads to a breakdown of the recordkeeping system and by extension to a breakdown of organizational accountability.

Compliance Monitoring and Auditing

Any system that is built with the overall aim of delivering quality service should be subjected to periodic checks and balances. Compliance monitoring and auditing guard against complacency and helps to recognize the fact that unmonitored systems, be they recordkeeping systems or otherwise decay and degenerate when subjected to neglect. ISO 15489-1 (2016) reminds us that compliance monitoring and auditing provides effective measures of ensuring that the recordkeeping system meets anticipated outcomes and user satisfaction. Crockett and Forster (2004) opine that the international records management standard is intended to provide a framework for planning and implementing a records management programme. The comprehensive nature of the standard with regard to current and non-current records and the clear categorization of its requirements also makes it a proper choice on which to base audits of records management programmes for purposes of compliance monitoring.

FUTURE RESEARCH DIRECTIONS

The records management field, just like its archives counterpart, has gone through dramatic changes witnessed through a miscellany of research literature from within and outside the professions (Pearce - Moses, 2005). The future research direction points towards digital recordkeeping systems- which are difficult to put a hand on-because they are still evolving and unstable. While the convenience of these systems is beyond question serious research needs to be done to provide a simple blueprint to practitioners on records security, records retention and disposition and issues of long term credible access. It would look like in the new digital recordkeeping age traditional methods of ensuring authenticity and reliability are sacrificed on the altar of speed with little thought placed on the trustworthiness of evidence carried by these systems.

CONCLUSION

Horsman (2001) offers the best conclusion on the topic of good recordkeeping systems by asserting that a "good recordkeeping system is, therefore, more than a computer system. Recordkeeping is supporting administrative function carried out by people, although with the help of various technology tools such as a computer, it is based on certain methods derived to protect the integrity of the records themselves. Thus let us consider the recordkeeping system first as an abstract concept, then as a concrete object" (Horsman, 2001, p. 12).

REFERENCES

ACARM Newsletter. (2004). Essential Elements of a Records Management. *ACARM Newsletter,* 35. Retrieved 20 June 2016 from: http://www.acarm.org/documents/issue35/35.18%20Essential%20Elements%20of%20Records%20Management.pdf

Ackoff, R. L. (1981). *Creating the corporate future.* New York: John Wiley & Sons.

ARMA International. (2014). *Generally Accepted Recordkeeping Principles*. Retrieved 10 July, 2017, from: http://www.arma.org/docs/sharepoint-roadshow/the-principles_executive-summaries_final.doc

Atherton, J. (1985). From Life Cycle to Continuum: Some Thoughts on the Records Management-Archives Relationship. *Archivaria, 21,* 43–51.

Bearman, D. (1994). Recordkeeping systems. In Electronic Evidence. Strategies for Managing Records in Contemporary Organizations. Archives & Museum Informatics.

Buckland, M. (1994). On the Nature of Records Management Theory. *The American Archivist, 57*(2), 346–351. doi:10.17723/aarc.57.2.y2340p4025584485

Chinyemba, A., & Ngulube, P. (2005). Managing records at higher education institutions: A case study of the University of KwaZulu-Natal, Pietermaritzburg Campus. *South African Journal of Information Management, 7*(1), 1–19. doi:10.4102/sajim.v7i1.250

Commonwealth of Australia. (2003). *Overview of Classification Tools for Records Management*. Retrieved 13 September, 2017, from: http://www.naa.gov.au/Images/classifcation%20tools_tcm16-88850.pdf

Crocket, M., & Foster, J. (2004). *Using ISO 15489 as an Audit Tool*. Retrieved 10 August, 2017, from: http://www.arma.org/bookstore/files/CrockettFoster.pdf

Diamond, S. (1995). *Records Management*. New York: Amacom.

DL Forum Foundation. (2010). *MoReq2010, Modular Requirements for Records Systems*. Publications Office of the European Union.

Duranti, L. (2009). From Digital Diplomatics to Digital Records Forensics. *Archivaria: The Journal of the Association of Canadian Archivists, 68,* 39–66.

Edmonson, R. (2004). *Audiovisual Archiving: Philosophy and Principles*. Paris: UNESCO. Retrieved 27 August, 2016, from: http://www.fiafnet.org/images/tinyUpload/E-Resources/Official-Documents/Philosophy-of-Audiovisual-Archiving_UNESCO.pdf

European Communities. (2008). *Model requirements for the Management of electronic records*. Retrieved 27 August, 2017, from: http://moreq2.eu/attachments/article/189/MoReq2_typeset_version.pdf

Flynn, S. J. F. (2001). The records continuum model in context and its implications for archival practice. *Journal of the Society of Archivists, 22*(1), 79–93. doi:10.1080/00379810120037522

Franks, P. C. (2013). *Records and information management*. American Library Association.

Horsman, P. (2001). *Electronic Recordkeeping: The Recordkeeping System as Framework for the Management of Electronic Records*. Retrieved 23 August, 2016, from: http://www.archiefschool.nl/docs/horselec.pdf

Hurley, C. (2004). *What, If Anything, Is Records Management?* Retrieved 25 August, 2017, from: https://www.descriptionguy.com/images/WEBSITE/what-if-anything-is-records-management.pdf

International Council on Archives (ICA). (1997). *Committee on Electronic Records, Guide for Managing Electronic Records from an Archival Perspective*. Paris: ICA.

ICA. (1997). *Guide for managing electronic records from an archival perspective: committee on electronic records*. Retrieved 5 September, 2017, from: https://www.ica.org/sites/default/files/ICA%20Study%20 8%20guide_eng.pdf

International Council on Archives (ICA)/International Records Management Trust (IRMT). (2016). *Managing Metadata to Protect the Integrity of Records*. Retrieved 30 November, 2016, from: http:// www.ica.org/sites/default/files/Metadata%20Module.pdf

InterPARES. (2002). *Requirements for Assessing and Maintaining the Authenticity of Electronic Records*. Retrieved 30 April, 2016, from: http://www.interpares.org/book/interpares_book_k_app02.pdf

International Records Management Trust (IRMT). (1999). *From Accounting to Accountability: Managing Accounting Records as a Strategic Resource*. Retrieved 7 September, 2017, from: http://www.irmt. org/documents/research_reports/accounting_recs/IRMT_acc_rec_background.PDF

International Records Management Trust (IRMT). (2004). *E-records readiness tool*. Retrieved 23 September, 2016, from http://www.nationalarchives.gov.uk/rmcas/documentation/eRecordsReadiness-Tool_v2_Dec2004 .pdf

International Records Management Trust (IRMT). (2008). *Sierra Leone Case study: Fostering Trust and Transparency in Governance*. Retrieved 17 July, 2016, from: http://www.irmt.org/documents/building_integrity/case_studies/IRMT_Case_Study_Sierra%20Leone.pdf

International Records Management Trust. (2009). *Understanding the context of electronic records management*. Retrieved 30 August, 2017, from: http://www.irmt.org/documents/educ_training/term%20 modules/IRMT%20TERM%20Module%201.pdf

International Standards Organisation (ISO). (2014). *Requirements for bodies providing audit and certification of candidate trustworthy digital repositories. ISO 16919:2014(E)*. Geneva: International Standards Organisation.

International Standards Organisation (ISO). (2016). *ISO 15489-1, Information and Documentation – Records Management Part 1: General*. Geneva: International Standards Organisation.

Jenkinson, H. (1937). *A Manual of archives administration*. Retrieved from: https://ia800806.us.archive. org/32/items/manualofarchivea00iljenk/manualofarchivea00iljenk.pdf

Laudon, K. C., & Laudon, J. P. (2012). *Management Information System: Managing the Digital Firm*. Boston: Pearson.

Lukičić, M., Tesla, E. N., & Sruk, V. (2009). *Electronic Records Management System Requirements*. Retrieved 8 August, 2017, from: http://infoz.ffzg.hr/INFuture/2009/papers/2-02%20Lukicic,%20Sruk,%20 ERMS%20requirements.pdf

Lavoie, B. (2014). *Recommendation for Space Data System Practices: Reference model for an open archival information system (OAIS)*. Retrieved 22 September, 2017, from: http://www.dpconline.org/ docs/technology-watch-reports/1359-dpctw14-02/file

Macneil, H. (2000). Providing Grounds for Trust: Developing Conceptual Requirements for the Long-term Preservation of Authentic Electronic Records. *Archivaria, 50*, 52–78.

Maina, D. M. (2011). *Role of records and archives management standards in enhancing the quality of records.* Retrieved 2 November, 2016, from: https://www.academia.edu/23730467/ROLE_OF_RE-CORDS_AND_ARCHIVES_MANAGEMENT_STANDARDS_IN_ENHANCING_THE_QUAL-ITY_OF_RECORDS

Marsh, M., Deserno, I., & Kynaston, D. (2005, March). Records Managers in the Global Business Environment. *The Information Management Journal*, 30-36.

Mdluli, M. (2016). *Ghost employees caused by poor records keeping.* Retrieved 7 August, 2017, from: http://www.pressreader.com/swaziland/swazi-observer/20160121/281775628168432

Microsoft. (2008). *Elements of a Records Management System.* Retrieved 20 September, 2016, from: http://technet.microsoft.com/en-us/library/cc261982.aspx

National Archives of Malaysia. (2011). *Electronic Records Management Systems - System Specifications for Public Offices.* Retrieved 2 November, 2016, from: http://www.arkib.gov.my/documents/10157/b10c4054-a5b9-4bc4-9173-1eaefe551cab

Ngulube, P. (2003). *Preservation and Access to Public Records in South Africa (Unpublished Degree of Doctor of Philosophy).* University of Natal.

Ngoepe, M. S. (2008). *An exploration of records management trends in the South African Public Sector: a case study of the Department of Provincial and Local Government.* Retrieved 30 August, 2017, from: http://uir.unisa.ac.za/handle/10500/2705

Nsibirwa, Z., & Hoskins, R. (2008). The future of the past: Preservation of, and access to, legal deposit materials at the Msunduzi Municipal Library, Pietermaritzburg. *ESARBICA Journal, 27*, 88–116.

Park, E. G. (2005). *Understanding "Authenticity" in Records Management: A Survey of Practitioners and Users.* Retrieved 28 August, 2017, from: http://www.interpares.org/display_file.cfm?doc=ip1_dis-semination_jar_park_jksarm_3-1_2005.pdf

Pearce-Moses, R. (2005). *A Glossary of Archival and Records Terminology.* Retrieved 27 January, 2017, from: http://files.archivists.org/pubs/free/SAA-Glossary-2005.pdf

Piggott, M. (1988). The history of Australian record-keeping: A framework for research. *The Australian Library Journal, 47*(4), 343–354. doi:10.1080/00049670.1998.10755861

Regan, E. A., & O'Connor, B. N. (2002). *End User Information Systems: Implementing Individual and Work Group Technologies.* Upper Saddle River, NJ: Prentice Hall.

Shepherd, E., & Yeo, G. (2003). *Managing Records: A Handbook of Principles and Practice.* London: Facet Publishing.

Spiteri, L. (2014). *Records Continuum Model.* Retrieved 29 August, 2017, from: https://www.slideshare.net/cleese6/records-continuum-model

Standards Malaysia. (2009). *Information and Documentation - Records Management - Part 1: General* (ISO 15489-1:2001, IDT). Retrieved 17 July, 2017, from: https://www.msonline.gov.my/download_file.php?file=15624&source=production

State Records Authority of New South Wales. (2002). *Vital records protection (Counter disaster strategies)*. Retrieved 10 December, 2016, from; https://www.records.nsw.gov.au/recordkeeping/advice/counter-disaster-strategies/5-vital-records-protection

Tshotlo, K., & Mnjama, N. (2010). Records management audit: the case of Gaborone City Council. *ESARBICA Journal, 29*.

United Nations. (2006). *Manual for the Design and Implementation of Recordkeeping Systems (DIRKS)*. Retrieved 10 April, 2017, from: https://archives.un.org/sites/archives.un.org/files/files/French%20files/Manual_for_the_Design_and_Implementation_of_Recordkeeping_Systems.pdf

United Nations Archives and Records Management Section. (2016). *How do I know which records are vital?* Retrieved 13 August, 2017, from: https://archives.un.org/sites/archives.un.org/files/uploads/files/Guidance%20Vital%20Records.pdf

United States Department of Energy. (2016). *Records management handbook*. Retrieved 7 May, 2017, from: https://www.energy.gov/sites/prod/files/2016/12/f34/Records%20Management%20Handbook_0.pdf

University of Sheffield. (2014). *Records Management Policy: Corporate Information and Computing Services*. Retrieved 8 May, 2016, from: www.sheffield.ac.uk/cics/records/policy

University of Tasmania. (2014). *Staff recordkeeping manual*. Retrieved 20 November, 2016, from: http://www.utas.edu.au/__data/assets/pdf_file/0009/268155/Staff-Recordkeeping-Manual.pdf

University of Tasmania. (2015). *What is a recordkeeping system?* Retrieved 12 September, 2017, from: http://www.utas.edu.au/it/records/support/faqs/sorting-records/accordion-items/what-is-a-recordkeeping-system

University of Toronto Archives and Records Services. (1999). *Records Management Glossary*. Retrieved 25 August, 2017, from: http://www.library.utoronto.ca/utarms/info/glossary.html

University of Washington. (2015). *Vital records*. Retrieved 29 August, 2017, from: https://finance.uw.edu/recmgt/vitalrecords

Upward, F. (2000). Modelling the Continuum as a Paradigm Shift in Recordkeeping and Archiving Processes, and Beyond - A Personal Reflection. *Records Management Journal, 10*(3), 15–139. doi:10.1108/EUM0000000007259

United States Agency for International Development. (2012). *Examples of Vital Records*. Retrieved 7 September, 2017, from: https://www.usaid.gov/sites/default/files/documents/1868/511sab.pdf

Wooster, M. (2017). *Are certifications important when selecting a records management system?* Retrieved 6 September, 2017, from: https://www.laserfiche.com/ecmblog/are-certifications-important-when-selecting-a-records-management-system/

Yusof, Z. M., & Chell, R. W. (2000). The Records Life Cycle: An inadequate concept for technology-generated records. *Information Development, 16*(3), 135–141. doi:10.1177/0266666004240413

ADDITIONAL READING

Borglund, E. (2006). *A Predictive model for attaining quality in recordkeeping.* Retrieved 3 October, 2017, from: https://www.diva-portal.org/smash/get/diva2:2005/FULLTEXT01.pdf

Federal Aviation Administration. (2014). *Recordkeeping systems.* Retrieved 2 October, 2017, from: https://www.faa.gov/about/initiatives/records/faq/recordkeeping_systems/

Iacovino, L. (2008). Electronic health records: *Achieving an effective and ethical legal and record-keeping framework.* Retrieved 2 October, 2017, from: https://www.monash.edu/__data/assets/pdf_file/0005/857624/arc-report2.pdf

Macintosh, S., & Real, L. (2007). *DIRKS: Putting ISO 15489 to work.* Retrieved 2 October, 2017, from: http://www.arma.org/bookstore/files/Macintosh_Real.pdf

Millar, L. (2003). *The right to information – the right to records the relationship between record keeping, access to information, and government accountability.* Retrieved 2 October, 2017, from: http://www.humanrightsinitiative.org/programs/ai/rti/articles/record_keeping_ai.pdf

Ombudsman Western Australia. (2009). *Guidelines for good recordkeeping.* Retrieved 2 October, 2017, from: http://www.ombudsman.wa.gov.au/Publications/Documents/guidelines/Good-record-keeping-Guidelines.pdf

KEY TERMS AND DEFINITIONS

Framework: A guiding structure with requisite components.

Record: Documents produced or received in the course of undertaking business activities.

Recordkeeping: All of processes, people, technology and other components of a records management programme necessary for successful records management.

System: An entity made of sub parts that make up a whole and these sub parts work together in a relationship to make the whole complete.

Chapter 12
Management of Public Sector Records and Archives in Botswana

Segomotso Masegonyana Keakopa
University of Botswana, Botswana

ABSTRACT

This chapter looks at the management of public sector records and archives in Botswana. The chapter starts with an overview of developments in the East and Southern African Regional Branch of the International Council on Archives (ESARBICA), which provides a foundation for discussion of developments in Botswana. It looks at the extent to which the Botswana National Archives and Records Services (BNARS) has fulfilled its role as the overseer of the creation, maintenance, use, disposition of public sector records, and preservation of the country's cultural heritage. It also looks at the impact of information and communication technologies and management of electronic records together with issues of staffing, training, and the challenges and prospects the country is faced with in managing records and archives as a symbol of cultural heritage. The chapter is based on an extensive review of the literature and the author's personal experience. It ends with recommendations on future directions.

INTRODUCTION

As organisations become increasingly dependent on records and archives to operate and make informed decisions, the pressure for their management is being greatly felt. The management of public records and archives, therefore, has been of major concern in developing countries. In fact, the International Records Management Trust (IRMT)[1] has for example, since its formation in 1989, taken the lead in guiding the management of public sector records and archives in developing nations. The IRMT working in collaboration with the World Bank (WB) has committed itself to ensuring good governance in the electronic age through strengthening information systems (IRMT, 2002, 2008). These institutions have

DOI: 10.4018/978-1-5225-3137-1.ch012

been working together in raising awareness, inspiring collaborative efforts, and improving tools, training and strategies to improve electronic-readiness (e-readiness) in developing countries. Specifically, this has helped in ensuring that public records and archives are efficiently managed to ensure accountability, good governance, transparency and preservation of corporate memory as cultural heritage.

In the East and Southern African Regional Branch of the International Council on Archives (ES-ARBICA)[2], the management of public sector records and archives has been driven by a number of strategies and development frameworks, including national public sector reforms and implementation of e-government strategies through adoption of Information and Communications Technologies (ICTs) as in case of Tanzania and South Africa. In Botswana, which is the focus of this chapter, the main drivers include the new long-term vision, Vision 2036[3], the National ICT Policy (Maitlamo), Electronic Government (e-government) strategy; the Electronic Records (evidence) Act, 2014 and the role of the Botswana National Archives and Records Services (BNARS). Vision 2036, for example, focuses on a knowledge based economy and the need to improve the regulatory environment in ICTs and ensure digital access by all. Further, it recognises that culture is an ingredient for national building and that Botswana recognises institutions that promote its cultural heritage and as such aims to promote and preserve cultural heritage through research and documentation. This places BNARS in a strategic position to contribute to preservation of culture through management of records and preservation of archives. In addition, the National ICT policy (Maitlamo) and E-government strategy have accelerated technological advancement which in turn demands good recordkeeping in the electronic environment to ensure governance and accountability in the public sector. It also requires preservation of digital records. On the other hand, the Electronic Records Evidence Act of 2014 specifically provides for admissibility of electronic records as evidence in legal proceedings and authentication of electronic records (Electronic Records (evidence) Act, 2014). In the mist of all this, BNARS as the agency responsible for custody of public records and preservation of Botswana's cultural heritage has been pressurised to take the lead in advising and supervising records management activities in the whole of government and providing archival services. These developments will guide this chapter in discussion of management of public sector records and archives in Botswana.

METHODOLOGY

The compilation of this chapter depended on an extensive search of the literature in the ESARBICA region and in Botswana. Books, journal articles and electronic sources were used. Some professional experience over a 23 year period as a practitioner and academic also informed discussions and opinions in this chapter. Interactions and sharing of experiences with other professionals in the region and internationally at the recent ESARBICA conference in Lilongwe, Malawi held from 7-11 August 2017 also provided information that confirmed some information from the literature. The discussion in this chapter is guided by the life cycle model which looks at the management of records through the stages of creation, maintenance, use, and appraisal and disposition where some records become archives because of their continuing values.

OVERVIEW OF ARCHIVAL AND RECORDS MANAGEMENT DEVELOPMNETS IN THE ESARBICA REGION

A number of authors in the region have traced and documented the developments of archives and records management in the ESARBICA region (Mnjama, 2005; Ngulube, & Tafor, 2006; Kemoni, 2009; 2010; Ngoepe, & Keakopa, 2011). An overview of this literature points to uniform archival and records management practices and similar challenges in the management of records and preservation of cultural heritage. The literature points out that the mandate, mission and scope of national archives in the ESARBICA region is to broadly manage records and promote preservation of archival heritage (Ngoepe, & Keakopa, 2011). The respective legislations make provision for preservation and custody, control and disposal of public records. It follows, therefore, that archival institutions in the region have a responsibility for management of cultural heritage and coordination of records management activities. It also emerges from this literature that while Archival legislations have this massive responsibility, many are still operating on old and outdated legislation. Ngoepe and Saurombe (2016) have provided a detailed analysis of each act in the region, and their shortcomings in terms of preservation and provision of access to documentary heritage. They argue that amongst other challenges, the legal ownership of electronic records is a challenge as most National Archives do not have capacity to take them. Some, however, like South Africa and Tanzania have amended their legislation to cater for management of electronic records and systems. Many others are still to amend their legislation to provide for this new role. However, for those that have not amended their legislation it is naturally assumed that archives cover records. Apart from legislation, a number of challenges such as: inadequate staffing levels; professional training; preservation of cultural heritage; backlogs of records to be appraised in government offices; management of electronic records are still issues that member states are grappling with (Mnjama, 2005; Keakopa, 2011; Ngoepe & Saurombe, 2016; ESARBICA conference resolution, 2017).

The ESARBICA conferences from 1969 until the recent one held in Lilongwe, Malawi in August 2017 have continued to make resolutions that are still to be addressed. A regional strategy accompanied by the action plan were developed and approved in 2015 and have not yet been implemented.[4] It is expected that the new Executive Board of ESARBICA will take up implementation of this plan to be able to deal with the outstanding challenges. It is against the backdrop of this regional background that developments in Botswana are discussed.

ORIGINS OF ARCHIVES AND RECORDS MANAGEMENT IN BOTSWANA

The beginnings of archives administration in Botswana can be traced to 1965 when preparations were being made to move the capital from Mafikeng to Gaborone. In the words of C. H. Thompson, the first Government archivist, "the Botswana National Archives came into existence almost by accident as a result of the transfer of the seat of government from Mafikeng to Gaborone" (Thompson, 1970). It can be deduced that this was by "accident" because at the time of transfer there were no plans in place to set up a National Archives. When Thompson was assigned by the Protectorate Government to select records to be transferred, he found out that there were no specific working instructions for transfer and no formal authority to destroy totally worthless paper (Kukubo, 1986). Authority was, however, given by the government to decide on the fate of closed files, their disposal schedules and retention periods.

As that time, preparations for the move of the new archives building included conducting a survey of records in various institutions. The main observations made at that time were that:

- There was lack of storage space for the current records;
- Care of records was left to very junior members of staff; and
- Senior management were too busy to pay attention to the care of records. (Thompson, 1970).

Even though these challenges were noted in the early 1970s, they continue to be witnessed as evidenced by literature on management of archives and records in Botswana (Ramokate & Moatlhodi, 2010; Tshotlo & Mnjama, 2010).

While traces of archives administration have been traced to 1965, it was not until 1974 that early signs of modern records management became evident in Botswana (Ngoepe & Keakopa, 2011). This was when J. Rose (then Government Archivist) started drawing procedures for the guidance of government departments and visited outstations to advice on records management procedures (Lekaukau, 1990). These guidelines were to form the basis for new procedures developed by the National Archives to guide government agencies on proper management of records. The main concern during Rose's time was the bulk of files not only in government offices but also those that had been dumped in an unsystematic way in the archives. The uncontrolled accumulation of departmental files found their way into the archives just to create room in departmental offices. In addition, they reflected no logical order as they were transferred neither arranged nor listed. Retrieval of any one file involved a lengthy and frustrating search. According to Rose the situation was made worse by the fact that there was a lack of interest and support among highly placed officials in government agencies, making the "registry" (now referred to as Records Management Units (RMUs)[5] the most neglected office in the government administrative structure. Until recently, in Botswana records have continued to be created as long as space and equipment were available without ensuring a balance between creation and disposition as guided by the life cycle model. Whenever that space is filled, more was found on top of cabinets and along corridors to store the records. This made retrieval of information difficult because they were not properly arranged.

Although there were signs of records management during this early period, it was not until 1992 that government through the reorganisation of the Botswana National Archives started to seriously tackle records management activities and ensuring their preservation for prosperity. This development has been vastly documented in the available literature in Botswana and the ESARBICA region (Kenosi, 1999; Ngoepe & Keakopa, 2011; Chebani, 2005). Since the time when Thompson and Rose first raised the issue about the state of records management in Botswana, the government has paid more attention to the development of RMUs in order to control the amount of records being created and to improve efficiency and effectiveness and ensure archival records are preserved. This informed the emergence of a new role for BNARS in managing public sector records in addition to the traditional archival practices of preserving documentary heritage. As will be discussed in the sections that follow Botswana has to date continued to improve the management of public sector records and archives, even though it is still faced with a number of challenges that continue to haunt the rest of the ESARBICA region.

THE ROLE OF BNARS IN THE MANAGEMENT OF PUBLIC SECTOR RECORDS AND ARCHIVES

Importance of Records and Archives and the Need for Their Management

Records and archives, whatever their format, are important as they document, direct, control the expectations and actions of government business. They also serve as corporate memory and part of the nation's cultural heritage. The two are linked by the life cycle and one cannot be discussed without mentioning the other. Contemporary organisational activities from management of finance to personnel depend on reliable information to deliver services and operate. As such records form evidence of organisational activities and are kept for administrative purposes and use in the daily operations. Records are kept for their legal value, as proof evidence especially in regulated areas (Shepherd & Yeo, 2003). Examples of such records include agreements, deeds and contracts. Records are also kept because of their historical values. For example, minutes of meetings in an organisation can provide evidence of organisational accomplishment. Furthermore, records are important for business continuity and risk management in case of disasters where they can be used for survival and to reconstruct. They ensure the effective implementation of data protection principles, Freedom of Information (FOI) laws; facilitate knowledge management; support accountability; good governance; policy-making; planning and delivery of successful programmes and services; and safeguarding the rights and freedoms of citizens (Crockett & Yeo, 2001; IRMT, 2002, 2008; Ngoepe & Saurombe, 2016). On the other hand, archives serve as a memory of the nation; as a culture of society and as such need to be protected and preserved.

The need to manage records and information for accountability is important, particularly in Africa where governments need to use this resource for managing their problems. The worsening problems in African countries since the early 1980s and mid 1990s have been traceable to public sector and political mismanagement. These problems have resulted in lack of transparency, human rights abuse, and corruption, including mismanagement of public funds. Institutions of policy-making in Africa tend not to recognise records and information as a strategic resource. In Botswana, there are examples of legal cases involving the state which have been postponed in the past because of missing court records. Keorapetse and Keakopa (2012) have documented the role of records in combating corruption in Botswana. There is, therefore, an urgent need to formulate integrated strategies for the management of public sector records and preservation of archival materials and further build the capacity for managing electronic records.

In realising the importance of records and the need for their management, the International Standards Organisation (ISO) released a records management standard, ISO 15489, 2016. This standard is used to guide the management of records in all formats and media. It provides the concepts and principles that serve as a basis for promoting best practices in records management, including metadata from records and records systems (ISO 15489, 2016). Areas covered in the standard include: policies and responsibilities, strategies, design and implementation for records systems, record processes and control, and records monitoring and auditing. The main strength of the standard is its generic nature and applicability in a variety of environments. Botswana and the rest of the region should use this standard in developing their own national policies and procedures.

Overview of Legislation Relating to the Management of Records and Archives

As stated in the overview of developments in ESARBICA region, National Archives Acts provide essential frameworks which enable records and archives services to operate with acceptance and authority. However, as has been observed in the literature in the region most legislations are outdated and do not cover management and preservation of records in networked environment commonly known as electronic records (Ngulube & Tafor, 2006; Keakopa, 2010; Ngoepe & Saurombe, 2016).

In Botswana, the management of public sector records and preservation of archival heritage has been declared by the National Archives Act No. 37 of 1978, as amended in 2007. This 1978 Act appeared "vague" about the management of records as it did not give the legal definition of electronic records and other electronic transactions as is the case with the acts in other countries as South Africa (Keakopa, 2006). However, following adoption of new technologies, there has been massive computerisation in government agencies and increased generation of electronic records. To cater for the management of this format of records, amendments have been made to the 1978 Act and were approved by Parliament in August 2007. The amendments, however, appear to have only made an addition of the words "electronic records". Thus, it still remains unclear on how these records are to be treated. Failure to stipulate clearly on how electronic records and systems are to be handled is one of the impediments to the proper management of these records. It leaves uncertainties as to what constitutes the emerging new forms of records as well making record creators and legal officers uncomfortable with the use of such records as evidence because of their unclear status in the legislative provision. The amendments in the BNARS Act are also silent on electronic recordkeeping systems and do not clearly stipulate how these systems should be regulated. Further, the amended legislation does not specifically require government agencies to provide infrastructure and other competencies for the management of electronic records. It is, however, expected that the establishment of the Electronic Records Evidence Act of 2014 will give force of legislation in admissibility of electronic records as evidence in courts of law. However, it is unfortunate that BNARS was not involved in the drafting of this legislation and as such will have no say or role in its implementation. This new legislation still has to be tested in a court of law.

The current author is of the view that BNARS has to be more proactive and keep up the pace with technological developments by engaging and participating in ICT committees through the e-government strategy to be able to influence developments related to e-government and see how these affect recordkeeping and archival preservation. Their participation in ICT issues will help in forming partnerships that would enable them make contributions to the regulatory frameworks, policies and other guidelines that impact on records and archives. This may also help Botswana in developing national policies and other guidelines for the management of electronic records and have their role accepted by organisations. On the positive note, the e-government initiatives have led to formation of clusters including the records management cluster. It is, however, unfortunate that the cluster has not been active and this has denied the profession an opportunity to participate and align itself with public sector reforms. BNARS needs to be more proactive in using such platforms that have been availed by government.

Other legislations and regulations in Botswana that relate to records include the following: the Public Service Act (Act No. 13 of 1998), Copyright and Neighbouring Rights Act (2000), Evidence in Civil Proceedings (No. 26 of 1977) and Financial Regulations. Section 37 (1) of the Public Service Act contains restrictions on disclosure of public information or records. For example, it says that any person who publishes or discloses contents of any documents, communication or information for private purposes and against the provisions of the act is guilty of an offence. Further, the Public Service Charter

contained in the General Orders of 1996, as reviewed in 2000 and 2005 which governs the conditions of the public service in Botswana declares that the principle of transparency dictates that members of the public are entitled to have access to non-confidential information on the operation and activities of the public services. This, however, does not entitle members of the public to breach confidentiality, nor have access to private information concerning others which is to be found in public service files. The Evidence in Civil Proceedings Act, which declares the law of evidence, provides for certified copies or extracts of documents from the proper custody to be admissible in evidence. The Botswana Government Office Security Instructions on the other hand, contain information on security of official documents and information is the concern of everyone in government service. According to the Instructions, official documents must be protected, if harm would result from the disclosure of the information to unauthorised persons and further provides conditions for the custody and storage of such documents. In spite of the fact that these acts contain sections that make reference to how public information or records should be treated, all of them are currently not aligned to the archives act. The Public Service Standards for records management released in 2008 are a welcome development in ensuring records management in the public sector is aligned to performance management, Other stakeholders including the Auditor General and Public Accounts Committee (PAC) are playing a significant role in enforcing compliance with records management policies and procedures. BNARS should take advantage of their role and partner with them to ensure auditing of the records function in the public sector and other state owned enterprises.

Management of Current Records: Creation and Classification

The realisation that no government can function effectively without accurate and relevant information provided to decision makers convinced the Government of Botswana to recognise the need for integrated management of records and information systems. As clearly stated under the section on origins of archives and records in Botswana, the Government took a decision to integrate the management of current records with archives administration (Lekaukau, 2000). Although the idea of integrating Records management Units (RMUs) into the National Archives was conceived in 1982, it was not until 1992 that the National Archives took over the new responsibility. The National Archives derives its new mandate from Sections 5 (3A) a, b e and 5 (4) k of the National Archives Act (as amended in 2007) read together with Sections 10 and 11 of the same Act. The rationale behind this involvement is contained in the Report on Organisation and Methods (O & M Report) on Improving Efficiency and Effectiveness of Records Management Functions in the Public Service. It reads:

good archives are an invaluable cultural heritage of Botswana and are dependent upon effective records management programmes, for only when such programmes exist is there assurance that the records of permanent value are created on durable materials, organised for easy retrieval, adequately cared for during the active period of their existence, and properly scheduled, appraised and transferred to the National Archives for preservation. (DPSM & BNARS, 1989).

This new responsibility included providing professional advice to government on all matters relating to records; establishing close links with Central and Local Government authorities; helping records personnel to undertake all kinds of training related to the records; and above all enhancing career prospects for records personnel. This was meant to develop a professional, competent and committed records cadre and properly induct, train and educate action officers in the proper use of records services and facilities

(DPSM, 1992). It gave the National Archives responsibility to issue guidelines which insist on proper handling of files to ensure preservation of cultural heritage and its accessibility. It is, however, unfortunate as argued earlier that at the time of writing this chapter BNARS had not yet developed a national records management policy and other guidelines.

Following the integration of RMUs into the National Archive function, BNARS deployed records officers to different ministries and departments to manage RMUs and responsibilities involved. Kenosi (1999) argued that this was a radical move. This can be said to be true because some years down the line BNARS appeared to be overwhelmed by staffing demands from government agencies and was not able to meet them which made its centralised model of managing public sector records ineffective. The current author had an opportunity to witness some of these challenges as an employee during the integration. As a result, there were criticisms alleged by some agencies and records officers against BNARS for failure to meet its records management responsibilities. The idea of seconding records management staff to agencies has over the years overstretched BNARS as it did not have the capacity to cope with this huge responsibility. BNARS bowed to the pressure and has now decentralised records management activities to government agencies and it is only left with an advisory role (Chebani, 2005; Keakopa, 2010). This was a good move as it now follows a similar model adopted by other member countries in ESARBICA.

The creation of records in most organisations is the responsibility of RMUs. In the past, not many government agencies in Botswana had given high priority to the running of RMUs, thus contributing to the poor state of records creation, maintenance and use in the public sector. At that time, not much thought was given to the logical allocation of papers to appropriate files which resulted in the loss of important records. In follows from this that RMUs have for a long time been neglected and left undeveloped. They were only considered important only as long as they provided information needed for decision-making. This state of affairs meant that there was no control; there was accumulation of records in prime office space; delays in retrieving information; unnecessary duplication of documents; poor organisation of current and non-current records; poor filing systems and lack of training for records staff (Botswana National Archives Report, 1976/77). This state of affairs has also been observed by Chebani (2005), Maakwe (2006), Kalusopa and Zulu (2009), Mosweu (2011), and Mampe and Kalusopa (2012) suggesting that problems experienced as early as the 1970s are still existing in most government agencies. The current challenges include lack of an approved national policy and other guidelines; professional training in the management of electronic records and long term preservation of digital / electronic records (Keorapetse & Keakopa, 2012). At the time of writing this chapter the situation still seemed to be the same.

In spite of the problems mentioned above, Botswana has made significant progress in guiding the management of public records in the country since its reorganisation in 1992. There are already drafts of guidelines and other procedures in place including the Registry Handbook which was published in 1993 describing step by step procedures in records work. As part of attempts to revise the Handbook, copies were distributed to stakeholders for feedback in 2006/7 though no follow up has been made to date[6]. BNARS has to follow up on this Handbook so that it becomes a reference tool in day to day RMU operations while waiting for approved national guidelines. In 2009, BNARS developed a draft policy and procedures that are still to be approved and which government agencies can use in developing their own. Many are eager to change but feel that the National Archives is too slow in proving the necessary guidelines for policy development (Keakopa, 2007). This same sentiment was expressed by participants at the ESARBICA conference in Malawi that was held in August 2017.

In Botswana, records in government agencies are classified in such a way that particular files relating to establishment and structure of any agency, to its internal administration, and to its personnel, are separated from the files relating to the execution of functions. In this case, policy and general files are separated from those relating to the application of polices and individual cases. This has made the work of archivists easier in formulating principles of appraisal in accordance with the values of files which are judged on the basis of their administrative origins and functional relationships.

Management of Semi-Current Records

With BNARS given the responsibility for records management activities in government, it became necessary to open records centres so that information could be properly and safely stored and retrieved. For a long time the only records centre in operation has been the one housed in the central archives building in the capital, Gaborone. In addition to this, and due to storage constraints as well as the need to decentralise operations, three (3) record centres has already been opened in the outskirts of the city; the northern part of the country in Francistown and southern part of the country, Kanye. These records centres are in full operation. The records centres are decentralised such that the one in the northern part of the country caters for government offices in that region and the one in the southern region caters for the offices in that region. This will ensure that the District Administration programmes are not delayed on account of information being centralised in Gaborone, as well as minimise the risk of total destruction in case of disaster. This will also minimise transportation of records over long distances in terms of costs, time, space and security. These three record centres will be important in storing semi-current records which have continued values for limited periods, whilst BNARS will only store non-current records of permanent value. Consequently, prime office space in government agencies will only be used for storage of current records which are referred to frequently.

BNARS also advices other government and parastatal offices which are interested in opening their own records centres within their headquarters building concerning the layout of the RMU and environmental conditions. Already, the Botswana Defence Force (BDF) has been able to open its own records centre. However, the question of where its non-current records of permanent value are to be stored is still open to debate. This is because BDF strongly believes that its records are security records and as such their custody cannot be trusted with a third party. Kenosi (1999, 2000) provides a detailed account of security records and their management. He argues that records of the military remain outside ambit of the National Archives.

The process of arrangement, listing and packing of the records ready for transfer to the records centre is done by the agencies. BNARS only supervises to ensure that the whole process is done correctly. Until recently, all the necessary stationery for use in transferring records, including accessions forms, labels and boxes were provided by BNARS. The agencies only had to provide their own transport to take the records to the record centre. There are, however, new arrangements for transferring agencies to provide their own stationery including boxes.

Together with the existence of government records centres, is the Document Bank and Crown Records Management which are fully operational commercial records centre located in the capital, Gaborone. These commercial records centres have since their establishment played a significant role in proving storage and retrieval services to some government agencies who have not been able to transfer their

records to the National Archives records centre due to lack of storage capacity. It is important that these commercial records centres advise transferring agencies to have their records accompanied by retention schedules so that they are advised on disposition when periods have ceased. However, it appears this practice is not taking place as they only receive the records which run the risk of acting against professional ethics of not advising on retention of records in the semi-current stage.

Records Appraisal, Retention and Disposition

It is impossible today to care for all modern records without limit because of insufficient resources. For records to be kept in a manageable size and to maintain them at low cost there should a regular system to review and weed them because not all records created in the conduct of government operations or any organisation's business are worth keeping permanently. The proper management of records in organisations can, therefore, be achieved through the processes of appraisal, retention scheduling and disposition. Appraisal has been defined in the literature as determining the eventual disposition of records based upon their current and future administrative, informational, fiscal, evidential, research and legal values (The National Archives, 2013). The process of appraisal has become an essential part of records management. In almost all legislations of countries in the ESARBICA region, the final decision to appraise and destroy records is made either by the Director of the National Archives in his/her own authority or by the Minister to whom archives is subordinated. The archivist's role is to guide appraisal mainly for identification of documentary heritage and its preservation (Kenosi, 2000).

On the other hand, a retention schedule can be been defined as a time-table that plans the life of records from creation to disposition (The National Archives, 2013). When Thompson was assigned to the Bechuanaland Protectorate, it became evident that the Protectorate Administration had never issued any instructions for the destruction of totally worthless paper except for the routine accounting records. Consequently, Thompson prepared records disposal schedules containing all the decisions he had reached about the period of retention for various classes of records. At that time, government agencies were referred to the *Schedule of Retention Periods for Various Classes of Records and Subjects of Correspondence* and the *Guidelines for transferring files to the archives*[6] for advice as to what categories of records were to be kept and for how long.

The main weakness of the retention schedule at that time was that it emphasised on what was to be destroyed and not what was to be kept or preserved (Thompson, 1970). This was, however, a good beginning as it formed the basis for new retention schedules that were to be developed following the reorganisation of the National Archives. Since then, agencies have either prepared or are in the process of preparing their own retention schedules with advice from BNARS. The drawing up of detailed retention and disposition schedules for specific classes of records is the responsibility of the custodians of records in consultation with the archives which gives advice as to the kinds of records that can be kept and those that can be destroyed. These schedules are used as guidelines for final disposition of records. However, as noted earlier, the National Archives still has to develop the national policy and guidelines.

With regards to the provisions of the Botswana National Archives Act No. 37 of 1978, Chapter 59:04, Section 11 (1), (as amended in 2007), offices wishing to destroy any of their closed files have to submit a list of such files to the National Archives. This is because it is the Director of the National Archives who has the final responsibility of judging the secondary values of records and determine whether they should be preserved as evidence. The Director is specifically entitled to consult with any person whom s/he considers qualified to advice as to the worth of such public records for permanent preservation be-

fore authorising destruction. The archivist, however, has to be familiar with research needs and interests through her/his training in the methodology of her/his profession and should know proper approaches to be taken in judging the values for records. Consequently, there should be professional assistance from either public officials or from other scholars.

BNARS has made an effort by facilitating the formation of records committees in most government agencies. Through this, BNARS has been able to make periodic review to ensure that unwanted records are appraised and disposed of. This has, however, been a very slow process because of shortage of staff to cover all agencies and the rest of the country. Earliest efforts were made during the period 1993/94 to review medical records at the Sekgoma Memorial Hospital in Serowe. Following this, records dating back to the 1960's were sorted, boxed and labelled and transferred to the record centre housed at National Archives.[7] At the end of the review process, the hospital staff recommended that retention and disposal schedules be drawn for medical records so that they are properly disposed of. Further, they called for adequate infrastructure for effective recordkeeping in hospitals and additional manpower to help clear the backlog of records congesting their offices. During the same period, reviews of legal records in Selibe Phikwe; District Commissioner's records in Kasane, Molepolole, Gantsi and those of Jwaneng Town Council were made. According to the Botswana National Archives Reports for the periods 1999/2001 and 2001 to 2005 visits were made to agencies in different parts of the country to survey records, help with appraisal and advice on the formation of records committees. As reported in the 2005 report, records committees have already been formed in Ministries of Agriculture; Trade and Industry and Minerals, Energy and Water Resources. There is, however, little or nothing reported on the activities of these committees and it still to be established if they are playing any meaningful role. This can be an area of further research. In 2010 records of Prisons Department were appraised and a total of 118 boxes destroyed (Tshedimoso, 2011). Although such efforts have been made, very little has been done in destroying worthless records and most offices remain congested with non-current records.

Through appraisal, retention scheduling, and disposition programmes, Botswana has been able to lessen the extent to which valueless records are sent to the archives for preservation. This has also helped to remove the general thinking that archives is a storeroom for unwanted old records in government agencies. Despite efforts to appraise, draw retention schedules and dispose off unwanted records, it has proved difficult to keep pace with tremendous amount of records created in the public sector. Mnjama (2005) and Ramokate and Moatlhodi (2010) have pointed to storage problems and congestion in most records management units. In the ESARBICA region, studies have shown that there are still backlogs (Ngulube, & Tafor, 2006). In addition to these problems, the new format of records created in the electronic environment has become more challenging as BNARS has to reposition itself to be seen to be relevant in management of all public sector records in this new environment.

Management of Audio-Visual Records

Ngulube and Tafor (2006) have made an observation that the management of audio visuals in the ESARBICA region is not taken seriously as they remain neglected in a number of countries. In Botswana, BNARS's audio-visual collection which includes videotapes and CDs is mainly acquired through legal deposit from filming crews and researchers who have to deposit copies of their research conducted using the archival collections (BNARS Annual Report 2006/2007). BNARS has, however, done very little in terms of coordinating the management of audio-visual materials in government. At the moment, there appears to be no deliberate programme in place to coordinate audio-visual materials generated by

different government agencies such as Information and Broadcasting Services, Museum and National Library. BNARS as a custodian of public records should play a leading role in ensuring these formats of records are well preserved across government. In fact challenges of digital preservation in Botswana have been documented by Kalusopa (2008), Kalusopa and Zulu (2009) Keakopa (2010) and Abankwah (2011). They have noted that there are still lack of policies and standards for preservation of cultural heritage. BNARS should use some of these recommendations and include them in their strategic plans so that they are addressed. In fact, the new ESARBICA strategic plan has this area as one of its objectives and it has to encourage member states to tackle the challenge. As observed by Ngulube and Tafor (2006) most member countries in the region have no preservation strategies and no disaster management plans. There are also no coordinated strategies for their management and plans for continued migration.

Management of Electronic Records

Electronic records have generally been defined in the literature as files created by electronic systems, readable by means of those systems, which are created in the course of some business, administration or activity and used to continue that business, administration and activity (Procter, & Cook, 2000). Although some of these records maybe be stored and preserved in some physical media as CDs and DVDs, some begin and end their life in electronic networks. In Botswana, almost all business processes in government agencies produce electronic records. Examples include processes dealing with accounting, finance, land, human resources and health care (Keakopa, 2006; Moloi & Mutula, 2007). Generally, most of these agencies are running on Microsoft applications. The Ministry of Health is using Medical Information Technology (MEDITECH), Oracle and Access for the management of different types of medical records. Oracle is used for finance management and Lotus Notes and Infinium for file tracking. Examples of computerised systems include: Computerised Case Management System; Computerised Personnel Management System and the Government Accounting and Budgeting System among others (Moloi, & Mutula, 2007).

The new developments brought about by the use of ICTs have affected the functions of BNARS. Consequently, BNARS is faced with new responsibilities and challenging roles to play in developing strategies and issue guidelines to ensure the management of records and archives in the electronic environment. In general, these new responsibilities should include advising agencies on guidelines for managing electronic records, metadata standards, file plans, retention and disposition of electronic records and software requirements for records and document management systems. However, BNARS currently lacks the capacity and skilled professionals required to advice on management of these new formats of records. Regarding the survey on the management of e-mail in selected organisations in Botswana, Venson (2007) has found e-mail management to be a serious challenge that also has to be addressed. He found that people spent a lot of time in handling emails resulting and lost productivity. In terms of their preservation, the general practice in most organisations is to print and file the hard copy as there are no clear policy guidelines (Keakopa, 2008). Creators use their own discretion on whether to file or delete.

BNARS has as yet not been able to form partnerships with relevant stakeholders as the ICT industry that could help with design and implementation of the systems that meet records management requirements (Keakopa, 2006; 2016). This is still one of the challenges that BNARS has to seriously deal with. A model used by South Africa can guide Botswana and the rest of the region if adapted. For example

in South Africa, the National Archives and Records Service of South Africa working with the State Information Technology Agency (SITA) has compiled a list of vendors and solutions that government agencies can choose from (Keakopa, 2006, 2016).

In spite of computerisation projects in government agencies and increased generation of electronic records, BNARS has not created any direct linkages as far as advising on procurement and implementation of records and document management systems in concerned. BNARS is an important stakeholder in this initiative and it should in fact be a partner in ICT issues in the public sector, which is currently not the case. BNARS has itself tried implementing a computerised records management system following the launching of its computerisation project in August 2002 (Tshedimoso Newsletter, 2009). The first phase of the project included setting the ICT infrastructure in both government agencies and BNARS offices, mainly computer hardware, networking software, operating system software, web-server software and database server software. This phase was successfully completed.

The second phase of the project was concerned with development of the document on the Statement of User Requirement (SOUR). This was brought about by the fact that BNARS wanted to extend the use of ICT facilities to cover the core business of the department, that is, records management and archives administration. The SOUR, was therefore, aimed at offering a computerisation solution for the management of paper records throughout their life-cycle as current records in the RMUs, semi-current in the records centre and non-current at the national archives. The proposed computerisation solution which was known as the National Archives and Records Service System (NARMS) was expected to help staff manage the information they required to carry out their day-to-day operational functions. This system was expected to provide standards, tools, methodologies, and capacity for the management of electronic records. This would use NARMS as a tool to manage the control of electronic records in the same way it will be used for managing paper-based records.

It is important to mention that a number of supplementary documents provided key inputs to the final SOUR document. These included ISO 15489 and the United States Department of Defense 5015.2 (US DoD 5015.2), Design Criteria Standard for Electronic Records Management Applications. US DoD 5015.2 was used because it establishes mandatory baseline functional requirement for software applications. The SOUR document had identified hardware and networking requirements, interfaces with departments and assessed the training requirements for staff members who will operate the systems.

The third phase of the computerisation project which was expected to implement the requirements as proposed in the SOUR document and provide a gateway for electronic records management in the public sector in Botswana. The project seemed to provide a vision for BNARS to begin tackling the challenges of managing electronic records. The project was, however, short lived and did not live to its expectations as BNARS was facing project and change management challenges relating to planning and implementation (Chebani, 2005, Keakopa, 2006). As a result the project was prematurely aborted. This in itself calls on the need to have clear guidelines on systems procurement and implementation. Elsewhere, a number of systems have been tried on management of land records and these have also had challenges of project management. As observed by the IRMT (2008), there seems to be a disconnect between paper and electronic records management systems. The record professionals are taking care of paper records whereas IT experts are taking care of electronic records and there is still no relationship between the two.

BNARS is currently working on another project and there are fears it might fail as it is not clear whether lessons from the first project were taken on board. Efforts to get updates on this were unfruitful as information was said to be confidential. There are no documented guidelines to guide management of electronic records and it will be interesting to see how the new project at BNARS unfolds without these guidelines and the necessary partnerships with the ICT industry. Other stakeholders who include the Auditor General and the Public Accounts Committee (PAC) who are always concerned about poor recordkeeping in their reports can be brought on board.

ISSUES OF STAFFING AND PROFESSIONAL TRAINING

Staffing

The human resource component for managing records and archives is an important factor. The staffing levels at BNARS remain inadequate to meet the demands in government agencies. The situation has been worsened by the fact that some qualified records officers are leaving government to work in the private sector. For example, records managers who have been trained at postgraduate level are leaving to join the private sector, where salaries are higher. As of 2009 there were about 15[8] records managers and archivists who have been trained at the post-graduate level and out of these, 9 were trained in the UK (University College London and University of Liverpool and Wales), while 6 were trained at the University of Botswana. Out of these 15 professionals, 10 have already left BNARS to join parastatal organisations and the private sector, leaving the department with few or no professionally trained personnel. It is expected that in future more will leave for better opportunities elsewhere[9].

These records managers blame their exodus on lack of motivation, lack of interest from their employer (BNARS) in their work, poor working conditions, and lower salaries in the public sector (Keakopa & Kalusopa, 2009). In most cases, development programmes in the area of archives and records management are "shelved" due to shortage of staff. However, these professionals have continued to impact positively in management of records and archives in other sectors of the country.

Inadequate staffing levels in both national archives and RMUs in government agencies in Botswana has slowed down progress in supervising records management activities and has made implementation of government-wide records management programmes suffer. For example, some records officers have to do a combination of other duties in addition to records management responsibilities. A case in point is where in some agencies, the records managers are expected to undertake performance management tasks as well as records management.

The restructuring of schemes of service for records management personnel in Botswana can make the posts attractive and improve the calibre of people joining the profession. Schemes of service at the moment remain unattractive because of the low salaries pegged to the records management posts and lack of progression to senior positions. So it would appear that the main challenge is to raise the status and remuneration of the profession first. Most RMUs are disadvantaged by being allocated personnel who did not match the required qualifications. In most cases, people are removed from general administrative duties to records management responsibilities.[10] So the calibre of staff is not only inadequate but is also far below par. There is lack of trained and dedicated staff (Tshotlo & Mnjama, 2010). There is need to elevate the function of records management in organisational structure to show that records are a strategic resource in organisations. This will also make the profession attractive to professionals.

Professional Training

When BNARS took over the responsibility for RMUs, it inherited staff with no training in the management of records. At that time staff assigned to records management responsibilities in the agencies found themselves in RMUs because they had nowhere else to go. Most of these people had to learn on the job, and in most cases depended on experience. Botswana has, however, made considerable strides in training its records officers. At the national level, the Department of Library and Information Studies (DLIS) at the University of Botswana (UB) is providing archives and records management courses which were started following negotiations with BNARS in 1995 (Moyo, 1996, Kenosi, 1999). At its inception, the course was meant to clear the backlog of records personnel already working in "registries" estimated at approximately 400 in 1996 (Moyo, 1996). The courses have since been improved to cover aspects of electronic records management and computer usage. There is also the Master of Arts (MARM) and PhD in archives and records management. Graduates from the MARM programme have contributed significantly to the management of records in the country and the rest of the region. In addition to courses offered at UB, BNARS is liaising with training houses such as the Institute of Development Management (IDM) and the Botswana Public Officers College (BPOC) to provide basic training on archives and records management. However, IDM has introduced a degree programme in archives and records management which now gives UB competition in offering professional training. This, however, will not deter UB as it boasts of highly professional pool of experts in the profession.

BNARS is making all the necessary efforts to provide basic training to prepare records officers for a role in the management of records. It would, however, appear that while this training has been able to prepare these officers for the management of paper records in their life-cycle, it has not given them practical skills to apply in the management of electronic records. Although BNARS is doing well in managing paper records through their life-cycle, it still has insufficient competencies to manage electronic records. Training still appears inadequate and more relevant training on the impact of ICTs in the management of records and archives is still needed. It emerged clearly from the resolutions of the ESARBICA pre-conference in Malawi in 2017 that the region has to provide more training on management of electronic records and preservation of digitised materials. This is one of the major objectives in ESARBICA's strategic plan which is still lagging behind in terms of implementation.

The author is of the view that introduction of professionally accredited courses through regional professional associations and the strengthening of the current archives and records management curriculum in universities in the region may help meet the needs of the profession. The courses at UB have, however, been helpful in producing a new generation of records managers and archivists able to operate in a modern archival and recordkeeping environment. In spite of this, the issues of staffing and training still remain major long-term problems in Botswana, much as they do in the rest of the region. Ngulube and Tafor (2006) have found this to be a challenge in the whole of ESARBICA region. The training should produce highly skilled graduates able to meet national demands and not simply be part of the brain drain. These graduates should be paid competitive salaries in the professional market, and provided with tools and resources to improve on their working conditions. Further, career prospects should be developed to enable their progression to positions of responsibility. They should also be provided with funding to attend refresher courses, regional and international conferences and workshops to provide them with valuable experience and help them develop an understanding of international perspectives in recordkeeping and archival practices.

Management of Records in Parastatal and Private Organisations

The pressures of managing records as tools for transparency, accountability and good governance have also seen parastatal and private organisations in Botswana initiating proper management procedures for recordkeeping. The regulatory framework that establishes these parastatals emphasise on the need to maintain reliable records for accountability. This has created pressure for them to develop and implement records management strategies. This has been important in ensuring that policies and procedures are put in place to ensure proper creation, maintenance, retrieval, use and disposal of their corporate records. In fact Moloi and Mutula (2007) in their study recommended that parastatals should set up records management programmes. Such organisations have since established professional records management posts and recruited qualified records officers to fill those posts. This development has, however, been a "blow" for BNARS as most of its qualified professionals have left to join these organisations citing better salaries as the main reason. Keakopa and Kalusopa (2009) have in fact found out there is a high professional staff turnover at BNARS. Examples of organisations that have established records management strategies and programmes or are in the process of doing so include: Botswana Unified Revenue Services (BURS); Water Utilities Corporation, Botswana Telecommunications Corporation (BTC); SADC Secretariat; Public Procurement and Asset Disposal Board (PPADB), Botswana Qualifications Authority (BQA), Botswana Post; Local Enterprise Authority (LEA) and Civil Aviation Authority of Botswana (CAAB). Others like Botswana Housing Corporation (BHC) and Botswana Institute of Technology and Research (BITRI) have issued tenders for development of records strategies. At PPADB for example, the establishment of a records management programme was part of the whole establishment of the organisation as stated in section 84 of PPADB Act of 2001 which reads " ...the Board, its committees, sub-committees and procuring or disposing entities shall maintain detailed records of all their proceedings (Bayane, 2007). BNARS, however, continues to advice these organisations on proper records management procedures and was able to assist PPADB with appraisal of its records in 2006. As stated in earlier sections, BNARS still needs to develop national policies and guidelines to ensure that the guidance they provide is professional. Many of these organisations have draft policies and procedures for management of records and are developing at a faster pace than BNARS itself. This should be a wakeup call for BNARS to speed up development of national policy and guidelines.

ROLE OF BNARS IN PROFESSIONAL ASSOCIATIONS[11]

Role in ESARBICA

Botswana has played a significant role as a member of ESARBICA. Since its formation in 1969, ESARBICA has been the most active member of the International Council on Archives (ICA). Botswana has attended all meetings and conferences of ESARBICA since 1976 without fail and on a number of occasions presented papers at these occasions. BNARS has held a number of senior positions in the executive board of ESARBICA. For example, the Director has held positions of President and is currently Treasurer of ESARBICA. In 1991 and 2005 Botswana hosted both the pre-conference and general conference of ESARBICA. It has also hosted a number of meetings of the Executive Board of

the ESARBICA. The Director has also been a member of the executive committee of the ICA and has attended a number of ICA board meetings. During the ESARBICA conference in Tanzania in 2007, a good number of presentations addressing issues of ICT and records management were from Botswana.

FUTURE RESEARCH DIRECTIONS

A number of areas that still need to be addressed have emerged from discussions in this chapter. These are discussed as follows:

First, there is still a need to develop national polices and guidelines in most countries in the region and in particular, Botswana, to guide the management of records and preservation of archives. In addition to this, there is a need to develop a framework that will guide the procurement and implementation of electronic document and records management systems in the public sector. South Africa already has a national framework and the rest of the region can learn from it. Keakopa (2016) also presented a proposed regional framework that the region can also look at as they plan on the way forward. A future study should develop a framework for implementation of these guidelines.

Secondly, countries that have not updated their archival legislations in the region should do it. For Botswana a new revision is needed to harmonise the Act with the Electronic evidence act.

Third, there is a need to undertake records surveys or current situation analysis to guide development and implementation of the ESARBICA regional strategic plan.

Fourth, future research should investigate the impact of the new Electronic Records (evidence) Act, 2014 on management of electronic records in the country and how BNARS could be a strategic partner in its implementation. Further, the new Vision 2036 should also be looked into to see how it will influence management of public sector records in the context of social, environmental and national development.

CONCLUSION

The ESARBICA region and Botswana, in particular, have without doubt taken strides in the management of records and archives. For Botswana this has been done through integration of RMUs into BNARS. This has involved advise on drafting filing systems, appraising records in offices, and developing the scheme of service for records management personnel and setting up records management committees in agencies to assist in coming up with records retention schedules.

Since the introduction of a records management programme, Botswana has taken advantage of its responsibility to spearhead training of records personnel in government. Offices are visited time and again to assess needs and review filing systems. Surveys are undertaken to identify problems existent in the offices concerned. Meetings are held with senior records officers to address issues of concern. The Director has taken a step further by requesting that Senior Records Offices write reports in a quarterly basis to update the National Archives on their needs. Botswana has not achieved its present level of records management without problems. Survival and growth of records management will depend on the commitment and initiative of the Government Archivist. All stakeholders have to be brought on board in this initiative.

From all these, Botswana's experiences to some extent can be used as a model in the region where a number of countries have shown some interests. For instance, Mozambique visited BNARS in 2007 to understudy its record management model. Malawi has also shown interest by inviting the author of this chapter to present the Botswana experience to policy makers in government with a view to implementing records management programme. It is, however, important that, in drawing from Botswana's experiences, they should be aware of Botswana's challenges as well as the need to modify the model to their contextual situations.

In terms of preservation of cultural heritage, Botswana still has a long way to go in developing national preservation policies to guide cultural institutions.

REFERENCES

Abankwah, R. (2011). Policies and strategies that govern the management of audio visuals materials in East and Southern African Regional Branch of the International Council on Archives. *Journal of the South Africa Society of Archivists, 44,* 90–106.

Bayane, S. (2007). *Recordkeeping for transparency and accountability: the case of Public Procurement and Asset Disposal Board (PPADB).* Paper presented at the ESARBICA Conference, Dar-es-Salaam, Tanzania.

Botswana National Archives Act (Act No. 37 of 1978; as amended in 2007), Government of Botswana Botswana National Archives and Records Service (BNARS). (2003). Statement of User Requirements (SOUR) for the computerisation of Botswana National Archives and Records Service. Prepared by MJ Consultants (Pty). Gaborone, Botswana.

Botswana National Archives and Records Services. (2009). *BNARS computerises public sector records: reflections on the stakeholders forum.* Tshedimoso Newsletter.

Botswana National Archives and Records Services. (2011). *Timely destruction of records is vital.* Tshedimoso Newsletter.

Botswana National Archives and Records Services Report. (1999/2001). Gaborone: Government Printer.

Botswana National Archives and Records Services Report. (2001-2005). Gaborone: Government Printer.

Botswana National Archives and Records Services Report. (2006/2007). Gaborone: BNARS.

Botswana National Archives Report. (1976/77). Gaborone: Government Printer.

Chebani, B. (2005). Merits and challenges of the integrated records services in the public service – a case of Botswana. *ESARBICA Journal, 24,* 139–156.

Copyright and Neighbouring Rights Act (Act No. 8 of 2000). (n.d.). Government of Botswana. Retrieved September, 10, 207 from http://www.wipo.int/wipolex/en/details.jsp?id=548

Crockett, M., & Yeo, G. (n.d.). *Why electronic records are important?* Retrieved November, 10, 2015 from http://www.ucl.ac.uk/e-term/why.htm

Directorate of Public Service Management (DPSM). (1992). *O and M Review.* Report of Ministerial Organisation Review.

Directorate of Public Service Management (DPSM) and Botswana National Archives and Records Services. (1989). *Organisation and Methods Review.* Report on Improving Efficiency of Records Management Functions in the Public Service.

Electronic Records (evidence) Act of 2014. (2014). Government of Botswana. Retrieved September, 10, 2017 from https://www.bocra.org.bw/sites/default/files/Electronic%20Records%20and%20Evidence%20Act%202014.pdf

Evidence in Civil Proceedings (No. 26 of 1977). (n.d.). Government of Botswana.

Government of Botswana Vision 2036. (2016). *Achieving Prosperity for all.* Lentswe la Lesedi: Author.

International Records Management Trust (IRMT). (2002). *Evidence-Based Governance in the Electronic Age.* Retrieved November, 10, 2015 from http://www.irmt.org/evidence/wbnews.html

International Records Management Trust (IRMT). (2008). *Fostering trust and transparency in governance: Investigating and addressing the requirements for building integrity in public sector information systems in ICT environment. Annual Report, 2007-2008.* Retrieved September, 10, 2017 from http://www.irmt.org/documents/building_integrity/Annual%20Reports/Annual%20Report%20%202008%20- %20Fostering%20Trust%20and%20Transparency%20in%20Governance.pdf

International Standards Organization ISO 15489-1. (n.d.). *Information and documentation-concepts and principles.* Retrieved August, 16 2017 from https://www.iso.org/standard/62542.html

Kalusopa, T. (2008). Challenges of digital heritage materials preservation in Botswana. *ESARBICA Journal, 27,* 171–202.

Kalusopa, T., & Zulu, S. (2009). Digital heritage material preservation in Botswana: Problems and prospects. *Collection Development, 38*(3), 98–107.

Keakopa, S. M. (2006). *The management of electronic records in Botswana, Namibia and South Africa: opportunities and challenges* (Unpublished PhD Thesis). University College London, London, UK.

Keakopa, S. M. (2007). Policies and procedures for the management of electronic records in Botswana, Namibia and South Africa. *ESARBICA Journal, 26,* 70–82.

Keakopa, S. M. (2008). Management of email a challenges for archivists and records managers in Botswana, Namibia and South Africa. *ESARBICA Journal, 27,* 72–83.

Keakopa, S. M. (2010). Trends in long-term preservation of digital information: Challenges and possible solutions for Africa. *Africa Media Review, 18*(1&2), 73–84.

Keakopa, S. M. (2010). Overview of archival and records management development in the ESARBICA region. *Archives and Manuscripts, 38*(1), 51–77.

Keakopa, S. M. (2016). *Developing an integrated framework for procurement and implementation of Electronic Records Management Systems (EDRMS) in the ESARBICA region.* Paper presented at the SASA Conference, Mafikeng, South Africa.

Keakopa, S. M., & Kalusopa, T. (2009). Professional staff turnover at the Botswana National Archives & Records Services (BNARS). Zambia Library Association, 24(1-2), 53-74.

Kemoni, H. (2009). Management of electronic records: Review of empirical studies from east and southern Africa (ESARBICA) region. *Records Management Journal, 10*(3), 190–203. doi:10.1108/09565690910999184

Kenosi, L. (1999). Records management in the public service and Botswana's national archives and record services. *African Journal of Library Archives and Information Science, 9*(2), 119–127.

Kenosi, L. (2000). Managing records in restricted organizations. *Information Development, 16*(2), 65–69. doi:10.1177/0266666004240260

Keorapetse, D., & Keakopa, S. (2012). Records management as a means to fight corruption in Botswana. *ESARBICA Journal, 31*, 24–35.

Kukubo, R. (1986). The historical development of archival services in Botswana, Lesotho and Swaziland. *Proceedings of the 9th Biennial General Conference and Regional Seminar on Archives Administration and Regional Planning Meeting: Guide to the sources of African History*, 161-262.

Lekaukau, M. (2000). Serving the administrator: The archivist in the new millennium. *Archivum, 45*, 119–123.

Lekaukau, T. M. (1990). *Botswana National Archives and Records Services Annual Report.* Gaborone: Government Printer.

Maakwe, G. (2006). *An evaluation of the impact of integrating government records management units (RUMs) with Botswana National Archives and Records Services (BNARS)* (Unpublished M.A. dissertation). University of Botswana.

Mampe, G., & Kalusopa, T. (2012). Records Management and service delivery: Case of Department of Corporate Services in Ministry of Health in Botswana. *Journal of the South Africa Society of Archivists, 45*, 1–23.

Mnjama, N. (2005). Archival landscape in east and southern Africa. *Library Management, 26*(8/9), 457–470. doi:10.1108/01435120510631747

Moloi, J., & Mutula, S. (2007). E-records management in an e-government setting in Botswana. *Information Development, 23*(4), 290–306. doi:10.1177/0266666907084765

Mosweu, O. (2011). Performance audit in Botswana public service and arising records management issues. *Journal of the South African Society of Archivists, 44*, 107–115.

Moyo, L. M. (1996). Introduction of archives and records management programmes at the University of Botswana. *ESARBICA Journal, 15*, 39–51. PMID:10153766

Ngoepe, M. & Saurombe. (. (2016). Provisions for managing and preserving records crated in networked environments in the archival legislative frameworks of selected member states in SADC. *Archives and Manuscripts, 44*(1), 24–41. doi:10.1080/01576895.2015.1136225

Ngoepe, M., & Keakopa, S. M. (2011). An assessment of the state of national archival and records systems: South Africa-Botswana comparison. *Records Management Journal, 21*(2), 45–160. doi:10.1108/09565691111152071

Ngulube, P., & Tafor, V. F. (2006). The management of public records and archives in member countries of ESARBICA. *Journal of the Society of Archivists, 27*(1), 57–83. doi:10.1080/00039810600691288

Procter, M., & Cook, M. (2000). *M, Manual of archival description* (3rd ed.). Aldershot, UK: Gower.

Public Service Public Service Act (Act No. 13 of 1998). (n.d.). Government of Botswana. Retrieved on August, 16 2017 from http://www.gov.bw/globalassets/moe/acts/chapter-2601-public-service.pdf

Ramokate, K. (2006). Preserving the African memory: Critical challenges for ESARBICA archival organisations. *ESARBICA Journal, 25*, 84–94.

Ramokate, K., & Moatlhodi, T. (2010). Battling the appraisal backlog: A challenging professional obligation for BNARS. *ESARBICA Journal, 39*, 67–86.

Shepherd, E., & Yeo, G. (2003). *Managing records: a handbook for principles and practices*. London: Facet Publishing.

The National Archives. (2013). Retrieved on August, 16 2017 from http://www.nationalarchives.gov.uk/documents/information-management/what-is-appraisal.pdf

Thompson, C. H. (1970). *Report to the Government Archivist on five years work, 1965-1970*. Gaborone: Government Printer.

Tshotlo, K., & Mnjama, N. (2010). Records management audit: The case of Gaborone City Council. *ESARBICA Journal, 29*, 5–35.

United States Department of Defense 5015.2 STD. (n.d.). *Design criteria standard for electronic records management software applications*. Retrieved November 2016 from http://jitc.fhu.disa.mil/recmgt/p50152s2.pdf

Venson, S. (2007). *A survey of email management practices in selected organisations in Botswana. Recordkeeping for transparency and accountability: the case of Public Procurement and Asset Disposal Board (PPADB)*. Paper presented at the ESARBICA Conference, Dar-es-Salaam, Tanzania.

ENDNOTES

1. The IRMT is a UK-based non-profit making organisation committed to improving records management and supporting education and training in developing countries.

2. . ESARBICA is a regional association bringing together a group of countries in eastern and southern African so as to cooperate and assist each other in professional matters and work as a team in carrying out the aims and objectives of the mother body, The International Council on Archives.

3. . Vision 2036 has been launched as a platform for national development.

4. . The current author led the task team that developed the strategy and action plan and has been pushing the Board for implementation the plan. Hopefully the next ESARBICA Board will take it up and start implementation this year, 2017.

5. . The records management units were, until integration of records management activities into the Botswana National Archives and Records Service, known as registries. The records management units are based in government agencies and with guidance from the national archives, they offer records creators services relating to all aspects of records management.

6. These guidelines were drawn in the 1970s and have since been revised to cater for new developments and keep them in line with public sector reforms.

7. . This information is drawn from my own experience having worked as an Archivist with BNARS. At that time, I was involved in the review process.

8. Readers should note that this number does not include the 2 professionals who have PhD degrees (and were once employees of BNARS) but are now University of Botswana archives and records management lecturers.

9. This observation was made following discussions with records managers some of who are the author's former students from the University of Botswana.

10. This information is from personal experience having worked as an Archivist for BNARS.

11. Although there is evidence to suggest that the Records and Information Association was formed in the 1990s, as shown its proposed constitution, it has never been active.

Chapter 13
Managing Public Sector Records in Namibia

Cathrine T. Nengomasha
University of Namibia, Namibia

ABSTRACT

The benefits of records management have been well documented; from preserving evidence and supporting accountability and transparency, to preserving nations' documentary heritage. Governments as with many other organisations have realised the importance of records management for good governance and have put in place policies, programmes and procedures aimed at managing their records effectively and efficiently. In spite of the many benefits that can be derived from records management and efforts made, challenges continue to be reported. This chapter discusses these challenges within the context of the records management programme of the Namibia public sector. The author cites studies conducted by various researchers on records management in a variety of public sector institutions ranging from central government, regional and local authorities and academic institutions. Some recommendations to address a number of the challenges identified are presented.

INTRODUCTION

Governments as with all organizations need to keep records of decisions and transactions to meet the demands of accountability and to meet their own information requirements. As governments strive to improve service delivery, utilize resources efficiently, respond to citizens' needs and be open about decision-making processes and procedures, they have realized the need to manage and utilize information effectively. Records management is one of the pillars of good governance. However some governments, particularly in Africa, have failed to manage records effectively. Records management challenges facing the public sector in East and Southern Africa Branch of the International Council on Archives (ESARBICA) region have been highlighted by several writers (Keakopa, 2003; Makhura, 2001; Mutiti, 2001; Wamukoya & Mutula, 2005; Ngulube & Tafor, 2006; Sejane, 2004). These challenges facing ESARBICA are summarized by Mnjama and Wamukoya (as cited in Wamukoya & Mutula, 2005, p.75) and they include:

DOI: 10.4018/978-1-5225-3137-1.ch013

- Absence of organizational plans for managing e-records;
- Low awareness of the role of records management in support of organizational efficiency and accountability;
- Lack of stewardship and coordination in handling paper as well as electronic records;
- Absence of legislation, policies and procedures to guide the management of both paper and electronic records;
- Absence of core competencies in records and archives management;
- Absence of budgets dedicated for records management;
- Poor security and confidentiality controls;
- Lack of records retention and disposal policies; and
- Absence of migration strategies for e-records.

Poor records management in the public sector in ESARBICA seems to persist. Ngoepe (as cited in Ngoepe and Makhubela, 2015) refer to poor records management in the public sector in South Africa. Marutha and Ngulube (2012) conducted a study on the management of electronic records in the public health sector of the Limpopo province in South Africa whose findings confirm this observation by Ngoepe. They found problems of shortage of filing space, missing files and misfiling, damage to records and shortage of staff. Chaterera, Ngulube and Rodrigues (2014) report of most government departments congested with semi- and non-current records kept in corridors and on the floor in offices. In Uganda, Luyombya and Sennabulya (2014) identified the following records management problems during their study into existing infrastructure for managing public archives in Uganda: a lack of national policy for archives management; absence of assigned responsibilities for archives management; limited resources and facilities including low staffing levels and inadequate buildings and equipment. The Uganda National Archives had not set standards to be followed by ministries, departments and agencies.

With regards to electronic records, Kemoni's (2009, p. 190) drew the following conclusion:

The empirical research findings indicate most countries in the ESARBICA region lack capacity and face various challenges in managing electronic records. These relate to: lack of policy and legislation, standardization, authenticity, capacity building, physical infrastructure and lack of awareness among recordkeeping professionals and government authorities on electronic records management issues.

Mutsagondo and Chaterera (2016) concur on the issue of policies from their observation that many ESARBICA members do not have archival legislation that specifically caters for the creation, use, maintenance and disposal of electronic records. Luyombya and Sennabulya (2012) reported a lack of information and communication technology infrastructure at the National Archives of Uganda. In South Africa, Marutha and Ngulube (2012) found an electronic document and management system which was not in use in the Limpopo province hospitals; as well as absence of disposal plan and disposal authority for e-records.

Namibia shares common concerns regarding records management with most ESARBICA member countries. This chapter discusses the management of records in the public sector in Namibia, highlighting the current situation and existing problems and concludes with recommendations on how the management of public sector records in Namibia can be improved.

BACKGROUND

Namibia is a vast country of 824 290 sq km (United Nations Statistics Division as cited in Countrymeters, 2016) with a population of 2 578 935 (Worldometers, 2017). Namibia is bordered by South Africa in the south, Angola and Zambia in the north and Botswana and Zimbabwe in the east. The National Archives is charged with the responsibility of providing a records management service to the entire public sector, that is, all bodies instituted by an Act of Parliament; and these include central government, local authorities, regional councils and parastatals.

Currently the National Archives is a sub-division of the Directorate of Namibia Library and Archives Services (NLAS) and is located in the Ministry of Education, Arts and Culture. While this makes sense with regard to the National Archives' responsibilities as a cultural institution, it makes it difficult for the National Archives to meet statutory responsibilities for records management services in the public service. It is important to note that the *Archives Act* not only delineates responsibility but also provides for the inspectorate role of the Head of Archives. The Head of Archives is below the level of Director. In some countries, the Head of Archives is at Directorship level and in others such as U.S.A., at Permanent Secretary level (Barata, Bennett, Cain & Routledge, 2001). In member countries of Eastern and Southern African Branch of the International Council on Archives (ESARBICA), the top management post of national archives are typically Deputy Director (Assistant Director) and Director level, such as in Botswana, South Africa, Zimbabwe and Zambia, but because of the placement of Archives Services in NLAS, the Head of Archives is below Deputy Director (Ministry of Basic Education Sport and Culture, 2004, p. 107).

In 1994 the then Head of The National Archives of Namibia referred to Namibia as being in a "stage of transition as the whole administration was being restructured" (Lau, 1994, p. 246). Independence brought in a new government and reorganization of the public service, which has been attributed to the collapse of good records management systems, which used to exist in the public service (Taylor, 1994, p. 62). Studies on records management in the public service of Namibia (Barata, *et al.*, 2001; Ipinge, 2015; Kazavanga, 2015; Karlos, 2015; Nengomasha, 2004; Nengomasha, 2009; Nengomasha & Amiss, 2002) have established that the situation has not changed much. Poor records keeping is still evident in the public service of Namibia.

Surveys of records in Ministries and Departments, regional councils and local authorities have shown evidence that there once were good records keeping systems in place which for some reason collapsed (Barata, *et al.*, 2001; Nengomasha, 2004; Nengomasha, 2009; Nengomasha & Amiss, 2002). Taylor (1994) attributes the collapse of records management systems to "offices assuming different functions, being re-named, being closed, new offices being opened, which have resulted in many offices having no records management programme at all and each person doing his or her own thing. As new functions were created and some old ones closed, records were taken to the National Archives without following proper procedures" (Taylor, 1994, p., 62). In a study by Nengomasha (2009) several members of staff interviewed in the Ministries, Regional Councils and Local Authorities attributed the collapse of records keeping systems to lack of commitment from top management and inadequate monitoring. According to the National Archives, failure to carry out routine inspections is due to staff shortages. Records management activities in the National Archives comprise of 1/3 inspections (records surveys), 1/3 filing systems and 1/3 training. A detailed discussion of the status of public service records management programme follows.

Legal and Regulatory Framework

The National Archives of Namibia is in the process of finalising the records management policy and the revision of the Archives Act. Legislation plays a significant role in records management. A first step in designing a records management programme is to establish the legal and regulatory framework (World Bank, 2000). From experiences of other countries, relevant legislation includes the records and archives laws, e-commerce laws, freedom of information and data protection laws. For instance, the University of Edinburgh (2017), in its "Records Management Policy Framework" cite Data Protection Act and Freedom of Information Act as being of general relevance to the University as a whole; and the Finance Act, Taxes Act, Pension Act which guide specific functions. A study carried out in the United Kingdom by Loadman (2001) showed that out of 35 respondents working in conformity to legislation, about thirty-three responded that they used the Data Protection Act. The next most used legislation was the Financial Services Act and the Statutes of Limitations Acts with about 22 respondents each. About 7 respondents used the Public Records Act.

Namibia's *Archives Act* no 12 of 1992 empowers the Nationals Archives of Namibia to regulate the filing and care and disposal of records in central government, local government and statutory institutions. It is implied that records include electronic records as well. There is need to make this explicit in the *Archives Act* as well as clarify the basic concepts such as "record" and "archives". The on-going exercise to review the *Archives Act* aims to address these concerns and other issues as well. The *Archives Act* needs to be revised in order to address the management of electronic records fully.

Namibia has an *Access to Information Bill* (Namibian Broadcasting Corporation (NBC), 2016). There are lessons to be learnt by Namibia from the experiences of other countries. One such lesson is that a freedom of information or access to information law should take into account records management considerations. As Sebina (2006, p. iii) points out, "Freedom of Information (FOI) legislation is mostly adopted on the presumption that good records management exists." Experiences from other countries have shown that any freedom of information legislation is only as good as the quality of records to which it provides access. Such rights are of little use if reliable records are not created in the first place, if they cannot be found when needed, or if the arrangements for their eventual archiving or destruction are inadequate. With regard to data protection, Namibia's E-Laws Working Group notes "there is need for privacy laws in relation to for example, data protection, data interference and data monitoring" (Office of the Prime Minister (OPM), 2005a: 4). Namibia does not have a data protection law yet. However Article 13 of the *Constitution of the Republic of Namibia* makes provision for the protection of privacy.

A Draft "Use of Electronic Communications and Transactions Bill" has been prepared and distributed for public comments by the E-Laws Working Group under Office of the Prime Minister. The Bill's overall objective is:

To provide for the regulation and facilitation of electronic (e-communications and transactions; to promote the use of electronic communications and transactions; to provide legal certainty, recognition and functional equivalence of e-communications, e-transactions and information systems management, especially in relation to the use of electronic signatures, records and archives, and the security thereof; to promote and facilitate the use of information and communication technologies, to prevent the abuse thereof; and to provide for matters connected therewith (OPM, 2005b: p. 2).

Another law which has an impact on records management in the public sector are the State Finance Act and the Treasury Instructions issued based on this Act.

The Archive Code based on the *Archives Act* is the standard for records management in the public Sector in Namibia. It provides guidelines on managing records throughout their entire life cycle.

CURRENT STATUS OF RECORDS MANAGEMENT IN THE NAMIBIA PUBLIC SECTOR

A complete records management programme for the public service was developed between 1978 and 1990. The implementation of the programme has not been very successful. Barata, Bennett, Cain and Routledge (2001) observed that there is no active government-wide records management programme, which would normally be coordinated through the National Archives. Nengomasha (2004); Ministry of Basic Education Sport and Culture (2004); Nengomasha and Amiss (2002) support this observation.

The records management programme consists of the following components:

- Compilation and approval of filing systems;
- Disposal guidelines/authorities and records transfers;
- Office inspection (i.e. records surveys);
- Training of officials in records management; and

Compilation and Approval of Filing Systems

Each office is expected to implement an approved classification scheme based on the functional approach. These are supposed to be compiled with the help of the National Archives staff who visit Ministries and Departments and carry out records surveys.

Records management studies (Ilukena, 2016; Kazavanga, 2015; Mapiye, 2016; Matangira, Katjiveri-Tjiuoro & Lukileni, 2013; Nengomasha, 2004; Nengomasha, 2009; Nengomasha & Amiss, 2002; Nengomasha & Nyanga, 2012) conducted in Namibia have shown that the implementation of classification schemes has had varying levels of success in the public sector. Some institutions were operating without any at all, in some institutions they were out-dated and in general they were not used properly or effectively. In some Ministries, the Permanent Secretary would not sign any correspondence that did not have a reference number, so the officers just put any number to get the documents signed (Nengomasha, 2009). The situation has not changed much in most Ministries and Departments. At two workshops with two separate Ministries in the last twelve months, this author established from the discussions with the participants that even though classification schemes were in existence they were not effectively used, with some participants explaining that they did not know how to reference the records. One of the implications of this is misfiled records.

The general trend in central government, local authorities and regional councils is that the registry is used as an archives or store room where staff take the records from their "mini" registries when they leave the institution for one reason or other. The registries then are faced with a task of sorting all the records to file them in the central registry files. In such a situation, it is not surprising that records get

lost and there have been cases of wrong decisions and loss of entitlements by individuals due to loss of records. For instance, in a study by Nengomasha (2009), 78% of officers to whom the following was addressed "explain circumstances if any of records which could not be located or damaged" said they had experienced or heard of cases of lost records in the Ministry. One instance was cited where the Namibian Government was taken to court and paid a large sum of money as an out of court settlement due to poor records keeping.

A study by Kazavanga (2015) in one of Namibia's colleges, established that the college did not have an institution wide classification scheme. There was neither records management unit nor a records keeping system in place, with individual units and individual staff members responsible for managing and keeping their own records. This is similar to findings of a survey of records at the University of Namibia (Unam) which reported a lack of standard and formal ways of managing records. "There was no standard filing system that was being used at Unam. As a result, each department, unit or office was using their own personal ways of filing records which often changed with the coming of a new office bearer (Matangira, *et al.*, 2013, p. 110). On a positive note, the records survey at Unam was carried out as part of a records management project whose objectives were to:

- Investigate records management practices at the University of Namibia;
- Recommend formal and standard ways of managing records at the University of Namibia;
- Create and standardize policies, guidelines and tools for the management of records at the University of Namibia; and
- Make preparations for the adoption of an electronic records management system at the University of Namibia (Matangira, et al., 2013, p. 106).

As part of the project, a classification scheme and retention schedules have been put in place. The classification scheme is currently being rolled out to the entire University structures.

Disposal Guidelines/Authorities and Records Transfers

In terms of the *Archives Act* 12 of 1992, no record may be destroyed without the permission of the Head of the National Archives. The National Archives issues disposal guidelines and disposal authorities. Disposal guidelines are issued for files in approved filing systems which have been correctly functioning for three years or more and to approved "List of Other Archives" These guidelines indicate how long an item should be kept in the office of origin before it is either destroyed or transferred to the National Archives for permanent preservation. Disposal guidelines are issued for current filing systems only. Offices can request for disposal authorities to be issued for specified items. These include records of discontinued classification schemes. The office lists the items and makes suggestions as to the disposal of the items, either destruction or preservation. An archivist then appraises the items and determines if they have future research value or not. The Head of Archives is then requested to issue a disposal authority after which the items are transferred to the National Archives or destroyed (Taylor, 1994, p. 60, National Archives, n. d.). As stated in the *Archives Act* 12 of 1992, records are transferred to the National Archives of Namibia when they are 20 years old and master films immediately.

Heavily congested offices and store rooms are an indication that not many transfers of records have taken place in the last few years. Most institutions in central, regional or local authorities in Namibia have a serious shortage of space for records, which a Senior Records Manager in the National Archives refers to as "artificial shortage" due to absence of retentions schedules. The National Archives attributes the absence of disposal guidelines to registry staff not being capable to develop retention schedules. Nengomasha (2009) established that although officers did not destroy paper records, they destroyed e-mail messages and attachments, resulting in the loss of these electronic official records. This author's recent discussions with public servants during training workshops and seminars have revealed that this situation has not changed.

There is a state of the art National Archives building but there is no records centre facility for the storage of semi-current and non-current records. Section 5 of the *Archives Act* 12 of 1992 makes provision for the setting up of "intermediate depots" (records centres). Barata, *et al.* (2001); Namibia Resource Consultants (2002); Nengomasha (2004); Nengomasha and Amiss (2002); Nengomasha and Nyanga (2012) have recommended the setting up of records centres. Namibia Resource Consultants (2002) recommends decentralization of records management functions to the regions by the setting up of records centres in the regions. The National Archives drew up requirements which commercial records centres should meet to be able to service the public service. There are three commercial records centres in operation. However, although these records centres are providing the much needed storage space which the public service lacks, they fall short in various areas, such as staff trained in records management, to be a permanent solution for the management of public service semi-current records (Nengomasha & Nyanga, 2012). The National Archives encourages Ministries and other government institutions to set up their own in-house records centres. Records centres are being set up at Omusati and Karas Regional Councils.

Office Inspection/Records Surveys

Each Office, Ministry, Agency (popularly referred to as OMAs) is supposed to be inspected in form of a records survey at least once a year by the National Archives staff. A report on the records survey, with recommendations is sent to the respective OMAs. The OMAs will then provide a date when the recommendations will be implemented. The National Archives sends follow-up reminders and expects progress reports on the implementations (Taylor, 1994, p. 60). A consultancy report on the functioning of the National Archives of Namibia conducted in 2002 found that no inspections had been carried out since 1999 and even then the few inspections which had been done since the 1995/96 annual report had been carried out by a Records Manager placed on attachment by the International Records Management Trust (IRMT) (Ministry of Basic Education Sports and Culture, 2004, p. 74). A regional council and a local authority some 200 kilometers from Windhoek where the National Archives is situated had not had any inspections done in 17 years. The National Archives confirmed explaining that inspections outside Windhoek in the last five years had been done upon request from the institutions (Nengomasha, 2009). However the situation improved with the appointment of a Senior Records Manager in 2005 only to hit a set-back in recent months due to staff mobility. Chaterera, Ngulube and Rodrigues (2014, p. 367) highlight the importance of records surveys as "a primary mechanism for monitoring and improving records management activities".

This problem of inspections has been compounded by the fact that records keeping staff lack adequate supervision within their respective institutions. Recommendations from these inspections are mostly not implemented. In the public service, the registry personnel are supervised by Chief Control Officers who do not have professional training or skills in managing records. Most of them have not had any course on records management. These Chief Control Officers have many other tasks in addition to records keeping. They end up not giving records management adequate attention (Ipinge, 2015; Nengomasha, 2009; Nengomasha & Amiss, 2002). Namibia is not an exception. Chaterera, Ngulube and Rogrigues (2014) lament the failure of records surveys in Zimbabwe to foster "acceptable records management practices." (p. 367)

Training of Officials in Records Management

Informal courses in records management ranging from two to five days are meant for registry clerks and officers in charge of archives. Training for officers in charge of archives is based on the Archives Code (a standard for managing records in the public sector) and that training for registry clerks is more on practical aspects of registry management. Due to a shortage of staff the National Archives has not been able to offer as many training courses. From 2005, the National Archives was able to conduct more training workshops for registries staff, secretaries and senior officials (Nengomasha & Nyanga, 2012). A study of the National Archives by Ilukena (2016), found that the shortage of staff at the National Archives persists.

Lack of trained records management professionals is another problem hindering the implementation of Namibia's record management programme (Barata, *et al.*, 2001; Ipinge, 2015; Ilukena, 2016; Namibia Resource Consultants, 2002; Nengomasha, 2004; Nengomasha, 2009; Nengomasha & Amiss, 2002; Taylor, 1994). The training offered locally was for a long-time inadequate to address the national need for trained records management professionals. Until 2011, the Department of Information and Communication Studies at the University of Namibia offered records and archives management as part of a broadened programme which incorporates library studies at graduate level. The four-year BA Records and Archives Management (Honours) had its first cohort complete the programme end of 2015. Most of these have been absorbed by industry, both private and public sector. Similarly, a two-year Diploma in Information Studies with a choice for specialization in the second year, records management being one of the specializations was offered until 2006 when it was revised into separate specialized two-year Diplomas namely: Diploma in Records and Archives Management (Level 5) and Diploma in Library and Information Science (Level 5). The University of Namibia offers MA and PhD qualifications (by thesis/research).

Other forms of training are workshops offered in-house by Ministries and Departments using consultants; short courses on an irregular basis by the Polytechnic College of Namibia, University of Namibia and other management training companies.

The low salaries paid by government do not attract the few trained professionals. Registry staffs are usually amongst the lowest paid in the public service. Most of these only have grade 10 certificates (O level) and this has consequences for provision of an effective records management service. The limited prospects for progression within the records management field for registry staff do not provide an incentive for the registry staff to take advantage of the formal training programmes. Financial constraints are also an impediment. As with the position of the Head of Archives, the level of the registry staff is too low for them to be recognised and taken seriously.

Too low for the competencies and skills required, the action officers have very little regard for these registry clerks resulting in them setting up their own ring binder system of storing paper documents in their offices, or store information in their PCs, or assign their filing to private secretaries, who have no training in this respect (Namibia Resource Consultants, 2002, p. 23).

A study by Ipinge (2015) on the recognition of the records management profession in the public service of Namibia concluded that the profession is still looked down upon with the registries seen as "dumping places for trouble makers from other Departments / Divisions" (p. 29).

An ongoing restructuring in the public service of Namibia, has set diploma level six as the entry requirement for para professionals positions. A similar restructuring of the records management cadre will be a major shift from the current position where registries are manned by staff with primary school grade 10 qualifications. In response to this restructuring and after consultation with the Directorate of National Library and Archives Services, the University of Namibia, through its Department of Information and Communication Studies has revised the two-year level 5 Diploma in Records and Archives Management to a three-year level 6 Diploma in Records and Archives Management. A one year level 6 Diploma in Records and Archives Studies will offer students who graduated with a level five Diploma to upgrade to a level six Diploma. These new Diplomas will be offered starting in 2018.

Electronic Records

The problems of records management in the public service have been compounded by electronic records. The way that organizations operate has been radically changed by information technology. There has been an increase in the number of organizations doing business online including governments (Wamukoya & Mutula, 2005) and as a consequence of this, there has been an increase in the creation of electronic records. In addition to correspondence on paper we now have e-mail messages. Records keeping in organizations has also changed as a result. Where there were common registries managing paper based files, there are now also shared folders on organisations' intranets in a number of computerized information systems, each managing a part of the organisations' information needs (National Archives of Australia, n. d., p. 2).

Information systems conducting business in many organizations are not able to operate as record keeping systems, as they have been set-up without any consideration of current record keeping issues (International Records Management Trust (IRMT), 1999). The result is that these systems are not able to manage, preserve and make accessible, records, which provide evidence of the organizations' business operations. The management of electronic records poses special challenges and meeting these challenges is critical, as well managed records have authority and provide sources of information and evidence which support some of the principles of good governance such as transparency and accountability.

In Namibia, the impact of the information revolution is evidenced by developments in various sectors such as e-government, e- learning, e- banking and e-commerce (Stork & Aochamub, 2003). In an address in 2003 the then Prime Minister of Namibia, Theo Ben Gurirab summarized the direction that Namibia was going to take regarding some of these sectors.

It is by advancing further science and technology–led development that we see the need for Namibia striving with confidence towards a knowledge-based society. The vision is not just of students sitting behind computers. It is rather of an economy having innovative capabilities, productive excellence and networking and servicing capacity. (Gurirab, 2003, p.3)

Namibia's Vision 2030 (Office of the President, 2004) spells out the role of ICTs, in promoting good governance. Namibia's e-governance policy's objectives can be summarized as "Providing guidelines for an over-arching framework that will allow for the use of ICT applications to promote good governance" (Department of Public Service Information Technology Management, 2005, p. 7).

There has been an increase in the number of computers and e-mail use. Nengomasha (2009) interviewed 85 members of staff in central government, regional councils and local authorities. All of them had computers and only two said they did not have access to e-mail. There were no e-mail policies and no guidelines on how to manage e-mail messages and attachments. Officers were conducting business through e-mail. However officers decided upon themselves what to do with e-mail and accompanying attachments. The common practice was to print and file but others copied into folders but still left the e-mail messages in the in box until they ran out of memory then had to delete or were directed to do so by the systems administrators. Matangira, *et al.* (2013) came up with similar findings. "The majority of the respondents indicated that they print and file their electronic records. However, email messages are usually left in the Inbox" (p. 110).

Several electronic information management systems are running in the Public Service. The systems use varying systems architecture, data formats and language, raising the issue of operability and the ability to share data. As part of the e-government strategies, the public service is moving towards web-based technology. However most of the systems are developed and maintained by private companies, some of them from outside the country (Nengomasha, 2009).

An electronic records management system has been implemented in some of the Ministries in Namibia. Contrary to best practice, this system was not acquired with collaboration and cooperation between the IT experts and records management experts. The National Archives with the records management expertise and mandate to provide a records management service in the public service was not fully involved in the selection of this solution to the extent that the National Archives was not sure what the system could do and whether it had the mandatory records keeping functionalities (Nengomasha, 2009). However, a review of the system applying the MoReq model and DoD 5015.2 shows that the system acquired by the Public Service of Namibia has the required requirements. This raises the question "Why has the implementation of the system met with a number of challenges?" Some of these include very little to no use of the system by the users (Karlos, 2015). The service provider (personal communication August 2016) explained that the problem has been a lack of functional filling systems, poor records management awareness and computer skills by staff. In addition to these problems, Karlos (2015) established that change management was also an issue contributing to the poor uptake of the system by users.

Records Security

Security measures should include security counters in the registries. However it's not all registries which have security counters. Some registries accommodate photocopiers and refrigerators, compromising security as officers come in to utilize these services. Some and not all registries have burglar bars.

According to the *Archives Code* all registries must have fire extinguishers, but most registries were observed not to fulfil this requirement. Where there were fire extinguishers, in a number of cases these had not been serviced in a long time and staff did not know how to operate them (Nengomasha & Nyanga, 2012). There have been several fire disasters in Namibia leading to loss of records. These include the Ministry of Education's Ondangwa East Regional Office (Namibia) that had all its human resources records

and 2000 library materials burnt in 2003 (Shivute, 2003); and a fire that destroyed the Eastern block of Outjo Municipality offices (Namibia) reducing all municipality files to ashes in 2009 (NAMPA, 2014).

Creation and preservation of trustworthy records require that records be protected from unauthorised alteration. For computer records the main security feature is the pass word but as one Systems Administrator remarked, the system was not water tight as officers passed on their pass words to their colleagues when they were out of the office for long periods (Nengomasha, 2009).

The systems lack proper back-up procedures, with some Ministries only doing back-up on the main servers. A local authority was reported in one of the local newspapers to have lost all its financial records when thieves broke into its offices and stole the main server. This left the local authority with no records to audit (Maletsky, 2006). What this news item portrayed was absence of a back-up strategy in the local authority. Those who back-up on tapes store the tapes either on site, in the same place as the main server, in offices or at home. A server at the National Archives of Namibia could be put to use for this purpose. Currently it is being used to store National Archives' digitised collections and other databases.

Several institutions (New South Wales, State Archives, 2003; Kansas Historical Society, 2005) have opted for the practice of "distributed custody model" for electronic archives, with creators migrating electronic records to successive hardware and software environments. The National Archives could look into adopting this model.

Audio Visual Archives

A study by Mapiye (2015) on the management of audio visual archives in the National Archives of Namibia and Namibia Broadcasting Corporation found "absence of skilled employees, inadequate machinery, the lack of management policies and the obsolescence of AV materials as the main problems affecting the management of AV materials" (p. I). Mapiye confirms Hillebrecht's (2010) reports that audio visual materials "are in danger of being irretrievably lost". For instance all scripts of television and English news bulletins at the Namibian Broadcasting Corporation are preserved for four years, where after they are transferred to the National Archives of Namibia. However the National Archives of Namibia is unable to address the challenges of managing sound archives. Such challenges are more to do with ongoing technological innovation, which has led to the collection having a variety of formats - from audio tape recordings to compact cassette, to magnetic optical discs, to mini discs to, currently, compact discs and flash disks being used to store material (Tyson, 2009).

The following highlights from the Education and Training Sector Improvement Programme (ETSIP) (Government of the Republic of Namibia, 2007) highlight the Government of Namibia's plans to preserve audio visual archives:

The challenge for the National Archives to ensure the preservation of the historically important national heritage documentation will be addressed by establishing adequate physical facilities and staff capacity. Work has already started in developing and evaluating specifications to establish a national preservation laboratory to save photos, films and other historically important documents in danger of being lost because of disintegrating materials or obsolete technologies. The preservation facility will serve the needs of all scientific and other institutions as well as individuals throughout the country by providing adequate expertise and tools to preserve endangered historically important documents (p. 64).

This much needed facility unfortunately has not yet materialised.

Preserving Archives

The urgent need to address the preservation of audio visual archives was brought out in the discussion in the previous section. This section presents an overall picture of preservation at the National Archives of Namibia.

The National Archives of Namibia has a purpose built storage meant to minimise dangers of fire spreading in the event of a fire through compartmentalisation and fire proof doors for the repositories. Preventive measures include sleeves around fluorescent lights, shelves purposefully placed to avoid being directly under the lights and rules to avoid eating and drinking in storage areas and search room. However Nakale (2016) observed that fire extinguishers had been past their service date without being services and staff was not aware of how to use them. The same study found that smoke detectors were not functional.

Ngulube (2003) points out that disaster planning or emergency preparedness is fundamental to the preservation of records and archives. The National Archives of Namibia has a Disaster Management Plan in place unfortunately most staff members were not aware of the existence of the disaster plan (Nakale, 2016). Lyall (1993, p. 6) warns that one of the main reasons for the failure of a disaster plan is "lack of staff awareness."

The National Archives does not have a preservation policy. According to Ngulube, Modisane and Mkeni-Saurombe (2011, p. 244) "Preservation policies are a fundamental ingredient of accountability as they justify why certain decisions are taken, demonstrate how funds were spent and facilitate the development of preservation strategies and plans".

RECOMMENDATIONS

The following recommendations for managing records in the public service of Namibia adopt best practices.

- **Regulatory Framework:** The finalisation of a records management policy is long overdue. Once implemented, different public sector organizations would need to come up with their own policies. Each organization would benefit from the establishment of a records committee, of which one of its tasks is to draw up records management policies and strategies.
- **Management of Semi-Current Records:** The setting-up of records centres and development of retention schedules is much needed to ensure the safety and efficient management of semi-current records
- **Resources:** The public service of Namibia should establish a records management cadre. In determining resources and facilities for records management, a major issue to consider is a trained, skilled and experienced records manager to coordinate records management for each Ministry. An ideal situation is for each records management units to have their own budgets. At least within General Services, there should be a budget item specifically for records management.
- **Preserving Archives:** There is a need for the National Archives of Namibia to come up with a preservation policy and digital preservation strategies to protect electronic records and sound recordings. The National Archives of Namibia should also create awareness amongst staff on the Disaster Management Plan.

FUTURE RESEARCH DIRECTIONS

The chapter has highlighted a number of issues which warrant further research. These include the following:

- **Implementation of Electronic Records Management Systems:** Such studies could look into issues of legacy systems and compatibility, change management, pre-implementation stage and skills required by staff.
- **Records Retention and Disposal:** The lack of retention schedules requires investigation which could highlight the magnitude of the problem and the consequences thereof; as well as recommendations on how to solve the problem.

CONCLUSION

This chapter gave an overview of the situation regarding records management in the public service of Namibia. Namibia experiences the problems such as a lack of skills; lack of awareness of records management by action officers and looking down upon records keeping staff; inadequate legal and regulatory framework for records in particular audio visual and electronic records management.

REFERENCES

Barata, K., Bennett, R., Cain, P., & Routledge, D. (2001). *From accounting to accountability: Managing financial records as a strategic resource: Namibia: A case study*. London: International Records Management Trust.

Chaterera, F., Ngulube, P., & Rodrigues, A. (2014). Records surveys in support of a framework for managing public records in Zimbabwe. *Information Development, 30*(4), 366–377. doi:10.1177/0266666913497611

Countrymeters. (2016). *Namibia population*. Retrieved October 5, 2016, from http://countrymeters.info/en/Namibia

Department of Public Service Information Technology Management. (2005). *The E-governance Policy for the Namibian Public Service*. Windhoek: Author.

Geingob, H. G. (2002). *Building economics from the government up: Celebrating a new charter for the public service in Africa*. Paper presented at the Annual Conference of the American Society for Public Administration. Retrieved January 19, 2008, from http://www.opm.gov.na/pm/speeches/2002/economics.htm

Gurirab, T. B. (2003). *Address at the Closing of the National Forum on Human Capital Development and Knowledge Management for Economic Growth with Equity*. Retrieved April 27, 2004, from http://www.opm.gov.na/pm/speeches/2003/closing.htm

Hillebrecht, W. (2010). *The Preservation of the audiovisual heritage of Namibia, challenges and opportunities*. Paper Presented at the Sound Archives Workshop, Windhoek, Namibia. Retrieved November 11, 2016, from http://baslerafrika.ch/wp-content/uploads/WP_2010_1_Hillebrecht.pdf

Ilukena, K. R. (2016). *Marketing and public programming activities at the National Archives of Namibia* (Unpublished research project report). University of Namibia, Windhoek, Namibia.

International Records Management Trust (IRMT). (1999). *Electronic records*. London: Author.

International Records Management Trust (IRMT). (2000). *Managing records as the basis for effective service delivery and public accountability in development: An introduction to core principles for staff of the World Bank and its Partners*. London: Author.

International Records Management Trust (IRMT). (2004). *The e-records readiness tool.* Retrieved February 26, 2007, from http://www.nationalarchives.gov.uk/rmcas/documentation/eRecordsReadinessTool_v2_Dec2004.pdf

International Standard Organisation (ISO) ISO 15489-1. (n.d.). *Information and documentation - records management.- Part 1: General*. Geneva, Switzerland: Author.

Ipinge, A. (2015). *An investigation of the recognition of the records management profession in the public service of Namibia* (Unpublished undergraduate research report). University of Namibia.

Joint Information Systems Committee (JICS). (2003). *JICS records management policy statement*. Retrieved March 23, 2007 from: http://www.jics.ac.uk/index.cfm?name=pres_rmps

Kansas State Historical Society. (2005). *Kansas electronic records management guidelines*. Topeka, KS: Author.

Karlos, A. (2015). *A study on the implementation of the electronic document and records management system (EDRMS) in the public service of Namibia* (Unpublished undergraduate research report). University of Namibia.

Kazavanga, U. (2015). *The status of records management in parastatals in Namibia: A case study of Namibia College of Open Learning (NAMCOL)* (Unpublished undergraduate research report). University of Namibia.

Keakopa, M. S. (2003). Automated records management systems in the ESARBICA region. *ESARBICA Journal, 21*(2), 41–48.

Kemoni, H. N. (2009). Management of electronic records: Review of empirical studies from the Eastern, Southern Africa Regional Branch of the International Council on Archives (ESARBICA) region. *Records Management Journal, 19*(3), 190–203. doi:10.1108/09565690910999184

Lau, B. (1994). National Archives of Namibia: Country report. In *Archives in the nineties: The challenges for Eastern and Southern Africa Regional Branch of the International Council on Archives* (pp. 246-247). Gaborone, Botswana: ESARBICA.

Loadman, J. (2001). Does the position of records management within the organization influence the records management provision? *Records Management Journal, 11*(1), 45–63. doi:10.1108/EUM0000000007266

Luyombya, D. & Sennabulya, S. (2012). An analysis of the public archives infrastructure in Uganda. *Comma, 2012*(1), 67-78.

Lyall, J. (1993). *How to develop a disaster plan for a library or archival institution.* Pan African Conference on preservation of library and archival materials, Nairobi, Kenya.

Makhura, M. M. (2001). *The role of electronic records management in a service organization* (Unpublished Masters Dissertation). Rand Afrikaans University, South Africa.

Maletsky, C. (2006). Computer theft paralyses Omaruru. *The Namibian.* Retrieved August 3, 2008, from http://www.namibian.com.na/2006/November/national/065A605530.html

Mapiye, T. (2015). *The management of audio-visual archives in Namibia: A comparative study of National Archives of Namibia and Media Organisations* (Unpublished undergraduate research report). University of Namibia.

Marutha, N. S., & Ngulube, P. (2012). Electronic records management in the public health sector of the Limpopo province in South Africa. *Journal of the South African Society of Archivists, 45,* 39–67.

Matangira, V., Katjiveri-Tjiuoro, M., & Lukileni, H. (2013). Establishing a university records management programme: A case study of the University of Namibia. *Journal for Studies in Humanities and Social Sciences, 2*(2), 103–117. Retrieved from http://repository.unam.edu.na/bitstream/handle/11070/1402/Matangira_establishing_2013.pdf?sequence=1

Mbakile, L. (2007). *An outline of records management initiatives from the Office of the President, Botswana.* Paper read at the XIX Bi-Annual ESARBICA conference, Dar es Salaam, Tanzania.

Mutiti, N. (2001). The challenges of managing electronic records in the ESARBICA region. *ESARBICA Journal, 20*(3), 57–61.

Mutsagondo, S., & Chaterera, F. (2016). Mirroring the National Archives of Zimbabwe Act in the context of electronic records: Lessons for ESARBICA member states. *Information Development, 32*(3), 254–259. doi:10.1177/0266666914538272

Nakale, A. (2016). *An investigation of preservation and conservation of archival materials at the National Archives of Namibia* (Unpublished undergraduate research report). University of Namibia.

Namibia Resource Consultants. (2002). *An assessment of the function of the National Archives of Namibia and the way forward: Final report.* Windhoek, Namibia: Author.

Namibian Broadcasting Corporation (NBC). (2016). *Access to information bill consultations underway.* Retrieved August 4, 2017, from https://www.namibian.com.na/151572/archive-read/Access-to-Information-Bill-consultations-underway

NAMPA. (2014). *Alleged Outjo fraudster Koen going on trial on Monday.* Retrieved from January 14, 2017, from http://www.lelamobile.com.content/19890/Alleged-Outjo-raudster-Koen-going-on-trial-on-Monday/

National Archives. (n.d.). *Archives code.* Windhoek, Namibia: Author.

National Archives of Australia. (n.d.). *Digital records.* Retrieved January 26, 2007, from http://www.naa.gov.au/recordkeeping/er/summary.html

National Planning Commission. (2000). *Government of the Republic of Namibia Second National Development Plan (NDP2) 2001/2002 – 2005/2006: Volume one: Macroeconomic, sectoral and cross-cultural policies*. Windhoek, Namibia: Author.

Nengomasha, C. T. (2004). *Report on a Records Survey Conducted in National Planning Commission* (Unpublished). Windhoek, Namibia: University of Namibia.

Nengomasha, C. T. (2009). *A study on the management of electronic records in the public service of Namibia in context of e-government* (Unpublished doctoral dissertation). University of Namibia.

Nengomasha, C. T., & Beukes-Amiss, C. M. (2002). *Ministry of Health and Social Services: Records Management Survey Reports No. 1 and 2* (Unpublished). Windhoek, Namibia: University of Namibia.

Nengomasha, C. T., & Nyanga, E. H. (2012). Managing semi-current records: A case for records centres for the public service of Namibia. *Journal for Studies in Humanities and Social Sciences*, *1*(2), 231–245.

Ngoepe, M., & Makhubela, S. (2015). Justice delayed is justice denied: Records management and the travesty of justice in South Africa. *Records Management Journal*, *25*(3), 288–305. doi:10.1108/RMJ-06-2015-0023

Ngulube, P. (2003). *Preservation and access to public records and archives in South Africa* (PhD thesis). Natal University.

Ngulube, P., Modisane, C. K., & Mkeni-Saurombe, N. (2011). Disaster preparedness and the strategic management of public records in South Africa: Guarding against collective cultural amnesia. *Information Development*, *27*(4), 239–250. doi:10.1177/0266666911417641

Ngulube, P., & Tafor, V. F. (2006). The management of public sector records in the member countries of ESARBICA. *Journal of the Society of Archivists*, *27*(1), 57–83. doi:10.1080/00039810600691288

Office of the President. (2004). *Namibia Vision 2030*. Windhoek, Namibia: Author.

Office of the Prime Minister. (2005a). Discussion document on the activities of the [E-Laws] Working Group for the Seminar/Workshop for Development of E-laws (Electronic or Cyber Laws for Namibia). Windhoek, Namibia: Author.

Office of the Prime Minister. (2005b). *Use of Electronic Communications and Transactions Draft Bill*. Windhoek, Namibia: Author.

Sebina, P. M. M. (2006). *Freedom of information and records management: A learning curve for Botswana* (Unpublished doctoral thesis). University of London.

Sejane, L. (2004). *An investigation into the management of electronic records in the public service in Lesotho* (Unpublished MA Thesis). University of KwaZulu-Natal, Pietermaritzburg.

Shivute, O. (2003, August 7). Namibia: Missing docket and burnt evidence stall fraud probe. *The Namibian*. Retrieved June 8, 2017, from allafrica.com/stories/200308070437.html

Stork, C., & Aochamub, A. (2003). *Namibia in the information age. NEPRU Research Report, 25*. Windhoek, Namibia: Namibia Economic Policy Research Unit.

Taylor, M. (1994) Records management in Namibia: Prospects and problems. In *Archives in the nineties: The challenges for Eastern and Southern Africa Regional Branch of the International Council on Archives* (pp. 58-62). Gaborone, Botswana: ESARBICA.

Tyson, R. (2009). *Tools of the Regime: Namibian Radio History and Selective Sound Archiving 1979–2009.* Paper Presented at the Sound Archives Workshop. Retrieved April 6, 2016, from http://baslerafrika.ch/wp-content/uploads/WP-2009-3-Tyson.pdf

University of Edinburg. (2017). *Records management policy framework.* Retrieved June 6, 2017, from http://www.ed.ac.uk/records-management/records-management/policy-framework

Wales, N. S., & Records, S. (2003). *Strategies for documenting government business: the DIRKS manual.* Retrieved April 4, 2010, from http://www.records.nsw.gov.au/publisector/DIRKS/final/downloadable/introproj.html

Wamukoya, J., & Mutula, S. M. (2005). Capacity-building requirements for e-records management: The case of East and Southern Africa. *Records Management Journal, 15*(2), 71–79. doi:10.1108/09565690510614210

World Bank. (2000). *Managing records as the basis for effective service delivery and public accountability in development: An introduction to core principles for staff of the World Bank and its partners.* Retrieved February 23, 2007, from http://siteresources.worldbank.org/EXTARCHIVES/Resources?Core%Principles.pdf

Worldometers. (2017). *Namibia population.* Retrieved September 15, 2017, from http://www.worldometers.info/world-population/namibia-population/

Zibiso, M. S. (2015). *An analysis of records management practices in Namibia: A case study of the Ministry of Education at Otjiwarongo Regional Office* (Unpublished undergraduate research report). University of Namibia.

ADDITIONAL READING

Adu, K. K., & Ngulube, P. (2016). Preserving the digital heritage of public institutions in Ghana in the wake of electronic government. *Library Hi Tech, 34*(4), 748–763. doi:10.1108/LHT-07-2016-0077

Chisita, C. T., & Chinyemba, F. Z. (2015). Towards an open and accessible sound and audiovisual archives: Case study of Zimbabwe. *IASA Journal, 45*, 47–53.

Mnjama, N. (2005). Archival landscape in Eastern and Southern Africa. *Library Management, 26*(8/9), 457–470. doi:10.1108/01435120510631747

Nengomasha, C. T. (2009). Managing public sector records in Namibia: A proposed model. *Information Development, 25*(2), 112–126. doi:10.1177/0266666909104712

Smith, K. (2007). *Public sector records management. A practical guide.* London: Ashgate Publishing.

KEY TERMS AND DEFINITIONS

Archives: Records preserved because of value other than the purpose for which they were created. About 3% of records become archives.

Digital Preservation: Policies and strategies to ensure that electronic records remain accessible overtime.

Disaster Management: Preparedness to deal with a situation that could harm records which will include an ability to respond and recover in the event of a disaster.

E-Government (Electronic Government): Use of information and communication technologies by government to enhance service delivery.

E-Readiness (Electronic Readiness): Degree to which a country is prepared to operate in an information and communications (ICTs) networked environment.

E-Records (Electronic Records): Records created and accessible through the use of a computer. Some traditional/paper records become electronic through digitising.

E-Records Readiness (Electronic Records Readiness): Preparedness to create, manage, share, and use electronic records and the information they contain.

Public Sector: Institutions or bodies that are set up through an act of parliament which exists to provide public service.

Public Service: Services provided by government and those responsible for the provision of such services.

Record: A document regardless of subject or form created in course of a transaction or conducting business. It is evidence of a transaction or business activity.

Records Management: Systematic management of records throughout their entire life cycle (i.e., from creation through maintenance and use to the time when they are no longer) at which time they are either destroyed or permanently preserved.

Trustworthy Records: Records whose provenance as well as what they purport to be can be proven, are a full reflection of the transaction they represent, have not been tempered with, and are usable.

Vital Records: Records which in the event of a disaster will ensure business continuity.

Chapter 14
Management of Records and Archives in Uganda's Public Sector

David Luyombya
East African School of Library and Information Science, Uganda

ABSTRACT

This chapter discusses the role of the archives legislation, the national archives, and the records and archives management (RAM) training institutions in nurturing public records and archives management in Uganda's public sector (UPS). Specific areas addressed include the legal framework and regulations related to recordkeeping, the role of the Uganda National Archives (UNA) and RAM education and training institutions that train records and archives managers in the delivery of their services. It also reports findings of a study that investigated issues, controversies, and constraints bearing on the management of public sector records and archives in government of Uganda ministries.

INTRODUCTION

Records and archives in the public sector refer to the information sent or received in connection with the transactions made by government agencies or any other agency wholly or partially supported by public funds (Government of British Columbia, 2015). In this chapter, the public sector refers to the 23 ministries of the Government of Uganda (GoU) which form part of the Ugandan public sector. The increased importance of transparency and accountability in public administration has led to a focus on the need to manage records and archives so that information can easily be accessed by the creating agencies. Sound records and archives management delivers transparency within governments and enables the effective delivery of public services (Meijer, 2001). Government agencies, therefore, need to be able to efficiently manage their records and archives to ensure business continuity in their operations and sound decision-making (Meijer, 2003). Consequently, public records and archives must be accurate and complete, with appropriate access and effective maintenance measures (Okello-Obura, 2011). The legislation, national archives and RAM training institutions are, therefore, a cornerstone in nurturing proper public records and archives services.

DOI: 10.4018/978-1-5225-3137-1.ch014

In an effort to improve the management of public records and archives, the GoU undertook a number of restructuring initiatives, such as recruiting records staff and re-equipping registries (Ministry of Public Service [MoPS], 1998). The GoU also recognised that records and archives management plays a vital role in the process of modernising a country (MoPS, 2005). This resulted in a series of records and archives management improvement projects to being carried out. The British Council engaged the International Records Management Trust (IRMT), under British Aid arrangements with the GoU, to provide assistance in the development of records and archives management capacity in support of the Public Service Reform Programme (Phase I (1988), Phase II (1992-1996) and Phase III (1998). Records and archives management was, therefore, viewed as a tool that had the potential to boost the delivery of quality services in the public sector.

Luyombya (2010), however, observes that the management of public sector records and archives had not progressed in Uganda and the RAM system remained in a sorry state. Okello-Obura (2011) and Magara (n.d.) point out that the management of public records and archives was weak, uncoordinated and inadequate owing to a weak legal framework, an inadequate curriculum and the failing role of the national archives. It is against this background that this chapter highlights the impact of the Ugandan records legislation, the national archives and the records and archives management (RAM) training institutions in the management of public records. Records management legislation, a national archive and RAM training institutions are, therefore, a cornerstone in nurturing proper public records and archives services.

The underlying principle for this chapter is that the key step in developing a sound basis for effective public records and archives management is to have records legislation, a national archive and RAM training institutions (The New South Wales Government, 2004; Ngulube & Tafor, 2006; Thurston, 2005). The goal is to determine how far the records legislation, the national archive and the RAM training institutions have gone in enhancing sound records and archives management practices in the Ugandan public sector, thereby improving public service delivery, accountability and good governance.

STATEMENT OF THE PROBLEM

The Inspectorate of Government (IGG), which is the country's ombudsman charged with the responsibility of investigating embezzlement, bribery, nepotism, influence peddling, theft of public funds or assets, fraud, forgery, causing financial or property loss and false accounting in public affairs, frequently cites the absence of records and archives or their inefficient maintenance as the main reasons for poor service delivery. While the work of the IGG relies entirely on having access to accurate and timely records and archives, the reports from the office of the IGG overtly highlighted the lack of the required records and archives as a situation that frustrates the fight against maladministration in the UPS (IGG, 2012, 2014). When the IGG seeks answers to an inquiry, they expect to receive the official records and archives, indicating evidence of the decisions and actions taken in fulfilment of the government duties. However, the IGG noted that more often than not records and archives could not be located or verified during the audit inspections. This chapter, therefore, set out to establish whether records legislation, the Uganda National Archives (UNA) and the RAM training institutions have satisfactorily carried out their mandate to support the management of the public sector records and archives.

Objectives

The objectives of the chapter are:

1. To inform the reader about the role of the Uganda records legislation and the UNA in the public sector records management process.
2. To report the success of the RAM training institutions in building human resource capacity for the management of records and archives in the Ugandan public sector by tracing their history.
3. To share the challenges faced by the records legislation, the UNA and RAM institutions to effectively guide the management of public sector records and archives in Uganda.
4. To specify the strategies most likely to lead to improved management of public sector records and archives in Uganda.

SIGNIFICANCE OF THE CHAPTER

The chapter aims at:

1. Informing the reader about the relationship between records legislation, the national archive and the RAM training institutions as well as to enforce accountability for managing public records and archives for good governance.
2. Revealing obstacles that are hindering the records legislation, the national archive and the RAM institutions from attaining their intended goals of nurturing proper public records and archives management.

HISTORICAL BACKGROUND OF RECORDS MANAGEMENT IN UGANDA

In an attempt to understand the contextual factors that influenced the evolution of RAM in Uganda, this section offers a general outline of how RAM practices has evolved over time in UPS. Because of the serious social, economic and political challenges that confront Uganda today, it might be useful to begin with some history and perspective – some rather old history and some more recent perspective (Carson, 2005). This will help one to understand the progression of records management in Uganda from the colonial period to the present time.

The foundation of records management practices in the UPS is traced from the establishment of British colonial rule in the late 1800s (Akita, 1979). This was confirmed by Tough (2004) and Aloufi (2007), who observe that the insistence on meticulous recordkeeping in Commonwealth countries indeed started during the colonial period. Ketelaar (2008) confirm that post-colonial governments have continuously built their records management systems on the foundations laid by colonial administrations. The colonial administrations introduced recordkeeping regulations in all their colonies, including Uganda (Tough & Lihoma, 2012). These regulations inculcated a records management culture which is still common in UPS. For instance, the British colonial administration introduced a full-fledged, registry-based filing

system to control records from the time of their creation up to their final disposition. They also instituted regulations which required heads of departments in government ministries to introduce an integrated recordkeeping system in the form of two registries – one open and the other confidential – which is still the practice in the UPS (MoPS, 2005; Thurston, 1995). Thurston (1995) observed that this system saved time for the Governor when undertaking routine business.

Upon the attainment of political independence, the newly independent African countries, including Uganda, had to take over the records formerly managed by the colonial administrators (Elkins, 2005). By the time the Ugandan government declared independence on 9 October 1962, the UPS had incorporated the records and archives management system used by the colonial administration (Akita, 1979).

The provision of RAM education in Uganda started in the 1960s by state-sponsored institutions, which was a sign of commitment to improve the management of public records. In 1969, the Institute of Public Administration (IPA), now the Uganda Management Institute (UMI), started RAM education in Uganda (Okello-Obura & Kigongo-Bukenya, 2011). At its inception, the IPA provided training in RAM at certificate level. In 1996, it introduced a Diploma in Records and Information Management (DRIM). As a result, the UPS started seeking only those employees with qualifications in records and archives management for recruitment and promotion.

In 1999 Makerere University, the oldest institution of higher education in Uganda (established in 1922), started a Diploma in Records and Archives Management (DRAM) course to address the growing demand for records and archives management skills (Appendix 1). With greater government demand for more highly qualified personnel to manage public records, Makerere University started a Bachelor of Records and Archives Management (BRAM) degree course in 2009 (Appendix 2). Other public universities, such as Kyambogo and Busitema universities, and a number of private universities, including Kabale University, Uganda Christian University (Mukono), Islamic University in Uganda (IUIU), Kampala International University (KIU), Mutesa I Royal University and Busoga University, followed suit in offering records and archives management courses. However, unlike Makerere University where the training is located in the East African School of Library and Information Science (EASLIS), which is part of the College of Computing and Information Sciences, records and archives management in other universities is offered within the Business and Information Technology courses where it seems not to be rightly located. As highlighted above, several agencies have been at the forefront of the development of RAM in the UPS.

Previous Research

Theoretical and empirical investigations have emphasised the crucial role that records legislation, national archives and RAM training institutions play in fostering the development of public records and archives. The debate about the role of public records legislation, national archives and RAM training institutions in the public sector has been continuous, as indicated below.

The Role of Records Legislation in Governing the Management of Public Records and Archives

Compliance to legal requirements is one of the drivers of records management in the public sector. A government uses legislation to ensure that its records and archives are appropriately managed and preserved over time for accountability and historical reasons (Okello-Obura, 2011). Hence, records and

archives legislation is an essential component of the wider legislative base of an accountable and effective government. Chibambo (2003) notes that managing records and archives requires understanding the legal context in which the records are created. Parer (2001) observes that records legislation establishes the leadership and direction within which appropriate records systems can be created to ensure that governments meet their accountability requirements while delivering public services. The key attribute is that legislation provides for the management of all records and archives to promote RAM readiness (Okello-Obura, 2011). As Carlin (2007) notes, records legislation is expected to compel public sector agencies to manage public records in the performance of their duties.

American records specialists and researchers such as Cushing (2010), Wallace (2010), Behrnd-Klodt (2008), Jimerson (2007), Cook (2007), Cox and Wallace (2002) and Yakel (2000) hold the view that without legislation, records and archives will not be efficiently managed. Similarly, the African scholars defended the perspective when they stated that records legislation is set up to specify the requirements for managing public records (Katuu, 2015; Asogwa, 2012; Ngoepe & Keakopa, 2011; Ngoepe & Ngulube, 2011; Mazikana, 2007; Ngulube & Tafor, 2006; Mnjama, 2005). However, African researchers are of the view that most African countries have outdated records and archives management legislation, resulting in many difficulties that hinder the effective management of public records and archives (Ngoepe, 2014). Decman and Vintar (2013) emphasise that the efficient creation and management of public records and archives rests on the authoritative role that records and archives legislation play in setting mandatory standards that ensure that all the essential records of all agencies are maintained and made accessible.

To emphasise the role of legislation in managing public records, Miller (2003) indicates that the records and archives law must allow for:

- The requirement that all actions and transactions of government be documented in an accountable fashion;
- The effective planned management of all government records throughout their life cycle, regardless of the medium or technology used for their creation;
- The oversight of all public-sector recordkeeping activities by the national archive;
- The application of internationally accepted standards for records care;
- The development of effective internal policies and procedures for records care;
- The provision of adequate physical storage and protection of records, regardless of medium;
- The destruction of records only according to established schedules and only with the prior authorisation of the National Archivist; and
- The implementation and maintenance of professional standards and schemes of service for the employment of any personnel responsible for records-related activities in government.

To the African scholars, a records and archives statute and legal provision are required as they result in greater standardisation of records and archives management practices where they exist (Ngoepe & Ngulube, 2011, Mazikana, 2007). This is in agreement with Wamukoya's argument (2000) that effective RAM can better be achieved with a legislative framework. As such, most countries have had National Records and Archives Acts as the basis for managing their public records and archives (IRMT, 2009). The records and archives legislation also provides the essential framework that enables a national records and archives service to operate with authority in its dealings with other agencies of the state.

The Role of a National Archive in the Management of Public Records

A national archive is formally entrusted with powers to produce regulations for government agencies to follow while creating and managing public records and to ensure that those requirements are met (Chaterera, Ngulube & Rodrigues, 2014). The national archives are responsible for setting mandatory standards for the creation of records and the management of archives and such standards are binding on all government agencies, and compliance monitoring is another task of national archives institutions (Mutiti, 2002). The standards represent a workable compromise in setting out characteristics that RAM systems should possess without overtly contradicting national legal systems (Healy, 2001). Therefore, national archives often provide a legislative mandate to public agencies at an early stage in establishing and prescribing recordkeeping requirements.

According to Ngoepe (2014) and Asogwa (2012), a national archive is expected to develop, monitor and enforce procedural controls over public records creation, maintenance, disposal and preservation. Duranti and Preston (2008) observe that for the public agencies to manage their records efficiently, consistent standards must be in place and these should be spearheaded by national archives. For example, national archives from developed parts of the world, particularly the UK, the United States and Canada, have developed standards which determine or influence records management requirements (Goh, Duranti & Chu, 2012). Standards cover aspects that should be addressed to implement RAM systems such as policy, responsibilities and strategies for designing and monitoring RAM systems (Ngoepe & Keakopa, 2011). The standards emphasise the fact that records are inputs and outputs of public sector business processes and their creators and users have a role in managing them (Healy, 2001). McLeod and Hare (2006) point out that records management procedures and guidelines are also produced by national archives as primary documents to govern the creation and management of records and archives in the public sector.

Cox (2005) observes that failure of a national archive to be vigilant and proactive in guiding public bodies in records management operations will adversely affect their work and the attainment of set public sector goals. Therefore, national archives are required to ensure that public agencies comply with the national records management requirements (Mnjama, 2000). The maintenance of records of long-term value also largely depends on cooperation between state agencies and the national archives (Skelton, 2000). The question, therefore, is what is the situation in Uganda? In developed regions such as North America and Europe, where government services have their records online, national archives are instrumental in guiding and managing electronic records (Cox, 2006). In such countries, national archival institutions have put in place procedural guidelines and instructions to address the problems of electronic records management in the public agencies (Duranti, 2012; Bantin, 2008).

The Role of RAM Training Institutions in Managing Public Records

The provision of records education and training is a core function of RAM training institutions (McLeod, Hare & Johare, 2004). RAM training has evolved over the years in line with overall development within the Library and Information Science (LIS) profession. LIS institutions provide a solid foundation for RAM courses. These institutions provide the human resource capacity to manage records and archives.

Johare (2006) argues that the concern of RAM institutions is to ensure that the training reflects the needs of the industry and the potential employers. As early as 1968, Schellenberg strongly stressed that since record management activities are of a highly specialised type, RAM institutions had to provide specialised knowledge and skills. According to Shepherd (2011), delivery of professional skills and

encouraging students to think conceptually was the focus when the records and archives curricula in developed countries, such as the UK, was being designed. Jimerson (2010), in the United States, argues that RAM institutions upgraded curricula to accommodate the changes brought about by electronic records management, rapid administrative change resulting from modern management practice and the need for stricter accountability.

The future of the records and archives services relies on required knowledge and skills (Keakopa, 2007). According to Keakopa, in order to overcome the RAM challenges, record-keepers have to be educated and trained afresh so as to be better informed of their roles and responsibilities. Records creators need to understand the methods of managing the records they create and/or use as they keep pace with the technological advances in the workplace (Mnjama, 2005). RAM curricula are addressing the electronic environment, convergent technologies, e-transactions, e-business and information management to meet the new RAM requirements. The International Council on Archives (ICA) also resolved, as part of its strategic plan 2008-2010, to build capacity and promote continuing archives professional development for archives professionals' identity and affiliation.

Studies conducted in Africa since the early 2000s have shown that there is lack of records and archives training capacity, leading to failure by public offices to achieve good governance, effective public service delivery and transparency (Mutiti, 2002; Wamukoya & Mutula, 2005; Wato, 2006). Wright (2013) is of the view that training in RAM training institutions in Africa was weak but addressing the capacity deficit would be through revising the education and training programmes in place. A review of the literature of RAM education in Africa includes some critical statements, which reflect that little has been done in terms of education and training (Katuu, 2015; Ngulube & Noko, 2013; Katuu, 2009; Mnjama, 2005). Findings like a lack of knowledge, skills and abilities to manage records and the need for re-education and re-training are common in the literature (Katuu, 2015; Ngulube & Noko, 2013). The literature specifically confirms that RAM training institutions have the role to train personnel to manage public records and archives (Katuu, 2015). Katuu (2015) further reports that there is lack of a comprehensive RAM curriculum in Africa and hence RAM institutions lag behind the developed countries such as Australia, the UK and the United States in imparting skills and knowledge that are relevant to the needs of the public sector.

Technological Initiatives and Their Impact on the Management of Public Records and Archives

Technological initiatives have come up with solutions to the poor delivery of public services and the ineffective management of records and archives (Forlano, 2004; Garson, 2004). These technologies serve to ensure that governments are able to meet the demands of working in an electronic environment (Fang, 2002). They collect and share data and execute legally mandated government activities in such a way that information is protected from unauthorised access (Heeks, 2002). They provide improved accuracy in the filing and retrieval of information (McLeod & Hare, 2006). The technologies provide the hardware and software for the management of both manual and electronic records (Meijer, 2001).

Bantin (2008) argues that technology potentially offers remedies: the improved capture, retrieval and preservation of records of value. He aptly notes that governments are striving to manage their records and archives by using modern technology because the future of RAM is seen to be with electronic systems. Some studies show that the justification for the move towards managing records and archives with modern technology is that it is more efficient and cheaper (Basu, 2004; Forlano, 2004). However,

the absence or weaknesses in technological requirements are factors that hamper the management of records and archives, especially in developing countries (Mnjama, 2003). Mnjama cautions governments with regard to acquiring the required technologies for managing records and archives, especially those that are created with the aid of information and communication technologies (ICTs) because they require a special environment. Before a government adopts ICTs for RAM purposes, it should assess whether its physical infrastructure and RAM procedures are adequate, as well as making sure that staff are appropriately trained in RAM issues (Mnjama & Wamukoya, 2007). The need to change from the traditional practices and tools has been suggested by different authors, who state that technology should shape RAM processes (Ngulube & Tafor, 2006).

RAM ISSUES, CONTROVERSIES AND PROBLEMS IN THE UGANDAN PUBLIC SECTOR

To establish the success and challenges faced by records legislation, and to enable the UNA and RAM institutions to effectively guide the management of public sector records and archives in Uganda, a study was conducted in the Ugandan government ministries in April 2016. This study utilised a multi-methods approach to understand the phenomenon being investigated (Creswell, 2014). Data was collected using the approach by applying four different techniques, namely interview, questionnaire, observation and document analysis. Interview was applied as the main data-collection technique and the other techniques were applied in a limited way to clarify issues on the interview data (Ngulube, 2015).

Interviews were held with the personnel officers while questionnaires were distributed to the records managers. A records manager refers to the person in charge of records and archives management in government ministries and departments. Personnel officers are the immediate supervisors of the records managers. The opinions of the personnel officers were collected since they are the active directors and actors playing "a formative role" in the management of public records and archives (McKemmish, Gilliland-Swetland & Ketelaar, 2005).

Response Rate

Twenty-three questionnaires were distributed to records managers in the 23 government ministries and out of the 23 targeted respondents, a total of 19 (83%) responded. This good participation could be a realisation by the respondents of the value attached to records and their role in achieving effective service delivery.

The study investigated the qualifications of the records managers in the Ugandan public sector. The respondents were required to indicate their areas of study. The findings are as shown in Table 1.

Table 1 indicates that the majority of the respondents, i.e. 11 (58%), had a Bachelor's Degree in Records Management, 21% a diploma qualification and three (16%) held a Certificate in Librarianship. One questionnaire had no response to the question regarding qualifications. Despite the high number of records managers with degrees, their areas of specialisation varied. This confirms Katuu's (2015) observation that "the career of records management has traditionally been pursued without specialised RAM training". This also confirms that qualified RAM personnel were still required in UPS.

Records managers were required to rate the records legislation, the UNA and the RAM training institutions in supporting records and archives management. Their responses are summarised in Table 2.

Table 1. Qualifications of the records managers in Uganda's 23 ministries (N=19)

Qualification	No. of Staff	Percentage	Area of Specialisation
Degree	11	58	Records and Archives Management, Library and Information Science, Information Technology, Office Management
Diploma	4	21	Records and Information Management, Records and Archives Management, Secretarial Studies
Certificate	3	16	Librarianship, Database Management, Office Practice, Registry Procedures
No response	1	5	
Total	**19**	**100**	

Table 2. Records managers' rating of records legislation, the UNA and RAM training institutions (N=19)

	Agree	Not Sure	Disagree	Total
Legislation	9	8	2	19
UNA	8	6	5	19
RAM training institutions	10	6	3	19
Total	**27**	**20**	**10**	**57**
Representation by %	**47**	**35**	**18**	**100%**

Twenty-seven respondents (47%) agreed that the three areas of ratings are very necessary in support of records and archives management in their individual offices. Twenty responses (35%) were not sure and 10 respondents (18%) totally disagreed. It must, however, be noted that across many public sector organisations, the tendency to mismanage records stems from the dormant role played by legislation, national archives and RAM training institutions (Chaterera, Ngulube & Rodrigues, 2014).

The study also asked the records managers about the challenges they faced from the records legislation, the UNA and RAM institutions in the achievement of good records and archives management practices in the Ugandan public sector and the results were as given in Table 3.

Emerging Issues from a Review of Documents and Interviews

Legal Framework and Regulations

Document analysis revealed that a number of legislations address issues of public records and archives management such as the Uganda National Records and Archives Act (2001), the 1995 Constitution of Uganda, the 2005 Access to Information Act and the Local Government Act (2001).

The Uganda National Records and Archives Act was enacted in (2001) and anticipated the development of RAM infrastructure for national development. The Act indicated the need to establish a National Records and Archives Agency (UNRAA) (Section 4) which would guide the public agencies in following good practices in managing public records and archives. The UNRAA is required to establish and implement procedures for the timely disposal of public records of no continuing value and for the transfer

Table 3. Issues arising from the records legislation, UNA and RAM training institutions

Areas of Concern	Challenges Faced
Records legislation	Clarity regarding what constitutes a record
	Provision of what is precisely required by the legislation
	Lack of a legal RAM authority for implementation and monitoring
	Legislation non-operational and remains hanging
Uganda National Archives	Mandatory records management requirements not promulgated
	Procedures, rules and regulations not updated
	No relevant RAM standards publicised
	Weak monitoring and supervision guidance to provide a useful RAM operating framework
ARM training institutions	No reviewed curricula
	Shortage of qualified personnel
	Shortage of hi-tech skills and knowledge
	Supply of RAM professionals less than current demands

of public archives for preservation in the national archives (Section 5). However, a personnel officer remarked that "16 years since enactment of the records legislation, UNRAA has not been established as required by the legislation." Further reference by the interviewees to the Uganda Records and Archives Act (2001), regarding its promulgation clearly indicated the fact that the records legislation only exists on paper because no serious effort has been made to implement it.

Section 7 of the Act requires every head of a government department and every chief executive of a state corporation or local authority to be responsible for adequate documentation of the functions and activities of their respective institutions through the establishment of a registry system. The records managers indicated that there is a registry system in each of the ministry. The registry system, therefore, is to ensure that the records and archives created in public registries are properly managed at every stage of their life cycle.

Other provisions in the records Act such as Section 22 provides a penalty for removal, destruction or mutilation of public records and archives; and Section 11 deals with the responsibilities of the National Archives, recognize the potential role of the Act in giving direction on the establishment and management of records management systems and the security of the records.

The supreme law of Uganda, the 1995 Constitution, sub-section 10, spells out national monuments, antiquities, archives and public records as a responsibility of the GoU and requires the UPS agencies to be accountable for the management of public records and archives. There is also the Access to Information Act (2005) which imposes a duty on GoU agencies to keep all public records and archives in a way that meets the requirements of this legislation. The Local Government Act (2001) provides for local governments to establish an active and continuing program for the economical and efficient management of their records and archive. There are also cyber related laws such as the Electronic Transactions Act (2010), the Electronic Signatures Act (2011) and the Computer Misuse Act (2011) which provide for the opportunity of using electronic records. While the legal framework recognised that it was important to create and maintain records and archives in the public sector, there are gaps and inconsistencies in the legislation.

The interviewees argued that the Uganda legal system provides for RAM but there are no implementation strategies to operationalise the laws. One personnel officer noted that "while waiting for the implementation of the records Act, there are no regulations for the management of records and archives to operationalise the law. Another personnel officer remarked that "there is no policy document and standard operating procedures for the management of records and archives." This is a sign of non-compliance with the records legislation requirements. This response underscores the role of records legislation in directing the management of records and archives in the Ugandan public sector.

A personnel officer remarked that "records legislations focus on the management of information, not the broader issues involving recordkeeping." The records legislations facilitate records sharing and cooperation between government departments and streamline recordkeeping processes (Luyombya, 2010), but by observation across the government ministries this was not the case.

These views indicated that Uganda has a very weak legislative framework pertaining to RAM. The RAM function is not properly provided for in the Ugandan legislative framework. There is, therefore, a crucial need to review the legal framework for public records and archives management in GoU ministries and agencies.

Role of the Uganda National Archives

The Uganda National Archives (UNA) was established in 1955 to be the repository for the archives of the GoU as well as historical records of national significance (Uganda, 1998). In this study, an assessment of the role of the UNA was made with regard to its relationship with the government agencies in providing control over materials coming into the UNA. The Uganda National Records and Archives Act 2001, section 12 stipulates that the UNA shall accept custody of archival records that have been scheduled for retention from the government agencies (Uganda, 2001). One personnel officer remarked that while the UNA was meant to be the repository for archives of the GoU as well as historical records of national significance, it lacks a clear programme to manage the national archives. There is very little that has been done with regard to developing national standards and regulations pertaining to transferring archival materials from government agencies to the UNA. While another personnel officer stated there was lack of professional standards and appropriate guidance from the UNA.

As a follow-up on the role of the UNA in managing public records and archives, the personnel officers revealed that "they were not sure of the guidance provided to the UPS agencies as there was no clear linkage between the UPS agencies and the UNA." The records management supervisors in the ministries indicated no standards that the UNA had set out for managing records and archiving in the public sector. The biggest challenge was how to manage the electronic records as more government transactions are now electronic. A personnel officer stated that "disappointingly, the standards for digital records are missing and this is the way to manage business today." It was observed the records managers continued to arrange and keep the ministry records without a documented plan or guiding documents because the national archives did not provide any. The records and archives management operations like filing and archiving procedures were not documented.

Further observation revealed that the UNA had no collection or acquisition policy, which would set out the detail of what should, or should not, form the fabric of the public archives collection. The personnel officers were not aware of any decisions regarding which records to collect and transfer to the UNA and how to go about collecting them. As a result, archival records are kept in their respective ministries, which do not possess adequate standards for their safety.

These reviews confirmed that the UNA had not provided advice and leadership in relation to best practices in records and archives management in the public sector agencies. These varied views obscure the role of the UNA in guiding records and archives management in the Ugandan public sector.

The RAM Curricula and Trends in the Growth of RAM Training Institutions

A review of the curricula for RAM training institutions revealed a lack of breadth and depth in addressing the creation and management of records, especially the digital records and archives. The curriculum of the Makerere University undergraduate RAM training program (see Appendices 1–4) was reviewed. A systematic analysis of the structure and design of this curriculum shows that the content of RAM across the curricula was not emphasised. The curricula focus on understanding the instructional role of a records manager and archivist. While the changing dynamics of the public sector focus on information technology and evidence-based practice, this is not effectively addressed in the curriculum. For instance, electronic records management technological issues are not clearly spelt out in the curriculum. They are rather assumed. Information technology systems and skills for preserving and archiving of government records online are not outlined in the curricula.

In general, the curricula do not introduce learners to the fundamental theoretical and professional foundations and frameworks that underpin a RAM programme. The proliferation of ICT and the application of e-government across many governments of the world calls for an in-depth understanding of the scientific applications for the efficient management of records and archives but ICT and e-governance are not emphasised in the current university curricula. Noko and Ngulube (2013) observed that the curricula should address the digital environment so that public records and archives are available for future generations.

The records managers were also asked to indicate what they would consider should be included in the curricula of RAM training institutions if public records and archives were to be managed effectively. The results are indicated in Table 4.

Table 4. Records managers suggested areas for inclusion in RAM curricula

Required Skill and Knowledge	Frequency	Percentage
E-governance	14	74
Applying knowledge of the laws, regulations and governing authorities affecting RAM	11	58
E-records management	9	47
E-filing and online storage	7	37
Software packages and hardware combinations for RAM	6	32
Utilisation of computer technology and software applications to perform RAM activities	4	21
Conducting archival processing	3	16
Security standards and systems	2	11

Table 4 reveals that the most singled out was skills in e-governance (74%) followed by knowledge of the laws, regulations and governing authorities affecting RAM. All records managers indicated that their poor performance is due to difficulties in the RAM curriculum. The above references from the respondents revealed that graduates from RAM training institutions lack the professional competence required to deliver excellent services in records and archives management. This finding further enforces the view that records managers need support from RAM training institutions if they are to deliver an efficient and effective records support service throughout the public sector.

The study established that though a number of institutions were offering RAM education, their curricula was embedded in the Library and Information Science curricula. RAM gets only 3 contact hours a week in a semester of 15-17 weeks. One personnel officer stated that most of the RAM staff posted to his ministry had library training whereas RAM services cannot be compared to a library service. The following views were aired:

Most of the staff posted to the ministry have not trained to work with records and archives.
Ensuring the effectiveness and efficiency of records and archives management requires training in core registry areas which seems not the case with the new recruits.
Records and archives management laws and regulations exist on paper but can only be enforced if the training institutions address them.

Most of the personnel officers were of the view that merely increasing the number of RAM training institutions without offering appropriate skills was compromising the quality of the RAM services delivered in public offices. One of them stated that "individuals with no professional competency continue to be recruited to manage records and archives."

The following views emerged:

Uganda is in short supply of records and archives professionals in government ministries and departments who can ably augment policy issues, design and implement best practices for records and archives management.
The sector lacks professionals who are able to address the challenges posed by technology and RAM demands.
There is lack of professionals who can critique and evaluate the existing records and archives management systems in the public sector.

The personnel officers expressed that they were in search of records officers with ICT knowledge and skills to manage records and archives in both paper and electronic formats. The demand was for RAM personnel with modern skills and knowledge in e-records management, information systems; and RAM systems design and implementation. Indeed, the above findings confirm that RAM training institutions need to review their curricula. As noted by Okello-Obura and Kigongo-Bukenya (2011), none of the programmes offered by the training institutions in Uganda provided exhaustive coverage of RAM requirements.

FUTURE RESEARCH DIRECTIONS

Emerging from this chapter are issues related to the relationship between records legislation, national archives and RAM training institutions which are critical in the management of public records and archives. Owing to this situation, it would be necessary to find possible ways in which the linkages between these three institutions could be attained, hence improving the manner in which public records and archives are managed.

CONCLUSION AND RECOMMENDATIONS

This chapter has highlighted the various ways in which specific agencies have helped the RAM services to grow and develop. Records and archives are valuable resources of governments to support evidence-based decision-making, to meet operational and regulatory requirements, and to provide accountability. The literature supports the theory that records and archives management is supported by records legislation, national archive and RAM training institutions. Several agencies have been actively involved in the development of RAM in the UPS but the UPS still faces significant challenges and this has undermined any efforts to streamline records and archives management services. It was evident that the UNA was oblivious of its role of guiding records and archives management in the public bodies, and that archival legislation was not fully implemented. The other hindrance was that the RAM training institutions lacked coherent curricula to develop the required competencies in knowledge and skills to effectively and efficiently manage public records and archives in a contemporary public sector. As a result, the quality of records and archives services offered in the UPS leaves a lot to be desired. The following recommendations are proposed to improve the situation:

Review of the Existing Records Legislation

The GoU should take control of records legislation. Records legislation should be updated to put greater emphasis on recordkeeping standards as a crucial prerequisite for building an effective, integrated system for managing public records and archives. There is need for the GOU to review the legislation on a regular basis. Improvement in the existing legislation should provide for advances in technology to incorporate electronic records and outline how to deal with the disposal of both paper and electronic records.

Review of the Existing Structure of the UNA

The GoU should formally recognise and establish a lead institution to champion the management of public records and archives as required by law. Experience elsewhere has shown that an agency would lead the role in directing public RAM but this does not seem to be the case with the UNA. The UNA should be restructured to enable it to coordinate the activities of RAM in public agencies and eliminate duplication in their work. A Uganda Records Authority should be established. The agency should:

- Establish formal relationships with all the ministries;
- Be responsible for guiding the documentation of government actions in a transparent manner;

- Play a proactive role of developing regulations and, in coordination with ARM programmes, equip records and archives managers with the required knowledge and skills;
- Draft and implement retention and disposal schedules for both paper and electronic records, and transfer inactive records with ongoing value to secure storage and provide preservation facilities;
- Set up records and archives management curricula in line with international standards to ensure that public offices follow good practices; and
- Provide a clear records and archives management policy that supports national requirements for high-quality records and archives. The policy should define the government's approach to creating, managing and preserving records in all formats, along with their metadata. The policy should:
 - Clarify the means of determining which information and recorded communications should be defined as records and archives, and managed accordingly;
 - Define the roles and responsibilities involved in ensuring that reliable and useable records are created, managed and kept for as long as they are needed for business, accountability and historical purposes; and
 - Define requirements for compliance with the records law and establish responsibility for monitoring non-compliance.

Review RAM Training Institutions Curriculum

The existing knowledge and skills do not support RAM staff in delivering services to their full potential. Therefore, the RAM training institutions need to:

- Structure programmes and approaches to adequately tackle the needs of the workplace. They should structure their curricula according to the needs reflected in the framework of international records management standards and those of the country's updated legislation;
- Introduce ongoing professional development training for records managers and archivists in light of the advancing information technology. Meanwhile, those without qualification should be provided with training focused on specific skills;
- Work hand in hand with the public sector agencies to coordinate the process of identifying the competencies necessary to meet the performance expectations in records and archives management;
- Review curricula after every cohort so that the training and education remain relevant to the needs of the public sector; and
- Collaborate and harmonise the development of the curricula in such a way that guidelines are developed for curricula that stress the importance of research in RAM.

ACKNOWLEDGMENT

The author is grateful for the research grant received from the Fulbright fellowship which enabled this research study to be completed. The author is also grateful to the School of Information Science, University of Pittsburgh, USA, and to Professor Acker Amelia, who provided constructive comments on an early draft of this paper.

REFERENCES

Akita, A. (1979). *Development of the national archives and the national documentation centre: Report prepared for the Government of Uganda by the United Nations Educational Scientific and Cultural Organisation (UNESCO)*. UNESCO.

Aloufi, Z. (2007). The legacy: British mandate record management system in Israel. *Archival Science*, 7(3), 207–211. doi:10.1007/s10502-007-9048-4

Asogwa, B. E. (2012). The challenge of managing electronic records in developing countries: Implications for records managers in sub-Saharan Africa. *Records Management Journal*, 22(3), 198–211. doi:10.1108/09565691211283156

Brett, E. A. (1993). Voluntary agencies as development organisations: Theorizing the problem of efficiency and accountability. *Development and Change*, 24(2), 269–303. doi:10.1111/j.1467-7660.1993.tb00486.x

Carson, J. (2005). *Challenges and change in Uganda. Conference held on Uganda: An African 'success' past its prime*. Woodrow Wilson International Center for Scholars (WWICS). Retrieved January 14, 2017, from https://www.wilsoncenter.org/sites/default/files/Uganda2.pdf

Chaterera, F., Ngulube, P., & Rodrigues, A. (2014). Records survey in support of a framework for managing public records in Zimbabwe. *Information Development*, 30(4), 366–377. doi:10.1177/0266666913497611

Cushing, A. L. (2010). Career satisfaction of young archivists: A survey of professional working archivists, age 35 and under. *The American Archivist*, 73(2), 600–625. doi:10.17723/aarc.73.2.gh8330h51124j144

Decman, M., & Vintar, M. (2013). A possible solution for digital preservation of e-government: A centralised repository within a cloud computing framework. *Aslib Proceedings*, 65(4), 406–424. doi:10.1108/AP-05-2012-0049

Elkins, C. (2005). *Imperial reckoning: The untold story of Britain's gulag in Kenya*. New York: Macmillan.

Goh, E., Duranti, L., & Chu, S. (2012, August). Archival legislation for engendering trust in an increasingly networked electronic environment. *Proceedings of Climate Change: International Council on Archives Congress*. Retrieved March 3, 2017, from http://www.ica2012.com/files/data/Full%20papers%20upload/ica12Final00287.pdf

Government of British Columbia. (2015). *Recorded information management manual: RIM 102*. Retrieved March 14, 2017, from http://www.gov.bc.ca/citz/iao/records_mgmt/policy_standards/rim_manual/rim102.pdf

IGG. (2012). *Inspectorate of Government: report to Parliament, July – December 2011*. Kampala: IGG.

IGG. (2014). *Inspectorate of Government: report to Parliament, July–December 2013*. Kampala: IGG.

International Records Management Trust (IRMT). (2009). *Implementing electronic records management: Training in electronic records management*. Retrieved March 3, 2017, from http://www.irmt.org/documents/educ_training/termresources/IRMTRouteMapforImplementingElectronicRecordsManagement.pdf

IRMT. (2014). Fostering trust and transparency in governance (2006 to 2008). *IRMT Training in Electronic Records Management Proceedings*. Retrieved November 14, 2016, from http:// irmt.org/portfolio/ fostering-trust-transparency-governance-investigating-addressing-requirements-building-integrity-public-sector-information-systems-ict-environment-2006-2008

Jimerson, R. C. (2010). From the Pacific Northwest to the global information society: The changing nature of archival education. *Journal of Western Archives*, *1*(1), 1–23.

Katuu, S. (2009). Archives and records management education and training: What can Africa learn from Europe and North America? *Information Development*, *25*(2), 133–145. doi:10.1177/0266666909104714

Ketelaar, E. (2008). Exploration of the archived world: From De Vlamingh's plate to digital realities. *Archives and Manuscripts*, *36*(2), 13–33.

Kreimer, A. (2000). *Uganda post-conflict reconstruction: Country case study series*. Washington, DC: The World Bank. Retrieved January 14, 2017, from http://ieg.worldbank.org/Data/reports/uganda_post_conflict.pdf

Magara, E. (n.d.). *Building capacity for archives and dissemination of information in Uganda: A case of study of Uganda Broadcasting Corporation and Directorate of Information*. Retrieved March 14, 2017, from www.uneca.org/icadla1/docs/Thursday/Magara.ppt

Mazikana, P. (2007, June). A missed opportunity: Archival institutions and public sector reforms. *Proceedings of the XIX Bi-Annual East and Southern Africa Regional Branch of the International Council on Archives General Conference*.

McLeod, J., & Hare, C. (2006). *How to manage records in the e-environment* (2nd ed.). London: Routledge.

Mnjama, N. M. (2005). Archival landscape in Eastern and Southern Africa. *Library Management*, *26*(9), 457–470. doi:10.1108/01435120510631747

Nengomasha, C. T., & Chiware, E. (2009). *Report on the tracer study of the Department of Information and Communication Studies 2000-2007*. Windhoek: University of Namibia.

Ngoepe, M., & Masegonyana, K. S. (2011). An assessment of the state of national archival and records systems in the ESARBICA region: A South Africa-Botswana comparison. *Records Management Journal*, *21*(2), 145–160. doi:10.1108/09565691111152071

Ngoepe, M., & Ngulube, P. (2011). Assessing the extent to which the National Archives and Records Service of South Africa has fulfilled its mandate of taking the archives to the people. *Innovation: Journal of Appropriate Librarianship and Information Work in Southern Africa*, *42*, 3–22.

Ngoepe, M. S. (2014). Records management models in the public sector in South Africa: Is there a flicker of light at the end of the dark tunnel? *Information Development*, 1–16.

Ngulube, P. (2015). Trends in research methodological procedures used in knowledge management studies. *African Journal of Library Archives and Information Science*, *25*(2), 125–143.

Ngulube, P., & Tafor, V. F. (2006). The management of public records and archives in the member countries of ESARBICA. *Journal of the Society of Archivists*, *27*(1), 57–83. doi:10.1080/00039810600691288

Noko, P., & Ngulube, P. (2013). A vital feedback loop in educating and training archival professionals: A tracer study of records and archives management graduates in Zimbabwe. *Information Development, 31*(3), 270–283. doi:10.1177/0266666913510308

Okello-Obura, C. (2011). Records and archives legal and policy frameworks in Uganda. *Library Philosophy and Practice, 608*. Retrieved March 14, 2017, from http://digitalcommons.unl.edu/libphilprac/608

Okello-Obura, C., & Kigongo-Bukenya, I. M. N. (2011). Library and information science education and training in Uganda: Trends, challenges, and the way forward. *Education Research International, 2011*, 1–9. doi:10.1155/2011/705372

Schellenberg, T. R. (1968). Archival training in library schools. *The American Archivist, 31*(2), 55–66. doi:10.17723/aarc.31.2.g2k6132m5332737k

Shepherd, E. (2011). An 'academic' dilemma: The tale of archives and records management. *Journal of Librarianship and Information Science, 44*(3), 174–184. doi:10.1177/0961000611427067

Thurston, A. (1996). Records management in Africa: Old problems, dynamic new solutions. *Records Management Journal, 6*(3), 187–199. doi:10.1108/eb027096

Thurston, A., & Pugh, R. B. (1997). *Records of the Colonial Office, Dominions Office, Commonwealth Relations Office, and Commonwealth Office.* London: TSO, HMSO.

Tough, A. (2004). Records management standards and the good governance agenda in Commonwealth Africa. *Archives and Manuscripts, 32*(2), 142–161.

Uganda. (2001). *The National Records and Archives Act.* Kampala: UPPC.

Uganda, MoPS. (1998). *Draft for discussion: Extension of the computerised personnel management Information system, proposal for ODA assistance.* Kampala: MoPS.

Uganda, MoPS. (2005). *Public service reform programme strategic framework (2005/6-2009/10).* Kampala: MoPS.

Wallace, D. A. (2000). Survey of Archives and Records Management Graduate Students at Ten Universities in the United States and Canada. *The American Archivist, 63*(2), 284–300. doi:10.17723/aarc.63.2.72050g01j3v858j1

Wright, T. (2013). Information culture in a government organisation: Examining records management training and self-perceived competencies in compliance with a records management program. *Records Management Journal, 23*(1), 14–36. doi:10.1108/09565691311325004

Yakel, E. (2000). The future of the past: A survey of graduates of master's-level archival education programs in the United States. *The American Archivist, 63*(2), 301–321. doi:10.17723/aarc.63.2.p8843508857g69v5

Yakel, E., & Jeanette, A. B. (2006). A*CENSUS: Report on graduate archival education. *The American Archivist, 69*(2), 349–366.

KEY TERMS AND DEFINITIONS

National Archives: The institution set up by law to guide the creation and keeping of government records.

Public Records and Archives: Recorded information in fulfilment of government business.

Public Sector: All agencies employing government staff.

Records and Archives Legislation: The law that governs the creating and keeping of government records throughout their lifetime.

Records and Archives Training Institutions: Institutions with a curriculum geared towards teaching how to manage records and archives.

Uganda: A country in Africa which lies astride the equator.

ENDNOTE

[1] Those with a Science background take courses from the Science faculties, while those from Arts take courses from either the Faculty of Arts or the Faculty of Social Sciences.

APPENDIX 1

Bachelor of Records and Archives Programme: Makerere University Undergraduate

Table 5.

Semester	Course Name	Credit
1.	Principles of Records and Archives Management	3
	Organisation and Office Systems	3
	Palaeography and Oral History Management	3
	Supplies and Materials Management	3
	Information Technology I	4
	Communication Skills and Practice	3
2.	Papermaking and Reprography	3
	Audio-visual Records Management	3
	Classification and Cataloguing	4
	Applied Organisational Psychology	3
	Government Information Resources and Systems	3
	Information Technology II	4
3.	Information and Documentation Services	3
	Ethics in Records and Archives Management	3
	Records Processing and Organisation	3
	Database Management Systems	4
	Desktop Publishing and Editing	4
	Research Methods	3
4.	Management Principles and Practices	3
	Analysis of Records Management Systems	3
	Health Records Management	3
	Archives Administration	3
	Records Storage and Security	3
	Research Data Analysis	3
	Field Attachment	5
5.	Project Planning and Management	3
	Management of Business Records	3
	Preservation and Conservation	3
	Automation of Records Management Systems	4
	Website Development and Internet Technology	4
6.	Management of Museums	3
	Managing of Records and Archives Institutions	3
	Management of Electronic Records	4
	Records Management and the Law	3
	Project	6

Source: EASLIS Curriculum, 2009

APPENDIX 2

Bachelor of Library and Information Science:
Makerere University Undergraduate

Table 6. Semester Four

Code	Course Name	CU
BLS2207	Documentation Work and Service	3
BLS2211	Classification II	4
BLS2212	Cataloguing II	4
BLS2208	Database Management and Information Retrieval	4
BLS3117	Publication Design and Production	3
	Plus at least 1 course from other faculties amounting to a minimum of 3 Credit Units1	3

Table 7a. Recess Semester

Code	Course Name	CU
BLS2301	Field Attachment	5

Table 7b. Semester Five

Code	Course Name	CU
BLS3122	Web Document Management	4
BLS3123	Research Methods	4
BLS3124	Multimedia Librarianship	3
BLS3113	Management of Information Institutions and Resources	3
BLS3116	Preservation and Conservation	3
BLS3125	Automation of Library and Information Systems	4

Table 8. Semester Six

Code	Course Name	CU
BLS1112	Communication Skills and Practice	3
BLS3220	Community and Specialised Information Systems	3
BLS3221	Management of Electronic Resources	4
BLS3222	Legal, Policy and Information Ethics	3
BLS3223	Information Entrepreneurship	3
BLS3224	Project	5

Source: EASLIS Curriculum, 2010 APPENDIX 3

Diploma in Records and Archives Programme: Makerere University Undergraduate

Table 9. Semester One

Code	Course Name	CU
DRA 1101	Foundations of Records Management	4
DRA 1103	Information Technology	4
DRA 1106	Foundations of Knowledge Management	4
DRA 1107	Office Organisation and Management	4

Table 10. Semester Two

Code	Course Name	CU
DRA 1105	Records Processing and Organisation	4
DRA 1205	Documentation Work and Information Service	4
DRA 1206	Information Technology in Records Management	4
DRA 2101	Stores and Materials Management	4

Table 11. Semester Three

Code	Course Name	CU
DRA 1104	Oral History and Palaeography	4
DRA 1204	Archives Management	4
DRA 2106	Basics of Financial Management	4
DRA 2202	Museology	4

Table 12. Semester Four

Code	Course Name	CU
DRA 1203	Legal and Policy Aspects of Records Work	4
DRA 2102	Preservation and Conservation	4
DRA 2206	Project Planning and Management	4
DRA 2207	Communication Skills	4

Table 13. Recess Term

Code	Course Name	CU
DRA 2208	Field Attachment	5

Source: EASLIS Curriculum, 2009 APPENDIX 4

Diploma in Library and Information Science: Makerere University Undergraduate

Table 14. Semester One

Code	Course Name	CU
DLS 1106	Libraries in their Social Setting	4
DLS 1102	Classification: Theory and Practice I	4
DLS 1103	Cataloguing: Theory and Practice I	4
DLS 2104	Information Technology I	4
DLS 1107	Basic Accounts	

Table 15. Semester Two

Code	Course Name	CU
DLS 1201	Management and Administration of Libraries and Information Institutions	4
DLS 1202	Classification: Theory and Practice II	4
DLS 1203	Cataloguing: Theory and Practice II	4
DLS 2201	Information Technology II	4
DLS 1206	Communication Skills	

Table 16. Semester Three

Code	Course Name	CU
DLS 2203	Community Information Services	4
DLS 2106	Specialised Information Services	4
DLS 2103	Records Management and Archival Administration	4
DLS 1104	Marketing of Information Services	4
DLS 2105	School Library Studies	

Table 17. Semester Four

Code	Course Name	CU
DLS 2206	Database Management	4
DLS 2207	Publishing and Book Trade	4
DLS 1204	Bibliographic Control	4
DLS 2207	Internship	4

Table 18. Recess Term

Code	Course Name	CU
DRA 2208	Field Attachment	5

Source: EASLIS Curriculum, 2009

Section 2

Chapter 15
Some Economics of Conservation of Cultural Heritage:
The Key Questions

Marilena Vecco
Université Bourgogne Franche-Comté, France

ABSTRACT

This chapter contributes to theoretical debates in the study of the economics of cultural heritage conservation. In particular, it deals with the economic analysis, the effects, and the normative aspects of decision making on the preservation of artistic and historical heritage. The different concepts of conservation (re-use, restoration, preservation) are discussed from an economic and historical perspective. A formalised model is presented to ground the analysis. The most relevant dilemmas characterising the issue are studied on this basis. The impossibility of deriving optimum solutions from the market is argued together with the arbitrariness of all non-market decisions on this subject. The rejection of the current definition of conservation as "preservation" on economic grounds is therefore suggested, given its pure ideological nature.

INTRODUCTION

Il faut se garder de deux extrêmes (mortels s'ils sont exclusifs): la conservation (embaumement, sans valeur d'usage), la vulgarisation (forme de cannibalisme virtuel et collectif). F. Mosser (1994, p. 24)[1]

This chapter contributes to theoretical debates in the study of the economics of cultural heritage conservation. In particular, it deals with the economic analysis, the effects and the normative aspects of decision-making on the preservation of artistic and historical heritage. The different concepts of conservation (re-use, restoration, preservation) are discussed from an economic and historical perspective (for a more extensive discussion see Vecco (2005; 2007). A formalised model is presented to ground the analysis.

DOI: 10.4018/978-1-5225-3137-1.ch015

The most relevant dilemmas characterising the issue are studied on this basis. Specifically, the focus is on the economic analysis of decisions regarding the conservation of artistic and historical heritage, in particular, in the context of heritage situations where conservation objectives may compete with other market interests and more valuable options of utilising the cultural heritage. The author argues that to be sustainable in the medium- and long-term, this economic analysis must be integrated within the heritage conservation discourse and narratives, and answer these logical questions:

- Why preserve?
- What and for whom?
- For how long?
- What are the different meanings of preservation?

This chapter is organised as follows. A review of the reasons for conserving 'everything' is proposed. Next, a short history of preservation is presented to contextualise the topic. Section 3 introduces the different concepts that make up conservation (re-use, restoration, preservation) and discusses these from an economic and historical perspective. This serves a discussion on the dilemmas embedded in the conservation process and their social and economic implications. The two final sections present future research directions and finish with final conclusions.

WHY PRESERVE?

To preserve a good for artistic/cultural reasons requires that it can be initially identified as being artistically/culturally qualified. This means adding an information value stemming from its interpretation as art or culture, which can be included in the production function based on the good itself. Its inclusion can be represented by lowering the marginal cost function to qualify the supply aesthetically. This does not mean that an artistic/cultural item is less expensive than a non-artistic/cultural one; it simply means that his producer (the artist) benefits from its creation more than from the production of a non-cultural work. There is more value for the same price, meaning that the same quantity has a lower cost. This gives an immediate economic reason for preserving aesthetic/cultural stock, because preservation results, *ceteris paribus*, in an expansion of welfare (Figure 1, area *KML*). Of course, as preservation has a cost (direct and indirect, including the cost of the 'certification' of the stock to be preserved), its expansive effect will be at least partially absorbed in the long-run (*LRMc*) in Figure 1). Therefore, if $q_r > q_o$, the preservation will be beneficial, otherwise it will not. The so-called 'dying-arts' problem leads, however, to some complications. In this case, the decision to preserve allows the continuing existence of the stock, while the opposite (no preservation) would suggest, in the long run, no stock. As some stock is usually always better than no stock, this could result in an absurd decision to 'preserve everything'. As resources afforded to preservation are scarce, this is an unsatisfactory solution. The author then needs to introduce a further element for economic calculation into our decision.

Figure 1. Marginal costs of preservation of cultural heritage
Source: own elaboration.

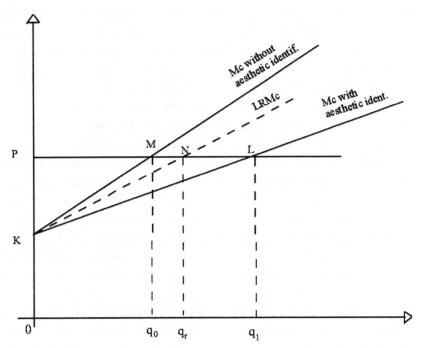

WHAT TO PRESERVE: THE REASON FOR PRESERVING EVERYTHING

'Preserving everything' (Peacock, 1994; Mossetto & Vecco, 2001; Vecco, 2005, 2007, 2010) is a characteristic of many contemporary preservation policies. Besides the trivial truism that something is better than nothing, there are also economic reasons for this approach. The first and perhaps most important, is the preservers' strategy of maximising their field of intervention. The larger the domain to be preserved, the larger the transfer from consumers. The more extensive the definition of the stock to be preserved as an 'aesthetic' or 'cultural' asset, the larger the monopolistic power of 'preservation' of the cultural establishment. This reason is relevant for both past and present considerations of the problem, while the 'urgency for preservation' is more typical of contemporary practice, stemming from the twentieth century.

In the eighteenth century, the ruins of ancient Rome were contemplated without any concern about how to preserve them. Papal Rome transformed Teatro Marcello into a prince's palace and swallowed up Pompey's theatre in a slum in a sixteenth century version of real-estate speculation. Renaissance towns were built over their medieval forerunners and were in turn devoured by Baroque construction, and successively demolished by twentieth century 'vanguards'. Only communist regimes prevented Prague and Kraków from suffering a similar evolution to Paris, London and Rome. That said, Prague is a unique and fascinating open air museum precisely because of the huge transformations it underwent further back in time. Nobody, however, is shocked by that. Why then should the residents of Paris scream against the

destruction of the 'Marché aux Halles', or the Romans strongly defend Vittorio Emanuele II's Memorial, both being rather modest examples of questionable architecture? Two economic answers can be given: either nineteenth century cultural production seems more important in terms of quality and quantity to our contemporaries than it did to the decision-makers of the past; or the net destruction rate of the culture of the past has been increasing. Both arguments are historically grounded. Benedictine monks copied Classical works to preserve them, but, at the same time, they built great Gothic cathedrals with a concern for permanence shared only by the great architects of the past.

It can be argued that contemporary re-examination of the cultural themes of the past is not linked to any permanent innovation. This is not because any innovation is present, but rather because innovation is a permanent rule in the arts. The 'vanguard' is now the 'post-vanguard' of the 'vanguard', as its output is expressly and conceptually intended to be consumed and destroyed. Modern and contemporary art is conceptual and, as such, structurally ephemeral. If on the one hand, technology makes preservation more possible, on the other, it is also responsible for the increased destruction rate in art and culture. Conserving a movie is different from conserving a literary work. Modern and contemporary art is multimedia and, therefore, technologically ephemeral. Economic growth has supplied several good arguments for the urgency of preservation, too. Industrialisation has created an unprecedented increase in negative externalities, with destructive effects on both environmental and artistic resources. For example, water pollution in the Venetian lagoon has also had unprecedented negative effects on its artistic/cultural heritage.

On the other hand, economic growth, with the related expansion of the market, has caused a decline in quality due both to economic reasons (an ugly thing is often cheaper than a beautiful one) and to the above-mentioned strategic behaviour of certifiers. All the arguments discussed, however, besides the latter, refer to contemporary art and not to the art of the past. From that point of view, the chief difference between us and a citizen in the sixteenth century is the level of pollution and its effects on the artistic heritage. While this is a good reason to intensify preservation initiatives, it does not justify blanket preservation, blocking any transformation of heritage. Contemporary attitudes to freezing the past are likely to result from a negative judgement of contemporary artistic and cultural production. If culture is a different way of using the same resources, it is evident that our contemporaries' opinion of their own practices is worse than that of their grandparents. Why should the re-use or reconstruction of the Venice Arsenal give aesthetically worse results than sixteenth century restoration?

The truth is that this negative judgement is mainly grounded on negative empirical administrative evidence. What is particularly striking is the decision-making attitude of those who 'interpret' heritage in order to preserve it. Why should sixteenth century Venetian public officials be judged to make worse better decisions than their contemporary successors? As well as all ideological arguments, there is also an economic reason for this. Compared to decision makers of the past, the decisions of contemporary certifiers are worse because they are rarely financially liable for the consequences. *Ceteris paribus*, that is assuming for decision-makers of all times the same level of interpretation and social welfare maximization capability, contemporaries subjectively decide on the heritage they perceive as being a public good, while decision-makers in the past mainly owned it personally or as a part of a collectively-shared wealth, the accumulation and maintenance of which they paid for. A bureaucratic behaviour may be developed on these grounds, aimed at non-Pareto optimum solutions for society. This has nothing to do with the aesthetic process, which therefore cannot be considered a reason for 'heritage freezing' in itself. Preservation decisions go through an interpretation process which helps to define aesthetic priorities but removes their significance due to economic and political influence. This can lead to the refusal of the present as well as of the past. 'What to preserve?' is a question that must be analysed on this basis.

PRESERVATION IN HISTORY OR SOME HISTORY OF PRESERVATION

Any economic treatment of the process of preserving the cultural and artistic heritage of the past and of the related decision-making processes must start from a very accurate definition of preservation itself. This is not because of the usual fussy economists' attitude towards definitions but because the subject risks otherwise being strongly undetermined. The meaning of conservation has been changing over time and its current cultural and technical significance is substantially different from that of the Middle Ages or even of the eighteenth century. The ancient way of thinking about conservation is linked with the effective re-use of the good to be conserved: *reficere* in Latin. The head of a statue of the Roman Empress Livia used in the eleventh century as the face of Christ in the Herimankreuz, conserved in Cologne, is a good example of this approach which originated in pre-Medieval times and prevailed throughout Europe until the late seventeenth century. The re-make of ancient paintings (*ridipintura*) as regards their iconographic content but also with relevant contemporary integrations, is the rule followed in many famous cases like Ambrogio Lorenzetti's Buongoverno and Simone Martini's Guidoriccio da Fogliano fourteenth century 'rifacimenti' in Siena (Conti, 1998) Restoration in the sense of restoring original works of art to their previous state belongs to the seventeenth century, the first relevant case probably being that of the 'pubbliche pitture' in Palazzo Ducale in Venice, by Giambattista Rossi, Sebastiano Ricci, and later on, Pietro Edwards, the first of the great restorers of our times (Conti, 1998). It was only during the nineteenth century, however, that the current conservative goals grounding our concept of preservation were progressively adopted by states like France, aiming effectively to preserve the heritage of the past in its integrity, mainly for educational purposes (as was demonstrated by the founding of the Louvre (Conti, 1998)). The philological unearthing of the past and the extension of the domain to be protected to all existing heritage, which characterises present practice, dates only from the late nineteenth century (Jokihleto, 1999).

DIFFERENT ECONOMIC MEANINGS OF CONSERVATION

These different definitions of conservation have different economic consequences not only for the utilisation of the good they refer to but, more generally, for the way in which the value of the good is determined, and therefore for the answer to the crucial questions raised by any conservation process: what to preserve, at what price, for whom?

Reficere

Starting from one old approach (Hale, 1978; Gold, 1975) (and extending it with many modifications), taking the perspective of conservation as the re-make or re-use of a pre-existing resource leads to a definition of the value of the conserved good, such as

$$Vn - Cn = Vo + Do \tag{1}$$

where

Vn = market value of the good in the new use,

Cn = production cost of the new use,
Vo = market value of the good in the previous destination,
Do = destruction cost of the previous destination.

This equivalence also helps illustrate the rationale of any conservation choice under the above-mentioned definition, as the conservation process will only take place if its first term is greater than the second. No social cost is relevant here, and the distribution of the decision-making rights on the good is irrelevant, too, as the market takes care of defining optimum solutions efficiently (as far as it is able to do so for any other private good).

Restaurare

Let us then think of conservation in modern terms as *restaurare*. No destruction of the work is included in this definition, while it is still regarded as strictly private in the economic sense, as far as its excludability and rivalry of consumption are concerned. In this case, other consumers are not indifferent to the existence or inexistence of the original good as they were in the former model where its destruction was decided simply on a market price bases. While the previous concept excluded any external positive effect caused by the existence of the original good, this one includes specifically an excludable externality. The market price will thus include its value and no free-riding will be possible; that is, it will be the case of a willingness-to-pay-based optimum solution. In ancient Venice, the cost of restoring the paintings in Palazzo Ducale was shared by those who benefited from it (the members of the noble families who met there, held ceremonies and received ambassadors to develop Venetian trade and economic influence were also the main tax-payers of the Republic). More generally, the Maecenas of those times were essentially interested in the enhancement of their economic or political image deriving from the investment in art or its restoration. Restoration could be seen an investment, with its own costs and returns. In this case, therefore, the value of the restored good may be defined as:

$$Vn - Cn \geq Vo \tag{2}$$

where

Vn = market value of the restored good (including its external excludable effect),
Cn = cost of restoration,
Vo = market value of the good before restoration (including its external excludable effect).

The market does, in principle, assure the social optimum in this case, too.

Preservation

The economic significance of this last definition of conservation is somewhat different. The way in which the good is economically conceived has changed. It is no longer a strictly private good. It becomes a semi-public one, whose nature is affected by partial non-excludability and non-rivalry of consumption. Public interest comes into account together with the information asymmetry typical of artistic goods, causing strategic anomalies like free-riding consumer behaviour and information-based rent-seeking.

The appreciation of the artistic quality of a good is conditioned by the ability of the producer to 'create' or of the consumer to 'interpret' it, attributes not distributed homogeneously among the agents. A specific case of market failure can occur when one of them (the supplier/demander) is endowed with it, while the other (the demander/supplier) is not (see Mossetto, 1992 for art market asymmetry). Someone certifying the good as 'artistic' (critics, art historians, merchants, etc.) is needed to determine social optima in the market (as well as out of it). The value of the preserved good, under these assumptions, is therefore the following:

$$Vn - Cn + An \geq Vo + Ao \tag{3}$$

where all other things being equal to expression (2),

An = historical-aesthetic value of the good after preservation,
Ao = historical-aesthetic value of the good before preservation.

Social costs are relevant here as is the distribution of decision-making rights, as they are determinant in defining the value of An and Ao. The market does not supply optimum solutions by itself.

PRESERVATION AND ITS ECONOMIC DILEMMAS

La conservation patrimoniale se charge du dépôt des souvenirs et nous délivre du poids des responsabilités infligées à la mémoire.[2] *(H-P. Jeudy, 2001, p. 24).*

When dealing with the conservation process, one inevitably comes up against some restrictive dilemmas, very often making the actual conservation intervention problematic. Any individual or collective preservation decision under the last mentioned definition is therefore subject to the evaluation of the elements included in the two terms of (3). Let us assume that the market takes care of determining Vn, Cn, and Vo efficiently, for the reasons listed above. The discussion is limited (but not made any easier) to the definition of An and Ao. Any A-like value is defined by taking into account the above-mentioned semi-public and information-asymmetrical nature of the market of the good. The need for non-market decision-making-choice optimization is caused by this. The qualification of the value of the good being historical, too, means that non-market decisions are further characterised by the historical features of the jurisdiction, including the preferences of the individuals belonging to it and the distribution of decision rights among them.

SOME ANALYTICAL REPRESENTATIONS

The problem is easiest to solve if $Ao = 0$ and $Vn - Cn \geq Vo$ is imposed. In this case, the decision to preserve will be taken if $An > 0$. Preservation, in other words, means attributing an aesthetic/historical additional value to a given good - to be here assumed for simplicity as homogeneous in all its quantities q - which results in an increase of social welfare. Defining the supply of the preserved good by Mc (Figure 2) and its demand by D, the decision to preserve it can be represented by the shift of the supply

to *Mc'*, as its marginal cost decreases with the increase of its value for the producer (the preserver), as *An>0* and *Ao = 0*. The preserved good increases its value for the preserver because he recognizes it ('interprets' it) as being artistic or historical and therefore worthy of preservation. This leads to a Pareto optimum *L (q1, P)* which is socially preferred to *M (qo, P)* because the social welfare net surplus there is increased by the area *KLM>0*.

If the preservation cost is included, the supply/cost function goes to *Mc* and the net social benefit of the operation is reduced, the social optimum being *N (q2, P)*. It will in any case be beneficial as far as *KNP>KMP* (this conclusion holding also for any case of less elastic demand curves).

This simple case, unfortunately, has to be complicated by some relevant additional qualifications, arising from the nature of the preserved good as illustrated above. The first complication comes from the uncertainty characterising the output of the preservation process and from the ignorance regarding its external effects, which risk leaving the social welfare outcome of the operation (that is, the area *KLM*) undetermined. In other words, the answer to the question: 'Does preservation effectively raise the value of the good?', cannot be given on market-price bases because:

a. The size of the value increase is not only a matter of the 'interpretation' of the preserver but also of that of the consumer of the preserved good. Preservation consists in a formal statement (certification) of the social (artistic/historical) value of the good to be preserved. This can be made by the producer (preserver), by the consumer or by someone who is generally not its final consumer but who is delegated by him to 'interpret' the artistic/historical value of the good (art merchants, art historians and academics, critics, public officers and administrators, etc.). The consumer, however, may not be able to 'interpret' the rationale of preservation and a mismatch between him and the preserver may occur. Moreover, delegated testifiers may act strategically.

Figure 2. Preservation costs
Source: own elaboration.

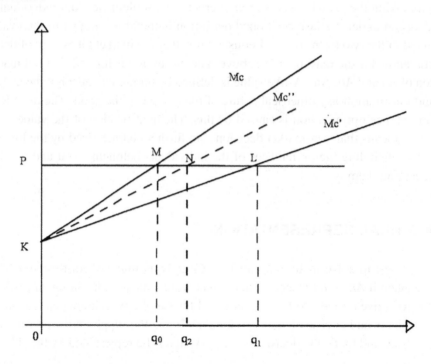

What if they act in order to maximise profit rather than social welfare or if they certify as artistic something which is not (Mossetto, 1992)? The output of the preservation process will be undersized in the former case and oversized in the latter. An undue limitation of the quantity certified as 'artistic', and therefore to be preserved, may result from the monopolistic attitude of the 'informed' agent (the one who is able to 'interpret') to maximise his surplus. An excessive expansion of the preservation activity may be the outcome of the certifier's revenue-maximising strategy.

b. The value increase is subject to non-excludability. This is the case where the external positive effect coming from the existence of the preserved good is completely non-excludable (the opposite to that theorised under the concept of 'restoration' discussed above where the external effect is completely excludable). Here the market failure is the usual one connected with this public-good feature (Figure 3).

These cases can be analysed following the approach in Figure 3, where the value increase due to preservation is represented from the point of view of its consumer through an increase in the demand function (from D to D'). The modification of the supply (from Mc to Mc'') is here due only to the cost of preservation, the additional benefit coming to the producer from his choice being assumed equal to zero to simplify the model, excluding the mismatch between producer and consumer caused by the information asymmetry between them. In other words, following equivalence (3), we consider

$$An = (P'-P)\,q$$

and

Figure 3. Market failure in presence of cultural heritage preservation
Source: own elaboration.

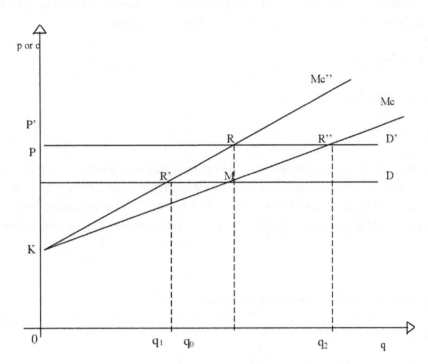

$$Cn = (Mc'' - Mc)\, q$$

The decision to preserve the good moves the optimum from *M* to *R*. It has therefore to be taken following

$$KMP < KRP'$$

This condition can be easily studied if we assume the quantity of the given good as constant (in *M* and *R*) while its value varies. This assumption represents the way in which the mentioned effects of non-excludability and information asymmetry work. In their presence, price or cost vary independently from the variation of quantity.

In this case, $KMP < KRP'$ is always true if, the system being in equilibrium, $P' = Mc'$, $P'>P$, that is if there is an increase in the value of the good caused by its preservation.[3] The measurement of P', however, is crucial, even if one considers *P* as being determined by the market (and equal to *Mc*), and therefore in the absence of any external effect deriving from the existence of the good before preservation ($Ao = 0$, in (3)), and even excluding for simplicity any other value variation depending on the operation ($Vn = Vo$).

$R(q, P')$ depends not only on *Mc'* which is here determined because one assumed its coincidence with the preservation cost function which is technically determined, but also on the shift of the demand function upright in its quadrant, the market determination of which is more critical. This is due to the evaluation of the external effect arising from the preservation decision (which is non-excludable) and from the outcome of the asymmetry of information between the producer (who knows the effective value of the preserved good) and the consumer (who does not).

All this can lead to *R'*, where the consumer is unaware of the value of the preserved good, or to *R*, where he is not willing to pay the price for the non-excludable externality (or where he is unaware of it). The former solution under-evaluates the social output. The latter over-evaluates it. In other words, coming back to point (3) discussed above, as it can also be written as

$$(Vn - Vo) + (An - Ao) \geq Cn \tag{4}$$

when $Ao = 0$, and $Vn = Vo$,

$$An = Cn \tag{4'}$$

the basic condition of any preservation decision being the difference between the cost of preservation, which is determined on a market basis, and the historic/artistic value of the preserved good, which is not. Rational decision-makers are biased by this. The heritage to be preserved being a stock and its preservation cost an additional investment to it, its rate of return results remain undetermined, too, being:

$$rc = An/Cn$$

More generally the rate of return, in instant terms, is

$$rp = \Delta V + \Delta A/\Delta C$$

or, for returns during a period from time 0 to time n,

$$rp = t(\Delta V + \Delta A)/\Delta C \qquad\qquad\qquad (5)$$

where t = rate of discount from time 0 to time n.

This analytical presentation can be used to discuss the economic dilemmas to be faced by a rational decision-maker willing to ground his preservation decisions on an economic basis.

THE DYING-ARTS DILEMMA

The economic capacity of conservation decreases with an increase in conservation commitment, owing to the growing scarcity of the resources destined for conservation. This assumption is linked to the conceptual changes of the word conservation: conservation as re-use, 're-doing' (*reficere*), restoration and philological preservation. These diverse meanings emphasise the importance given to the weight of historical and artistic judgement in the field of deciding on the quantification in economic terms of the conservation intervention, whilst also increasing the marginal cost of the actual conservation. The current period stands out from all earlier ones with its sort of 'obsession' with cultural conservation (Buchanan, 1975)[4], going beyond the mere and justified worry with conserving the cultural heritage that has accumulated in the history of mankind. Furthermore, one must also remember that during the twentieth century, heritage that was made subject to protection, and therefore the total cost of conservation expanded as much as the park of cultural heritage to preserve. This situation was the result of three different elements. First of all, the extensive use of the conceptual definition of the term 'culture' (up to that of 'material culture'); a re-definition of the temporal obligation establishing when one can carry out conservation (the tendency being that of conserving anything that is older than fifty, while in the past the obligation was at a hundred); finally, an explosion of manufactured products during this century, which is considerable when compared to centuries past.

The first dilemma to be considered comes from the so called 'dying-art problem' (Peacock, 1991). How can one judge the opportunity cost of investing resources in preservation of an art form which is otherwise bound to die, the issue being not only the available quantity of the resource but its survival?

This question can apparently be answered by referring to the standard solution of optimal pricing of exhaustible environmental resources, this being a 'pure depletion prototype' à la Baumol (Baumol & Oates, 1988), where the resource is bound to run out completely within a defined period of time. More specifically, the case of heritage preservation is apparently a case of complete depletion of a good endowed with absolute non-substitutability. When a type of art is dead, it is dead and cannot be replaced by means of some technical innovation. As resources are scarce, how can one decide on which art will die and which has to survive?

In the usual presentation of the dying-art problem, the effective ability of the consumer/investor to judge the optimum level of cultural consumption/accumulation in the presence of his cultural ignorance is questioned. It is suggested that this is due to his ignorance being the cause of his need for cultural accumulation. The dilemma can be found in Mill's well-known question: "How can the uncultivated be competent judges of cultivation?" (Mills, 1848). Art, like education, has to be considered a 'merit-good' for which preferences are distorted by a generalised 'veil of ignorance'. The author's argument is different. Current market price cannot be a rational basis for the calculation because of the market-failure caused by

the asymmetrical nature of art information and by the non-excludability of the external effect generated by the existence of the heritage. The result is, in any case, the same: the impossibility of grounding the choice of preservation on the market. The standard market solution provided by environmental analysis, therefore, does not hold. The possibility of a market determination of price being critical, Baumol's standard optimal pricing rule on *1,..., n* periods (Baumol & Oates, 1988, p. 147):

$$p1 = p2 = = pn$$

(in real terms), cannot be practised. No optimum p can be set, no correspondence being verified between market prices and preferences of the kind assumed by Baumol and Oates in their pure depletion model

$$Cjpxt = u^j xt = du^j/dxjt \ (cj \ \text{being a constant})$$

The market price does not reflect the social cost of depletion, because it does not reflect the social value of the good. Going back to (4) the market price fails in evaluating *An*.

THE "FUTURE GENERATIONS" DILEMMA

Considered as the maximisation of the choice capacities of future generations, conservation involves minimising the consumption choices of present generations, an impasse that can be put down to the intergenerational scarcity of resources. The slogan of this approach could be Jacques Duhamel's formula: "Mieux vaut mille monuments pour cinquante ans que cinquante monuments pour mille ans"[5] (Duhamel, 1973, p. 52). Contemporary conservation policies are founded on protecting the interests of those who today are unable to decide whether they should be able to enjoy cultural heritage produced in the previous centuries in the future or not. Without knowing the preferences of the future generations, the tendency is to conserve the entire heritage of the past so that the future offers the greatest choice possible.

This is an extension of the conservation principle devised by Krutilla and Fisher (1985) in reference to environmental assets: although there is no actual demand, society is required to attempt to foresee the needs of future generations. The principle of sustainable development - or the principle of constant capital - foresees the adoption of a specific position regarding the equity of the transfer of goods between people over time. The ethical reasoning is that future generations have the right to a heritage that guarantees them a level of well-being that is no less than that of the present generation. An intergenerational social contract is required that is founded on the premise of 'justice as an opportunity', guaranteeing the same opportunities in the future that are available in the present.

This reasoning can only stand if one assumes that the conservation of cultural heritage is a value that is felt by all generations and does not change over time. Likewise, in conditions of uncertainty, the present generation's decision between conservation and the other uses of cultural heritage are less important than the possibility of the option transmitted to future generations. If these two suppositions are removed, conservation could paradoxically be a cost for the current generation that sacrifices alternative uses of public resources, as it deems preferable, without producing the expected benefits for future generations.

The principle of intra-generational equity has been discussed in terms of the influence of public policy (Baer & Snickars, 2001), economic valuation of heritage (Throsby, 2002) and sustainability (Cassar,

2003). Throsby defines it as follows: "The intra-generational equity dilemma is a classic inter-temporal allocation problem - that is, a choice between present and future consumption" (Throsby, 2002, p. 104). Both present and future consumption entail costs with respect to preservation and maintenance, but is it possible to define the first or second best option within this scenario? The point is to decide how far the principle of intra-generational equity and its authority should be applied, and what the impact is on the present generation. As Taylor (2013) points out, the problem that arises in any intra-generational consideration is whether and to what extent an action or resource will be valued in the future. Is it possible to understand the needs of future generations that are not concurrent with our own? And should we accept that intergenerational equity should be limited by the intra-generational one?

There is one more matter to deal with: how important is cultural heritage compared to the satisfaction of a society's basic needs, or compared to any financial operation on this heritage? What could the substitution terms of an investment between the protection and destruction of heritage be?

It is rational that an individual tends to prefer well-being in the present over the future, but it might prove unequal on the basis of the principle of equal treatment that imposes an "agent-neutral behaviour" that is impartial towards the diverse figures who benefit. In a cooperative scheme, nobody has the right to act so that they themselves are advantaged, whilst damaging others: "The futures of our selves are something similar to those of future generations. We can damage their destiny and as they do not yet exist, they are unable to defend themselves. Just like the future generations, the futures of ourselves have no right to vote and their future interests need to be protected" (Parfit, 1984, p. 45). Intergenerational and intra-generational equity must be established:

[...] the intergenerational equity principle requires the interests of future generations in the project outcomes to be acknowledged. This might be pursued in several different ways. In quantitative terms, respect for intergenerational concerns might suggest adoption of a lower discount rate than might be otherwise accepted on time-preference or opportunity-cost grounds in the process of reducing both economic and cultural benefits streams to present value terms. In qualitative terms, the issue of fairness itself should be explicitly considered in terms of the ethical or moral dimensions of taking account of the likely effect of the project on future generations. [...], the principle of intra-generational equity would recognize the welfare effects of the heritage project on the present generation. Consideration might be given to the distributional impacts of the capital costs of the investment project under study, to identify whether any regressive effects might be present. (Throsby, 2001, p. 87)

According to Jonas, one must not only consider the immediate consequences of our actions, but also the more distant ones, taking into account the irreversibility of acts, behaviour and ecological practices:

But the new imperative states that yes we can put our lives in danger but not that of humanity; [...] but that we do not have the right to choose or even risk the non-being of future generations in view of the being of the ones present now. (Jonas, 1985, p. 17)

People must be guided by an ethical responsibility to "leave future generations a legacy of a land that is fit for humans to live in and not change the biological conditions of humanity; without this supposition, the generations would not be assuming their own responsibility".[6] This results in a pragmatic version of Kant's imperative:

Act in such a way that the consequences of your action are compatible with the permanence of authentic human life on earth, [...], act in such a way that the consequences of your action do not destroy the future possibility of such life; [...] include man's future integrity in your current choice as an object of your desire. (Jonas, 1985, p. 17)

According to Robinson, the broader protection of heritage has an economic yield known as the 'recompense of waiting' or the 'recompense of abstinence' (Robinson, 1959, 1969). Rather than spending or consuming and therefore destroying cultural heritage, its owner (whether public or private) decides to conserve it. This offers the possibility of a very high yield linked to a real estate or financial project. Since cultural heritage is a scarce resource that does not meet a growing demand, an appropriate way to use it must be found.

A second complication can be added to the general scheme presented above. Until now the argument has dealt with current consumers/investors; new agents can now be introduced, that is, future generations and so-called optional consumers. Let us discuss the two separately, beginning with the former. The usual argument is that the current decision-maker has to take into account not only his present interest but also that of those consumers who are not in the market as they have not yet been born, or who cannot, as yet, express their demand. Some better qualification of this argument is probably needed. The traditional presentation of the issue is limited to the statement of the relative failure of the market to represent the preferences of those as yet unborn, either because they are not there or because the price fails to express a proper discount rate on the ordinary bases of ignorance and uncertainty. Current wear and tear are not taken into account.

Environmental theory, on the contrary, underlines the relevance of wear and tear in optimising the system. This can help towards a better understanding of this specific market failure. Wear and tear results from the present usage of a good instead its preservation for future consumption. The more it is consumed now, the less is left for future consumers. "What is involvedis not really an externality but rather a redistribution of the available stock of resources" (Baumol & Oats, 1988, p. 150). To state the market capacity of allocating optimally the given resources over time means, therefore, that the current price has to include this redistribution opportunity component. Consequently, it has to exceed the current marginal cost of the resource by this additional value. This extra cost is reflected by the market which is likely to supply the optimal intertemporal allocation of the resource. However, even assuming market perfection, this solution does not work in the case of preservation decisions. Technical substitutability characterising any depletable environmental resource is impossible when dealing with artistic and historical heritage.

This may lead to the following new dilemma. Let us admit that the market is able to price correctly the opportunity cost of intertemporal redistribution. Let us moreover assume that current consumers will decide to consume all the resources now. This will leave nothing for future generations and current prices will grow uncontrollably. No preservation will therefore be equal to no current consumption, which is of course absurd. Back to (5), the problem is not the evaluation of *An*, to which the former dilemma on the dying-arts is more appropriately referred, but that of the discount factor *t* which has to take into account the benefit (i) coming to future generations from the investment in preservation (*Cn*). The higher this benefit, the lower *t*, because, excluding other factors like uncertainty and risk which are irrelevant in the present discussion,

$t=1/(1+i_n)^n$

Total preservation of existing heritage, which characterizes the present attitude to conservation, suggests no consumption, and involves a discount rate equal to zero, corresponding to *i* equal to infinity. This leads to a rate of return on the preservation investment absurdly equal to zero, too. In other words, all current preservation decisions should be based on essentially altruistic (or perhaps masochistic) decision makers. In actuality, no current limitation of resource exploitation is likely to be obtained through price, because the current consumer can free ride on future availability. Furthermore, prices do not rise uncontrollably even when no preservation decisions are taken.

Total preservation, on the other hand, has a cost for the current consumer, which is at least the cost of renouncing current consumption (or the marginal private cost of preservation). The current decision-maker, therefore, has to be either an altruist (and, maybe even a masochist), or a future potential consumer willing to pay now in order to be able to consume in the future. The alternative emerges as a limitation of the applicability of preservation policies, assuming some interdependence of utility functions in an intergenerational context lessened by some degree of egoism by the current decision-maker.

THE OPTIONAL CONSUMER DILEMMA

Optional consumers are those won't consume now and who do not declare any future desire to consume. They cannot be considered in the market like future generations, as they are not willing to expose themselves to it. But they are to be taken into account in determining social equilibria, hence the dilemma: how to express what must by definition be unexpressed?

Preserving artistic and historical heritage for those who wish to use it independently of any present or future expressed demand, means first of all stating its not completely private nature (on the ground of a specific non-excludability). Optional consumers cannot be excluded from the consumption of the preserved heritage even though they never express a demand for it. If the good were strictly private, in principle, it could be produced and exchanged in response to demand expressed on some market (including the so-called 'futures' markets).

Even though he doesn't, the optional consumer holds a right to express his willingness to consume at any point (in this sense he is the freest among free-riders). Moreover, the optional consumer's safeguard involves the utilization of 'peak-load' demand functions. The possibility that current non-active consumers become active at any time in the future gives rise to the possibility of fluctuations of demand over time. If fluctuations occur in the presence of non-storable goods (such as the services deriving from artistic heritage), marginal costs may prove to no longer be a non-controversial measure of price determination (Crew & Kleindorfer, 1979, 2014). Marginal costs can differ for the same supplied quantity, depending on whether it is supplied in 'peak-load' periods or not. Different production capacities are needed in each period involving different fixed (and often also variable) costs to satisfy total demand. The same good, therefore, has different optimum prices according to the period in which it is consumed. They are bound to be higher in 'peak-load' periods and lower for the rest of the time. Peaks can be determined in time ('fixed') or not ('mobile'). Optional consumers give rise to 'mobile peak-load' periods. Optimum price, therefore, must be determined as in presence of public goods, through a total demand curve resulting from the vertical sum of individual demand functions in the two periods (the 'peak-load' and the 'ordinary' one). Besides free-riding problems, preservation choices should therefore require a system of price discrimination to be applied to ordinary (non-'peak-load') and optional ('peak-load') consumers.

Unfortunately, (and this is the dilemma) no optional consumer will ever declare his willingness to consume. By doing so he would become by definition an effective consumer. In the author's scheme, the optional consumer can be seen as someone expressing a demand not endowed with 'interpretation' (*DD1* in Figure 3 referred to a good originally not-preserved (because it was not subject to interpretation)). Being an optional consumer, he can qualify his demand at any time from an aesthetic-historical point of view (passing to *D'D'1*).

This demand shift will lead him to become a peak-load period consumer. To be allowed to do so he should declare his willingness to pay at least:

$$p_2 = a + b = C_n \text{ in (4')}$$

where

$a = p_1$ = variable cost of the service,

b = fixed cost of preservation.

In this case, however, he has to renounce his own nature. The conceptual determination of the optional consumer is grounded on the merger of a value judgement (on the freedom of general access to the heritage) with a prediction regarding reality (the probability that somebody will desire and have access to it in the future).

Source: own elaboration.

NON-MARKET DECISION-MAKING SOLUTIONS

The above-mentioned arguments lead to the conclusion that non-market decision-making processes are needed to reach optimum solutions on preservation. Preservation, therefore, has to be a matter of public policies. Unfortunately, the same arguments can also be used to reach the opposite conclusion. Lack of culture, which may produce information asymmetry, non-altruism and the consequences of the agents' free-riding strategies may affect public choices as well as private ones. Besides these objections, moreover, optimal public decision-making on heritage may be conditioned by another factor: the distribution of decision rights on heritage itself. General environmental theory demonstrates the relevance of heterogeneity inside jurisdictions and of interjurisdictional competition in obtaining Pareto-optimum solutions in the determination of environmental standards (Baumol & Oats, 1988). Heterogeneous decision-making groups inside a jurisdiction can cause the failure of median-voter-based processes, the prevalence of given interest groups matching the representativeness of the voter. Individuals not endowed with 'interpretation' capacities may, for instance, be the majority. Interjurisdictional competition can lead to non-optima, too, in the presence of a zero-sum game, that is when no net welfare increase for society results from it. As any preservation decision is based on 'interpretation', non-homogeneous interest groups are always relevant (culture itself is a source of non-homogeneity): the 'hijacking of history by dominant groups' being the decision-making historical standard in this field (Ashworth & Voogd, 1986; Mossetto & Vecco, 2001).

Figure 4. Optional consumer's demand for cultural heritage preservation

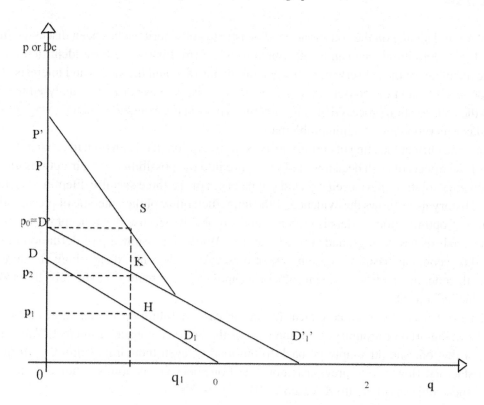

Interjurisdictional competition can be seen developing through time and space if the resources available for preservation are aggregated in time (intergenerational aggregation) or are globally seen as a worldwide endowment. This leads to the conclusion of a substantial impossibility of dealing with preservation issues by means of the usual optimisation models.

FUTURE RESEARCH DIRECTIONS

The purpose of this chapter is not to propose concrete solutions but rather to encourage discussion and debate regarding the dilemmas that the conservation process may imply and the economic calculation of cultural heritage conservation on a number of levels. A better understanding of the economic implications and relationship between economic valuation and heritage conservation narratives is expected to suggest more rational use of resources. This should highlight the current and future value and significance of transferring knowledge and memory from the past to the present and future generations through cultural heritage. More attention should be paid on the sustainability of cultural heritage conservation management in order to reduce the impact of the analysed dilemmas, which could highly affect the future of cultural heritage and its management.

CONCLUSION

The problem of deciding on the conservation of artistic historic heritage has been discussed in the light of the different definitions that can be attributed to this term. Firstly, we have identified the different economic meanings of the conservation concept, taking into account the values and interests of different stakeholders involved in the conservation process. Secondly, we have critically analysed the dilemmas raised by the conservation process that may sometimes restrict the extent of its action, very often making the actual conservation intervention problematic.

The specific current meaning of conservation as 'preservation' has been used to ground the economic analysis of the effects of such decisions and to inquire into the possibility of their optimisation. Market and non-market solutions have been rejected on the bases of the three specific dilemmas characterising the issue. History itself shows the evidence of the unpredictability of the outcome of preservation. If the application of optimization models is critical, this is probably because the concept of preservation on which this analysis has been grounded is critical, too. While the assumed past definition of conservation rested on economic bases, the current one of preservation does not. Its ideological nature contrasts sharply with economic reality and the results of its application to reality are strongly affected by some sort of value judgement.

The bases of decisions become ethical (as in the case of future generations), aesthetic (as in the case of the dying-arts) or arbitrary (as in the case of the optional consumer interest). The author does not suggest that one should simply go back to the market, even though its cultural performance was not unsatisfactory. However, as previously noticed, if one doesn't, economists should probably give up analysing such subjects (Mossetto & Vecco, 2001; Vecco, 2005).

REFERENCES

Ashworth, G., & Voogd, H. (1986). The marketing of urban heritage as an economic resource. In J. Angement & A. Bongenaar (Eds.), *Planning without a passport* (pp. 38–50). Utrecht, The Netherlands: Ehinkwyk.

Baer, N. S., & Snickars, F. (2001). *Rational decision-making in the preservation of cultural property*. Berlin: Dahlem University Press.

Baumol, W., & Oates, W. (1988). *The theory of environmental policy*. Cambridge, UK: Cambridge University Press. doi:10.1017/CBO9781139173513

Buchanan, C. (1975). Cities in crisis. *The Planner, 61*(7), 236–264.

Cassar, M. (2003). Places and stuff: Is it only the language of conservation that is changing? In Conservation of historic buildings and their contents: Addressing the conflicts (pp. 41-51). Shaftesbury: Don Head Publishing and De Montfort University.

Conti, A. (1988). *Storia del restauro e della conservazione delle opere d'arte*. Milano: Electa.

Crew, M. C., & Kleindorfer, P. R. (1979, 2014). Public utility economics. London: The Macmillan Press Ltd.

Duhamel, J. (1973). Discours de Jacques Duhamel devant l'Assemblée nationale, 28 mai 1971. In Discours et écrits (1971-1973). Paris: La Documentation française/Comité d'histoire du Ministère de la culture.

Gold, A. (1975). Welfare economics of historical preservation. *Connecticut Law Review*, *8*, 348–369.

Hale, R. (1978). Economic aspects of historic preservation. *Journal of Cultural Economics*, *2*(2), 43–53. doi:10.1007/BF00247853

Jeudy, H. P. (2001). *La machinerie patrimoniale*. Paris: Sens & Tonka.

Jokihleto, J. (1999). *A history of architectural conservation*. Elsevier.

Jonas, H. (1985). *The Imperative of responsibility: In search of an ethics for the technological age*. Chicago: The Chicago University Press.

Krutilla, J. V., & Fisher, A. C. (1985). *The economics of natural environments*. Baltimore, MD: John Hopkins Press.

Mosser, F. (1994). Monuments historiques et tourisme culturel. *Les Cahiers d'Espaces*, *37*(24), 23–27.

Mossetto, G. (1992). *Culture and environmental waste*. Working paper, University of Venice.

Mossetto, G. (1993). *Aesthetics and economics*. Boston: Kluwer. doi:10.1007/978-94-015-8236-0

Mossetto, G., & Vecco, M. (2001). *Economia del patrimonio monumentale*. Milan: Franco Angeli.

Parfit, D. (1984). *Reasons and Persons*. Oxford, UK: Claredon Press.

Peacock, A. (1991). Economics, cultural values and cultural policies. *Journal of Cultural Economics*, *15*(2), 1–18. doi:10.1007/BF00208443

Peacock, A. (1994). A future for the past: The political economy of heritage. Lecture at the British Academy, 27th October 1994. *Proceedings of the British Academy*, *87*, 189–243.

Robinson, J. (1959, 1969). The accumulation of capital. New York: Palgrave McMillan.

Taylor, J. (2013). Intergenerational justice: A useful perspective for heritage conservation. In *CeROArt: Conservation, Exposition, Restauration d'Objets d'Art*. Retrieved July 14, 2014, from: http://ceroart. revues.org/3510

Throsby, D. (2001). *Economics and culture*. Cambridge, UK: Cambridge University Press.

Throsby, D. (2002). Cultural capital and sustainability concepts in the economics of cultural heritage. In Assessing the value of cultural heritage (pp. 101-117). Los Angeles, CA: Getty Conservation Institute.

Turner, R. K., Pearce, D. W., & Bateman, I. J. (1994). *Environmental economics: An elementary introduction*. Baltimore, MD: Harvester Wheatsheaf and John Hopkins University.

Vecco, M. (2005). *L'évolution économique du concept de conservation* (Thèse pour obtenir le grade de Docteur). de l'Université Paris 1, Panthéon-Sorbonne, Paris, France.

Vecco, M. (2007). *Economie du patrimoine monumental*. Paris: Economica.

Vecco, M. (2010). A definition of cultural heritage: From the tangible to the intangible. *Journal of Cultural Heritage*, *11*(2), 321–324. doi:10.1016/j.culher.2010.01.006

KEY TERMS AND DEFINITIONS

Asset: Something valuable that an entity owns, benefits from, or has use of in generating income.

Certifier: The person in charge of making known the value of a good/item. In this context it is assumed to be an expert.

Ceteris Paribus: "All other things being equal" or "other things held constant."

Cost: An amount that has to be paid or given up in order to get something. In business, cost can include a monetary valuation of effort, material, resources, time and utilities consumed, risks incurred, and opportunity forgone in production and delivery of a good or service.

Elasticity of Demand: The degree to which demand for a good or service varies according to its price. Normally, sales increase with a drop in prices and decrease with a rise in prices.

Marginal Costs: The increase or decrease in the total cost of a production run for making one additional unit of an item.

Market Failure: A situation in which the allocation of goods and services is not efficient, and where action could be taken to address an identified support or supply gap left by market forces or private enterprise.

Merit Good: Goods or services whose cost is met by public finance for the benefit of society.

Net Social Benefit: The increase in the welfare of a society that is derived from a particular course of action. Some social benefits, such as greater social justice, cannot easily be quantified.

Private Good: A good/service of consumption that, if used by one party, may not be available for others. It implies it is rivalrous and excludable in the consumption.

Production Function: It relates physical output of a production process to physical inputs or factors of production.

Public Good: An item whose consumption is not decided by the individual consumer but by society as a whole, and which is financed by taxation. A public good (or service) may be consumed without reducing the amount available for others, and cannot be withheld from those who do not pay for it. This good is characterised by two features: it is not rivalrous and not excludable in the consumption.

Semi-Public Good: A good/service having characteristics of both a public and private good.

ENDNOTES

1. "We must beware of two extremes (mortal if they are exclusive): conservation (embalming, without use value), vulgarization (form of virtual and collective cannibalism)".

2. "The heritage conservation takes care of the deposit of the memories and delivers us of the weight of the responsibilities inflicted to the memory".

3. This can be demonstrated as $KMP = 1/2Pq < KRP' = 1/2P'q$, dividing both members for $1/2q$, becomes $P < P'$.

4. As regards the extremism of conservation, we can mention Buchanan's observations: "What happens when everything is conserved? When conservation is expanded to such an extent that one can no longer walk without tripping over some object of veneration, what happens then? Does the danger exist one will become a prisoner of the past, being trapped in a network of bureaucratic paperwork in an uncreative world?" (Buchanan, 1975, p. 251).

5. "Better to conserve one thousand monuments for fifty years than fifty monuments for a thousand years".

Chapter 16
Culture and Heritage Preservation in an Era of Globalization and Modernism:
A Comparative Study of China and Nigeria

Floribert Patrick Calvain Endong
University of Calabar, Nigeria

ABSTRACT

According to a number of myths, the cultural effects of globalization and modernization have not really impeded East Asian countries' efforts towards cultural heritage preservation. In tandem with this, many "fascinated" members of the African intelligentsia view Eastern Asian nations such as China, South Korea, Japan, Singapore, Malaysia, and Thailand among others as true models to be emulated by their nations in the realm of cultural heritage preservation. This chapter examines the extent to which this thesis is plausible, through a critical study of the impact of globalization and modernization on cultural heritage preservation in China and Nigeria. The chapter begins by exploring the question of cultural preservation in an era of modernization and cultural globalization and ends up assessing the degree to which China and Nigeria's efforts towards cultural heritage preservation have been affected by cultural globalization and a West-dominated model of modernization.

INTRODUCTION

Modernization and cultural globalization have constituted a serious problematic and a dilemma for both Asian and African countries, particularly in the socio-cultural realm (Ekpang, 2008; Endong 2015; Hirai, 2014; Keping, 2012). This observation is connected to the fact that the two paradigms are mostly associated with a number of socio-cultural and political forces that are visibly inimical to the preservation of cultural diversity particularly in Third World countries. Modernization for instance, is arguably equated to a pro-westernization force, and is therefore viewed as one of the phenomena responsible for cultural erosion in Third World countries. In tandem with this, a good number of imaginations stipulate

DOI: 10.4018/978-1-5225-3137-1.ch016

that the modernization paradigm has facilitated Asian and African countries' systematic adoption of western patterns of development (Endong 2015; Matunhu 2011; Odinye & Odinye 2012; Tunde, 2005). Such an adoption of western patterns has been in almost all realms of human endeavors including the cultural domain. This position visibly hinges on the maxim that, the modernization paradigm entails that developed countries (mostly the US-led West) serve as infallible models and pathfinders to all developing countries. As Giddens (1982) succinctly observes, the modernization paradigm assumes that industrialism and modernism constitute a liberalizing and progressive force; and hence, western societies provide a model to be followed by developing nations, even in the cultural realm. Furthermore, the modernization paradigm stipulates that developing nations are not just *under*developed, but they are in real sense, *un*developed as they await the impact of industrial transformation. To safely reach the shore of socio-cultural and political development, they must follow the route designed and followed by the western developed countries. Following similar pattern of socio-cultural development with Europe and America has, in essence, meant westernization, Europeanization or Americanization and serious challenges in the domain of culture and heritage preservation in both Asia and African countries.

Similarly to the modernist paradigm, cultural globalization has, for some critics, entailed unavoidable cultural erosion and for others, culture mutations. Scholars such as Griesbrecht (2011) pertinently note that cultural globalization actually presents visible paradoxes. On one hand, the phenomenon enables the cultural empowerment of people and facilitates the construction of a collective identity, meanwhile, on the other hand, it is susceptible to dis-empower people as it enables misrepresentation; facilitates neo-colonization and subtly propels the loss of individualism and group identity. Quoting a large number of culture theorists, Griesbretch (2011) adds that cultural globalization has given rise to two competing visions, one of which is unfriendly to cultural diversity. This vision – which, to him, is inimical to cultural diversity – specifically envisages a corporate-dominated monoculture where nations and cultural groups alike are deprived of autonomy and identity.

Despite the quasi-indomitable nature and the relative "rigidity" of the westernizing effects of globalization and modernism on world cultures, critics have observed that East Asian countries have made some formidable efforts to resist westernization. This has been to the extent that many "fascinated" African scholars and intelligentsia even view Eastern Asian nations such as China, South Korea, Japan, Singapore, Malaysia and Thailand among others as true models of cultural preservation. As Elsje (2011) insightfully puts it, "from Kenya to Ethiopia, policymakers are looking east in the search for an adaptable development blueprint" not only in the sphere of politics and economics but equally in the realm of cultural development (particularly culture and heritage preservation). In the same line of argument, Afro-centric scholars such as Idowu (1999), Ekpang (2008), Odinye and Odinye (2012) and Endong and Essoh (2015) have enjoined African countries to emulate the singular efforts of Asian countries, particularly those of the Chinese government towards a phenomenal preservation of their respective cultures and heritage.

This position or imagination however foregrounds a number of questionings, some of which include the followings: to what extent have China's efforts towards culture and heritage preservation been exemplary and different from those of the Black African countries? To what extent have the Chinese cultural values or models of cultural preservation been immune to the phenomena of pro-west modernization and cultural globalization? Is it possible to achieve real cultural preservation in an era of cultural globalization and modernization (which have been synonymous with westernization or Americanization)? What are similarities (if ever they exist) and differences in Asian and African countries' patterns of heritage and culture preservation?

Answering the above mentioned interrogations definitely entails broad methodologies which fall outside the preview of this chapter. However, following the logic of the above mentioned interrogations, this chapter presents a comparative study of China's efforts towards culture and heritage preservation and those of Nigeria (a Black African country). The chapter is divided into three major sections. The first section provides conceptual clarifications on the three terms of cultural/heritage preservation, modernism and cultural globalization. The second part explores the question of cultural preservation in an era of modernization and cultural globalization while the last part provides a comparative perspective on China and Nigeria's efforts towards cultural preservation assessing the degree to which these efforts have been affected by cultural globalization and a pro-west model of modernization.

CONCEPTUAL AND THEORETICAL ISSUES

As earlier mentioned, this chapter will begin by providing a number of conceptual clarifications. These conceptual clarifications aim to enable clarity of analyses in the subsequent articulations of this discourse. Here the three terms of culture and heritage preservation, modernism and globalization will be given attention.

Culture and Heritage Preservation

A good explication of this concept will necessitate providing definitional illuminations on the two terms of culture and cultural heritage. There are various definitions of culture. Despite this plurality of definitions, culture is mainly envisaged as the ensemble of learned and socially transmitted customs, behaviors, knowledge and material objects which may include world views, ideas, values, skills and specific artifacts of a group of people. A cliché simplistically refers to it as the mannerism or total way of life of people in a given society, which may include food habits, dress codes, beliefs people hold and activities they engage in. The UNESCO (2009) refers to such activities as those experiences that "embody or convey cultural expressions, irrespective of the commercial value they may have". They may be an end in themselves or contribute to the production of cultural goods and services. Culture is therefore not exclusively limited to the art and heritage of indigenous or native people. It encompasses a broader spectrum of phenomena. No doubt the participants of the World Conference on Cultural Policy in Mexico defined culture as "the whole complex of distinctive spiritual, material, intellectual and emotional features that characterize a society or social group. It includes not only arts and letters, but also modes of life, the fundamental rights of the human being, value systems, traditions and beliefs" (UNESCO 1982).

The term "cultural heritage" emanates from the aphorism that culture could be seen as a propriety which is inherited and transmitted from generation to generation. It is envisaged as the legacy of both tangible and intangible attributes of a community or society, which are inherited from past generations, preserved/protected and bestowed for the benefit of future generations. According to the UNESCO (2009), cultural heritage includes artifacts, monuments, clusters of buildings and sites having a diversity of values including symbolic, historic, artistic, aesthetic, ethnological or anthropological, scientific and social significance. Cultural heritage however includes other intangible phenomena such as folklore, language, traditions and knowledge, as well as natural heritage such as culturally significant biodiversity and landscapes.

Culture and heritage preservation is therefore the act of using deliberate and well designed methodologies, to maintain cultural heritage from the past for the benefit of the present and future generations. It emphasizes the imperatives to protect, restore and honor all forms of cultural biodiversity. It goes beyond the development and protection of cultural sites and artifacts to include human rights, tolerance and intellectual propriety rights for cultural specific languages and arts. Culture and heritage preservation may be seen as a complex but subtle process which begins with recognizing and/or understanding the various strands of culture (language, stories, songs, dances, practical skills; buildings; sacred sites; artifacts; arts and crafts; relationships to the land; and forms of subsistence among others), then valuing these facets of culture and then proceeds to caring for them and finally enjoying them. Culture and heritage preservation equally entails the appropriate re-use of well-loved and culturally significant buildings and sites. Such re-use may facilitate cultural renewal. The UNESCO (2009) provides a definition of the concept which seems to be more relevant for natural and tangible heritage protection or preservation. It states that cultural heritage preservation aims to "obviate damage liable to be caused by environmental or accidental factors, which pose a threat in the immediate surroundings of the object to be conserved" (p.90). This will entail adopting preventing methodologies and measures which, usually are not applied directly but

are designed to control the microclimatic conditions of the environment with the aim of eradicating harmful agents or elements, which may have a temporary or permanent influence on the deterioration of the object. (UNESCO 2009, p.90)

However, as earlier mentioned, cultural preservation goes beyond protecting only tangible cultural heritage. With westernization, standardization and Americanization serving as cultural threats in Third World countries, cultural heritage preservation has come to be understood by some critics and policy makers as entailing the designing or adoption of strategies to resist western cultural imperialism (Ekpang, 2008, Nwegbu, Eze & Asongwa, 2011).

The philosophy of culture and heritage preservation strongly rests on a number of popular myths. One of these myths stipulates that there cannot be reasonable socioeconomic and political development without cultural preservation. As Oladunjoye (2004) puts it, there is no nation that has been able to achieve economic progress "without proactive promotion of its essential cultural components". It is for instance impossible to dissociate Japan's phenomenal economic and technological achievement from the country's culture. Another myth underlying the idiom of cultural preservation stipulates that cultural diversity – a byproduct of heritage preservation – is a virtue and an imperative for the healthy functioning of the world.

Apologists of the concept of cultural diversity actually think that rather than being a threat, cultural diversity "points to a sharing of the wealth embodied in each of the world's cultures and, accordingly, to the links uniting us all in processes of exchange and dialogue" (UNESCO 2016, p.1). The non-governmental initiative *Reliable Prosperity* (2014) somehow underscores the view that cultural heritage preservation is in line with recognizing the wealth of all world cultures when it concedes that any time a language or culture is extinct in the world, we automatically lose an irreplaceable and exquisite way of being; and "each time a well-loved building is torn down without a trace, or a gathering place paved over, a strand of culture is frayed". In view of the necessity of preserving the cultural diversity of the world, the UNESCO has, as far back as 1972, taken a number of measures and preventive methodologies to protect a number of important world cultural heritage. In line with this, the organization has included a

wide range of objects and sites in its list of protected world cultural heritage. In 2003, it adopted another convention to protect intangible cultural heritage. This move has enabled a multiplicity of traditions observed in developing countries to be included in UNESCO's official list of protected cultural heritage.

Despite the fact that the concept has a visible rationale and is presently championed in the global sphere by the UNESCO, cultural heritage preservation largely depends on political will and the internal policies adopted by each country. First and foremost, it is the product of a process of selection done by the society. Franchi (2014) calls this phenomenon a "process of memory and oblivion" which, being characteristic of all nations, consists in choosing for both political and cultural reasons, which of the traditions, values, beliefs and other aspects of the culture deserves to be preserved for future generations and which of these phenomena is to be abandoned.

Modernization

Modernization could be defined as a process of progressive socio-economic transformation or evolution witnessed by a nation. It describes the movement of a people from the stage of traditional or "pre-modern" to that of modern society. This brings to the fore the binary opposition between the concepts of "pre-modern society" and "modern society". The first refers to a society which is still very conservative and strongly attached to traditional values and religion. Pre-modern societies are equally considered relatively primitive and arguably "less civilized". They rely principally on the extraction or cultivation of natural resources (notably agriculture, hunting, mining and gathering among others) as economic activities. Another characteristic of this type of societies is that their government institutions are mostly minimal and rudimentary.

The modern society on the other hand is industrialized and mainly driven by the free will aphorism. It is characterized by a rejection of traditions (particularly the ones considered unprogressive) and weaker adherence of people to religious precepts. In a nutshell, a modern society could be construed as being remarkably driven by the spirit of modernism. This socially progressive school of thought affirms the power of man to innovate, ameliorate and transform his environment with the aid of practical experimentation, scientific knowledge and sophisticated technology. Based on this premise, one may enthuse that the modernization process hinges on the re-examination of all sectors of human endeavor to detect impediments to human progress and design new, appropriate and efficacious techniques to surmount such impediments and ultimately engender sustainable development. Huntington (1996) puts it simple by describing the phenomenon of modernization as a compendium of industrialization, urbanization, increasing level of literacy, education, wealth and social mobility, and more complex and diversified occupational structures.

However, modernization is not construed exclusively as a process, but a theory used in the fields of development, sociology, anthropology, cultural studies and some related disciplines. As a theory, it assumes that traditional societies can achieve development only by following the footsteps of the industrialized west. The implication of this assumption is that the west represents an expedient developmental model which traditional societies –essentially constituted of Third World countries – should "emulate" to safely reach the shores of socio-economic and political advancement and human progress. Western capitalist values and liberalist paradigms are, in this context, viewed as the bases for modernizing Third World nations and enabling them achieve economic growth or strength. As we shall see in the subsequent paragraphs of this discourse, adopting western patterns of industrialization and development has always had serious cultural implications and potential to adversely affect cultural preservation in developing

countries. The modernization paradigm has, in many ways been a vector of westernization, cultural imperialism and cultural erosion in many Third World countries. As rightly argued by Sorensen (2014), modernization seriously hinders the socio-cultural development of third world countries in that, given the fact that the latter do not have the modern conveniences and attitudes that accompany developed first world countries, they are, in the name of modernization, compelled "to leave too much of who they are traditionally behind them". This, of course, amounts to cultural erosion and extinction. Third World countries have traditional social institutions that have worked for them for centuries. Any attempt at modernizing these institutions – particularly according to western models – may only bring greater problems to the global community.

Cultural Globalization

Simply put, cultural globalization refers to a process in which particular cultures, meanings, ideas, values and experiences are disseminated throughout the world through various means. Such transmission of cultural artifacts aims to extend and deepen social relations. Cultural globalization thus involves the spread of language, art, technology, food and business ideas, making its impact to be felt in all the climes of the globe. It is facilitated by such transmission agencies as popular culture media, transnational movements of people, transnational cooperation, the UNO, and electronic communications (the internet, the telephone, fax, e-mail and social media) among others. An egregious example of cultural globalization is the phenomenal diffusion of the American fast food chains, illustrated by the MacDonald and Starbucks phenomena in the world. As of 2008, these two American food and beverage outlets could respectively boast of 32 000 and 18 000 locations operating in various countries of the world. Another egregious illustration of cultural globalization is the remarkable proliferation of the "Davos" subculture throughout the world. In almost all countries, the "Davos" culture is observed among an elite group of highly educated people who operate in the rarefied domains of international finance, media, and diplomacy. The adepts of this "Davos" culture, have similar convictions about individualism, democracy, and market economics. They are said to follow a recognizable lifestyle. They are instantly identifiable anywhere in the world, and feel more comfortable in each other's presence than they do among their less-sophisticated compatriots.

Like the other two main facets of globalization (political and economic globalization), cultural globalization enables and fosters interconnectedness among different cultures and populations. It creates a situation in which the quotidian experiences of people, as influenced by the diffusion of commodities and ideas, reflect a standardization of cultural expressions around the world. It is rooted in the two myths of a "global culture" and a "global village". The first of these two myths, stipulates that the intense cultural diffusion and spread of standards among cultures engender a situation wherein world cultures tend to resemble one another and cultural diversity tends to be a mirage/myth. The "global culture" myth is similarly rooted in the imagination that (cultural) globalization is a constant move towards homogeneity which will subsequently render human experience essentially the same across the world. However, this myth is challenged by critics who see cultural diversity as an eternal phenomenon. Such critics argue that though globalization has visible homogenizing influences, these influences are far from creating anything akin to a single world culture. Smith (cited by Ekeanyanwu, 2015) for instance, sees the idea of a global culture as an impossibility and an oddity *vis-à-vis* the widely acclaimed thesis that culture is a way of life specific to a people. In other words, according to him, culture can only be conceptualized as a singular phenomenon. As he puts it,

If by "culture" is meant a collective mode of life, or a repertoire of beliefs, styles, values and symbols, then we can only speak of cultures, never just culture; for a collective mode of life, or a repertoire of beliefs, etc., presupposes different modes and repertoires in a universe of modes and repertoires. Hence, the idea of a "global culture" is a practical impossibility, except in interplanetary terms. (Cited in Ekeanyanwu 2015, p.171)

The standardization and homogenization influences of cultural globalization are believed by many to be vectors of Americanization, given the perceived American cultural domination of the global sphere. In line with this, cultural globalization has been associated with western cultural imperialism. Keping (2012) notes, for instance, that America is the leading global force in the development of material and spiritual civilization and represents the "highest development level of modern western culture". Her cultural influence/hegemony is tremendously perceived in almost all climes. As he put it, "not only are the developing countries facing the challenge of Americanization, other Western countries are to some extent suffering from this headache as well. In some sense then, 'Sinification' versus Westernization is essentially a stand-in for 'Sinification' versus Americanization" (p.36).

Despite the pertinence of this argument, it should be borne in mind that globalization is not a one-way traffic as American and other western nations have, over the years, subtly absorbed a considerable number exocentric cultures to "enrich" theirs, in the process of cultural globalization. No doubt Slaten (2010) likens cultural globalization to a game of cards. As he enthuses, if one goes by the premise that culture is a set of playing cards combined to make a unique cultural "hand", Western influence is, at most, "one culture taking a card from the West's hand, thereby making a new cultural hand". Following this line of reasoning, cultural globalization is simply the game of swapping cultural cards from other countries. While a number of cultural cards are swapped from the west, the west is likewise compelled to swap some from exocentric civilizations.

A good illustration of this thesis can be seen in the fact that the Rock & Roll musical genre – which many hastily describe as American – has African origins or influences. This musical genre is actually rooted in the voodoo culture recognized as being purely African or Afro-centric. Another illustration is the fact that exocentric (Eastern) cultures such as sporting Chinese tattoo, the practice of yoga and the consumption of Sushi among others, are becoming widespread among Americans and other westerners. All these are evidences pointing to the verity that the European and American civilizations have, in the course of their evolution absorbed a multiplicity of exocentric ideas and cultural concepts. Based on this premise, there is a tendency among a number of scholars to perceive what is traditionally viewed as western or American culture as global culture (Dugin, 2001; Ibok, 2008; Sen, 2015; Slaten, 2010; Thai, 2010).

EXAMINING THE FEASIBILITY OF HERITAGE PRESERVATION IN AN ERA OF MODERNIZATION AND CULTURAL GLOBALIZATION

Globalization and modernization have arguably been presented as threats to cultural diversity in the world, as well as agents of homogenization and westernization (Endong, 2015, Tomlison, 1991; UNESCO, 2016). On these bases, it becomes difficult or "delirious" to conceive the possibility of perfectly pre-serving cultures, particularly in the Third World. Though there have been formidable models of cultural resistance to their deleterious effects, there is no cultural system in the Third World that will claim to have

remained totally untouched by globalization and modernization. Cultural purism and (perfect) cultural preservation seem a myth, an illusion if not an impossibility in most, if not all Third World countries. Even the Chinese, Japanese and Indian models of cultural preservation and resistance to western cultural domination have not totally been infallible. There are still undeniable indexes of westernization or Americanization in these countries. As reviewed by a number of critics, issues like western dress code, western musical genres, English and MacDonaldization among others have permeated these societies (Global Heritage Fund, 2010; Hirai, 2014; Odinye & Odinye, 2012; Ola, 2015; Onyima, 2016; Thai, 2010; Watson, 2016). Irrespective of ideologies, the concepts of modernization, industrialization and development have entailed the faithful imitation of the developed/"more civilized" countries – that is the west – even in the cultural sector. Perhaps, the most expedient way to illustrate the thesis of the indomitableness of western cultural imperialism in an era of modernization and globalization will be to discuss some of the most palpable effects of these two phenomena on cultural development or preservation in most Third World countries.

Modernization as a Threat to Cultural Heritage Preservation in the Third World

Modernization is today mainly viewed by Third World nations as a phenomenon which is synonymous with westernization (the social process whereby non-western cultures are assimilated into American or European). In the strict sense of the terms, there is no synonymy between modernization and westernization but in a practical sense, the two terms have, in the context of Third World, virtually meant the same thing. The western model of development is certainly not the most authentic. However, most Third World nations (particularly Black African countries) have found it difficult to design their own model of development. This has made the west to continue to assume the position/role of a pathfinder and model in almost all realms of human life including the cultural domain. In effect, most critics view the west as the highest level of socio-economic and political development and a success that should – or must – be replicated by developing countries. And so, at first sight, it could be argued that there are many "modernities" but when we scratch beneath surface, the western model of modernization remains paramount in most Third World countries.

Other nations strive to give local/national colorations to their models of modernity but these nationalistic efforts are hardly radical departures from western capitalist designs. The relationship between Third World nations' models of development and those of the developed world can be likened to the relationship between a father and his son(s). In effect, it goes without saying that though there may not be perfect resemblance between a father and his son, the two beings remain tied by blood relationship. The predominant adoption of the western model of development in Third World nations has, these last decades, tended to profoundly affect cultural preservation in these countries. This has been so as the adoption of a specific model of development obviously has cultural ramifications. An egregious illustration is seen in the logic that a pre-industrial culture – notably the underdeveloped or traditional Black African nations – cannot support an industrial civilization. Tunde (2008) corroborates this position thus:

The idea that societies head in the same general direction seems proven by the development of the global economy. Nations that have made economic progress have irrespective of ideology, undergone similar processes. Development has involved capital accumulation, industrialization, the transformation of productive forces through machine technology and the introduction of factory systems of production. It entailed urbanization, the rationalization of thought and changes in social beliefs and institutions, includ-

ing family life. All modernization involved a move away from traditionalism. There have been differences in the methods of organization adopted by modernizing nations. […] Nevertheless, both socialists and capitalists followed the same fundamental steps to economic development. (p.38)

In the African context in particular, the westernization effects of modernization seem more accentuated. In effect, to most Africans, being modern and civilized entails, to a large extent, the imperative acquisition of western education and western language, the observance of western dress code and the adoption of many other cultural patterns attributable to the west. Such a frame of mind has for instance driven most Africans to jettison local values such as communalism, respect for the elders and the extended family system in favor of the European values of individualism, western materialism and other emanations of the western capitalist system. As argued by Maduagwu (1999), these western values are regarded by Africans as final stages of world civilizations and ideals each culture much strive to attain.

Another index of the westernizing effects of modernization is the fact that African systems of leadership have been relegated to primitivism and obscurity while western values of liberal democracy and human rights have been associated with one of the cardinal imperatives of modernity. Wambu (2009) is thus right to lament that progressive modernization has made contemporary African countries to largely be (neo)colonial constructs built on European ideas of the modern state. Blood and land, the source of traditional authority and legitimacy, have radically been jettisoned and replaced by civic ideas of democracy. However there remains enormous confusion about what to do with traditional leadership.

The modernization paradigm – or rather misinterpretation of the concept by most of the African intelligentsia – has caused cultural heritage preservation and presentation to exclusively be concerned with the rehabilitation of heritage sites from a technical point of view and according to designs which totally exclude local communities which, before the coming of the white colonizers, were the custodians of these sites. In tandem with this, most governments have embarked on the paradigm of adopting legislations which give attention exclusively to the protection of architecturally spectacular places while hampering the cultural activities that used to be practiced in these sites by riverine populations. Modernization has caused many African governments to have a sometimes subtle or clear aversion for traditions and to relegate such traditions to obscurity and backwardness.

Modernity is thus viewed as a phenomenon having a complex mix of imperatives, one of which is the adoption a dominantly western world view in such realms as politics, and social development. As pertinently put by Matunhu (2011) modernization has motivated most Black African nations to abandon their individual cultural values in favor of that of their former colonizers. In other words, as understood by the apologists of modernization, African peoples are bound to suffer deculturalization as a collateral damage or an imperative for effective socio-economic and political development. This has given credence to the popularization of controversial concepts such as "modernization of culture" since economic modernization entails cultural transformation. As further explained by Matunhu (2011), modernization of culture entails a transformation in the broader values, norms and attitudes of the larger contexts within which people in Africa find themselves.

Cultural Globalization as a Threat to Culture and Heritage Preservation in the Third World

As earlier indicated, cultural globalization also represents a monumental challenge to Third World countries' efforts towards cultural preservation. This myth or thesis is principally rooted in the fact that

globalization has been a serious threat to cultural diversity and a vector of cultural erosion in most developing countries. In effect, the increased business and cultural activities enabled by interconnection and interdependence among nations tend to seriously weaken the cultural unity of individual states. This is causing many critics to view the phenomenon of globalization as a postmodern phase of western cultural, economic and political domination in the world and a paramount dilemma for culturalists. As Tomlinson (1997) puts it, globalization "is either just the latest term for, or the latest stage in a process with a long history, a history more or less co-extensive with the history of western imperialism". It is equally simply a global working facilitated by a process of economic, political and cultural domination in which "the west draws all cultures into its ambits" (p.1). In such a context, one may talk more of Americanization or westernization than of cultural diversity and intangible culture preservation.

Globalization seems to have intensified the difficulties faced by developing countries – particularly Black African nations – to independently and properly chart their history, culture and identity. This problem has its roots in the African nations' experiences of European colonization and the slavery. Globalization is helping the problem to have a greater dimension and to be more glaring. It is even believed that the root of the Black African inferiority complex – which most often causes Africans to jettison their cultural values and ideas in favor of western ones – is in these two experiences (colonization and slavery). The various agents of globalization have pushed large segments of most African nations to view western or American values as inherently normative, most ideal or universal. These agents of globalization have subtly resuscitated and nourished Africans' inferiority complex. Many studies have, for instance, demonstrated that the global media has mainly been advertising or selling a pro-western culture to Third World audiences (Ekeanyanwu, 2015; Endong, 2015, 2016; Thai, 2010; UNESCO, 2016; Watson, 2016). These media have actually been subtly orchestrating a cultural synchronization process whereby, local audiences tend to view most of their cultures as primitive, irrelevant and not compatible with today's modernist imperatives. The other side of this trend is that it makes local audiences to attach greater values to western cultural artifacts.

The globalization of such cultural industries as Hollywood and European cinemas has made audiences in many nay, all Black African countries to develop an endemic empathy for the western world view, ideas, cultural values and models of cultural development thereby developing greater dispositions to abandon a number of African cultural values. Similarly, transnational corporations such as Coca-Cola, have successfully advocated cultural synchronization in many African climes as they have made many quarters in these countries to elevate the culture of consuming Coca-Cola among other brands and western cultural artifacts as an epitome of civilization and modernity. In the language of Maduagwu (1999), global CNN and other western media have subtly pushed and sold such concepts as individualism and western materialism to most Africans, causing the latter to look low on the African values of communalism symbolized in the popular aphorism emphasizing man as his brother's keeper. He notes that "civilized" and "modern" life as depicted or constructed by these Western media is mainly anchored on the material and technological perspectives. Little or no focus is placed on humanity that is supposed to be the beneficiary of these developments. As he contends,

For the ordinary modern African, development, as being transmitted by the CNN and other Western media means: fast cars, sky-scrappers, mobile telephones, punk hair styles, extravagantly luxurious houses with imported furnishings, international designers wears from clothing to shoes to hand-bags, wrist-watches and perfumes, and weekend jamborees in five-star hotels in and outside the country - especially at public expense. (p.104)

Most African nations have found it difficult to arrest these various agents of cultural synchronization and westernization in their climes. It is no exaggeration to lament that Americanization and westerniza-tion – thus cultural erosion – have progressively become a fatalism in some Third World countries. In other words, some developing countries have found it totally futile to resist western cultural imperialism. With close reference to China, Keping (2012) notes that it is inevitable to embrace westernization when cultural globalization entails opening your doors to the outside world. The question is even more complex and delicate as globalization is often considered not inherently aggressive or western from a cultural point of view. It is even argued by certain globalization scholars that instead of branding it an exclusively western phenomenon, it will be fairer to see the universal dimension of the concept. Globalization is thus, neither viewed necessarily as a western symbol nor it is regarded as a curse, they claim. In line with this, some critics are of the persuasion that it will be more judicious not to lose sight of the fact that some of the ideas and values that are hastily branded westernizing agents of globalization are emanations of cultural creolization. Others are cultural concepts borrowed from exocentric (non-western) civilizations. This thesis sounds plausible if one considers the fact that civilizational concepts such as algorithm, the rock & roll musical genre and the decimal system employed in mathematics among others represent scientific, technological and cultural importations from Asia and Africa. Europe and America have, at one point in their history embraced these concepts and ideas, enriching their civilizations. Based on this premise, Sen (2015) considers as non-progressive, the idea of resisting globalization under a number of so-called cultural pretexts. She pointedly notes that rejecting globalization because of cultural essential-ism will only amount to overlooking the global contributions to the engineering of a global culture and undermining the benefits susceptible to be derived by the world from this global culture. As she puts it,

Our global civilization is a world heritage — not just a collection of disparate local cultures. [...] The misdiagnosis — that globalization of ideas and practices has to be resisted because it entails dreaded Westernization — is so misplaced. [...] It only incites parochial tendencies and undermines the possibil-ity of objectivity in science and knowledge. It is not only counterproductive in itself. Given the global interactions throughout history, it can also cause non-Western societies to shoot themselves in the foot — even in their precious cultural foot. (p.16)

Some counties (notably Nigeria, Cameroon, Zimbabwe and South Africa among others) have however embarked on indigenization policies as cultural protectionist tactics. According to such policies, major sectors of these countries' life were to be designed mainly according to local cultural specificities. In line with this, cultural production industries such as the media are compelled to have higher local contents and lower foreign contents. However, besides being poorly articulated, these indigenization policies have, in some contexts, been viewed as incompatible with the present era of cultural globalization (Endong 2014, 2015). All these factors point to monumental difficulties in preserving cultural heritage (particularly the intangible ones), in Africa and in some other developing nations.

Based on the indexes discussed above, it has been recommended that cultural preservation in devel-oping nations should be rooted or should begin with a systematic de-westernization of peoples' minds (Ekeanyanwu 2015; Endong 2014). According to such a school of thought, cultural heritage preservation in the Third World must be predicated on the emancipation of Third World people from mental slavery. Such de-westernization or emancipation entails the return to sources and a radical shattering of the Third World nations' inferiority complex. It is in line with this that such slogans as "globalization without westernization" and "modernization without westernization have stricken a cord in the ears of some

nationalist cultural theorists in the Third World, one of which is Huntinton (1996). In the same line of argument, Hirai (2014) believes in a compatibility between modernism and traditionalism. He notes that it is futile for traditional cultures to resent and reject modernity or to resist their being absorbed into the stream of modernization. Rather, traditional cultures and modernism must imperatively harmonize and complement each other in the respective countries. This will represent an excellent way of engendering national(ist) and unique models of modernization.

IMPACTS OF MODERNISATION AND GLOBALIZATION ON CULTURAL PRESERVATION IN CHINA AND NIGERIA: A COMPARATIVE PERSPECTIVE

Despite the homogenizing effects of cultural globalization and the perceived pro-western nature of modernization, some non-western nations (mostly Asian countries) seem to be distinguishing themselves in terms of cultural heritage preservation. There is a widespread myth stipulating that countries such as Japan, South Korea, India, Singapore and China among others have, to a visible extent charted their cultural identity and made considerable efforts to modernize without significant cultural influence from the west. With close reference to Singapore, Thai (2010) notes for instance that, instead of being culturally aggressive, the two concepts of globalization and modernization have subtly maintained and strengthened national distinctive cultural practices. According to him, the two phenomena have remarkably strengthened local/national cultural identities. In the same line of thought, Keping (2010) notes that cultural globalization and modernization have led to the emergence of a Chinese culture which, though novel, hybrid and creolized to some extent, remains authentically Chinese as it is deeply rooted in core Chinese traditions. As he succinctly puts it, modernization and globalization has led to the formation of

A new kind of Chinese culture [...] that represents neither the simple renaissance of traditional culture nor a carbon copy of Western values. This new Chinese culture has its roots in Chinese tradition but absorbs the best elements of other civilizations as well. It combines tradition and modernity while emphasizing both national identity and our common humanity. (p.37)

However, the above mentioned persuasions are arguable to some extent. They all call for more profound reviews of Asian country's efforts – notably China's initiatives – towards the preservation of national cultures. This section offers a comparative perspective on China and Nigeria's efforts towards preserving their respective national cultural identities in the face of cultural globalization and modernization. In other words, this section will examine the extent to which these two countries have demonstrated enthusiasm and capacity to preserve their cultural heritage irrespective of western cultural imperialism. It appears expedient to remark from the outset that comparing China and Nigeria's approaches towards culture and heritage preservation definitely implies broader methodological designs that fall outside the preview of this discourse. Based on this premise, this section will principally focus on exploring evidences of westernization/Americanization emanating from cultural globalization and modernization in the two countries and which could be viewed as indexes of ineffective cultural heritage preservation in the two nations. The exploration will consider specific facets of both tangible and intangible cultural heritage and will be organized under the headings "similarities" and "differences".

Similarities

Modernization and globalization have had several effects on cultural heritage preservation in both China and Nigeria. In effect the two countries have, at varying degrees, profoundly been influenced by western cultures, particularly the American culture. The implications of globalization and modernization on cultural heritage preservation in these two countries can be illustrated with indexes drawn from such domains as architecture, dress patterns, food habits, family system, technologies, weddings, festivals, hair style and historic sites preservation among others.

Despite the adoption by government of various policies aimed to protect national cultures, most government officials, town developers, members of the general public and the intelligentsia in both nations have tended to view cultural heritage preservation and modernization as being inextricably incompatible. Modernization has, in many contexts been interpreted as a call to abandon traditional cultures in favor of Eurocentric or American paradigms (sometimes arguably referred to as universal traditions). With close respect to China, Harvard professor of Chinese history and philosophy Tu Wei-ming (2005) contends that a radical transformation of *Chineseness* is a pre-requisite for effective modernization. According to him such a radical transformation demands that the "sacred symbols of ancestral land [ideographic language and Confucianism] stand condemned" and that, such symbols be substituted with science, free market economy, democratic institutions, metropolises, technologies and mass communication which, to a great extent are imports from the west. Similarly, a good number of Nigerian schools of thought view the death of traditionalism as an imperative for human progress (modernization). Such schools of thought perceive the importation of anything western as a mark of civilization. Onwuejuogwu notes for instance that most Nigerians regard a piece of African traditional arts as "a piece of juju wood or a bronze object which Europeans only admire out of curiosity". Similar observers relegate traditional African music to "a cacophony of barbarous pagan noise" and perceive traditional African drama or dances as "forms of incoherent or grotesque pagan displays" (As cited in Endong, 2014, p.126). As shall be illustrated in the following paragraphs, the prevalence of westernized liturgies and religious vitalities have demonized a number of local moves towards cultural heritage preservation.

The imperative to modernize has pushed government authorities and the intelligentsia in both China and Nigeria to show a decreasing enthusiasm for the preservation of historical and cultural sites. One easily notes for instance that western architectural patterns and models of town planning have been popularized in both nations as a result of modernization. This has been to the detriment of local architecture. In China, for instance, Skyscrapers (arguably regarded as symbols of westernization) and other architectural designs are today elected to Chinese traditional castles equipped with picked roofs, the *Siheyuans* and the *Dazayuans* (types of traditional houses). The random implantation of buildings and structures designed after western models have been critiqued by a number of Chinese preservationists as urbanization movements that structurally deface Chinese historic cities rendering them "soulless". Some of these critics have described such modernist moves as an orgy of destruction which drives culture out of Chinese cities or simply as a degradation of historic China (Merle & Youjun, 2006; Stafford 2013). Healthcote for instance, censures the westernization of urbanization in China with an article titled "Modernism Minus Utopia'". In this article, he underlines the heavy cultural cost of urbanization/modernization in China, lamenting the fact that:

Coolly extruded, identikit modernist towers rise beside bland commercial slabs, green-tiled dragon roofs are applied like false noses to dumb façades only a couple of years old. The city is an architectural cacophony leavened by occasional snippets of harmony. Most striking is the contrast between the old city and the crushing march of the new. (Cited in Stafford, p.5)

A similar scenario is observable in Nigeria where vernacular architecture has long been associated with backwardness or underdevelopment. In the Hausa regions – which used to be very conservative in nature – for instance, most recent house construction projects have been tailored according to western styles and executed with imported materials. Construction techniques have in most cases tended to satisfy modernity-egos. According to a number of critics, the prevalent adoption of imported (mostly western) architectural designs to the detriment of vernacular ones is the (accidental) product of successive stages of modernization of which colonization is one. As rightly put by Oluwagbemiga and Modi (2014), "the advent of colonialism in Nigeria changed the traditional life and culture of Nigerian which creates a weak connection between traditional architecture and contemporary architecture in Nigeria" (p.61). Building houses according to western architectural models is today, generally viewed as a status symbol and a mark of advancement in most Nigerian cities. Very rare are efforts initiated to develop and popularize traditional patterns of building given the fact that traditional architecture is popularly seen as less functional than the western one (Mouktar & Shuhana, 2008). For functionality purposes some critics advocate a harmonization of modern and traditional architecture while others view the emergence of a hybrid but west-dominated architecture as an inevitable up-shot of the present wave of globalization that is touching all the climes of the globe. In line with this, Osasona (2012) notes that:

The British colonization of Nigeria (and the consequent facilitation of Brazilian and saro influences) [have] greatly impacted the ethnic cultures, translating into physical expressions that, to date, reverberate in contributing to the hybrid styles that characterize both the nation's vernacular and 'global style' building expressions. [...] The extent to which the world continues to tend toward a 'global culture', to the same extent will the generality of Nigerian culture continue to be re-defined along similar lines – and with a resultant tangible impact on its builtscape. (p.69)

The western architectural designs and models of town planning often lie at the root of projects aimed to raze historically or culturally significant sites. The desire to further modernize major Chinese cities (notably Beijing and Peking) and to render them livable has for instance, justified a number of culturally insensitive governmental projects as well as popular myths which make historical preservation one of China's least concerns. A good example is the demolition of Golou *Hutong* in 2008 in Beijing as a strategic action connected to the urbanization of the town. Meanwhile, to many Chinese quarters, the Golou *Hutong* – a neighborhood situated north the Forbidden City and around the Drum and Bell Tower – can be regarded as "kind of the living museums of China, or Beijing at least" (Watt 2013), or as "a special place where the past with its historical monuments combines with the everyday life of the inhabitants who often live in very modest conditions" (Krajewska 2009, p.63).

The impact of modernization and globalization on cultural preservation in China and Nigeria is also visible in the realms of the values system, food pattern, dress pattern and other aspects of fashion. The

McDonaldization phenomenon is for instance observable in both China and Nigeria. MacDonald and KFC's restaurants are becoming popular venues for birthday parties and vectors of socio-cultural change in China. Taking meals in such venues embeds a number of western cultural concepts – such as personal choice – which may not be experienced when meal is taken at home. In addition to this, modernism and modernization have caused a number of Chinese communities to re-assess and rebrand particular food habits. For instance, to many Cantonese, the hitherto traditional practice of eating sweet potatoes has changed from an irresistible culture to a symbol of past hardships. Revolutions in food patterns in China seem actually to be part of a larger wave of social transformation greatly influenced by modernization. As rightly contended by Borg (2010),

Much culture is being eroded in China. Aside from New Year, almost all the other cultural events have almost lost their visibility. All that remains of many traditional festivals is some special dishes that a few people still eat. Even some of the manifestations of lunar New Year are dying out. This is a pitiful loss.... [Society is] becoming more individualistic, devoid of community bondage (sic) or sense of belonging, and the new generations [are] seeking flashier and immediate gratifications in life.(p. 6-7)

Similarly in Nigeria, globalization and modernism have caused consumerism, individualism and other values popularly viewed as western to become prevalent. This has been to the detriment of the indigenous value systems and central social institutions/structures such as marriage, family and kinship. In effect, modernization has made the traditional form of administration, education and family system to be regarded as archaic. So too have indigenous values such as the respect for elders, polygamy and communalism been jettisoned if not "demonized".

The impact of modernization and globalization on cultural heritage preservation in China and Nigeria is equally felt in the domains of hair style dress pattern and fashion. The traditional hair styles have quickly be jettisoned in both countries in favor of western ones. In China for instance, the Manchu Queue (Pigtail hair style) is progressively viewed as archaic by modernists. Many Chinese now prefer western hair dressing techniques notably die colored hair. Similarly, the culture of applying artificial colored hair and other corrective hair styles – arguably to look like European – are two constituting symbols of sophistication and modernity among Nigerians of all ages. Traditional hair styles such as plated hair are no longer in vogue. A similar situation is observed with the fact that traditional dress patterns are in serious competitions with western dress styles in both countries. In some contexts, these traditional dress styles are even jettisoned in favor of western ones – often viewed as modern and more appropriate. In China and Nigeria, the tree piece suit and tie is toady holding sway in many facets to social life. So too are other western wears such as jeans, t-shirt and leggings among others. The popularization of western versions of suits and casual wears has been to the detriment of the culture of wearing local suit such as the Mao suit. In effect, the death in 1976 of the Communist Party Chairman, Mao Zedong led to serious economic and social reforms that affected the Chinese fashion in favor of westernization. Such reforms led to the popularization of western types of suits and casual dress. These aspects of western fashion became marks of modernity. Traditional wears such as the Mao suit on the other hand, became a symbol of traditionalism and a uniform for conservatives who continued nostalgically to believe in a cultural revolution in the country. As enthused by Watson (2016), Mao suits are since the 1990s sold in Hong Kong and Shanghai boutiques "as high-priced nostalgia wear, saturated with postmodern irony".

Differences

As earlier mentioned, the impact of modernization and globalization on cultural heritage preservation in China and Nigeria varies considerably. This can be illustrated in at least two domains: national policies on language and religion. China has adopted a conservative language policy that permits her to preserve her language (the Mandarin). This has been despite the wave of cultural globalization which is friendly to the internationalization of the English language. This language policy has enabled the Chinese people, to resist linguistic subjugation from the west. Contrarily to China, Nigeria has elevated English (a colonial tongue) to the status of official language. This has been to the detriment of national/indigenous languages. In tandem with this, most Nigerians regard English as a symbol of literacy, sophistication and modernism. Indigenous languages are progressively dying and no serious effort is done to remedy the situation. Parents, school institutions and policy makers which were supposed to drive the transmission of these languages from old generations to younger ones seem to be westernized. They seem not to see speaking local tongues as an imperative in an era dominated by "English mania" and cultural globalization. According to some experts and pessimistic futurists, the present trend indicates that indigenous Nigerian languages may be extinct in the next decades.

In the domain of religion, China seems to show greater enthusiasm to protect indigenous/Asian spiritualities. In line with this, Confucianism, Taoism and Buddhism remain the dominant religions in China meanwhile imported religions (Christianity and Islam) have over the years taken the place of traditional religions in Nigeria. In effect, many Nigerian consider animism (ancestral worship) the bane of civilization and modernism. This myth does not only affect the "lifespan" and status of animism but facilitates the prominence of charismatic religious movements and liturgies that have been antithetical to traditional arts preservation. The hatred of animism has many Pentecostal churches in the country to launch serious campaigns against traditional arts and folk art conservation projects. In some cases, old trees, shrines and sanctuaries have been "stormed" and destroyed in the name of fighting heathens.

CONCLUSION

Modernism and cultural globalization remain serious threats to cultural heritage preservation particularly in the Third World. As illustrated in this essay, the two phenomena are carriers of a dominantly western culture and constitute two vectors of western cultural imperialism in both Asian and African countries. It has, in effect been difficult – if not impossible – for Third World nations to develop or modernize along purely national models in all realms of human endeavors. Modernization has therefore entailed a high deal of westernization and "cultural dilution". In line with this, it has been difficult for Third World nations to secure cultural autonomy and to perfectly preserve their cultural heritage. Despite their efforts in creating museums and handicrafts; in mapping out historic, archeological and cultural sites as well as in conceiving various other culture conservation programs, their respective national cultures have largely remained endangered by globalization and modernization.

Countries like China and Nigeria have to some extent, witnessed the same impact of globalization and modernization on their cultures and cultural heritage preservation mechanisms. This has been illustrated in a wide range of domains including fashion, food habits, architecture, value system and historical site preservation among others. Despite these similarities in impacts of modernization and globalization on culture, China shows greater enthusiasm in protecting her cultural heritage. This is seen in the fact that she has elected her language (the mandarin) to foreign tongues and has preserved Confucianism, Taoism and Buddhism as major religions in her territory. This is contrary to Nigeria which has allowed colonial tongues and imported religions to hold sway in various facets of social life in her territory. The prevalence of these imported religions – particularly overzealous Pentecostal denominations – represents a serious threat to traditional arts and historical site preservation in the country.

REFERENCES

Borg, V. P. (2010). National identity depends on culture, too. *China Daily*, pp. 2-9.

Bush, C. (2016). Contexts for modernism. In *Routledge Encyclopedia of modernism* (pp. 13–43). London: Routledge.

Dugin, A. (2001). Modernization without westernization. *The Fourth Political Theory*. Retrieved December 25, 2016, from http://www.4pt.su/en/content/modernization-without-westernization

Ekeanyanwu, N. T. (2015). *International communication* (3rd ed.). Ibadan: Stirlin-Horden Publishers Ltd.

Ekpang, J. (2008). Globalization and cultural imperialism: The Nigerian experience. *WAACLALS: West African Association for Commonwealth Literature and Language Studies*, 2(2), 1–17.

Endong, F. P. C., & Essoh, N. E. (2015). Is the Chinese cultural policy in Africa a threat to the teaching and learning of the Spanish language in Nigeria? *International Journal of Art, Culture. Design and Language Works*, 1(1), 14–18.

Endong, F. P. C. (2015). Indeginization of media in Nigeria and cultural globalization: Mutual bedfellows or implacable arch-foes? *Journal of Globalization Studies*, 5(2), 82–93.

Garner, B. (2013). *The news cultural revolution: Chinese cultural policy reform and the UNESCO Convention on Cultural Diversity*. Peking: UNESCO.

Giddens, A. (1982). *Sociology. A brief but critical introduction*. New York: Harcourt Brace Jovanovich, Publishers.

Giesbrecht, D. (2011). Globalization and its effects on cultural diversity. *ETEC*. Retrieved December 28, from http://etec.ctlt.ubc.ca/510wiki/Globalization_and_its_Effect_on_Cultural_Diversity

Global Heritage Fund. (2010). *Saving our vanishing heritage. Safeguarding endangered cultural heritage site in the developing world*. Palo Alto, CA: Global Heritage Fund.

Hazel, F. X. (2005). Cultural loss: How real is the threat? *Micronesian Counselor, 16*, 15–27.

Hirai, N. (2014). Traditional cultures and modernization: Several problems in the case of Japan. In R. Peters (Ed.), *Cultural identity and modernization in Asian countries* (pp. 13–23). New York: Palgrave.

Ibok, E. (2008). Globalizing Nigeria's culture through the contemporary blend of indigenous pop-rap music. *WAACLALS: West Africa Association of Commonwealth Literature and Language Studies, 2*(2), 38–61.

Idowu, S. O. (1999). *Media in Nigeria's security developmental vision.* Ibadan: Spectrum Books Limited.

Keping, Y. (2012). The transformation of Chinese culture sine the launching of reform: A historical perspective. *Theory China: A Resource for Understanding China.* Retrieved September 26, 2016, from http://en.theorychina.org/xsqy_2477/201306/t20130611_270481.shtml

Krajewska, J. (2009). The *Hutong*s of Beijing: Between past and present. *Architectus, 1*(2), 59–65.

Maduka, C. T. (2003). The clouds are thickening: Nigerian languages and literatures in national development. *JONEL: Journal of Nigerian English and Literature, 4*, 11–19.

Matunhu, J. (2011). A critique of modernization and dependency theories in Africa: Critical assessment. *African Journal of History and Culture, 3*(5), 65–72.

Merle, A., & Youjun, P. (2006). Peking between modernization and preservation. *China Perspectives, 45*, 1–7.

Moukhar, M. M., & Shuhana, S. (2008). Ethnic special identity in the context of urbanization: The transformation of Gbagyi compounds in North Central Nigeria. *Journal of Urbanism, 1*(3), 265–280. doi:10.1080/17549170802532096

Nwegbu, M. U., Eze, C. C., & Asongwa, B. E. (2011). Globalization of cultural heritage. Issues, impacts and inevitable challenges for Nigeria. *Library Philosophy and Practice, 13*, 166–181.

Odinye, I., & Odinye, I. (2012). Western influence on Chinese and Nigerian cultures. *Ogirisi: A New. Journal of African Studies, 9*, 108–115.

Ola, C. O. (2015). Cultural heritage collections, preservation and access: Case of the University of Ibadan. *The African Symposium: An Online Journal of the African Educational Research Network, 15*(2), 50-55.

Oladunjoye, T. (2004, April 18). Cannes film festival knocks: where is Nigeria? *The Guardian Newspaper*, pp. 35-36.

Oluwagbemiga, P. A., & Modi, S. Z. (2014). Development of traditional architecture in Nigeria: A case study of Hausa house form. *International Journal of African Society Cultures and Traditions, 1*(1), 61–74.

Onyima, B. N. (2016). Nigerian cultural heritage: preservation, challenge and prospects. *Ogirisi: A New. Journal of African Studies, 12*, 273–292.

Osasona, C. O. (2012). Transformed culture, transforming builtspace: Experience from Nigeria. *International Journal of Sustainable Development and Planning*, 7(1), 69–100. doi:10.2495/SDP-V7-N1-69-100

Reliable Prosperity (2014). *Cultural Preservation*. London: The Project of Ecotrust.

Resker, J. S., & Suhadolnik, N. V. (2013). *Modernization of Chinese culture: continuity and change*. Newcastle, UK: Cambridge Scholars Publishing.

Sen, A. (2015). Does globalization equal westernization? *The Globalist. Rethinking Globalization*. Retrieved December 25, 2016, from http://www.theglobalist.com/does-globalization-equal-westernization/

Slaten, K. (2010). A War on westernization in China. *China/Divide*, March 1 Edition, 16-19.

Sorensen, L. (2014). Modernization and the Third World. *Global Studies 410 – Gender Identity*. Retrieved December 23, 2016, from http://the_imperfect_planet.tripod.com/sorensenportfolio/id10.html

Stafford, L. B. (2013). Cultural heritage preservation in modern China: Problem, perspectives and potentials. *Asia Network Exchange*, 21(1), 1–13.

Thai, N. (2010). Is globalization the western cultural imperialism? The case of Singapore. *Journeys*. Retrieved December 25, 2016, from https://jjourneys.wordpress.com/2012/06/08/is-globalisation-the-western-cultural-imperialism-the-case-of-singapore/

UNESCO. (2009). *UNESCO Framework for cultural statistics*. Paris: UNESCO.

UNESCO. (1982). *Mexico City declaration on cultural policies. World conference on cultural policies*. Mexico City, Mexico: United Nations.

Wambu, O. (2015). Tradition versus modernity. *New African Magazine*. Retrieved August 30, 2016, from http://newafricanmagazine.com/tradition-versus-modernity/

Watson, J. L. (2016). Cultural Globalization. *Encyclopedia Bitannica*. Retrieved September 8, 2016, from https://www.britannica.com/science/cultural-globalization

Watt, L. (2013). *History vs. history as China plans to rebuild past*. Beijing Cultural Heritage Protection Centre. Retrieved January 14, 2017, from http://en.bjchp.org/?p=5098

Zhu, G. (2012). China's architectural heritage conservation movement. *Frontiers of Architectural Research*, 1(1), 10–22. doi:10.1016/j.foar.2012.02.009

KEY TERMS AND DEFINITIONS

Confucianism: A system of ethical and philosophical teachings founded by Confucius, developed by Mencius, and later used to educate the general public.

Cultural Globalization: Process whereby particular cultures, meanings, ideas, values, and experiences are disseminated throughout the world through various means.

Cultural Imperialism: A process whereby the culture or language of a dominant nation is promoted and subtly injected into another country.

Cultural Preservation: The act of using deliberate and well-designed methodologies to maintain cultural heritage from the past for the benefit of the present and future generations.

Indigenization: Process whereby foreign concepts are adapted to suit local contexts.

McDonaldization: A process whereby the principles of fast-food restaurants more and more dominate various sectors of a society.

Modernization: Process of socio-economic transformation whereby a nation changes from a pre-modern to a modern stage.

Westernization: Social process whereby a given nation or society systematically comes under or adopts/absorbs Western cultural values at multiple levels of its life.

Chapter 17
The Nature and Scope of Cultural Heritage Resources Management in South Africa

Anton C. van Vollenhoven
University of North-West, South Africa

ABSTRACT

The main aim of this chapter is to provide assistance to institutions and individuals involved in cultural heritage management (for example, contract work), especially entry level. An overview of important aspects to take note of are given and some are discussed in detail. The concept of protection as indicated in the National Heritage Resources Act, the methodology of heritage resources management (also known as CRM), the concept of cultural significance, and the way of dealing with graves are all defined. This is placed in a global perspective by including applicable international conventions related to the protection of heritage. Information on the cultural context within South Africa is given to provide an understanding of possible issues to be dealt with. The result is a reference guide for the management of the cultural heritage of South Africa.

INTRODUCTION

Heritage legislation in South Africa is amongst the most progressive in the world (Van Vollenhoven, 2003a). The lack of knowledge about the NHRA and the capacity problems experienced within heritage agencies unfortunately creates a situation where the act is not as effective as it should be.

The main objective of this chapter is therefore to assist South African institutions and individuals involved in cultural heritage management (for instance, contract work). It gives an overview of important aspects to take note of and discuss in detail, such as definitions, the concept of protection as indicated in the National Heritage Resources Act (NHRA), the methodology of heritage resources management (also known as cultural resources management [CRM]), the concept of cultural significance, and the way of dealing with graves.

DOI: 10.4018/978-1-5225-3137-1.ch017

Apart from the NHRA, other applicable legislation will also be noted. A brief overview of institutions dealing with heritage in South Africa will be given, and the role of the South African Heritage Resources Agency (SAHRA) will be discussed. The complex three-tier system of heritage management will also receive attention.

Heritage management in South Africa is placed into an international context with a short discussion of the most important international charters related to preservation and conservation. Finally, the South African cultural context is briefly referred to in order to facilitate an understanding of the potential heritage sites to be dealt with.

BACKGROUND

The creation of infrastructure during development projects is increasingly threatening cultural resources all over the world. It is no different in South Africa. During these development activities, which may include mining, infrastructure development, housing, among others, the cultural heritage resources are affected and are in danger of being destroyed or damaged.

It is, however, not possible to preserve all cultural resources, as it may not be economically viable or because there may be a number of similar heritage sites. It therefore is of the utmost importance that a balance needs to be struck between progress (development) and the conservation of cultural resources.

Cultural heritage resource management, sometimes called cultural resources management (CRM), deals with the minimisation of impact on the fragile heritage. This gave rise to the concept of heritage management, mainly (but not exclusively) dealt with by private heritage practitioners.

The aims of CRM involves inter alia that an economically viable solution is being found where the human (cultural) environment can coexist with modern-day developments. One such option is the possible tourism value that can be derived from properly managed heritage sites.

Before continuing, it is necessary to define a few principal concepts related to heritage management.

- **Culture:** The concept of culture has been defined many times before. A basic definition is that it includes everything made by humans (Coertze, 1977). This includes physical objects such as furniture and consumer goods, but also intangible creations such as music, language, and religion (Burden, 2000).
- **Heritage:** Heritage refers to the legacy from the past (Meyer, 1995).
- **Conservation:** All the processes used to maintain a place or object in order to keep its cultural significance. The process includes preservation, restoration, reconstruction, and adaptation (ICOMOS, 2013).
- **Preservation:** This is the action of ensuring that something is not neglected or lost (protection) and includes maintenance of the fabric of such a site in its existing state (ICOMOS, 2013).
- **Restoration:** To bring a place or object back as close as possible to a known state, without using any new materials (ICOMOS, 2013).
- **Reconstruction:** To bring a place or object as close as possible to a specific known state by using old and new materials (ICOMOS, 2013).

- **Rehabilitation:** The repairing and/or changing of a structure without necessarily taking the historical correctness thereof into account (NMC, 1983).
- **Adaptation:** Adaptation means changing a place to suit the existing use or a proposed use (ICOMOS, 2013).
- **Heritage Management:** The concept of CRM developed in the United States during the 1970s. From here it gradually reached Europe, Britain, Australia, and New Zealand. It later also spread to the African continent where it reached South Africa in the early 1990s (Van Vollenhoven, 1998).

The first African state to promulgate legislation aimed at the protection of cultural resources was Nigeria in 1953. It was however only during the 1970's that the protection of heritage resources became effective when additional legislation was proclaimed (Agbaje-Williams, 1996; Folorunso, 1996). Historical sites in Kenia were protected since 1927 by virtue of legislation. During the 1980's the protection of heritage resources were emphasized by including legislation as a section in the constitution of this country (Wandibba, 1996). Mozambique developed heritage legislation between 1988 and 1994, but as is the case in afore mentioned countries, protection for cultural resources are still lacking (Macamo, 1996).

Heritage management is more effective in Botswana, where legislation in this regards was promulgated first in 1970. The concept of 'Cultural Resources Management' has been actively promoted here since 1985 (Van Waarden, 1996). In Zimbabwe heritage for a long time only focused on the protection of large stone ruins. After the establishment of the National Museums and Monuments Council of Zimbabwe in 1991, this changed so that heritage management it practised more regularly and includes other historical sites (Pwiti, 1997; Ndoro, 2001). Heritage management in South Africa will be discussed in this chapter.

Scholars seem to largely agree about this concept. Definitions tend to stress the philosophy and methodology of the conservation of cultural resources, management principles (planning, organisation, control, guidance), conservation requirements, the conservation or management of such resources to benefit the community, community involvement, and the sensitisation and education of the community (see, for instance, Fowler, 1982; Renfrew & Bahn, 1991; De Jong, 1995).

Heritage management therefore implies the management of cultural resources and can be defined as follows:

Heritage management is the application of management techniques to conserve and develop cultural resources, so that they remain part of a cultural heritage with long-term value and benefit for the general public (community). (Van Vollenhoven, 1998)

Cultural Resources: Here, too, there is a lot of agreement about the concept. Descriptions emphasise physical objects made by humans, but also include the nonmaterial or spiritual dimension and emphasise that cultural resources must be valuable to people and meet certain needs of communities (see, for instance, Coetzee, 1994; De Jong, 1995; Küsel, 1997). Cultural resources are nonrenewable and are, for instance, listed broadly in the NHRA as:

- Places, buildings, structures, and equipment of cultural significance
- Places to which oral traditions are attached or which are associated with living heritage
- Historical settlements and townscapes

- Landscapes and features of cultural significance
- Geological sites of scientific or cultural importance
- Sites of archaeological and paleontological importance
- Graves and burial grounds
- Sites of significance relating to the history of slavery
- Movable objects (such as archaeological, paleontological, meteorites, geological specimens, military, ethnographic, books) (Republic of South Africa, 1999).

The latter point should be noted, as it is common that reference is only made to sites and structures when dealing with heritage matters. Moveable objects are as important and are therefore particularly mentioned in the NHRA.

Cultural resources can therefore be defined as all unique and nonrenewable, intangible (spiritual) and material phenomena (natural or made by humans) that are associated with human (cultural) activities. This includes sites, structures, and artefacts to which an individual or group attaches some value with regard to its historic, archaeological, architectural, spiritual, and human (cultural) development (Van Vollenhoven, 1998).

MAIN FOCUS OF THE CHAPTER

The main focus of this chapter is to be of assistance to institutions and individuals involved in cultural resources or heritage management. Not much has been written from a South African perspective in this regard. In fact, contributions about heritage made over the last few years in some of the accredited journals are site specific and rarely discuss the broad framework thereof (see, for instance, the *South African Archaeological Bulletin, South African Journal of Cultural History*).

The chapter therefore aims to give an overview of important aspects with regard to heritage management and uses the NHRA (Act No. 25 of 1999) as starting point. In order to place this in a global context, reference is made to international conventions related to the preservation of heritage. The methodology of heritage resources management is derived from these documents, as well as the guidelines provided by the South African Heritage Resources Agency (SAHRA).

Finally, the South African cultural context, meaning the chronology of the history of the country, is briefly discussed. Thus the background is given for the application of heritage management in South Africa.

THE AIM OF HERITAGE MANAGEMENT

Heritage management has two sets of aims. The first deals with the methodological side and the second is community based.

Methodological aims:

- The location and documentation of cultural resources
- Producing inventories and valuing cultural resources
- Conserving and protecting cultural resources

- Studying the influence of human activities (such as development projects on the environment and heritage resources)
- Making alternative proposals during development projects
- Reconciling and coordinating conservation and development objectives (the quest for a form of symbiosis, an equilibrium, or a balance between the advantages and disadvantages, the positive and negative impacts of development and conservation)
- Rescue work (Van Vollenhoven, 1993)

 Community-based aims:

- Making people aware of heritage, its importance, use of, and interaction with the environment and the community
- Motivating people to take responsibility for the protection and responsible utilisation of cultural resources
- Cultivating the necessary skills and values with regard to the effective conservation and responsible utilisation of cultural resources
- Identifying meaningful cultural resources worthy of being conserved together with the community
- Supplying the development and implementation of appropriate policy and strategies for the effective protection and responsible utilisation of cultural resources (Clift, 1993)

 It is important to note that communities are the custodians of their heritage and that they often provide the catalyst for the protection of cultural resources. Heritage managers should actively be aware of such issues and assist communities in enhancing their heritage. In fact, the NHRA clearly states that local communities are an important role player in heritage management (Republic of South Africa, 1999). This is especially true in Africa, where communities for a long time have not been included in the process of heritage management of sites linked to them and have even been denied access thereto (Ndoro, 2001).

HERITAGE LEGISLATION IN SOUTH AFRICA

Various laws apply to cultural heritage resource management and the implementation of impact studies within a multidisciplinary context as discussed below.

Legislation About Heritage Resources and Heritage Management

- The National Heritage Resources Act (Act No. 25 of 1999) – to be discussed later and referred to in this chapter as Republic of South Africa 1999a
- The National Heritage Council Act (Act No. 11 of 1999) – referred to in this chapter as Republic of South Africa 1999b
- The Cultural Institutions Act (Act No. 119 of 1998)
- Cultural Laws Second Amendment Bill (B46 of 2000)

Legislation Regarding Environmental Conservation

- The Environmental Conservation Act (Act No. 73 of 1989)
- The National Environmental Management: Protected Areas Act (Act No. 57 of 2003)
- The National Environmental Management: Biodiversity Act (Act No. 10 of 2004)
- The National Environmental Management Act (Act No. 107 of 1998) –
- Section 2(4)(iii) of this act constitutes that it is compulsory to do a heritage impact assessment when any disturbance to the landscape or sites that will influence the cultural heritage is engaged in.

Legislation Regarding Mining

The Minerals Amendment Act (Act No. 103 of 1993) – The Minerals Act is an important indicator of heritage, as mines are required to compile environmental management programme (EMP) reports. The EMP requires cultural resources within mining areas to be identified and management guidelines to be proposed regarding the preservation of such cultural resources.

Legislation Regarding the Exhumation and Reinterment of Human Remains

- The Human Tissues Act (Act No. 65 of 1983)
- The Ordinance on Exhumations (No. 12 of 1980)
- The National Heritage Resources Act (Act No. 25 of 1999)

These laws describe procedures for the exhumation and reburial or reinterment of human remains that have been buried for less than 60 years. These acts inter alia refer to applications by landowners (exhumation and reburial) to the national government, applications to provincial government, public participation, the handling of human skeletal materials. The latter law applies when tombstones and the content of graves are older than 60 years.

Other Applicable Legislation

Almost every act may have an effect on cultural heritage, and therefore the list is almost endless. The most important, however, are the following:

- National Film and Video Foundation Bill (B17B of 1997)
- Tourism Act (Act No. 72 of 1993)
- National Parks Act (Act No. 57 of 1976)
- (Also see the Appendix A)

THE NATIONAL HERITAGE RESOURCES ACT (ACT NO. 25 OF 1999)

The act makes provision for the establishment of a government agency tasked with the management of the cultural heritage of South Africa. This body is called the South African Heritage Resources Agency (SAHRA).

An important aspect of this act is that it indicates that any place that has cultural importance to society deserves protection. It also emphasises that cultural resources are nonrenewable. In the act it is described how these can be classified as Grade I, Grade II, and Grade III cultural resources. This refers to the perceived importance of heritage sites and the relevant level of government that would be responsible for the management thereof (see later).

The protection of heritage resources is vested in two ways. These are formal protection and general protection (Republic of South Africa, 1999a).

Formal Protection of Cultural Resources

This category includes sites with heritage value that are formally declared by means of a notice in a government gazette. The following subcategories are set out in the act (Section 27-33):

- National heritage sites
- Provincial heritage sites
- Protected areas
- Heritage registers
- Heritage areas
- Provisional protection
- Heritage objects

National Heritage Sites

These are sites with unique characteristics which are of national importance. Such sites are declared Grade I heritage resources.

The following criteria (ICOMOS, 1964, 2013; Kerr, 1985) are used to determine the grading:

- Cultural significance (for example, the Voortrekker Monument in Pretoria or Mapungubwe in the Limpopo Province)
- Social significance (for example, Freedom Park in Pretoria)
- Historical significance (for example, the Magersfontein battlefield close to Kimberley or Robben Island close to Cape Town)
- Aesthetic (architectural) significance (for example, the Union Buildings in Pretoria or the Castle of Good Hope in Cape Town)
- Scientific significance (for example, the Cradle of Humankind in Gauteng)

Provincial Heritage Sites

These are sites with unique characteristics that are of provincial importance. Such sites are declared Grade II heritage resources.

The same criteria as indicated earlier are used to determine the grading:

- Cultural significance (for example, the Paul Kruger church in Pretoria or Lake Funduzi in Limpopo
- Social significance (for example, the Solomon Mahlangu monument in Mamelodi)
- Historical significance (for example, the Rorke's Drift battlefield or uMgungundlovu, both in KwaZulu-Natal)
- Aesthetic (architectural) significance (for example, Fort Klapperkop in Pretoria or Groot Constantia in Cape Town)
- Scientific (for example, the Tswaing meteor crater north of Pretoria)

Protected Areas

This refers to the land surrounding a heritage site that is declared together with the site in order to protect the view. An example is the area around the house of President Paul Kruger in Pretoria, which was declared to prevent the house from being dwarfed in by development.

Heritage Registers

Heritage registers are a register of all the heritage sites in each province and have to be kept by the provincial heritage resources agencies of the different provinces. The register also indicates the grade of each site (Grade I, II, or III—the latter are sites of local importance).

Heritage Areas

This refers to large areas that are of natural or cultural significance and can include various heritage sites within their boundaries. An example is the Wonderboom Nature Reserve in Pretoria, which includes the 'Wonderboom' fig tree, a fort, some Iron Age sites, and caves containing cultural artefacts.

Preliminary Protection

This entails the temporary protection of any heritage site or area for a period of two years by either SAHRA or one of the provincial heritage agencies. Local authorities can implement provisional protection for a period of three months.

This is done when there is uncertainty about the significance of a site or when research is needed to clarify certain aspects. The declaration is then used to do research or negotiate in order to obtain clarification.

Heritage Objects

The act gives the following list of heritage objects:

- Objects taken from the soil or water of South Africa, including archaeological and palaeontological objects, meteorites, and rare geological objects
- Objects of ethnographic art or ethnography
- Military objects
- Objects of decorative art
- Objects from the fine arts
- Objects of scientific or technological importance
- Books, records, documents, photographic positives and negatives, graphic material (including film or video), and sound recordings
- Any other prescribed category

General Protection for Cultural Resources

The general protection of heritage resources refers to sites that are automatically being protected. It therefore does not need to be officially declared. The following subcategories are indicated (section 33-38):

- Objects protected by legislation in other countries
- Archaeology, paleontology and meteorites
- Graveyards and graves
- Structures
- Public monuments and memorials
- Management means

Objects That Are Protected by Legislation in Other Countries

Such objects may not be imported into South Africa without the necessary permits. This section of the act also links with international conventions for control over the illicit export of stolen cultural goods.

Archaeology, Palaeontology and Meteorites

Permits are needed to:

- Destroy, damage, excavate, alter, deface, or disturb any archaeological or paleontological site or any meteorite
- Destroy, damage, excavate, remove from its original position, collect, or own any archaeological or paleontological material or object or any meteorite
- Trade in, sell for private gain, export, or attempt to export from the republic any category of archaeological or paleontological material or object, or any meteorite
- Bring onto or use at an archaeological or paleontological site any excavation equipment or any equipment that assists in the detection or recovery of metals or archaeological and paleontological material or objects, or use such equipment for the recovery of meteorites
- Alter or demolish any structure or part of a structure that is older than 60 years as protected.

Graveyards and Graves

Permits are required to:

- Destroy, damage, alter, exhume, or remove from its original position or otherwise disturb the grave, any burial ground, or part thereof of:
 - A victim of conflict
 - Older than 60 years and is situated outside a formal cemetery administered by a local authority
- Bring onto or use at a burial ground or grave any excavation or any equipment that assists in the detection or recovery of metals.

Structures

All structures older than 60 years are protected and may only be changed or demolished if a permit has been issued. This implies that gravestones older than 60 years are also protected under this 60-year clause.

Public Monuments and Memorials

Monuments and memorials on public land or erected by public funds are automatically protected. They receive the same protection as heritage resources in the heritage registers. This implies that such monuments and memorials are protected, irrespective of age.

Management Means

The act provides certain management means to assist regarding heritage resources management.

Other Stipulations

The so-called 60-year clause in the act specifies that anything older than 60 years is protected (Republic of South Africa, 1999a). It is important to note that this actually is only the first criterion. Hereafter, other aspects are investigated to determine the cultural significance of a building, site, object, or other heritage feature, and to determine whether it indeed is worthy of being conserved.

There are no exceptions before the law. This means that no kind of development is exempted from any stipulation under heritage legislation.

All heritage objects are deemed to be government property. In actual fact this means that the government is the custodian and that the private owner of such a site cannot make changes without going through the necessary permit application process. This also means that the government fulfils a watchdog role to ensure the protection of the entirety of the South African heritage.

It remains the responsibility of the owner (which, of course, may be the government in certain instances) to maintain a heritage site. An order for obligatory repair of such sites can be issued to owners, and in extreme cases the relevant heritage authority will take the necessary measures to carry out the needed work, for the account of the owner.

The act emphasises the importance of local communities with regard to their heritage and specifically makes mention of consultation with communities when graves are to be affected by development.

Furthermore, communities with a bona fide interest in cultural objects or sites that are kept in a public institution (a museum for instance) can institute a claim for the return of the object. It is important to bear in mind that a process of negotiation is needed, as everything cannot be returned without careful consideration. The spirit of the law definitely is that artefacts should be returned to their place of origin or as close as possible thereto. It is important that these original places provide proof that they are in a position to properly curate these objects.

The following criteria are used in order to determine heritage importance (Section 3(3)):

- The resources must be important to the course of or important in the events of South African history.
- The resource must be an unusually rare or endangered aspect of South Africa's natural or cultural heritage.
- Sites that potentially contain information important for an understanding of South Africa's natural or cultural heritage.
- Sites that may be regarded as important due to their ability to demonstrate or depict important features of the natural or cultural environment or objects of a particular group in South Africa.
- Sites that may be regarded as important because they reveal features to which a particular community or cultural group attaches particular aesthetic values.
- Sites that display a high degree of creative or technological achievement (from a particular period).
- The resource must be very strongly associated or linked with a particular community with regard to social, cultural, or religious aspects.
- Such sites can also be strongly associated with the work and life of an important person, group, or organisation in South African history.

THE ADMINISTRATIVE HERITAGE SYSTEM IN SOUTH AFRICA

Various institutions are involved in heritage management. Some are directly involved due to legislation, but others are involved more indirectly. Institutions that are directly involved due to legislation are state departments, developers, and the SAHRA. Institutions that are involved indirectly include research institutions such as universities, consultants, museums, and the community.

The Department of Environmental Affairs normally coordinates all interested and affected parties when environmental impact studies are undertaken. The Department of Mineral and Energy Affairs is involved when EMPs are undertaken for mines.

The role of the community in the protection of heritage is steadily increasing. The community forms part of interested and/or affected parties identified in the legislation. Public involvement is required by the NHRA, environmental conservation legislation, and the Human Tissues Act.

The community has rights regarding its residential areas (for example property values, aesthetic appearances, changes to or destruction of residential areas or the environment, security in residential areas). Thus, communities can form pressure groups during development activities when environmental impact studies are done (Schoeman, 1987). The communities concerned should be consulted as early as possible whenever development activities are planned. The proposed development should also benefit the community concerned.

Specialists therefore have a public responsibility regarding the research or studies that are conducted. The community must be educated regarding its responsibilities with respect to conservation and its rights with respect to environmental conservation issues, but can also be a valuable source of knowledge for specialists. Moreover, the community must also be alerted to both the positive and the negative impacts of development.

The South African Heritage Three-Tier System

On a national level South African heritage is handled by the SAHRA. When dealing with Grade I sites, SAHRA has to be involved.

In each of the nine provinces, a provincial heritage agency was established to manage Grade II sites. In the Western Cape, this agency is called Heritage Western Cape; in KwaZulu-Natal, it is called AMAFA; and in Limpopo, LIHRA. In the other provinces, it is known as the Provincial Heritage Resources Agency of that specific province. For instance, in Gauteng, it is the PHRA-G.

The provincial bodies are regularly assessed by SAHRA to determine its competency to function in accordance with the act. In most cases they are only competent to deal with the built environment. Other aspects (such as archaeology) for which they were not deemed competent remain a function of SAHRA (Republic of South Africa, 1999a).

The third tier is that of local government, but none of the local authorities has yet been declared competent to perform this function. The task then remains either with the provincial agencies or SAHRA. The eventual aim is that Grade III sites will be managed by local authorities in a similar manner as is done by the SAHRA or provincial authorities.

The owner of a heritage site remains responsible for the management and maintenance of such a site. The applicable heritage body therefore has to be consulted and grant permission for any work to be done on such sites and also handles demolition applications. Any application to declare a building or site also is lodged with the applicable heritage authority, for example, for national (Grade I) status to SAHRA and for provincial (Grade II) status to the relevant province.

There is a specific unit within SAHRA working with graves. It is called the Burial Grounds and Graves (BGG) unit. Any application where graves may be affected has to be lodged with them.

Everything else that is of heritage significance but that is not officially declared automatically becomes a Grade III site. These heritage resources are assessed in line with the prescribed heritage resources assessment criteria, consistent with those indicated in section 3(3) of the NHRA. The assessment is done in terms of the intrinsic, comparative and contextual significance of a heritage resource and the relative benefits and costs of its protection. These resources are placed on the heritage register to be kept by provinces.

Responsibilities and Competence of Heritage Resources

Finally, the act makes it compulsory that heritage impact studies be done whenever a development is planned. These have to be approved by the heritage authorities before work on a site may commence. Such reports should include public consultation, and the decision made by the heritage authorities may be appealed by anyone should they disagree with the decision. This process in the act allows the public scrutiny of reports to ensure the protection of heritage resources (Republic of South Africa, 1999a).

At SAHRA there are different sections, each dealing with a different aspect of heritage. These are:

- Archaeology
- Palaeontology and meteorites
- Rock art
- Private collections
- The built environment
- Burial grounds and graves
- Heritage objects
- Maritime and underwater heritage
- National inventory
- Heritage objects, including museum collections

SAHRA's Inventorying System

SAHRA makes use of an electronic inventorying system called the South African Heritage Resources Information System (SAHRIS). Any institution or individual can register and make use of SAHRIS. For instance, developers can load heritage reports on the system, specialists and researchers can use it as a database to obtain information about the heritage of the areas where they will be working, and the public may use it to obtain information about declared heritage sites.

Currently the system is not linked to the provinces, but in the future it will be rolled down, even to a municipal level. This would create an integrated system for the management of heritage in South Africa (SAHRA, 2016).

THE METHODOLOGY OF HERITAGE MANAGEMENT

Heritage impact studies are usually undertaken as part of environmental impact studies, but can also be done as separate studies. Heritage studies proceed through the three phases as follows:

Phase I: Identification and impact assessment
Phase II: Detailed investigation (research) aimed at the mitigation of impact
Phase III: Management plans (Van Vollenhoven, 1998)

The three phases are not necessarily successive. A management plan sometimes is done directly after the first phase without first doing in-depth research. A management plan can also be compiled for well-known historical landmarks without doing detailed research, as the latter may already be available. This usually happens when the history of such a site is well known and there is motivation to have it officially declared a heritage site.

Phase I or the Initial Impact Study

This phase is designed to identify cultural resources in a particular region or area where development is planned. The aim is not to inhibit development, but to enable informed management decisions. This phase should involve objective identification and analysis of impacts, consideration of realistic alterna-

tives, a quest for solutions, consultation with interested and affected parties, and effective communication of information.

The report in this phase provides a description of earlier research done in the area, the environment, cultural resources found, and the cultural history of the area. It provides a value judgement regarding the cultural resources found and the cultural historical value of the area. The main aim is to determine the impact of development projects on the cultural heritage environment (Fagan, 1991; Deacon, 1996).

During this phase it is established whether further research or investigation will be necessary, research problems are identified, and recommendations proposed about the future of heritage resources (De Jong, 1995). In short, this phase entails a decision on whether a proposed development may continue and an assessment of the conservation potential of heritage resources identified.

Recommendations will therefore usually either indicate that a specific resource is insignificant and that it may not need to be preserved or the heritage resource is significant and must be preserved (Van Vollenhoven, 1995a). The latter will need to be mitigated, whereas in the first case the development may continue.

Phase II or Detailed Study

The aim of this phase is to acquire detailed information about a specific identified heritage resource (Deacon, 1989, 1996,). This is mainly achieved by doing research. Attempts to find a balance between development and conservation create opportunities for innovation, and new options should be developed. These options are unique to every development project and the type of cultural resources that may be affected.

Four possibilities (Van Vollenhoven, 1998) can be considered during Phase II studies, namely:

- The scientific removal (destruction) of heritage resources
- In situ preservation of cultural resources
- Symbiosis between conservation and development
- Subterranean preservation

Scientific Removal (Destruction) of Cultural Resources

When development proceeds, the cultural resources that may be affected are subjected to scientific investigation, and then they may be destroyed by the development project (Hall, 1991). Examples would be a historical house that has to be documented first and an archaeological site that needs to be excavated.

When permission for such destruction is granted, the cultural resources concerned are normally reasonably significant, but not of the highest level of importance. A permit needs to be granted by SAHRA or the provincial agency before any cultural resources may be destroyed.

In Situ Preservation of Cultural Resources

When it is decided that development may not proceed, the cultural resources are developed in situ, for instance, as a site museum (Van Vollenhoven, 1995a). In these circumstances, the cultural resources are highly significant.

A management plan needs to be drafted for the sustainable preservation of such a site. It sometimes needs to be fenced in to protect it from the influence of the development. An application to have it officially declared a heritage site should also be made to the relevant heritage authority.

Symbiosis Between Conservation and Development

This is when an element of the past is incorporated into the present. Development can proceed as long as important elements from the past are preserved in the present. This can be done by a display at the development or the memorialisation of certain elements into the design of the new development (Hall, 1991).

Examples are the preservation of the water reservoir of Governor Wagenaar from the 1600s in the Golden Acre shopping mall in Cape Town, the preservation of a section of an 1898 water furrow in Pretoria, and the buildings of the Western Façade on Church Square, Pretoria.

Subterranean Preservation

This may occur when development continues over the foundations of cultural resources or archaeological remains. It then is protected in situ, but under new structures (Hall, 1991).

Examples are the Jorvik Viking Centre in England, sections of the water furrows in Pretoria, and the Chavonne naval gun battery at the waterfront in Cape Town.

Phase III or Management Plans

This phase is concerned with the sustainable preservation, interpretation, and utilisation of cultural resources (Fagan, 1991; Deacon, 1996). Ideally, a cultural resource study should always conclude with a Phase III management plan (Van Vollenhoven, 1998). Heritage sites will only be officially graded (Gr I-II) if such a management plan has been compiled.

SAHRA and the provincial heritage agencies have guidelines for the drafting of management plans, as well as for reports related to the other two phases. These guidelines may differ from each other, but the core remains the same. The most important sections of such reports include the following:

- History of the site
- Public consultation
- Visual impact
- Association with other sites
- Value judgement
- Determination of impact
- Mitigation
- Determination of cultural significance (Provincial Heritage Resources Agency of Gauteng, n.d.)

GENERAL PRINCIPLES APPLICABLE TO CULTURAL HERITAGE RESOURCES STUDIES

Scholars have compiled general principles that should be kept in mind and are of great assistance when dealing with heritage resources. The most important of these are:

- Heritage practitioners should know the relevant legislation (Van Vollenhoven, 1998).
- The value of cultural resources must be determined as soon as possible to prevent expensive interruptions of development once development proceeds. Coetzee (1994) distinguishes between economic, aesthetic, information, and symbolic values. Criteria to determine value differ from region to region, period to period, and for every type of cultural resource.
- The developer is responsible for the costs of the investigation (Republic of South Africa, 1999a).
- Any cultural objects collected must be donated to a relevant museum for preservation and utilisation (Lynott, 1997).
- As many cultural resources and sites must be preserved as completely as possible, but one has to be prepared to compromise (Fagan, 1991).
- The objectives of cultural resource management must be reconciled with the principles of academic research (for instance publications) (Fagan, 1991; De Jong, 1995).
- The community should be involved in cultural resource management, and they should be informed of decisions (Fagan, 1991; De Jong, 1995; Lynott, 1997).
- Internationally accepted methods of documenting heritage resources should be followed (Butler, 1979).
- If possible, heritage resources should be used for educational purposes. This is only possible if sufficient knowledge is available. One should also strive to utilise the resources in an economic viable way without compromising the cultural integrity of sites (De Jong, 1995; Lynott, 1997).

CULTURAL SIGNIFICANCE

Cultural significance is a core concept in the determination of the importance of a heritage site. The following criteria are used to determine cultural significance (ICOMOS, 1964, 2013; Kerr, 1985):

- Cultural value
- Social value
- Historic value
- Scientific value
- Aesthetic value

These values imply that the 60-year clause mentioned earlier only is a trigger to warn that something has latent significance in terms of heritage. The five values are then used to determine heritage or cultural significance, which then determines whether a site is worthy of conservation and, if so, to which extent (ICOMOS, 2013).

Cultural Value

This refers to the value a heritage site holds for the community or for a section of the community. It is mainly based on the assessment of the other four values. Cultural significance is embodied in the place itself, its fabric, setting, use, associations, meanings, records, related places, and related objects (ICOMOS, 2013).

Social Value

Social value refers to the embracement of qualities for which a place has become a focus of spiritual, political, national, or other cultural sentiments to a majority or minority group. The value is influenced by factors such as how well known a site is, the state of preservation thereof, or the scientific importance thereof and is seen as the most important factor in determining cultural significance (Van Vollenhoven, 2003b).

Historic Value

This value recognises the contribution a place makes to our achievements and our knowledge of the past. The condition of the site is evaluated, and questions asked include whether it is a typical or well-preserved example of a specific style, whether it is unique or has unique characteristics, or if it can be associated with a specific important individual. Historic value is increased by a long contextual history and authenticity (Van Vollenhoven, 2003b).

Scientific Value

Scientific value refers to the potential of a place to provide knowledge and is closely associated with rarity, quality, and representativeness (Van Vollenhoven, 2003b).

Aesthetic Value

Aesthetic value has to do with beauty of design, ambience, association, and mood that a place possesses. It includes design, style, artistic development, and level of craftsmanship (Van Vollenhoven, 1998, 2003b). Clearly this is of great importance when dealing with buildings, and therefore it sometimes is called the architectural value.

INTERNATIONAL CHARTERS RELATED TO MUSEUMS, MONUMENTS, AND CULTURAL HERITAGE

South African heritage legislation is based on international conventions and charters. A larger number of charters and conventions are related to cultural heritage. It would be impossible to discuss or list all of these. Internet searches on the sites of the International Council on Museums and Sites (ICOMOS) and of the United Nations Educational, Scientific and Cultural Organisation (UNESCO) can be utilised to obtain more information.

Four of the more frequently used documents are referred to briefly in order to provide some applicable information. These are:

- The Australian ICOMOS charter for places of cultural significance, also called the *Burra charter*, of November 1999 and adapted in 2013
- The *Venice charter* of 1964 and adapted in January 1996
- The Conservation plan: a guide to the preparation of conservation plans for places of European cultural significance by James Semple Kerr of August 1985
- The International Finance Corporations' performance standard for cultural heritage of 2012

The Burra Charter

The Burra charter is concerned with the implementation of conservation to repair the cultural significance of a place. Article 2 emphasises this and indicates that it includes the protection, maintenance, and future of such a place. Factors to be taken into account in this regard are the context of the ethical, historical, scientific, and social value of a place (ICOMOS, 2013). This clearly is in line with the principles of heritage management explained earlier. Only the most important articles are discussed.

In Article 3 it is stated that work on a heritage site should be done with caution in order to take into consideration the existing material, functions, associations, and meaning of a site. This means that as much change as necessary, but as little as possible, should be implemented.

Articles 4 and 5 go hand in hand. The first indicates that all disciplines that can potentially play a role in studying a place should be used in the study thereof. The latter indicates that all aspects of the cultural significance of a place should be taken into consideration without emphasising any one to the detriment of the others.

In line with what has been discussed earlier, Article 6 emphasizes that the cultural significance is what determines the conservation policy of a place and that this policy provides the rules for the use, changes, protection, and preservation of a historical site.

It is further stated that even the condition of a place gives ample reason for the preservation thereof in terms of cultural significance. Under the explanation of preservation, it includes the protection, maintenance, and stabilisation of structures. Only after research has indicated that not enough information is available on a previous state of the structure, which may be used to recapture and emphasise its cultural significance, may one use the processes of restoration, reconstruction, and adaptation of structures. However, the cultural significance of various periods should be taken into account.

Article 25 elaborates on this further by expressing the view that the cultural significance of a place should be strengthened by supporting information such as photographs, drawings, and material samples. This is very important, as it influences the methodology with regard to the research on places of cultural importance. It includes the documentation of sites by all means available and as completely as possible. It also includes the safekeeping and making available of this documentation and material.

The Venice Charter

The Venice charter is mainly in agreement with the Burra charter. It concludes that historical sites are the most important living witnesses of the past, and therefore heritage is the responsibility of today's generation. Again it emphasises that sites should be conserved in an authentic state (ICOMOS, 1996).

The above mentioned implies that the application of the Venice charter supports the basic conventions for heritage management, and applying it will contribute to the upkeep of international standards in the conservation, preservation, and restoration of historical places.

The Conservation Plan of Kerr

This document also is closely associated with the Burra charter. It gives an explanation of the use of the charter and the steps to be followed in the implementation of the conservation of a historical place.

The plan has two phases. The first deals with establishing cultural significance and includes the collection of information (documents and physical), the analysis of the importance thereof, the assessment of this importance, and making a statement of this importance. Assessment consists of the establishment of criteria for the determination of cultural significance, whilst the stating of the cultural importance is only an explanation thereof.

The second phase entails the conservation plan. Information should be collected from different role players regarding the needs of the client, external needs, requirements for the maintenance of the cultural significance, and the physical condition of the place. Based on this a conservation management plan is developed, a conservation policy is derived, and a strategy for the implementation of the conservation plan is set (Kerr, 1985).

The International Finance Corporations' Performance Standard for Cultural Heritage

This document recognises the importance of the cultural heritage for current and future generations and aims to ensure that clients protect the cultural heritage in the course of project activities (International Finance Corporation, 2012). This needs to be done by clients abiding to the law and having heritage surveys done in order to identify and protect cultural heritage resources (via field studies and documentation of such resources).

It indicates that these studies need to be done by competent professionals (archaeologists and cultural historians among others). This includes a management protocol for possible chance finds encountered during project development and which need to be managed by not disturbing them and by having them assessed by professionals. Similar to the other documents discussed, including the NHRA, it emphasises that impacts on cultural heritage should be minimised and that critical cultural heritage may not be impacted on. This includes the possible maintenance of such sites in situ or, when impossible, the restoration of the functionality of the cultural heritage in a different location.

In the latter case, when the removal of cultural heritage resources is done, it may only be considered if there are no technically or financially feasible alternatives. In considering the removal of cultural resources, it should be outweighed by the benefits of the overall project to the affected communities. The professional work in this regard should only be done by professionals by abiding to the applicable legislation and by using the best available techniques.

The engagement into consultation with affected communities is highlighted. This inter alia entails that access for communities should be granted to their cultural heritage and that the utilisation of cultural heritage should be agreed on with them. This may also include agreements regarding financial issues, such as the equitable sharing of benefits from commercialisation of such a site.

THE SOUTH AFRICAN CULTURAL CONTEXT

A very short discussion of the South African cultural context is provided, as it will sensitise readers as to what is to be expected when working in this country. The chronology on the history of South Africa is divided in three eras: the Stone Age, Iron Age, and Historical Age.

The Stone Age

The Stone Age is the period in human history when lithic material was mainly used to produce tools (Coertze & Coertze, 1996). In South Africa the Stone Age can be divided into three periods. It is, however, important to note that dates are relative and only provide a broad framework for interpretation and that research results in these dates being continuously adapted. The division for the Stone Age according to Korsman and Meyer (1999) is as follows:

- Early Stone Age (ESA) 2 million to 150,000 years ago
- Middle Stone Age (MSA) 150,000 to 30,000 years ago
- Later Stone Age (LSA) 40,000 years ago to 1850 A.D.

The bulk of the rock art of South Africa is associated with the San and Khoi people of the Later Stone Age. Two types of rock art are found: rock paintings and rock engravings. Stone Age sites are frequently found in caves or rock shelters, but in the arid regions, of course, these are open-air sites. They frequently are in close association with water sources (Korsman & Meyer, 1999).

The Iron Age

The Iron Age is the name given to the period of human history when metal was mainly used to produce metal artefacts (Coertze & Coertze, 1996). These people therefore had the skills to either smelt or rework metal into tools.

In South Africa it can mostly be divided in two separate phases according to Van der Ryst and Meyer (1999), namely:

- Early Iron Age (EIA) 200 to 1000 A.D.
- Late Iron Age (LIA) 1000 to 1850 A.D.

In the northern parts of the Limpopo Province, however, Huffman (2007) indicates that a Middle Iron Age should be included. His dates, which are widely accepted in archaeological circles, are:

- Early Iron Age (EIA) 250 to 900 A.D.
- Middle Iron Age (MIA) 900 to 1300 A.D.
- Late Iron Age (LIA) 1300 to 1840 A.D.

Again it needs to be clarified that continuous research is conducted and the dates are therefore adopted accordingly. Overlaps in dates are the result of this, but it also indicates that different groups may have been in different stages of technological development at the same period in time.

Not many Early Iron Age sites have been identified. Research indicates that these are mainly found close to water sources. There is an abundance of the later sites, which are usually against the lower slopes of high-lying ground (mountains, hills) or on top thereof. These sites are characterised by stone walls forming different features, as these people built things like their homes and livestock enclosures from stone (Van der Ryst & Meyer, 1999).

Another feature of these sites is ceramic pottery. The different decorations on the pottery provide information on the cultural groups associated therewith, as well as on the geographical spread of groups of people (Huffman, 2007).

The Historical Age

The Historical Age started with the first recorded oral histories of groups of people in South Africa (Fagan, 1991). Oral histories have been documented by anthropologists. It also includes the moving into the area of people who were able to read and write (Van Vollenhoven 1995b). Therefore, apart from the cultural remains left in the earth (archaeological artefacts), historical sources are also available for research.

Due to factors such as population growth and a decrease in mortality rates, more people inhabited the country during the recent historical past. Therefore, many more cultural heritage resources have been left on the landscape. As indicated earlier, all sites older than 60 years are included as part of the cultural heritage of South Africa.

Graves

Graves, of course, also are historical features, but one also may find even older (archaeological) graves. Four categories of graves exist:

- Younger than 60 years
- Older than 60 years, but younger than 100 years – historical graves
- Older than 100 years – archaeological graves
- Graves of victims of conflict or individuals of royal descent

The last three are considered heritage graves (Republic of South Africa, 1999a). Graves where the date of death is not known are named 'unknown' graves. They are handled similar to heritage graves until more accurate information is received.

Options When Dealing With Graves

Usually there are two options when dealing with graves:

- In situ conservation
- Excavation and relocation

In Situ Conservation

This option is implemented when there is no direct impact from a development on the graves. The site is fenced in and a management plan drafted for the preservation and maintenance thereof. A buffer zone is usually created to safeguard the site. Subsequently the management plan needs to be approved by the SAHRA Burial Grounds and Graves Unit (BGG), and access to descendants should be guaranteed (SAHRA, 2015).

Excavation and Relocation

Option 2 is only permitted in cases where there is a direct impact on the graves and the development cannot be changed. It needs to be approved by the SAHRA BGG unit, after which the necessary permits will be issued. The mortal remains usually are relocated to the nearest municipal cemetery.

A thorough process of social consultation is also implemented in order to obtain consent from families of the deceased. Graves younger than 60 years are handled only by a registered undertaker, but for all other graves (including those with an unknown date of death), an archaeologist is also involved in the process (Van Vollenhoven, 2010).

The grave relocation process consists of nine steps (Van Vollenhoven, 2010):

- Reporting the discovery
- Identification of the buried individual
- Stakeholder identification
- Social consultation
- Authorisation
- Exhumation
- Confirmation of identity
- Reinterment
- Heritage report

Reporting the Discovery

The discovery of all graves not located in a formal cemetery administered by a recognised local authority should be reported to the regional representative of the SAHRA and the South African Police Service (SAPS). SAHRA and the SAPS should visit the site and are required to advise regarding heritage-related and possible criminal and judicial and legal issues (Republic of South Africa, 1999a).

Identification of the Buried Individual

The four categories of graves mentioned earlier are used for this purpose. The graves to be relocated should be classified as accurately as possible into these categories. A concerted effort should also be made to identify the specific buried individual. These tasks must be accomplished by the heritage survey and social consultation process already in place (Van Vollenhoven, 2010).

Stakeholder Identification (Public Consultation)

Section 36 (3)(a) of the National Heritage Resources Act 25 of 1999 reads that no person may, without a permit issued by SAHRA or a provincial heritage resources authority:

- Destroy, damage, alter, exhume or remove from its original position or otherwise disturb the grave of a victim of conflict, or any burial ground or part thereof which contains such graves;
- Destroy, damage, alter, exhume, remove from its original position or otherwise disturb any grave or burial ground older than 60 years which is situated outside a formal cemetery administered by a local authority; or
- Bring onto or use at a burial ground or grave referred to in paragraph (a) or (b) any excavation equipment, or any equipment which assists in the detection or recovery of metals.

Furthermore, Section 36 (5) of the act reads that SAHRA or a provincial heritage resources authority may not issue a permit for the exhumation of graves unless it is satisfied that the applicant has, in accordance with regulations made by the responsible heritage resources authority:

- Made a concerted effort to contact and consult communities and individuals who by tradition have an interest in such grave or burial ground; and
- Reached agreements with such communities and individuals regarding the future of such grave or burial ground.

In terms of social consultation and permits issued by SAHRA, these sections from the act mean that a permit will only be supplied if a "concerted effort" has been made to "contact and consult" the relatives or persons associated with those specific graves. Normally, such a social consultation process would (at a minimum) consist of the following (SAHRA, 2015):

- Full documentation of the entire social consultation process, including signed permission forms from the closest relatives providing permission for the grave to be relocated
- Site notices (in the format and for the duration required by the act) and proof thereof
- Newspaper notices and proof thereof
- Documentary proof of the social consultation process (i.e., minutes of meetings held with family members/affected parties)

Authorisation

This component incorporates obtaining permissions, permits, and authorisations from the relevant compliance agencies. Different legislation applies to the different categories of graves.

Graves younger than 60 years fall under Section 2(1) of the Removal of Graves and Dead Bodies Ordinance (Ordinance No. 7 of 1925) as well as the Human Tissues Act (Act No. 65 of 1983). These graves fall under the jurisdiction of the national department of health and the relevant provincial department of health and must be submitted for final approval to the office of the relevant provincial premier. This function is usually delegated to the provincial member of the executive council (MEC) for local government and planning or, in some cases, the MEC for housing and welfare (Van Vollenhoven, 2010).

Authorisation for exhumation and reinterment must also be obtained from the relevant local or regional council where the grave is situated, as well as the relevant local or regional council to where the grave is being relocated. All local and regional provisions, laws, and bylaws must also be adhered to. The institution undertaking the relocation must be authorised under Section 24 of the Human Tissues Act to handle and transport human remains (Republic of South Africa, 1983).

Graves older than 60 years but younger than 100 years fall under the jurisdiction of two acts, namely the National Heritage Resources Act (Section 36) and the Human Tissues Act. For graves older than 60 years and unknown graves located outside a formal cemetery, the procedure for consulting regarding burial grounds and graves (Section 36(5) of the Heritage Resources Act is applicable.

However, graves older than 60 years but younger than 100 years that are located within a formal cemetery administered by a local authority will also require the same authorisation as set out for graves younger than 60 years over and above SAHRA authorisation. If the grave is not located within a formal cemetery but is to be relocated to one, permission must also be acquired from the local authority and all regulations, laws, and bylaws set by the cemetery authority must be adhered to. The institution undertaking the relocation must be authorised under Section 24 of the Human Tissues Act to handle and transport human remains. A qualified archaeologist accredited by SAHRA must personally supervise any alteration to or relocation of graves in this category (SAHRA, 2015).

Graves older than 100 years are classified as archaeological and are protected in terms of Section 35 of the National Heritage Resources Act. Authorisation from SAHRA is required for these graves. A qualified archaeologist accredited by SAHRA must also supervise any alteration to or relocation of graves in this category (SAHRA, 2015).

At the discretion of SAHRA, the procedure for consultation regarding burial grounds and graves (Section 36(5) of the NHRA) might also be required. If the grave is situated in a cemetery administered by a local authority, the authorisations as set out for graves younger than 60 years are also applicable over and above SAHRA authorisation. Again, the institution undertaking the relocation must be authorised under Section 24 of the Human Tissues Act to handle and transport human remains (Republic of South Africa, 1983).

All graves of victims of conflicts, regardless of age or where they are situated, are protected by the NHRA (Republic of South Africa, 1999a). SAHRA authorisation is required for all graves in this category. Any alteration to a grave in this category or the relocation thereof must be personally supervised by a qualified archaeologist accredited by SAHRA.

If the grave is situated in a cemetery administered by a local authority, the authorisations as set out for graves younger than 60 years are also applicable over and above SAHRA authorisation. On the discretion of SAHRA the procedure for consultation regarding burial grounds and graves (Republic of South Africa, 1999a) might also be required. In order to handle and transport human remains, the institution conducting the relocation should be authorised under Section 24 of the Human Tissues Act (Republic of South Africa, 1983).

Exhumation

The methods employed during exhumation will aim to recover all the remains, to minimise damage to the remains, to record the three-dimensional context of the remains, and to preserve and respect the dignity of the buried individual (SAHRA, 2015). All evidence that might allude to the events leading to the death of the individual and circumstances regarding the event will be recorded and interpreted.

The aim of the excavation should be the in situ exposure of the burial and associated artefacts (Nienaber & Steyn, 1999). The focus should be on accurate and complete documentation (Nienaber, 1997). Various methods for the excavation of graves have been proposed by different authors (Hester et.al., 1975; Morse, 1978; Joukowsky, 1980; Krogman & Iscan, 1986), but all stress the need for adequate workspace around the exposed remains and a systematic approach to the removal of individual bones.

The archaeological method, including extensive test trenching to prevent damage to the remains, should be employed. This approach should be largely similar to that of forensic archaeology where buried bodies are concerned. This approach should be adapted for the situation since graves vary in shape, size, depth, and content (Nienaber, 1999). The methods of forensic archaeology are discussed in detail by Steyn, Nienaber, and Iscan (2000).

Confirming the Identity of the Buried Individual (Analysis)

Physical anthropological analysis of remains of archaeological origin could be required at the discretion of SAHRA. Where any doubts exist regarding the identity of exhumed remains, a physical anthropological analysis aiming to help confirm or ascertain the identity should be conducted. This can be accomplished by comparing the results of the reconstruction of certain characteristics of the remains with known facts regarding the individual. Data on the remains should be recorded in a suitable format (such as that proposed Buikstra & Ubelaker, 1994) for future reference and comparison.

The techniques that are applied should aim to achieve the reconstruction of individuals rather than the study of populations. The only parallel methodology that exists includes the techniques of forensic anthropology that also aim to ascertain the identity of individuals (Krogman & Iscan, 1986). Where possible, deductions regarding pathology, health, and other indicators of stress should be considered during a reconstruction of events and the interpretation of evidence.

Reinterment

In most cases the remains are reburied. This will be done by a registered funeral undertaker acting in compliance with the relevant local regulations, laws, and bylaws stipulated by the cemetery authority. The ceremony will be organised with the full participation of stakeholders and according to the wishes of the concerned families where these are identified (SAHRA, 2015).

Sometimes, if the outcome of the social consultation allows for the curation of the remains (i.e., reinterment is not required by the identified families, persons, or communities), the remains should be handed over for curation to a collaborating institution under the National Heritage Resources Act (Republic of South Africa, 1999a) authorised under Section 24 of the Human Tissues Act (Republic of South Africa, 1983).

Heritage Report

Reports compliant with the stipulations of the relevant legislation have to be submitted as required by the relevant compliance agencies. All the information gathered needs to be included (SAHRA, 2015).

Copies of all reports should be made available to the families and other stakeholders on request. In fact, all stakeholders are to have access to information generated by the project at any stage.

CONCLUSION

It is clear that heritage management in South Africa has a firm basis consisting of various pieces of legislation. The most important is the National Heritage Resources Act (Act No. 25 of 1999), which provides the necessary legal framework to provide the government, cultural institutions, developers, and the public with sufficient information. Additionally the SAHRA and some of the provincial heritage bodies have guidelines and regulations to this effect.

It has also been shown how South African legislation is linked with international norms and standards creating a globally applicable heritage management system. From this the concept of 'cultural significance' was explained as it forms a crucial component in decision making.

Despite the vast amounts of information and management tools available, it seems as if heritage management is not understood well and the legal process is not well known. This chapter provided the much-needed description of the processes involved and an explanation of how heritage is to be dealt with. A broad outline of the South African cultural context provides the necessary understanding of possible issues to be dealt with. The result is a reference guide available to all parties involved in the management of the fragile heritage of South Africa.

REFERENCES

Agbaje-Williams, B. (1996). Some associated problems of archaeological heritage management in Nigeria: Northwest Yorubaland as a case study. In G. Pwiti & R. Soper (Eds.), *Aspects of African Archaeology* (pp. 801–808). Harare: University of Zimbabwe Publications.

Buikstra, J. E. & Ubelaker, D. H. (1994). *Standards for data collection from human skeletal remains.* Fayetteville, AR: Arkansas Archaeological Survey.

Burden, M. (2000). Die metodologie van Kultuurgeskiedenis. *South African Journal of Cultural History, 14*(2), 13–30.

Butler, W. B. (1979). The no-collection strategy in archaeology. *American Antiquity, 44*(4), 795–799. doi:10.2307/279122

Clift, H. (1993). The role of museums in cultural resources management. *The Cultural Historian, 8*(1), 90–95.

Coertze, P. J. (1977). *Inleiding Tot die algemene Volkekunde.* Johannesburg: Voortrekkerpers.

Coertze, P. J., & Coertze, R. D. (1996). *Verklarende vakwoordeboek vir Antropologie en Argeologie.* Pretoria: RD Coertze.

Coetzee, I. (1994). Cultural resources – a tour through our world in one country. In W. Loots (Ed.), *Cultural resources & regional tourism* (pp. 23–32). Pretoria: National Cultural History Museum.

De Jong, R. C. (1995). Cultural resources and how to manage them. In J. W. van den Bos & H. J. Moolman (Eds.), Methodology in research. (pp. 16-34). Sunnyside: SASCH.

Deacon, J. (1989). *Factors to be considered in contracts between historical archaeologists and developers* (Unpublished report). Cape Town: National Monuments Council.

Deacon, J. (1996). Cultural resources management in South Africa: legislation and practice. In G. Pwiti & R. Soper (Eds.), *Aspects of African archaeology* (pp. 839–848). Harare: University of Zimbabwe Publications.

Fagan, B. M. (1991). *In the beginning. An introduction to archaeology*. Glenview, IL: Scot, Foresman & Company.

Folorunso, C. A. (1996). The place of archaeology in heritage management in Africa: the case of Nigeria. In G. Pwiti & R. Soper (Eds.), *Aspects of African Archaeology* (pp. 795–800). Harare: University of Zimbabwe Publications.

Fowler, D. D. (1982). Cultural resources management. In B. Schiffer (Ed.), *Advances in archaeological method and theory V* (pp. 1–50). New York: Academic Press. doi:10.1016/B978-0-12-003105-4.50006-6

Hall, M. (1991). Archaeology's involvement in CRM. A case study. *Muniviro, 8*(1), 1–5.

Hester, T. R., Heizer, R. F., & Graham, J. A. (1975). *A guide to field methods in archaeology*. Palo Alto: Mayfield Publishing.

Huffman, T. N. (2007). *Handbook to the Iron Age: The archaeology of pre-colonial farming societies in Southern Africa*. University of KwaZulu-Natal Press.

ICOMOS. (1964). *International charter for the conservation and restoration of monuments and sites (the Venice charter)*. Venice: ICOMOS.

ICOMOS. (1996). *International charter for the conservation and restoration of monuments and sites (the Venice charter)*. Venice: ICOMOS.

ICOMOS. (1999). *The Burra charter. The Australia ICOMOS charter for places of cultural significance*. Burra: ICOMOS.

ICOMOS. (2013). *The Burra charter: The Australia ICOMOS charter for places of cultural significance*. Burra: ICOMOS.

International Finance Corporation. (2012). *Performance standard 8: Cultural heritage*. Retrieved April 21, 2013, from http://www.ifc.org/wps/wcm/connect/dd8d3d0049a791a6b855faa8c6a8312a/PS8_English_2012.pdf?MOD=AJPERES

Joukowsky, M. (1980). *A complete manual of field archaeology*. Englewood Cliffs, NJ: Prentice-Hall Incorporated.

Kerr, J. S. (1985). *The conservation plan. A guide to the preparation of conservation plans for places of European cultural significance*. Sydney: ICOMOS.

Korsman, S. A., & Meyer, A. (1999). Die Steentydperk en rotskuns. In J. S. Bergh (Ed.), *Geskiedenisatlas van Suid-Afrika. Die vier noordelike provinsies* (pp. 93–95). Pretoria: JL van Schaik.

Krogman, W. M., & Iscan, M. Y. (1986). *The human skeleton in forensic medicine*. Charles C. Thomas.

Küsel, U. (1997). Kultuurhulpbronne. In K. Basson (Ed.), *The development of cultural resources for tourism* (pp. 4–10). Pretoria: National Cultural History Museum.

Lynott, M. J. (1997). Ethical principles and archaeological practice: Development of an ethics policy. *American Antiquity, 62*(4), 589–599. doi:10.2307/281879

Macamo, S. L. (1996). The problems of conservation of archaeological sites in Mozambique. In G. Pwiti & R. Soper (Eds.), *Aspects of African Archaeology* (pp. 813–816). Harare: University of Zimbabwe Publications.

Meyer, A. (1995). From hunting grounds to digging fields: Observations on aspects of cultural heritage management in some national parks. *South African Journal of Ethnology, 18*(4), 159–163.

Morse, D. (Ed.). (1978). *Handbook of forensic archaeology and anthropology.* Tallahassee, TN: Rose Printing Company.

National Monuments Council. (1983). *Aanbevole riglyne vir restourasie van strukture en terreine in Suid-Afrika. Arcadia* National Monuments Council.

Ndoro, W. (2001). Heritage Management in Africa. *The Getty Conservation Institute Newsletter, 16*(3). Retrieved April 21, 2014, from http://www.getty.edu/conservation/publications_resources/newsletters/16_3/news_in_cons1.html

Nienaber, W. C. (1997). Exhumation and reinternment of Burger C. G. Naude. *South African Journal of Cultural History, 11*(1), 123–133.

Nienaber, W. C., & Steyn, M. (1999). Exhumation and analysis of the remains of a black native participant in the Anglo-Boer War (1899-1902), KwaZulu-Natal. *South African Journal of Cultural History, 13*(2), 94–110.

Provincial Heritage Resources Agency of Gauteng. (n.d.). *Report requirements for HIA reports.* Retrieved May 27, 2016, from http://theheritageportal.co.za/sites/default/files/Organisation%20Downloads/PHRA-G%20HIA%20Report%20requirements.pdf

Pwiti, G. (1997). Taking African cultural heritage management into the twenty-first century: Zimbabwe's masterplan for cultural heritage management. *African Archaeological Review, 14*(2), 81–83. doi:10.1007/BF02968367

Renfrew, C., & Bahn, P. (1991). *Archaeology. Theories, methods and practice.* London: Thames & Hudson.

Republic of South Africa. (1976). *National parks act (Act No. 57 of 1976).* Pretoria: The Government Printer.

Republic of South Africa. (1980). *Ordinance on excavations (Ordinance No. 12 of 1980).* Pretoria: The Government Printer.

Republic of South Africa. (1983). *Human tissue act (Act No. 65 of 1983).* Pretoria: The Government Printer.

Republic of South Africa. (1989). *Environment conservation act (Act No. 73 of 1989).* Pretoria: The Government Printer.

Republic of South Africa. (1993). *Tourism Act (Act No. 72 of 1993)*. Pretoria: The Government Printer.

Republic of South Africa. (1993). *Mineral amendment act (Act No. 103 of 1993)*. Pretoria: The Government Printer.

Republic of South Africa. (1997). *National film and video amendment bill (Bill No. 17B of 1997)*. Cape Town: The Government Printer.

Republic of South Africa. (1998). *National environmental management act (Act No. 107 of 1998)*. Pretoria: The Government Printer.

Republic of South Africa. (1998). *Cultural institutions act (Act No. 119 of 1998)*. Pretoria: The Government Printer.

Republic of South Africa. (1999a). *National heritage council act (Act No. 11 of 1999)*. Pretoria: The Government Printer.

Republic of South Africa. (1999b). *National heritage resources act (Act No. 25 of 1999)*. Cape Town: The Government Printer.

Republic of South Africa. (2000). *Cultural laws second amendment bill (Bill No. B46 of 2000)*. Cape Town: The Government Printer.

Schoeman, S. (1987). *Argeologiese en kultuurbestuursversleg. Die posboom museumkompleks, Mosselbaai* (Unpublished report). Stellenbosch: University of Stellenbosch).

South African Heritage Resources Agency. (2015). *Draft SAHRA guidelines to burial grounds and graves permitting policy* (Unpublished document). SAHRIS. Retrieved October 27, 2016, from http://www.sahra.org.za

Steyn, M., Nienaber, W. C., & Iscan, M. Y. (2000). Excavation and retrieval of forensic remains. In J. A. Siegel, P. J. Saukko, & G. C. Knupfer (Eds.), *Encyclopaedia of forensic sciences* (pp. 235–242). Sidcup: Academic Press. doi:10.1006/rwfs.2000.0758

Van der Ryst, M. M., & Meyer, A. (1999). Die Ystertydperk. In J. S. Bergh (Ed.), *Geskiedenisatlas van Suid-Afrika. Die vier noordelike provinsies* (pp. 96–102). Pretoria: J. L. van Schaik.

Van Vollenhoven, A. C. (1993). 'n Argeologiese ondersoek van die Bronkhorstruïne as voorbeeld van kultuurhulpbronbestuur (KHB) (Unpublished scription). Pretoria: University of Pretoria.

Van Vollenhoven, A. C. (1995a). Die bydrae van argeologie tot kultuurhulpbronbestuur (KHB). In J. W. van den Bos & H. J. Moolman (Eds.), Methodology in research (pp. 35-50). Sunnyside: SASCH.

Van Vollenhoven, A. C. (1995b). *Die militêre fortifikasies van Pretoria 1880-1902. 'n Studie in die historiese argeologie*. Pretoria: Heinekor.

Van Vollenhoven, A. C. (1998). *Kultuurhulpbronbestuur (KHB) binne die funksionele konteks van museums in Suid-Afrika* (Unpublished master's dissertation). University of Stellenbosch, Stellenbosch, South Africa.

Van Vollenhoven, A. C. (2003a). Die Wet op Nasionale Erfenishulpbronne. *South African Journal of Cultural History, 17*(2), 23–45.

Van Vollenhoven, A. C. (2003b). Kultuurhulpbronbestuur (KHB) as museumfunksie. *South African Journal of Cultural History, 17*(1), 33–46. doi:10.4314/sajch.v17i1.6315

Van Vollenhoven, A. C. (2010). *The grave relocation process* (Unpublished report). Wonderboompoort: Archaetnos.

Van Waarden, C. (1996). The pre-development archaeology programme of Botswana. In G. Pwiti & R. Soper (Eds.), *Aspects of African Archaeology* (pp. 829–836). Harare: University of Zimbabwe Publications.

Wandibba, S. (1996). The legal basis of conservation in Kenya: a review. In G. Pwiti & R. Soper (Eds.), *Aspects of African Archaeology* (pp. 809–812). Harare: University of Zimbabwe Publications.

KEY TERMS AND DEFINITIONS

Cultural Resources: Cultural resources are all unique and nonrenewable intangible (spiritual) and material phenomena (natural or made by humans) that are associated with human (cultural) activities. This includes sites, structures, and artefacts to which an individual or group attaches some value with regard to its historic, archaeological, architectural, spiritual, and human (cultural) development.

Cultural Significance: The key concept in determining the value of cultural heritage. It consists of five values, namely cultural, social, historic, scientific, and aesthetic significance.

Culture: Everything made by humans, including tangibles and intangibles.

Heritage: The legacy of the human past.

Heritage Management: Heritage management is the application of management techniques to conserve and develop cultural resources so that they remain part of a cultural heritage with long-term value and benefit for the general public.

Impact Assessment: The determination of the impact of development on cultural resources.

Management Plan: A detailed document aimed at the sustainable preservation and utilisation of heritage resources.

APPENDIX

INTERNATIONAL LAWS AND GUIDELINES

United Nations Educational, Scientific and Cultural Organisation (UNESCO)

- UNESCO Convention for the Protection of Cultural Property in the Event of Armed Conflict. The Hague Convention, First Protocol, 1954 and Second Protocol, 1999.
- UNESCO Convention on the Means of Prohibiting and Preventing the Illicit Import, Export and Transfer of Ownership of Cultural Property, 1970.
- Convention for the protection of the world cultural and natural heritage, 1972.
- UN Convention on Biological Diversity, 1992.
- Convention on International Trade in Endangered Species of Wild Fauna and Flora, 1993.
- Unidroit Convention on Stolen and Illegally Exported Cultural Object, 1995.
- UNESCO Convention on the Protection of the Underwater Cultural Heritage, 2001.
- UNESCO Convention for the Safeguarding of the Intangible Cultural Heritage, 2003.
- UNESCO Charter on the Preservation of the Digital Heritage, 2003.

International Council on Monuments and Sites (ICOMOS)

- International Charter for the Conservation and Restoration of Monuments and Sites (The Venice Charter), 1964 and 1996.
- The Florence Charter (Historic Sites and Landscapes), 1982.
- Charter on the Conservation of Historic Towns and Urban Areas (The Washington Charter), 1987.
- Charter for the Protection and Management of the Archaeological Heritage, 1990.
- Charter for the Protection and Management of the Underwater Cultural Heritage, 1996.
- Charter on the Built Vernacular Heritage, 1999.
- International Charter for Cultural Tourism, 1999.
- Principles for the Preservation of Historic Timber Structures, 1999.
- Australia ICOMOS Charter on the Conservation for Places of Cultural Significance (Burra Charter), 1999.
- Charter for the Interpretation and Presentation of Cultural Heritage Sites (Ename Charter), 2006.

South African Legislation

- Arms and weapons
 - Firearms Control Act, Act No. 60 of 2000 and Regulations
 - Firearms Control Amendment Act, Act No. 43 of 2003 and Regulations
- Arts and culture
 - Copyright Act, Act No. 78 of 1978

- ○ Copyright Amendment Bill (B93-2000)
- ○ Cultural Institutions Act, Act No. 119 of 1998
- ○ Culture Promotion Act, Act No. 35 of 1983
- ○ National Archives of South Africa Act, Act No. 43 of 1996
- ○ National Arts Council Act, Act No. 56 of 1997
- ○ National Council for Library and Information Service Act, Act No. 6 of 2001
- ○ National Heritage Council Act, Act No. 11 of 1999
- ○ National Heritage Resources Act, Act No. 25 of 1999
- ○ Pan South African Language Board Act, Act No. 59 of 1995
- ○ Public Holidays Act, Act No. 36 of 1994
- ○ South African Geographical Names Act, Act No. 118 of 1998
- ○ Cape of Good Hope (Province) Museums Ordinance, Ordinance No. 8 of 1975
- ○ Eastern Cape Museums Act, Act No. 7 of 2004 (EC)
- ○ Legal Deposit Act No. 54 of 1997
- Constitutional matters
 - ○ Commission for the Promotion and Protection of the Rights of Cultural, Religious and Linguistic Communities Act, Act No. 19 of 2002
 - ○ Constitution of the Republic of South Africa, Act No. 108 of 1996 as amended
 - ○ Promotion of Access to Information Act, Act No. 2 of 2000 and regulations
 - ○ Promotion of Administrative Justice Act, Act No. 3 of 2000
 - ○ Promotion of Equality and Prevention of Unfair Discrimination Act, Act No. 4 of 2000
 - ○ Protected Disclosure Act, Act No. 26 of 2000
 - ○ Intergovernmental Relations Framework Act No. 13 of 2005
- Education
 - ○ National Education Policy Act, Act No. 27 of 1996
 - ○ South African Council for Educators Act, Act No. 31 of 2000
 - ○ South African Schools Act, Act No. 84 of 1996
- Environment
 - ○ National Environmental Management Act, Act No. 107 of 1998 as amended
 - ○ National Environmental Management: Biodiversity Act, Act No. 10 of 2004
 - ○ National Environmental Management: Protected Areas Act No. 57 of 2003 as amended and regulations
 - ○ Environmental Conservation Act (Act No 73 of 1989)
 - ○ World Heritage Convention Act, Act No. 49 of 1999
- Buildings and property
 - ○ National Building Regulations and Building Standards Act No. 103 of 1977
 - ○ Architectural Profession Act No. 44 of 2000
- Defence and safety
 - ○ National Key Points Act, No. 102 of 1980 (amended 1984 and 1985)
- Graves
 - ○ Human Tissues Act (Act No 65 of 1983)
 - ○ The Ordinance on Exhumations (No 12 of 1980)

Chapter 18
Revitalising the South African Museum Sector:
New Museological Trends

Helene Vollgraaff
University of South Africa, South Africa

ABSTRACT

The chapter discusses the South African museum sector in terms of changing museum functions as well as museum management. The research findings confirm the perception of a sector in crisis. Museum professional associations do not have the capacity to promote a professional museum service. Though there are museum professionals that keep up to date with museological trends and technology, a picture is painted of museums not supported by government departments, debilitating bureaucratic structures that hamper creativity and responsiveness to public demands, institutional performance structures that direct museums away from museum functions, problematic recruitment practices, and problematic models assessing the value of museums. Research is based on literature study, a review of the South African Museums Association Bulletin (SAMAB), a peer-reviewed journal dealing with museum matters, an analysis of policy recommendations of museum professional associations and interviews with the museum association leadership.

INTRODUCTION

The South African museum scene of the 1980s and 1990s was vibrant and innovative. Yet two decades on as the South African Museums Association (SAMA) and the South African National Committee of the International Council of Museums (ICOM-SA) took stock of the status of the sector and its progress in terms of transformation ideals as stated in the 1980s and 1990s, a picture of a sector in crisis emerged. The international museum scene, on the other hand, is vibrant and dynamic as the discussion below will indicate. Museological theory and museum practice continue to evolve at a rapid pace. Traditionally the primary role of museums was focused on the care and interpretation of collections. This has been augmented by a people oriented approach that emphasises inclusivity and museums as places of memory

DOI: 10.4018/978-1-5225-3137-1.ch018

and, instead of authenticating the past, become agents of social change. In addition, museums had to reposition themselves in an information landscape dominated by digitised information and social media. Lastly, sustainability of museums has also become increasingly under the spotlight which presents a challenge for museums to adopt new management structures and models.

The chapter focuses on status of the South African museum sector through comparing museum practice with theory and documenting the perceptions of South African museum practitioners. In this chapter, it will be shown that the South African museum sector is lagging behind international museum practice. The reasons for this situation is explored and possible solutions are provided.

A theoretical framework is provided through a short overview of museum theory and practice, focusing on aspects that have been identified as problematic by the South African museum sector. The status of South African museum practice in relation to museum theory is explored through a literature review and interviews. Rather than repeating reviews of official policy statements and initiatives, this study focuses on the responses and initiatives of the museum professionals as represented by ICOM-SA and SAMA. Workshop reports are discussed together with articles that have been published in the *South African Museums Association Bulletin*, generally known as *SAMAB*, an accredited journal produced by SAMA, and interviews with the recent and current leadership of the two organisations. Using the museum professional associations as entry point, one also avoids the fragmented nature of the museum sector with no government agency able to speak on behalf of the sector as a whole.

MODELS, CONCEPTS AND THEORIES

Many of the pressures to South African museums to transform are not particular to the South African context, but experienced by museums worldwide. During the last five decades, museums have evolved from being mainly research and educational institutions to becoming social institutions that not only research, document and communicate cultural and natural heritage, but also actively shape society. Concerns regarding equality, social justice and human rights have taken centre stage (Nightingale & Sandell, 2012, p. 1).

The ICOM definition of museums, adopted in 2007, combines the conventional core functions of acquisition, conservation, research, communication and exhibition of collections with the emphasis on the role of a museum as an "…institution in the service of society and its development…" (Mairesse, 2010, p. 19). This role is elaborated on in the United Nations Educational, Scientific and Cultural Organization (UNESCO) *Recommendation on the Protection and Promotion Museums and Collections* which was formally adopted by the General Conference on 17 November 2015.

[…] dating back to the Declaration of Santiago Chile (1972), modern museums are increasingly viewed in all countries as playing a key role in the social system and as a factor in social integration. In this sense, they can help communities face profound changes in society, including those leading to the rise in social inequality, the impoverishment of some classes in society and the breakdown of social ties. Museums present themselves as places that are particularly open to all and are highly sensitive to the idea of providing access to everyone; in particular, this entails those who are the most fragile and most alienated and who, due to financial reasons, physical difficulties or education, do not normally visit cultural or natural sites. They constitute places of reflection and transformation for the development of

human rights and gender equality within society. As an agent for social inclusion, the museum also constitutes a specific medium for questioning and discussing current societal challenges. (UNESCO, 2015)

The changing definition is more than just a shift in emphasis. Since the first museums were established in the 16th century, museums have adapted to their social and political environment. Museums reflect the cultural, political and epistemological frameworks within which they operate while the political, social and technological environment of museums changed significantly during the last five decades. Museums have been established in a growing number of societies that enriched museum practice with new perspectives on cultural and heritage management as well as exposing museum practice to new social environments and needs (Simpson, 2007, p. 235; Woodward, 2012, pp. 15-16).

The social movements of the 1960s and 1970s with its emphasis on grassroots democracy and critique of social and political power relations of the day, impacted on social studies methodology and museum theory is no different. Generally referred to as new museology, the new museological approach acknowledged that power relations are embedded in conventional museum practice. Museums are not neutral, but rather validate specific forms of knowledge and perceptions of culture, by classifying and codifying cultural practices. As Peterson (2015, p. 3) comments on museum practice in Africa, museums were part of the colonising programme by ordering and codifying local cultures. African indigenous cultures were analysed according to different frameworks than those of European cultures, particularly the distinction made between cultural anthropology and cultural history. Museums are described as media that are not neutral, but actively shape social and moral opinions. There is also a growing emphasis on community-based museum practice and the growth of new curatorial practices to facilitate participation from the bottom up (Kreps, 2003, pp. 3, 10; Mairesse, 2010, p. 44; Sandell, 2012, p. 211-212).

Far from being an academic discourse, new museology is reflected in the debate in formal museum professional networks, for example:

- ICOM, through its International Committee dealing with museology, ICOFOM, explored new museum definitions and mandates from the 1970s onwards. The ICOFOM Declaration of Quebec (1984) states that the new museology is primarily concerned with the museum as a democratic, educational institution that includes community development and social progress (Kreps, 2003, p. 10).
- The ICOM theme for its General Conference and Assembly in Vienna, 2007, was *Museums as Agents of Social Change* (International Council of Museums, 2017).
- Another International Committee of ICOM, INTERCOM, issued the Declaration of Museum Responsibility to Promote Human Rights in November 2009 at its annual conference in Torreon, Mexico. According to this statement: "INTERCOM believes that it is a fundamental responsibility of museums, wherever possible, to be active in promoting diversity and human rights, respect and equality for people of all origins, beliefs and backgrounds." In 2012 the Federation of the International Human Rights Museum (FIHRM) was established with key figures responsible for the Torreon Declaration involved in the FIHRM (Fleming, 2012, p. 81).

The post-modern museum differs significantly from the authoritative source of specialist knowledge of five decades ago. The change of focus and programmes and the resulting new models are important in the South African context where the disruption of collecting and research foci and power relations within museum practice should be the core the of the transformation of the local museum sector.

Firstly, museum practice moved away from being object focused to being people centred, and from being about authenticating the past towards being future oriented. Collecting and research foci adapted to cultural and heritage management practices outside the Western world as well as epistemological and methodological trends in social sciences to include collective memory, oral traditions, personal history and everyday experiences. Social concerns such as health issues, development, human rights, social justice and sexuality are included in the museum gaze and stretched beyond merely documenting or disseminating public policy to taking an activist stance. Museums have changed from being the voice of authority or the specialist to becoming the expression of diverse communities within society (Kreps, 2003, pp. 10-11, 43; Nightingale & Sandell, 2012, p. 1; Sandell, 2012, pp. 195-198; Winchester, 2012, p. 143; Woodward, 2012, p.16).

Taking note of other forms of cultural conservation seeking to include to under-represented and new audiences, resulted in new ways of participation. Museum practice adapted in order to become more representative, focusing on increased and more equitable access to museum programming, including collecting, interpreting and communicating that previously were the prerogative of the curatorial specialist (Keith, 2012, p. 45; Nightingale & Sandell, 2012, p. 11 Woodward, 2012, p. 16, 19).

Non-Western models of heritage conservation and curatorial practice also influenced mainstream conservation practices. Whereas the Western model focused on conserving the tangible object, non-Western models include practices that prioritise the transfer of knowledge from generation to generation and prioritising the conservation of the spirit embodied in the object rather than the fabric of the object only. The decontextualisation of museum objects by removing them from their cultural and physical context when they are accessioned into a museum collection has also been problematized. Where the conventional Western model focused on describing and classifying an object by giving it a new meaning as a museum object, non-Western models of heritage conservation, trends in social studies methodology and technological developments, lead to the creation of new models for documenting objects in museum collections. The social life of objects, i.e. to whom the object belonged, who used them and for what purposes, what meaning the user attached to the object and the circumstances of the transfer of ownership, are being documented as well. New information technologies supported documentation processes through the enablement of complex narratives and linkages (Cheddie, 2012, p. 270; Henning, 2006, p. 1-3, 9; Kreps, 2003, pp. 1, 149-150; Winchester, 2012, pp. 142-143).

New information and communication technologies (ICT) and social media did not only create new communication media for museums, but also changed museum practice. It is already mentioned that ICTs enable museums to manage the complex network of meanings of objects in the museum collection. Digital media such as website, blogs and wikis created new channels for communications that reach non-localised communities while social media also impact on the creation and documentation of meaning and multiple narratives.

Social media created new patterns of consumption of museum services, enabling museums to reach people anywhere at any time. The museum audience is therefore broadened to include people from remote locations. Museums responded by creating information and virtual exhibitions specifically designed to reach people who will not physically visit a museum. This increased the "floor space' as collections not on display can be made accessible to the public through, for example, storytelling platforms. The increased accessibility of museums, services that enable access to museum collections such as portals to web-based museum resources and services, stimulated the demand for these museum services and information. At the same time, people still travel to and visit museums and museums should take care not

to neglect this audience. Some argue that digital services lead to an increased interest in physical access (Amestoy, 2013, p. 97; Mancini & Carreras, 2010, pp. 61-62; Smeds, 2007, p. 172; Wong, 2012, p. 285).

The use of social media enables participative curatorial practices that support initiatives to engage with more diverse communities in creating multiple sources of authorship and curatorial input through posting, commenting and tagging, thereby blurring the relationship between the museum curator and the audiences. Social media is a useful tool to disseminate information in a format that is open-ended, processual and even argumentative, thus enabling the role of the museums as agents of social change (Mancini & Carreras, 2010, p. 61-62; Russo, Watkins & Groundwater-Smith, 2009, pp. 160-161; Wong, 2012, p. 285). In addition to reaching new audiences, audiences are also diversified as the use of social media enables museums to potentially reach people who have never visited museums or introduce museums to people who may have found them intimidating. As social media has relative low set-up costs and require little training, it enables museums to diversity its audiences without major budget implications (Wong, 2012, pp. 281-283; 287).

Social media is not without pitfalls. Though it is a tool to democratize curatorial practice, social media platforms do not necessarily result in communication that reflect the views and needs of the general public. The openness of social media allows it to be used to disseminate inaccurate information and rumours without checks and balances in place to manage curatorial outputs by museum curators and discussions may include hate speech. Though social media enable multiple perspectives, it does not require critical thinking, reflection or empathy from contributors. There is also a concern that the backroom filtering processes of social media create silo thinking with people interacting with like-minded people mistaking their social media network for representing the universe of perspectives (Mancini & Carreras, 2010, p. 72; Wong, 2012, p. 289).

It is not only museum practice and priorities that evolved during the last five decades, but heritage conservation in general. This resulted in new opportunities for museums within heritage conservation and enable heritage and museum practice to contribute to social and economic development planning. During the greater part of the 20th century, development was associated with industrial and technological development and thus Western-style economies. Cultures that did not support industrialisation were seen as obstacles to development and long-term human well-being. Current development frameworks prioritise quality of life goals resulting in culture, and cultural diversity, being a resource for development instead of a barrier. Cultural diversity is valued as a manifestation of human creativity, resilience and adaptability. At the same time, contemporary heritage conservation does not focus exclusively on examples of outstanding heritage structures or sites as identified by specialists, but incorporate methodologies such as historical landscape characterisation that identifies elements within a cultural landscape that are necessary to conserve the specific landscape. These elements are not necessarily a structure or event, but could also be, for example, the social relations associated with a structure or a lifestyle related to a place. Focusing on the latter creates a space for development while maintaining the character of the cultural landscape (Kreps, 2003, pp. 10-12; Streeten, 2006, pp. 401-404).

In 2016, ICOM focused on the role of museums in cultural landscapes as their theme for the General Conference and Assembly. The theme was proposed by ICOM Italy who hosted the conference in July 2016 and also produced the Sienna Charter on *Museums and Cultural Landscapes* at an International Conference in Siena, 7 July 2014 which emphasized the importance of cultural significance of the Italian landscape. The Sienna Charter calls for museums to extend their functions beyond the preservation, display and information of their collections to take responsibility for the cultural heritage of their surrounding towns and communities. This includes research, interpretation and dissemination of knowledge

about a museum's environment. It is acknowledged in the Charter that cultural landscapes are constantly changing, consist of multiple narratives and meanings that include unresolved conflicts and demand active intervention. Furthermore, museums should become members of landscape communities that include other organisations involved in the conservation of cultural landscapes such as conservation interest groups, heritage organisations and local governments. Museums also have to review their collecting and exhibition practice to avoid freezing or reducing cultural landscapes to objects that can be preserved in a museum. Instead museum practices should contribute to the conservation and maintenance of the characteristics that defines a cultural landscape and acknowledge that cultural landscapes are continuously evolving and adapting (International Council of Museums Italy, 2014).

Museums had to adapt to a new economic and managerial environment. Cultural budgets are easy targets for cost reduction as it does not impact directly on people in the same way as other public services do, for example health services if social grants are cut. According to Janes & Sandell (2007, pp. 8-9), creative management of the tension between market forces and museum missions may turn out to be the most vital issue confronting museums in the 21st century. Museums are not a good fit for performance in market-driven criteria. Museums are complex, and efforts to measure their performance in terms of financial indicators not only do not do justice to museum services but also, as noted by Klamer (2013, pp. 428-429), direct museum resources such as human resources and budgets towards performance indicators that can be quantitatively measured e.g. as income generated, cost per visitor or visitor numbers. Thus, an overemphasis of economic measurements instead of performance assessment in terms of museum roles may result in the opposite effect, i.e. museums performing negatively in terms of museum services.

While museums manage assets that can be operated according to commercial business models like shops, restaurants and conference venues, they also manage assets that have nothing to do with the marketplace such as the preservation and care of collections. As Janes and Sandell (2007, p. 9) commented, tongue in cheek, contemporary business models do not provide for business plans stretching over 300 to 500 years as is required for object conservation. Museums provide services for both current and future generations and it is impossible to measure the performance in terms of outcomes in the distant future.

Models to measure or assess the value of the cultural sector, including museums, make provision for social considerations such as inclusion, national pride, education and prestige. The value of museums is not limited to performance against economic criteria, but also by the value they add to other public policies and programmes such as social cohesion, tourism, education. These models distinguish between economic and cultural value. Economic value is measured in financial terms and divided into use value and non-use value. Use value is assessed from market-based data, e.g. revenue from entrance fees or income generated by venue hire. Non-use value is measured using methodologies such as willingness to pay using survey results, revealed behaviour of people such as higher property values close to a cultural organisation or a travel cost approach measuring the money people are prepared to spend to visit a cultural organisation. The data is collected through surveys of both museum visitors and non-visitors (Benhamou, 2013, p. 4; Frey & Meier, 2006, pp. 1023-1024; Klamer, 2013, pp. 423-424; Rizzo, 2006, pp. 996-997; Throsby, 2013, p. 461).

Non-use value refers to the value people attach to a cultural asset such as a museum while not using the services of the relevant asset. Non-use value includes:

- **Option Value:** People may value the possibility of visiting the museum and making use of its services even though they may not have any plans to do so in the immediate future.

- **Existence Value:** People may attach value to the existence of a museum though they may not have the intention to visit or use services.
- **Bequest Value:** People may value the possibility that their descendants will be able to enjoy the museum in the future.
- **Prestige Value:** People may value the fact that the museum enjoys prestige from outside their community as it adds prestige status to the community.
- **Educational Value:** People are aware that a museum contributes to their own or to other people's sense of culture and value it for that (Benhamou, 2013, pp. 4-5; Frey & Meier, 2006, pp. 1022-1023; Klamer, 2013, pp. 423-424; Rizzo, 2006, p. 996).

On the other hand, there is no apparent unit of account to measure cultural value. Throsby (2013, pp. 460-461) and Rizzo (2006, p. 998) distinguish the following components of cultural value:

- Aesthetic value exists because the item displays qualities such as beauty or harmony.
- Spiritual value arises when an object or site provides people with a sense of connection with the infinite or with a particular faith or belief, or if it conveys a religious meaning or messages.
- Social value derives from the definition of culture as shared values and beliefs that bond groups together. Heritage items convey social value if they inform people about the nature of society or if they contribute towards social stability or cohesion in the community.
- Historical value is intrinsic to any heritage object or site and is one of the easiest components of cultural value to identify. The historical value of an object or site contributes to define identity by providing a connectedness with the past and revealing the origins of the present.
- Symbolic value relates to the general characteristic of cultural goods and services as vehicles for conveying cultural meaning. Symbolic value refers to the way the object or site assists people to receive and interpret cultural messages or narratives, particularly those relating to cultural identity.
- Authenticity value is attributable to the fact that a particular item is real and not a fake and that it has not been altered, tampered with or defaced.
- Locational value arises when cultural significance attaches to the physical or geographical location of a heritage item. This includes value gained by being part of a group of related objects or sites such as historical urban landscapes.

Museum performance assessment should be able to accommodate long-term goals and processes while assessing, rather than just measuring, economic and cultural value. For example, efficiency should not be measured against the cost of the programme only, but also against the cost of alternative programmes that will produce the same results. One should also consider the costs and implications if a programme is not implemented (Scott, 2007, p. 183; Weil, 2007, p. 45).

New curatorial practices and a new economic and managerial environment require new management structures and styles. One of the results of new museology is the growth of decentralized museum models such as the neighbourhood museum, eco-museum, integrated museum and community museum. Relationships between communities and the museum have become important with museums having to actively build strong relationships with different communities. Museums no longer provide services to potential audiences only, but establish collaborative partnerships with community-based organisations (CBOs) and other representatives of interested communities (Janes & Sandell, 2007, pp. 10-11; Keith, 2012, p. 45; Kreps, 2003, p. 122).

Dewdy, Dibosa and Walsh (2012, p. 116) warns against equating the transformation of museums with an increase in external and auditable markers such as staff diversity quotas and visitor demographics as it may result in equating transformation with reflecting the population demographics rather than interrogating and changing the underlying philosophy and values. Transformation also includes how decisions are made and curatorial responsibilities are shared with community members in a meaningful way. Sharing curatorial responsibility with community members requires planning and decision-making structures that are responsive, open-ended and able to tolerate ambiguity, instability and unpredictability. Staff members should be empowered to make decisions and to creatively manage programmes within this environment, focusing on outputs rather than following specific procedures and set plans. Museum project teams combine curatorial specialists from various museum disciplines complemented by new museum professionals whose expertise lies in community interaction, public programming and the ability to work across disciplines (Janes & Sandell, 2007, p. 5- 6, 11; Weil, 2007, pp. 43-44; Woodward, 2012, p. 20).

THE SOUTH AFRICAN MUSEUM SECTOR

Museums in South Africa have a long history with the first museums proclaimed in 1855. A century later, the sector was large and organized enough to establish a professional museum association in 1936 (South African Museums Association, 2016, p. 7). As elsewhere in the world, the South African museum sector reflected its local political and social environment. As with the international environment, the local environment demands a redefinition and restructuring of museums to become more representative, to identify and challenge power relations embedded in established museum practices and to introduce processes that facilitate multiple sources of knowledge and interest.

This section focuses on the museological discussion amongst museum professionals as reflected in SAMA and ICOM-SA reports and publications. This is augmented with a survey conducted amongst SAMA and ICOM-SA leadership. Though the SAMA and ICOM-SA membership are very small, they do provide valuable insight in the understanding of management and governance of museums. SAMA has been organising annual conferences that are well supported by members and non-members since its establishment. ICOM-SA, though having relative few members, is part of an international professional association that represent 35 000 professionals across the world. As such, it provides an interface between the South African museum sector and its counterparts elsewhere and facilitates the participation of South African museum professionals in international debates.

Historical Overview

The political tide towards political transformation reached SAMA in the mid-1980s resulting in the Pietermaritzburg Declaration adopted at the 1987 SAMA National Conference, committing SAMA and its members to promote inclusivity and to create spaces where people can openly express their views (Wilmot, 1996, p.4). SAMA (2001, p.6) adopted a new definition of museums in the 1990s that emphasises inclusivity and participative community development.

A number of governmental and political initiatives to transform the museum sector followed in the 1990s with SAMA a key participant. The Arts and Culture Task Group (ACTAG) Report in 1995 and the White Paper on Arts, Culture and Heritage in 1996 formed the foundation of museum policy. In 2008, a review of heritage policy and legislation was conducted by the Department of Arts and Culture (DAC)

and in 2014, DAC circulated a Policy Framework for National Museums for comment (Arts and Culture Task Group, 1995; Republic of South Africa, Department of Arts, Culture, Science and Technology [RSA], 1996; Vollgraaff, 2015, pp. 41-42).

Though written within a context of the democratisation of South African society, ACTAG did not provide direction for the philosophical review of museum practice in the country. The ACTAG recommendations did acknowledge the inadequate emphasis on intangible culture and the need to redress neglected themes in South African heritage. Most of the recommendations dealt with museum governance structures. The White Paper on Arts, Culture and Heritage (RSA, 1996) emphasised increased access to heritage management resources such as museums and called for a reconceptualization of the sector in terms of redress and nation building. However, the need to review and transform the museum sector is identified rather than the provision of guidelines or direction on what should be included. The Policy Framework for National Museums also focus mainly on institutional arrangements, equitable funding models, improved coordination and alignment of museum programmes with the national government imperatives as main priorities (Vollgraaff, 1995, p. 43-44).

By 2014, the debate within the South African museum sector indicated a feeling of despondency and frustration amongst museum professionals. According to a survey conducted by the Technical Support and Dialogue Platform (TSDP) in 2012, museum staff felt that they worked within inappropriate organizational structures, were under-funded, under-staffed and that museums continue to suffer from a persistent negative image. The survey was circulated to the SAMA membership database and 31 museums responded (Technical Support and Dialogue Platform [TSDP], 2012). According to Vollgraaff (2015, p. 41, 52), by 2014 few of ACTAG's recommendations and subsequent policy initiatives had been implemented or successfully implemented. She also noted that where SAMA has been an active participant in museum policy in the 1980s and 1990s, it did not play any significant role in that regard during the last decade and that there does not appear to be any synergy between discussions within SAMA and ICOM-SA on the one hand and official policy and decision-makers in South Africa on the other.

Though SAMA had been organising a national conference annually over the past 80 years, the organisation contributed little to policy development and professional standards since 2000. A booklet on *Professional Standards and Transformation Indicators*, funded by the DAC as part of the SAMA Transformation Training Programme was published in 2006. This is the only significant policy document produced since 2000 (Vollgraaff, 2015, pp. 44-45). SAMA, on its own initiative, did submit a Human Resource Framework to DAC dated 12 November 2012 in response to the Department's Heritage Sector Human Resources Development Strategy. The Framework identifies museum-specific positions and related skills and qualifications. No further correspondence took place between SAMA and DAC in this regard and neither SAMA nor ICOM-SA or any other body representing museum professionals has been involved as stakeholders in the development of the Policy Framework on National Museums.

A SAMA workshop forming part of the TSDP Museum Dialogue programme, was held on 5 November 2014 during the SAMA Annual Conference in East London. The purpose of the workshop was to discuss the TSDP proposed value proposition for museums. Though not using the same terminology as in the literature on the economic and cultural value of museums, the TSDP value proposition is aligned with changes in the focus and methodology in museums worldwide and received the support of the SAMA delegates. According to this proposition, museums are about people and the world they live in. The unique contribution of museums lies in the way in which research, conservation and communication programmes and the spaces in which they operate are integrated to provide a multi-level service to diverse audiences. Through research museums could generate new knowledge, provide solutions to

current and future problems and present ideas for reflection. Collecting and preserving the collections they hold are resources for research, problem-solving and aesthetic, cultural and technical inspiration. Communication programmes that are enhanced by conservation and research will provide spaces where people could express themselves with confidence and contribute to sustainable societies by promoting social cohesion, social development, education and environmental awareness. It was also acknowledged that museums form partnerships with social and civil societies such as human rights organisations to provide information and awareness programmes. However, museums are also spaces that can be enjoyed by individuals or in groups of families and friends (Vollgraaff, 2014a).

Though ICOM-SA has been more active in debates than SAMA in recent years, it also does not have a strong relationship with the DAC. ICOM-SA organised a conference on museum research held in Durban, August 2014. The conference was co-sponsored by DAC and eThekwini Municipality. The purpose of the conference was to review the status of research and to provide guidelines for future practice. The conference report (International Council of Museums South Africa [ICOM-SA], 2014) noted the lack of research into museum studies, including research that requires cross-institutional research.

The ICOM-SA conference delegates problematized the current museum structures and performance management systems as well as the staffing of museums. Though focusing on research, many of the concerns raised impacts museum practice in general. One of the concerns identified by the ICOM-SA delegates is the fragmentation of the governance of museums resulting in a lack of coordinated policy and strategic direction within the museum sector. The sector was reconfigured in terms of funding authorities after 1994. Museums are funded by all three spheres of government in addition to museums funded by corporates, universities, communities and independent individuals. Not only is there a lack of strategic direction for the sector as a whole, but the fragmentation also hampers institutional collaboration. It was proposed that cooperation should be facilitated through collegial support structures such as the professional associations as well as the promotion of the concept of collection mobility that allow for shared use of collections between museums. The fragmented governance system was also identified as a stumbling block for research regarding the sector's environment and new trends across funding bodies (ICOM-SA, 2014).

The delegates noted that a defining characteristic of museums is the interrelatedness between the core functions of research, conservation and communication as well as the interactive, creative processes employed by museums. It was proposed that the notion of museums as multidisciplinary knowledge centres should be explored, especially in terms of the creation and promotion of interdisciplinary and inter-institutional research (ICOM-SA, 2014). Again, though the focus is on research, the proposal is valid for all museum core functions.

Finally, the ICOM-SA delegates proposed that the performance assessment systems of museums should be reviewed in order to accommodate the scope of museums that tend to be broader than the government departments they report to; they should also promote and recognize creativity and assess the quality of programmes rather than focus on short-term statistical indicators that are designed to produce easily auditable performance indicators rather than assessing the performance of complex museum deliverables (ICOM-SA, 2014). No feedback was received from DAC on the conference report submitted to the department in December 2015 other than acknowledging receiving the report.

In 2016, ICOM-SA and its counterpart of the International Council for Monuments and Sites (ICOMOS-SA), organised focus groups in seven cities in five provinces with the aim to drafting a policy statement on *Museums and Cultural Landscapes*. The focus group meetings were followed up by a national

workshop on 26 August 2016 resulting in a *Declaration on Museums and Cultural Landscapes*. A total of 152 delegates participated in the process, some of them in more than one meeting.

In part the Declaration addresses a response to the vandalism of memorials in 2015. It is argued that "Neither colonial nor indigenous narratives alone can capture the whole experience of an individual as these narratives are thoroughly intertwined, interconnected and to an extent inseparable. This approach [cultural landscapes] allows a heritage conservation methodology that accommodates the complex layering of meaning attached to the landscape while considering the transformation and development needs of society." The Declaration also commits ICOM-SA and ICOMOS-SA and their members to problematize existing codification systems of cultural and natural heritage, to use museums as spaces for intervention, dialogue and education with regard to heritage, and to promote research and documentation methodologies that acknowledge multiple narratives and contextualise collections within landscapes (ICOM-SA, 2016).

Review of *SAMAB*

SAMAB, the peer reviewed journal of SAMA, is a platform for museum theorists to interact with museum practitioners. As most of the papers were originally read at SAMA annual national conferences, it does provide insight into the museum sector in respect of the work done by museum practitioners. The *SAMAB* editions for the period 2004- 2015 are reviewed in this section. For the purposes of this study, the author used her own collection of *SAMAB* back issues that is complete with the exception of volume 30 of 2004. The 2008 conference papers were never published and the 2015 conference papers were in press at the time this research was in progress.

The keynote speaker at the 2005 conference in Bloemfontein, Maurice Davies of the Museum Association, United Kingdom, read a paper on the changing approaches to collecting and collection management, including collection mobility, sharing of information, deaccessioning as a positive and responsible practice and the need to become more flexible in developing collecting policies (Davies, 2005: pp. 7-8). Keene & Wanless (2005, pp. 10-11) challenged the then accepted practice of avoiding de-accessioning at all costs and presented a framework for a future de-accessioning policy. Pitman (2005, pp. 22-24) argued that museum library collections should be considered part of the museum collection – a challenging position at the time, but very few will argue with her these days. Most of the papers in that conference dealt with the condition of specific collections.

Other interesting papers of the 2005 SAMA conference include that of Heunis (2005, pp. 31-34) who provided a policy framework for access for people with disabilities; Molapisi (2005, pp. 43-45) challenged the way in which ethnographic collections are collected and studied from a new museology perspective and Jacobs (2005, pp. 56-57) argued for the role of museums as social agents in describing a project of the Anglo-Boer War Museum to present war and the impact of war from a pacifist perspective.

The 2006 conference focused on intangible cultural heritage. Several papers dealt with the 2003 UNESCO Convention on the Safeguarding of Intangible Cultural Heritage (see for example Deacon, 2006, pp. 2-9; Malherbe, 2006, pp. 75-79; Manetsi, 2006, pp. 80-84). However most papers dealt with specific case studies related to intangible cultural heritage, indigenous knowledge systems and oral history (Garside, 2006, pp. 5-16; Moodley, 2006, pp. 85-87; Molapisi, 2006, pp. 65-68; Morris, 2006, pp. 40-45; Nungu, 2006, pp. 53-59; Pyper, 2006, pp. 37-39; Tongo, 2006, pp. 60-64; Victor, 2006, pp. 49-52). Three papers dealt with contemporary socio-political issues and how museums can and should include these issues as part of their mandate. These papers are by Gamieldien (2006, pp. 7-25) on gender issues, Vollgraaff (2006, pp. 10-11) on ecologism, and Petersen (2006, pp. 29-36) on social justice and

peace issues. However, they dealt with specific projects and not museums as gendered or ideological spaces. Carman (2006, pp. 69-72) in the only mainstream museological paper argued that the naming of objects is ideologically loaded. It is interesting to note though that the theme "intangible heritage" was interpreted more broadly than how it is defined in the 2003 Convention for the Safeguarding of Intangible Cultural Heritage and of living heritage in South African legislation and policies.

The 2009 conference focused on museum practice and most of the papers are descriptive case studies. An exception is the one by Van der Merwe (2010, pp. 60-69) with her review of the centenary exhibition of the University of Pretoria and the challenge to include the different layers of history and the different perspectives and experiences of the history of the University.

The 2010 SAMAB is also thin on museological studies. Jacobson and Bailie (2011, pp. 21-29) addressed museums within the context of the broader heritage sector. They challenge the implementation of heritage policy to be misconstrued in order to emphasise heritage tourism products. Jacobson and Bailie argue that museums are part of the larger heritage sector, but arrive at a restricted view of the role of museums as limited to mainly documenting, storage and conservation of heritage.

The trend was repeated at the 2012 conference where only two papers critically engaged with trends in museum practice and neither was strong on theory. Vollgraaff (2013, pp. 23-27) gave an overview of trends within the heritage sector and argued that there is no real coordinated debate on how South African museums should address these trends. Thomas (2013, pp. 75-91) presented a paper the new National English Literary Museum buildings, the first museum building in South Africa to comply fully with green architectural criteria.

SAMAB 35 covered the conferences of 2014 and 2012. Nytagodien (2014, pp. 1-7) dealt with the democratisation of museums in South Africa using the McGregor Museum as a case study. Noteworthy is the strong emphasis on post-colonialism and Critical Race theory making it one of the few papers at a SAMA conference with a strong theoretical base. In the same volume, Vollgraaff (2014b, pp. 31-35) explores the concept and role of museums in response to the perspective that museums are foreign to African culture. She argues that museum methodologies and practice are shared, but the purpose and content of museum programmes are determined locally.

Mdanda (2014, pp. 8-12) and Mdlalose (2014, pp. 13-16) provided an overview of the vision and programmes of Freedom Park while Morris (2014, pp. 17-23) discussed the Biesje Poort site project. His paper is framed within the policy documents of the Department of Science and Technology (DST) entitled *South African Strategy for Palaeosciences* and the *Draft Revised White Paper on Arts, Culture and Heritage* by DAC. The paper thus contains important aspects of museum practice including the construction of complex narrative of sites, thereby creating awareness of heritage and the role of a museum in heritage site conservation, curation and research. Though not the main thrust of their paper, Tempelhoff, Gouws and Motloung's (2014, pp. 24-30) paper deals with a river as object thereby challenging the concept of a museum object as being movable. The paper deals with the Groot Marico River as a cultural object.

In *SAMAB* 37, Keene & Parle (2015, pp. 6-16) focus on the problematic legal status of medical archives and the lack of appropriate national ethical protocols and guidelines regarding access to medical records for researchers. They argue that the museum sector, for example SAMA, should develop guidelines as the current guidelines used by the biomedical professional bodies are inadequate for historical research purposes. Williams (2015, pp. 55-60) deals with the methodology of new historicism to create linkages and collaborative projects between natural and human sciences in museums while Vollgraaff (2015, pp. 41-52) gives an overview of museum policy initiatives.

One would have expected that the debate within SAMA would reflect the debates within museum literature as many of these issues are relevant to the South African environment. Though these issues are referred to in policy documents and statements, it seems that the museological perspective is under-developed within SAMA forums and that most of the papers focus on discipline specific research or on practical museum issues.

Views of Museum Association Leadership

A questionnaire consisting of nine open-ended questions were sent to members of the SAMA National Council (2015-2017), SAMA Regional Committees, i.e. Eastern Cape, Western Cape, KwaZulu-Natal and North, ICOM-SA Executive Board (2013-2016) and the ICOM-SA Chairpersons of 2010-2013 and 2016-2019. A total of 35 surveys were sent and 12 completed surveys were returned. The returned surveys were followed up with telephonic interviews. The respondents were from SAMA National Council (1), SAMA KwaZulu-Natal (1), SAMA Eastern Cape (3), SAMA Western Cape (2), SAMA North (1) and ICOM-SA (4). The respondents employed by nationally funded museums (3), provincial museums (4), other museums (3) and one respondent who is self-employed. The geographical spread of respondents is: Eastern Cape (5), Western Cape (4), Gauteng (2) and KwaZulu-Natal (1).

The questions dealt with both museological trends and museum management concerns. Respondents were promised confidentiality and were numbered in order of the completed questionnaires returned for reference purposes. Though the respondents cannot be considered representative of the museum sector, the consistency of answers provided independently across type of museum and geographical location, indicate structural and management challenges facing the sector that cannot be ascribed to a specific department or the management of a specific museum. Though percentages are given where appropriate and in a few cases, a respondent is quoted, the questions were open-ended and therefore do not make quantitative analysis possible.

Only a few of the respondents (42%) seemed to engage critically with museum theory. Only three of the respondents, i.e. 25% were able to give detailed responses to the question on museum theory, a very low percentage if one considers that the surveys were send to the professional museum association leadership only. However, most are aware of trends regarding community participation (67%), the use of social media as both a communication medium and a platform for community participation (58%), and museums as agents of social change (67%). Though emphasis was placed on different issues, the opinions expressed are consistent and mutually supportive.

In the 1980s South African museums were grappling with transformation in museums and debate was informed by social and museum theory that problematizes knowledge generation from a decolonisation and post-structuralist perspective. The inclusion and exclusion of voices in the development of narratives were framed within the context of an apartheid ideology. However, current museum practice focuses on logistics, administration and Treasury compliance requirements. As respondent 9 put it,

Museums have been hijacked by bureaucracy and choked to death." According to respondent 5, museums do not grapple with theoretical issues such as decolonization and new pedagogical approaches. Museum training is not intellectually rigorous and there is no real dialogue or engagement in theoretical matters.

On the other hand, museums are aware of new trends towards public participation in knowledge generation, meaningful participation in museum programme development including the documentation of

collections, conducting research and conceptualising exhibitions. Two-thirds (67%) of the respondents commented on museum practice in this regard, 17% were not able to answer questions while another 17% interpreted public participation as limited to the public visiting museum or attending museum events.

However, four respondents commented that public participation in general is not meaningful. They commented on the focus of government departments on large one-off consultative events with a formal programme that did not invite meaningful engagement from the public and were often poorly documented. With these events the emphasis was on ticking the boxes, in other words ensuring that consultation had taken place in terms of performance plans, but not necessarily ensuring consultation on a meaningful basis.

Other challenges mentioned were a lack of skills amongst museum staff to engage meaningfully with the public, the tendency to engage with supportive and known groups only, resistance by curators to engage with the public, working within a culture that did not encourage museum visitation and working within an environment where people feel marginalised and excluded from government services in general or have no history of engagement with museums. In the case of the latter, it was argued that it takes time and sustained effort to build relationships to create an environment where people feel free to engage with museum programmes. The lack of skills to build such relationships was identified as one of the challenges. For example, curators limit public participation to sending vague emails to established interest groups.

In addition, some of the respondents had a problem with the concept of public. Public participation is often seen as participation with marginalised communities. However, all publics, whether they are marginalised communities, interest groups or specialised interest groups should be considered as part of a museum's public. Nevertheless, engagement processes will differ depending on the programme and the target group.

Social media is seen as a powerful tool to increase public participation (58%) while another 33% consider social media as a tool for disseminating information. There are museums that use social media to elicit comments on museum programmes, as discussion forums, as forums to conceptualise exhibition ideas and to involve community members in research projects. However, it is felt that in general museums do not use social media to its full potential. There are too many social media sites that overload people with a constant stream of information and blogs of a poor standard.

Although just about all museums use social media and consider it a cost effective way to disseminate information about the museum and its programmes, museums do not have dedicated staff to create content for and manage these platforms. In addition, few museums have the staff that understand the background workings of internet search engines and social media and therefore are unable to leverage the full potential of these platforms or recognize the limits of the social media debate.

All the respondents that completed the section on museums as agents of social change are positive about this trend. It is argued that museums should inform the public, foster dialogue, encourage discussion and understanding and promote a feeling of belonging. However, the perception exists that museums in South Africa are not successfully contributing to social change.

Firstly, respondents questioned the concept of social change emphasising that it does not necessarily imply political activism or support a specific opinion. Social change refers to any change in social consciousness and can take place on a societal or individual scale. Social agency implies that it should be a platform to enable the public to develop an informed opinion. For example, social consciousness can include a profound aesthetic experience in an art museum, promoting understanding between groups in

a social history museum or obtaining insight into an environmental issue in a natural history museum. A young child that becomes interested in science by visiting a museum and later makes an important contribution to scientific knowledge is another example of social change.

Secondly, there is a perception amongst the respondents that museums in South Africa are under pressure to adhere to a single, authorised narrative of the past and the present. Museums are therefore reluctant to become involved in contentious issues, especially where there is public dissatisfaction with official policy or government services. In addition, the tendency of "history about ourselves, made by ourselves, for ourselves" (respondent 11) results in a lack of perspective on social and scientific issues from a global perspective, lack of self-reflection and a lack of creativity in programme development. The standardised version of history results in a neglect of local concerns and stories.

Respondents argued that, although museums should play a role as agents of social change, they rarely do so in South Africa. This is especially the case in government funded museums. Government funded museums are playing an increasing role in the organisation of seminars and debates on issues of public interest and participate in advisory committees to develop public policy, but activities seldom focus on contentious issues in society.

The second part of the survey dealt with museum management practices. The responses were consistent with a sector in crisis that is unable to deliver on museum functions. The picture painted by the respondents show a sector that is perceived in negative terms as "untransformed" and not adding value to society while, at the same time, museums are systematically disabled to be creative and performing through recruitment and resourcing practices. In other words, museums are dismissed as not adding value while at the same time the managerial environment dooms museums to failure. This negative perception is consistent across various types of museums and indicates a deeper systematic crisis that cannot be blamed on a specific department or particular governmental officials. Even respondents who are not employed in government funded museums experience interaction with government agencies as uncooperative.

Four questions were put to respondents dealing with institutional performance systems, government perception of the value of museums, human resources and the fragmentation of the management of museums in terms of reporting to government departments. A fifth question dealt with the role and impact of museum professional associations. Though originally intended as a separate issue, the responses indicate that the issue is interlinked with the management environment.

Respondents identified the value of museums in terms of cultural value as discussed in the session on rethinking the way museums operate. None of the respondents commented on the value of the museums in terms of the economic use and non-use framework as discussed in the same section.

The perception is that government departments responsible for museums have insufficient knowledge of what museums do and how they engage with their users. According to respondents, government departments see museums as "platforms" (respondent 7) or "décor" (respondent 3) to stage events. Museums are also instructed to produce exhibitions at short notice without any budget, indicating a lack of understanding that exhibitions require research, object conservation and meaningful public participation. There is little understanding for collection management and research processes. Museums are seen as tourist sites and not as knowledge generating institutions. One positive trend has been noted though; the DST is investing in the care of natural history collections and promoting natural science networks that include museums.

Museum work is not seen as a specialist field that require sector specific knowledge or experience. There are no standardised job descriptions for museums specifying outputs, experience, knowledge and skill sets and as already noted, DAC did not respond to SAMA's initiative to create a human resource framework. Few departments responsible for museums employ staff with practical museum experience or knowledge of museum theory. This not only results in a lack of visionary leadership for museums, but also impact on recruitment practices as staff recruitment is based on inadequate job descriptions. In addition, recruitment interviews are conducted by senior departmental staff with no or little museum experience. The situation is exacerbated by outdated museum organigrams that have not been adapted to new museum practices and the growing interdisciplinary nature of museum work. Other challenges mentioned include understaffing, freezing of jobs. One museum reported a vacancy rate of 40%, growing compliance and an administrative-related workload resulting in a poor and unfulfilling work environment for staff.

Institutional performance management systems also reflect a lack of understanding of how museums operate. Most museums are subject to governmental performance monitoring systems consisting of strategic plans, annual performance plans and quarterly reporting. Strategic plans and key performance indicators are determined by the governmental Medium Term Strategic Framework and do not make provision for museum-specific outputs or responsiveness to local circumstances. The government performance management system is very efficient in that it tracks delivery on key performance indicators. However, the system is very ineffective as it does not measure whether the museum is performing as a museum. The opinions expressed by the respondents are aligned with the findings of the ICOM-SA Conference on research.

Respondents in managerial positions described the performance system as promoting mediocrity. It overemphasises outputs that are predictable, quantifiable and can be completed in short time periods. In addition, the system is very labour intensive resulting in already limited human and financial resources spent on maintaining a bureaucracy rather than core function outputs. The performance system is not relevant to a creative museums environment with its focus on public participation processes of which the outcomes and duration cannot always be predicted. Little evaluation is done on exhibitions and educational programming. One respondent (respondent 1) did give examples of museums that have developed additional performance indicators to evaluate research and collection management outputs. It seems as if natural history museums, rejuvenated by the establishment of the National Science Collections Facility are taking the lead in this regard.

Though the fragmentation of museums across the tiers of government has been mentioned in forums such as SAMA and ICOM-SA as problematic, there is no agreement that it is indeed the case. There is agreement amongst respondents that museums lack an official vision and standardised policies, professional standards and ethics. However, this lack is ascribed to a lack of leadership and knowledge of museums within departments rather than the constitutional division of responsibilities and roles. The need for a national policy and a forum where all role players at national, provincial and local museums as well as professional associations work together was mentioned by a number of respondents (75%).

Respondents identified the need for a body that can provide a vision and leadership for the museum sector across reporting authorities and to develop policies and set standards that are applicable to all museums regardless whether they are government funded, independent or corporate. Such a body should be government funded and staffed by professional museum staff. Although SAMA can potentially fulfil such a role, it is not recognised as representative of the museum sector by government officials. Attempts to engage with DAC regarding the concerns of museums by both ICOM-SA and SAMA have not resulted in any sustained interaction.

SOLUTIONS AND RECOMMENDATIONS

Despite the seemingly overwhelming challenges facing museums, there are systems and processes in place that can be expanded to address these issues. In addition, initiatives of SAMA and ICOM-SA, together with the study conducted among their leadership, indicate that there is a core of museum professionals that critically engage with museological theory and practice and museums that are developing and participating in innovative museum practice.

The need for a platform that incorporates all role players, including those government departments responsible for museums and professional associations, to develop a national vision for museums, standardised occupational frameworks, training frameworks and standards, performance management systems, professional standards and professional ethics is needed. Such a platform should have the professional and logistical capacity to coordinate such projects and enjoy the support of the government and private stakeholders. Training programmes are also crucial to address the lack of skills in the sector. Though a professional association such as SAMA could take on this task, it has neither the capacity nor the governmental support to do so. Some of the participants in the study argued that DAC should take responsibility for establishing such a platform and that it should include different government departments responsible for museums as well as museum associations.

However, SAMA and ICOM-SA can take the initiative by starting with focus groups and discussion networks, such as those used by ICOM-SA and ICOMOS-SA, to develop the *Declaration on Museums and Cultural Landscapes*, while the SAMA national and regional conferences could also include policy workshops as has been done in East London in 2014. The Western Cape Educators Forum, an informal network of museum educators that meet monthly to share experiences, was mentioned as another model for museum discipline-based networks. However, though professional networks will be strengthened in this way, such efforts will have limited value unless an official interface with government departments is established to ensure that initiatives are able to influence government policies and practices.

The National Science Collection Facility has been noted by two participants in the study as a successful initiative to rejuvenate collection management and create networks across museums that report to different departments. It is argued that this model should be expanded to other museums disciplines. It should also be noted that the DST is taking the lead in establishing this Facility while the DAC would be responsible for art and social history collections.

FUTURE RESEARCH DIRECTIONS

The museum sector is under-researched in South Africa. In 2014, delegates at the ICOM-SA Conference on Museum Research identified the following research areas that require more attention:

- The impact of and responses to the changing environment of museums, for example:
 ○ Information and communication technology and social media replacing museums as main source of scientific information;
 ○ Academic trends such as new museum disciplines and an emphasis on interdisciplinary approaches;
 ○ Social and cultural changes such as increased literacy and access to information leading to developments such as citizen science, community heritage practice and social activism;
 ○ The changing political landscape, e.g. emphasis on economic and social development, cultural justice and reconciliation;
 ○ New trends in learning and communication theory, including visitor studies;
 ○ Organisational and sectorial changes with an emphasis on the impact of government policies, including transformation related policies, on the functioning and programming of museums.
- Museums as agents of social change, i.e. the role of museums in creating a reflective society, in creating a sense of community, in creating a sense of place and in promoting social and cultural justice;
- New trends in museum practice, e.g. collection mobility, new museum models that include transcending physical structures, new approaches to ethics as well as adapting museums to local heritage practices;
- An African museum theory;
- Museums as economic entrepreneurs; and
- Museum theory and functions with an emphasis on and inclusion of local heritage practices and values.

In addition, museum practice should be researched on a sectorial scale, in other words, benchmarking museum practice and best practice case studies. The social impact of museums should also be studied. Studies to determine the value of museums in South Africa that are based on the models of economic use and non-use value, as well as cultural value, as discussed in this chapter, can be utilised in the development of strategic frameworks. This is another neglected area of research.

CONCLUSION

The South African museum sector is in crisis. Museological theory research output is low and little is done in terms of the development of policy and professional standards. The relationship between the government departments responsible for museums and the two professional associations is unsatisfactory and when the associations do engage with the department to discuss policy issues, their efforts have little, if any, impact on official policy and structures. There is no other organisation in existence that is a recognised representative forum of museum professionals.

The weakness of the professional museum sector organisations could be linked to the challenges experienced in terms of museum management. Decision makers in government departments do not critically engage with museum-related concerns. In addition, the widespread practice to appoint staff with no background in museum management and specialist positions results in a falling base of professionals who can be mobilised to provide leadership to the sector. Furthermore, in the past museum associations were managed by museum staff on a volunteer basis and supported by their institutions. With many museums understaffed and in survival mode, employees do not receive the same level of support from their management to undertake activities not directly related to the strategic outputs of the institution.

South African museums experience debilitating challenges in terms of management structures. Performance systems do not measure museum outputs and direct museums towards predictable and quantifiable outputs that are inadequate for the museum environment. In addition, the performance systems are labour intensive, directing museum resources towards maintaining a bureaucracy instead of museum functions. Research into museum outputs and museum management models on a sectorial level is lacking. There is no organisation that is responsible for development standards, benchmark practices and address challenges for the sector as a whole, or for conducting sectorial research.

Museums have the potential to give a voice to the public, from the specialist to the marginalised, to contribute to social development by empowering communities to express their needs and take informed decisions, to contribute to interdisciplinary knowledge production and be places of contemplation and reflection. However, museum management and human resources strategies should be reviewed to ensure that museum staff has the interest, knowledge and skills to conceptualise and implement complex research and social intervention programmes. Performance assessment in museums should make provision for long-term programmes that can adapt and respond to interactions with the public.

REFERENCES

Amestoy, V. A. (2013). Demand for cultural heritage. In I. Rizo & A. Mignosa (Eds.), *Handbook on the Economics of Cultural Heritage* (pp. 89–110). Cheltenham, UK: Edward Elgar. doi:10.4337/9780857931009.00012

Arts and Culture Task Group. (1995). *A new policy for the transformation of South African museums and museum services*. Unpublished report. Author.

Benhamou, F. (2013). Public intervention for cultural heritage: normative issues and tools. In I. Rizo. & A. Mignosa.(Eds.), Handbook on the Economics of Cultural Heritage (pp. 3-16). Cheltenham, UK: Edward Elgar. doi:10.4337/9780857931009.00008

Carman, J. (2006). The naming of heritage. *SAMAB, 32*, 69–72.

Cheddie, J. (2012). Embedded shared heritage. Human rights discourse and the London Mayor's Commission on African and Asian Heritage. In R. Sandell & E. Nightingale (Eds.), *Museums, Equality and Social Justice* (pp. 270–280). London: Routledge.

Davies, M. (2005). Integrating collections, communities and curators. *SAMAB, 31*, 6–9.

Deacon, H. (2006). The 2003 Intangible Heritage Convention. *SAMAB, 32*, 2-9.

Dewdney, A., Dibosa, D., & Walsh, V. (2012). Cultural diversity. Politics, policy and practices. The case of Tate Encounters. In Museums, Equality and Social Justice (pp. 114-124). London: Routledge.

Fleming, D. (2012). Museums for social justice: Managing organisational change. In R. Sandell & E. Nightingale (Eds.), *Museums, Equality and Social Justice* (pp. 72–83). London: Routledge.

Frey, B. S., & Meier, S. (2006). The economics of museums. In V. A. Ginsburgh & D. Throsby (Eds.), *Handbook of Economics of Art and Culture* (Vol. 1, pp. 1017–1047)., doi:10.1016/S1574-0676(06)01029-5

Gamieldien, M. (2006). The museum as a public space in which subaltern can be represented. *SAMAB, 32,* 17–25.

Garside, V. (2006). 'The colour purple': An examination of the use of indigenous dyes among the ama-Zulu. *SAMAB, 32,* 15–16.

Henning, M. (2006). *Museums, media and cultural theory.* Berkshire: Open University Press.

Heunis, V. (2005). Museum accessibility: Reaching out to the disabled community. *SAMAB, 31,* 27–30.

International Council of Museums. (2017). *Past General Conferences.* Retrieved on 12 September 2017 from icom.museum/event/general-conference/past-general-conferences

International Council of Museums Italy. (2014). *The Siena Charter. Museums and Cultural Landscapes.* Retrieved on 26 April 2016 from icom.museum/uploads/media/Carta-di-Siena-EN-final.pdf.

International Council of Museums South Africa. (2014). *Museum research in South Africa – Relevance and Future, 26 – 27 August 2014.* Unpublished report. Author.

Jacobs, F. (2005). The suffering of war. *SAMAB, 31,* 56–57.

Jacobson, L., & Baillie, G. (2011). Heritage and museums: Scope, roles and responsibilities. *SAMAB, 34,* 21–29.

Janes, R. R., & Sandell, R. (2007). Complexity and creativity in contemporary museum management. In Museum Management and Marketing (pp. 1-14). London: Routledge.

Keene, R., & Parle, J. (2015). Museums, archives and medical material in South Africa: Some ethical considerations. *SAMAB, 37,* 17–31.

Keene, R., & Wanless, A. (2005). The curse of collections: From canons to kitty litter. *SAMAB, 31,* 10–11.

Keith, K. F. (2012). Moving beyond the mainstream. Insight into the relationship between community-based heritage organizations and the museum. In R. Sandell & E. Nightingale (Eds.), *Museums, equality and social justice* (pp. 45–58). London: Routledge.

Klamer, A. (2013). The values of cultural heritage. In I. Rizo & A. Mignosa (Eds.), *Handbook on the economics of cultural heritage* (pp. 421–437). Cheltenham, UK: Edward Elgar. doi:10.4337/9780857931009.00035

Kreps, C. F. (2003). *Liberating culture. Cross-cultural perspectives on museums, curation and heritage preservation.* London: Routledge.

Mairesse, F. (2010). The term museum. In A. Davis, F. Mairesse, & A. Desvallées (Eds.), *What is a museum?* (pp. 19–58). Munich: ICOM ICOFOM.

Malherbe, C. (2006). Making the intangible, tangible: The policy pen put to paper. *SAMAB, 32,* 75–79.

Mancini, F., & Carreras, C. (2010). Techno-society at the service of memory institutions: Web 2.0 in museums. *Catalan Journal of Communication & Cultural Studies, 2*(1), 59–76. doi:10.1386/cjcs.2.1.59_1

Manetsi, T. (2006). Safeguarding intangible cultural heritage: Towards drafting a policy for the sustainable management and conservation of living heritage. *SAMAB, 32,* 80–84.

Mdanda, S. (2014). Social cohesion versus coercion: How Freedom Park seeks to unite South Africans through inclusive nationalism. *SAMAB, 35,* 8–12.

Mdlalose, N. (2014). Storytelling at Freedom park://Hapo Interactive Space. *SAMAB, 35,* 13–16.

Molapisi, M. (2005). The past or living heritage: The struggle between museums and local communities in South Africa. *SAMAB, 31,* 43–45.

Molapisi, R. M. J. (2006). From farms to peri-urban; Anthropological insight into the life histories and socio-economic changes amongst amaXhosa of Kuyasa township area (Colesberg) in the Northern Cape Province. *SAMAB, 32,* 65–68.

Moodley, S. (2006). Rock art and national identity: A museum perspective. *SAMAB, 32,* 85–87.

Morris, D. (2006). Interpreting Driekopeiland: The tangible and the intangible in a Northern Cape rock art site. *SAMAB, 32,* 40–45.

Morris, D. (2014). Biesje Poort Rock engraving site: A case study on issues in conservation, research and outreach in the southern Kalahari. *SAMAB, 35,* 17–23.

Nightingale, E., & Sandell, R. (2012). Introduction. In Museums, equality and social justice (pp. 1-9). London: Routledge.

Nungu, N. (2006). Conservation of storytelling. *SAMAB, 32,* 53–59.

Nytagodien, R. L. (2014). Reflection on the politics of memory, Race and confrontation at the McGregor Museum. *SAMAB, 35,* 1–7.

Petersen, T. (2006). Lessons for humanity. *SAMAB, 32,* 29–36.

Peterson, D. R. (2015). Introduction: Heritage management in colonial and contemporary Africa. In D.R. Peterson, K. Gavua, & C. Rassool (Eds.), The Politics of Heritage in Africa (pp. 1-36). New York: Cambridge University Press.

Pitman, D. (2005). Are museum library collections a museum collection? *SAMAB, 31,* 22–24.

Pyper, B. (2006). Memorialising Kippie: On representing the intangible in South Africa's jazz heritage. *SAMAB, 32,* 37–39.

Republic of South Africa, Department of Arts Culture Science and Technology. (1996). *White Paper on Arts, Culture and Heritage. All our legacies, all our futures.* Retrieved on 3 September 2009 from www.dac.gov.za/content/white-paper-arts-culture-and-heritage-0

Rizzo, I. (2006). Cultural heritage: Economic analysis and public policy. In V. A. Ginsburgh & D. Throsby (Eds.), *Handbook of economics of art and culture* (Vol. 1, pp. 983–1016)., doi:10.1016/S1574-0676(06)01028-3

Russo, A., Watkins, J., & Groundwater-Smith, S. (2009). The impact of social media on informal learning in museums. *Educational Media International, 46*(2), 153–166. doi:10.1080/09523980902933532

Sandell, R. (2012). Museums and the human rights frame. In R. Sandell & E. Nightingale (Eds.), *Museums, equality and social justice* (pp. 195–215). London: Routledge.

Scott, C. (2007). Measuring social value. In R. Sandell & R. R. Janes (Eds.), *Museum management and marketing* (pp. 181–194). London: Routledge.

Simpson, M. G. (2007). Charting the Boundaries. Indigenous models and parallel practices in the development of the post-museum. In S. J. Knell, S. MacLeod, & S. Watson (Eds.), *Museum revolutions* (pp. 235–249). London: Routledge.

Smeds, K. (2007). The Escape of the Object? – crossing territorial borders between collective and individual, national and universal. In *ICOFOM International Study Series 36*, (pp. 172-178). Retrieved on August 8, 2014 from http://network.icom.museum/icofom

South African Museums Association. (2001). *A short history of SAMA.* Grahamstown: SAMA.

South African Museums Association. (2016). *The museum profession in South Africa 1936-2016.* Cape Town: SAMA.

Streeten, P. (2006). Culture and economic development. In V. A. Ginsburgh & D. Throsby (Eds.), Handbook of economics of art and culture (Vol. 1, pp. 399–412). Academic Press. doi:10.1016/S1574-0676(06)01013-1

Technical Support & Dialogue Platform. (2011). *Sustainability in contemporary South Africa, 28 July 2011, Cape Town.* Unpublished meeting report.

Tempelhoff, J., Gouws, C., & Motloung, S. (2014). The River as artefact: Interpreting the Groot Marico and its people in the 21st Century. *SAMAB, 35,* 24–30.

Thomas, B. (2013). The first "green" museum in South Africa. *SAMAB, 36,* 75–91.

Throsby, D. (2013). Assessment of value in heritage regulation. In Handbook on the Economics of cultural heritage (pp. 456-469). Cheltenham, UK: Edward Elgar. doi:10.4337/9780857931009.00037

Tongo, N. (2006). A critical analysis of oral history methods in collecting memories of the past: A case study of the Robben Island Museum ex-political group project. *SAMAB, 32,* 60–64.

United Nations Educational, Scientific and Cultural Organization. (2015). *Recommendation on the Protection and Promotion of Museums and Collections.* Retrieved on August, 10, 2016 from www.unesco. org/new/en/culture/themes/museums/recommendation-on-the-protection-and-promotion-of-museums-and-collecting

Van der Merwe, R. (2010). Including diverse voices from the past: A case study of the University of Pretoria centenary exhibition. *SAMAB, 33,* 60–69.

Victor, S. (2006). Celebrating heritage: The case of Old Town. *SAMAB, 32,* 49–52.

Vollgraaff, H. (2006). Challenges in preserving the greens for the future. *SAMAB, 32,* 10–11.

Vollgraaff, H. (2013). Defining the role of museums in heritage practice. *SAMAB, 36,* 23–27.

Vollgraaff, H. (2014a). *Affirming "museumness".* Unpublished report on the SAMA Workshop on Policy.

Vollgraaff, H. (2014b). Museum practice – Rooted in social space. *SAMAB, 35,* 31–35.

Vollgraaff, H. (2015). A vision for museums in South Africa; A review of policy proposals. *SAMAB, 37,* 41–54.

Weil, S. E. (2007). From being *about* something to being *for* somebody. In R. Sandell & R. R. Janes (Eds.), *Museum management and marketing* (pp. 30–48). London: Routledge.

Williams, B. (2015). Integrating the Human and Natural Sciences: A two-dimension literary and organisational approach to collections make connections. *SAMAB, 37,* 55–60.

Wilmot, B. (1996). Presidential Lecture: A review of SAMA and South African museums, 1973-1995. *SAMAB, 22*(2), 1–6.

Winchester, O. (2012). A book with its pages always open? In R. Sandell & E. Nightingale (Eds.), *Museums, equality and social justice* (pp. 142–155). London: Routledge.

Wong, A. (2012). Social media towards social change. In R. Sandell & E. Nightingale (Eds.), *Museums, equality and social justice* (pp. 281–293). London: Routledge.

Woodward, S. (2012). Funding museum agendas: Challenges and opportunities. *Managing Leisure, 17*(1), 14–28. doi:10.1080/13606719.2011.638202

KEY TERMS AND DEFINITIONS

Agents of Social Change: Within the context of museum practice, this term refers to the role of museums to actively shape society in addition to merely documenting and reflecting on it. This approach implies that museums should address sensitive social issues.

Community-Based Curatorial Practice: People-centred curatorial practices use methodologies that enable communities to actively participate in and impact on curatorial decisions. Community-based curatorial practice acknowledges that local communities and users of the museums' services contribute to knowledge generation and perspectives in a meaningful way.

Curatorial Practice: Curatorial activities refer to the activities that forms part of the core functions of museums, namely research (research, interpretation), collection management (documentation, conservation) and communication (exhibitions, education and public programming). Curatorial practice refers to methodologies and professional standards grounding these activities. In New Museology, it is acknowledged that curatorial practice is not value neutral, but reflects power relations.

Museum Value Models: Analysis of museum performance in terms of the value it contributes to society or alternatively, the impact of museum programmes on society.

New Museology: The term refers to a new approach to museum practice that appeared at the end of the 1980s. New Museology reflects a greater awareness of the social and political role of museums and encompasses meaningful community participation in curatorial practices.

Social Media: Computer-mediated technologies that facilitate sharing of ideas and information. Within museum practice, social media facilitate inclusive participative curatorial practices.

Chapter 19

Incorporating Indigenous Knowledge in the Preservation of Collections at the Batonga Community Museum in Zimbabwe

Simbarashe Shadreck Chitima
Midlands State University, Zimbabwe

Ishmael Ndlovu
Midlands State University, Zimbabwe

ABSTRACT

Museums in Zimbabwe often face several conservation challenges caused by different agents of deterioration. The Batonga Community Museum find it challenging to maintain and properly take care of the collections on display. This chapter examines the effectiveness of the conservation strategies being employed at the BCM. The study made use of qualitative and ethnographic research approaches. The majority of collections at the BCM are deteriorating at an unprecedented level. The study gathered that bats have posed serious and extreme conservation challenges as well as affected the presentation of exhibitions. The chapter concludes that bats are the main problem bedeviling the museum and needs immediate control.

INTRODUCTION

Museum collections are a valuable resource that can be used to define a people's identity, history and culture. The concept of Intergenerational Equity (IE) by Weiss (1992:6) posits that the existing human race holds the planet on behalf of their species and for future generations. According to the concept of IE, the present generation has a right to use and benefit from their cultural heritage as well as protecting it for the benefit of future generations. As such museums have an obligation to effectively take care of

DOI: 10.4018/978-1-5225-3137-1.ch019

humanity's cultural heritage. This includes societal history, material culture and to make this heritage accessible to the public. Museum collections are always under threat from relative humidity, temperatures, pollution, light and pests as well as rodents. Chiwara (2017) cites that all public museums in Zimbabwe experience conservation challenges due to lack of storage space and have little or outdated equipment to maintain microenvironments. Almost all museums in Zimbabwe are under equipped to effectively conserve the collections they hold (Chiwara, 2017).

Chiwara (2017, p. 349) further indicates that to a large extent museums in Zimbabwe employ remedial or restorative conservation as compared to preventive conservation. Remedial or restorative conservation is done when collections are already deteriorating or damaged. For example museums would want to fumigate when they realise an object has been infested by pests and this may be done by people in many cases not trained in conservation science. Chiwara has observed and gathered that fumigations done at the Zimbabwe Military Museum have contributed to further deterioration of collections and posing health risks to staff members (2017, p. 348). Chiwara (2017) indicates that they are benefits if museums actively embrace preventive conservation in the protection of collections as compared to initiating remedial or restorative work. This study was undertaken at the Batonga Community Museum in Binga in 2015 and 2016. Nyangila (2006, p. 2) indicates that museums may realise great opportunities of operating efficiently and effectively if they develop a participatory relationship with local communities. Nyangila (2006:2) points out that local communities are a valuable resource that can contribute to the development and growth of a museum. Therefore they are several levels in which local communities may assist in heritage management and that can be through sharing of knowledge (Nyangila, 2006:3). The study argues that museums have great opportunity to realise effective, green and less cost conservation strategies if they tap and make use of indigenous knowledge. This can only happen if museums seize to see themselves as experts but collaborate and share curatorial control.

AGENTS OF DETERIORATION

It takes quite a lot to effectively look after and maintain a collection. Museum collections are constantly under threat from agents of deterioration. So much research has been published about how relative humidity, temperature, pollution, light and pests and rodents as well as human factors affect museum collections (Caple, 2012; Pinniger & Winsor, 2004). Caple (2012:26) highlights that human beings contribute to the deterioration of museum collection. This can be through touching, vandalism, incorrect handling, incorrect packaging and movement of objects. Human factors include museum visitors and staff who may touch objects on display contributing to physical or mechanical damage through the salts in their hands. Museum personnel have also been observed to contribute to the deterioration of museum objects through incorrect handling, use and movement of objects, vandalism and graffiti (Caple, 2012:26; Ambrose and Paine, 2012). Chiwara (2017) has also pointed to the fact that human beings contribute to the deterioration of museum collections through using poor chemicals and methods in fumigating and housekeeping. For example Chiwara (2017) has observed at the Zimbabwe Military Museum that lack of storage space led to museum personnel piling up artifacts on top of the other in the JOC Hut.

Incorrect or fluctuating relative humidity is another agent of deterioration that is known to cause shrinkage, embrittlement, swelling and cracking in collections (Caple, 2012; Ambrose & Paine, 2012, Chiwara, 2017). Relative humidity (RH) is a ratio of water vapour in the air to the amount it could hold if fully saturated, and is expressed as a percentage. Incorrect relative humidity has been documented to

be caused by poor housekeeping, leaking roofs, floods and excretion from rodents and bats (Chiwara, 2010; Strang & Dawson, 1991). Insects, pests and rodents are also attracted to food that is consumed in galleries by either visitors or staff members and this ultimately lead to artifact infestation especially on collections made from organic material (Strang & Dawson, 1991:2). Light is another agent of deterioration that has been observed by Conn (2012) to cause numerous problems for museum collections. Damage from light has been in the form discoloration, fading, physical and chemical damage to the structure of collections (Conn, 2012). Conn (2012) posits that the most notorious type of light is ultraviolet radiation and efforts should be made to prevent artifacts from being affected by light because damage from light is cumulative and irreversible. Pollution has also been cited as contributing to the deterioration of museum collections. Blades (2016) posit that pollution is mainly caused by internal sources such as carpeting, textiles, wood, varnishes, solvents and coatings. These materials are usually used as materials in the designing of exhibitions and are very high in volatile organic compounds that affect collections. Some of the pollution is also caused by atmospheric pollutants such as dust and gases from vehicles. Blades (2016) recommended the implementation of a good housekeeping procedure to mitigate against pollution.

Another agent of deterioration widely researched and published is the conservation challenges posed by pests and rodents. Most of the pests found in museums are attracted by food and water sources in specific areas of the museum and efforts should be made to monitor the building shell and eliminate them (Pinniger & Windsor, 2004; Strang & Dawson, 1991). Pinniger & Windsor (2004:3-9) classify pests and rodents as insects, rats, mouse and birds and pointed out that these are more attracted by food, water sources as well as conducive disused spaces that provide warmth. It has also been observed that pests cause infestation, soiling, and degreasing of artifacts (Pinniger and Windsor, 2004:9). To deal with pests and rodents Pinniger and Windsor have advocated for an Integrated Pest Management (IPM) approach that involves initiating preventive, remedial and restorative conservation (Pinniger & Windsor, 2004:28-30).

Bats are a real problem to museums but very little research is available that documents how and the extent to which they destroy cultural property (Voigt & Kingston, 2010; Strang & Kigawa, 2009). Studies done about bats has been related to their characteristics as small mammals and the mitigation of bats in historic churches (Voigt and Kinston, 2016; Zeale *et al*, 2014; Hales, 2014). Voigt & Kingston (2016) posit that bats can be grouped into two types and these are Megachiroptera (Fruit eating bats) and Micro-chiptera (Insect eating bats). Voigt and Kingston (2016:431) highlight that many different species of bats are not capable of constructing their own roosts and therefore depend on pre-existing roosting structures such as caves or human dwellings. Bats prefer to live in buildings inhabited by human beings because buildings provide perfect environments shielding them from predation as compared to natural roosts such as caves and trees. Roosts in buildings reduce the exposure of bats to predators such as snakes, birds and giant centipedes that are less in urban environments (Voigt and Kinston, 2016). The second reason is that buildings provide perfect environments shielding bats from harsh weather conditions (Maloney *et al*, 1999; Voigt and Kinston, 2016:434). Buildings provide protection from extreme sunlight, heavy rains or low ambient temperatures (Voigt and Kinston, 2016:434). It has also been researched and observed that bats hibernate in buildings because building temperatures rarely reach freezing temperatures (Voigt and Kinston, 2016:433). Buildings have also been observed to provide maternity roosts for bats (Voigt and Kinston, 2016:432). About 35 bat species have been observed by Voigt and Kingston (2016) to use buildings as maternity roosts. The third reason is that buildings are a favorite roosting environment for bats and therefore they are opportunities for social advantages and the presence of mating partners.

Bat colonies may develop in attics and roof areas of older and historic buildings as well as well in areas that are warm such as thatched roofs (Pinniger, 2001; Zeale *et al*, 2016). When bats roost or hi-

bernate within walls and attics, the staining from their urine or faeces can present significant problems of sanitation, insect infestation, and aesthetics (Voigt & Kinston, 2010; Strang & Dawson, 1991). The physical presence of bats is often unnerving for staff and members of the public (Strang & Dawson, 1991:5). This study therefore assesses the effectiveness of measures put in place by the BCM to control problems posed by agents of deterioration especially caused by bats. The conclusion is that the BCM should do more to include local community in the preservation of cultural heritage because they are a reservoir of knowledge that can assist in the conservation of collections.

METHODS

The study employed qualitative and the case study research approaches. The study was undertaken in 2015 and 2016 with a population of 43 participants that included 3 museum tour guides, 1 curator, 15 museum visitors, 23 Tonga families groups and 1 biologist. The study also employed interviews, observations, photography, diary methods and conducted a conservation need assessment. Qualitative research provided insight into the views of the local community about how bats can be dealt and to solicit information about the quality of visitor experience. The study sought information from museum personnel including the tour guides and the museum curator. The curator and tour guides provided information about the preservation challenges they face at the form and the measures they have implemented to control bats. The biologist provided information about the type of bats found at the BCM. The Tonga families that participated in the study provided information about indigenous knowledge that could be used in the conservation of collections.

RESULTS

The authors gathered that at administrative level the BCM operates without an official collections management policy. This then has left the museum staff to implement whatever strategies they deem fit in the conservation of collections. However the museum employs two main conservation strategies and these include housekeeping and fumigation as well as security of collections. In housekeeping the museum is cleaned everyday in the morning where sweeping and mopping is done. The mopping of galleries is mainly done with water from the tap. The authors observed that the museum was having challenges with bats and insects. The author's observed that there was nearly a colony of 100 bats in the museum. The study interviewed a biologist from Midlands State University to characterise the bats and gathered the bats were called the Wahlberg fruit eating bats. These bats fed on fruits because the authors collected fruit droppings in the galleries. The biologist indicated to the authors that Wahlberg bats usually take shelter or roost under building in urban areas. The museum building provided the preferred environment that bats required because of the thatched roof (see Figure 1).

The BCM also employs fumigation of collections once a year and this was done by the curator. The curator indicated through an interview that their major problem at the museum was to find resources and necessary chemicals for fumigation because they experienced problems with bats and insects. The curator cited that pests infested artifacts that were mainly made from organic material. The curator also indicated that the museum did not have any conventional equipment to maintain microenvironments.

Figure 1. The Batonga Community Museum with thatched roof suitable for bat roosting

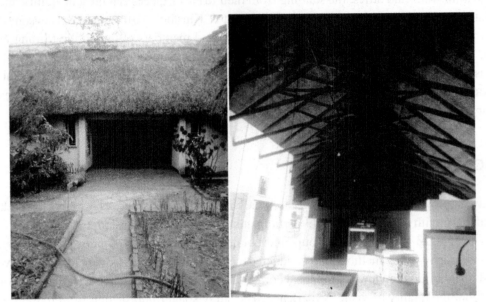

The curator and tour guides cited that the museum did not have the necessary equipment to maintain collections and this was a major hindrance to effective conservation.

The authors observed that all collections on display were deteriorating at unprecedented levels. The nature of deterioration included infestation of artifacts, soiling and mould growth on textile collections as well as physical damage. The most affected artifacts were the Drum (Mulupa), Statue of the traditional healer (Mung'anza), Smocking pipe both for men and women, Fishing spear (Ng'umba), Axe (kaleba), Grain bin (Katula), Statue of the legend Nyaminyami, Tonga doors (Nyelenyele), Skin of a python, Music pipes (Nyele), Knob Kerry (Nkoli), Pounding stick and Wooden gourd (Munsii and Nchili). Museum collections were deteriorating due to bat excretions that also attracted other pests which caused secondary infestation of museum material. The study gathered that the museum started to experience bats from 2002 and fumigation was done twice or thrice if resources permitted. One of the tour guide interviewed cited that although fumigation was done the problem persisted.

The major conservation challenge was from bats that excreted urine and guano in galleries. The authors observed that bat urine provided the necessary atmosphere to attract pests and mould growth on artifacts. The authors observed the bats and discovered that they excrete 6 or 7 times a day. This meant that in estimate 100 bats would excrete at least 600 to 700 droppings every day. The tour guide interviewed cited that every day in the morning they would clean bat droppings in the museum. The most disturbing thing is that the droppings were occurring near models installed in the museum. Bat urine tends distorted the background colour for exhibitions in the museum hence affecting the aesthetics of the exhibitions. Apart from causing conservation worries for the museum, bat excretion caused an unpleasant sighting. Further bat excrement produced an unpleasant odor as it decomposed. The pungent, musty, acrid odor could be detected from outside the museum building.

Bats were also a nuisance to the general visiting public who visited the museum. Bats could be seen hovering in the museum sometimes during the day. The study also observed and heard visitors complaining of the bats. Seven visitors interviewed complained of bats hovering in the museum. A family group

that had visited the museum had to spend less time because the bats were so relentlessly flying in the museum and disturbing visitors. Some feared that they would pluck, or bite them and spread disease. Therefore this meant that bats sometimes flew in the museum and disturbed visitors. Further just because bats had a colony in the roof, sounds were heard by museum personnel and visitors. Disturbing sounds were heard from vocalizations and grooming, scratching, crawling, or climbing in attics. Bats became particularly noisy on hot days in attics, before leaving the roost at dusk, and upon returning at dawn. Figures 2 and 3 provide photographs taken by the authors as evidence of bat urine and guano in galleries.

The study also observed that bat excretion attracted other pests to chew and eat museum collections. This included termite infestations of material. It is not surprising that horns, drums, a hut and other models were being affected. Horns were eaten inside out, the urine socked the horns and chemical reactions invited insects. Clothes on human models were stained white by bat urine. The drum in the museum had its Own fair share of problems that included weakened material and leading to it being torn up (see figure 4).

The model in Figure 5 shows hands of a traditional healer have turned whitish in colour that is a sign of chemical reaction. The study observed several arthropods (fungivores, detritivores, predators, and bat ectoparasites) on objects and caused by bat excretion. Arthropods such as dermestid beetles contributed to the decomposition of guano and insect remnants, but also became a pest of stored goods and/or a nuisance in the museum. The drums were observed to have weakened fabric and that arthropods were eating them from inside as well the drums were showing signs of rotting.

The authors observed that the BCM was having challenges with termites. These termites were mainly found nesting in the floors of the galleries. The wooden tiles that were used to make floors of the galleries provided conducive environments especially because wooden tiles are made from organic material. Termites mounts were observed building up on the floor, walls and some collections were seen deteriorating due to their chewing of material and soiling.

Figure 2. Bat excretion accumulating in the museum and near artifacts

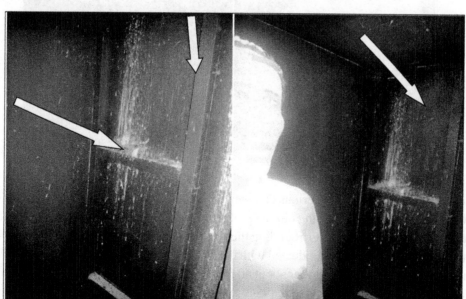

Figure 3. Bat excretion accumulating near artifacts and discoloration from bats

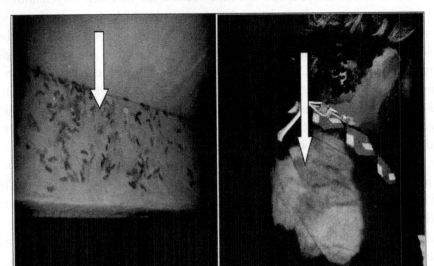

Figure 4. Drums at the museum that are torn infested and rotting

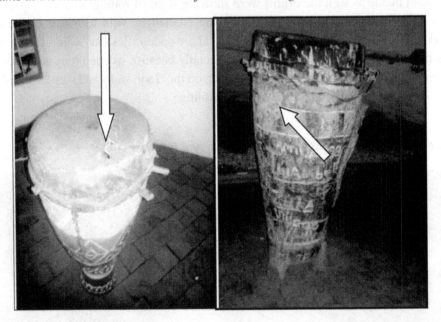

In general the BCM was having serious challenges with bats and pests. The fumigations done at the museum were not successful in curbing out the problems caused by bats. Therefore the authors decided to interview the local communities surrounding the museum for knowledge to curb the problems posed by bats and pests. Interviews were conducted with the Batonga residing in the neighborhoods of Donga, Garikai and Govera. Interviews lasted for about 40 minutes each and a total of 23 families were involved in the study. The authors had observed that bats and pests were the major challenge at the BCM and therefore set to seek information about how these could be mitigated using indigenous knowledge. The

Figure 5. Chemical reaction of infested hands of a traditional healer model

author were interested to find out what the local community knew about bats found in Binga and how the problems posed by bats be mitigated. From the interviews conducted by the authors from the 23 Tonga families only five particularly assisted to get an idea of the indigenous knowledge that needed to be tested and assess their applicability. The study sampled only five responses gathered from local communities the authors felt provided some basis on which to try and test the indigenous knowledge they put across. The five responses were:

Respondent 1: *"I have seen bats at my house and they make a lot of noise. They usually want to eat fruits from my garden. I have fig trees and guava trees. They usually want to live in the roof of my house and my wife always find fig fruits droppings when she cleans in the morning. My father before he died he told me that he also had problems with bats eating from his garden fruits. I have heard that bats do not like burnt chili although I haven't tried to test it".*

Respondent 2: *"I know bats like to move during the nights because I have always heard their screams and sound during the night. Bats do not like to fly during the day so they hide under crevices of houses. I think you can catch bats using nets".*

Respondent 3: *"I have seen bats during the night flying when I went to the toilet because ours is outside the house. When bats move around they make sounds as if communicating to each other. I have heard that they carry disease and therefore I do not like seeing them staying in the roof of my house. I can say that my grandfather used to burn charcoal and put chili and close the doors so that the*

smoke to get to every area of the house. Do you know that smoke killed unnecessary insects like mosquitoes and bats will move away to other shelters".

Respondent 4: "Bats mainly found in Binga eat insects and some eat fruits. But we have many bats in Binga that eat fruits. I don't know about how one can scare away bats form the roof but if you want to do away with pests you can clean the floors with water that have been used to clean fresh fish. That water kills troublesome termites and insects and you will not have any other challenges".

Respondent 5: "I know that bats urinate and their urine is a big problem. I used to have a problem with bats at my house. I did not know that their urine smelled awful and they left an walls in my spare bedroom yellowish. It is difficult to clean the urine off the walls however I tried to spray repellants to no avail. However, if you want to deal with termites use the isihaqa tree. You burn the ash and spray on the flow or wherever you notice termites and other insects that infest valuable things and they will die".

The above responses have been considered by the researchers as providing information that required further testing to see if the indigenous knowledge really worked. However the authors only managed to test if chili helped to mitigate against bats. The authors with the help of museum personnel who themselves were Tonga, agreed to test this idea after working hours. The first step was to identify the areas where bats roosts and the authors discovered that the majority of roosts were inside the roof. The museum and the authors decided to close all crevices, doors and openings except for 1 window which the bats would use to exit the museum. The authors took charcoal that was placed in metal bowls and burnt it until hot. A handful of Red chili was placed inside the burnt charcoal for 3 hours. The authors observed bats using the opened window as exit and they left for good. By the following morning no bats could be seen in the museum and for more than a year the museum has not recorded any bat roosts in its roof. Therefore it was gathered that chili in burning charcoal was a long lasting solution to the problems caused by bats at the museum. Red chili in burnt charcoal is so intoxicating to the extent that no bat could stay in place with its smell. Further this meant that indigenous knowledge can be used in museums to help preserve collections.

DISCUSSION

The BCM has rich and valuable material culture of the Tonga people. However this heritage on display is under serious threat from deterioration. The authors observed and gathered from museum personnel that bats were the major challenge they face. The Wahlberg bats observed at the BCM preferred to roost in the thatched roof of the museum probably because the roof provided dry and warm temperatures suitable for roosting. Thatched roofs have been observed as potential roosts for bats because they are warm. Therefore bats usually roost where they find warmth and food. Most often bats find a roosting where there is a foraging habitat (eating) relatively close together. This is the reason why the bats at the BCM opted to roost at the BCM and surviving on fruit trees nearby (Graig and Holroyd, 2007:3-8). The location of the museum where they are fruit trees in the museum perimeter is an attractive environment for bats. However bats were not going to be a big problem to the BCM if the roof was bat proof. This means bats were not going to have access into the museum if the museum building did not have crevices and attic and other open areas where bats accessed. Therefore there is need for the BCM to seal off all areas that can be accessed by bats.

The Wahlberg bats fed on fruits like figs and guava and these are easily found near the museum premise. However it has been observed that Wahlberg carry their food to their roosts hence the waste is dropped in the museum (Voigt and Kingston, 2016). It is these food droppings that attracted other pests as well as affected the aesthetics of the museum. Further, bat urine and guano caused a lot of conservation challenges for museum collections. Bats guano and urine is said to be harmful to both museum staff and visitors because it causes lung diseases. Guano (bat feaces) accumulations fell from the roof of the museum into the galleries. Bat urine affected the fabric of collections and contributed to an odor not conducive for visitor and staff comfort. The urine is acidic to the extent that the statue of a traditional healer had parts that turned whitish in color. Further the microscopic fungus called the histoplasma capsulatum causes lung diseases especially if inhaled (McClure, 2017). This disease is mainly caused by inhaling bat guano and urine and therefore careful consideration should be taken when cleaning bat excretion. According to the Attic Solutions Inc (2017) lung diseases caused by inhaling bat guano are not necessarily carried through feces. The mold that grows in bat guano is the most dangerous type of mold because it can be spread by other agents such as rodents. Therefore museum personnel and visitors were at risk of getting diseases from bats because bat guano is pathogenic, a health hazard to humans. Having bats hovering in the museum was a scary thing. Some visitors complained about the flying bats and feared that they were going to bite them. It is true that bats in many instances carry diseases.

It has also been observed by the authors that bat guano attracted other pests. Cockroaches, bat bugs, ectoparasites such as ticks, mites, fleas and bugs are attracted to guano. These pests are responsible for secondary infestation of museum collections on display at the BCM. This is the reason why drums and horns at the museum were eaten away by arthropods. These secondary pests are attracted to bat excretion and cause conservation problems as they usually contribute to the weakening of fibers and rotting of material. Bat urine is known to cause chemical reactions with artifacts because it is acidic and corrosive as it contains ammonia. When urine is in contact with any material it is likely to change to a whitish colour. The study also observed that museum objects such as the drums were being affected by borers. They create holes and surface erosion on the drums (Kopannha, 2008:14). Borers are insects that, in their larval stage bore their way through timber. Most borer larvae eat the sugars and protein in the sapwood (Strang and Dawson, 1991).

The authors also observed that the museum faced challenges from termites and pests that took habitat in the gallery floors. Termites were attracted to the wooden tiles used on the gallery floors. Pinniger & Harmon (1999) posits that termites and insects are not easily noticeable but they destroy museum collection if left unchecked. Termites eat wood because it contains cellulose and at the BCM wooden floor tiles and other artifacts on display made from organic material were destroyed. Some microscopic insects were not easily identifiable until the museum collections such as the drums and the reception desk started to show signs of infestation. The drums and the desk have been infested to the extent that restoration conservation is required or even to bring in new drums and quarantine the existing drums on display. Fumigations that were being conducted at the museum were not successful to circumvent the challenges posed by pests. Therefore they is need for the use of Integrated Pest Management (IPM) principles and practices at the BCM. IPM involves the use of various types of control and management procedures to prevent pest invasion and to discourage insects from becoming established (Pinniger & Harmon, 1999:153). The curator at the BCM indicated that several efforts were made involving the National Museums and Monuments (NMMZ) headquarters to assist in curbing this problem but to no avail. Therefore at national level they is need for NMMZ to invest and proritise small museums in allocating resources that would assist in curbing out challenges posed by different agents of deterioration on mu-

seum collections. At local level the BCM should collaborate with local communities in the management of collections. Local communities have rich indigenous knowledge that can benefit the museum in ways that would help effectively take care for collections. Local communities have knowledges that may be effective and less cost as well as share green strategies that will not harm collections, staff and visitors.

FUTURE RESEARCH DIRECTIONS

Conservation of collections is an unending process. Museums need effective ways in which to maintain their collections. The authors had gathered from local communities that cleaning museum floors with water that has been used to clean fresh fish my help mitigate the problems of termites in museums. Further it was also gathered from local communities that spraying on the floor with the Long-tail cassia ash will help kill termites. These methodologies require to be tested and find out their applicability in the museum and therefore are possible future research areas.

CONCLUSION

The study concludes that local communities harbour knowledge that can be used by museums to properly preserve collections. Museums stand to benefit a lot if they give opportunities to work with local communities in the protection of collections. There is need also for museums to embrace preventive conservation as a way to mitigate the effects posed by agents of deterioration. Preventive conservation is less expensive as compared to initiating remedial or restorative conservation. Bats and pests have the capacity to destroy museum collections and therefore if deterioration is prevented by good housekeeping practices and initiating an integrated pest management program.

REFERENCES

Ambrose, T., & Paine, C. (2012). *Museum Basics* (3rd ed.). New York: Routledge.

Blades, N. (2008). Measuring pollution in the museum environment. *Conservation Journal*, (14). Retrieved from http://www.vam.ac.uk/content/journals/conservation-journal/issue-14/measuring-pollution-in-the-museum-environment

Caple, C. (2012). *Preventive Conservation in museums.* Leicester, UK: Routledge.

Chiwara, D. (2017). Securing the future of collections in Zimbabwe through preventive conservation: the case of Zimbabwe Military Museum. In M. Manyanga & S. Chirikure (Eds.), *Archives, objects, places and landscapes: multidisciplinary approaches to decolonised Zimbabwean pasts.* Bamenda, Cameroon: Langaa Research & Publishing CIG.

Conn, D. (2012). *Protection from Light Damage*. Northeast Document Conservation Centre. Retrieved from https://www.nedcc.org/free-resources/preservation-leaflets/2.-the-environment/2.4-protection-from-light-damage

Hales, J. (2014). Bats in Churches: Objective Assessment of Associated Damage Mechanisms. *Archaeology International*, *17*, 94–108. doi:10.5334/ai.1703

Keopannha, V. (2008). *Museum Collections and Biodeterioration in Laos*. (Masters Thesis). Gotheburg University.

Maloney, S. K., Bronner, G. N., & Buffenstein, R. (1999). Thermoregulation in the Angolan free-tailed bat Mops condylurus: A small mammal that uses hot roosts. *Physiological and Biochemical Zoology*, *72*(4), 385–396. doi:10.1086/316677 PMID:10438676

Nyangila, J. M. (2006). *Museums and community involvement: A case study of community collaborative initiatives - National Museums of Kenya*. INTERCOM Conference paper.

Pinniger, D., & Winsor, P. (2004). *Integrated pest management: A guide for museums, libraries and archives*. Museums, Libraries and Archives Council.

Pinniger, D. B., & Harmon, J. D. (1999). Pest management, prevention and control. In Care and Conservation of Natural History Collections. Oxford, UK: Butterwoth Heinemann.

Strang, T. J. K., & Dawson, J. E. (1991). *Controlling Vertebrate Pests in Museums*. Ottawa: Canadian Conservation Institute.

Voigt, C. C., Kendra, L. P., Luis, F. A., Schoeman, C. M., Vanitharani, J., & Zubaid, A. (2016) Bats and Buildings: The Conservation of Synanthropic Bats. In Bats in the Anthropocene: Conservation of Bats in a Changing World. DOI doi:10.1007/978-3-319-25220-9_14

Weiss, E. B. (1992). *Intergenerational equity: A legal framework for global environmental change*. Tokyo: United Nations University Press.

Zeale, M., Stone, E., Bennitt, E., Newson, S., Parker, P., Haysom, K., & Jones, G. (2014). *Improving Mitigation success where bats occupy houses and historic buildings, particularly churches*. University of Bristol.

Chapter 20

Challenging the Concept of Infinity Retention of Collections in Selected National Museums in Zimbabwe

Nyasha Agnes Gurira
Midlands State University, Zimbabwe

ABSTRACT

The chapter challenges the concept of undefined, infinity, and indefinite retention periods of collections in Zimbabwe's state museums and underscores the need for each state museum to develop a collections management policy. The concept of indefinitely retaining collections characterizes Zimbabwe's National Museums. In that regard, this chapter interrogates issues surrounding collections management in Zimbabwe's state museums. Museums in Zimbabwe are overburdened with inherited collections from the past with limited supporting information. This coupled with the need to store contemporary collections congests the storage space in museums. A multiple case study approach was employed to examine the state of collections in three selected state museums in Zimbabwe. Findings revealed that collections in these museums have been inherited from the past collectors who amassed collections with limited information about them. There was no formal collections management policy. The chapter proposes a regime to guide museums in dealing with their collections.

INTRODUCTION

The concept of indefinitely retaining collections characterizes museums worldwide. This is because museums are custodians of the inheritance of humanity. It is their duty to preserve, interpret and promote the use of this heritage and ensure that it is kept and passed on to future generations. When an object is made a museum object the overall intention is to ensure that it is permanently maintained as a primary source of evidence. The concept of keeping collections indefinitely is also characteristic in Zimbabwean state museums (Chaterera, 2017, p. 330). This was a realization made by the author while investigating

DOI: 10.4018/978-1-5225-3137-1.ch020

issues surrounding collections management in Zimbabwe's State Museums. This chapter underscores the critical need for a collections management policy in facilitating the smooth flow of museum operations within the context of Zimbabwean museums. Museums are repositories of collections and more often than not museologists struggle over the need to create more space for collections. Zimbabwean museums are overburdened with inherited collections from the past, most of which either fall outside the scope of their collections mandate or have very little to no supporting information. In some cases, storerooms are filled with "the unknown" where there are incomplete collections registries or absent object records. This, coupled with the need to store contemporary collections, congests the storage space in museums.

A multiple case study approach was employed to examine the state of collections in Zimbabwe's state museums (Baxter & Jacks, 2008). Face to face interviews were conducted with the members of staff responsible for the management of collections in these museums. A total of 12 interviews were conducted. Observations of the museum storage environment were conducted, in the form of object, museum building, condition assessments and use of storage space surveys. This chapter starts by discussing the conceptual framework that governs the management of collections, it presents the research findings by presenting each case of the three selected museums namely the Zimbabwe Museum of Human Sciences (ZMHS), the National Museum of Transport and Antiquity (NMTA) and Zimbabwe Military Museum (ZMM), it then gives a general discussion of collections management in the three selected Zimbabwean state museums. It ends by suggesting a suitable regime for dealing with crowded storerooms for collections management in Zimbabwean Museums.

COLLECTION MANAGEMENT IN MUSEUMS AND THE PROBLEM OF MANAGING SPACE

According to article 3 subsection 1 of the International Council of Museums (ICOM, 2017) statutes

A museum is a non-profit, permanent institution in the service of society and its development, open to the public, which acquires, conserves, researches, communicates and exhibits the tangible and intangible heritage of humanity and its environment for the purposes of education, study and enjoyment. (ICOM statues, 2017, p. 2)

This ICOM definition provides an understanding of the roles and functions of a museum. It underlines the primary goals of a museum, which are to acquire and keep the natural and cultural, tangible and intangible collections of humanity (ICOM, 2017). Acquisition is an everyday function in museums and this is a practice that has its origins as far back as the second millennium BC. As old as the practice is, there have been a lot of collections amassed in museums over the years (Lewis, 2004). The reason for these collections being made is evident in the museum code of professional ethics principle II which, gives museums the mandate to hold collections in trust for mankind and its development (ICOM code of ethics for museums, 2017, p. 7). There have been efforts by museologists to gather this primary evidence of mankind's development. With the vast improvements to technology made by humankind in a bid to adapt and successfully use their environment, humankind has created and disposed a lot of material. Evidence of which is found in museum repositories.

These collections are made from the value that is placed on objects by individuals, communities', societies, nations and even by the whole of humanity. It is because of this value placed by society on these collections, that there is a need to keep these collections for a minimum of a hundred years (Lewis, 2004). The overall goal is to keep these objects for posterity in other words 'forever' because of their cultural, symbolic and economic significance as evidence of humankind's development. In this case the code of ethics in its article 2.18 explicates that, the goal of museums is to ensure the continuity of collections through comprehensive conservations policies, procedures and facilities. This entails the need to reduce the effects of natural decay on the museum objects. This can be done by manipulating the museums micro-environment.

The first line of defense from the environment is the museum building, as it enables museum professionals to create a suitable micro-environment to facilitate the conservation of the collections it houses (Dardes, 1998; Chiwara, 2017). These buildings are either purpose built or have been rehabilitated to become museum buildings. Storage facilities are created or tailor-made to house collections. Museum(s) storage spaces are often limited with little room for expansion. The conundrum lies between the fact that museum collecting is an everyday practice while de-accessioning is an unfavorable practice in museology. According to article 2.13 of the ICOM code of ethics for museums,

the removal of an object from the museum specimen must be undertaken with a full understanding of the objects significance.... character, legal standing and any loss of public trust that may result from it. (ICOM code of ethics, 2017, p. 9)

The underlying notion in this section of the code - which specifies that deaccessioning as a practice can result in the loss of public trust - creates an unwillingness within museologists to undertake deaccessioning and encourages a professional reticence towards the practice. The fear emanates from the fact that traditionally deaccessioning is supposed to be amicably and evidently justified. Museum objects can only be deaccessioned under 'special or inescapable' circumstances and even then, the museum must keep a record of transaction (*ICOM code of ethics*, 2017; Simmons & Munoz-Saba, 2003, Ambrose & Paine, 2006). This professional reticence towards the practice of deaccessioning has led to uncontrolled growth of museum collections.

Over the decades the continual collecting and lack of disposal creates an imbalance as there is no expansion in space yet there is an increase in the growth of the collection. This is why Simmons and Munoz-Saba (2003, p. 39) argue that the development of entropy in museums is inevitable. This situation, in the context of museums, is further worsened by inherited collections were curators are employed in museums with an already large collection that was created from its inception. In this case curators have to continually grapple with the challenge of managing space and keeping their collections. They also have to grapple with the burden of keeping collections with very little to no information about them. These collections are usually a result of unsystematic collecting methods where objects were simply collected out of curiosity and made a part of the museum collection without any research regards to their origin, provenance and even the values attached to them. More often than not curators struggle over what to do with such collections, the biggest question being whether they should discard of these collections through deaccessioning or whether they should simply keep this inheritance. These tribulations stem from the fact that an object absent of its information or its record is useless (Chaterera, 2017, p. 331).

New museology has tried to come up with mechanisms to counter these challenges faced by curators as it argues for creating and maintaining systematic collecting methods, professionalizing musealisation as a process (guided by the museum mandate and vision) together with coming up with and maintaining collections management planning, policies and procedures. Merriman (2004, p. 10) discusses the context of making museums sustainable institutions he argues that de-accessioning and disposal should be used as a tool for controlling collections growth. He argues that the idea of 'husbanding' collections for time immemorial defeats the overall goal of museums as they simply end up as repositories of old things which are rarely used. If collections continue to grow and museums continue to keep everything they inherited from their predecessors this has implications on the human, financial and physical resources used by the public body. Though it is their duty to collect these objects there are serious implications of cost to the museum, the collection itself and to the people whose heritage these museums are entrusted with. This chapter analysed how museums in Zimbabwe are managing their collections. This was done by analyzing the museums organizational and physical environment. The study assessed the museums state of documentation of the selected collections in these museums and also investigated whether there are complete object registries with adequate information regarding the source, provenance and use of the objects. Sample collection condition assessments were also done. It also assessed the organizational environment focusing on whether it provides mechanisms such as a detailed context specific collections management policy and collections plan. The findings of each state museum are presented.

ZIMBABWE MUSEUM OF HUMAN SCIENCES (ZMHS)

The Zimbabwe Museum of Human Sciences is located in Rotten Row road in Harare. It is the headquarters to the National Museums and Monuments (NMMZ) northern region. The museum was originally built in honor of Queen Victoria in 1902 but was later changed to the Museum of Human Sciences after Zimbabwe's independence from colonial rule. The museum houses archaeological and ethnographic collections from around Zimbabwe. Archaeological collections range from Stone Age to Iron Age collections. The ethnography department holds a lot of contemporary cultures from all over Zimbabwe and it also houses other collections from other African nations. The museum is a purpose-built museum. However, collecting only began after the museum had already been built. The study focused on the museum's archaeological collections management and care. The museum has two main storerooms for Stone Age and Iron Age collections.

Evidence from interviews conducted with respondents at the institution, the care of these collections is governed by the ICOM code of ethics of 2017 and there is no specific collections management policy except for a national policy which was crafted to cater for all museums around the country in 2003. These collections include beads, pottery, iron tools, human remains, stone tools and rock art painting replicas. According to the respondents,

the issue of collections management was under the collections management department as the museum was run under a centralized system and since 2003 the office of collections manager has been vacant.

One of the respondents pointed out that the museum cares for its collections and manages them using the ICOM code of Professional Ethics. However, there is no specific code for the management of the collections at the Museum of Human Sciences. Interviews with respondents revealed that the ZMHS

collects objects from excavations, transfers from sister institutions and surface collections made by individuals. They pointed out that in order to control the influx of collections the museum grants permits to researchers to carry out excavations and that it is mandatory that they submit whatever they have found with the museum. They also revealed that as a part of their acquisition process curators deliberate on whether or not to accession an object that has been brought to the museum.

The respondents also revealed that there is a backlog in accessioning of the collections in the museum and though there are provided shelves for storage there is no more space in the storage shelves. This has led to boxes of collections being placed on the ground and heaped one on top of the other. The current registration backlog dates back to 2004 and 2008, a situation which they attribute to high staff turnover. When asked when they last carried out a collection inventory the respondents highlighted that the museum currently faces financial challenges and so inventories are done with collections in the display areas. They indicated that the museum rarely carries out collections inventories and collections condition assessments for collections in the storage room areas. According to the respondents the museum houses collections from as far back as the 1900s which constituted stone and iron tools collected by Jones from excavations done at Bambata cave. They also have collections made by Gardner in 1928, Schofield in 1932, and Peele in 1936 to mention but a few. These collections were not on display but being housed in the archaeology storerooms.

With regards to the conservation of collections the museum fumigates its collections at least twice a year. The museum has no resident conservation specialist. However, they use photogrammetry as a method of noting change on a collection. They keep their collections in acid free boxes and handling and care is done by trained professionals (see Figure 1). The museum respondents revealed that they only de-accession collections based on the approval of the NMMZ board of directors, and even though there are no outlined procedures for de-accessioning this can only be done in instances where the museum no longer has the resources to care for the objects. When asked whether they have de-accessioned any objects as of late, the respondents pointed out that they have not de-accessioned any objects of late. One of the respondents pointed out that the practice of de-accessioning and disposal is an 'unfavorable practice' in museum. When asked if they had collections without information about them the respondents noted that this is true of some of the collections they have in their storage room. One of the respondents highlighted that their greatest fear as a museum would be to de-accession such objects and later discover that these were objects with immeasurable value to society.

NATIONAL MUSEUM OF TRANSPORT AND ANTIQUITIES (NMTA)

The National Museum of Transport and Antiquities (NMTA) is located in Aerodrome road Mutare. The museum began operations in 1957. The museum collecting began earlier in 1953 with collections of antiques, botanical collections and archaeological collections. The niche of the museum is to collect antiques; however, it also has archaeological collections. The museum houses a variety of displays from themes such as archaeology, ethnography, transport and natural history. There are three main departments, namely Archaeology, responsible for the preservation of archaeological heritage found in the Manicaland province: Botany, carries out research documentation, dissemination of botanical resources found in Zimbabwe and lastly Antiquities department, has a wide variety of objects that are manufactured all over the world such as numismatics, tools and equipment of scientific purposes. The museum building

Figure 1. Observation of archaeology storeroom at ZMHS: Shows collection boxes heaped one on top of the other in the archaeology storeroom at the ZMHS

Figure 2. Observation of archaeology storeroom at ZMHS: Shows collections placed on top of analyzing tables

is not purpose built. It was built after the collections were made. NMTA houses an estimated 15500 collections ranging from antiques, transport, botany and archaeological collections.

The researcher conducted interviews with respondents from NMTA. The researchers asked whether there is a specific collections management policy used at NMTA, one of the respondents said that "*as department we do not have a collections policy.*" And when asked to clarify on how they manage their collections the respondents revealed that "*As a museum, we ascribe to the ICOM guidelines and they employ the national collections policy that all Zimbabwean museums use.*" The researcher noted that the museum uses a national collections management policy, but the problem with this policy is that it is not specific to NMTA only but it is a policy that covers all the museums in Zimbabwe.

The researcher also enquired about how they undertake collections planning at NMTA and the respondents said "the museum does not have a collections plan". When they were questioned on how they go about the process of collecting the respondents alluded to the fact that the museum acquires objects through bequests, transfers, donations, excavations and surface collections. One of the respondents highlighted that the museums had a lot of transfers for antiques from its sister institutions and as a result they had amassed a lot of collections that were antiques and they had very little space for these collections. They indicated that it is their responsibility as museum professionals to assess whether the objects collected add value to their collection, after which they will request to the director that the object be accessioned. There is no planning process for collecting unless they are looking for a particular collection. The researcher undertook to understand whether the respondents at the museum maintain an inventory of collections, curators affirmed that they undertake collections inventory of all the collections that are in the museum display sections. However, in regards to the storerooms one of the respondents said:

we do not undertake inventories of collections that are in the storage rooms because, there is no space to walk around accounting all the collections that are in the storage rooms, there are inadequate resources to undertake the inventories of the collections, hatitozive kuti tine macollections mangani ari mustorage room macho nekuti akawandisa (translation: we do not even know how many collections are in the storage rooms simply because they are too many).

From the observations carried out by the researcher it was evident that there was no way of accounting for what is not or what is in the storerooms mainly because the museum has way too many collections in their storage spaces (see Figure 3).

The researcher asked the respondents whether they carry out collection condition assessments, they revealed that,

The departments at the NMTA usually carry out in-house collection conservation assessments; these assessments are usually coordinated by the curatorial staff since the museum doesn't have a conservator.

When asked how frequent they carry out these condition assessments. The respondents revealed that these assessments are done fortnightly by the departments to make sure that the collections are stable. The researcher asked when last they had conducted these collections condition assessments for collections in storage rooms, the respondent said

the problem is we are a government funded institution and in as much as we might want to undertake these assessments fortnightly we can't, because mustorage room hamuna nzvimbo (translation: there

is no space to move around in the storage room) and we can't keep moving objects around in circles as this will also increase the rate of deterioration and damage to the collections, so we only and mostly pay attention to the collections that we see are deteriorating at a much faster rate and really need and require conservation.

Observations made by the researchers in the storage areas revealed that there is no equipment to ensure environmental controlling such as humidifiers, dehumidifiers. Collections are in heaps because of inadequate storage space and the museum building has a leak from the ceiling (see Figure 5) When asked whether they have collections whose information is missing the respondents revealed that they are not sure of all the objects in their storerooms and they are still to find out once they clear their accessions backlog from the transfers that had been made. When asked if they carry out de-accessioning and disposal, one of the respondents highlighted that he had not witnessed any de-accessioning done at their museum but had heard about such things being done by other sister museums.

ZIMBABWE MILITARY HISTORY MUSEUM (ZMM)

The ZMM was founded in the 1960's. The establishment was spearheaded by Mrs Boggie who was the wife of a former soldier and collector, her intention was to exhibit the collections accumulated by her husband. The museum was known as the Midlands Museum most of its collections were colonial in nature. After independence, the museum focus was changed to exhibit the military history of Zimbabwe. The museum began to collect objects related to the military history of the country. These collections according to the respondents were made through transfers from sister institutions and donations from their stakeholders. The museum's scope of collections ranges from medals, military regalia and civilian

Figure 3. Observation of Antique storeroom at NMTA: The heaped collections in storage rooms at NMTA

Figure 4. Observation of Antique storeroom at NMTA: Evidence of leaking on the museum building roof in storage spaces

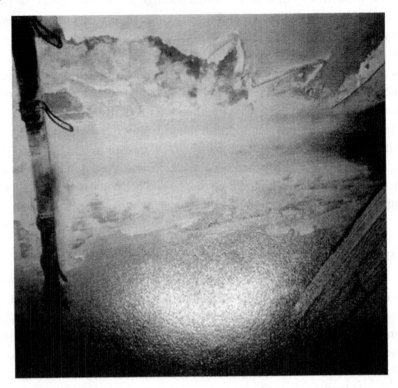

Figure 5. Observation of Antique storeroom at NMTA: An example of an object deteriorating as a result improper storage

clothing, aircrafts, armed cars, boots, guns and military documents. The museums houses over 30,655 collections. There are two main departments in the museum which are Archaeology and Military.

When asked whether there is a collections management policy for the museum the respondents highlighted that there was a national collections management policy that is used to manage collections for all museums in Zimbabwe and that it was generalized and not specific to the military museum. They highlighted that the museum makes its collections through donations and transfers mainly because of the nature of their collections. When asked whether they have a collection plan the reply was,

we do not have a physically written plan however we know what we need in the museum as we are in constant liaison with the military in regards to artefacts that they can donate that will add value to our collection.

When asked how they go about the process of accession and who determines or decides what is to be accessioned, the respondents explained that it was amongst the curatorial duties to do accessioning and when it comes to decisions about collections it is a collaborative effort of the curator and the regional director to decide whether to accession an object. Respondents also alluded to the fact that the museum has a collection accessioning backlog for the military collections and that a lot of the objects were simply registered and piled up in the museum storerooms waiting to be accessioned.

When asked whether they carry out collections inventories the respondent affirmed that collections inventorying was a regular practice in their museum for both their display and storerooms, a respondent said that "when we do inventorying of collections in the storage rooms we do not do a physical count of the collections". The researcher asked whether they carry out conditions assessments they highlighted that,

There is no resident conservation specialist in the museum however it has become a part of curatorial duties to do collections condition assessments and that they do this regularly because the storage space is not good and so there is a need to check the objects condition to ensure we don't not lose the objects.

The respondents emphasized that the issue of lack of space is serious problem in the museum as there is very little storage space and that they have had to use other collections such as the Jock hut as a make shift storage facility (see Figure 6). As part of conservation efforts, the museum fumigates at least twice a year.

When asked whether all the collections housed in the museum were relevant to its collection it was emphasized that at least two percent of the material that they have is irrelevant. One of the respondents said,

There are cases where they can have ten or more objects of the same kind yet according to the international benchmarks we are supposed to have three objects per one type of object, however we are blessed we found these things in abundance so we can't throw away what is ours.

It was also highlighted that the backlog in accessioning was also strained by the fact that there were some objects that they house that they do not have information or with incomplete information which they are keeping and intend to researching on. The respondents highlighted that the objects with missing information were collected during colonial times and they found them already in the custody of the museum.

When asked whether they carried out de-accessioning, it was indicated that the museum rarely carries out de-accessioning and that in the last ten years the museum had not yet de-accessioned any objects. It was also highlighted that they are aware of the practice and that they only will consider it for objects which pose a threat to other objects in terms of conservation or those whose overall cost of conservation is too high such that they cannot afford it. To them it would be taboo to de-accession any of the extra objects that they have and that if they have the opportunity they would add more to what they already have.

OVERVIEW OF THE STATE OF COLLECTIONS MANAGEMENT IN STATE ZIMBABWEAN MUSEUMS

According to article 2 item 1 of the ICOM code of ethics for museums, "The governing body for each museum should adopt and publish a written collections policy that addresses the acquisition, care and use of collections, the policy should clarify the position of any material that will not be cataloged conserved or exhibited.''(ICOM, 2017) It is apparent that in all three case studies there is no individual collections policy for each museum instead there is an overall national policy which is being used to manage all collections in Zimbabwe. Collections management according to Simmons (2003) can be understood as everything we do in a museum to take care of the collections help them grow and make them available for use. Collections management was specifically designed to fight entropy or chaos in a collection (Simmons, 2003, Simmons & Munoz-Saba, 2003).

Chaos or entropy is a scenario where collections are not in their individual cells a situation that is apparent (see Figures 1, 2, 3, 6 and 7). It is apparent that in the cases of the ZMM, ZMHS and NMTA

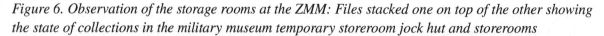

Figure 6. Observation of the storage rooms at the ZMM: Files stacked one on top of the other showing the state of collections in the military museum temporary storeroom jock hut and storerooms

Figure 7. Observation of the storage rooms at the ZMM: Collections heaped one on top of the other

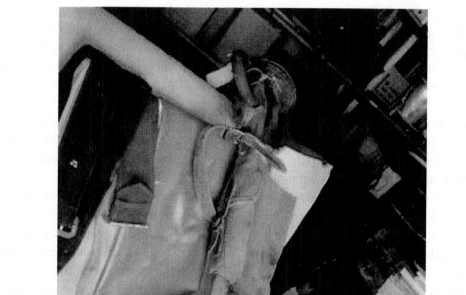

collections are being piled one on top of the other. In a chaotic situation one of the major indicators towards extreme disorder is the inability to retrieve collections in a system. Of the three case studies NMTA evidences the worst-case scenario where navigation within the storage spaces becomes impossible and even poses a threat to the collection itself. Collections management was designed to curb the disastrous effects of uncontrolled growth in a collection. This can only be achieved by a museum organizing its collections environment.

The first step to this process of organizing the environment is dealing with museum organizational environment itself by coming up with a contextual collections management policy. The efforts by the NMMZ are commendable as they are aimed at creating a guiding framework from which all museums were supposed to then come up with individual collections management policies for their respective museums. A national framework simply serves as guide on how to then come up with individual collections management policies. This is largely because for collections, like any other form of heritage, there is no one size fit all approach to effective conservation (Schmidt & Pikirayi, 2016, p. 2).

According to the American Alliance of Museums (2012)

A collections management policy is a set of policies that address various aspects of collections management. This policy defines the scope of a museum's collection and how the museum cares for and makes collections available to the public. A collections management policy also explains the roles of the parties responsible for managing the museum's collections. (AAM, 2012, p. 1)

A collections management policy (CMP) is the heart of collections management - it directs the flow of operation like a heart pumping blood to the veins and arteries of a body. The CMP firstly outlines the museum mandate spelling out its purpose; it then explains the vision, mission and functions of the museum (Ambrose and Paine 2006, Simmons 2003, AAM, 2012).

The CMP has within sub-policies, a set of procedures and plans which direct the everyday functions of the museum from acquisition to de-accessioning. The acquisition policy (which answers the questions how will the museum acquire collections where and why), the accession policy and procedure (which guides on how the museum will undertake the process of accepting objects into the museum registry, this policy also spells out who does what in accessioning and who makes final decisions on what to acquire). In all three case studies in this research it is apparent that the lack of policy on acquisitions has led to a haphazard system of collection.

The ZMHS acquires all archaeological collections recovered in excavations and it is mandatory for all researchers to submit their findings to the museum, while this is a good strategy for ensuring that they have legal tittle to collection found underground in Zimbabwe, it has serious implications for space management at the museum - this can lead to duplication of materials in the museum especially those found in similar areas. It also means that anything which is found is collected thereby eliminating the processes of musealisation which is the careful selection of an object to become a part of the museum collection among other objects. Carman (2010) insists that not everything is heritage and there is a need for a selection process and the idea of representation should proceed otherwise we will end up amassing objects which is the scenario at ZMHS.

The ZMM is also another case where the process of musealisation is being overlooked while they collect objects as donations from their stakeholders there is no form of selection. Ironically one of the respondents actually pointed out that they are aware that according to the code of ethics they are supposed to select only three of one specimen to represent an object however they dismissed the need for the selection by proclaiming *"We are lucky, it is ours and we have found it in abundance."* This type of thinking leads to haphazard collecting and in the absence of standing instructions from the collections policy, resultantly the museum can have eight (8) swords of the same type or thirteen (13) rifles of the same type. As a process, musealisation is guided by an awareness of the significance of the objects selected. Selection should also consider the element of representation. Objects with similar values should be carefully selected to come up with at least three representative objects. While the idea of collecting and keeping are noble, what the implications of space for the museum and who is supposed to carry the burden of keeping these collections and at what and whose cost. There is a need to realize that the cost of collections care is a public burden as museums are public bodies reliant on public funding. According to the national CMP deaccessioning must be considered "with duplicates where there are more than two of the same object", which clearly supports the idea that selection must be done. As Merriman (2004) suggests, it is imperative that museums should know the cost of keeping a collection before they acquire

it. According to him, this was a realization made in Europe which led to the reduction of collections growth in most European museums.

In all three cases decisions for accessioning are a collaborative effort between museum directors and the curatorial staff while this is outlined in their national policy there is a need to come up with a committee system that regulates what is accessioned and what is rejected. The curatorial staff should ideally submit a justification for accessioning to a collections committee (Ambrose & Paine, 2006). This justification should have details of the value of the object to society, its history use, manufacture and unique attributes. A scenario that lacks an approving collections committee can lead to the accessioning of everything that was acquired. Museologists are trained to identify and collect thus, there is little emphasis on the element of justification as a result a lot of the collections in the museum repositories lack information about them. While museologists argue that they will eventually research about these objects, new museology argues for the idea of researching first and then accessioning this reduces the age-old problem of carrying out research on specimens already in the museum. It is because of such approaches to accessioning that museums have had to deal with and keep collection with little to no information inherited from their predecessors.

The CMP also controls collections growth and preservation through its disposal and de-accessioning policy and procedures. Disposal and de-accessioning policy should be specific regards the circumstances for which these actions can occur. The current national policy used by these three museums carries with it a strong sense of professional reticence regards to de- accessioning as it is guided by the ICOM code of ethics (Merriman 2004, Betts 2006). Article 2.13 and 2.15 underscore that de-accessioning must be done with an awareness of the potential for loss of public trust that can come with the practice and in recognition of the significance of the object being de-accessioned. According to the national policy, disposal and de-accessioning can only occur in these instances where the objects state of conservation poses a threat to other collections, the cost of preservation of the object is now no longer rational to the actual value of the object itself and last but not least the object has been damaged beyond repair. This idea of museum keeping objects for eternity is the reason why there are a lot of objects piled up in the museums repositories. The reasons for the justification of deaccessioning and disposal recognized in both the national and international guidelines do not adequately guide museologists in terms of what to do with objects with limited or without information with regards to their values or significance. The lack of guidance creates an information gap and the safest way of avoiding dealing with this problem is keeping everything, as is the practice in the three museums.

Interviews with respondents from all three museums were similar in that they have not carried out any de-accessioning, they are not willing to de-accession objects that are irrelevant to their mandate nor are they willing to part with the objects they have no knowledge of. It is this approach which led to the "discovery" of the *ngomalungundu* in the storerooms of the ZMHS. This is clear evidence that these museums are not aware of what is in their collection. In this research, all three museums highlighted that they rarely do inventories of collections in the storage rooms; they also admitted that they rarely carry out condition assessments. If inventorying is not done how is it possible to know what is in our repositories? Such practices in museum can justify museums being labeled as old dusty object repositories where old things that we are unaware of in terms of their value are kept.

According to Chaterera (2017), a major revelation of her research was that it is apparent that most of the objects in Zimbabwean museums lack records about their use and value and as she rightly argues, what use is an object absent of its information. Though it is rational to argue that disposing of these objects can be costly to the museum. It is a reality that the status quo in these museums is unmanageable,

with NMTA unable to have accurate inventories and unable to carry out conditions assessment. This situation is also prevalent at ZMM where conditions assessments are being done by simply looking at the objects and where it is stored without a physical count and physical analysis. This emphasizes the fact that to some extent they do not know what they have but they are still collecting.

A lack of object condition assessments can be costly to museum's collections growth and deterioration can go unnoticed and eventually lead to the loss of a valued collection. From a sample condition assessment carried out by the researcher at ZMM of objects that were stored in the Jock hut it was apparent that moisture, rodents and pests where major factor affecting the conservation of collection at the museum (see Figure 8). While it seems the better evil to keep these objects that are irrelevant and lack information, it is apparent that there is an overload and strain in resources imbedded with keeping them and this also has implications on the cost of space to a collection. According to Merriman (2004) this is a scenario where curators are held at ransom by the objects they keep.

This chapter challenges the concept of infinity retention of collections in Zimbabwean state museums, The study questions this professional reticence towards disposal and de-accessioning that is characteristic of Zimbabwean museums. According to Lowenthal (2000;19) there is a need accept that the idea of husbanding heritage forever is no longer practical, that is if we intend to meet the goal of sustainability and permanence. Thus, the need to question the philosophical foundations of the museum concept in regards to disposal and de-accessioning. This according to Merriman (2004) is the only way we can effectively deal with the collections of our predecessors. This philosophy of keeping things forever is no longer working in our favor as museum professionals, instead, it continues to burden us and the public for whom we keep this heritage in trust. Questions have been raised by scholars asking whether museums should continue collecting. The study supports the ideologies put forth by Merriman (2004) where he argues that:

Figure 8. Rifle holster condition assessment: Showing rodent droppings inside the holster

Figure 9. Rifle holster condition assessment: Evidence of moisture residue

current literature on cultural heritage and the anthropology of memory provides a framework for challenging the notion that museums still function as repositories of objects and specimens that represent an objective record or collective memory. Instead, they should be seen for what they are: partial, historically-contingent assemblages which reflect the tastes and interests of both the times and the individuals who made them.

Only through this approach of realizing that these are partial historically contingent assemblages can the future of collections in Zimbabwe's state museum be ascertained. This approach can allow us to rework what is in our repositories evaluate its worth and value and then determine whether it should be kept or disposed. Only when this reworking is done should we then continue with our day to day collecting. A continuation of current practices in Zimbabwean State Museums can be counter active as it can lead to a loss of a valued heritage over time.

CHARTING THE WAY FORWARD

The current situation at these three state museums is alarming, as a way of providing a solution to their state of collections management, I suggest a starting point for coming up with a contextualized collections management regime. It is ideal to understand that a collections management policy should be based on an understanding of the collections in one's custody. However, there are some fundamental principles that can be followed as a guide.

Step 1: Defining the Museum Mandate, Vision and Mission

Every museum in this context has a defined area of specialization. It is from this defined area of specialization where it is important to draw one's purposes for example the niche of the ZMM is centered of telling the story of the military history of Zimbabwe, so its purpose is to collect objects that enable it to tell this military history. After having outlined a clear purpose then the museum must determine its vision. A vision is a statement of intent, this answers what the museum wishes to attain in the future, this is critical as it gives us the direction which the museum intends to take. This direction is critical as it guides the future activities of the museum. It is also important to understand the mission of the museum. A museum mission statement is as a statement of the museums objectives, these also guide the CMP.

Step 2: Defining the Scope of Collections

By defining the scope of collections, one is defining what sort of objects would constitute a collection suitable and relevant to the museum. This sets the parameters for collecting where one decides the types of collections they need to fulfill their mandate.

Step 3: Inventories of collections

This is an element that is critically needed by the three Zimbabwean museums, they need to know what is in their storerooms. There is need for an assessment of the information available on each and every object and whether it is relevant to the set mission and mandate of the institution. Inspection of each object should be done together with a collections condition assessment to ascertain the condition of the collections. There is need to also establish the core collection and the supporting collections. After carrying out these assessments there is a need to establish what the museum needs as part of its collection and what is not relevant to its mission and what it has no information about.

Step 4: Musealisation

It's also important to note how many of each object a museum has. In the case that there are more than three objects of the same kind there is a need for selections. Selections should be based on the characteristics of the objects and whether there are unique attributes of the object - they should also consider the results from the condition assessments done of each object. It is important to note that this process requires careful analysis. The reason for this selection is to ensure that the notion of representation is established as these are partial assemblages not an accumulation of everything. During this process, there is a need to ensure that all objects selected have information in regards to their provenance, origin and values.

Step 5: Accessioning

After having sorted and selected these objects the curators must create a justification of accessioning for each selected object. Decisions on what to accession must be left to an established collections committee. Accessioning is the formal acceptance of an object into the museum register and so should not be

taken lightly. It should be guided by an accessions policy and an acquisition policy. After accessioning there is a need to reorder the storerooms in such a way that one knows what is where.

Step 6: Use and Maintenance of Collections

Museum collections should be useful and not gather dust in repositories. They should be made accessible to the public through exhibitions for the purposes of entertainment and education. While in storage rooms the location of objects should be known together with their state of conservation. As these are partial assemblages it is important to create a micro-environment that expands the life time of the objects. This means investing in preventive conservation measures and ensuring that housekeeping practices are maintained. Inventories of collections should be done annually with continued evaluations on whether objects in the storerooms are in line with the museum mandate. Ideally CMP should constantly be re-evaluated and reviewed to ensure the museums long term goals of collecting evidence of humanity's development are maintained.

Step 7: Deaccessioning and Disposal

After having selected those objects relevant to the museum and with enough information there is need to formally de-accession the remaining objects from the museum register. This should also pass through the collections committee where a justification for deaccessioning is also necessary. While this can happen for a lot of the duplicated material it is necessary to understand that not all the objects can go through this process. Those objects with little to no information require the museum personnel to practice due diligence in their disposal. There is need to try and engage the public in trying to find out information about these objects. This may also include consulting other information sources such as the internet. In this process, it is imperative to consult as widely as possible. Only after consulting should museums either keep or discard the objects. Discarding these objects should also entail transfers to sister institutions who might need the object or might find it relevant to their collection. Selling these objects is also an option. In this case these objects must not be sold to museum personnel. Proceeds from these sales should be used to improve conservation technology.

DIRECTIONS FOR FUTURE RESEARCH

This chapter focused on a qualitative study, further research can be done to calculate the growth of collections in the Zimbabwean museums and therefore try and curb issues relating to making these institutions sustainable. This chapter only focused on selected museums as a sample thus a further study to ascertain the state of collections management in all the five state museums can be regarded as an avenue for future research. The issue of collections management is broad and not exclusive to public museums even private museums face such challenges hence the need to assess that scenario as well.

CONCLUSION

Museum collections are a unique and irreplaceable heritage, it is our duty to hand them down to future generations in the best possible state. While present day museologists have inherited chaos, there is still an opportunity to rectify the problem. This can only be done if an effort is made. For museums to become sustainable institutions there is a need to address the challenges faced by museums today. This scenario is not unique to Zimbabwean museums alone but it is a global problem. The suggestions made here may not be applicable in managing the state of chaos in all museums but it is a step toward improving our chances in ensuring a future for this heritage. A continuation of current practice could be costly as it may result in the loss of this unique testimony of human existence.

REFERENCES

Ambrose, T., & Paine, C. (2003). *Museum Basics*. London: Routledge.

Ambrose, T., & Paine, C. (2012). *Museum Basics: Heritage: Care, Preservation, Management* (3rd ed.). London: Routledge.

American Alliance of Museums. (2012). *Developing a Collections Management Policy*. Retrieved 20 June 2017 from http://www.aam-us.org/docs/defaultsource/continuum/developing-a-cmp-final.pdf?sfvrsn=4

Baxter, P., & Jack, S. (2008). Qualitative Case Study Methodology: Study Design and Implementation for Novice Researcher. *Qualitative Report*, *13*(4), 544–559. Retrieved from http://nsuworks.nova.edu/tqr/vol13/iss4/2

Betts, C. (2004, June). Welsh nationals pledge to streamline their collections. *Museums Journal*.

Carman J. (2010). Promotion to heritage: How museum objects are made. *Encouraging collections mobility: A way forward for museums in Europe*. Academic Press.

Chaterera, F. (2017). The artefact and its record; towards a holistic approach in the management of collections in Zimbabwe's Museums. In M. Manayanga & S. Chirikure (Eds.), *Archives, Objects, places and landscapes: Multi-Disciplinary approaches to a decolonized Zimbabwean past. Laanga Research and Publishing CIG*.

Chiwara, D. (2017). Securing the future of collections through preventive conservation: the case of Zimbabwe Military Museum. In M. Manayanga & S. Chirikure (Eds.), *Archives, Objects, places and landscapes: Multi-Disciplinary approaches to a decolonized Zimbabwean past. Laanga Research and Publishing CIG*.

Dardes, K. (1998). *The conservation assessment. A proposed model for evaluating museum environmental management needs*. Retrieved June 27, 2017, from: http://www.getty.edu/conservation/publications

Desvallees, A., & Mairesse, F. (2010). *Key concepts of museology*. Singapore: Armand Colin.

ICOM. (2017). *ICOM statutes*. ICOM. Retrieved 10 June 2017, from http://archives.icom.museum/statutes.html#intro

ICOM. (2017). *ICOM Code of ethics for museums*. ICOM.

Lewis, G. (2004). The role of museums and the professional code of ethics. In Boylan. P (Ed.), Running a museum: A practical handbook (pp. 1-16). Paris: ICOM – International Council of Museums.

Lowenthal, D. (2000). Stewarding the Past in a Perplexing Present. In E. Avrami, R. Mason, & M. de la Torre (Eds.), *Values and Heritage Conservation. Research Report* (pp. 18–25). Los Angeles: Getty Conservation Institute.

Merriman, N. (2004). *Museums and Sustainability: Published thesis: Clore Leadership fellow*. Retrieved 13 June 2017 from https://www.museumsassociation.org

Schmdit, P. R., & Pikirayi, I. (2016). *Community Archaeology and Heritage in Africa; decolonizing practice*. New York: Routledge.

Simmons, J. E. (2003). *Managing collections management*. Retrieved 10 June 2017 from http://www.academia.edu/1870670/The_theoretical_bases_of_collections_management

Simmons, J. E., & Muñoz-Saba, Y. (2003). The theoretical bases of collections management. *Collection Forum, 18*(1-2), 38-49.

Chapter 21
Coverage of Cultural Heritage in Mass Media Publications in Zimbabwe

Marlvern Mabgwe
Midlands State University, Zimbabwe

Petronella Katekwe
Midlands State University, Zimbabwe

ABSTRACT

This chapter evaluates the pattern and trend of mass media coverage of Zimbabwe's cultural heritage, with a focus on the newspaper publications produced between the years 2010 and 2015. The working hypothesis is that the level and nature of mass media coverage of cultural heritage is directly proportional to the nature of public opinion and attitude towards their own cultural heritage. As such, in order for cultural heritage to make a meaningful contribution to socio-economic and political developmental in Zimbabwe, there is a need for cultural heritage to be visible in all mass media productions. Using document analysis, questionnaires, and interviews, the research identified that the coverage of cultural heritage in mass media in Zimbabwe is alarmingly low. That jeopardizes the regard of cultural heritage as a driver for socio-economic and political development amongst the public. However, through reprioritization of media agenda-setting, media policy, and fostering of a closer collaboration between heritage managers and media professionals, the situation can be salvaged in Zimbabwe.

INTRODUCTION

This chapter was inspired by the proceedings of the 2015 Biennial Conference of the Association of Southern African Professional Archaeologists (ASAPA) hosted by Zimbabwe which challenged researchers to find new avenues through which they could disseminate information on the role of cultural heritage in human development. A similar call had earlier on been made during the adoption of the Charter for African Cultural Renaissance in Khartoum in 2006. Given the wide range of disciplines that underline archaeology and its related disciplines, it literally translates to an infinite number of stakeholders whose

DOI: 10.4018/978-1-5225-3137-1.ch021

development is at stake. With the resurgent drive towards concepts such as African Renaissance (see Louw, 2000), Ubuntu and Human Development, the role of cultural heritage in human development becomes ever more apparent. Cultural heritage inspires identity and pride in people such that societies' perception on its own heritage directly influences how it develops. For Africa, this notion has been clearly articulated in the African Union's Charter for African Cultural Renaissance (2006). It is this invaluable link between indigenous African communities and their cultural way of life that had been the target of imperialist policies. With cultural alienation, cultural invasion and cultural disorientation, imperialism had significantly threatened African cultural systems. However, the attainment of sovereignty in almost all African countries today creates an opportunity for resuscitation of cultural heritage awareness. However, all this is feasible only under strict conditions where all stakeholders work effortlessly towards a single goal rather than against each other.

Colonialism brought with it a new way of perceiving human development as conceptualized by dependence upon the rate of adoption of new ways of life by a society. The faster a community embraced new concepts, the faster it development. For colonialism, this made sense but for post-colonial Africa, this manner of approaching development is myopic. The Charter for African Cultural Renaissance (2006) goes on to outline that media has a role to play towards the realization of the goal that cultural heritage is an avenue for human development. This is because media shapes the human mind and perception of the world.

Cultural heritage, regardless of its types and categories, ought to be recognized as important in human development. From the 2015 ASAPA conference, what became clear was the fact that identification, preservation and promotion of cultural heritage needs to incorporate all stakeholders for cultural sustainability and human development. As defined by the United Nations Development Programme (2016) human development is not about the creation or amount of economic wealth within a society. Rather, it is more about the richness of human life largely achieved through enhancing opportunities and choices of individuals and their societies. By defining human development concepts such as Ubuntu, African Renaissance and even the targeted goals of Zimbabwe's blueprint for socio-economic and political development (ZIMASSET) become relevant. It is therefore crucial to understand the position of mass media in such a bold drive. This particular focus on mass media follows the opinion of Hesselink (2004) who argues that media has power to stimulate human development. Through content analysis, the chapter identifies the nature and influence that mass media has within Zimbabwe. The working assumption was that, 'news' reflects what is regarded as very important for decision making by a society. Since there is liberalization of the media in Zimbabwe, through understanding their concerted efforts, it should be clear as to how the coverage of cultural heritage relates to development in the country.

The objectives of this chapter should allow the reader to:

- Understand the socio-economic and political context that has shaped the media agenda and setting within Zimbabwe over the past 20 years.
- Understand the trends of visibility of cultural heritage in public and private newspaper publications that have been made accessible to Zimbabweans between 2010 and 2015.
- Appreciate the correlation between visibility of cultural heritage in newspapers and public awareness of the potential of cultural heritage in human development.

The organization of this chapter follows the following outline. The first section contextualizes Zimbabwean media as a product of the past 20 year history of socio-economic and political challenges. This

20 year period has successfully set the media agenda and setting in the country. It then establishes the trends and patterns of cultural heritage coverage in Zimbabwe's newspaper publications using content analysis as the main technique. Such trends denote visibility of cultural heritage in published newspapers. The chapter then goes on examine factors that have influenced 'news' within Zimbabwe as a platform for understanding noted trends of cultural heritage coverage in newspaper publications. It is this visibility that is argued as influencing how the general public links cultural heritage and the notion of development. Avenues for future research are then suggested.

MEDIA AND ZIMBABWE'S SOCIO-ECONOMIC AND POLITICAL PAST: CONTEXTUALISING THE DILEMNA

Zimbabwe's political past is plagued by a host of socio-economic and political challenges whose implications reach far and wide. The challenges began around the late 1990s with the stoppage of all critical international aid to the country. Soon the taxpayer was bearing the full weight of financing government projects, obligations and expenditures. Industrial strikes across all sectors of industries became the order of the day (Sutcliffe, 2013; Alexander, 2001) up until the establishment of the inclusive government (Government of National Unity-GNU) in 2009 (Sutcliffe, 2013). The magnitude of this economic and political meltdown went as far as seeing Zimbabwe's worst hyperinflationary economy (a term coined by Cagan in 1956). The world's first 100 trillion dollar note was printed (Koech, 2011). From an economic perspective, printing this note made sense but to the ordinary Zimbabwean, this hardly softened the blow (Hanke & Kwok, 2009) against daily life struggles such as high unemployment, diminishing real income (Campbell 2008), high staff turnover, high company closures, closure of schools and state universities (around 2008), increase in corruption and nepotism amongst a host of other debilitating challenges. On top of that, mass media reportedly became highly polarized along political lines (Sutcliffe, 2013). Two distinct camps of mass media reporting became apparent. On one hand was the publicly-funded mass media houses that sought to portray the prevailing socio-economic and political challenges as scheming of the imperialist western countries led by Britain and United States of America. One the other end of the spectrum was the privately-funded mass media institutions who argued from the perspective of the suffering multitudes. At the centre of this protracted war of printed words was the general public. Gullible in how their thinking is easily swayed by creative writing and suggestions from media, mass media literally determined what the public would think and believe. Such action is referred to as media setting (Wilson & Wilson, 2001).

Littlejohn (2002) has argued that the public largely react not to the actual events around them but to suggestions created for them. As a consequence of Zimbabwe's socio-economic and political challenges, mass media has constantly played the decisive role in shaping public opinion. This notion is shared by Skaff (2015); Fuchs (1995); Castro & Wyss (2004) and Millar (2012). In Zimbabwe, two central issues arise. Firstly, the series of political actions and consequences subsequently created a vulnerable socio-economic and political system in which mass media became polarized (Zeilig, 2002). Secondly, as media polarity became commonplace, it made the ordinary Zimbabwean more vulnerable. As Schlee, (2011); Gwisai, (2009) and Masunungure, (2006a) outlined, the general public in Zimbabwe became more concerned about politics and their day to day life-struggles than other facets of life.

As Zimbabwe's socio-economic and political fortunes were in turmoil, National Museums and Monuments of Zimbabwe, amongst other closely related institutions that deal with cultural heritage were not

spared. As the government struggled to finance its obligations, grants awarded to quasi-governmental institutions such as NMMZ were significantly reduced thereby compromising all its central functions. Research was under-funded and maintenance of cultural heritage properties became a serious challenge. Most importantly, the promotion of cultural heritage to indigenous communities became limited to what academics published through their own efforts. The sense of human development through capacities enabled by cultural heritage became jeopardized as even media downplayed the capacity of cultural heritage to initiate and sustain human development (Cuccia & Cellini, 2007) which may come though the different values of cultural heritage resources.

Although the socio-economic and political strife experienced by Zimbabwe since the late 1990s up until 2009 dominated the headlines of mass media institutions, there has since been a resurgence of focus on cultural heritage and its contribution to sustainable human development. Set as an agenda at both international and national levels, cultural heritage in its varied forms is singled out as one of the most important facets for rejuvenation of national pride and development. This concept became part of both the agenda for the African Union (see African Cultural Renaissance 2006) as well as Zimbabwe's 2013 mid-term economic recovery blueprint. In both instances, the central argument is that whilst the ordinary person might be worried about the 'bread and butter issues', there is a need for the rejuvenation of other facets of life such as the recognition of cultural heritage in human development. 'ZIMASSET', as a socio-economic and political framework, laid the foundation upon which the interplay of media in cultural heritage can be explored. As outlined earlier, the socio-economic and political challenges that the country faced since the 1990s created a polarized media industry whose agenda was influenced by politics. Since the funding institutions determined what sold the newspapers, the general public was therefore swamped in political issues at the expense of other themes of news. It is therefore this recognition of the value and potential of cultural resource towards development which prompted this introspection of how key players such as media houses have been contributing towards the achievement of this noble goal since 2010.

AIM OF THE RESEARCH

The aim of this chapter was to establish the level of mass media coverage of cultural heritage in Zimbabwe between 2010 and 2015 by both public and privately-owned print media. This allows for a determination of the extent to which mass media has complimented efforts of heritage practitioners through disseminating vital information about Zimbabwe's cultural heritage in such a manner that it facilitates for human development amongst the general public.

RESEARCH DESIGN AND METHODOLOGY

This chapter employed the mixed method approach to augment content analysis. The researchers identified relevant articles specifically published in the newspapers between 2010 and 2015. These selected newspapers were Herald, Sunday Mail, News Day and Daily News. The relevant articles were placed into pre-selected categories which cater across some of the forms of cultural heritage in the country. The assumption was that, the more the relevant articles, the more the visibility of cultural heritage hence the higher the acceptance and knowledge about Zimbabwe's cultural heritage amongst the general public.

The researchers were of the opinion that if the general public has an increased awareness of the diversity of cultural heritage from Zimbabwe, it would stand to reason that they would be aware of it and at the same time readily embrace it as an avenue for their development. Supportive qualitative data was collected from professionals in the heritage and media industries as well as the general public. This general public was selected from the Midlands Province of Zimbabwe.

The research participants were 5 Zimpapers journalists, 15 heritage managers from NMMZ, Midlands State University staff and students (four lecturers and 18 students from the Department of Archaeology, Cultural Heritage and Museum Studies and four Lecturers and 52 students from the Department of Media and Society Studies), and 200 members of the general public selected from both urban and rural areas in the province.

In order to collect qualitative data, face to face interviews were conducted with the Zimpapers journalists, heritage managers and lecturers. The average length of each interview was 20 minutes with the aim of allowing the research participants to exhaustively share their thoughts and opinions.

Focus group discussions were employed to facilitate for the collection of data from the undergraduate and post-graduate students. These students had been randomly selected to represent the First year, Second year, Fourth year and Post-graduate levels only. This criterion excluded all Third year students (from MSU) on the basis that during this year of their university education, they are on work-related learning hence not readily available on campus. The statistical breakdown of research participants from the Department of Archaeology was that five students per level would adequately represent all First, Second and Fourth year students. Only three post-graduate students from the same department were considered. These low numbers were in line with the low enrollment within the department. This was contrary to the number of participants who were selected from the Department of Media and Society Studies where 15 students per academic level represented the First, Second and Fourth year students whilst seven represented the post-graduate students.

Informal interviews were conducted over a period of 2 years through-out the Midlands Province. The researchers took advantage of their field excursions to interact with the general public who were all assumed to be stakeholders to Zimbabwe's diverse heritage.

In all instances, data collection from the research participants was preceded by a declaration of the participant's ethical obligation. The research aim and objectives were explained in three common languages spoken within the Midlands Province. These are English, Shona and Ndebele. The participants were informed of their right to anonymity (unless they expressed their wish to be quoted verbatim). Only when the participant was satisfied, would the interviews and discussions pertaining to this research begin.

This research only focused on both hardcopy and online newspaper publications made by the pre-selected institutions between the years 2010 and 2015. The advantage of the hardcopy newspapers was that they could be verified and were also easily accessible from Midlands State University library's newspaper repository. Online sources were obtained from their relevant websites. This choice to focus on Herald, Sunday Mail, Newsday and Daily News emanated from the fact that they could make a fair representation of both publicly-funded and privately-funded the mass media publications. The Herald and Sunday Mail newspapers represented the publicly-funded newspaper publications whilst the Daily News and Newsday represented the privately-funded newspaper publications. Subsequently, the researchers' choice of the Daily News and Newsday emanated from the fact that journalists from these publishing houses also obtained some of their news-articles from a host of other related non-governmental news publishing agencies. Statistically, between 2010 and 2015, a combined total of over 21000 newspapers were printed by these four newspaper publishing institutions alone (see Table 1). This translates to

nearly 1.8 million individual news-articles in total over the 5 year period. Due to this large number of newspapers and news-articles therein, the researchers chose to only cover a maximum of 60 percent of all the newspapers and online publications. These (60 percent) were selected through systematic random sampling considering the month and days of publications.

In order to categorize the newspaper articles, the following categories were developed and used as they pertain to the Zimbabwean context. These were Stone Age, Iron Age, Historical Period, Colonial Heritage, Liberation Heritage, Cultural Landscapes, National Museums and lastly Contemporary Arts and Culture. For this research, focus was therefore not placed upon other institutions that work with Zimbabwe's diverse heritage such as the country's archival repositories. The researchers are however cogniscant of the fact that Zimbabwe's cultural heritage is even broader than portrayed in this research.

In terms of statistical representativeness of the publications, table 1 below presents the summary.

SUMMARY OF RESEARCH FINDINGS

Coverage of Cultural Heritage in Newspapers Between 2010 and 2015

The central aim of this chapter was to establish the number of newspaper articles (published between 2010 and 2015) that focused on the pre-selected categories of Zimbabwe's diverse cultural heritage forms. This allowed the researchers to determine visibility of cultural heritage in the local newspaper publications. The researchers noted that some categories of Zimbabwe's cultural heritage frequently appeared in the newspapers. However, of concern was their disproportionate coverage. Table 2, shows the extent of such discrepancies. From the content analysis, the notable trend was that generally, cultural heritage featured more in publicly-funded newspapers as compared to the privately-funded newspapers. Herald and the Sunday Mail had a total of 2275 articles on a diverse range of subjects as compared to 237 that appeared in both the Newsday and Daily news. Whilst these figures give an illusion that cultural heritage features prominently, but when these figures are reduced to percentages, the real truth becomes apparent. When presented as a percentage of the total number of featured articles, only 0.67% of the articles from publicly-funded newspapers mention some aspect of cultural heritage. The situation is even worse with privately-funded newspapers where only 0.030% of the news articles focus on some aspect of cultural heritage. What this alludes to is that visibility of cultural heritage in newspapers is tragically low to insignificant at most. The central question therefore is, if cultural heritage does not consistently feature in any newspaper, should cultural heritage be expected to a driver of development amongst the general public?

Table 1. Statistics of Newspapers consulted in the research

Newspaper Publisher	Total No of 2010-2015 Publications	Number of Newspapers Consulted	Total Average No. of Stories Covered
Herald	6240	3144	282960
Sunday Mail	1040	624	56160
Newsday	7280	4368	393120
Daily News	7280	4368	393120

Table 2. Statistics of relevant news stories in designated themes

Category of Cultural Heritage	Herald	Sunday Mail	Newsday	Daily News
Stone Age	6	10	0	0
Iron Age	40	20	0	0
Historical Period	10	15	2	1
Colonial Heritage	50	120	6	0
Liberation Heritage	600	450	120	50
Contemporary Arts and Culture	300	540	30	25
Cultural Landscapes	30	24	0	0
National Museums	40	20	2	1

The researchers noted that whilst the pre-selected range of themes of cultural heritage was wide, the noticeable trend was that the Stone Age, Iron Age, Historical Period, Colonial Heritage, Cultural Landscapes as well as National Museum issues were the least covered. This is in contrast to a significant number of articles centred on Zimbabwe's Liberation Heritage as well as Contemporary Arts and Culture (See Table 2). Upon closer inspection of the relevant articles, in terms of focus and time of publication, what is apparent are the efforts of reinforcing nationalism. The bulk of the articles on Zimbabwe's Liberation Heritage followed commemorations of gains of independence. Key time-periods included the Independence Day celebrations held in April as well as the celebration of both the National Heroes Day as well, Africa Day, Defence Forces Day as well as the mourning of fallen hero or heroine. It was also noted that the privately-funded newspapers also covered the same themes fairly extensively although they were predominantly silent on all the other themes.

What this entails in summation is that although cultural heritage issues are covered as news stories in both government-funded and privately-funded newspaper publications, the visibility of such issues is rather negligible. The impression created by media is therefore that cultural heritage is not news-worthy as compared to issues such as politics, religion, business and sport which featured permanently in all publications.

What Prominent Themes on Cultural Heritage Feature in Newspapers?

As outlined in Table 2, the clear trend noted was that 3 these of cultural heritage get significant coverage.

Liberation Heritage

As a theme, Zimbabwe's liberation heritage is the most covered cultural heritage theme. Statistically, 1040 articles appeared in the Herald and Sunday Mails between 2010 and 2015 alone. The central focus of the news articles on Zimbabwe's liberation heritage commemorated the life, sacrifices and gains of Zimbabwe from the colonial government. Such commemorations not only identified the central players in such victory but also reiterated the loss of human life as reflected in the mass graves such as Chimoio, Nyadzonyia, Iron Monkey Mine (Chibondo) (see Herald of 9 April 2015, 13 April 2011 as well as 30 April 2011) amongst others. Days leading to every independence, Heroes and Defense Forces Day commemorations thereby become the time when this theme is most apparent. This theme has been presented

through some emotionally-challenging articles. The Herald of 16 March 2015 and 9 April 2015 recounted the Chimoio attacks (complimented by the Sunday Mail). Some touching articles even carried the titles '*Remember Chibondo Liberation mass graves*", "*Memories of sobbing shadows of Nyadzonia*", "*Weeping bone of Chibondo*", as well as *"848 fighters exhumed from Chibondo Mineshaft to date"*.

Contemporary Arts and Culture

From the newspaper articles analyzed, visual and fine arts are the second most visible theme of cultural heritage in Zimbabwe. A selection of some of the headlines that explored Zimbabwe's diverse visual and fine arts include; *"Creative arts and culture – Tengenenge Art community sculptors"*(Herald-11 March 2015) and *"Visual and fine arts-Art of Print making"* (Herald-13 March 2015), '*Centre to Preserve cultural heritage* (Newsday on 29 February 2012), '*Amagugu benefits from International Culture Fund* (Newsday of 19 December 2015). The articles focused more on methods, support organization and intellectual property rights on visual and artistic work. As a platform for human development these articles impressed upon the need for practitioners of the visual and fine arts in Zimbabwe to continue educating artists on Intellectual Property rights as a way of protecting their work. Only with such protection could artist's creativity and craftsmanship be recognized both locally and internationally. Such vital piece of information (when read by a person with talent on visual and fine arts) help prevent abuse of artists as well as safeguarding them in this cutthroat industry. Such concern has also been raised by Thinley (2007).

The articles on Visual and Fine arts did not only celebrate the works of artists but also examined the contemporary challenges facing minority cultures in some parts of the country. With such dissemination of information on ethnic cultures such as Tonga, Venda and Sotho, Shangani and Venda (see the Herald of 5 April 2015 on the annual culture week commemorations, the reporters explored the challenges posed upon minority cultures by the unclear position of the Zimbabwean government when it comes to the importance of culture and cultural diversity as well as how the government could revitalize the arts industry a source of employment and income generating in the country.

Within the same vein of disseminating information on indigenous cultures, a substantial number of newspaper articles also looked at the intangible heritage as part of the concerted efforts championed by UNESCO, NMMZ as well as other related institutions. The range of coverage of such issues ranged from looking into available streams of funding to celebrating diversity of intangible heritage in the country. Traditional practices such as 'Chinamwali" and Mbende, Jaka and Chokoto and Nyai dances and their significance to the sustenance of cultures amongst the indigenous people were examined. Such dissemination of information goes beyond the VaRemba, VaNyai, but allows the general public from Zimbabwe to have an understanding and tolerance of the diverse cultures that define Zimbabweans.

Museum and Contemporary Research in Zimbabwe

Content analysis showed that there has been some coverage of national museums in Zimbabwe. The thrust of such coverage examined the role and potential of museums in the protection of Zimbabwe's material culture. However, not all articles painted a similar glowing picture as other critiqued the safety of Zimbabwe's cultural heritage in such institutions. Regardless, media used its power of suggestion to disseminate information pertaining to the national museums in the country. Given the breadth and depth of Zimbabwe's national museums towards education, entertainment, research, protection and promotion

of the country's rich heritage, this information goes a long way in dismantling notions of museums as irrelevant institutions. Some of the notable articles around this wide theme included the 2nd of April 2013 Herald article that joined National Museums and Monuments of Zimbabwe in commemorating the International Museum Day. The article explained the role of museums in education. Similarly, the News Day also complimented the Herald through its exploration of the Zimbabwe Museum of Human Sciences' displays and their significance to the country's cultural heritage and history. This article appeared in its publication of 11 December 2013. A similar theme was also portrayed in the Daily News highlighting of museums and human development. It is such efforts by the media which establish a vital communication channel ideal for human development (Gamble and Gamble cited in Nwaolikpe 2013 & Yusuf 2016). It can therefore be argued that such intervention of media publications goes a long way in supporting the efforts of heritage researchers who have dedicated their professional lives to the identification, protection and promotion of Zimbabwe's cultural heritage which now lies within the country's national museums.

Statistical Representation of Cultural Heritage as Percentages

In order to fully explore the visibility of cultural heritage issues in newspaper publications, it was also necessary to convert the actual number of articles into percentages. These percentages are calculated from the estimated number of articles (see Table 1 above) that were featured in all the newspapers consulted. What is very clear is that whilst the published newspapers between 2010 and 2015 carried so many articles (around 1.8 million in total), there is an insignificant coverage of cultural heritage issues. The figures are so negligible that it seems as if cultural heritage is not even any subject matter which warrants attention. This is despite the resurgence in calls for African Renaissance as a pivot for resuscitation of African cultures and pride. Despite the concerted efforts of National Museums and Monuments of Zimbabwe, individual heritage researchers and other supportive institutions, all that effort does not have room within the newspaper publications.

From these percentages, the researchers sought to find explanations to the seeing absence of cultural heritage from daily newspaper publications. In order to achieve this, there was a need to consult both journalists as well as leading experts on media.

Table 3. Number of articles on Cultural heritage as percentages

Heritage Category	Herald	Sunday Mail	Newsday	Daily News
Stone Age	0.002	0.018	0.000	0.000
Iron Age	0.014	0.040	0.000	0.000
Historical Period	0.003	0.030	0.000	0.000
Colonial Heritage	0.020	0.030	0.001	0.000
Liberation Heritage	0.210	0.021	0.030	0.012
Contemporary Arts and Culture	0.110	0.961	0.007	0.006
Cultural Landscape and Associated resources	0.010	0.042	0.000	0.000
Museums and Contemporary Archaeological Research	0.014	0.040	0.000	0.000

Agenda-Setting in Zimbabwean Media

From the content analysis, what became apparent was that whilst some themes on cultural heritage featured in newspaper publication between 2010 and 2015, the sad truth was that cultural heritage was not a prominent feature at all. The amount of cultural heritage-related themes was negligible when compared to other issue such as politics, business, law and sport. As such, it was prudent to determine how news then appeared in the newspapers. Such views would help explain the visible trends noted in tables 2 and 3 above.

Readership and High Profit Determines Coverage

Upon enquiry from journalists and media practitioners, the researchers sought to understand how 'news' was determined. Through interviews and informal discussions, what was apparent was that all journalists write many potential 'news-stories'. Unfortunately, the final selection on which articles would make it into the newspaper rested in the office of the Editor-in-chief. As such, as much as cultural heritage issues might have been one of the 'potential' stories, the journalists do not have any power to influence their publication. At the same time, mass media houses are run on a profit-basis, hence are expected to make as many sales as possible. This factor also played a crucial role in influencing the choice of the editor-in-chief. Apparently, the limited visibility of cultural heritage issues in the local newspapers is an indication that such themes do not appeal to the public hence do not have a commanding room in newspapers. This is despite the importance of cultural heritage in human development. It was also explained that newspapers base their gross income on two main issues; readership and advertisements. This is the reason why adverts also feature prominently in all newspapers regardless of funding sources.

Limited Awareness and Interest on Cultural Heritage Amongst Some Journalists

Through the discussion and explanations on what defined news and ultimately, the newspaper publication, it was became prudent to enquire into what journalists understood about cultural heritage. Since the 5 journalists were from the Midlands Province, the researchers sought to understand their perception of cultural heritage and its value to human development within the context of the Midlands Province. One journalist remarked *"...munombori nechiiko muMidlands chinganzi chakakosha?"* (Translation; 'what exactly is culturally important in the Midlands Province?)* Upon critical analysis of the implication of this opinion, the researchers realized that journalists are therefore more likely to cover issues that they are familiar with. As this journalist clearly was not aware of the diversity of cultural heritage in the Midlands Province, it was not likely that he would cover anything other than the liberation heritage. However, a synergy between the journalists and local cultural heritage managers could easily resolve this debacle but there were no provisions for these two camps to even collaborate given the fact that the final choice rested with the editor-in-chief based in Bulawayo.

Nepotism and Waning Passions in Contemporary Journalism

As a follow-up question after the journalists had expressed that news that got covered was news that sold the most newspapers, the researchers enquired on the extent on nepotism in journalism. Preferring anonymity, three journalists admitted that with the massive brain drain that affected many sectors of

industries in Zimbabwe since the late 1990s, the face of journalism has been guided by nepotism. Journalists and other media practitioners (60%) outlined that whilst it went against the ethical principles of journalism, at times journalists were 'paid' to favorably cover some aspects. In some cases, journalists would be invited to attend sponsored functions under the unwritten impression that they would in-turn portray such events in a glowing manner. Upon reflection on what this meant for themes already castigated as 'less-appealing' to the newspaper's buying customers, it implied that as long as there is no *'under-the-table dealings'*, journalists would always favour those that 'pay something'. This sentiment was also shared amongst media and society studies lectures and students when asked whether they would consider a bribe in order for them to cover a suggested story-line.

The Conflicted Position of 'Community' Newspapers in Zimbabwe

The researchers sought to establish whether there was a possibility that the coverage of cultural heritage issues in newspapers could be a direct result of more than nepotism and waning passions in journalism. From the comments, it was also apparent that whilst the Herald, Sunday Mail, News Day and Daily News were national in their approach to news, a similar trend is noticeable with community newspapers. Despite the fact that their mandate lies with dissemination of information more relevant to their own immediate communities, they merely focused on the same stories already published by the national newspapers. This gave an impression that the media system initiated during the colonial period is still at play in the post-independent Zimbabwe. Besides, most of these community newspapers are also products of the seasoned journalists and media practitioners who at one point in tome or the other have worked for the traditional newspaper houses in Zimbabwe.

Significance of Cultural Heritage to Contemporary Zimbabweans and the Role of Information Dissemination

As a follow-up to sentiments raised by journalists, media students and well as media practitioners, the researchers approached heritage practitioners to get their views on why heritage is significant and why dissemination of information is crucial. 80% of the participants to this question brought up the issue of disservice of the media fraternity towards the featuring of cultural heritage issues in newspapers. Whilst they indicated that heritage managers did not have the capacity to influence media publishers, 60% noted that if given an opportunity, they would make cultural heritage a permanent feature in daily newspapers. A common opinion was that when cultural heritage regardless of theme appeared as news, it would give the ordinary person an opportunity to learn something about Zimbabwe's cultural heritage. With such dissemination of information, newspapers could actively celebrate the achievements of individuals, communities and institutions working with cultural heritage. Only then would the general public stop thinking that Great Zimbabwe and Khami ruins are the only notable heritage sites in the country.

When asked on the noted trends that liberation heritage was the most common cultural heritage theme in Zimbabwe, 80% of the NMMZ employees lamented on this fact. They argued that the apparent preference by journalists to cover Zimbabwe's liberation heritage gave the wrong impression about the value of Zimbabwe's diverse cultural heritage. A comprehensive appreciation of what Zimbabwe has to offer in the form of cultural heritage goes well beyond the liberation heritage. By looking at the legal mandate of NMMZ, the government had noted that Zimbabwe had some much to offer but this vision entrusted in NMMZ is not shared with the media fraternity. As such, they felt that their concerted

efforts are going to waste as through their own means and strategies, it is near impossible for heritage managers to approach as wide an audience as mass media publications. These sentiments resonate with Yusuf (2016) and Onabajo (2005) who agree that one function of mass media is to promote and transmit cultural heritage from one generation to the other. Unfortunately, when media becomes polarized, that function becomes compromised and the future becomes uncertain. In all instances, it jeopardizes human development relevant to the African continent.

Media and Public Opinion of Reality

After collecting information from the media and heritage fraternity, the researchers turned their attention to the general public. On the basis that these interactions with the public took place over 2 years in many rural and urban areas around Zimbabwe, their sentiments are regarded as faithful to the views of the majority. The main objective was to understand whether or not the public regarded media as influential to how they perceived Zimbabwe in general.

Whilst the truth is that media has influence on public opinion, 70% of the public (characteristically aged between 15 and 50) thought media did not have a stronghold upon how they thought and perceived the world. However, 20% (see figure 1 above) cited that media had a significant influence whilst only 10 percent were not sure. The 70% who disagreed related their opinion on the role of cultural heritage in their day to day lives. 67% argued that due to the ongoing challenges, they are more focused on surviving and putting food on their tables hence even when cultural heritage issues are presented in the news, they are not inclined to acknowledge it. However, upon being asked to confirm whether or not visibility or lack thereof, of any particular theme gave an impression that such theme was not relevant, they then concurred that indeed media had an influence on how they perceived reality.

Figure 1. Public view on the influence of media coverage on public opinion

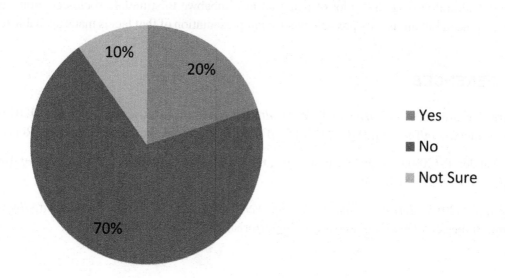

Public view on influence of media coverage on public opinion
regarding cultural heritage and its role in their lives

SUGGESTIONS FOR FUTURE RESEARCH

From the data collected, what is not apparent, but can significantly enhance our understanding of media presentation of cultural heritage is to look at character of language in communication. An attention to the nature of content as well as contextual meaning implied within such content has a huge bearing on the extent to which media actively contributes to disseminating the right information. It is one thing for a reporter without a proper background on cultural heritage to write a newspaper article and it is another thing to present information on the same site from an academic perspective. The more factual and consistent the data presented, the relevant the contribution. Unfortunately, in our research, the preliminary aim was to determine if cultural heritage issues appear in the newspapers. However, subsequent research ought to take a closer academic look at those articles that do appear. It is also prudent to examine closely the co-relation between public and private interests when it comes to funding mass media publications. In this research, the assumption was that all forms of news receive fair coverage based upon the fact that these newspapers served the same interests. However, this is not always true.

CONCLUSION

What is apparent is that cultural heritage, as a special theme, does not feature prominently in Zimbabwean newspapers to such an extent that this has led the public to believe that it does not really matter in their lives. From the content analysis, less that 2% percent of all newspaper articles focus on some aspect of Zimbabwe's diverse cultural heritage. What this means is that with the resultant invisibility of cultural heritage in the newspapers, the public is led to believe that this absence reinforces their belief that cultural heritage does not really contribute to their contemporary life situation. Whilst this is so far from the truth, the extent of the influence of media in shaping what the public see and believes as reality is ever more powerful. However, whilst there are a number of challenges that explain the prevailing scenario, there is a need for a change in the polarization of media in Zimbabwe. As long as media is polarized and therefore keen to satisfying those in positions of power, it negatively influences the public into focusing more on how they should see the world rather than allowing the public to appreciate the reality around them. Cultural heritage has a lot of potential in Zimbabwe to stimulate socio-economic and political development, but this is only possible when a fair presentation of that fact is made available to the public.

REFERENCES

African Union. (2006). *Charter for African Cultural Renaissance*. Retrieved September 10 2017 from:http://www.unesco.org/fileadmin/MULTIMEDIA/FIELD/Dakar/pdf/CharterAfricanCulturalRenaissance.PDF

Alexander, P. (2001). Zimbabwean workers, the MDC and the 2000 elections. *Review of African Political Economy*, 27(85), 85–406.

Azziz, S. (2015). *Terrorism and the Muslim Veil*. Retrieved 24 July, 2015, from: http://www.oxfordislamicstudies.com/public/focus/essay1009_terrorism_and_the_muslim_veil.html

Cagan, P. (1956). The monetary dynamics of hyperinflation. In M. Friedman (Ed.), *Studies in the Quantity Theory of Money* (pp. 25–117). Chicago: University of Chicago Press.

Campbell, H. (2008). The Zimbabwean working peoples: Between a political rock and an economy hard place. *Association of Concerned African Scholars. Bulletin, 80.* Retrieved from http://concernedafrican-scholars.org/the-zimbabwean-working-peoples

Castro, H., & Wyss, J. (2004). Mass media and engaging journalists: supporting biodiversity conservation. In D. Hamú, E. Auchincloss, & W. Goldstein (Eds.), *Communicating Protected Areas, Commission on Education and Communication, IUCN* (pp. 14–312). Cambridge, UK: Gland.

Chan, S. (2012). Zimbabwe: The sanctions of no sanctions. *E-international relations.* Retrieved June 11, 2015 from: http://www.e-ir.info/2012/07/25/the-sanctions-of-no-sanctions

Cuccia, T., & Cellini, R. (2007). Is cultural heritage really important for tourists?: A Contingent Rating Study. *Applied Economics, 39*(2), 261–271. doi:10.1080/00036840500427981

Gwisai, M. (2009). Revolutionaries, resistance and crisis in Zimbabwe. In L. Zeilig (Ed.), Class Stuggles and Resistance in Africa (pp. 219-251). Chicago: Haymarket Books.

Hanke, S., & Kwok, A. (2009). On the measurement of Zimbabwe's hyperinflation. *Cato Journal, 29*(2), 353–64.

Littlejohn, S. W. (2002). *Theories of Human Communication* (7th ed.). Albuquerque, NM: Wadsworth.

Livesey, C. (2011). The Mass Media: Defining mass media. *Sociology Central.* Retrieved 12 September 2017 from: http://www.sociology.org.uk/notes/media_defined.pdf

Louw, A. H. (2000). *The concept of the African Renaissance as a force multiplier to enhance lasting peace and stability in Sub-Saharan Africa. Executive National Security Programme 02/2000.* South African Defence College.

Makochekanwa, A. (2009). *Clothed in Rags by Hyperinflation: The Case of Zimbabwe. Munich Personal RePEc Archive (MPRA) (28863).* Pretoria: University of Pretoria.

Masunungure, E. (2006a). *Why Zimbabweans do not rebel. Part 1.* Retrieved 13 March 2017 from: // www.zimonline.co.za/Article.aspx?ArticleId=192

Millar, P. (2012). *Fighting for the front page: The challenges of environmental reporting in Malawi: Field notes.* Journalists for Human Rights. Retrieved 17 January 2015 from: http://www.jhr.ca/blog/2012/05/fighting-for-the-front-page-thechallenges-of-environmental-reporting-in-malawi/

Newsday. (2011). *Intangible Cultural Heritage under threat.* Retrieved 24 November 2016 from: http://www.newsday.co.zw/2011/03/21/21-03-21-intangible-cultural- heritage-under- threat/

Nwaolikpe, O. N. (2013). Culture and Nigerian Identity in Print Media. *Arabian Journal of Business and Management Review, 3*(3).

Onabajo, F. (2005). Promoting indigenous culture and community life in Nigeria through mass media. *Stud Tribes Tribals 3*(2), 92-98.

Schlee, B. (2011). *Economic Crisis and Political Apathy in Zimbabwe: The impotent society*. Retrieved 24 July 2015 from: http://paperroom.ipsa.org/papers/paper_26446.pdf

Skaff, R. (2015). *The misinformation burnout: Media fatigue with 'Islamism' and 'Terrorism'*. Retrieved 24 July 2015 from: http://www.globalresearch.ca.org/the-misinformation-burnout-media-fatigue-with-islamism-and-terrorism/5450606

Sutcliffe, J. (2013). *The labour movement in Zimbabwe 1980-2012*. Retrieved 12 July 2016 from: www.e-ir.info/2013/0/07/the-labour-movement-in-zimbabwe-1980-2012/

Thinley, D. (2007). Cultural maintenance and promotion: The print media's role in providing space for knowledge and discourse. In *Media and Public Culture: Proceedings of the Second International Seminar on Bhutan Studies* (pp 70-106). Retrieved 14 December 2016 from http://crossia-repository.ub.uni-heidelberg.de/342/

UNDP. (2016). *Human Development Reports*. Retrieved 10 September 2017 from:http://hdr.undp.org/en/humandev

UNESCO. (2001). *Universal Declaration on Cultural Diversity*. Retrieved 14 March 2017 from: http://unesdoc.unesco.org/images/0012/001271/127160m.pdf

UNESCO. (2017). *Illicit Trafficking of Cultural Property*. Retrieved 10 September 2017 from: http://www.unesco.org/new/en/culture/themes/illicit-trafficking-of-cultural-property/unesco-database-of-national-cultural-heritage-laws/frequently-asked-questions/definition-of-the-cultural-heritage/

Wilson, J. R., & Wilson, R. S. (2001). *Mass Media, Mass Culture* (5th ed.). Boston: Mc Graw Hill.

Yusuf, M. K. (2016). Media Programming and Cultural Reflections: A Comparative Analysis of Selected Local Media. *Journal of Advances in Social Science- Humanities, 2*(2), 8-14.

Zeilig, L. (2002). Crisis in Zimbabwe. *International Socialism Journal*, (94).

Compilation of References

Abankwah, R. (2008). *The management of audio-visual materials in the member states of the East and Southern Africa Regional Branch of the International Council on Archives (ESARBICA)* (Unpublished doctoral thesis). University of KwaZulu-Natal, Pietermaritzburg, South Africa.

Abankwah, R. M. (2007). *The management of audio-visual materials in the member states of the East and Southern Africa Regional Branch of the International Council on Archives (ESARBIACA)* (PhD. Dissertation). University of KwaZulu-Natal.

Abankwah, R. (2011). Policies and strategies that govern the management of audio visuals materials in East and Southern African Regional Branch of the International Council on Archives. *Journal of the South Africa Society of Archivists, 44*, 90–106.

Abankwah, R. (2011). Policies and strategies that govern the management of audio-visual materials in Eastern and Southern Africa Regional Branch of the International Council on Archives. *Journal of the South African Society of Archivists, 44*, 90–106.

Abankwah, R., & Ngulube, P. (2012). Environmental conditions and the storage of audio visual materials in archival institutions in the ESARBICA region. *ESARBICA Journal, 31*, 75–82.

Abioye, A. (2009). Searchers' perceptions of access regulations in Nigerian national archives. *Library Philosophy and Practice*. Retrieved August 17, 2017 from: http://unllib.unl.edu/LPP/abioye.htm

Abioye, A. (2009). Searchers' perceptions of access regulations in Nigerian national archives. *Library Philosophy and Practice*. Retrieved December 14, 2016, from http://unllib.unl.edu/LPP/abioye.htm

Abraham, T. (1997). *The Next Step: Outreach on the World Wide Web*. Paper prepared for the Annual Meeting of the Society of Rocky Mountain Archivists, Cheyenne, WY. Retrieved January 24, 2008 from: http://www.uidaho.edu/special-collections/papers/outreach.htm

ACARM Newsletter. (2004). Essential Elements of a Records Management. *ACARM Newsletter, 35*. Retrieved 20 June 2016 from: http://www.acarm.org/documents/issue35/35.18%20Essential%20Elements%20of%20Records%20Management.pdf

Ackoff, R. L. (1981). *Creating the corporate future*. New York: John Wiley & Sons.

Adams, R. (1975). Where do our ideas come from? Descartes vs Locke. In S. Stitch (Ed.), Innate ideas (71–87). Berkeley, CA: University of California Press.

Adams, J., Cochrane, M., & Dunne, L. (2012). Introduction. In J. Adams, M. Cochrane, & L. Dunne (Eds.), *Applying theory to educational research: An introductory approach with case studies* (pp. 1–10). Chichester, UK: Wiley-Blackwell.

Adamson, J. (1960). *Born free. A lioness of two worlds*. London: William Collins.

Adu, K. K. (2015). *Framework for digital preservation of electronic government in Ghana* (Unpublished doctoral dissertation). University of South Africa, Pretoria, South Africa.

Adu, K. K., & Ngulube, P. (2017). Key threats and challenges to the preservation of digital records of public institutions in Ghana. *Information Communication and Society, 20*(8), 1127–1145. doi:10.1080/1369118X.2016.1218527

African Commission on Human and Peoples Rights. (2002). *Resolution on the Adoption of the Declaration of Principles on Freedom of Expression in Africa.* Retrieved August 1, 2017 from: http://www.achpr.org/sessions/32nd/resolutions/62/

African Union. (2006). *Charter for African Cultural Renaissance.* Retrieved September 10 2017 from:http://www.unesco.org/fileadmin/MULTIMEDIA/FIELD/Dakar/pdf/CharterAfricanCulturalRenaissance.PDF

Agbaje-Williams, B. (1996). Some associated problems of archaeological heritage management in Nigeria: Northwest Yorubaland as a case study. In G. Pwiti & R. Soper (Eds.), *Aspects of African Archaeology* (pp. 801–808). Harare: University of Zimbabwe Publications.

Akita, A. (1979). *Development of the national archives and the national documentation centre: Report prepared for the Government of Uganda by the United Nations Educational Scientific and Cultural Organisation (UNESCO).* UNESCO.

Akussah, H. (2003). *Preserving documentary heritage in Ghana: the National Archives of Ghana in focus* (Unpublished doctoral thesis). University of Ghana, Legon, Ghana.

Akussah, H. (2005). Preservation of Public Records in Ghana: The training, education and awareness factors. *Information Development, 21*(4), 295–302. doi:10.1177/0266666905060090

Alegbeleye, G. O. (1999). *The role of the joint IFLA/ICA Committee on Preservation and Conservation of library and archival materials in Africa.* Paper presented at the 65TH IFLA Council and General Conference, Bangkok, Thailand.

Alexander, P. (2001). Zimbabwean workers, the MDC and the 2000 elections. *Review of African Political Economy, 27*(85), 85–406.

Alexander, P. N., & Samuels, H. W. (1987). The Roots of 128: A Hypothetical Documentation Strategy. *The American Archivist, 71*(4), 518–531. doi:10.17723/aarc.50.4.v889q1182r11p36u

Allan, S. A. (2014). *Government digital records and archives review.* London: Cabinet Office. Retrieved 1 August 2017 from https://www.gov.uk/government/publications/government-digital-records-and-archives-review-by-sir-alex-allan

Allen, M. B., & Baumann, R. M. (1991). Evolving appraisal and accessioning policies of Soviet Archives. *The American Archivist, 54*(Winter), 96–111. doi:10.17723/aarc.54.1.n488un809u87v150

Aloufi, Z. (2007). The legacy: British mandate record management system in Israel. *Archival Science, 7*(3), 207–211. doi:10.1007/s10502-007-9048-4

Ambrose, T., & Paine, C. (2012). *Museum Basics* (3rd ed.). New York: Routledge.

Ambrose, T., & Paine, C. (2012). *Museum Basics: Heritage: Care, Preservation, Management* (3rd ed.). London: Routledge.

American Alliance of Museums. (2012). *Developing a Collections Management Policy.* Retrieved 20 June 2017 from http://www.aam-us.org/docs/defaultsource/continuum/developing-a-cmp-final.pdf?sfvrsn=4

Amestoy, V. A. (2013). Demand for cultural heritage. In I. Rizo & A. Mignosa (Eds.), *Handbook on the Economics of Cultural Heritage* (pp. 89–110). Cheltenham, UK: Edward Elgar. doi:10.4337/9780857931009.00012

Anfara, V. A. Jr. (2008). Theoretical frameworks. In L. Given (Ed.), *The SAGE encyclopedia of qualitative research methods* (pp. 870–874). Thousand Oaks, CA: Sage.

Anon. (2004). *Luangwa. Memories of Eden. David Kelly paints South Luangwa National Park.* Lombarda: David Kelly.

Antonenko, P. D. (2015). The instrumental value of conceptual frameworks in educational technology research. *Educational Technology Research and Development, 63*(1), 53–71. doi:10.1007/s11423-014-9363-4

Archives Act 12 of Namibia. (1992). Retrieved September, 18, from https://laws.parliament.na/annotated-laws-regulations/law-regulation.php?id=319

Argyris, C., Putman, R., & Smith, D. (1985). *Action science.* San Francisco: Jossey-Bass.

ARMA International. (2014). *Generally Accepted Recordkeeping Principles.* Retrieved 10 July, 2017, from: http://www.arma.org/docs/sharepoint-roadshow/the-principles_executive-summaries_final.doc

Arts and Culture Task Group. (1995). *A new policy for the transformation of South African museums and museum services.* Unpublished report. Author.

Ashworth, G., & Voogd, H. (1986). The marketing of urban heritage as an economic resource. In J. Angement & A. Bongenaar (Eds.), *Planning without a passport* (pp. 38–50). Utrecht, The Netherlands: Ehinkwyk.

Asiamah, K. O. (2008). Preservation of print and non-print library materials: A case study of the Kwame Nkrumah University of Science and Technology Main Library, Kumasi, Ghana. *Journal of Science and Technology, 28*(2), 142–149.

Asogwa, B. E. (2012). The challenge of managing electronic records in developing countries: Implications for records managers in sub-Saharan Africa. *Records Management Journal, 22*(3), 198–211. doi:10.1108/09565691211283156

Atherton, J. (1985). From Life Cycle to Continuum: Some Thoughts on the Records Management-Archives Relationship. *Archivaria, 21*, 43–51.

Attenborough, D. (2010). *A life on air* (rev. ed.). London: BBC Books.

Australia ICOMOS Incorporated. (2013). *The Burra Charter: The Australia ICOMOS Charter for Places of Cultural Significance.* Retrieved July 27, 2017, from: http://australia.icomos.org/wp-content/uploads/The-Burra-Charter-2013-Adopted-31.10.2013.pdf

Aviles, M., & Eastman, J. K. (2012). Utilizing technology effectively to improve Millennials' educational performance: An exploratory look at business students' perceptions. *Journal of International Education in Business, 5*(2), 96–113. doi:10.1108/18363261211281726

Azziz, S. (2015). *Terrorism and the Muslim Veil.* Retrieved 24 July, 2015, from: http://www.oxfordislamicstudies.com/public/focus/essay1009_terrorism_and_the_muslim_veil.html

Babbie, E. (2007). Paradigms, theory and social research. In *The practice of social research* (11th ed.; pp. 30–59). Belmont, CA: Thomson Wadsworth.

Babu, P. B., & Krishnamurthy, M. (2013). Library automation to resource discovery: A review of emerging challenges. *The Electronic Library, 31*(4), 433–451. doi:10.1108/EL-11-2011-0159

Baer, N. S., & Snickars, F. (2001). *Rational decision-making in the preservation of cultural property.* Berlin: Dahlem University Press.

Bailey, C. (1997). From the Top down: The Practice of Macro Appraisal. *Archivaria, 43*, 89–128.

Bailey, S. (2007). Taking the road less travelled by: The future of the archive and records management profession in the digital age. *Journal of the Society of Archivists, 28*(2), 117–124. doi:10.1080/00379810701607777

Baker, C. (2003). *A fine chest of medals.* Cardiff, UK: Mpemba Books.

Ball, B. (n.d.). *A summary of motivation theories*. Retrieved July 2, 2017, from: http://www.yourcoach.be/blog/wp-content/uploads/2012/03/A-summary-of-motivation-theories1.pdf

Barata, K., Bennett, R., Cain, P., & Routledge, D. (2001). *From accounting to accountability: Managing financial records as a strategic resource: Namibia: A case study*. London: International Records Management Trust.

Barbara Lamport-Stokes photographic collection. (n.d.). Available in digitised form at the Library of the Society of Malawi, Blantyre, Malawi.

Barker, A. W. (2003). Archaeological ethics: Museums and collections. In L.J. Zimmerman, K.D. Vitelli, & J. Hollowell-Zimmer (Eds.), Ethical Issues in Archaeology (pp. 71-84). Walnut Creek, CA: AltaMira Press.

Baumol, W., & Oates, W. (1988). *The theory of environmental policy*. Cambridge, UK: Cambridge University Press. doi:10.1017/CBO9781139173513

Baxter, P., & Jack, S. (2008). Qualitative Case Study Methodology: Study Design and Implementation for Novice Researcher. *Qualitative Report*, *13*(4), 544–559. Retrieved from http://nsuworks.nova.edu/tqr/vol13/iss4/2

Bayane, S. (2007). *Recordkeeping for transparency and accountability: the case of Public Procurement and Asset Disposal Board (PPADB)*. Paper presented at the ESARBICA Conference, Dar-es-Salaam, Tanzania.

Bayissa, G., Ketema, G., & Birhanu, Y. (2010). Status of digitization process in selected institutions of Ethiopia: A baseline stakeholders' analysis survey report. *Ethiopia Journal of Education & Science*, *2*(5), 1–18.

Beagrie, N. (2008). *Digital preservation policies*. Retrieved July 4, 2016, from http://www.beagri.com

Bearman, D. (1994). Recordkeeping systems. In Electronic Evidence. Strategies for Managing Records in Contemporary Organizations. Archives & Museum Informatics.

Bearman, F., & Kissel, E. (2000). A global approach: Setting up a preservation program at Makerere University Library in Kampala, Uganda, 2000. *The Book and Paper Annual Group, 18*. Retrieved October 13, 2016, from: http://aic.stanford.edu/sg/bpg/annual/v19/bp19-02.html

Bekele, D. (2006). *Digital Material Preservation in Ethiopia. Report to UNESCO under its Digital Heritage Project*. Paris: UNESCO.

Bell, F. (2011). Connectivism: Its place in theory-informed research and innovation in technology enabled learning. *International Review of Research in Open and Distance Learning*, *12*(3), 98–118. doi:10.19173/irrodl.v12i3.902

Benhamou, F. (2013). Public intervention for cultural heritage: normative issues and tools. In I. Rizo. & A. Mignosa.(Eds.), Handbook on the Economics of Cultural Heritage (pp. 3-16). Cheltenham, UK: Edward Elgar. doi:10.4337/9780857931009.00008

Bereijo, A. (2004a). The conservation and preservation of film and magnetic materials (1): Film materials. *Library Review*, *53*(6), 323–331. doi:10.1108/00242530410544411

Bereijo, A. (2004b). The conservation and preservation of film and magnetic materials (2): Magnetic materials. *Library Review*, *53*(7), 372–378. doi:10.1108/00242530410552313

Betts, C. (2004, June). Welsh nationals pledge to streamline their collections. *Museums Journal*.

Bezuidenhout, R. M. (2014). Theory in research. In F. du Plooy-Cilliers, C. Davis, & R. M. Bezuidenhout (Eds.), *Research matters* (pp. 36–59). Claremont: Juta & Company.

Bishops in Africa. (n.d.). Retrieved 19 September 2017 from http://myweb.tiscali.co.uk/espenett/index04.htm

Blades, N. (2008). Measuring pollution in the museum environment. *Conservation Journal*, (14). Retrieved from http://www.vam.ac.uk/content/journals/conservation-journal/issue-14/measuring-pollution-in-the-museum-environment

Blaise, G. & David, E. (1990). From Paper Archives to People Archives: Public Programming in the Management of Archives. *Archivaria, 31*, 101-113.

Bless, C., Higson-Smith, C., & Sithole, S. L. (2013). *Fundamentals of social research methods: An African perspective* (3rd ed.). Cape Town: Juta.

Booms, H. (1987). Society and the Formation of a Documentary Heritage: Issues in the Appraisal of Archival Sources. *Archivaria, 24*, 69–107.

Booms, H. (1991). Urberlieferungsbildung: Keeping Archives as a Social and Political Activity. *Archivaria, 33*, 25–33.

Borg, V. P. (2010). National identity depends on culture, too. *China Daily*, pp. 2-9.

Botswana Government. (2000). *Copyright and Neighbouring Rights Act: supplement A*. Gaborone: Government Printer.

Botswana Government. (2005). *Mission Statement: Botswana National Archives and Records Service*. Retrieved July 8, 2014, from http://www.digital preservation\Botswana\.html

Botswana National Archives Act (Act No. 37 of 1978; as amended in 2007), Government of Botswana Botswana National Archives and Records Service (BNARS). (2003). Statement of User Requirements (SOUR) for the computerisation of Botswana National Archives and Records Service. Prepared by MJ Consultants (Pty). Gaborone, Botswana.

Botswana National Archives and Records Services Report. (1999/2001). Gaborone: Government Printer.

Botswana National Archives and Records Services Report. (2001-2005). Gaborone: Government Printer.

Botswana National Archives and Records Services Report. (2006/2007). Gaborone: BNARS.

Botswana National Archives and Records Services. (2009). *BNARS computerises public sector records: reflections on the stakeholders forum*. Tshedimoso Newsletter.

Botswana National Archives and Records Services. (2011). *Timely destruction of records is vital*. Tshedimoso Newsletter.

Botswana National Archives Report. (1976/77). Gaborone: Government Printer.

Bradley, E. (1950). *Dearest Priscilla. Letters to the wife of a colonial civil servant*. London: Max Parrish.

Bradley, K. (1947). *Diary of a District Officer*. London: Thomas Nelson.

Branin, J. J. (2003). Knowledge management in academic libraries: Building the knowledge bank at the Ohio State University. *Journal of Library Administration*, *39*(4), 41–56. doi:10.1300/J111v39n04_05

Brett, E. A. (1993). Voluntary agencies as development organisations: Theorizing the problem of efficiency and accountability. *Development and Change*, *24*(2), 269–303. doi:10.1111/j.1467-7660.1993.tb00486.x

Bridges.org. (2001). *Overview of the Digital Divide?* Retrieved February 2008 from: Retrieved August 17, 2017 from: http://www.bridges.org/digital_divide

Bridges, E. C. (1988). The Soviet Union's Archival Research Center: Observations of an American visitor. *The American Archivist*, *51*(Fall), 486–500. doi:10.17723/aarc.51.4.5p05tu52176x8t60

British Standards Institution. (2012). Guide for the storage and exhibition of archival materials; BSPD5454 2012. London: British Standards Institution (BSI Group).

Brockliss, L., Cardwell, J., & Moss, M. (2005). *Nelson's surgeon*. London: Oxford University Press.

Bruemmer, B. H. (1997). *An Analysis of World-Wide Web Sites For Archival Repositories*. Retrieved January 24, 2008, from http://www.cbi.umn.edu/bruce/arcweb.htm

Brunton, P., & Robinson, T. (1993a). Accessioning. In Keeping archives (2nd ed.; pp. 207-221). Port Melbourne: The Australian Society of Archives.

Brunton, P., & Robinson, T. (1993b). Arrangement and description. In Keeping archives (2nd ed.; pp. 222-247). Port Melbourne: The Australian Society of Archives.

Brydon-Miller, M., Kral, M., Maguire, P., Noffke, S., & Sabhlok, A. (2013). Jazz and the banyan tree: Roots and riffs on participatory action research. In N. K. Denzin & Y. Lincoln (Eds.), *Strategies of qualitative inquiry* (4th ed.; pp. 347–375). Los Angeles: Sage.

Bubenik, B. (2005, October). *Storage equipment and technology: from shelves to near on-line Mass Storage development of storage technologies*. Paper presented at the FIAT/IASA Southern African Workshop on Film, Video and Sound Archives, SABC, Johannesburg, South Africa.

Buchanan, C. (1975). Cities in crisis. *The Planner*, *61*(7), 236–264.

Buchmann, W. (1999). Preservation: Buildings and equipment. *Journal of the Society of Archivists*, *20*(1), 5–23. doi:10.1080/003798199103695

Buckland, M. (1994). On the Nature of Records Management Theory. *The American Archivist*, *57*(2), 346–351. doi:10.17723/aarc.57.2.y2340p4025584485

Buikstra, J. E. & Ubelaker, D. H. (1994). *Standards for data collection from human skeletal remains*. Fayetteville, AR: Arkansas Archaeological Survey.

Burbules, N. C., & Warnick, B. R. (2006). Philosophical inquiry. In J. I. Green, G. Camilli, P. B. Elmore, A. Skukauskaite, & E. Grace (Eds.), *Handbook of complementary methods in education research* (pp. 489–502). London: Lawrence Erlbaum.

Burden, M. (2000). Die metodologie van Kultuurgeskiedenis. *South African Journal of Cultural History*, *14*(2), 13–30.

Bush, C. (2016). Contexts for modernism. In *Routledge Encyclopedia of modernism* (pp. 13–43). London: Routledge.

Butler, W. B. (1979). The no-collection strategy in archaeology. *American Antiquity*, *44*(4), 795–799. doi:10.2307/279122

Buys, R., & Assmann, I. (2013). Copyright vs Accessibility: The challenge of exploitation. *International Association of Sound and Audio-visual Archives Journal*, *41*, 7–14.

Byers, F. R. (2003). *Information Technology: Care and Handling of CD's and DVD's- A Guide for Librarians and Archivists*. National Institute of Standards and Technology and Council on Library and Information Resources. Retrieved September 15, 2003, from http://www.itl.nist.gov/iad/894.05/docs/CDandDVDCareandHandlingGuide.pdf

Cagan, P. (1956). The monetary dynamics of hyperinflation. In M. Friedman (Ed.), *Studies in the Quantity Theory of Money* (pp. 25–117). Chicago: University of Chicago Press.

Cambra-Fierro, J., & Wilson, A. (2010). Qualitative data analysis software: Will it ever become mainstream? Evidence from Spain. *International Journal of Market Research*, *53*(1), 17–24. doi:10.2501/IJMR-53-1-017-024

Cameron, R. (2013). Mixed methods research: a world of metaphors. In W. Midgley., K. Trimmer, & A. Davies (Eds.), Metaphors for, in and of education research (pp. 51–65). Newcastle upon Tyne, UK: Cambridge Scholars Publishing.

Campbell, H. (2008). The Zimbabwean working peoples: Between a political rock and an economy hard place. *Association of Concerned African Scholars*. *Bulletin, 80*. Retrieved from http://concernedafricanscholars.org/the-zimbabwean-working-peoples

Camp, W. G. (2001). Formulating and evaluating theoretical frameworks for career and technical education. *Career and Technical Education Research, 26*(1), 4–25. doi:10.5328/JVER26.1.4

Caple, C. (2012). *Preventive Conservation in museums.* Leicester, UK: Routledge.

Carman J. (2010). Promotion to heritage: How museum objects are made. *Encouraging collections mobility: A way forward for museums in Europe.* Academic Press.

Carman, J. (2006). The naming of heritage. *SAMAB, 32*, 69–72.

Carr, B. (1965). *Cherries on my plate.* Cape Town: Timmins.

Carr, B. (1969). *The beastly wilds.* London: Wingate-Baker.

Carr, N. J. (1962). *Return to the wild.* London: Collins.

Carr, N. J. (1969). *The white impala.* London: Collins.

Carr, N. J. (1996). *Kakuli. Harae.* CBC Publishing.

Carson, J. (2005). *Challenges and change in Uganda. Conference held on Uganda: An African 'success' past its prime.* Woodrow Wilson International Center for Scholars (WWICS). Retrieved January 14, 2017, from https://www.wilsoncenter.org/sites/default/files/Uganda2.pdf

Casbah. (2001). *Caribbean Studies and history of Black and Asian peoples in the United Kingdom.* Preserved in the United Kingdom Web Archive. Retrieved 18 September 2017 from, https://www.webarchive.org.uk/ukwa/target/59703347/source/alpha

Cassar, M. (2003). Places and stuff: Is it only the language of conservation that is changing? In Conservation of historic buildings and their contents: Addressing the conflicts (pp. 41-51). Shaftesbury: Don Head Publishing and De Montfort University.

Castro, H., & Wyss, J. (2004). Mass media and engaging journalists: supporting biodiversity conservation. In D. Hamú, E. Auchincloss, & W. Goldstein (Eds.), *Communicating Protected Areas, Commission on Education and Communication, IUCN* (pp. 14–312). Cambridge, UK: Gland.

Cathro, W., Webb, C., & Whiting, J. (2009). *Archiving the web: the Pandora archive at the national Library of Australia - National Library of Australia Staff Papers.* Retrieved July 6, 2016, from https://www.nla.gov.au/digital-preservation/related-staff-papers

Chan, S. (2012). Zimbabwe: The sanctions of no sanctions. *E-international relations.* Retrieved June 11, 2015 from: http://www.e-ir.info/2012/07/25/the-sanctions-of-no-sanctions

Chandler, D., & Torbert, B. (2003). Transforming inquiry and action: Interweaving 27 flavors of action research. *Action Research, 1*(2), 133–152. doi:10.1177/14767503030012002

Chan, W.-Y., & Ma, S.-Y. (2004). Heritage preservation and sustainability of Chinas' development. *Sustainable Development, 12*(1), 15–31. doi:10.1002/sd.224

Chaputula, A. H., & Kanyundo, A. J. (2014). Collection development policy: How its absence has affected collection development practices at Mzuzu University Library. *Journal of Librarianship and Information Science, 46*(4), 317–325. doi:10.1177/0961000614531005

Chaterera, F. (2017). The artefact and its record; towards a holistic approach in the management of collections in Zimbabwe's Museums. In M. Manayanga & S. Chirikure (Eds.), *Archives, Objects, places and landscapes: Multi-Disciplinary approaches to a decolonized Zimbabwean past. Laanga Research and Publishing CIG.*

Chaterera, F., Ngulube, P., & Rodrigues, A. (2014). Records surveys in support of a framework for managing public records in Zimbabwe. *Information Development, 30*(4), 366–377. doi:10.1177/0266666913497611

Chebani, B. B. (2003). *The role of restructuring national archives institutions: Botswana case study* (Unpublished MSc. Thesis). University of Wales.

Chebani, B. (2005). Merits and challenges of the integrated records services in the public service – a case of Botswana. *ESARBICA Journal, 24*, 139–156.

Cheddie, J. (2012). Embedded shared heritage. Human rights discourse and the London Mayor's Commission on African and Asian Heritage. In R. Sandell & E. Nightingale (Eds.), *Museums, Equality and Social Justice* (pp. 270–280). London: Routledge.

Chida, M. (1994). Preservation management in tropical countries: a challenging responsibility and limited resources: the case of Zimbabwe National Archives. *ESARBICA Journal, 4*, 22–33.

Chida, M. (1994). Preservation management in tropical countries: A challenging responsibility and limited resources: The case of Zimbabwe National Archives. *ESARBICA Journal: Journal of the Eastern and Southern Africa Regional Branch of the International Council on Archives, 14*, 22–36.

Chinyemba, A., & Ngulube, P. (2005). Managing records at higher education institutions: A case study of the University of KwaZulu-Natal, Pietermaritzburg Campus. *South African Journal of Information Management, 7*(1), 1–19. doi:10.4102/sajim.v7i1.250

Chipungu, S. (Ed.). (1992). *Guardians in their time. Experiences of Zambians under colonial rule, 1890-1964.* London: Macmillan.

Chiwara, D. (2017). Securing the future of collections in Zimbabwe through preventive conservation: the case of Zimbabwe Military Museum. In M. Manayanga & S. Chirikure (Eds.), *Archives, objects, places and landscapes: multidisciplinary approaches to decolonised Zimbabwean pasts.* Bamenda, Cameroon: Langaa Research & Publishing CIG.

Chiwara, D. (2017). Securing the future of collections through preventive conservation: the case of Zimbabwe Military Museum. In M. Manayanga & S. Chirikure (Eds.), *Archives, Objects, places and landscapes: Multi-Disciplinary approaches to a decolonized Zimbabwean past. Laanga Research and Publishing CIG.*

Christensen, C. M. (1997). *The innovator's dilemma: When new technologies cause great firms to fail.* Boston, MA: Harvard Business School Press.

Clarke, V., & Braun, V. (n.d.). Teaching thematic analysis: Overcoming challenges and developing strategies for effective learning. *The Psychologist, 26*(2), 120–123.

Clift, H. (1993). The role of museums in cultural resources management. *The Cultural Historian, 8*(1), 90–95.

Coates, P. R. (2000). *JICPA Survey of the conservation facilities and experts in Africa.* Retrieved October 13, 2016, from: http://www.epa-prema.net/jicpa/survey.htm

Coertze, P. J. (1977). *Inleiding Tot die algemene Volkekunde*. Johannesburg: Voortrekkerpers.

Coertze, P. J., & Coertze, R. D. (1996). *Verklarende vakwoordeboek vir Antropologie en Argeologie*. Pretoria: RD Coertze.

Coetzee, I. (1994). Cultural resources – a tour through our world in one country. In W. Loots (Ed.), *Cultural resources & regional tourism* (pp. 23–32). Pretoria: National Cultural History Museum.

Coghlan, D., & Brannick, T. (2014). *Doing action research in your own organisation* (4th ed.). Thousand Oaks, CA: Sage.

Coghlan, D., & Shani, A. B. (2014). Creating action research quality in organization development: Rigorous, reflective and relevant. *Systemic Practice and Action Research, 27*(6), 523–536. doi:10.1007/s11213-013-9311-y

Coghlan, D., & Shani, A. B. R. (2005). Roles, politics and ethics in action research design. *Systemic Practice and Action Research, 18*(6), 533–546. doi:10.1007/s11213-005-9465-3

College of Computing and Information Science. (2017). Retrieved January, 10, 2017, from https://www.mak.ac.ug/academic-units/colleges-and-departments

Collis, J., & Hussey, R. (2014). *Business research: A practical guide for undergraduate and postgraduate students*. London: Palgrave. doi:10.1007/978-1-137-03748-0

Commonwealth of Australia. (2003). *Overview of Classification Tools for Records Management*. Retrieved 13 September, 2017, from: http://www.naa.gov.au/Images/classifcation%20tools_tcm16-88850.pdf

Conn, D. (2012). *Protection from Light Damage*. Northeast Document Conservation Centre. Retrieved from https://www.nedcc.org/free-resources/preservation-leaflets/2.-the-environment/2.4-protection-from-light-damage

Conti, A. (1988). *Storia del restauro e della conservazione delle opere d'arte*. Milano: Electa.

Cook, M. (1990). The management of information from archives (2nd ed.). Bookfield: Gower.

Cook, T. (1997). The Place of Archives and Archives as Place: Preserving societal memory at the end of the Millennium. In *Proceedings of the 14th Biennial Conference of the East and southern African regional Branch of the International council on archives on archives and the protection of the people's rights*. Pretoria National Archives of South Africa.

Cook, T. (2001). *Appraisal Methodology: Macro Appraisal and Functional Analysis – Part B: Guidelines for performing an archival appraisal on Government records*. Retrieved 27 August, 2016, from: http://www.bac-lac.gc.ca/eng/services/government-information-resources/disposition/records-appraisal-disposition-program/Pages/appraisal-methodology-part-b-guidelines.aspx

Cooke, B., & Cox, J. W. (2005). Introduction. In B. Cooke & J. W. Cox (Eds.), *Fundamentals of action research: The early years* (Vol. 1, pp. xvii–xliii). Thousand Oaks, CA: Sage.

Cook, T. (1992). Documentation Strategy. *Archivaria, 34*, 181–191.

Cook, T. (1992). Mind over matter: Towards a new theory of archival appraisal. In B. L. Craig (Ed.), *The Archival Imagination: Essays in Honour of Hugh A. Taylor* (pp. 38–70). Ottawa, Canada: Association of Canadian Archivists.

Cook, T. (1997). What is Past is Prologue: A History of Archival Ideas since 1898, and the Future Paradigm Shift. *Archivaria, 43*, 17–63.

Cook, T. (2005). Macro appraisal in Theory and Practice: Origins, Characteristics, and implementation in Canada, 1950-2000. *Archival Science, 5*(2-4), 101–161. doi:10.1007/s10502-005-9010-2

Cook, T. (2011). We are what we keep; we keep what we are': Archival appraisal past, present and future. *Journal of the Society of Archivists, 32*(2), 173–189. doi:10.1080/00379816.2011.619688

Cooper, G., & Meadows, R. (2016). Conceptualising social life. In N. Gilbert & P. Stoneman (Eds.), *Researching social life* (4th ed.; pp. 10–24). Los Angeles, CA: Sage.

Copyright and Neighbouring Rights Act (Act No. 8 of 2000). (n.d.). Government of Botswana. Retrieved September, 10, 207 from http://www.wipo.int/wipolex/en/details.jsp?id=548

Corey, S. M. (1953). *Action research to improve school practice*. New York: Teachers College Press.

Cornell Library. (2005). *Passive climate control; mould*. Retrieved January 9, 2014, from: http://www.library.cornell.edu/preservation/librarypreservation/mee/glossary/glossary_popup.php?ID=69

Countrymeters. (2016). *Namibia population*. Retrieved October 5, 2016, from http://countrymeters.info/en/Namibia

Couture, C. (2005). Archival Appraisal: A Status Report. *Archivaria, 59*, 83–107.

Cox, R. J. (1989). A Documentary Strategy Case Study: Western New York. *The American Archivist, 52*(2), 192–200. doi:10.17723/aarc.52.2.6280321313744409

Cox, R. J. (1992). *Managing institutional archives: foundational principles and practices*. Westport, CT: Greenwood Press.

Cox, R. J. (1996, Spring). The Archival Documentation Strategy and its implications for the appraisal of architectural records. *The American Archivist*, 144–154.

Craig, B. L. (1990-91). What are the Client? Who are the Products? The Future of Archival Public Services in Perspective. *Archivaria, 31*, 135–141.

Craig, B. L. (1992). The acts of the appraisers: The context, the plan and the records. *Archivaria, 34*, 175–180.

Creswell, J. W. (2009). *Research design: Qualitative, quantitative, and mixed methods approaches* (3rd ed.). Los Angeles, CA: Sage.

Creswell, J. W. (2013). *Qualitative inquiry and research design: Choosing among five approaches* (3rd ed.). Los Angeles: Sage.

Creswell, J. W., & Plano Clark, V. L. (2011). *Designing and conducting mixed methods research* (2nd ed.). Thousand Oaks, CA: Sage.

Crew, M. C., & Kleindorfer, P. R. (1979, 2014). Public utility economics. London: The Macmillan Press Ltd.

Crocket, M., & Foster, J. (2004). *Using ISO 15489 as an Audit Tool*. Retrieved 10 August, 2017, from: http://www.arma.org/bookstore/files/CrockettFoster.pdf

Crockett, M., & Yeo, G. (n.d.). *Why electronic records are important?* Retrieved November, 10, 2015 from http://www.ucl.ac.uk/e-term/why.htm

Cronin, P., Coughlan, M., & Smith, V. (2015). *Understanding nursing and healthcare research*. Los Angeles, CA: Sage.

Cuccia, T., & Cellini, R. (2007). Is cultural heritage really important for tourists?: A Contingent Rating Study. *Applied Economics, 39*(2), 261–271. doi:10.1080/00036840500427981

Cunningham, A. (2011). Good digital records don't just happen. *Archivaria, 71*. (Spring 2011), 21-34

Cushing, A. L. (2010). Career satisfaction of young archivists: A survey of professional working archivists, age 35 and under. *The American Archivist, 73*(2), 600–625. doi:10.17723/aarc.73.2.gh8330h51124j144

Daniels, V. (1996). The chemistry of paper conservation. *Chemical Society Reviews, 25*(3), 179–186. doi:10.1039/cs9962500179

Dardes, K. (1998). *The conservation assessment. A proposed model for evaluating museum environmental management needs.* Retrieved June 27, 2017, from: http://www.getty.edu/conservation/publications

Davies, M. (2005). Integrating collections, communities and curators. *SAMAB, 31*, 6–9.

Day, M. (2008). Toward distributed infrastructure for digital preservation: The roles of collaboration and trust. *International Journal of Digital Curation, 1*(3), 15–28. doi:10.2218/ijdc.v3i1.39

De Jong, R. C. (1995). Cultural resources and how to manage them. In J. W. van den Bos & H. J. Moolman (Eds.), Methodology in research. (pp. 16-34). Sunnyside: SASCH.

Deacon, H. (2006). The 2003 Intangible Heritage Convention. *SAMAB, 32*, 2-9.

Deacon, J. (1989). *Factors to be considered in contracts between historical archaeologists and developers* (Unpublished report). Cape Town: National Monuments Council.

Deacon, J. (1996). Cultural resources management in South Africa: legislation and practice. In G. Pwiti & R. Soper (Eds.), *Aspects of African archaeology* (pp. 839–848). Harare: University of Zimbabwe Publications.

Dean, J. F. (2002). *Environment and passive climate control chiefly in tropical climates.* Paper Read at the 68th IFLA Council and General Conference, Glasgow, UK. Retrieved January 14, 2014, from: http://www.ifla.org/IV/ifla68/papers/120-158e.pdf

Dečman M. & Vintar M. (2013). A possible solution for digital preservation of e-government. *Aslib Proceedings, 65*(4), 406 – 424. 4910.1108/AP-05-2012-00

Decman, M., & Vintar, M. (2013). A possible solution for digital preservation of e-government: A centralised repository within a cloud computing framework. *Aslib Proceedings, 65*(4), 406–424. doi:10.1108/AP-05-2012-0049

Denzin, N. K., & Lincoln, Y. S. (2003). *The landscape of qualitative research* (2nd ed.). Thousand Oaks, CA: Sage.

Denzin, N. K., & Lincoln, Y. S. (2005). Introduction: The discipline and practice of qualitative research. In N. K. Denzin & Y. S. Lincoln (Eds.), *The Sage handbook of qualitative research* (3rd ed., pp. 1–32). Thousand Oaks, CA: Sage.

Denzin, N. K., & Lincoln, Y. S. (2011). *Introduction: The discipline and practice of qualitative research. In The SAGE handbook of qualitative research* (4th ed.; pp. 1–19). Thousand Oaks, CA: Sage.

Department of Public Service Information Technology Management. (2005). *The E-governance Policy for the Namibian Public Service.* Windhoek: Author.

Desjardins, F. J. (2010). *Theoretical Framework.* Retrieved July 27, 2017, from: https://youtu.be/EcnufgQzMjc

Desvallees, A., & Mairesse, F. (2010). *Key concepts of museology.* Singapore: Armand Colin.

Dewah, P., & Mnjama, N. (2013). An assessment of the National Archives of Zimbabwe Gweru Records Center. *ESARBICA Journal, 23*, 87–101.

Dewdney, A., Dibosa, D., & Walsh, V. (2012). Cultural diversity. Politics, policy and practices. The case of Tate Encounters. In Museums, Equality and Social Justice (pp. 114-124). London: Routledge.

Dewey, J. (1916). *Democracy and education: An introduction to the philosophy of education.* New York: The Macmillan company.

Diamond, S. (1995). *Records Management*. New York: Amacom.

Diers, D. (1979). *Research in nursing practice*. Philadelphia: Lippincott.

Digital Library Federation. (1995). *America's Heritage: Mission and Goals for a Digital Library Federation*. Retrieved September 29, 2016, from http://www.diglib.org/about/dlfcharter.htm

Digital Preservation Coalition & Pennock. (2013). *Web Archiving, DPC Technology Watch Reports*. Retrieved September 10, 2017, from http://www.dpconline.org/about/working-groups-and-task-forces/524-web-archiving-andpreservation-task-force

Digital Preservation Coalition. (2002). *DPC/PADI What's new in digital preservation*. Retrieved October 10, 2007, from http://www.dpconline.org/graphics/whatsnew/

Digital Preservation Coalition. (2015). *Digital Preservation Handbook*. Retrieved September 10, 2017, from http://www.dpconline.org/handbook/contentshttp://dpconline.org/docs/digital-preservation-handbook2/1552-dp-handbook-digital-preservation-briefing/file

Directorate of Public Service Management (DPSM) and Botswana National Archives and Records Services. (1989). *Organisation and Methods Review*. Report on Improving Efficiency of Records Management Functions in the Public Service.

Directorate of Public Service Management (DPSM). (1992). *O and M Review*. Report of Ministerial Organisation Review.

DL Forum Foundation. (2010). *MoReq2010, Modular Requirements for Records Systems*. Publications Office of the European Union.

Dollar, C. M. (2000). *Authentic electronic records: strategies for long-term access*. Chicago: Cohasset Associates, Inc.

Downes, S. (2012). *Connectivism and connective knowledge: Essays on meaning and learning networks*. National Research Council Canada. Retrieved January 13, 2017, from http://www.downes.ca/files/books/Connective_Knowledge-19May2012.Pdf

Dugin, A. (2001). Modernization without westernization. *The Fourth Political Theory*. Retrieved December 25, 2016, from http://www.4pt.su/en/content/modernization-without-westernization

Duhamel, J. (1973). Discours de Jacques Duhamel devant l'Assemblée nationale, 28 mai 1971. In Discours et écrits (1971-1973). Paris: La Documentation française/Comité d'histoire du Ministère de la culture.

Dunaway, M. K. (2011). Connectivism: Learning theory, and pedagogical practice for networked information landscapes. *RSR. Reference Services Review*, *39*(4), 675–685. doi:10.1108/00907321111186686

Duranti, L. (2015). *Overview of InterPARES Trust - Work to Date. Third International Symposium of InterPARES Trust*. Retrieved 5th June, 5, 2017, from https://interparestrust.org/assets/public/dissemination/IPT_20150515_International-Symposium3_Duranti_InterPARESTrustOverview_Presentation.pdf

Duranti, L. (1994). The concept of appraisal and archival theory. *The American Archivist*, *57*(2), 328–344. doi:10.17723/aarc.57.2.pu548273j5j1p816

Duranti, L. (2007). Reflections on the InterPARES 2 Project (2002– 2007): An Overview. *Archivaria: The Journal of the Association of Canadian Archivists*, *64*, 113–121.

Duranti, L. (2009). From Digital Diplomatics to Digital Records Forensics. *Archivaria: The Journal of the Association of Canadian Archivists*, *68*, 39–66.

Eastwood, T. (2002). Reflections on the Goal of Archival Appraisal in Democratic Societies. *Archivaria*, *54*, 59–71.

Ebersöhn, L., Eloff, I., & Ferreira, R. (2010). First steps in action research. K. Maree (Ed.), First steps in research (pp. 124–143). Pretoria: Van Schaik.

Edmondson, R. (2004). *Ethics and new technology.* Retrieved from http://www.unesco.org/webworld/ramp/html

Edmondson, R. (2016). *Audiovisual archiving: philosophies and principles* (3rd ed.). United Nations Educational, Scientific and Cultural Organization. Retrieved May, 20, 2016 http://unesdoc.unesco.org/images/0024/002439/243973e.pdf

Edmonson, R. (2004). *Audiovisual Archiving: Philosophy and Principles.* Paris: UNESCO. Retrieved 27 August, 2016, from: http://www.fiafnet.org/images/tinyUpload/E-Resources/Official-Documents/Philosophy-of-Audiovisual-Archiving_UNESCO.pdf

Ehrlich, C. (1973). Building and caretaking. Economic policy in British Tropical Africa. *The Economic History Review, 26*(4).

Eikeland, O. (2012). Action research – Applied research, intervention research, collaborative research, practitioner research, or praxis research? *International Journal of Action Research, 8*(1), 9–44.

Ekeanyanwu, N. T. (2015). *International communication* (3rd ed.). Ibadan: Stirlin-Horden Publishers Ltd.

Ekpang, J. (2008). Globalization and cultural imperialism: The Nigerian experience. *WAACLALS: West African Association for Commonwealth Literature and Language Studies, 2*(2), 1–17.

Electronic Records (evidence) Act of 2014. (2014). Government of Botswana. Retrieved September, 10, 2017 from https://www.bocra.org.bw/sites/default/files/Electronic%20Records%20and%20Evidence%20Act%202014.pdf

Elkins, C. (2005). *Imperial reckoning: The untold story of Britain's gulag in Kenya.* New York: Macmillan.

Endong, F. P. C. (2015). Indeginization of media in Nigeria and cultural globalization: Mutual bedfellows or implacable arch-foes? *Journal of Globalization Studies, 5*(2), 82–93.

Endong, F. P. C., & Essoh, N. E. (2015). Is the Chinese cultural policy in Africa a threat to the teaching and learning of the Spanish language in Nigeria? *International Journal of Art, Culture. Design and Language Works, 1*(1), 14–18.

Ennis, C. D. (1999). The theoretical framework: The central piece in the research plan. *Journal of Teaching in Physical Education, 18*(2), 129–140. doi:10.1123/jtpe.18.2.129

Ericson, T. L. (1990-91). Preoccupied With Our Own Gardens: Outreach and Archivists. *Archivaria, 31,* 114-122.

Estonian Ministry of Economic Affairs and Communications. (2016). *Transforming Digital Continuity: Enhancing It Resilience Cloud Computing: A Joint Research.* Retrieved September 29, 2016 from https://www.Mkm.Ee/.../Transforming_Digital_Continuity-_Joint_Research_Report_Final

European Communities. (2008). *Model requirements for the Management of electronic records.* Retrieved 27 August, 2017, from: http://moreq2.eu/attachments/article/189/MoReq2_typeset_version.pdf

Evidence in Civil Proceedings (No. 26 of 1977). (n.d.). Government of Botswana.

Fagan, B. M. (1991). *In the beginning. An introduction to archaeology.* Glenview, IL: Scot, Foresman & Company.

Feather, J. (1996). *Preservation and management of library collections* (2nd ed.). London: Library Association Publishing.

Feather, J. (1996). *Preservation and the management of library collection* (2nd ed.). London: Library Association Publishing.

Ferguson, N. (2002). *Empire: the rise and demise of the British World Order and the Lessons for Global Power.* London: Allen Lane.

Fleming, D. (2012). Museums for social justice: Managing organisational change. In R. Sandell & E. Nightingale (Eds.), *Museums, Equality and Social Justice* (pp. 72–83). London: Routledge.

Flick, U. (2014). *An introduction to qualitative research* (5th ed.). Los Angeles, CA: Sage.

Flynn, S. J. F. (2001). The records continuum model in context and its implications for archival practice. *Journal of the Society of Archivists, 22*(1), 79–93. doi:10.1080/00379810120037522

Folorunso, C. A. (1996). The place of archaeology in heritage management in Africa: the case of Nigeria. In G. Pwiti & R. Soper (Eds.), *Aspects of African Archaeology* (pp. 795–800). Harare: University of Zimbabwe Publications.

Foot, M. (2006). Preservation policies and planning. In G.E. Gorman & S.J. Shep (Eds.), Preservation management for libraries and museums (pp. 19–41). London: Facet.

Forde, H. (2007). *Preserving archives.* London: Facet.

Forde, J. W. (1990). *Archival principles and practice: a guide for archives management.* Jefferson, NC: McFarland.

Ford, S. (1988). The Library Newsletter: Is it for you? *College & Research Libraries, 49.*

Forgas, L. (1997). The preservation of videotape: Review and implications for libraries and archives. *Libri, 47*(1), 43–56. doi:10.1515/libr.1997.47.1.43

Fortson, J. (1992). *Disaster planning and recovery: a how-to-do-it manual for librarians and archivists.* New York: Neal-Schuman, Inc.

Fowler, D. D. (1982). Cultural resources management. In B. Schiffer (Ed.), *Advances in archaeological method and theory V* (pp. 1–50). New York: Academic Press. doi:10.1016/B978-0-12-003105-4.50006-6

Frankfort-Nachmias, C., & Nachmias, D. (2008). *Research methods in the social sciences* (7th ed.). New York: Worth.

Franks, P. C. (2013). *Records and information management.* American Library Association.

Freire, P. (1972). *Pedagogy of the oppressed.* Harmondsworth, UK: Penguin Books.

Frey, B. S., & Meier, S. (2006). The economics of museums. In V. A. Ginsburgh & D. Throsby (Eds.), *Handbook of Economics of Art and Culture* (Vol. 1, pp. 1017–1047)., doi:10.1016/S1574-0676(06)01029-5

Fricke, W. (2006). General reflections on how to practice and train for action research. *International Journal of Action Research, 2,* 269–282.

Furse, R. (1962). *Aucuparius. Recollections of a recruiting officer.* London: Oxford University Press.

Gamieldien, M. (2006). The museum as a public space in which subaltern can be represented. *SAMAB, 32,* 17–25.

Garaba, F. (2007). The State of Archival Appraisal Practices in the ESARBICA Region. *African Journal of Library Archives and Information Science, 17*(1), 59–63.

Garfinkle, H. (1967). *Studies in ethnomethodology.* Englewood Cliffs, NJ: Prentice Hall.

Garner, B. (2013). *The news cultural revolution: Chinese cultural policy reform and the UNESCO Convention on Cultural Diversity.* Peking: UNESCO.

Garrett, J., & Waters, D. (1996). *Preserving Digital Information: Report of the Task Force on Archiving of Digital Information.* Retrieved September 29, 2016, from https://www.clir.org/pubs/reports/pub6

Garside, V. (2006). 'The colour purple': An examination of the use of indigenous dyes among the amaZulu. *SAMAB, 32*, 15–16.

Geingob, H. G. (2002). *Building economics from the government up: Celebrating a new charter for the public service in Africa.* Paper presented at the Annual Conference of the American Society for Public Administration. Retrieved January 19, 2008, from http://www.opm.gov.na/pm/speeches/2002/economics.htm

Ghering, C. A. (1998). *Archives, Outreach and Digital exhibits.* Retrieved January 17, 2005 from: htt-personal.si.umich.edu/~cghering/600Paper.html

Giacomini, M. (2010). Theory matters in qualitative health research. In I. Bourgeault, R. Dingwall, & R. De Vries (Eds.), *The SAGE handbook of qualitative methods in health research* (pp. 125–157). London: Sage. doi:10.4135/9781446268247.n8

Giddens, A. (1982). *Sociology. A brief but critical introduction.* New York: Harcourt Brace Jovanovich, Publishers.

Giesbrecht, D. (2011). Globalization and its effects on cultural diversity. *ETEC.* Retrieved December 28, from http://etec.ctlt.ubc.ca/510wiki/Globalization_and_its_Effect_on_Cultural_Diversity

Ginsberg, P. E., & Mertens, D. M. (2009). Frontiers in social research ethics: Fertile ground for evolution. In D. M. Mertens & P. E. Ginsberg (Eds.), *The handbook of social research ethics* (pp. 580–614). Thousand Oaks, CA: Sage. doi:10.4135/9781483348971.n37

Given, L. M., & MacTavish, L. (2010). What is old is new again: The reconvergence of libraries, archives and museums in the digital age. *The Library Quarterly, 80*(1), 7–32. doi:10.1086/648461

Gkinni, Z. (2014). A preservation policy maturity model: A practical tool for Greek libraries and archives. *Journal of Insect Conservation, 37*(1), 55–64. doi:10.1080/19455224.2013.873729

Glaser, B., & Strauss, A. (1967). *The discovery of grounded theory: Strategies for qualitative research.* New York: Aldine de Gruyter.

Global Heritage Fund. (2010). *Saving our vanishing heritage. Safeguarding endangered cultural heritage site in the developing world.* Palo Alto, CA: Global Heritage Fund.

Goh, E., Duranti, L., & Chu, S. (2012, August). Archival legislation for engendering trust in an increasingly networked electronic environment. *Proceedings of Climate Change: International Council on Archives Congress.* Retrieved March 3, 2017, from http://www.ica2012.com/files/data/Full%20papers%20upload/ica12Final00287.pdf

Gold, A. (1975). Welfare economics of historical preservation. *Connecticut Law Review, 8*, 348–369.

Gollins, T., & Bayne, E. (2015). Finding archived records in a digital age. In Is digital different? How information creation, capture, preservation and discovery are being transformed. London: Facet Publishing.

Goodman, A. (2010) *Appraisal Reading Response.* Retrieved 27 August, 2016 http://www.godaisies.com/notes/Amanda%20Goodman_Appraisal_Reading_Response.pdf

Gordon, A., Tidblad, J., & Lombardo, T. (2012). *The effect of black carbon on soiling of materials.* Retrieved January 14, 2014, from: http://www.swereakimab.se/

Gould, E., & Gomez, R. (2010). New challenges for libraries in the information age: A comparative study of ICT in public libraries in 25 countries. *Information Development, 26*(2), 166–176. doi:10.1177/0266666910367739

Government of Botswana Vision 2036. (2016). *Achieving Prosperity for all.* Lentswe la Lesedi: Author.

Government of British Columbia. (2015). *Recorded information management manual: RIM 102*. Retrieved March 14, 2017, from http://www.gov.bc.ca/citz/iao/records_mgmt/policy_standards/rim_manual/rim102.pdf

Grafton, J., Lillis, A. M., & Mahama, H. (2011). Mixed methods research in accounting. *Qualitative Research in Accounting & Management, 8*(1), 5–21.

Grant, C., & Osanloo, A. (2014). Understanding, selecting, and integrating a theoretical framework in dissertation research: Creating the blueprint for your "house". Administrative Issues Journal: Connecting Education, Practice, and Research, 4(2), 12-26.

Gravemeijer, K. (1994). *Developing realistic mathematics education*. Utrecht, The Netherlands: CD-B Press.

Gray, S. J. (1984). *Information disclosure and Multinationals*. London: Wisey/IRM.

Greene, M. (2003). *Advanced Appraisal Workshop*. Retrieved 27 August, 2017, from: http://www.pacsclsurvey.org/documents/greene/SyllabusReadingList.pdf

Greene, M. (2009). *A Brief and Opinionated History of Archival Appraisal Theory, to 2005*. (Unpublished)

Green, H. (2014). Use of theoretical and conceptual frameworks in qualitative research. *Nurse Researcher, 21*(6), 34–38. doi:10.7748/nr.21.6.34.e1252 PMID:25059086

Greenwood, D. J., & Levin, M. (2007a). Introduction: Action research, diversity, and democracy. In D. J. Greenwood & M. Levin (Eds.), *Introduction to action research* (pp. 3–12). Thousand Oaks, CA: Sage. doi:10.4135/9781412984614.n1

Greenwood, D. J., & Levin, M. (2007b). A history of action research. In D. J. Greenwood & M. Levin (Eds.), *Introduction to action research* (pp. 13–35). Thousand Oaks, CA: Sage; doi:10.1108/11766091111124676

Greenwood, D. J., & Levin, M. (2007c). An epistemological foundation of action research. In D. J. Greenwood & M. Levin (Eds.), *Introduction to action research* (pp. 55–76). Thousand Oaks, CA: Sage. doi:10.4135/9781412984614.n4

Greenwood, D. J., & Levin, M. (2007d). Action science and organizational learning. In D. J. Greenwood & M. Levin (Eds.), *Introduction to action research* (pp. 224–236). Thousand Oaks, CA: Sage. doi:10.4135/9781412984614.n15

Greenwood, D. J., Whyte, W. F., & Harkavy, I. (1993). Participatory action research as a process and as a goal. *Human Relations, 46*(2), 175–192. doi:10.1177/001872679304600203

Gregor, A. A. P. (2001). Going Public: A History of Public Programming at the Hudson's Bay Company Archives M. A. Thesis Department of history (Archival Studies) University of Manitoba

Grimsted, P. K. (1982). Lenin's Archival Decree of 1918: The Bolshevik legacy for Soviet Archival Theory and Practice. *The American Archivist, 45*(4), 429–443. doi:10.17723/aarc.45.4.tjn581l686q4u0r1

Grotke, A. (2011). *Web Archiving at the Library of Congress*. Retrieved June 10, 2017, from http://www.infotoday.com/cilmag/dec11/Grotke.shtml

Gunnell, J. G. (1969). The idea of a theoretical framework: A philosophical critique. *Administration & Society, 1*, 140–176.

Gurirab, T. B. (2003). *Address at the Closing of the National Forum on Human Capital Development and Knowledge Management for Economic Growth with Equity*. Retrieved April 27, 2004, from http://www.opm.gov.na/pm/speeches/2003/closing.htm

Gwisai, M. (2009). Revolutionaries, resistance and crisis in Zimbabwe. In L. Zeilig (Ed.), Class Stuggles and Resistance in Africa (pp. 219-251). Chicago: Haymarket Books.

Gywnn, D. (2008). *Comparison of Jenkinson's and Schellenberg's Views on Appraisal and Valuation.* Retrieved 20 October, 2016, from: http://www.davidgwynn.com/pdf/505_appraisal.pdf

Haag, D. (2002). *Digital Preservation Testbed White Paper XML and Digital Preservation.* Retrieved September 29, 2016, from http://www.digitaleduurzaamheid.nl/bibliotheek/docs/white-paper_xml-en.pdf#search='whAT%20IS%20 ENCAPSULATION%20IN%20DIGITAL%20PRESERVATION.'

Habermas, J. (1987). *The theory of communicative action: The critique of functionalist reason.* Oxford, UK: Polity.

Habermas, J., & Rehg, W. (1998). Remarks on legitimation through human rights. *Philosophy and Social Criticism,* *24*(2/3), 157–171. doi:10.1177/019145379802400211

Hackam, L. (2011). *Many Happy Returns: Advocacy and the Development of Archives.* Chicago: Society of American Archivists. Retrieved September 19, 2017 from: https://issuesandadvocacy.wordpress.com/2016/07/21/great-advocates-larry-hackman/

Hackman, L. J., & Warnow-Blewett, J. (1987). Documentation Strategy Process: A Model and a Case Study. *The American Archivist,* *50*(1), 11–47. doi:10.17723/aarc.50.1.uxr6766121033766

Hale, R. (1978). Economic aspects of historic preservation. *Journal of Cultural Economics,* *2*(2), 43–53. doi:10.1007/BF00247853

Hales, J. (2014). Bats in Churches: Objective Assessment of Associated Damage Mechanisms. *Archaeology International,* *17*, 94–108. doi:10.5334/ai.1703

Hall, A. S. (2015). *Save our lives: America's Recorded Sound Heritage Project, Preserving Sound Recordings.* Retrieved from http://www.loc.gov/folklife/sos/preserve1.html

Hall, M. (1991). Archaeology's involvement in CRM. A case study. *Muniviro,* *8*(1), 1–5.

Hammoya, C., & Njobvu, B. (2010). Digitization of archival materials: The case of National Archives of Zambia. *ESARBICA Journal,* *29*, 234–247.

Hanke, S., & Kwok, A. (2009). On the measurement of Zimbabwe's hyperinflation. *Cato Journal,* *29*(2), 353–64.

Harris, V. (1993). Community Resource or Scholars' Domain? Archival Public programming and the User as a Factor in Shaping Archival theory and Practice. *S A Archives Journal,* *35*, 4-13

Harris, V. (2000). *Exploring archives: An introduction to archival ideas and practice in South Africa* (2nd ed.). Pretoria: National Archives of South Africa. Retrieved March 13, 2017, from http://www.dlib.org/dlib/november01/peters/11peters.html

Harrison, H. P. (1997). Selection and Audio Visual Collections. In *Audio-visual archives: A practical appraisal* (pp. 126-143). Paris: UNESCO. Retrieved from http://unesdoc.unesco.org/images/0010/001096/109612eo.pdf

Harrison, H. P. (1997/98). Audio-Visual Archives Worldwide. In *World Information Report* (pp. 182-188). Paris: UNESCO. Retrieved from http://unesdoc.unesco.org/images/0010/001096/109612eo.pdf

Harvey, R. (1993). *Preservation in Libraries: Principles, Strategies and Practices for librarians.* London: Bower.

Harvey, R. (1994). *Preservation in libraries: Principles, strategies and practices.* London: Bowker.

Harvey, R., & Mahard, M. R. (2014). *Preservation management handbook; 21st-century guide for libraries, archives and museums.* Lanham, MD: Rowman & Littlefield.

Hays, D. G., & Singh, A. A. (2012). *Qualitative inquiry in clinical and educational settings*. New York, NY: The Guilford Press.

Hazel, F. X. (2005). Cultural loss: How real is the threat? *Micronesian Counselor, 16*, 15–27.

Hedstrom, M. (1995). Electronic Archives: Integrity and Access in the Network Environment. In *Proceedings of the Second Conference on Scholarship and Technology in the Humanities*. London: Bowker-Saur. doi:10.17723/aarc.58.3.n7353726666u41v5

Hedstrom, M., & Montgomery, S. (1998). *Digital preservation needs and requirements in RLG member institutions, a study commissioned by the Research Libraries Group, Mountain View*. Research Libraries Group. Retrieved from http://www.rlg.org/preserv/digpres.htm

Henderson, J. (2013). *Environment: Managing the library and archive environment*. London: Preservation Advisory Center, British Library.

Henning, E., Van Rensburg, W., & Smit, B. (2004). *Finding your way in qualitative research*. Pretoria, South Africa: Van Schaik.

Henning, M. (2006). *Museums, media and cultural theory*. Berkshire: Open University Press.

Hennink, M., Hutter, I., & Bailey, A. (2011). *Qualitative research methods*. Los Angeles, CA: Sage.

Herr, K., & Anderson, G. L. (2005). *The action research dissertation: A guide for students and faculty*. Thousand Oaks, CA: Sage.

Hester, T. R., Heizer, R. F., & Graham, J. A. (1975). *A guide to field methods in archaeology*. Palo Alto: Mayfield Publishing.

Heunis, V. (2005). Museum accessibility: Reaching out to the disabled community. *SAMAB, 31*, 27–30.

Heussler, R. (1963). *Yesterday's rulers: the making of the British colonial service*. Syracuse, NY: Syracuse University Press.

Hillebrecht, W. (2010). *The Preservation of the audiovisual heritage of Namibia, challenges and opportunities*. Paper Presented at the Sound Archives Workshop, Windhoek, Namibia. Retrieved November 11, 2016, from http://baslerafrika.ch/wp-content/uploads/WP_2010_1_Hillebrecht.pdf

Hillebrecht, W. (2010). *The Preservation of the Audio Heritage of Namibia. Challenges and Opportunities*. Basler Afrika Bibliographien Klosterberg.

Hirai, N. (2014). Traditional cultures and modernization: Several problems in the case of Japan. In R. Peters (Ed.), *Cultural identity and modernization in Asian countries* (pp. 13–23). New York: Palgrave.

Hlabangaan, K., & Mnjama, N. (2008). Disaster preparedness in information centers in Gaborone, Botswana. *African Journal of Library Archives and Information Science, 18*(1), 63–74.

Hlope, P., & Wamukoya, J. (2007). Utilization of Archival Information at Swaziland National Archives. *ESARBICA Journal, 26*, 85–112.

Hohmann, P. (2016). On impartiality and interrelatedness: Reactions to Jenkinsonian Appraisal in the Twentieth Century. *The American Archivist, 79*(1), 14–25. doi:10.17723/0360-9081.79.1.14

Honer, E., & Graham, S. (2001). Should Users Have a Role in Determining the Future Archive? The Approach Adopted by the Public Record Office, the UK National Archive, to the Selection of Records for Preservation. *LIBER Quarterly, 11*(4), 382–399. doi:10.18352/lq.7657

Horrigan, J. B. (2016). *Digital Readiness Gaps.* Retrieved September 21, 2016, from http://www.pewinternet.org/files/2016/09/PI_2016.09.20_Digital-Readiness-Gaps_FINAL.pdf

Horsman, P. (2001). *Electronic Recordkeeping: The Recordkeeping System as Framework for the Management of Electronic Records.* Retrieved 23 August, 2016, from: http://www.archiefschool.nl/docs/horselec.pdf

House, A. (1993). *Great safari. Lives of George and Joy Adamson.* London: Harper Collins.

Huffman, T. N. (2007). *Handbook to the Iron Age: The archaeology of pre-colonial farming societies in Southern Africa.* University of KwaZulu-Natal Press.

Hunter, D. (2011). *Papermaking. The History and Technique of and Ancient Craft.* New York: Dover publications.

Hunter, G. S. (2000). *Preserving digital information.* New York: Neal-Schuman, Inc.

Hurley, C. (2004). *What, If Anything, Is Records Management?* Retrieved 25 August, 2017, from: https://www.descriptionguy.com/images/WEBSITE/what-if-anything-is-records-management.pdf

IASA. (2017). *Guidelines on the Production and Preservation of Digital Audio Objects.* Retrieved from https://www.iasa-web.org/tc04/audio-preservation

Ibok, E. (2008). Globalizing Nigeria's culture through the contemporary blend of indigenous pop-rap music. *WAACLALS: West Africa Association of Commonwealth Literature and Language Studies, 2*(2), 38–61.

ICA (International Council on Archives). (2008). *ICA Guidelines and Functional Requirements for Electronic Records Management Systems.* Retrieved June 27, 2017, from: http://www.ica.org/sites/default/files/1%20Overview.pdf

ICA. (1997). *Guide for managing electronic records from an archival perspective: committee on electronic records.* Retrieved 5 September, 2017, from: https://www.ica.org/sites/default/files/ICA%20Study%208%20guide_eng.pdf

ICA. (2011). *ISAD(G): General International Standard Archival Description* (2nd ed.). Retrieved June 27, 2017, from: http://www.ica.org/en/isadg-general-international-standard-archival-description-second-edition

ICA. (2012). *Principles of Access to Archives.* Retrieved June 27, 2017, from http://www.ica.org/sites/default/files/ICA_Access-principles_EN.pdf

ICOM. (2017). *ICOM Code of ethics for museums.* ICOM.

ICOM. (2017). *ICOM statutes.* ICOM. Retrieved 10 June 2017, from http://archives.icom.museum/statutes.html#intro

ICOMOS (International Council on Monuments and Sites). (1990). *Charter for the Protection and Management of the Archaeological Heritage.* Retrieved January 27, 2017, from: http://www.icomos.org/charters/arch_e.pdf

ICOMOS. (1964). *International charter for the conservation and restoration of monuments and sites (the Venice charter).* Venice: ICOMOS.

ICOMOS. (1999). *The Burra charter. The Australia ICOMOS charter for places of cultural significance.* Burra: ICOMOS.

ICOMOS. (2002). *ICOMOS International Cultural Tourism Charter: Principles and Guidelines for Managing Tourism at Places of Cultural and Heritage Significance.* Retrieved June 27, 2017, from: http://australia.icomos.org/wp-content/uploads/ICOMOS-International-Cultural-Tourism-Charter-English.pdf#7s8d6f87

ICOMOS. (2011). *Guidance on Heritage Impact Assessments for Cultural World Heritage Properties.* Retrieved June 27, 2017, from: http://www.icomos.org/world_heritage/HIA_20110201.pdf

ICOMOS. (2013). *The Burra charter: The Australia ICOMOS charter for places of cultural significance.* Burra: ICOMOS.

ICOMOS. (2014). *Approaches for the Conservation of Twentieth-Century Architectural Heritage Madrid Document 2014* (2nd ed.). Retrieved June 27, 2017, from: http://www.icomos-isc20c.org/pdf/madrid_doc_10.26.pdf

Idowu, S. O. (1999). *Media in Nigeria's security developmental vision*. Ibadan: Spectrum Books Limited.

IFLA. (2002). *Guidelines for Digitization Projects: for collections and holdings in the public domain, particularly those held by libraries and archives*. Retrieved September 20, 2016, from http://www.ifla.org/VII/s19/pubs/digit-guide.pdf

IFLA. (2003). *Audio-visual and Multimedia Section Annual Report January 2001-2003*. Retrieved from http://www.ifla.org/VII/s35/annual/sp35.htm

IGG. (2012). *Inspectorate of Government: report to Parliament, July – December 2011*. Kampala: IGG.

IGG. (2014). *Inspectorate of Government: report to Parliament, July–December 2013*. Kampala: IGG.

Ilukena, K. R. (2016). *Marketing and public programming activities at the National Archives of Namibia* (Unpublished research project report). University of Namibia, Windhoek, Namibia.

Imenda, S. (2014). Is there a conceptual difference between theoretical and conceptual frameworks? *Sosyal Bilimler Dergisi. Journal of Social Sciences, 38*(2), 185–195.

International Council of Archives. (2000). *International standard for archival description (general)* (2nd ed.). International Council of Archives.

International Council of Museums Italy. (2014). *The Siena Charter. Museums and Cultural Landscapes*. Retrieved on 26 April 2016 from icom.museum/uploads/media/Carta-di-Siena-EN-final.pdf.

International Council of Museums South Africa. (2014). *Museum research in South Africa – Relevance and Future, 26 – 27 August 2014*. Unpublished report. Author.

International Council of Museums. (2017). *Past General Conferences*. Retrieved on 12 September 2017 from icom.museum/event/general-conference/past-general-conferences

International Council on Archives (ICA). (1997). *Committee on Electronic Records, Guide for Managing Electronic Records from an Archival Perspective*. Paris: ICA.

International Council on Archives (ICA)/International Records Management Trust (IRMT). (2016). *Managing Metadata to Protect the Integrity of Records*. Retrieved 30 November, 2016, from: http://www.ica.org/sites/default/files/Metadata%20Module.pdf

International Council on Archives. (2005) *Committee on Archives: Guidelines on Appraisal*. Retrieved 26 October, 2016 from: http://www.ica.org

International Finance Corporation. (2012). *Performance standard 8: Cultural heritage*. Retrieved April 21, 2013, from http://www.ifc.org/wps/wcm/connect/dd8d3d0049a791a6b855faa8c6a8312a/PS8_English_2012.pdf?MOD=AJPERES

International Organisation Standards (ISO). (2003). *Information and documentation: Document storage requirements for archives and library materials, ISO 11799*. Retrieved September 16, 2015, from: http://www.unal.edu.co/una/docs/DT/ISO-11799_requirements_for_archive_and_library_materials.pdf

International Records Management Trust (IRMT). (1999). *Electronic records*. London: Author.

International Records Management Trust (IRMT). (1999). *From Accounting to Accountability: Managing Accounting Records as a Strategic Resource*. Retrieved 7 September, 2017, from: http://www.irmt.org/documents/research_reports/accounting_recs/IRMT_acc_rec_background.PDF

International Records Management Trust (IRMT). (2000). *Managing records as the basis for effective service delivery and public accountability in development: An introduction to core principles for staff of the World Bank and its Partners.* London: Author.

International Records Management Trust (IRMT). (2002). *Evidence-Based Governance in the Electronic Age.* Retrieved November, 10, 2015 from http://www.irmt.org/evidence/wbnews.html

International Records Management Trust (IRMT). (2004). *E-records readiness tool.* Retrieved 23 September, 2016, from http://www.nationalarchives.gov.uk/rmcas/documentation/eRecordsReadinessTool_v2_Dec2004 .pdf

International Records Management Trust (IRMT). (2004). *The e-records readiness tool.* Retrieved February 26, 2007, from http://www.nationalarchives.gov.uk/rmcas/documentation/eRecordsReadinessTool_v2_Dec2004.pdf

International Records Management Trust (IRMT). (2008). *Fostering trust and transparency in governance: Investigating and addressing the requirements for building integrity in public sector information systems in ICT environment. Annual Report, 2007-2008.* Retrieved September, 10, 2017 from http://www.irmt.org/documents/building_integrity/ Annual%20Reports/Annual%20Report%20%202008%20- %20Fostering%20Trust%20and%20Transparency%20in%20 Governance.pdf

International Records Management Trust (IRMT). (2008). *Sierra Leone Case study: Fostering Trust and Transparency in Governance.* Retrieved 17 July, 2016, from: http://www.irmt.org/documents/building_integrity/case_studies/ IRMT_Case_Study_Sierra%20Leone.pdf

International Records Management Trust (IRMT). (2009). *Implementing electronic records management: Training in electronic records management.* Retrieved March 3, 2017, from http://www.irmt.org/documents/educ_training/termresources/IRMTRouteMapforImplementingElectronicRecordsManagement.pdf

International Records Management Trust. (1999). *Building records appraisal systems,* Retrieved 27 August, 2017, from: http://www.irmt.org/documents/educ_training/public_sector_rec/IRMT_build_rec_appraisal.pdf

International Records Management Trust. (2009). *Understanding the context of electronic records management.* Retrieved 30 August, 2017, from: http://www.irmt.org/documents/educ_training/term%20modules/IRMT%20TERM%20 Module%201.pdf

International Standard Organisation (ISO) ISO 15489-1. (n.d.). *Information and documentation - records management.-Part 1: General.* Geneva, Switzerland: Author.

International Standards Organisation (ISO). (2014). *Requirements for bodies providing audit and certification of candidate trustworthy digital repositories. ISO 16919:2014(E).* Geneva: International Standards Organisation.

International Standards Organisation (ISO). (2016). *ISO 15489-1, Information and Documentation – Records Management Part 1: General.* Geneva: International Standards Organisation.

International Standards Organization ISO 15489-1. (n.d.). *Information and documentation-concepts and principles.* Retrieved August, 16 2017 from https://www.iso.org/standard/62542.html

InterPARES Trust - Team Africa. (2016a). *Proposal - AF03 Enterprise digital records management in Zimbabwe.* Pretoria: InterPARES Trust - Team Africa.

InterPARES Trust - Team Africa. (2016b). *Proposal - AF04 Enterprise digital records management in Botswana.* Pretoria: InterPARES Trust - Team Africa.

InterPARES Trust. (2017a). *About the Research.* Retrieved August, 17, 2017, from https://interparestrust.org/trust/ about_research/summary

InterPARES Trust. (2017b). *About Us: Team Index*. Retrieved August, 17, 2017, from https://interparestrust.org/trust/aboutus

InterPARES. (2002). *Requirements for Assessing and Maintaining the Authenticity of Electronic Records*. Retrieved 30 April, 2016, from: http://www.interpares.org/book/interpares_book_k_app02.pdf

Investopedia. (2017). *Social Media Marketing*. Retrieved August 3, 20017 from: http://www.investopedia.com/terms/s/social-media-marketing-smm.asp

Ipinge, A. (2015). *An investigation of the recognition of the records management profession in the public service of Namibia* (Unpublished undergraduate research report). University of Namibia.

IRMT (International Records Management Trust). (2004). *The E-Records Readiness Assessment Tool*. Retrieved June 27, 2017, from: http://www.irmt.org/portfolio/e-records-readiness-assessment-2005

IRMT. (2009). *Integrating Records Management in ICT Systems: Good Practice Indicators*. Retrieved June 27, 2017, from: http://www.irmt.org/documents/educ_training/term%20resources/IRMT_Good_Practice_Indicators.pdf

IRMT. (2014). Fostering trust and transparency in governance (2006 to 2008). *IRMT Training in Electronic Records Management Proceedings*. Retrieved November 14, 2016, from http:// irmt.org/portfolio/fostering-trust-transparency-governance-investigating-addressing-requirements-building-integrity-public-sector-information-systems-ict-environment-2006-2008

ISO 15415489:1. (2001). *Information and Documentation-Records Management, Part 1: General*. Geneva: ISO. Retrieved from www.iso.org/catalogue_detail.html

Ivankova, N. (2015). *Mixed methods applications in action research: From methods to community action*. London: Sage.

Ivey, J. (2015). Demystifying research: How important is a conceptual framework? *Pediatric Nursing, 14*(3), 145-153.

Jaccard, J., & Jacoby, J. (2010). *Theory construction and model-building skills*. New York: The Guilford Press.

Jacobs, F. (2005). The suffering of war. *SAMAB, 31*, 56–57.

Jacobson, M. (2008). Migration of 1.5 million hours of audio-visual material, Swedish National Archive of Recorded Sound and Moving Image (SLBA). *IASA Journal, 31*, 25-35. Retrieved from https://www.iasa-web.org/sites/default/files/iasa-journal-31-all.pdf

Jacobson, L., & Baillie, G. (2011). Heritage and museums: Scope, roles and responsibilities. *SAMAB, 34*, 21–29.

Janes, R. R., & Sandell, R. (2007). Complexity and creativity in contemporary museum management. In Museum Management and Marketing (pp. 1-14). London: Routledge.

Jenkinson, H. (1937). *A Manual of archives administration*. Retrieved from: https://ia800806.us.archive.org/32/items/manualofarchivea00iljenk/manualofarchivea00iljenk.pdf

Jenkinson, H. (1922). *A Manual for Archives Administration*. London: Academic Press.

Jeudy, H. P. (2001). *La machinerie patrimoniale*. Paris: Sens & Tonka.

Jimerson, R. C. (2003). Archives and manuscripts: Reference, access, and use. *OCLC Systems & Services, 19*(1), 13–17.

Jimerson, R. C. (2010). From the Pacific Northwest to the global information society: The changing nature of archival education. *Journal of Western Archives, 1*(1), 1–23.

Jimmerson, R. C. (2011). Archives 101 in a 2.0 World: The continued need for Parrall systems. In *A Different Kind of WEB: New Connections Between Archives and Users* (pp. 1–19). Chicago: Society of American Archivists.

JISC. (2008). *Selecting the right preservation*. Retrieved September 23, 2016, from http://www.paradigm.ac.uk/workbook/preservatio-strategies/selecting-migration.html

Johnson, E. S. (2008). Our Archives, Our Selves: Documentation Strategy and Re-Appraisal of Professional Identity. *The American Archivist, 71*, 190–202.

Johnston, L. R. (2014). *Why Engage in Preseravtion of Data for Long Term*. Retrieved September 10, 2017, from https://www.lib.umn.edu/about/staff/lisa-johnston

Joint Information Systems Committee (JICS). (2003). *JICS records management policy statement*. Retrieved March 23, 2007 from: http://www.jics.ac.uk/index.cfm?name=pres_rmps

Jokihleto, J. (1999). *A history of architectural conservation*. Elsevier.

Jonas, H. (1985). *The Imperative of responsibility: In search of an ethics for the technological age*. Chicago: The Chicago University Press.

Joukowsky, M. (1980). *A complete manual of field archaeology*. Englewood Cliffs, NJ: Prentice-Hall Incorporated.

Kalfatovic, M. R., Kapsalis, E., Spiess, K. P., Van Camp, A., & Michael, E. (2008). Smithsonian Team Flickr: A library, archives, and museums collaboration in web 2.0 space. *Archival Science, 8*(4), 267–277. doi:10.1007/s10502-009-9089-y

Kalusopa, T. (2017). *Implementation of enterprise-wide systems to manage trustworthy digital records in Botswana's public sector*. Paper Presented at XXIV Biennial ESARBICA General Conference: Public Sector Records - Accountability and Transparency, Lilongwe, Malawi.

Kalusopa, T., & Zulu, S. (2009). *Digital heritage material preservation in Botswana: Problems and prospects*. Retrieved September 23, 2016, from http//: www.emeraldinsight.com

Kalusopa, T. (2008). Challenges of digital heritage materials preservation in Botswana. *ESARBICA Journal, 27*, 171–202.

Kalusopa, T., & Zulu, S. (2009). Digital heritage material preservation in Botswana: Problems and prospects. *Collection Development, 38*(3), 98–107.

Kamatula, G. (2011). Marketing and Public Programming in Records and Archives at the Tanzania Records and Archives Management Department (RAMD). *Journal of the Society of South African Archivists, 44*, 304–333.

Kansas State Historical Society. (2005). *Kansas electronic records management guidelines*. Topeka, KS: Author.

Kanyengo, C. W. (2009). Preservation and conservation of information resources in the University of Zambia Library. *Journal of Archival Organization, 7*(3), 116–128. doi:10.1080/15332740903126736

Karlos, A. (2015). *A study on the implementation of the electronic document and records management system (EDRMS) in the public service of Namibia* (Unpublished undergraduate research report). University of Namibia.

Katuu, S. (1999). User Studies and User Educational Programmes and their Implications for Archival Institutions in Africa. In *Archives and the Protection of People's Rights, Proceedings of XVth Biennial Conference of the East and southern African regional Branch of the International council on archives on archives and the protection of the people's rights*. Pretoria National Archives of South Africa.

Katuu, S., & Ngoepe, M. (2015) *Managing digital heritage – an analysis of the education and training curriculum for Africa's archives and records professionals*. Retrieved September 20, 2016, from https://interparestrust.org/assets/.../Katuu-Ngoepe_20151022_ICCSM2015_Paper.pdf

Katuu, S. (2009). Archives and records management education and training: What can Africa learn from Europe and North America? *Information Development*, 25(2), 133–145. doi:10.1177/0266666909104714

Kavulya, J. M. (2004). Marketing of Library Services: A Case Study of Selected University Libraries in Kenya. *Library Management*, 25(3), 118–126. doi:10.1108/01435120410522334

Kawalya, J. (2011). Building the national memory in Uganda: The role of legal deposit legislation. *Information Development*, 27(2), 117–124. doi:10.1177/0266666911401180

Kazavanga, U. (2015). *The status of records management in parastatals in Namibia: A case study of Namibia College of Open Learning (NAMCOL)* (Unpublished undergraduate research report). University of Namibia.

Keakopa, S. (2006). *Management of Electronic Records in Botswana, Namibia and South Africa: Opportunities and Challenges* (Unpublished doctoral dissertation). University College London, London, UK.

Keakopa, S. M. (2006). *The management of electronic records in Botswana, Namibia and South Africa: opportunities and challenges* (Unpublished PhD Thesis). University College London, London, UK.

Keakopa, S. M. (2016). *Developing an integrated framework for procurement and implementation of Electronic Records Management Systems (EDRMS) in the ESARBICA region.* Paper presented at the SASA Conference, Mafikeng, South Africa.

Keakopa, S. M., & Kalusopa, T. (2009). Professional staff turnover at the Botswana National Archives & Records Services (BNARS). Zambia Library Association, 24(1-2), 53-74.

Keakopa, M. S. (2003). Automated records management systems in the ESARBICA region. *ESARBICA Journal*, 21(2), 41–48.

Keakopa, S. M. (2007). Policies and procedures for the management of electronic records in Botswana, Namibia and South Africa. *ESARBICA Journal*, 26, 70–82.

Keakopa, S. M. (2008). Management of email a challenges for archivists and records managers in Botswana, Namibia and South Africa. *ESARBICA Journal*, 27, 72–83.

Keakopa, S. M. (2010). Overview of archival and records management development in the ESARBICA region. *Archives and Manuscripts*, 38(1), 51–77.

Keakopa, S. M. (2010). Trends in long-term preservation of digital information: Challenges and possible solutions for Africa. *Africa Media Review*, 18(1&2), 73–84.

Keene, R., & Parle, J. (2015). Museums, archives and medical material in South Africa: Some ethical considerations. *SAMAB*, 37, 17–31.

Keene, R., & Wanless, A. (2005). The curse of collections: From canons to kitty litter. *SAMAB*, 31, 10–11.

Keikelame, M. J. (2017). 'The tortoise under the couch': An African woman's reflections on negotiating insider–outsider positionalities and issues of serendipity on conducting a qualitative research project in Cape Town, South Africa. *International Journal of Social Research Methodology*, 1–12. doi:10.1080/13645579.2017.1357910

Keith, K. F. (2012). Moving beyond the mainstream. Insight into the relationship between community-based heritage organizations and the museum. In R. Sandell & E. Nightingale (Eds.), *Museums, equality and social justice* (pp. 45–58). London: Routledge.

Kemmis, S. (2001). Exploring the relevance of critical theory for action research: Emancipatory action research in the footsteps of Jürgen Habermas. In P. Reason & H. Bradbury (Eds.), *Handbook of action research* (pp. 94–105). London: Sage.

Kemmis, S., & McTaggart, R. (1988). *The action research planner* (3rd ed.). Geelong: Deakin University Press.

Kemmis, S., & McTaggart, R. (2005). Participatory action research: Communicative action and the public sphere. In N. K. Denzin & Y. S. Lincoln (Eds.), *The Sage handbook of qualitative research* (3rd ed.; pp. 559–603). Thousand Oaks, CA: Sage.

Kemoni, H. (2002). The utilisation of archival information by researchers in Kenya: A case study of the University of Nairobi. *African Journal of Library Archives and Information Science, 12*(1), 69–80.

Kemoni, H. (2009). Management of electronic records: Review of empirical studies from east and southern Africa (ES-ARBICA) region. *Records Management Journal, 10*(3), 190–203. doi:10.1108/09565690910999184

Kemoni, H. N. (1996). Preservation and Conservation of Archive Materials: The Case of Kenya. *African Journal of Library Archives and Information Science, 6*(1), 46–51.

Kenosi, L. (2008). The South African Truth Commission's Audio-visual Record and Great Access Illusion. *IASA Journal, 31*, 85-89. Retrieved from https://www.iasa-web.org/sites/default/files/iasa-journal-31-all.pdf

Kenosi, L. (1999). Records management in the public service and Botswana's national archives and record services. *African Journal of Library Archives and Information Science, 9*(2), 119–127.

Kenosi, L. (2000). Managing records in restricted organizations. *Information Development, 16*(2), 65–69. doi:10.1177/0266666004240260

Kenosi, L. S. (1999). The Paradox of Appraisal and Archival Theory: An Uneasy marriage Relationship. Is there a Case for divorce? *South African Archives Journal, 41*, 20–28.

Kenosi, L., & Moatlhodi, T. (2012). The Determination of value Archival Science and the ever evolving theories Of Records Selection. *The Eastern Librarian, 23*(1), 24–36. doi:10.3329/el.v23i1.12116

Kenya National Archives. (2007). *Publications*. Retrieved September 12, 2007 from: http://www.kenyarchives.go.ke/publications.htm

Keopannha, V. (2008). *Museum Collections and Biodeterioration in Laos*. (Masters Thesis). Gotheburg University.

Keorapetse, D., & Keakopa, S. (2012). Records management as a means to fight corruption in Botswana. *ESARBICA Journal, 31*, 24–35.

Keping, Y. (2012). The transformation of Chinese culture sine the launching of reform: A historical perspective. *Theory China: A Resource for Understanding China*. Retrieved September 26, 2016, from http://en.theorychina.org/xsqy_2477/201306/t20130611_270481.shtml

Kerlinger, F. (1973). *Foundations of behavioural research* (2nd ed.). New York: Holt, Rinehart & Winston.

Kerr, J. S. (1985). *The conservation plan. A guide to the preparation of conservation plans for places of European cultural significance*. Sydney: ICOMOS.

Ketelaar, E. (1992). Archives of the People, for the People, by the People. *S. A. Archives Journal, 34*, 5–15.

Ketelaar, E. (2008). Exploration of the archived world: From De Vlamingh's plate to digital realities. *Archives and Manuscripts, 36*(2), 13–33.

Khamula, O. (2017). Mutharika signs Access to Information Bill into law: New dawn for transparency in Malawi. *Nyasa Times*. Retrieved 21 September 2017 from https://www.nyasatimes.com/mutharika-signs-access-information-bill-law-new-dawn-transparency-malawi/

Khayundi, F. E. (1995). An Overview of Preservation and Conservation Programmes in Eastern and Southern Africa. In *Proceedings of the Pan-African Conference on the Preservation and Conservation of Library and Archival Materials*. The Hague: IFLA.

King, S., & Pearson, C. (1992). *Environmental control for cultural institutions: Appropriate design and the use of alternative technology*. Paris: Collogue Internationale de I ARAAFU.

Kiplanga't, J. (1999). An Analysis of the Opportunities for Information Technology in Iproving Access, Transfer and use of Agricultural Information in the Rural Areas of Kenya. *Library Management*, 20(2), 115–127. doi:10.1108/01435129910251575

Kirchhoff, A. J. (2008). Digital preservation: Challenges and implementation. *Learned Publishing*, 21(4), 285–294. doi:10.1087/095315108X356716

Kirk, J. (2013). *Google to encrypt cloud storage data by default*. Retrieved September 23, 2016, from http://www.computerworld.com/s/article/9241670/Google_t

Kirk-Greene, A. H. M. (1991). *A biographical dictionary of the British Colonial Service, 1939-1966*. London: Hans Zell.

Kirk-Greene, A. H. M. (1999). *On crown service*. London: I.B. Tauris.

Kitchel, T., & Ball, A. L. (2014). Quantitative theoretical and conceptual framework use in agricultural education research. *Journal of Agricultural Education*, 55(1), 186–199.

Klamer, A. (2013). The values of cultural heritage. In I. Rizo & A. Mignosa (Eds.), *Handbook on the economics of cultural heritage* (pp. 421–437). Cheltenham, UK: Edward Elgar. doi:10.4337/9780857931009.00035

Klaue, W. (2004). *Education and training, audiovisual archives*. Retrieved from http://www.unesco.org/webworld/ramp/html/

Klaue, W. (1997). Audio-visual records as archival material. In H. P. Harrison (Ed.), *Audio-visual archives: A practical reader* (pp. 23–27). Paris: UNESCO.

Koch, G. (1997). A typology of media archives. In Audio-visual archives: A practical reader (p. 32-34). Paris: UNESCO, PG1-97/WS/4.

Kodak Imaging in Action, Eastman Kodak Company, Rochester. (1995). In *Audio visual archives, a practical reader*. Paris: UNESCO. Retrieved from http://unesdoc.unesco.org/images/0010/001096/109612eo.pdf

Kofler, B. (2004). *Legal issues in audiovisual archives*. Retrieved from http: www.unesco.org/webworld/ramp/htm

Kootshabe, T. J., & Mnjama, N. (2014). Preservation of government records in Botswana. *Journal of the South African Society of Archivists*, 47, 26–49.

Korsman, S. A., & Meyer, A. (1999). Die Steentydperk en rotskuns. In J. S. Bergh (Ed.), *Geskiedenisatlas van Suid-Afrika. Die vier noordelike provinsies* (pp. 93–95). Pretoria: JL van Schaik.

Kotler, P., & Fox, K. F. A. (1995). *Strategic Marketing for Educational institutions* (2nd ed.). Englewood Cliffs, NJ: Prentice Hall.

Krajewska, J. (2009). The *Hutong*s of Beijing: Between past and present. *Architectus*, 1(2), 59–65.

Kreimer, A. (2000). *Uganda post-conflict reconstruction: Country case study series.* Washington, DC: The World Bank. Retrieved January 14, 2017, from http://ieg.worldbank.org/Data/reports/uganda_post_conflict.pdf

Kreps, C. F. (2003). *Liberating culture. Cross-cultural perspectives on museums, curation and heritage preservation.* London: Routledge.

Krogman, W. M., & Iscan, M. Y. (1986). *The human skeleton in forensic medicine.* Charles C. Thomas.

Krutilla, J. V., & Fisher, A. C. (1985). *The economics of natural environments.* Baltimore, MD: John Hopkins Press.

Kufa, J. C. (1998). A Pilot Project on Preservation Awareness Training in the University of Botswana Library. *Restaurator (Copenhagen), 19*(2), 108–113. doi:10.1515/rest.1998.19.2.108

Kukubo, R. (1986). The historical development of archival services in Botswana, Lesotho and Swaziland. *Proceedings of the 9th Biennial General Conference and Regional Seminar on Archives Administration and Regional Planning Meeting: Guide to the sources of African History,* 161-262.

Kumasi, K. D., Charbonneau, D. H., & Walster, D. (2013). Theory talk in the library science scholarly literature: An exploratory analysis. *Library & Information Science Research, 35*(3), 175–180. doi:10.1016/j.lisr.2013.02.004

Küsel, U. (1997). Kultuurhulpbronne. In K. Basson (Ed.), *The development of cultural resources for tourism* (pp. 4–10). Pretoria: National Cultural History Museum.

Larsen, K. R., Allen, G., Vance, A., & Eargle, D. (Eds.). (2015). *Theories used in IS research Wiki.* Retrieved September 15, 2017, from: http://IS.TheorizeIt.org

Lau, B. (1994). National Archives of Namibia: Country report. In *Archives in the nineties: The challenges for Eastern and Southern Africa Regional Branch of the International Council on Archives* (pp. 246-247). Gaborone, Botswana: ESARBICA.

Laudon, K. C., & Laudon, J. P. (2012). *Management Information System: Managing the Digital Firm.* Boston: Pearson.

Laver, T. Z. (2003). In a class by themselves: Faculty papers at research university archives and manuscript repositories. *The American Archivist, 66*(1), 159–169. doi:10.17723/aarc.66.1.b713206u71162k50

Lavoie, B. (2014). *Recommendation for Space Data System Practices: Reference model for an open archival information system (OAIS).* Retrieved 22 September, 2017, from: http://www.dpconline.org/docs/technology-watch-reports/1359-dpctw14-02/file

Lawetz, H. (2008). When archives go digital. *IASA Journal, 31,* 36-41. Retrieved from https://www.iasa-web.org/sites/default/files/iasa-journal-31-all.pdf

Lekaukau. T. M. (1993). Catering for the User Needs, with Special Reference to Botswana National archives and Records Services. *S A Archives Journal, 35,* 24-32.

Lekaukau, M. (2000). Serving the administrator: The archivist in the new millennium. *Archivum, 45,* 119–123.

Lekaukau, T. M. (1990). *Botswana National Archives and Records Services Annual Report.* Gaborone: Government Printer.

Levy, D. (1994). Chaos theory and strategy: Theory, applications, and managerial implications. *Strategic Management Journal, 15*(S2), 167–178. doi:10.1002/smj.4250151011

Lewin, K. (1946). Action research and minority problems. *The Journal of Social Issues, 2*(4), 34–46. doi:10.1111/j.1540-4560.1946.tb02295.x

Lewis, A. F. (2005). *Risk reduction through preventive care, handling and storage*. Retrieved from http://www.arl.org/preserv/sound_savings_proceedings/lewis.html

Lewis, G. (2004). The role of museums and the professional code of ethics. In Boylan. P (Ed.), Running a museum: A practical handbook (pp. 1-16). Paris: ICOM – International Council of Museums.

Lewis, J. R. (2000). *Conservation and preservation activities in archives and library in developing countries: An advisory guideline on association of commonwealth archives and records managers*. London: Association of Commonwealth Archivists and Records Managers.

Library and Archives Canada. (2007). *Managing Audiovisual Records in the Government of Canada*. Retrieved from http://www.collectionscanada.ca/html

Library of Congress. (2016). *Library of Congress Digital Preservation Tools and Services Inventory*. Retrieved September 23, 2016, from http://www.digitalpreservation.gov/about/resources.html

Littlejohn, S. W. (2002). *Theories of Human Communication* (7th ed.). Albuquerque, NM: Wadsworth.

Livesey, C. (2011). The Mass Media: Defining mass media. *Sociology Central*. Retrieved 12 September 2017 from: http://www.sociology.org.uk/notes/media_defined.pdf

Llewelyn, S. (2003). What counts as "theory" in qualitative management and accounting research? Introducing five levels of theorizing. *Accounting, Auditing & Accountability Journal, 16*(4), 662–708. doi:10.1108/09513570310492344

Loadman, J. (2001). Does the position of records management within the organization influence the records management provision? *Records Management Journal, 11*(1), 45–63. doi:10.1108/EUM0000000007266

Lor, P. J. (2008). Digital libraries and archiving knowledge: Some critical questions. *South African Journal of Library and Information Science, 74*(2), 116–128.

Louw, A. H. (2000). *The concept of the African Renaissance as a force multiplier to enhance lasting peace and stability in Sub-Saharan Africa. Executive National Security Programme 02/2000*. South African Defence College.

Lowenthal, D. (2000). Stewarding the Past in a Perplexing Present. In E. Avrami, R. Mason, & M. de la Torre (Eds.), *Values and Heritage Conservation. Research Report* (pp. 18–25). Los Angeles: Getty Conservation Institute.

Lowry, J., & Wamukoya, J. (Eds.). (2014). Integrity in government through records management. Farnham: Ashgate.

Lucero, J., Wallerstein, N., Duran, B., Alegria, M., Greene-Moton, E., Israel, B., & Hat, E. R. W. et al. (2016). Development of a mixed methods investigation of process and outcomes of community-based participatory research. *Journal of Mixed Methods Research*, 1–20. Retrieved from sagepub.com/journalsPermissions.nav

Lugya, F. K. (2011). *Usability of Makula among Makerere University library users*. Retrieved January 12, 2017, from http:/hdI.handle.net/123456789/1967

Lugya, F., & Mbawaki, I. (2011). Usability of Makula among Makerere University Library users: A case study. In *Proceeding of the 3rd International Conference on Qualitative and Quantitative Methods in Libraries*. Athens, Greece: National Hellenic Research Foundation. Retrieved January 19, 2017, from http://dspace.mak.ac.ug/handle/123456789/1967

Lukičić, M., Tesla, E. N., & Sruk, V. (2009). *Electronic Records Management System Requirements*. Retrieved 8 August, 2017, from: http://infoz.ffzg.hr/INFuture/2009/papers/2-02%20Lukicic,%20Sruk,%20ERMS%20requirements.pdf

Luyombya, D. & Sennabulya, S. (2012). An analysis of the public archives infrastructure in Uganda. *Comma, 2012*(1), 67-78.

Luyombya, D. (2011). ICT and digital records management in the Ugandan public service. *Records Management Journal*, *21*(2), 135–144. doi:10.1108/09565691111152062

Lyall, J. (1993). *How to develop a disaster plan for a library or archival institution*. Pan African Conference on preservation of library and archival materials, Nairobi, Kenya.

Lynott, M. J. (1997). Ethical principles and archaeological practice: Development of an ethics policy. *American Antiquity*, *62*(4), 589–599. doi:10.2307/281879

Lysaght, Z. (2011). Epistemological and paradigmatic ecumenism in "Pasteur's Quadrant": Tales from doctoral research. The Third Asian Conference on Education Osaka, Japan, Official Conference Proceedings 2011. (The International Academic Forum (IAFOR): Nagakute-cho), pp. 567-579. Retrieved January 31, 2017, from: http://papers.iafor.org/conference-proceedings/ACE/ACE2011_proceedings.pdf

Maakwe, G. (2006). *An evaluation of the impact of integrating government records management units (RUMs) with Botswana National Archives and Records Services (BNARS)* (Unpublished M.A. dissertation). University of Botswana.

Macamo, S. L. (1996). The problems of conservation of archaeological sites in Mozambique. In G. Pwiti & R. Soper (Eds.), *Aspects of African Archaeology* (pp. 813–816). Harare: University of Zimbabwe Publications.

Macneil, H. (2000). Providing Grounds for Trust: Developing Conceptual Requirements for the Long-term Preservation of Authentic Electronic Records. *Archivaria*, *50*, 52–78.

Maduka, C. T. (2003). The clouds are thickening: Nigerian languages and literatures in national development. *JONEL: Journal of Nigerian English and Literature*, *4*, 11–19.

Maemura, E., Moles, N., & Becker, C. (2017). Organizational assessment frameworks for digital preservation: A literature review and mapping. *Journal of the Association for Information Science and Technology*, *68*(7), 1619–1637. doi:10.1002/asi.23807

Magara, E. (n.d.). *Building capacity for archives and dissemination of information in Uganda: A case of study of Uganda Broadcasting Corporation and Directorate of Information*. Retrieved March 14, 2017, from www.uneca.org/icadla1/docs/Thursday/Magara.ppt

Maher, J. (1997). *Society and Archives*. Retrieved September 15, 2017 from: http://chnm.gmu.edu/digitalhistory/links/cached/chapter1/link1.12a_maher.html

Maidabino, A. A. (2010). The Availability, Organization, and Use of Archival Records: A Study of Public Archives Agencies in the Northwestern States of Nigeria. *Library Philosophy and Practice*. Retrieved August 16, 2017 from: http://www.webpages.uidaho.edu/~mbolin/maidabino2.htm

Maina, D. M. (2011). *Role of records and archives management standards in enhancing the quality of records*. Retrieved 2 November, 2016, from: https://www.academia.edu/23730467/ROLE_OF_RECORDS_AND_ARCHIVES_MANAGEMENT_STANDARDS_IN_ENHANCING_THE_QUALITY_OF_RECORDS

Mairesse, F. (2010). The term museum. In A. Davis, F. Mairesse, & A. Desvallées (Eds.), *What is a museum?* (pp. 19–58). Munich: ICOM ICOFOM.

Makerere University Library. (n.d.). *Makerere University Mission*. Retrieved July 9, 2017, from http://www.mak.ac.ug/university-services/university-library

Makhura, M. M. (2001). *The role of electronic records management in a service organization* (Unpublished Masters Dissertation). Rand Afrikaans University, South Africa.

Makochekanwa, A. (2009). *Clothed in Rags by Hyperinflation: The Case of Zimbabwe. Munich Personal RePEc Archive (MPRA) (28863)*. Pretoria: University of Pretoria.

Malden, S. (2005, October). *Issues in cataloguing of visual material*. Paper presented at the FIAT/IASA Southern African Workshop on Film, Video and Sound Archives, SABC, Johannesburg, South Africa.

Maletsky, C. (2006). Computer theft paralyses Omaruru. *The Namibian*. Retrieved August 3, 2008, from http://www.namibian.com.na/2006/November/national/065A605530.html

Malherbe, C. (2006). Making the intangible, tangible: The policy pen put to paper. *SAMAB*, *32*, 75–79.

Malkmus, D. J. (2008). Documentation Strategy: Mastodon or Retro-Success? *The American Archivist*, *71*(2), 384–409. doi:10.17723/aarc.71.2.v63t471576057107

Maloney, S. K., Bronner, G. N., & Buffenstein, R. (1999). Thermoregulation in the Angolan free-tailed bat Mops condylurus: A small mammal that uses hot roosts. *Physiological and Biochemical Zoology*, *72*(4), 385–396. doi:10.1086/316677 PMID:10438676

Mampe, G., & Kalusopa, T. (2012). Records Management and service delivery: Case of Department of Corporate Services in Ministry of Health in Botswana. *Journal of the South Africa Society of Archivists*, *45*, 1–23.

Mancini, F., & Carreras, C. (2010). Techno-society at the service of memory institutions: Web 2.0 in museums. *Catalan Journal of Communication & Cultural Studies*, *2*(1), 59–76. doi:10.1386/cjcs.2.1.59_1

Manetsi, T. (2006). Safeguarding intangible cultural heritage: Towards drafting a policy for the sustainable management and conservation of living heritage. *SAMAB*, *32*, 80–84.

Maphorisa, O. M., & Jain, P. (2013). Applicability of the Gaps Model of Service Quality inMarketing of Information Services at Botswana National Archives and Records Services. *Zambia Library Association Journal*, *28*(1&2), 45–55.

Mapiye, T. (2015). *The management of audio visual materials in Namibia: A comparative study of the national archives of Namibia and media organisations* (Unpublished undergraduate research report). University of Namibia, Windhoek, Namibia.

Mapiye, T. (2015). *The management of audio-visual archives in Namibia: A comparative study of National Archives of Namibia and Media Organisations* (Unpublished undergraduate research report). University of Namibia.

Marketing Dictionary. (2008). *Personal selling*. Retrieved February 19, 2008 from: http://www.answers.com/topic/personal-selling?cat=biz-fin

Marsh, M., Deserno, I., & Kynaston, D. (2005, March). Records Managers in the Global Business Environment. *The Information Management Journal*, 30-36.

Marti, J. (2016). Measuring in action research: Four ways of integrating quantitative methods in participatory dynamics. *Action Research*, *14*(2), 168–183. doi:10.1177/1476750315590883

Marutha, N. S., & Ngulube, P. (2012). Electronic records management in the public health sector of the Limpopo province in South Africa. *Journal of the South African Society of Archivists*, *45*, 39–67.

Mason, M. K. (2007). *Outreach Programs: Can They Really Help to Garner Support for and Increase Use of Archives?* Retrieved September 4, 2007 from: http://www.moyak.com/researcher/resume/papers/arch4mkm.html

Massis, B. E. (2011). Information literacy instruction in the library: Now more than ever. *New Library World*, *112*(5/6), 274–277. doi:10.1108/03074801111136301

Masunungure, E. (2006a). *Why Zimbabweans do not rebel. Part 1*. Retrieved 13 March 2017 from: //www.zimonline. co.za/Article.aspx?ArticleId=192

Matangira, V. (2016). *Records and archives management in postcolonial Zimbabwe's Public Service* (PhD dissertation). University of Namibia.

Matangira, V. (2003). Audiovisual archiving in the third world – problems and perspectives: An analysis of audiovisual archiving in the East And Southern African Regional Branch of the International Council on Archives (ESARBICA) Region. *ESARBICA Journal: Journal of the Eastern and Southern Africa Regional Branch of the International Council on Archives, 22*, 43–49.

Matangira, V. (2003). Audiovisual archiving in the third world; problems and perspectives: An analysis of audiovisual archiving in the East and Southern African Region Branch of the International Council on Archives (ESARBICA). *ESARBICA Journal, 22*, 43–49.

Matangira, V., Katjiveri-Tjiuoro, M., & Lukileni, H. (2013). Establishing a university records management programme: A case study of the University of Namibia. *Journal for Studies in Humanities and Social Sciences, 2*(2), 103–117. Retrieved from http://repository.unam.edu.na/bitstream/handle/11070/1402/Matangira_establishing_2013.pdf?sequence=1

Matson, W. (2012). *Grand theories and everyday beliefs: Science, philosophy, and their histories*. Oxford, UK: Oxford University Press.

Matunhu, J. (2011). A critique of modernization and dependency theories in Africa: Critical assessment. *African Journal of History and Culture, 3*(5), 65–72.

Matwale, G. M. (1995). A Review of Problems Related to the Establishment of Effective Conservation Programmes for Library and Archives Materials in Kenya. In *Proceedings of the Pan-African Conference on the Preservation and Conservation of Library and Archival Materials*. The Hague: IFLA.

Maxwell, J. A. (2012). Foreword. In S. M. Ravitch & M. Riggan (Eds.), *Reason and rigor: How conceptual frameworks guide research* (pp. xi–xii). Thousand Oaks, CA: Sage.

Maxwell, J. A. (2013). *Qualitative research design: An interactive approach* (3rd ed.). Thousand Oaks, CA: Sage.

May, T. (2001). *Social research: Issues, methods and process* (3rd ed.). Buckingham, UK: Open University Press.

Mazikana, P. (2007). *A missed opportunity: archival institutions and public sector reforms*. Paper presented at the XIX Bi-Annual East and Southern Africa Regional Branch of the International Council on Archives (ESARBICA) General Conference on "Empowering Society With Information: The Role of Archives and Records as Tools of Accountability", Tanzania.

Mazikana, P. C. (1995). An Evaluation of Preservation and Conservation Programmes and Facilities in Africa. In *Proceedings of the Pan-African Conference on the Preservation and Conservation of Library and Archival Materials*. The Hague: IFLA.

Mazikana, P. C. (1997/98). Africa: archives. In World Information Report, 144-154.

Mazikana, P. C. (1999). Access to records: Conditions and constrains. In *Proceedings of the 15th Biennial Conference of the East and southern African regional Branch of the International council on archives on archives and the protection of the people's rights*. Pretoria: National Archives of South Africa.

Mazikana, P. (2007, June). A missed opportunity: Archival institutions and public sector reforms. *Proceedings of the XIX Bi-Annual East and Southern Africa Regional Branch of the International Council on Archives General Conference*.

Mazikana, P. C. (1992). *Survey of Archival Situation in Africa*. Paris: UNESCO.

Mbakile, L. (2007). *An outline of records management initiatives from the Office of the President, Botswana*. Paper read at the XIX Bi-Annual ESARBICA conference, Dar es Salaam, Tanzania.

Mbaruk, H., & Otike, J. (n.d.). *Marketing information services in Africa: a case study of Zanzibar National Archives*. Retrieved August 4, 2017 from: https://www.academia.edu/10825917/Marketing_information_services_in_Africa_a_case_study_of_Zanzibar_National_Archives

Mbwilo, F. (2011). *The Management and Access to the Former East African Community Archives* (MARM Dissertation). University of Botswana.

McCausland, S. (1993). Access and Reference Services. In *Keeping Archives*. Port of Melbourne: The Australian Society of Archivists.

McCullum, H. (1998, January 22). Media's Role in Democracy development. *Times of Zambia*.

McDonald, G., Macdonald, C., & Ounis, I. (2014). Towards a Classifier for Digital Sensitivity Review. *Proceedings of 36th European Conference on Information Retrieval*. doi:10.1007/978-3-319-06028-6_48

McKemmish, S. (Eds.). (2005). *Archives: recordkeeping in society*. Wagga Wagga, Australia: Centre for Information Studies. doi:10.1533/9781780634166

McKemmish, S., Reed, B., & Piggott, M. (2005). The archives. In S. McKemmish, M. Piggott, B. Reed, & F. Upward (Eds.), *Archives: Recordkeeping in society*. Centre for Information Studies. doi:10.1016/B978-1-876938-84-0.50007-X

McLeod, J., & Hare, C. (2006). *How to manage records in the e-environment* (2nd ed.). London: Routledge.

McMullen, M. (2004, June). *IASA Cataloguing rules for audio-visual media cataloguing and documentation committee publication project: Final report on the minimum level of description of a sound recording for an entry in a catalogue or discography*. Retrieved from http://www.gov.unesco.org/webworld/ramp/html

McNamara, C. (2008). *Basic Definitions: Advertising, Marketing, Promotion, Public Relations and Publicity, and Sales*. Retrieved February 19, 2008 from: http://www.managementhelp.org/ad_prmot/defntion.htm

McNiff, J. (2013). *Action research: Principles and practice* (3rd ed.). London: Routledge.

McNiff, J. (2014). *Writing and doing action research*. Thousand Oaks, CA: Sage.

Mdanda, S. (2014). Social cohesion versus coercion: How Freedom Park seeks to unite South Africans through inclusive nationalism. *SAMAB*, *35*, 8–12.

Mdlalose, N. (2014). Storytelling at Freedom park://Hapo Interactive Space. *SAMAB*, *35*, 13–16.

Mdluli, M. (2016). *Ghost employees caused by poor records keeping*. Retrieved 7 August, 2017, from: http://www.pressreader.com/swaziland/swazi-observer/20160121/281775628168432

Meliva, T. (2013). *A Post-Soviet problem: The management of conservation*. Retrieved September 29, 2013, from: http://forum2013.iccrom.org/post-soviet-problem-management-conservation/

Merle, A., & Youjun, P. (2006). Peking between modernization and preservation. *China Perspectives*, *45*, 1–7.

Merriman, N. (2004). *Museums and Sustainability: Published thesis: Clore Leadership fellow*. Retrieved 13 June 2017 from https://www.museumsassociation.org

Mertens, D. M., Bazeley, P., Bowleg, L., Fielding, N., Maxwell, J., Molina-Azorín, J. F., & Niglas, K. (2016). Expanding thinking through a kaleidoscopic look into the future: Implications of the Mixed Methods International Research Association's Task Force Report on the Future of Mixed Methods. *Journal of Mixed Methods Research*, 1–7. doi:10.1177/1558689816649719

Merton, R. K. (1968). *Social theory and social structure*. New York: Free Press.

Meyer, A. (1995). From hunting grounds to digging fields: Observations on aspects of cultural heritage management in some national parks. *South African Journal of Ethnology, 18*(4), 159–163.

Michelson, A., & Rothenberg, J. (1992, Spring). Scholarly Communication and Information Technology: Exploring the Impact of Changes in the Research Process on Archives. *The American Archivist, 55,* 236–315. doi:10.17723/aarc.55.2.52274215u65j75pg

Microsoft. (2008). *Elements of a Records Management System*. Retrieved 20 September, 2016, from: http://technet.microsoft.com/en-us/library/cc261982.aspx

Miles, M. B. A., & Huberman, M. (2014). *Qualitative Data Analysis: a methods sourcebook* (3rd ed.). Sage Publications.

Miles, M. B., & Huberman, A. M. (1994). *Qualitative data analysis: An expanded sourcebook of new methods* (2nd ed.). London: Sage.

Miliano, M. (2004). *IASA cataloguing rules for audio-visual media cataloguing and documentation committee publication project*. Retrieved from http://www.unesco.org/webworld/ramp/html

Millar, P. (2012). *Fighting for the front page: The challenges of environmental reporting in Malawi: Field notes.* Journalists for Human Rights. Retrieved 17 January 2015 from: http://www.jhr.ca/blog/2012/05/fighting-for-the-front-page-thechallenges-of-environmental-reporting-in-malawi/

Millar, L., & Roper, M. (1999). *Managing public sector records: Preserving records*. London: International Records Management Trust.

Miller, L. (2017). *Archives principles and practices* (2nd ed.). London: Facet Publishing.

Millett, R. A. (2015). Evaluation and social equity functioning in museums. *Visitor Studies, 18*(1), 3–16. doi:10.1080/10645578.2015.1016331

Mnjama, N. (1996a). National archives and the challenges of managing the entire life-cycle of records. *S. A. Archives Journal, 38,* 24–32.

Mnjama, N. (1996b). Establishing a records management programme: Some practical considerations. *ESARBICA Journal, 15,* 29–37.

Mnjama, N. (2005). Archival landscape in Eastern and Southern Africa. *Library Management, 26*(8/9), 457–470. doi:10.1108/01435120510631747

Mnjama, N. (2008). The Orentlicher Principles on the Preservation and Access to Archives Bearing Witness to Human Rights Violations. *Information Development, 24*(3), 213–225.

Mnjama, N. (2010). Preservation and management of audiovisual archives in Botswana. *African Journal of Library Archives and Information Science, 10*(2), 139–148.

Mnjama, N. (2010). Preservation and management of audio-visual archives in Botswana. *African Journal of Library Archives and Information Science, 20,* 139–148.

Mnjama, N. (2010). Preservation and management of audiovisual. *African Journal of Library Archives and Information Science, 20*(2), 139–148.

Mnjama, N. M. (2003). Records Management and Freedom of Information: A Marriage Partnership. *Information Development, 19*(3), 183–188. doi:10.1177/0266666903193006

Moalafi, J. M. (2010). *Utilization of Archival Information Resources at Botswana National Archives and Records Services* (Degree of Master of Archives and Records Management Thesis). University of Botswana.

Mokoena, L. (2002). South Africa oral history projects: Copyright and other legal implications. *ESARBICA Journal, 21*, 87–90.

Molapisi, M. (2005). The past or living heritage: The struggle between museums and local communities in South Africa. *SAMAB, 31*, 43–45.

Molapisi, R. M. J. (2006). From farms to peri-urban; Anthropological insight into the life histories and socio-economic changes amongst amaXhosa of Kuyasa township area (Colesberg) in the Northern Cape Province. *SAMAB, 32*, 65–68.

Molina-Azorín, J. F. (2011). The use and added value of mixed methods in management research. *Journal of Mixed Methods Research, 5*(1), 7–24. doi:10.1177/1558689810384490

Molina-Azorín, J. F., López-Gamero, M. D., Pereira-Moliner, J., & Pertusa-Ortega, E. M. (2012). Mixed methods studies in entrepreneurship research: Applications and contributions. *Entrepreneurship and Regional Development, 24*(5-6), 425–456. doi:10.1080/08985626.2011.603363

Moloi, J., & Mutula, S. (2007). E-records management in an e-government setting in Botswana. *Information Development, 23*(4), 290–306. doi:10.1177/0266666907084765

Moodley, S. (2006). Rock art and national identity: A museum perspective. *SAMAB, 32*, 85–87.

Morris, D. (2006). Interpreting Driekopeiland: The tangible and the intangible in a Northern Cape rock art site. *SAMAB, 32*, 40–45.

Morris, D. (2014). Biesje Poort Rock engraving site: A case study on issues in conservation, research and outreach in the southern Kalahari. *SAMAB, 35*, 17–23.

Morse, D. (Ed.). (1978). *Handbook of forensic archaeology and anthropology.* Tallahassee, TN: Rose Printing Company.

Mosser, F. (1994). Monuments historiques et tourisme culturel. *Les Cahiers d'Espaces, 37*(24), 23–27.

Mossetto, G. (1992). *Culture and environmental waste.* Working paper, University of Venice.

Mossetto, G. (1993). *Aesthetics and economics.* Boston: Kluwer. doi:10.1007/978-94-015-8236-0

Mossetto, G., & Vecco, M. (2001). *Economia del patrimonio monumentale.* Milan: Franco Angeli.

Moss, M. (2005). The Hutton Inquiry, the President of Nigeria and What the Butler Hoped to See. *The English Historical Review, 120*, 487. 577-592

Mosweu, O. (2011). Performance audit in Botswana public service and arising records management issues. *Journal of the South African Society of Archivists, 44*, 107–115.

Moukhar, M. M., & Shuhana, S. (2008). Ethnic special identity in the context of urbanization: The transformation of Gbagyi compounds in North Central Nigeria. *Journal of Urbanism, 1*(3), 265–280. doi:10.1080/17549170802532096

Moyo, C. (2012). Access to Archives at the National Archives of Zimbabwe Over the years. In P. Ngulube (Ed.), *National Archives 75@30: 75 Years of Archiving Excellence at the National Archives of Zimbabwe* (pp. 78–86). Harare: National Archives of Zimbabwe.

Moyo, L. M. (1996). Introduction of archives and records management programmes at the University of Botswana. *ESARBICA Journal, 15*, 39–51. PMID:10153766

Murambiwa, I. M., & Ngulube, P. (2011). Measuring access to public archives and developing an access index: Experiences of the national archives of Zimbabwe. *ESARBICA Journal, 30*, 83–101.

Murray, K. (2002). *Preservation Education and Training for South African Library and Archive Professionals and Students (MBibl).* Cape Town: University of Cape Town.

Musembi, M. (1986). Development of archival services in East Africa. In Kukubo, R. (ed.) *Proceedings of 9th biennial general conference East and Southern African Regional Branch of the International Council on Archives.* Roma: University Press of Lesotho.

Musoke, M. G. N., Kakai, M., & Akiteng, F. (Eds.). (2005). Library automation in East and Southern African Universities: In Proceedings of a Sub-regional Conference. Makerere University.

Musoke, M. G. N. (2008). Strategies for addressing the university library users' changing needs and practices in Sub-Saharan Africa. *Journal of Academic Librarianship, 34*(6), 532–538. doi:10.1016/j.acalib.2008.10.002

Musoke, M. G. N., & Kinengyere, A. A. (2008). Changing strategies to enhance the usage of electronic resources among the academic community in Uganda with particular reference to Makerere University. In D. Rosenberg (Ed.), *Evaluating electronic resource programmes and provision: Case studies from Africa and Asia. INASP Research and Education Case Studies No 3.* Oxford, UK: INASP.

Musoke, M. G. N., & Namugera, L. (2013). *The End Justified the Means: Building Makerere University Library Extension with a Low Budget.* Kampala: Makerere University.

Mutiti, N. (2001). The challenges of managing electronic records in the ESARBICA region. *ESARBICA Journal, 20*(3), 57–61.

Mutsagondo, S., & Chaterera, F. (2016). Mirroring the National Archives of Zimbabwe Act in the context of electronic records: Lessons for ESARBICA member states. *Information Development, 32*(3), 254–259. doi:10.1177/0266666914538272

Mwangwera, M. (2003, April). *Report on Audio-visual archives in Malawi.* Paper presented at the FIAT/IFTA workshop, Lusaka. Retrieved from http://www.Fiatifta.org/aboutfiat/ members/archive/Malawi_nat_arch.html

Nakale, A. (2016). *An investigation of preservation and conservation of archival materials at the National Archives of Namibia* (Unpublished undergraduate research report). University of Namibia.

Nakiganda, M. (2009). Preserving the past and creating the future: A case for Makerere University, Uganda. In *Proceedings of the 75th IFLA General Conference and Council.* Milan, Italy: IFLA.

Namaganda, A. (2011). *Digitization of Uganda's music cultural heritage: lessons from Makerere University Library Digital Archive.* Paper presented at the 2nd International Conference on African Digital Libraries and Archives (ICADLA-2), University of Witwatersrand, Johannesburg, South Africa.

Namibia Resource Consultants. (2002). *An assessment of the function of the National Archives of Namibia and the way forward: Final report.* Windhoek, Namibia: Author.

Namibian Broadcasting Corporation (NBC). (2016). *Access to information bill consultations underway.* Retrieved August 4, 2017, from https://www.namibian.com.na/151572/archive-read/Access-to-Information-Bill-consultations-underway

NAMPA. (2014). *Alleged Outjo fraudster Koen going on trial on Monday.* Retrieved from January 14, 2017, from http://www.lelamobile.com.content/19890/Alleged-Outjo-raudster-Koen-going-on-trial-on-Monday/

National Archives (UK). (2005). *Digital Preservation.* Retrieved October 7, 2016, from http://www.digitalpreservation/UK/theNationalArchivesServicesforprofessionalsPreservationDigitalpreservation.htm

National Archives and Records Service of South Africa (NARSSA). (2006). *Records Management Policy Manual.* Pretoria, South Africa: NARSSA.

National Archives and Records Services of Botswana. 1978, as amended 2007. (n.d.). Retrieved from http://en.wikipedia.org/wiki/National_Archives_and_Records_Administration

National Archives and Records Services of South Africa. (2016). Retrieved from http://www.nationalgovernment.co.za/units/view/123/Social-Services/National-Archives-and-Records-Service-of-South-Africa-NARSSA

National Archives and Resource Services (NARS). (2007). Retrieved from http://www.national.archives.gov.za

National Archives of Australia. (n.d.). *Digital records.* Retrieved January 26, 2007, from http://www.naa.gov.au/record-keeping/er/summary.html

National Archives of Malaysia. (2011). *Electronic Records Management Systems - System Specifications for Public Offices.* Retrieved 2 November, 2016, from: http://www.arkib.gov.my/documents/10157/b10c4054-a5b9-4bc4-9173-1eaefe551cab

National Archives of U.K. (2014). *The Technical Registry PRONOM.* Retrieved April 23, 2017, from http://www.nationalarchives.gov.uk/PRONOM/

National Archives of UK. (2004). *Appraisal Policy background paper – the 'Grigg System' and beyond.* Retrieved 27 September, 2017, from: http://www.nationalarchives.gov.uk/documents/information-management/background_appraisal.pdf

National Archives of UK. (2013). *Best practice guide to appraising and selecting records for The National Archives.* Retrieved 27 September, 2017, from: http://www.nationalarchives.gov.uk/documents/information-management/best-practice-guide-appraising-and-selecting.pdf

National Archives UK. (2011). *Web Archiving Guidance.* Retrieved from: https://nationalarchives.gov.uk/documents/information-management/web-archivingguidance.pdf

National Archives. (2017). *Research guide to migration.* Retrieved 18 September 2017 from, http://www.nationalarchives.gov.uk/help-with-your-research/research-guides/?research-category=social-and-cultural-history&sub-category%5B%5D=migration

National Archives. (n.d.). *Archives code.* Windhoek, Namibia: Author.

National Digital Information Infrastructure and Preservation programme (NDIIPP). (2005). NDIIPP holds three workshops for states, territories at library. *Library of Congress Information Bull, 64*(9), 1-2.

National Film & Sound Archive of Australia. (n.d.). Retrieved from https://www.nfsa.gov.au/

National Film and Sound Archive. (2016). *Preservation.* Retrieved from http://www.nfsa.afc.gov.au/Screensound/Screenso.nsf/

National Institute of Standards and Technology (NIST). (2011). *NIST definition of cloud computing.* Retrieved September 20, 2016, from http//csrc.nist.gov/publications/nistpubs/800-145/SP800-145.pdf

National Library and Information Act 4 of 2000. (n.d.). Retrieved from http://www.lac.org.na/laws/annoNAM/LIBRAR-IES%20(2000)%20-%20Namibia%20Library%20and%20Information%20Service%20Act%204%20of%202000%20 (annotated).pdf

National Monuments Council. (1983). *Aanbevole riglyne vir restourasie van strukture en terreine in Suid-Afrika. Arcadia* National Monuments Council.

National Park Service. (2005). *National Park Service Checklist for Preservation and Protection of Museum Collections, Museum hand book, part I*. Retrieved September 18, 2013, from: http://www.cr.nps.gov/museum/publications/MHI/AppendF.pdf

National Planning Commission. (2000). *Government of the Republic of Namibia Second National Development Plan (NDP2) 2001/2002 – 2005/2006: Volume one: Macroeconomic, sectoral and cross-cultural policies*. Windhoek, Namibia: Author.

National Records and Archives of Malawi (n.d.). *Personal file of Norman J. Carr. Reference Appt, 4031 (original Secretariat reference 1064)*. Zomba: Records Centre.

National Research Council. (1986). *Preservation of historical records*. Washington, DC: The National Academies Press.

Ndoro, W. (2001). Heritage Management in Africa. *The Getty Conservation Institute Newsletter, 16*(3). Retrieved April 21, 2014, from http://www.getty.edu/conservation/publications_resources/newsletters/16_3/news_in_cons1.html

Nengomasha, C. T. (2004). *Report on a Records Survey Conducted in National Planning Commission* (Unpublished). Windhoek, Namibia: University of Namibia.

Nengomasha, C. T. (2009). *A study on the management of electronic records in the public service of Namibia in context of e-government* (Unpublished doctoral dissertation). University of Namibia.

Nengomasha, C. T., & Beukes-Amiss, C. M. (2002). *Ministry of Health and Social Services: Records Management Survey Reports No. 1 and 2* (Unpublished). Windhoek, Namibia: University of Namibia.

Nengomasha, C. T., & Chiware, E. (2009). *Report on the tracer study of the Department of Information and Communication Studies 2000-2007*. Windhoek: University of Namibia.

Nengomasha, C. T., & Nyanga, E. H. (2012). Managing semi-current records: A case for records centres for the public service of Namibia. *Journal for Studies in Humanities and Social Sciences, 1*(2), 231–245.

Nesmith, T. (2010). Archivists and public affairs Towards a New Archival Public Programming. In *Better off forgetting? Essays on archives, public policy, and collective memory*. Toronto: University of Toronto Press. Retrieved August 5, 2017 from: https://books.google.co.bw/books?id=ORihHjTvyrcC&pg=PA169&lpg=PA169&dq=Nesmith:+Archivists+and+Public+Affairs&source=bl&ots=BiaeP2wQRf&sig=0r2Ix7NBBv861wpo6W8nut5INeE&hl=en&sa=X&ved=0ahUKEwiu3t7Hp8DVAhUlCsAKHTxIDBAQ6AEIOTAE#v=onepage&q=Nesmith%3A%20Archivists%20and%20Public%20Affairs&f=false

Newsday. (2011). *Intangible Cultural Heritage under threat*. Retrieved 24 November 2016 from: http://www.newsday.co.zw/2011/03/21/21-03-21-intangible-cultural- heritage-under- threat/

Newton, J. (2006). Action research. In V. Jupp (Ed.), *The Sage dictionary of social research methods* (pp. 2–3). London: Sage.

Ngoepe, M. S. (2008). *An exploration of records management trends in the South African Public Sector: a case study of the Department of Provincial and Local Government*. Retrieved 30 August, 2017, from: http://uir.unisa.ac.za/handle/10500/2705

Ngoepe, M. & Saurombe. (. (2016). Provisions for managing and preserving records crated in networked environments in the archival legislative frameworks of selected member states in SADC. *Archives and Manuscripts*, *44*(1), 24–41. do i:10.1080/01576895.2015.1136225

Ngoepe, M. (2017). *Archival orthodoxy of post-custodial realities for digital records in South Africa.* Archives and Manuscripts; doi:10.1080/01576895.2016.1277361

Ngoepe, M. S. (2014). Records management models in the public sector in South Africa: Is there a flicker of light at the end of the dark tunnel? *Information Development*, 1–16.

Ngoepe, M., & Keakopa, S. M. (2011). An Assessment of the State of National Archival and Records Systems in the ESARBICA region: A South Africa-Botswana Comparison. *Records Management Journal*, *21*(2), 145–160. doi:10.1108/09565691111152071

Ngoepe, M., & Makhubela, S. (2015). Justice delayed is justice denied: Records management and the travesty of justice in South Africa. *Records Management Journal*, *25*(3), 288–305. doi:10.1108/RMJ-06-2015-0023

Ngoepe, M., & Ngulube, P. (2011). Assessing the extent to which the National Archives and Records Service of South Africa has fulfilled its mandate of taking the archives to the people. *Innovation: Journal of Appropriate Librarianship and Information Work in Southern Africa*, *42*, 3–22.

Ngulube, P. (2003). *Preservation and access to public records and archives in South Africa* (Ph. D. dissertation). University of Natal.

Ngulube, P. (2003). *Preservation and access to public records and archives in South Africa* (PhD thesis). Natal University.

Ngulube, P. (2003). *Preservation and Access to Public Records and archives in South Africa* (PhD Thesis). University of Kwa-Zulu Natal, Pietermaritzburg.

Ngulube, P. (2003). *Preservation and access to public records and archives in South Africa* (Unpublished doctoral dissertation). University of Natal, Durban.

Ngulube, P. (2015a). Qualitative data analysis and interpretation: Systematic search for meaning. In E. R. Mathipa & M. T. Gumbo (Eds.), Addressing research challenges: Making headway for developing researchers (pp. 131–156). Noordywk: Mosala-Masedi.

Ngulube, P., Mathipa, E. R., & Gumbo, M. T. (2015). Theoretical and conceptual framework in the social sciences. In E. R. Mathipa & M. T. Gumbo (Eds.), Addressing research challenges: Making headway for developing researchers (pp. 43–66). Noordwyk: Mosala-Masedi.

Ngulube, P., Mathipa, E. R., & Gumbo, M. T. (2015). Theoretical and conceptual framework in the social sciences. In E. R. Mathipa & M. T. Gumbo (Eds.), Addressing research challenges: Making headway for developing researchers (pp. 43-66). Noordywk: Mosala-MASEDI Publishers & Booksellers cc.

Ngulube, P. (2001). Archival appraisal and the future of historical research. *South African Historical Journal*, *45*(1), 249–265. doi:10.1080/02582470108671410

Ngulube, P. (2002). Preservation reformatting strategies in selected Sub Saharan African archival institutions. *African Journal of Library Archives and Information Science*, *12*(2), 117–132.

Ngulube, P. (2002). Preservation reformatting strategies in selected Sub-Saharan African archival institutions. *African Journal of Library and Information Science*, *12*(2), 117–132.

Ngulube, P. (2003). *Preservation and Access to Public Records in South Africa (Unpublished Degree of Doctor of Philosophy).* University of Natal.

Ngulube, P. (2005). Environmental monitoring and control at national archives and libraries in Eastern and Southern Africa. *Libri, 55*(2-3), 154–168. doi:10.1515/LIBR.2005.154

Ngulube, P. (2006). Nature and Accessibility of Public Archives in the Custody of Selected National Archival Institutions in Africa. *ESARBICA Journal, 25*, 142.

Ngulube, P. (2007). Preserving South Africa's paper trail and making public records available for present and future generations. *ESARBICA Journal, 26*, 35–50.

Ngulube, P. (2009). *Preservation and access to public records and archives in South Africa.* Saarbrücken: Lambert Academic Publishing.

Ngulube, P. (2015b). Trends in research methodological procedures used in knowledge management studies. *African Journal of Library Archives and Information Science, 25*(2), 125–143.

Ngulube, P., Modisane, C. K., & Mkeni-Saurombe, N. (2011). Disaster preparedness and the strategic management of public records in South Africa: Guarding against collective cultural amnesia. *Information Development, 27*(4), 239–250. doi:10.1177/0266666911417641

Ngulube, P., & Ngulube, B. (2017). Application and contribution of hermeneutic and eidetic phenomenology to indigenous knowledge systems research. In P. Ngulube (Ed.), *Handbook of research on theoretical perspectives on indigenous knowledge systems in developing countries* (pp. 128–150). Hershey, PA: IGI Global. doi:10.4018/978-1-5225-0833-5.ch006

Ngulube, P., Sibanda, P., & Makoni, N. L. S. (2013). Mapping Access and use of Archival Materials held at the Bulawayo Archives in Zimbabwe. *ESARBICA Journal, 32*, 123–137.

Ngulube, P., & Tafor, V. F. (2006). The Management of Public Records and Archives in the Member Countries of ESARBICA. *Journal of the Society of Archivists, 27*(1), 1, 57–83. doi:10.1080/00039810600691288

Nicholas, J. (1998). *Marketing and Promotion of Library Services.* Retrieved September 19, 2017 from: https://www.scribd.com/document/165083194/Marketing-and-Promotion-of-Library-Services

Nienaber, W. C. (1997). Exhumation and reinternment of Burger C. G. Naude. *South African Journal of Cultural History, 11*(1), 123–133.

Nienaber, W. C., & Steyn, M. (1999). Exhumation and analysis of the remains of a black native participant in the Anglo-Boer War (1899-1902), KwaZulu-Natal. *South African Journal of Cultural History, 13*(2), 94–110.

Nieswiadomy, R. M. (2012). *Foundations of nursing research* (6th ed.). Boston: Pearson Education.

Nightingale, E., & Sandell, R. (2012). Introduction. In Museums, equality and social justice (pp. 1-9). London: Routledge.

Noffke, S., & Somekh, B. (2009). *The Sage handbook of educational action research.* London: Sage. doi:10.4135/9780857021021

Noko, P., & Ngulube, P. (2013). A vital feedback loop in educating and training archival professionals: A tracer study of records and archives management graduates in Zimbabwe. *Information Development, 31*(3), 270–283. doi:10.1177/0266666913510308

Northeast Document Conservation Center. (2012). *The Environment; monitoring temperature and relative humidity.* Retrieved December 9, 2013, from: www.nedcc.org/

Nsibirwa, Z., & Hoskins, R. (2008). The future of the past: Preservation of, and access to, legal deposit materials at the Msunduzi Municipal Library, Pietermaritzburg. *ESARBICA Journal, 27,* 88–116.

Nungu, N. (2006). Conservation of storytelling. *SAMAB, 32,* 53–59.

Nwaolikpe, O. N. (2013). Culture and Nigerian Identity in Print Media. *Arabian Journal of Business and Management Review, 3*(3).

Nwegbu, M. U., Eze, C. C., & Asongwa, B. E. (2011). Globalization of cultural heritage. Issues, impacts and inevitable challenges for Nigeria. *Library Philosophy and Practice, 13,* 166–181.

Nyangila, J. M. (2006). *Museums and community involvement: A case study of community collaborative initiatives - National Museums of Kenya.* INTERCOM Conference paper.

Nytagodien, R. L. (2014). Reflection on the politics of memory, Race and confrontation at the McGregor Museum. *SAMAB, 35,* 1–7.

Oakleaf, M. (2010). *Value of academic libraries: A comprehensive research review and report.* Chicago: Association of College and Research Libraries. Retrieved March 23, 2017, from www.acrl.ala.org/value

Ocholla, D. N., & Le Roux, J. (2011). Conceptions and misconceptions of theoretical frameworks in library and information science research: A case study of selected theses and dissertations from eastern and southern African universities. *Mousaion, 29*(2), 61–74.

OCLC/RLG. (2002). *Preservation Metadata Working Group.* Retrieved April 23, 2017, from http://www.oclc.org/research/pmwg/

Odinye, I., & Odinye, I. (2012). Western influence on Chinese and Nigerian cultures. *Ogirisi: A New. Journal of African Studies, 9,* 108–115.

Oestreicher, C. (2013). *Archival Advocacy> SAA Sampler.* Retrieved August 16, 2017 from: http://files.archivists.org/pubs/SamplerSeries/ArchivalAdvocacySampler.pdf

Office of the President. (2004). *Namibia Vision 2030.* Windhoek, Namibia: Author.

Office of the Prime Minister. (2005a). Discussion document on the activities of the [E-Laws] Working Group for the Seminar/Workshop for Development of E-laws (Electronic or Cyber Laws for Namibia). Windhoek, Namibia: Author.

Office of the Prime Minister. (2005b). *Use of Electronic Communications and Transactions Draft Bill.* Windhoek, Namibia: Author.

Ojo-Igbinoba, M. E. (1993). *The practice of conservation of library materials in Sub-Saharan Africa.* African Studies Programme.

Okello-Obura, C. (2011). Records and archives legal and policy frameworks in Uganda. *Library Philosophy and Practice, 608.* Retrieved March 14, 2017, from http://digitalcommons.unl.edu/libphilprac/608

Okello-Obura, C., & Kigongo-Bukenya, I. M. N. (2011). Library and information science education and training in Uganda: Trends, challenges, and the way forward. *Education Research International, 2011,* 1–9. doi:10.1155/2011/705372

Ola, C. O. (2015). Cultural heritage collections, preservation and access: Case of the University of Ibadan. *The African Symposium: An Online Journal of the African Educational Research Network, 15*(2), 50-55.

Oladunjoye, T. (2004, April 18). Cannes film festival knocks: where is Nigeria? *The Guardian Newspaper*, pp. 35-36.

Olatokun, W.M. (2008). A survey of preservation and conservation practices and techniques in Nigerian University Libraries. *LIBRES Library and Information Science Research Electronic Journal, 18*(2), 1-18.

Old Clarkonian Association website. (n.d.). Retrieved 19 September 2017 from http://www.clarkscollege.co.uk/

Oluwagbemiga, P. A., & Modi, S. Z. (2014). Development of traditional architecture in Nigeria: A case study of Hausa house form. *International Journal of African Society Cultures and Traditions, 1*(1), 61–74.

Onabajo, F. (2005). Promoting indigenous culture and community life in Nigeria through mass media. *Stud Tribes Tribals 3*(2), 92-98.

Onyima, B. N. (2016). Nigerian cultural heritage: preservation, challenge and prospects. *Ogirisi: A New. Journal of African Studies, 12,* 273–292.

Open Government Partnership. (n.d.). *About OGP.* Retrieved 1 August 2017 from https://www.opengovpartnership.org/about/about-ogp

Osasona, C. O. (2012). Transformed culture, transforming builtspace: Experience from Nigeria. *International Journal of Sustainable Development and Planning, 7*(1), 69–100. doi:10.2495/SDP-V7-N1-69-100

Ottong, E. J., & Ottong, U. J. (2013). Disaster management of library materials in federal universities in Cross River and Akwa Ibom States, Nigeria. *International Journal of Educational Research and Development, 2*(4), 98–104.

Otu, O. B., & Asante, E. (2015). Awareness and use of the national archives: Evidence from the Volta and Eastern regional archives. *Brazilian Journal of Information Studies: Research Trends, 9*(2), 21–25.

Oweru, P. J., & Mnjama, N. (2014). Archival preservation practices at the Records and Archives Management Department in Tanzania. *Mousaion, 32*(3), 136–165.

Palmer, J., & Stevenson, J. (2011). Something worth Still Sitting For? Some Implication of Web.2.0 for Outreach. In *A Different Kind of WEB: New Connections Between Archives and Users* (pp. 1–19). Chicago: Society of American Archivits.

Parfit, D. (1984). *Reasons and Persons.* Oxford, UK: Claredon Press.

Park, E. G. (2005). *Understanding "Authenticity" in Records Management: A Survey of Practitioners and Users.* Retrieved 28 August, 2017, from: http://www.interpares.org/display_file.cfm?doc=ip1_dissemination_jar_park_jksarm_3-1_2005.pdf

Park, P. (1997). Participatory research, democracy, and community. *Practical Anthropology, 19*(3), 8–13. doi:10.17730/praa.19.3.272k84p84u6801g4

Parsons, T., & Shils, E. A. (1962). *Toward a general theory of action.* New York: Harper and Row.

Passenger Lists. (n.d.). Retrieved March 2013 from http://www.findmypast.co.uk/

Paton, C. A. (1999). Preservation re-recording of audio-visual recordings in archives: problems, priorities, technologies and recommendations. *American Archivists,* (61), 188-219.

Pawson, R. (2000). Middle-range realism. *Archives Européennes de Sociologie, 41*(2), 283–325. doi:10.1017/S0003975600007050

Peace-Moses, R. (2005). *A Glossary of Archival and Records Terminology.* Retrieved September 4, 2007 from: http://www.archivists.org/glossary/list.asp

Peacock, A. (1991). Economics, cultural values and cultural policies. *Journal of Cultural Economics, 15*(2), 1–18. doi:10.1007/BF00208443

Peacock, A. (1994). A future for the past: The political economy of heritage. Lecture at the British Academy, 27th October 1994. *Proceedings of the British Academy, 87,* 189–243.

Pearce-Moses, R. (2005). *A Glossary of Archival and Records Terminology.* Retrieved 27 January, 2017, from: http://files.archivists.org/pubs/free/SAA-Glossary-2005.pdf

Pederson, A, (1988). User Education and Public Relations. In *Keeping Archives.* Port of Melbourne: The Australian Society of Archivists.

Pederson, A., & Casterline, G. (1982). *Archives and Manuscripts: Public Programs.* Chicago: Society of American Archivists.

Peoples, C., & Maguire, M. (2015). *ARSC Guide to Audio Preservation: Recorded Sound at Risk.* Retrieved from http://www.clir.org/pubs/reports/pub164/pub164.pdf

Peters, D. (1996). Our environment ruined? Environmental control reconsidered as a strategy for conservation. *Journal of Conservation and Museum Studies, 1.* Retrieved January 12, 2014, from: http://www.jcms-journal.com/article/view/jcms.1962/2

Peters, D., & Pickover, M. (2001). DISA: Insights of an African model for digital library development. *D-Lib Magazine, 7*(11). doi:10.1045/november2001-peters

Petersen, T. (2006). Lessons for humanity. *SAMAB, 32,* 29–36.

Peterson, D. R. (2015). Introduction: Heritage management in colonial and contemporary Africa. In D.R. Peterson, K. Gavua, & C. Rassool (Eds.), The Politics of Heritage in Africa (pp. 1-36). New York: Cambridge University Press.

Piggott, M. (1988). The history of Australian record-keeping: A framework for research. *The Australian Library Journal, 47*(4), 343–354. doi:10.1080/00049670.1998.10755861

Pinion, C. F. (1997). Legal issues in AV archives: an introduction. In *Audio-visual archives: A practical appraisal* (pp. 55-60). Paris: UNESCO. Retrieved from http://unesdoc.unesco.org/images/0010/001096/109612eo.pdf

Pinniger, D. B., & Harmon, J. D. (1999). Pest management, prevention and control. In Care and Conservation of Natural History Collections. Oxford, UK: Butterwoth Heinemann.

Pinniger, D., & Winsor, P. (2004). *Integrated pest management: A guide for museums, libraries and archives.* Museums, Libraries and Archives Council.

Pitman, D. (2005). Are museum library collections a museum collection? *SAMAB, 31,* 22–24.

Plano Clark, V. L., Huddleston-Casas, C. A., Churchill, S. L., O'Neil Green, D., & Garrett, A. L. (2008). Mixed methods approaches in family science research. *Journal of Family Issues, 29*(11), 1543–1566. doi:10.1177/0192513X08318251

Powell, H., Mihalas, S., Onwuegbuzie, A., Suldo, S., & Daley, C. (2008). Mixed methods research in school psychology: A mixed methods investigation of trends in the literature. *Psychology in the Schools, 45*(4), 291–309. doi:10.1002/pits.20296

Procter, M., & Cook, M. (2000). *M, Manual of archival description* (3rd ed.). Aldershot, UK: Gower.

Prom, C. J. (2010). Optimum access? Processing in college and university archives. *The American Archivist, 73*(1), 146–174. doi:10.17723/aarc.73.1.519m6003k7110760

Provincial Heritage Resources Agency of Gauteng. (n.d.). *Report requirements for HIA reports.* Retrieved May 27, 2016, from http://theheritageportal.co.za/sites/default/files/Organisation%20Downloads/PHRA-G%20HIA%20Report%20requirements.pdf

Public Service Public Service Act (Act No. 13 of 1998). (n.d.). Government of Botswana. Retrieved on August, 16 2017 from http://www.gov.bw/globalassets/moe/acts/chapter-2601-public-service.pdf

Purcell, A. D. (2015). *Academic archives: Managing the next generation of college and university archives, records, and special collections*. Chicago, IL: American Library Association.

Puthelogo, T., & Abankwah, R. M. (2015). An analysis of the broadcasting migration process from analogue to digital format: A comparison of Botswana Television and Namibian Broadcasting Cooperation. *IASA Journal, 44*, 65–73.

Pwiti, G. (1997). Taking African cultural heritage management into the twenty-first century: Zimbabwe's masterplan for cultural heritage management. *African Archaeological Review, 14*(2), 81–83. doi:10.1007/BF02968367

Pyper, B. (2006). Memorialising Kippie: On representing the intangible in South Africa's jazz heritage. *SAMAB, 32*, 37–39.

Queensland State Archives. (2010). *Glossary of archival and recordkeeping terms.* Retrieved 27 August, 2016, from: http://www.archives.qld.gov.au/Recordkeeping/GRKDownloads/Documents/GlossaryOfArchivalRKTerms.pdf

Ramokate, K. (2006). Preserving the African memory: Critical challenges for ESARBICA archival organisations. *ESARBICA Journal, 25*, 84–94.

Ramokate, K. (2006). Preserving the African memory: Critical challenges for ESARBICA organisations. *ESARBICA Journal, 25*, 84–93.

Ramokate, K., & Moatlhodi, T. (2010). Battling the appraisal backlog: A challenging professional obligation for BNARS. *ESARBICA Journal, 39*, 67–86.

Ravitch, S. M., & Riggan, M. (2012). *Reason and rigor: How conceptual frameworks guide research.* Thousand Oaks, CA: Sage.

Reason, P. (2006). Choice and quality in action research practice. *Journal of Management Inquiry, 15*(2), 187–203. doi:10.1177/1056492606288074

Reason, P., & Bradbury, H. (2001). Introduction: Inquiry and participation in search of a world worthy of human aspiration. In P. Reason & H. Bradbury (Eds.), *Handbook of action research* (pp. 1–14). London: Sage. doi:10.1016/B978-075065398-5/50002-9

Reason, P., & Bradbury, H. (2008). Introduction. In P. Reason & H. Bradbury (Eds.), *The SAGE handbook of action research: Participatory inquiry and practice* (2nd ed.; pp. 1–14). London: Sage. doi:10.4135/9781848607934

Reed, B. (2005). Records. In *Archives: recordkeeping in society.* Wagga Wagga: Centre for Information Studies, Charles Sturt University. doi:10.1016/B978-1-876938-84-0.50005-6

Reed, B. (2009). *Archival Appraisal and Acquisition. In Encyclopedia of Library and Information Sciences* (3rd ed.). New York: Taylor and Francis.

Regan, E. A., & O'Connor, B. N. (2002). *End User Information Systems: Implementing Individual and Work Group Technologies.* Upper Saddle River, NJ: Prentice Hall.

Reliable Prosperity (2014). *Cultural Preservation.* London: The Project of Ecotrust.

Renfrew, C., & Bahn, P. (1991). *Archaeology. Theories, methods and practice.* London: Thames & Hudson.

Republic of South Africa, Department of Arts Culture Science and Technology. (1996). *White Paper on Arts, Culture and Heritage. All our legacies, all our futures.* Retrieved on 3 September 2009 from www.dac.gov.za/content/white-paper-arts-culture-and-heritage-0

Republic of South Africa. (1976). *National parks act (Act No. 57 of 1976)*. Pretoria: The Government Printer.

Republic of South Africa. (1980). *Ordinance on excavations (Ordinance No. 12 of 1980)*. Pretoria: The Government Printer.

Republic of South Africa. (1983). *Human tissue act (Act No. 65 of 1983)*. Pretoria: The Government Printer.

Republic of South Africa. (1989). *Environment conservation act (Act No. 73 of 1989)*. Pretoria: The Government Printer.

Republic of South Africa. (1993). *Mineral amendment act (Act No. 103 of 1993)*. Pretoria: The Government Printer.

Republic of South Africa. (1993). *Tourism Act (Act No. 72 of 1993)*. Pretoria: The Government Printer.

Republic of South Africa. (1997). *National film and video amendment bill (Bill No. 17B of 1997)*. Cape Town: The Government Printer.

Republic of South Africa. (1998). *Cultural institutions act (Act No. 119 of 1998)*. Pretoria: The Government Printer.

Republic of South Africa. (1998). *National environmental management act (Act No. 107 of 1998)*. Pretoria: The Government Printer.

Republic of South Africa. (1999a). *National heritage council act (Act No. 11 of 1999)*. Pretoria: The Government Printer.

Republic of South Africa. (1999b). *National heritage resources act (Act No. 25 of 1999)*. Cape Town: The Government Printer.

Republic of South Africa. (2000). *Cultural laws second amendment bill (Bill No. B46 of 2000)*. Cape Town: The Government Printer.

Resenblum, A. L., Burr, G., & Guastavino, C. (2013). Survey: Adoption of Published Standards in Cylinder and 78 RMP Disc Digitization. *IASA Journal, 41*, 55.

Resker, J. S., & Suhadolnik, N. V. (2013). *Modernization of Chinese culture: continuity and change*. Newcastle, UK: Cambridge Scholars Publishing.

Reynolds, P. D. (1971). *A primer in theory construction*. New York: Macmillan.

Riazi, A. M. (2016). *The Routledge encyclopedia of research methods in applied linguistics: Quantitative, qualitative, and mixed methods research*. London: Routledge.

Ritzenthaler, M. L. (1993). *Preserving archives and manuscripts*. Chicago: The Society of American Archivists.

Rizzo, I. (2006). Cultural heritage: Economic analysis and public policy. In V. A. Ginsburgh & D. Throsby (Eds.), *Handbook of economics of art and culture* (Vol. 1, pp. 983–1016)., doi:10.1016/S1574-0676(06)01028-3

Roberts, D. (1993). Managing records in special formats. In Keeping archives (2nd ed.; pp. 385-427). Port Melbourne: The Australian Society of Archives.

Roberts, A. (2004). *Inventories and documentation in running a museum: A practical handbook*. Paris: ICOM.

Robinson, J. (1959, 1969). The accumulation of capital. New York: Palgrave McMillan.

RODLIBRARY. (2017). *Audio-Visual Material Policy*. University of Iowa. Retrieved from https://www.library.uni.edu/about-us/policies/collection-management/audio-visual-materials-policy

Romm, N., & Ngulube, P. (2015). Mixed methods research. In E. R. Mathipa & M. T. Gumbo (Eds.), *Addressing research challenges: Making headway for developing researchers* (pp. 157–175). Noordywk: Mosala-Masedi.

Roper, M., & Millar, L. (Eds.). (1999a). *The Management of public sector records: principles and context*. London: International Records Management Trust.

Roper, M., & Millar, L. (Eds.). (1999b). *Managing archives*. London: International Records Management Trust.

Rose, W. (1994). Effects of climate control on the museum building envelope. *Journal of American Institute of Conservation, 33*(2), 199–210. doi:10.2307/3179428

Rosin, M. (2005, October). *Rights, including broadcasts and non-broadcast material*. Paper presented at the FIAT/IASA Southern African Workshop on Film, Video and Sound Archives, SABC, Johannesburg, South Africa.

Ross, J. (2009). *Preservation of Archival Sound Recoding*. Retrieved from http://www.arsc-audio.org/pdf/ARSCTC_preservation.pdf

Ross, S. (2003). *Challenges to Digital Preservation and Building Digital Libraries, 69th IFLA World Library and Information Congress and Council, 1-9 August, 2003, Berlin*. Retrieved April 23, 2017, from http://www.ifla.org

Rothenberg, J. (1995, January). Ensuring the Longevity of Digital Documents. *Scientific American, 272*, 42–47. doi:10.1038/scientificamerican0195-42

Russell, K. (2002). Libraries and digital preservation: Who is providing electronic access for tomorrow? In C. F. Dekker (Ed.), *Libraries, the Internet, and Scholarship* (pp. 1–30). New York: Marcel Dekker, Inc.

Russo, A., Watkins, J., & Groundwater-Smith, S. (2009). The impact of social media on informal learning in museums. *Educational Media International, 46*(2), 153–166. doi:10.1080/09523980902933532

Rusuli, M. S., Tasmin, R., & Takala, J. (2012). Knowledge record and knowledge preservation: A conceptual framework of knowledge management practice at Malaysian university libraries. *International Journal of Information Technology and Business Management, 3*(1), 30–37.

SADC Nations Agree to Standardise Cyber Laws. (2005, May 25). *The Botswana Gazette*, p. 6.

Saffady, W. (1998). *Managing electronic records*. Prairie Village, KS: ARMA International.

Saintville, D. (1986). The preservation of moving images in France. In Panorama of audio-visual archives (pp. 3-7). London: BBC Data Publication.

Samuels, H. W. (1991). Improving our Disposition: Documentation Strategy. *Archivaria, 33*, 125–140.

Samuels, H. W., Orwell, G., & Clarke, A. C. (1986). Who Controls the Past? *The American Archivist, 49*(2), 109–124. doi:10.17723/aarc.49.2.t76m2130txw40746

Sandell, R. (2012). Museums and the human rights frame. In R. Sandell & E. Nightingale (Eds.), *Museums, equality and social justice* (pp. 195–215). London: Routledge.

Saurombe, N. P. (2016). *Public Programming of Public Archives in the East and Southern Africa Regional Branch of the International Council on Archives (ESARBICA): Towards an Inclusive and Integrated Framework* (PhD Thesis). University of South Africa.

Saurombe, N., & Ngulube, P. (2016). Public programming skills of archivists in selected national memory institutions of east and southern Africa. *Mousaion, 34*(1), 23–42.

Schellenberg, T. R. (1956b). *The Appraisal of Modern Records*. Retrieved 25 April, 2016, from: http://www.archives.gov/research/alic/reference/archives-resources/appraisal-of-records.html

Schellenberg, T. R. (1956a). *Modern Archives: Principles & Techniques*. Chicago: Academic Press.

Schellenberg, T. R. (1968). Archival training in library schools. *The American Archivist, 31*(2), 55–66. doi:10.17723/aarc.31.2.g2k6132m5332737k

Schifferdecker, K. E., & Reed, V. A. (2009). Using mixed methods research in medical education: Basic guidelines for researchers. *Medical Education, 43*(7), 637–644. doi:10.1111/j.1365-2923.2009.03386.x PMID:19573186

Schlee, B. (2011). *Economic Crisis and Political Apathy in Zimbabwe: The impotent society.* Retrieved 24 July 2015 from: http://paperroom.ipsa.org/papers/paper_26446.pdf

Schmdit, P. R., & Pikirayi, I. (2016). *Community Archaeology and Heritage in Africa; decolonizing practice.* New York: Routledge.

Schoeman, S. (1987). *Argeologiese en kultuurbestuursversleg. Die posboom museumkompleks, Mosselbaai* (Unpublished report). Stellenbosch: University of Stellenbosch).

Schuller, D. (1997). Storage Handling and Conservation: preserving of audio and visual m In *Audio-visual archives: A practical appraisal* (pp. 280-291). Paris: UNESCO. Retrieved from http://unesdoc.unesco.org/images/0010/001096/109612eo.pdf

Schuller, D. (2004b). *Strategies for the safeguarding of audio and video materials in the long.* Retrieved from http: http://www. Unesco.org/webworld/ramp/html/r9704e15.htm

Schuller, D. (2004a). Sound recordings: Problems of preservation. In J. Feather (Ed.), *Managing preservation for libraries and archives: current practice and future developments* (pp. 113–131). Aldershot, UK: Ashgate Publishing Ltd.

Schurink, E. (2009). Qualitative research design as tool for trustworthy research. *Journal of Public Administration, 44*(4), 803–823.

Schuursma, R. (2007). *Approaches to the national organisation of sound archives.* Retrieved March, 8, 2013 from http://www.unesco.org/webworld/ramp/html

Schwirtlich, A. M., & Reed, B. (1993). Managing the acquisition process. In Keeping archives (2nd ed.; pp. 137-156). Port Melbourne: The Australian Society of Archives.

Scott, C. (2007). Measuring social value. In R. Sandell & R. R. Janes (Eds.), *Museum management and marketing* (pp. 181–194). London: Routledge.

Sebastiani, F., Esuli, A., Berardi, G., Macdonald, C., & Ounis, I. (2015). Semi-Automated Text Classification for Sensitivity Identification. *Proceedings of International Conference on Information and Knowledge Management.*

Sebina, P. M. M. (2006). *Freedom of information and records management: A learning curve for Botswana* (Unpublished doctoral thesis). University of London.

Segaetsho, T. (2016). "A nation without a past is a lost nation, and a people without a past is a people without a soul": A wakeup-call for preservation in libraries and archives in Botswana. In *8th Botswana Library Association Annual Conference.* University of Botswana Library Auditorium.

Segaetsho, T. (n.d.). *Environmental consideration in the preservation of library and archival paper materials in selected heritage institutions in Botswana* (Unpublished doctoral thesis). University of Botswana, Gaborone, Botswana.

Segaetsho, T. (2014). Preservation risk assessment survey of the University of Botswana Library. *African Journal of Library Archives and Information Science, 24*(2), 175–186.

Segaetsho, T., & Mnjama, N. (2012). Preservation of library materials at the University of Botswana library. *Journal of the Society of South African Archivists, 45*, 68–84.

Seitshiro, B. T. (2006). *A study of the syntactic structure and the lexical fields of Setswana proverbs* (Unpublished masters' dissertation). University of Botswana.

Sejane, L. (2004). *An investigation into the management of electronic records in the public service in Lesotho* (Unpublished MA Thesis). University of KwaZulu-Natal, Pietermaritzburg.

Selatolo, O. (2012). *Map preservation at department of survey and mapping in Gaborone, University of Botswana* (Unpublished masters' dissertation). University of Botswana, Gaborone, Botswana.

Sen, A. (2015). Does globalization equal westernization? *The Globalist. Rethinking Globalization.* Retrieved December 25, 2016, from http://www.theglobalist.com/does-globalization-equal-westernization/

Setlhabi, K. G. (2010). *Documentation of material culture: A study of the ethnology division of Botswana National Museum* (Unpublished doctoral thesis). University of Botswana, Gaborone, Botswana.

Setshwane, T. (2005). *Preservation of sound recordings at the Department of Information and Broadcasting: The case study of Radio Botswana Music Library* (MIS dissertation). University of Botswana.

Sexton, M., & Lu, S. (2009). The challenges of creating actionable knowledge: An action research perspective. *Construction Management and Economics, 27*(7), 683–694. doi:10.1080/01446190903037702

Seychelle National Archives. (2011). Retrieved from http://www.sna.gov.sc/exhibitions.aspx

SGS. (2011). Draft audit report. Procurement review / audit of selected procuring entities in the public service. Lilongwe: Office of the Director of Government Procurement. Ref. ODPP/03/130/2011/1.

Shani (Rami), A. B., & Pasmore, W. A. (2010). Organisation inquiry: Towards a new model of the action research process. In D. Coghlan & A. B. Shani (Eds.), Fundamentals of organisational development (pp. 249–260). London: Sage.

Shani (Rami), A. B., Coghlan, D., & Cirella, S. (2012). Action research and collaborative management research: More than meets the eye? *International Journal of Action Research, 8*(1), 45–67.

Shepherd, E. (2011). An 'academic' dilemma: The tale of archives and records management. *Journal of Librarianship and Information Science, 44*(3), 174–184. doi:10.1177/0961000611427067

Shepherd, E., & Yeo, G. (2003). *Managing records: a handbook for principles and practices.* London: Facet Publishing.

Shepherd, E., & Yeo, G. (2003). *Managing Records: A Handbook of Principles and Practice.* London: Facet Publishing.

Shivute, O. (2003, August 7). Namibia: Missing docket and burnt evidence stall fraud probe. *The Namibian.* Retrieved June 8, 2017, from allafrica.com/stories/200308070437.html

Shoemaker, P. J., Tankard, J. W. Jr, & Lasorsa, D. L. (2004). *How to build social sciences theories.* Thousand Oaks, CA: Sage. doi:10.4135/9781412990110

Shuayb, M. (2014). Appreciative inquiry as a method for participatory change in secondary schools in Lebanon. *Journal of Mixed Methods Research, 8*(3), 299–307. doi:10.1177/1558689814527876

Siele, M. P. (2012). *Preservation programme and preservation status of information materials: A survey of selected institutions in Botswana* (Unpublished masters' dissertation). University of Botswana, Gaborone, Botswana.

Silver, C. (2016). Participatory approaches to social research. In N. Gilbert & P. Stoneman (Eds.), *Researching social life* (4th ed.; pp. 139–159). Los Angeles: Sage.

Simmons, J. E. (2003). *Managing collections management.* Retrieved 10 June 2017 from http://www.academia.edu/1870670/The_theoretical_bases_of_collections_management

Simmons, J. E., & Muñoz-Saba, Y. (2003). The theoretical bases of collections management. *Collection Forum, 18*(1-2), 38-49.

Simpson, M. G. (2007). Charting the Boundaries. Indigenous models and parallel practices in the development of the post-museum. In S. J. Knell, S. MacLeod, & S. Watson (Eds.), *Museum revolutions* (pp. 235–249). London: Routledge.

Sinclair, M. (2007). Editorial: A guide to understanding theoretical and conceptual frameworks. *Evidence-Based Midwifery, 5*(2), 39.

Six, P., & Bellamy, C. (2012). *Principles of methodology: Research design in social science*. Los Angeles, CA: Sage.

Skaff, R. (2015). *The misinformation burnout: Media fatigue with 'Islamism' and 'Terrorism'*. Retrieved 24 July 2015 from: http://www.globalresearch.ca.org/the-misinformation-burnout-media-fatigue-with-islamism-and-terrorism/5450606

Slaten, K. (2010). A War on westernization in China. *China/Divide*, March 1 Edition, 16-19.

Smeds, K. (2007). The Escape of the Object? – crossing territorial borders between collective and individual, national and universal. In *ICOFOM International Study Series 36*, (pp. 172-178). Retrieved on August 8, 2014 from http://network.icom.museum/icofom

Smith, H. (1993). Legal responsibilities and issues. In Keeping archives (2nd ed.). Port Melbourne: The Australian Society of Archives.

Smith, M. K. (2007) Action research. In *The encyclopedia of informal education*. Retrieved May, 13, 2017, from http://infed.org/mobi/action-research/

Snoj, B., & Petermanec, Z. (2001). Let users judge the quality of Faculty Library services. *New Library World, 102*(1168), 314–324. doi:10.1108/03074800110406196

Society of American Archivists. (2005). *A Glossary of Archival and Records Terminology*. Retrieved September 4, 2007 from: http://www.archivists.org/glossary/list.asp

Sorensen, L. (2014). Modernization and the Third World. *Global Studies 410 – Gender Identity*. Retrieved December 23, 2016, from http://the_imperfect_planet.tripod.com/sorensenportfolio/id10.html

Sote, A., & Aramide, K. A. (2010). Influence of self-efficacy, perceived ease of use and perceived usefulness on e-library usage by academic staff in Nigerian universities. In Proceedings of the Second Professional Summit on Information Science and Technology. University of Nigeria.

South African Heritage Resources Agency. (2015). *Draft SAHRA guidelines to burial grounds and graves permitting policy* (Unpublished document). SAHRIS. Retrieved October 27, 2016, from http://www.sahra.org.za

South African Museums Association. (2001). *A short history of SAMA*. Grahamstown: SAMA.

South African Museums Association. (2016). *The museum profession in South Africa 1936-2016*. Cape Town: SAMA.

South, A. C. A. 1978 (Act No. 98 of 1978, as amended up to Copyright Amendment Act 2002. (n.d.). Retrieved from http://www.wipo.int/wipolex/en/details.jsp?id=4067

Spiteri, L. (2014). *Records Continuum Model*. Retrieved 29 August, 2017, from: https://www.slideshare.net/cleese6/records-continuum-model

Stafford, L. B. (2013). Cultural heritage preservation in modern China: Problem, perspectives and potentials. *Asia Network Exchange, 21*(1), 1–13.

Standards Malaysia. (2009). *Information and Documentation - Records Management - Part 1: General* (ISO 15489-1:2001, IDT). Retrieved 17 July, 2017, from: https://www.msonline.gov.my/download_file.php?file=15624&source=production

Stapleton, R. M. (2004). *Pollution A To Z.* New York: Macmillan Reference USA.

State Records Authority of New South Wales. (2002). *Vital records protection (Counter disaster strategies).* Retrieved 10 December, 2016, from; https://www.records.nsw.gov.au/recordkeeping/advice/counter-disaster-strategies/5-vital-records-protection

Stephens, J., Barton, J., & Haslett, T. (2009). Action research: Its foundations in open systems thinking and relationship to the scientific method. *Systemic Practice and Action Research, 22,* 475–488. doi:10.1007/s11213-009-9147-7

Steyn, M., Nienaber, W. C., & Iscan, M. Y. (2000). Excavation and retrieval of forensic remains. In J. A. Siegel, P. J. Saukko, & G. C. Knupfer (Eds.), *Encyclopaedia of forensic sciences* (pp. 235–242). Sidcup: Academic Press. doi:10.1006/rwfs.2000.0758

St-Laurette, G. (1996). *The care and handling of recorded sound materials.* Retrieved from http://www. palimpsest.stanford.edu/byauth/st-laurent/care.html

Stork, C., & Aochamub, A. (2003). *Namibia in the information age. NEPRU Research Report, 25.* Windhoek, Namibia: Namibia Economic Policy Research Unit.

Strang, T. J. K., & Dawson, J. E. (1991). *Controlling Vertebrate Pests in Museums.* Ottawa: Canadian Conservation Institute.

Strauss, A., & Corbin, J. (1994). Grounded theory methodology. In N. K. Denzin & Y. S. Lincoln (Eds.), *Handbook of qualitative research* (pp. 273–285). Thousand Oaks, CA: Sage.

Streeten, P. (2006). Culture and economic development. In V. A. Ginsburgh & D. Throsby (Eds.), Handbook of economics of art and culture (Vol. 1, pp. 399–412). Academic Press. doi:10.1016/S1574-0676(06)01013-1

Stuckey, S. (2004). *Western theories of appraisal - from Europe to America to the perspective of an international society.* Retrieved 3 October, 2017, from: http://www.archives.go.jp/publication/archives/wp-content/uploads/2015/03/acv_18_p127.pdf

Suddaby, R. (2015). Editor's comments: Why theory? *Academy of Management Review, 4015*(1), 1–5.

Sutcliffe, J. (2013). *The labour movement in Zimbabwe 1980-2012.* Retrieved 12 July 2016 from: www.e-ir.info/2013/0/07/the-labour-movement-in-zimbabwe-1980-2012/

Swaisland, C. (1992). *Women's Corona Society, 1950-90.* London: Women's Corona Society.

Swartzburg, S. G. (1980). *Preserving Library materials: A manual.* The Scarecrow Press.

Tafor, V. F. (2001). *The management of public records in the member states of ESARBICA* (MIS dissertation). University of Natal.

Tamuhla, K. S. (2001). *The preservation and use of photographic materials: A case study of Department of Survey and Mapping Air Photo Library* (Unpublished masters' dissertation). University of Botswana, Gaborone, Botswana.

Tamulha, K. S. (2001). *The Preservation and Use of Photographic Materials: A Case Study of the Department of Surveys and Mapping Air Photo Library* (MLIS Dissertation). University of Botswana, Gaborone, Botswana.

Tashakkori, A., & Teddlie, C. (2010). Overview of contemporary issues in mixed methods research. In A. Tashakkori & C. Teddlie (Eds.), *SAGE handbook of mixed methods in social and behavioral research* (2nd ed.; pp. 1–41). Thousand Oaks, CA: Sage. doi:10.4135/9781506335193

Taylor, J. (2013). Intergenerational justice: A useful perspective for heritage conservation. In *CeROArt: Conservation, Exposition, Restauration d'Objets d'Art*. Retrieved July 14, 2014, from: http://ceroart.revues.org/3510

Taylor, M. (1994) Records management in Namibia: Prospects and problems. In *Archives in the nineties: The challenges for Eastern and Southern Africa Regional Branch of the International Council on Archives* (pp. 58-62). Gaborone, Botswana: ESARBICA.

Technical Support & Dialogue Platform. (2011). *Sustainability in contemporary South Africa, 28 July 2011, Cape Town*. Unpublished meeting report.

Tembo, E., Kalusopa, T., & Zulu, S. (2006). *Digital Material Preservation Project in Botswana. Report to UNESCO under its Digital Heritage Project*. Gaborone: University of Botswana.

Tempelhoff, J., Gouws, C., & Motloung, S. (2014). The River as artefact: Interpreting the Groot Marico and its people in the 21st Century. *SAMAB*, *35*, 24–30.

Thabakgolo, M., & Jorosi, B. N. (2014). Newspaper preservation at Botswana's legal repositories. *Journal of the South African Society of Archivists*, *47*, 61–76.

Thai, N. (2010). Is globalization the western cultural imperialism? The case of Singapore. *Journeys*. Retrieved December 25, 2016, from https://jjourneys.wordpress.com/2012/06/08/is-globalisation-the-western-cultural-imperialism-the-case-of-singapore/

Thanye, K., Kalusopa, T., & Bwalya, K. J. (2015). Assessment of the appraisal practices of architectural records at the Gaborone City Council in Botswana. *ESARBICA Journal*, *34*, 45–64.

The Council for Museums, Archives and Libraries. (2002). Benchmarks in Collection Care for Museums, Archives, and Libraries: A Self-assessment Checklist. Pennsylvania State University.

The Guardian. (2017). *The book rustlers of Timbuktu: how Mali's ancient manuscripts were saved*. Retrieved August 9, 2017, from: https://www.theguardian.com/world/2014/may/23/book-rustlers-timbuktu-mali-ancient-manuscripts-saved

The National Archives. (2013). Retrieved on August, 16 2017 from http://www.nationalarchives.gov.uk/documents/information-management/what-is-appraisal.pdf

Thinley, D. (2007). Cultural maintenance and promotion: The print media's role in providing space for knowledge and discourse. In *Media and Public Culture: Proceedings of the Second International Seminar on Bhutan Studies* (pp 70-106). Retrieved 14 December 2016 from http://crossia-repository.ub.uni-heidelberg.de/342/

Thomas, B. (2013). The first "green" museum in South Africa. *SAMAB*, *36*, 75–91.

Thompson, C. H. (1970). *Report to the Government Archivist on five years work, 1965-1970*. Gaborone: Government Printer.

Thompson, M. (1979). *Rubbish theory: The creation and destruction of value* (2nd ed.). Chicago: University of Chicago Press.

Throsby, D. (2002). Cultural capital and sustainability concepts in the economics of cultural heritage. In Assessing the value of cultural heritage (pp. 101-117). Los Angeles, CA: Getty Conservation Institute.

Throsby, D. (2013). Assessment of value in heritage regulation. In Handbook on the Economics of cultural heritage (pp. 456-469). Cheltenham, UK: Edward Elgar. doi:10.4337/9780857931009.00037

Throsby, D. (2001). *Economics and culture*. Cambridge, UK: Cambridge University Press.

Thurston, A., & Pugh, R. B. (1997). *Records of the Colonial Office, Dominions Office, Commonwealth Relations Office, and Commonwealth Office.* London: TSO, HMSO.

Thurston, A. (1996). Records management in Africa: Old problems, dynamic new solutions. *Records Management Journal, 6*(3), 187–199. doi:10.1108/eb027096

Toledo, F. (2007). *Museum passive building in warm, humid climates, contribution to the experts roundtable on sustainable climate management strategies.* The Getty Conservation Institute. Retrieved August 4, 2016, from: http://www.getty.edu/conservation/our_projects/science/climate/paper_toledo.pdf

Tongo, N. (2006). A critical analysis of oral history methods in collecting memories of the past: A case study of the Robben Island Museum ex-political group project. *SAMAB, 32,* 60–64.

Tough, A. (2004). Records management standards and the good governance agenda in Commonwealth Africa. *Archives and Manuscripts, 32*(2), 142–161.

Tough, A. G. (2004). Post-custodial / pro-custodial argument from a records management perspective. *Journal of the Society of Archivists, 25*(1), 19–26. doi:10.1080/0037981042000199115

Tough, A. G. (2009). Archives in sub-Saharan Africa half a century after independence. *Archival Science, 9*(3-4), 2009. doi:10.1007/s10502-009-9078-1

Tough, A. G. (in press). Norman Carr's Malawi days: From poacher to record keeper. *The Society of Malawi Journal.*

Townsend, A. (2013). *Action research: The challenges of understanding changing practice.* Berkshire: Open University Press.

Trant, J. (2009). Emerging convergence? Thoughts on museums, archives, libraries, and professional training. *Museum Management and Curatorship, 24*(4), 369–487. doi:10.1080/09647770903314738

Tschan, R. (2002, Fall). A Comparison of Jenkinson and Schellenberg on Appraisal. *The American Archivist, 65,* 1761–195.

Tsebe, J. (2005). *Networking Cultural Heritage: Africa.* Retrieved April 23, 2017, from http://www.ifla.org/IV/ifla71/papers/157e-Tsebe.pdf

Tshotlo, K., & Mnjama, N. (2010). Records management audit: the case of Gaborone City Council. *ESARBICA Journal, 29.*

Tshotlo, K., & Mnjama, N. (2010). Records management audit: The case of Gaborone City Council. *ESARBICA Journal, 29,* 5–35.

Turner, J. (1992). *A study of the theory of appraisal for selection.* Retrieved 25 September, 2017, from: https://open.library.ubc.ca/cIRcle/collections/ubctheses/831/items/1.0086420

Turner, R. K., Pearce, D. W., & Bateman, I. J. (1994). *Environmental economics: An elementary introduction.* Baltimore, MD: Harvester Wheatsheaf and John Hopkins University.

Tweedsmuir, L. (1971). *Always a countryman.* London: Robert Hale.

Tyson, R. (2009). *Tools of the Regime: Namibian Radio History and Selective Sound Archiving 1979–2009.* Paper Presented at the Sound Archives Workshop. Retrieved April 6, 2016, from http://baslerafrika.ch/wp-content/uploads/WP-2009-3-Tyson.pdf

Uganda, MoPS. (1998). *Draft for discussion: Extension of the computerised personnel management Information system, proposal for ODA assistance.* Kampala: MoPS.

Uganda, MoPS. (2005). *Public service reform programme strategic framework (2005/6-2009/10).* Kampala: MoPS.

Uganda. (1964). *University College (Deposit Library) Act.* Government Printers.

Uganda. (2001). *The National Records and Archives Act.* Kampala: UPPC.

UNDP. (2016). *Human Development Reports.* Retrieved 10 September 2017 from:http://hdr.undp.org/en/humandev

UNESCO. (1972). *Convention Concerning the Protection of the World Cultural and Natural Heritage.* Retrieved January 2, 2017, from: http://whc.unesco.org/en/convention/

UNESCO. (1982). *Mexico City declaration on cultural policies. World conference on cultural policies.* Mexico City, Mexico: United Nations.

UNESCO. (2001). *Universal Declaration on Cultural Diversity.* Retrieved 14 March 2017 from: http://unesdoc.unesco.org/images/0012/001271/127160m.pdf

UNESCO. (2002). *Johannesburg Declaration on World Heritage in Africa and Sustainable Development.* Retrieved January 27, 2017, from: http://whc.unesco.org/uploads/events/documents/event-500-1.pdf

UNESCO. (2003). *World Heritage Papers 5: Identification and Documentation of Modern Heritage.* Retrieved June 27, 2017, from: http://whc.unesco.org/uploads/activities/documents/activity-38-1.pdf

UNESCO. (2003a). *DPC/PADI; What's new in digital preservation.* Retrieved April 23, 2017, from http:// www.digital preservation\UNIVERSAL\DPC-PADI

UNESCO. (2003b). *Charter on the preservation of the digital heritage.* Retrieved April 23, 2017, from http://portal.unesco.org/ci/en/file

UNESCO. (2003c). *Guidelines for the Preservation of Digital Heritage.* Retrieved April 23, 2017, from http://unesdoc.unesco.org/images/0013/001300/130071e.pdf

UNESCO. (2007a). *UNESCO World Day for audiovisual heritage-feasibility study launched.* Retrieved from http://www.unesco.org/webworld/mdm/en/index_mdm.html

UNESCO. (2007b). *Audiovisual Archives: A practical reader.* Retrieved from http://www.org/webworld/ramp/html

UNESCO. (2009). *UNESCO Framework for cultural statistics.* Paris: UNESCO.

UNESCO. (2017). *Illicit Trafficking of Cultural Property.* Retrieved 10 September 2017 from: http://www.unesco.org/new/en/culture/themes/illicit-trafficking-of-cultural-property/unesco-database-of-national-cultural-heritage-laws/frequently-asked-questions/definition-of-the-cultural-heritage/

UNESCO/UBC. (2012). The memory of the world in the digital age: digitization and preservation. In *Proceeding of an international conference on permanent access to digital documentary.* Author.

United Nations Archives and Records Management Section. (2016). *How do I know which records are vital?* Retrieved 13 August, 2017, from: https://archives.un.org/sites/archives.un.org/files/uploads/files/Guidance%20Vital%20Records.pdf

United Nations Educational, Scientific and Cultural Organization. (2015). *Recommendation on the Protection and Promotion of Museums and Collections.* Retrieved on August, 10, 2016 from www.unesco.org/new/en/culture/themes/museums/recommendation-on-the-protection-and-promotion-of-museums-and-collecting

United Nations. (2006). *Manual for the Design and Implementation of Recordkeeping Systems (DIRKS).* Retrieved 10 April, 2017, from: https://archives.un.org/sites/archives.un.org/files/files/French%20files/Manual_for_the_Design_and_Implementation_of_Recordkeeping_Systems.pdf

United States Agency for International Development. (2012). *Examples of Vital Records.* Retrieved 7 September, 2017, from: https://www.usaid.gov/sites/default/files/documents/1868/511sab.pdf

United States Department of Defense 5015.2 STD. (n.d.). *Design criteria standard for electronic records management software applications.* Retrieved November 2016 from http://jitc.fhu.disa.mil/recmgt/p50152s2.pdf

United States Department of Energy. (2016). *Records management handbook.* Retrieved 7 May, 2017, from: https://www.energy.gov/sites/prod/files/2016/12/f34/Records%20Management%20Handbook_0.pdf

University of Edinburg. (2017). *Records management policy framework.* Retrieved June 6, 2017, from http://www.ed.ac.uk/records-management/records-management/policy-framework

University of Sheffield. (2014). *Records Management Policy: Corporate Information and Computing Services.* Retrieved 8 May, 2016, from: www.sheffield.ac.uk/cics/records/policy

University of Tasmania. (2014). *Staff recordkeeping manual.* Retrieved 20 November, 2016, from: http://www.utas.edu.au/__data/assets/pdf_file/0009/268155/Staff-Recordkeeping-Manual.pdf

University of Tasmania. (2015). *What is a recordkeeping system?* Retrieved 12 September, 2017, from: http://www.utas.edu.au/it/records/support/faqs/sorting-records/accordion-items/what-is-a-recordkeeping-system

University of Toronto Archives and Records Services. (1999). *Records Management Glossary.* Retrieved 25 August, 2017, from: http://www.library.utoronto.ca/utarms/info/glossary.html

University of Washington. (2015). *Vital records.* Retrieved 29 August, 2017, from: https://finance.uw.edu/recmgt/vitalrecords

Upward, F. (2000). Modelling the continuum as paradigm shift in recordkeeping and archiving processes, and beyond - a personal reflection. *Records Management Journal, 10*(3), 115–139. doi:10.1108/EUM0000000007259

van der Hoeven, J., Lohman, B., & Verdegem, R. (2007). Emulation for Digital Preservation in Practice: The Results. *International Journal of Digital Curation, 2*(2), 123–132. doi:10.2218/ijdc.v2i2.35

Van der Merwe, R. (2010). Including diverse voices from the past: A case study of the University of Pretoria centenary exhibition. *SAMAB, 33*, 60–69.

Van der Ryst, M. M., & Meyer, A. (1999). Die Ystertydperk. In J. S. Bergh (Ed.), *Geskiedenisatlas van Suid-Afrika. Die vier noordelike provinsies* (pp. 96–102). Pretoria: J. L. van Schaik.

Van der Walt, T. (2011). Re-thinking and re-positioning archives: Taking archives to the children. *ESARBICA Journal, 30*, 115–134.

Van Vollenhoven, A. C. (1993). 'n Argeologiese ondersoek van die Bronkhorstruïne as voorbeeld van kultuurhulpbronbestuur (KHB) (Unpublished scription). Pretoria: University of Pretoria.

Van Vollenhoven, A. C. (1995a). Die bydrae van argeologie tot kultuurhulpbronbestuur (KHB). In J. W. van den Bos & H. J. Moolman (Eds.), Methodology in research (pp. 35-50). Sunnyside: SASCH.

Van Vollenhoven, A. C. (1998). *Kultuurhulpbronbestuur (KHB) binne die funksionele konteks van museums in Suid-Afrika* (Unpublished master's dissertation). University of Stellenbosch, Stellenbosch, South Africa.

Van Vollenhoven, A. C. (2010). *The grave relocation process* (Unpublished report). Wonderboompoort: Archaetnos.

Van Vollenhoven, A. C. (1995b). *Die militêre fortifikasies van Pretoria 1880-1902. 'n Studie in die historiese argeologie.* Pretoria: Heinekor.

Van Vollenhoven, A. C. (2003a). Die Wet op Nasionale Erfenishulpbronne. *South African Journal of Cultural History*, *17*(2), 23–45.

Van Vollenhoven, A. C. (2003b). Kultuurhulpbronbestuur (KHB) as museumfunksie. *South African Journal of Cultural History*, *17*(1), 33–46. doi:10.4314/sajch.v17i1.6315

Van Waarden, C. (1996). The pre-development archaeology programme of Botswana. In G. Pwiti & R. Soper (Eds.), *Aspects of African Archaeology* (pp. 829–836). Harare: University of Zimbabwe Publications.

van Wijngaarden, H. (2004). Digital preservation in practice: The e-Depot at the Koninklijke Bibliotheek. *Vine*, *34*(1), 21–26. doi:10.1108/03055720410530951

Vecco, M. (2005). *L'évolution économique du concept de conservation* (Thèse pour obtenir le grade de Docteur). de l'Université Paris 1, Panthéon-Sorbonne, Paris, France.

Vecco, M. (2007). *Economie du patrimoine monumental*. Paris: Economica.

Vecco, M. (2010). A definition of cultural heritage: From the tangible to the intangible. *Journal of Cultural Heritage*, *11*(2), 321–324. doi:10.1016/j.culher.2010.01.006

Venson, S. (2007). *A survey of email management practices in selected organisations in Botswana. Recordkeeping for transparency and accountability: the case of Public Procurement and Asset Disposal Board (PPADB)*. Paper presented at the ESARBICA Conference, Dar-es-Salaam, Tanzania.

Venson, S. L., Ngoepe, M., & Ngulube, P. (2014). The role of public archives in national development in the East and Southern Africa Regional Branch of the International Council on Archives. *Innovation: Journal of Appropriate Librarianship and Information Work*, *48*, 46–68.

Verzosa, F. A. (2006). *The changing nature of collection development in academic libraries*. Center for Human Research and Development Foundation Inc.

Victor, S. (2006). Celebrating heritage: The case of Old Town. *SAMAB*, *32*, 49–52.

Vithal, R., Jansen, J. D., & Jansen, J. (2013). *Designing your first research proposal: A manual for researchers in education and the social sciences*. Claremont: Juta.

Voigt, C. C., Kendra, L. P., Luis, F. A., Schoeman, C. M., Vanitharani, J., & Zubaid, A. (2016) Bats and Buildings: The Conservation of Synanthropic Bats. In Bats in the Anthropocene: Conservation of Bats in a Changing World. DOI doi:10.1007/978-3-319-25220-9_14

Vollgraaff, H. (2014a). *Affirming "museumness"*. Unpublished report on the SAMA Workshop on Policy.

Vollgraaff, H. (2006). Challenges in preserving the greens for the future. *SAMAB*, *32*, 10–11.

Vollgraaff, H. (2013). Defining the role of museums in heritage practice. *SAMAB*, *36*, 23–27.

Vollgraaff, H. (2014b). Museum practice – Rooted in social space. *SAMAB*, *35*, 31–35.

Vollgraaff, H. (2015). A vision for museums in South Africa; A review of policy proposals. *SAMAB*, *37*, 41–54.

Vroom, V. H. (1964). *Work and motivation*. New York: John Wiley & Sons.

Waibel, G., & Erway, R. (2009). Think globally, act locally: Library, archive, and museum collaboration. *Museum Management and Curatorship*, *24*(4), 323–335. doi:10.1080/09647770903314704

Wales, N. S., & Records, S. (2003). *Strategies for documenting government business: the DIRKS manual*. Retrieved April 4, 2010, from http://www.records.nsw.gov.au/publisector/DIRKS/final/downloadable/introproj.html

Wallace, D. A. (2000). Survey of Archives and Records Management Graduate Students at Ten Universities in the United States and Canada. *The American Archivist, 63*(2), 284–300. doi:10.17723/aarc.63.2.72050g01j3v858j1

Walne, P. (1988). *Dictionary of Archival Terminology* (2nd ed.). Munich: K.G. Saur. doi:10.1515/9783110977691

Wambu, O. (2015). Tradition versus modernity. *New African Magazine*. Retrieved August 30, 2016, from http://newafricanmagazine.com/tradition-versus-modernity/

Wamukoya, J., & Mutula, S. M. (2005). Capacity-building requirements for e-records management: The case of East and Southern Africa. *Records Management Journal, 15*(2), 71–79. doi:10.1108/09565690510614210

Wandibba, S. (1996). The legal basis of conservation in Kenya: a review. In G. Pwiti & R. Soper (Eds.), *Aspects of African Archaeology* (pp. 809–812). Harare: University of Zimbabwe Publications.

Ward, A. (1990). *A manual of sound archive administration*. Brookfield: Gower Publishing Company Ltd.

Wato, R. (2002). Challenges and opportunities of information technology for archival practices in the 21st Century. *ESARBICA Journal, 17*, 125–134.

Watson, J. L. (2016). Cultural Globalization. *Encyclopedia Bitannica*. Retrieved September 8, 2016, from https://www.britannica.com/science/cultural-globalization

Watt, L. (2013). *History vs. history as China plans to rebuild past*. Beijing Cultural Heritage Protection Centre. Retrieved January 14, 2017, from http://en.bjchp.org/?p=5098

Weber, H. (1997/98). Preservation of archival holdings and unique library materials. In World Information Report. Paris: UNESCO.

Weil, S. E. (2007). From being *about* something to being *for* somebody. In R. Sandell & R. R. Janes (Eds.), *Museum management and marketing* (pp. 30–48). London: Routledge.

Weiss, E. B. (1992). *Intergenerational equity: A legal framework for global environmental change*. Tokyo: United Nations University Press.

Wengraf, T. (2001). *Qualitative research interviewing: Biographic narrative and semi-structured methods*. London: Sage. doi:10.4135/9781849209717

Westhues, A., Ochocka, J., Jacobson, N., Simich, L., Maiter, S., Janzen, R., & Fleras, A. (2008). Developing theory from complexity: Reflections on a collaborative mixed method participatory action research study. *Qualitative Health Research, 18*(5), 701–717. doi:10.1177/1049732308316531 PMID:18420539

Westwood, S. (2016, May 17). A brief guide to Clinton scandals. *Washington Examiner*.

Wiarda, H. (Ed.). (2010). *Grand theories and ideologies in the social sciences*. New York: Palgrave Macmillan. doi:10.1057/9780230112612

Wikipedia. (n.d.). *East African campaign (World War II)*. Retrieved 19 September 2017 from http://en.wikipedia.org/wiki/East_African_Campaign_(World_War_II)

Williams, B. (2015). Integrating the Human and Natural Sciences: A two-dimension literary and organisational approach to collections make connections. *SAMAB, 37*, 55–60.

Williams, C. (2012). On the Record: Towards a Documentation Strategy. *Journal of the Society of Archivists, 33*(1), 3–40. doi:10.1080/00379816.2012.665316

Williamson, K. (2013). Action research: Theory and practice. In K. Williamson & G. Johanson (Eds.), *Research methods: Information, systems and contexts* (pp. 188–202). Prahran, Australia: Tilde.

Wilmot, B. (1996). Presidential Lecture: A review of SAMA and South African museums, 1973-1995. *SAMAB, 22*(2), 1–6.

Wilson, I. E. (1990-91). Towards a Vision of Archival Services. *Archivaria, 31*, 91–100.

Wilson, J. R., & Wilson, R. S. (2001). *Mass Media, Mass Culture* (5th ed.). Boston: Mc Graw Hill.

Winchester, O. (2012). A book with its pages always open? In R. Sandell & E. Nightingale (Eds.), *Museums, equality and social justice* (pp. 142–155). London: Routledge.

Wong, A. (2012). Social media towards social change. In R. Sandell & E. Nightingale (Eds.), *Museums, equality and social justice* (pp. 281–293). London: Routledge.

Woodward, S. (2012). Funding museum agendas: Challenges and opportunities. *Managing Leisure, 17*(1), 14–28. doi:10.1080/13606719.2011.638202

Wooster, M. (2017). *Are certifications important when selecting a records management system?* Retrieved 6 September, 2017, from: https://www.laserfiche.com/ecmblog/are-certifications-important-when-selecting-a-records-management-system/

World Bank. (2000). *Managing records as the basis for effective service delivery and public accountability in development: An introduction to core principles for staff of the World Bank and its partners.* Retrieved February 23, 2007, from http://siteresources.worldbank.org/EXTARCHIVES/Resources?Core%Principles.pdf

Worldometers. (2017). *Namibia population.* Retrieved September 15, 2017, from http://www.worldometers.info/world-population/namibia-population/

Wright, T. (2013). Information culture in a government organisation: Examining records management training and self-perceived competencies in compliance with a records management program. *Records Management Journal, 23*(1), 14–36. doi:10.1108/09565691311325004

Yakel, E. (2000). The future of the past: A survey of graduates of master's-level archival education programs in the United States. *The American Archivist, 63*(2), 301–321. doi:10.17723/aarc.63.2.p8843508857g69v5

Yakel, E., & Jeanette, A. B. (2006). A*CENSUS: Report on graduate archival education. *The American Archivist, 69*(2), 349–366.

Yiotis, K., & Lindberg, L. (2005). *Two theories of appraisal: Cook and Duranti.* Retrieved 30 November, 2016, from: http://citeseerx.ist.psu.edu/viewdoc/download;jsessionid=7971BF35AF577D82CF4DF4C3C504797F?doi=10.1.1.306.4272&rep=rep1&type=pdf

Yusof, Z. M., & Chell, R. W. (2000). The Records Life Cycle: An inadequate concept for technology-generated records. *Information Development, 16*(3), 135–141. doi:10.1177/0266666004240413

Yusuf, M. K. (2016). Media Programming and Cultural Reflections: A Comparative Analysis of Selected Local Media. *Journal of Advances in Social Science- Humanities, 2*(2), 8-14.

Zaid, Y., Abioye, A., & Olatise, O. (2012). *Training cultural heritage preservation: the experience of heritage institutions in Nigeria.* World and Information congress 78th general conference and assembly (IFLA). Retrieved August 14, 2015, from: http://conference.ifla.org/past-wlic/2012/session-200.htm

Zeale, M., Stone, E., Bennitt, E., Newson, S., Parker, P., Haysom, K., & Jones, G. (2014). *Improving Mitigation success where bats occupy houses and historic buildings, particularly churches*. University of Bristol.

Zeilig, L. (2002). Crisis in Zimbabwe. *International Socialism Journal*, (94).

Zeleza, P. (2014). *Africa's resurgence: Domestic, Global and Diaspora Transformations*. Los Angeles, CA: Tsehai Publishers.

Zhang, W., Levenson, A., & Crossley, C. (2015). Move your research from the ivy tower to the board room: A primer on action research for academics, consultants, and business executives. *Human Resource Management*, *54*(1), 151–174. doi:10.1002/hrm.21616

Zhu, G. (2012). China's architectural heritage conservation movement. *Frontiers of Architectural Research*, *1*(1), 10–22. doi:10.1016/j.foar.2012.02.009

Zibiso, M. S. (2015). *An analysis of records management practices in Namibia: A case study of the Ministry of Education at Otjiwarongo Regional Office* (Unpublished undergraduate research report). University of Namibia.

Zinyengere, I. (2008). African Audio-Visual Archives: Bleak or Bright Future: A Case Study. *News*, *46*, 37–41.

Zolotarevsky, M. (2010). The information retrieval needs of archival users: A case study from the Jabotinsky Institute, Israel. *Comma: International Journal on Archives*, *20*(2), 47–53.

Zulu, S. F. C. (2005). *Issues in managing electronic records*. Gaborone: University of Botswana. (Unpublished)

About the Contributors

Patrick Ngulube (PhD) is a professor of information science and interdisciplinary research at the University of South Africa. His research interests as in records and archives, e-government, application of information and communication technologies, research methods and knowledge management, including indigenous knowledge systems.

* * *

Ruth M. Abankwah is a Senior Lecturer in information, archives and records management in the Department of Information and Communication Studies at the University of Namibia, in Southern Africa. She obtained a PhD in information studies, from the University of KwaZulu-Natal, South Africa, a Masters in Library and Information Studies from the University of Botswana, a Masters in Archives and Records Management from the University of Botswana, and BA Social Work and Administration from Makerere University, Uganda. She has published articles in peer reviewed journals. Her research interests are in audio visual records, health information systems (HIS), and public sector records. She has vast experience teaching in public and government institutions in Botswana, Namibia and Uganda. She has also conducted records management consultancies in various government and private organizations in Eastern and Southern Africa.

Simbarashe Chitima holds a Bachelor of Technology in Art and Design, Post Graduate Diploma in Tertiary Education, Master of Arts in Museum Studies and current a D Phil in Museum Studies student with the Midlands State University.

Floribert Endong (PhD) is a research consultant in the humanities and social sciences. He is a reviewer and editor with many scientific journals in the social sciences. His current research interest focuses on Afro-Asian cultures, globalization, religious communication, spirituality, Pentecostalism and sexuality. He is author of numerous peer-reviewed articles and book chapters on religious communication, spirituality and cultures.

Nyasha Gurira is a Lecturer at Midlands State University. Her research interests are in sustainable collections management in museums, sustainable cultural heritage tourism, heritage valuation and heritage conservation and management. She holds a Bachelor of Arts in Archaeology, Cultural Heritage and Museum Studies, Masters in Cultural Heritage Studies, and is currently undertaking her D. Phil Studies in Museum Studies.

Trywell Kalusopa is an NRF rated established researcher and senior academic in the information science discipline specializing in: digital records management; digital archives management, digital preservation, and, labour market information systems. Has academically attained associate professorial level and boasts of an impressive array of sustained research profile evidenced by several refereed journal articles; edited books, book chapters, public conference papers, technical policy reports and non-refereed monographs with a wide geographical spread of international, regional and national coverage. Has abundant evidence of mentoring junior scholars and colleagues and successfully supervised PhD and master's students in four different universities in Southern Africa (University of Zambia, University of Botswana, University of South Africa and University of Zululand).

Petronella Katekwe has research interests in the memorialization of Liberation Heritage in Zimbabwe, Records and Archival Administration in Zimbabwe, Cultural Heritage and legislation, stakeholder involvement and heritage management.

Segomotso M. Keakopa (PhD) has a wealth of experience and expertise in archives and electronic records management. She has served in various portfolios in the areas of information and records management in Botswana and the East and Southern African region. She has worked at the Botswana National Archives and Records Services (BNARS) as an Archivist; Botswana Unified Revenue Service (BURS) as Project Implementation Manager-Records Strategy and currently at the University of Botswana as Senior Lecturer. She also currently serves as post-graduate supervisor and internal examiner and reviewer of articles for International Journals across the world, notably in South Africa, Australia and Croatia. She has done research as well as consultancy in records management and is credited with several articles in international journals as well as book chapters. Her current research interests are electronic records management, e-government and impact of ICTs in archives and records management. During her career she has presented in conferences in South Africa, Mozambique, Zimbabwe, Kenya, Tanzania, Malawi, Namibia, Senegal and UK. Some of her key highlights in public/community serving research and consultancy activities in records and information management include: Development of a Strategic Plan for ESARBICA member countries to guide implementation of their Records Management Strategies (2015-17); Development of Records Management Strategy for the Botswana Unified Revenue Services (BURS) in 2008/09 and the same for SADC in 2009. She is currently part of the InterPares Project – Africa as part of Botswana team.

Lekoko Kenosi is Head of Archives - Qatar Foundation (Qatar National Library). Prior to that he was University Archivist and Records Manager for the King Abdullah University of Science and Technology in Saudi Arabia (KAUST). He has a Bachelor of Arts degree (BA) from the University of Botswana and a Masters' degree in Archival Studies (MAS) from the University of British Columbia, Canada. Lekoko has a Doctor of Philosophy Degree (PhD) in Information Science from the University of Pittsburgh, USA. He is a member of the UBC Interpares 3 project, ICA, SAA, ARMA, IASA and ESARBICA. Lekoko is a peer reviewer for Yale's Journal of Contemporary Archival Studies, the Emeralds journals, the ESARBICA journal and the South African Archives journal. He has published extensively in the area of archives, records and information management.

George Kiyingi is Senior Lecturer and Dean of the School of Library and Information Sciences, Makerere University in Uganda.

David Luyombya (PhD) is a Senior Lecturer in records management and archives administration in the East African School of Library and Information Science, College of Computing and Information Science, Makerere University, Uganda. He is also the Chair of the Department of Records and Archives Management. He holds a Ph.D. in archives studies from University College London. His thesis "Framework for Effective Public Digital Records Management in Uganda" was the first archival graduate study in Uganda. He is currenlty the chair of the Standards Committee of the Uganda Records and Archivists Association. He served as National Coordinator for the IDRC-funded research project on aligning records management with ICT, e-Government and Freedom of Information in East Africa (2010). He has also established records management systems for a number of institutions in Uganda including Bank of Uganda, Shell Uganda Limited, DFCU Bank and the Uganda Population Secretariat. In 2015 he was awarded a Fulbright African Research Scholar grant to conduct research in the United States in records and archives management curriculum. His research interests include public records management and application of ICT to management of records and archives. He has published articles in peer reviewed journals.

Marlvern Mabgwe is an archaeologist with research interests in Historical Archaeology of southern Africa, Public Archaeology and the Archaeology of Food in precolonial and colonial societies of southern Africa.

Nathan Mnjama is a Professor in the Department of Library and Information Studies, University of Botswana with specialization in Archives and Records Management. He has worked as an archivist and records manager at the Kenya National Archives and was responsible for the location and copying of Kenyan archives from the UK between 1980 and 1985. He has considerable experience in teaching and delivery of archives and records management programmes having lectured at the School of Information Sciences, Moi University Kenya, and since 1996 at the Department of Library and Information Studies University of Botswana where he has been instrumental in the design of archives and records management programmes. Prof Mnjama is a well-known speaker and presenter in archives and records management forums in East and Southern Africa, and he has written extensively in the field of archives and records management in Africa.

Olefhile Mosweu is currently working as a Records Management Officer for the Civil Aviation Authority of Botswana. He has a Masters in Archives and Records Management from the University of Botswana's Department of Library and Information Studies. He is now reading for a PhD in Information Science, Department of Information Science, at the University of South Africa. He holds a BA (History and English Language, and Literature in English) and a Post Graduate Diploma in Education from the University of Botswana. His research interest includes archives and records management, electronic records management, archival education and information systems. He is a member of ESARBICA, ICA, South African Society of Archivists. He is a Graduate Research Assistant for the InterPARES Trust's Team Africa.

Monica Naluwooza is an Archivist in Makerere University Library, Kampala, Uganda.

Ismael Ndlovu holds a Bachelor of Arts in Archaeology, Cultural Heritage and Museum Studies.

Cathrine Nengomasha is an Associate Professor in the Department of Information and Communication Studies at the University of Namibia. She has experience in managing records and information spanning over 30 years. She holds a PhD in information science. Her research interests include records, information and knowledge management; e-government and health information systems.

Thatayaone Segaetsho is a Conservator (April 2008 – Current) at the University of Botswana Library Services. He is currently a Secretariat of Africa China Research Group (ACRG) (June 2015-Current) at University of Botswana. He also served as an Assistant Secretariat (January 2013-December 2013) for The Review Committee of the Reorganization of the UB Administration, University of Botswana. He was a member of The Organizing Committee for the IFLA/RISS satellite meeting, The International Federation of Library Associations and Institutions (IFLA): Reference and Information Services Section (RISS) 2015 satellite meeting Gaborone. Mr Segaetsho have also worked at Imperial War Museum, Conservation department, London-UK (January-April 2012), Victoria and Albert's Museum, Conservation Department, London –UK (April- May 2012), City of Westminster Archives Centre, London SW1P 2DE (April-June 2011) on which he all worked as a Volunteer Conservator. He also worked at University of Botswana, Chemistry Department (August 2007 - April 2008) as a Demonstrator/Teaching Assistant. He have presented and participated in various conferences, seminars, and workshops both locally and internationally and have published papers on preservation related issues.

Alistair G. Tough is a Senior Lecturer in the Humanities Advanced Technology and Information Institute in the University of Glasgow. He is also the Archivist of NHS Greater Glasgow and Clyde. In 1999 and 2000 he was seconded to the Civil Service Department in Tanzania as an adviser to the Public Sector Reform Programme. He has undertaken Records Management consultancy work in Ethiopia, Malawi, Rwanda and Zambia. He has held research fellowships at Balliol College, Oxford and the universities of Michigan and Stanford. Between 2009 and 2011 he contributed to the development of a MLIS degree programme in Malawi which admitted its first students in 2015. In 2017 he carried out research on health management information systems and medical record keeping in Malawi in conjunction with Dr Paul Lihoma. In 2002 he received the Annual Award of the Records Management Society of Great Britain.

Anton C. van Vollenhoven (DPhil) has been a heritage specialist for more than 24 years. He holds a DPhil in Archaeology from the University of Pretoria as well as a DPhil in History from the University of Stellenbosch. Apart from working as researcher and museum manager for several years, he has been involved in Cultural Heritage Resources Management on a full-time basis for the past 11 years, working in all eleven provinces of the RSA as well as Lesotho. He also lectured in Archaeology and Museum studies and Heritage Management at the University of Pretorias. In 2015 he was appointed Extraordinary Professor of History at the Mafikeng Campus of the North-West University. He have authored more than 80 works in his field and delivered more than 60 papers at national and international conferences. He serves a term as councillor for the South African Heritage Resources Agency and currently is serving a second term as councillor for the Provincial Heritage Resources Authority of Gauteng. Anton is an accredited professional member of both the Association of South African Professional Archaeologists and the South African Society for Cultural History. Anton is frequently involved in the writing of regulations for heritage authorities in South Africa. With his extensive exposure to dealing with heritage related to mining projects, he has a thorough understanding of dealing with such.

Marilena Vecco is Associate professor in Entrepreneurship at Burgundy Business School, Dijon (France). She holds a PhD in Economic Sciences at University Paris 1, Panthéon Sorbonne, a PhD in Economics of Institutions and Creativity at University of Turin (I) and a MBA executive in International Arts Management from the University of Salzburg Business School in collaboration with Columbia College, Chicago. Between 1999 and 2010 she was head of research of the International Center for Arts Economics (ICARE) and Research Fellow and Adjunct Professor of Cultural Economics and Art markets at the University Ca' Foscari of Venice. Her research focuses on cultural entrepreneurship and management with a special focus on cultural heritage (tangible and intangible) and art markets. Marilena has over 17 years of academic and professional experience as a researcher, lecturer, and consultant. She has researched and consulted for several public and private organisations, including OECD, Centre for Entrepreneurship, SMEs and Local Development, World Bank, and The European Commission. She is the author of several books (recently published: The power of partnerships: Necessity or luxury in the cultural and creative sectors? With E. Konrad, Creative industries and entrepreneurship: paradigms in transition from a global perspective with L. Lazzeretti), book chapters and articles published on different journals: Journal of Cultural Heritage, Journal of Cultural Economics, Journal of Economics Behaviour and Organisations, Creativity and Innovation Management, etc. She is board member of ENCATC (European network on cultural management and policy).

Helene Vollgraaff (PhD) has 26 years' experience in the museum sector. She worked as curator/scientist focusing on the heritage of new social movements and memory projects at Iziko Museum of South Africa and more recently as heritage policy research specialist at the National Heritage Council. She was a member of the panel of experts drafting a Policy for National Museums for the Department of Arts and Culture. Currently, she works as an independent heritage and museum practitioner and teaches museum management in the University of the Western Cape's postgraduate diploma in heritage management. She served on the Council of the South African Museum Association from 2000 – 2007 and on the Executive Board of the South African National Committee of the International Council of Museum (ICOM-SA) from 2006 – 2010 and 2013 – 2016, the latter term as Chairperson of the Board. She is currently the Secretary of ICOM's International Committee on Collecting (COMCOL). She holds a D.Phil degree in Political Studies from the University of Stellenbosch and is a UNISA Research Fellow. She published on museology, heritage policy and heritage crime.

Index

U

Uganda 96-97, 100, 102-103, 113, 118, 166, 186, 258, 275-278, 280, 282-285, 287-288, 293

UNESCO 14-15, 126-127, 132, 134, 141-142, 149, 152, 156-158, 162, 165, 322-324, 326, 329, 356, 370, 373-374, 382, 435

University Archives 96-98, 100-109, 113

University Archives Users 108-109, 113

University Library 96-97, 104, 113, 119, 166, 432

V

Vital Records 213, 216, 221, 226-228, 274

W

Wahlberg bats 399, 404-405

Web Archiving 155, 159-160, 174

Westernization 321, 323, 325-332, 334-335, 339

wildlife conservation 118

Z

Zimbabwe Military Museum 397, 409

Zimbabwe Museum of Human Sciences 409, 411, 436

Information Resources Management Association

Advancing the Concepts & Practices of Information Resources
Management in Modern Organizations

Become an IRMA Member

Members of the **Information Resources Management Association (IRMA)** understand the importance
of community within their field of study. The Information Resources Management Association is an ideal
venue through which professionals, students, and academicians can convene and share the latest industry
innovations and scholarly research that is changing the field of information science and technology.
Become a member today and enjoy the benefits of membership as well as the opportunity to collaborate
and network with fellow experts in the field.

IRMA Membership Benefits:

- **One FREE Journal Subscription**

- **30% Off Additional
 Journal Subscriptions**

- **20% Off Book Purchases**

- Updates on the latest events and research on
 Information Resources Management through
 the IRMA-L listserv.

- Updates on new open access and downloadable
 content added to Research IRM.

- A copy of the Information Technology Management
 Newsletter twice a year.

- A certificate of membership.

IRMA Membership $195

Scan code or visit **irma-international.org** and begin by
selecting your free journal subscription.

Membership is good for one full year.

Lightning Source UK Ltd.
Milton Keynes UK
UKOW05n0321170118
316292UK00016B/475/P